64TH
ART
DIRECTORS
ANNUAL

D0786342

64TH
ART
DIRECTORS
ANNUAL

CREDITS

Book Division President
Ernest Scarfone
Book Division Committee
Bob Ciano
Blanche Fiorenza
Steve Heller
Andrew Kner
Jack G. Tauss
Call for Entries &
 Annual Book Design
Gene Federico
ADC Executive Administrator
Diane Moore
Editor
Paula Radding
Art Director
Ryuichi Minakawa
Category Dividers
Andrew Unangst
Pairoj Pugsasin
Exhibition
Paula Radding, Supervisor
Michael Chin,
 Assistant Supervisor
Daniel Forte
Glenn Kubota

Published by ADC Publications

Copyright © 1985 by the
Art Directors Club, Inc.

ISBN 0-937414-05-0

BOOK PACKAGING
Frank DeLuca
Supermart Graphics, Inc.
P.O. Box 900
Murray Hill Station
New York, New York 10156

TYPOGRAPHY
Gerard Associates
 Phototypesetting, Inc.
163 West 23rd Street
New York, NY 10011

MANUFACTURING
Toppan Printing Company
Tokyo, Japan

DISTRIBUTION
UNITED STATES
Robert Silver Associates
307 East 37th Street
New York, NY 10016

CANADA
General Publishing Co. Ltd.
30 Lesmill Road
Don Mills, Ontario M3B 2T6

EUROPE AND THE U.K.
Graphis Press Corp.
107 Dufourstrasse
CH-8008 Zurich
Switzerland

OTHER COUNTRIES
Fleetbooks, S.A.
c/o Feffer and Simons, Inc.
100 Park Avenue
New York, NY 10017

TABLE OF CONTENTS

HALL OF FAME

The criterion for a person to be inducted into the Hall of Fame is "one whose continuous, distinguished efforts—decade after decade and throughout an entire career—have made significant contributions to the field of art direction."

Such are the glittering records of achievements of the three laureates who have been elected to be inducted into this year's Hall of Fame.

Art Kane, Len Sirowitz and Charles Tudor are three individuals whose careers have not only distinguished each of them but have also left an indelible impression on the fields in which they practiced as well as upon all who have ever been associated with them.

It is hard to imagine the voids that would have existed in our field without their contributions.

The addition of their names to the distinguished list of artists who have already been inducted into the Hall of Fame honors all of us who have chosen to honor them.

Aaron Burns
Hall of Fame Chairman, 1985

HALL OF FAME SELECTION COMMITTEE

HALL OF FAME MEMBERS

1972
M.F. AGHA
LESTER BEALL
ALEXEY BRODOVITCH
A.M. CASSANDRE
RENÉ CLARKE
ROBERT GAGE
WILLIAM GOLDEN
PAUL RAND

1973
CHARLES COINER
PAUL SMITH
JACK TINKER

1974
WILL BURTIN
LEO LIONNI

1975
GORDON AYMAR
HERBERT BAYER
CIPE PINELES BURTIN
HEYWORTH CAMPBELL
ALEXANDER LIBERMAN
L. MOHOLY-NAGY

1976
E. McKNIGHT KAUFFER
HERBERT MATTER

1977
SAUL BASS
HERB LUBALIN
BRADBURY THOMPSON

1978
THOMAS M. CLELAND
LOU DORFSMAN
ALLEN HURLBURT
GEORGE LOIS

1979
W.A. DWIGGINS
GEORGE GIUSTI
MILTON GLASER
HELMUT KRONE
WILLEM SANDBERG
LADISLAV SUTNAR
JAN TSCHICHOLD

1980
GENE FEDERICO
OTTO STORCH
HENRY WOLF

1981
LUCIAN BERNHARD
IVAN CHERMAYEFF
GYORGY KRIKORIAN
WILLIAM TAUBIN

1982
RICHARD AVEDON
AMIL GARGANO
JEROME SNYDER
JEROME VIGNELLI

1983
AARON BURNS
SEYMOUR CHWAST
STEVE FRANKFURT

1984
CHARLES EAMES
WALLACE ELTON
SAM SCALI
LOUIS SILVERSTEIN

1985
ART KANE
LEN SIROWITZ
CHARLES TUDOR

ART KANE

A rt Kane was fascinated by snakes and fairy tale illustrations. He was the first boy scout in the Bronx to get a Reptile Study merit badge (he had 32 snakes) and he wanted to be a Norman Rockwell or N.C. Wyeth when he grew up. Drafted after his first semester at Cooper-Union, he volunteered for a camouflage battalion. He thought he would be painting jungle patterns on trucks but his real mission was to act as a decoy to deflect German artillery from American troops. He survived.

Kane pursued a theatre career for about a year after his army discharge. He returned to Cooper-Union and graduated in 1950 with straight A's. He took one photography course in his senior year but only because it was a requirement. His first experience with a camera, at age 12, had been a bad one. His photograph of the American flag gloriously waving atop a towering flagpole, looked like a pinstripe topped with a pinhead. Content did not follow concept.

At age 26, Kane was art director for Seventeen magazine. Professionally, it was satisfying to work on a magazine under the influence of Cipe Pineles who had a high regard for illustration, particularly for a freer, more painterly approach. Kane worked at Seventeen for six years and for six years received awards for his art direction.

In the meantime Kane was exploring photography on weekend outings with talented friends like art director, Roy Kuhlman and photographers, Dan Wynn and Carl Fischer. Kane also went shooting with Rudolph DeHarak who was then art director for the promotion department of Seventeen. DeHarak was an avid experimenter and urged Kane to be daring with the camera. It was with DeHarak that Kane remembers the revelation of discovering he could *control* the camera. It happened on Queens Boulevard, in front of a Howard Johnson sign. Content could follow concept.

Kane joined the Irving Serwar Agency, an outstanding fashion advertising house, in 1956. He continued to serve as an art director but his passion for photography grew. He studied with Alexey Brodovitch who nurtured and provoked photographic talent at The New School. Kane submitted work to photo annuals and was accepted.

In 1958 Kane spent his summer vacation on a photography assignment that changed his life. Esquire art director, Robert Benton and editor, Harold Hayes hired

him to do photographs for a story on the history of jazz. His portraits of Louis Armstrong, Lester Young and Duke Ellington, his shot of Charlie Parker's grave and finally his grand, sepia-toned jazz alumni photograph proved that the mind's eye and the heart's vision could speak on film. Mission accomplished, Kane gave up art directing to pursue photography full time.

With the strong conceptual skills of an art director and the discriminating eye of a photographer, Kane conceived and produced

HALL OF FAME

some of the most memorable and striking images of the past three decades. Not exactly documentary nor strictly journalistic, Kane's work is best described as photo-illustration. The images tell half a story, the viewer fills in the rest. While there is no one unifying style and in fact the variety of Kane's subject matter is remarkable, all of his photographs have an arresting quality. Odd angles, weird settings, saturated colors—we never see things as they are or ought to be. What we see is a sort of Freudian, reptilian otherworld which strikes some archetypal chords.

Kane's work has appeared in LIFE, LOOK, Esquire, Vogue, Harper's Bazaar, Italian Bazaar, GEO, Venture, McCall's, Italian and German Vogue, Amica, Stern and Zeit. For LIFE, Kane did portraits of rock stars The Who, Cream and Jefferson Airplane. He posed the rough, tough and hairy Mothers of Invention with smooth, clear-skinned babies. He shot Bob Dylan crouching in a corner. He put Jim Morrison in a green-tinged closet, a TV set turned on at his solar plexus, as if his life-force were run by game shows and sit-coms. For Esquire, Kane shot a somber, poignant Joe Louis for the story, "The Champ at 50." For the German magazine Zeit, New York School artists Larry Rivers, Christo, Cy Twombly and Robert Rauschenburg were depicted in a manner which bespoke each one's artistic sensibility: Larry Rivers standing on a macabre suburban porch, Christo here-one-minute-gone-the-next, and Twombly and Rauschenburg part of a Rauschenburg-style found object montage of newspapers and a snapshot.

Kane's illustrative vision translated the 60s' and 70s' counter-cultures, political upheavals and spiritual rejuvenation. A series of Kane's montage photographs accompanied the lyrics to songs by The Beatles in an issue of LIFE. For LOOK, Kane produced a powerful photo-essay to "Songs of Freedom" by posing studio model/dancers to evoke the tension and struggle of Southern blacks. He photographed the Viet Nam war, not in blood and guts but in the unnerving stare of an amputee. He documented the California throw-away culture with a towering junk car pile and he brought the West Coast world of therapeutic psycho-spiritualism into photos which merged the human body with the omnificent sun, sea and sky.

The fashion photos for Vogue, Stern, Harper's and other publications are characteristically a mix of oddly postured women in unconventional sets. Like Kane's editorial work, the commercial imagery evokes the same kind of storytelling, always with an unusual twist. For a spread on hosiery, the legs seem detached from the body. For an outerwear ad, the model is colored to match the coat. A bathing suit shot is not taken, as expected, at the beach or poolside, but on the roof of a checkered cab. The fashions are rendered in such painterly terms of color, texture and form, they become indistinguishable from the total sensual experience of the photograph.

The list of Kane's commercial clients is long and diverse: advertising campaigns for Marlboro, Camels, True, Virginia Slims and Gitanes cigarettes; beer ads for Miller, Heineken and Lowenbrau; automobile ads for Volvo, Saab and Volkswagen; ads for Coca Cola, Sears and Johnson & Johnson; campaigns for United Airlines, TWA, American Airlines, Eastern and British Airways; fashion layouts for Bloomingdale's, Cacharel, Revlon and Coty; and promotional publications for Heinz, Avis, Champion Paper, Hennegin Press, Zanders Paper and Exxon. Kane is extremely versatile as the scope of his work will attest, yet all his assignments bear the unique personal interpretation which gives the photographs their impact.

Kane's photographic techniques are fairly straightforward. With an emphasis on pre-production, he eschews the utilization of complicated equipment or manipulated processing. The one altering activity to which he has devoted time is sandwiching slide images for montage. This is a technique which Kane refined to great subtlety by using similar images whose separateness is barely discernible. The use of montage, selective focus, wide-angle lenses and inverted images approaches cliché status today but in the 60s and 70s, Kane's inventiveness was truly pioneering. His use of a 21mm lens to stretch an image to the edges of the frame was very controversial when it appeared in a Vogue fashion spread in the early 60s.

Art Kane is also a songwriter, lyricist and playwright. He has directed TV commercials. He was corporate design director for Penthouse-Viva International. His photographs are in the permanent collection of the Museum of Modern Art and the Metropolitan Museum. He has been honored by almost every photo-design organization in the United States: American Society of Magazine Photographers, Photographer of the Year, 1964; Newspaper Guild of America, Page One Award, 1966; Augustus Saint-Gaudens Medal for Distinguished Achievement given by Cooper-Union, 1967; New York Art Directors Club, 14 Medals and 28 Awards of Distinctive Merit; medals and awards from Philadelphia, San Francisco, Chicago, Detroit and New Jersey art directors clubs; and awards from the AIGA, Society of Typographic Arts and Communication Arts Magazine. In 1984 Kane was given the American Society of Magazine Photographers Lifetime Achievement Award.

When Art Kane made the monumentous decision to be a photographer, he vowed to himself that he would not compromise his craft for the lure of money or security. After thirty years of shooting, he is still excited about each assignment. And his work remains unmatched.

ART KANE

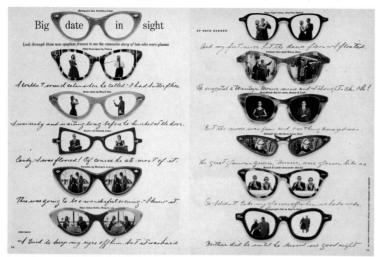

Seventeen, Peter Dimitri, photographer, 1954

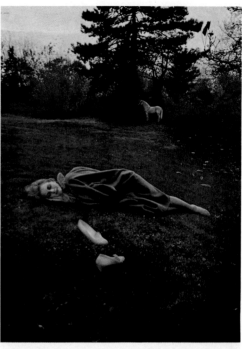

Bert Stern, photographer, 1956

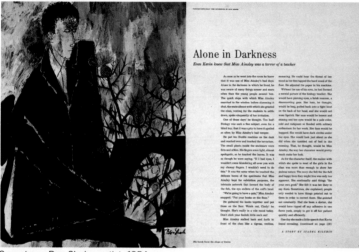

Seventeen, Ben Shahn, artist, 1954

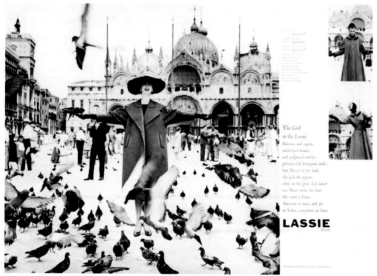

Richard Avedon, photographer, 1957

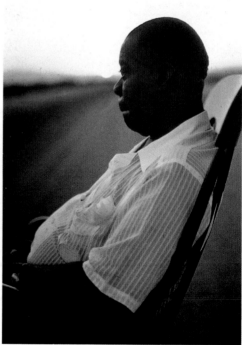

Louis Armstrong, Esquire, 1958

HALL OF FAME

Hopi Indian, LIFE, 1970

Mothers of Invention, LIFE, 1968

Issey Miyaki Collection

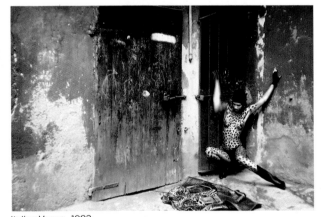

Italian Vogue, 1983

Cacharel Men's Fashions, 1977

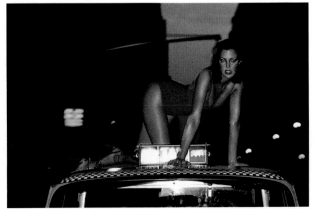

Red Swim Suit, 1974

LEN SIROWITZ

Len Sirowitz was chosen as "The Number One Art Director in America" in 1968 and 1970 polls taken by Ad Daily. He was then Senior Vice President and Creative Management Supervisor at Doyle Dane Bernbach and his accounts included corporate giants like Mobil, Volkswagen and Sony, regional accounts such as Laura Scudder Potato Chips and Rainier Beer and national advertisers like Sara Lee and Parker Pens. He credits DDB with providing the creative environment which encouraged talent like his to produce award-winning advertising. To work at DDB was to be part of the creative revolution of the 60s and for Sirowitz it was like being a team member for the 1927 Yankees. The other players on the art side included Helmut Krone, Bob Gage and Bill Taubin. On the copy side were Phyllis Robinson, Dave Reider, Leon Meadow, Ron Rosenfeld and Bob Levenson. The managing genius was Bill Bernbach.

In 1966 Bernbach dissuaded Mobil from doing a conventional centennial celebration and instead Sirowitz developed a campaign which came to be an exemplar for public service advertising. The powerful print and television ads drew attention to a topic of current national interest, highway safety, while promoting a caring corporate image for Mobil. In the midst of Ralph Nader's crusade for safer automobiles and numerous congressional reports on traffic fatalities, explicit ads like "Til death us do part" and "Fresh killed chicken" brought the problem close to home. One of the TV spots comparing a car falling off a ten-story building to a crash at 60 mph, is a classic in public service commercials and won a prize from Rutgers University for best corporate public service campaign.

The Better Vision Institute was another example of an account for which Sirowitz success-

fully personalized an issue, in this case the plight of people with vision problems. Sirowitz chose photographs by "new" talent Dick Richards, Phil Marco and Steve Horn for the numerous print ads which ran in LIFE and LOOK magazines. The photographs re-created the world of the blind and visually impaired as in "Why Johnny can't read," the best-known of the campaign which showed a blurry blackboard as if seen by a child with poor vision. The power of the ads to both inform and evoke an empathetic response is exemplified in the ad featuring a cross-eyed but otherwise normal little girl with the headline, "Why did Anne Flynn's parents allow us to use this picture?"

Sirowitz's talent for reaching the American public helped launch Sony products into the U.S. market in the mid 60s. Sony had introduced a startling 4"-wide TV set which though expensive, was a technological breakthrough in portability. In trying to portray practical uses for this new product, Sirowitz and copywriter Ron Rosenfeld hit upon an ingenious print campaign which showed an "average guy" enjoying the 4" Sony on his lap, "Pee Wee Tee Vee," on his stomach, "Tummy Television," and hanging around his neck, "The Walkie-Watchie."

The Volkswagen account was one of Sirowitz's tougher challenges. The basic and successful

HALL OF FAME

look of Volkswagen advertising had already been established by Helmut Krone when Sirowitz took over the account in 1962. He continued in Krone's style but infused his own blend of bluntness and humor as in the magazine ad which read "Will we ever kill the bug?" and pictured a VW beetle playing dead.

Sirowitz is a genius at finding a selling angle for his clients. Parker Pens for instance needed an idea to sell their fountain-type pens in a market of inexpensive ball-points. Sirowitz developed a TV campaign which conceptualized the ability of the pen to transmit and embellish the emotions of the writer. In these spots, "Puts new meaning into anything you write," the Parker Pen becomes a versatile conveyer of eloquent love or consumer anger or ultimately whatever the user wants it to be. With copywriter Bob Levenson, Sirowitz devised a memorable TV campaign for Sara Lee Baked Goods with the very catchy theme and song, "Everybody doesn't like something, but nobody doesn't like Sara Lee."

Sirowitz's regional accounts at DDB were just as notable as his national ones. Television commercials for Laura Scudder Potato Chips on the West Coast pioneered an accentuated audio effect equating crunchiness with freshness. In "The Noisiest Chips in the World" an incredibly cute child mimics a delightfully silly adult, riveting the viewer's attention to the ensuing dialogue. For Rainier Beer, also located on the West Coast, Sirowitz produced a full-page, poster-like newspaper campaign which won for best campaign in the R.O.P. Color Newspaper Awards in the early 60s.

While at Doyle Dane, Sirowitz put his advertising skills to another use—political activism. Working for organizations like SANE, Coalition for a Democratic Alternative and later for Eugene McCarthy's presidential campaign, Sirowitz galvanized the anti-war sentiments of middle class Americans, the so-called Silent Majority, to give the anti-war movement cross-generational scope and respectability. Like much of his advertising, the political work touched the average American. In a candid and convincing style, "Fathers and sons together against the war," "Press Button to End War," and "Man VS. Machine" sent the message that peace was not just the banner of long-haired crazies.

Sirowitz came to DDB with art directing experience at Channel 13, CBS Network TV, Grey Advertising and L.W. Frolich, a pharmaceutical agency. He remained with Doyle Dane for 11 years and though the idea of starting his own agency had always been tempting, the plunge to independence was really a spur-of-the-moment decision. He happened to run into Hubert Graf, advertising manager for Swiss Air who asked if he could recommend an agency for the airline. Without thinking, Sirowitz answered "mine" and thus committed, he recruited Ron Rosenfeld also from Doyle Dane, and Tom Lawson from Ogilvy & Mather.

Swiss Air was the first account of Rosenfeld, Sirowitz and Lawson, Inc. The agency broke the previous advertising mold of dimpled girls and snow-covered Alps and instead featured a bikini-clad blonde with the headline, "Heidi Lied." A campaign for ABC-TV won an Art Directors Club Award. A recruitment campaign for Pratt Institute which featured successful former graduates, won a gold award in The One Show. As Co-Chairman and Co-Creative Director, Sirowitz has helped build RS&L to over $140 million in billings since 1971. The firm's blue chip accounts include McDonald's, Chase Man-

hattan, Smith-Corona, Beatrice, Champion International and Charles of the Ritz. In 1979 Rosenfeld, Sirowitz and Lawson was named "Hottest Medium-Size Shop of the Year" by ANNY (now ADWEEK).

Sirowitz's work is persuasive because it is both intelligent and human. The print ads are bold, direct, sometimes humorous, sometimes poignant and always wonderfully thought-out. One of the outstanding features is how perfectly the copy and the art complement each other for maximum impact. It is as if both are conceived simultaneously. In fact, Sirowitz often functions as both art director and copywriter. The succinct headline style of Sirowitz's print work suggests a newsworthy message not to be ignored. Likewise Sirowitz's television commercials are neither technically overpowering nor esoteric but attention-getting by virtue of their clean, compelling style. The human element whether sad or silly, familiar or fanciful, imparts an accessibility which gives the message meaning.

Sirowitz has won over one-hundred awards for creativity in advertising from the New York Art Directors Club, Communication Arts, The Advertising Club of New York, American Institute of Graphic Arts, Saturday Review of Literature, The One Club for Art and Copy, the Cannes Film Festival and the American TV Film Festival. His commercials for Mobil, Volkswagen and Laura Scudder have been permanently installed in the Clio Hall of Fame. Most recently he was awarded an honorary Doctorate of Fine Arts from Pratt Institute where he graduated in 1953. Sirowitz is the quintessential art director, an idea man possessing sharp skills, precise instinct and a passion for his profession.

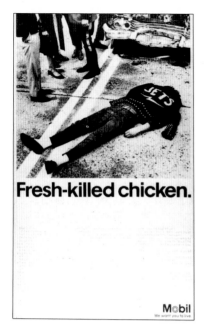

Fresh-killed chicken.

Mobil
We want you to live.

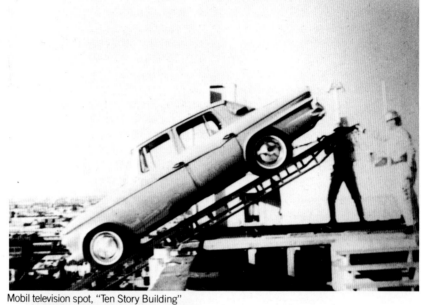

Mobil television spot, "Ten Story Building"

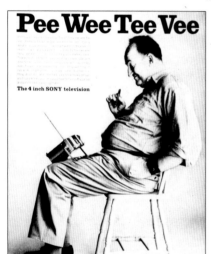

Pee Wee Tee Vee

The 4 inch SONY television

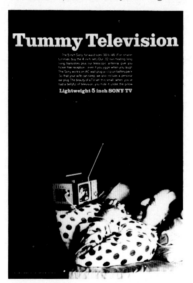

Tummy Television

Lightweight 5 inch SONY TV

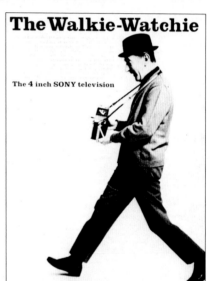

The Walkie-Watchie

The 4 inch SONY television

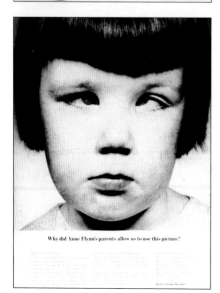

Why did Anne Flynn's parents allow us to use this picture?

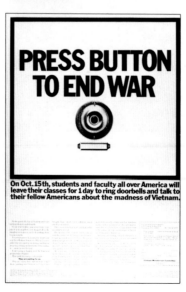

PRESS BUTTON
TO END WAR

On Oct. 15th, students and faculty all over America will
leave their classes for 1 day to ring doorbells and talk to
their fellow Americans about the madness of Vietnam.

HALL OF FAME

Will we ever kill the bug?

We learned something from the big boys.

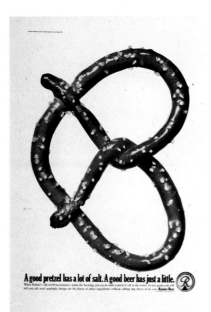

A good pretzel has a lot of salt. A good beer has just a little.

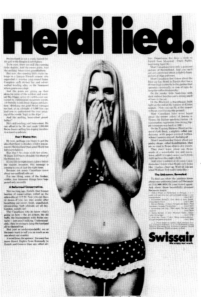

Heidi lied.

Swissair

This is what Heidi really looks like.

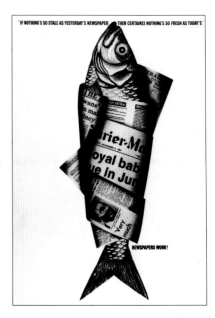

NEWSPAPERS WORK!

CHARLES TUDOR

Charles Tudor began his design career as a staff artist for the Cleveland Press. He was twenty years old, a graduate of the Cleveland Art School and the year was 1923. After three years at the Press he obtained a leave of absence to study in Paris. His employer thought it was for four weeks. Tudor intended on staying a year. He returned from Paris after five weeks and joined the New York Telegram in Cincinnati. Tudor was fired from the Telegram by the police reporter about whom Tudor said, "I don't think he liked my work." Broke, Tudor returned to Cleveland and in 1930 took a job as staff artist with Parade, a short-lived publication based in Cleveland.

Parade had a column called "Spinach and Vinegar" which contained bios of staff members as well as letters, pro and con, to the editor. The January 7, 1932 issue featured Charles Tudor and said, he "has drawn more slings and arrows from outraged readers than any other member of Parade's staff . . . An instance is Mr. Tudor's "The Runway," depicting a lusty, strident burlesque show. Though Parade published this picture more than a month ago, occasional letters of praise and protest still come in."

Tudor was dedicated to his artistic ideals and his journalistic ethics. His ambition was to be a painter and as much as his pursuant career was to demand from him, he continued to do pictorial work in oils and watercolors. He was also a man dedicated to his humanitarian ideals. During the depression years of 1935 and 1936 he went to work for the Rural Resettlement Administration in Washington. Along with Roy Stryker and photographers Dorothea Lang, Walker Evans and Carl Mydans, Tudor created a vivid and

1903 - 1970

compassionate picture of rural poverty. His experience in Washington was significant in another way. He worked with an extremely talented group of writers and artists, all of whom shared a conviction that their talents could affect a positive change on American society. Writer John Fischer went on to become editor for Harper Magazine. Artist Aurelius Battaglia became one of the first illustrators for Disney Studio and Robert Thorpe and Carl Mydans went with Tudor

to the newly formed LIFE magazine, Thorpe as editor and Mydans as photographer.

Tudor worked on Vol. 1, no. 1 of LIFE magazine in 1936. He was to remain at LIFE for 21 years. He did not however indulge himself in the security which LIFE offered. For a two-year period, Tudor took risks and accepted challenges which he felt worthy of his time and skills. Between 1939 and 1941 he was art director for a new venture newspaper called P.M., art

director for En Guardia, published by the Office of Inter-American Affairs, and art director for the Office of Emergency Management.

Tudor returned to LIFE the day after Pearl Harbor was bombed. In 1945 he was named art director and by 1955 he had, literally, changed the face of the magazine. In 1947 he began what was to be an eight-year project to design and manufacture a new typeface for LIFE. It would be an exclusive type which could accommodate the existing format and enhance the bold photojournalism which was the mark of the magazine. Tudor had thousands of existing type styles from which to choose but dissatisfied with the selection, he decided to design the type himself. The manufacture of LIFE's new face was beset by production problems which Tudor doggedly battled and won.

Tudor's first idea, for a style in which each letter graduated into seven width sizes, had to be shelved when production cost estimates ran to a quarter of a million dollars. But even with a more easily produced face in tow, Tudor was turned down by foundries and type manufacturers backlogged with post-World War II orders and not amenable to receiving no royalties or resales. Finally Tudor worked out an arrangement with Ed Rondthaler and Harold Horman, type engineers who freelanced with the Lanston Monotype Machine Co. in Philadelphia. Tudor, Rondthaler and Horman tested various sizes, measured for uniform impressions and ironed out technical problems. Even after all specifications were met, it wasn't until 1954 that the production go-ahead was granted by LIFE general manager, Arthur Murphy, Jr. The six to 60 pt. sizes were manufactured at a rate of one size per month. By 1956 the complete

range was ready.

Tudor Gothic made its debut as the body text accompanying the much acclaimed "Family of Man" photographic essay in the February 4, 1955 issue of LIFE. It was permanently incorporated into the magazine's table of contents format in March of the same year.

The changes in printing technology which LIFE pioneered such as high-speed rotary presses, simultaneous printing on both sides of coated stock, high-temperature ink drying and automatic stitchers and trimmers, presented constant challenges to Tudor's art direction. With the advent of the portable 35mm camera, LIFE was the first magazine to make use of it and new techniques in printing and papermaking. The result was the reproduction of photographs of unrivaled quality for a mass-produced magazine. Charles Tudor helped to usher in a new era of photojournalism. He worked with photographers on the caliber of Ernst Haas, Eliot Elisofon, Mark Shaw, W. Eugene Smith, Margaret Bourke-White and Gordon Parks. Tudor's work was not confined to the weekly pages of LIFE. A story on the Sistine Chapel for which Tudor experimented with a dozen printed colors rather than the usual four, was copied and incorporated into the Vatican exhibit at the 1964 World's Fair. It was also featured in the reception center of the TIME-LIFE building. Because LIFE was not strictly a reporter of news, Tudor was also involved with interpretive photo-essays and illustrated articles which required both the newsman's skills and the artist's vision. Tudor may well have been the most-seen art director in America. By 1946, LIFE had the highest mass circulation of an American weekly: 5,200,000 paid circulation and 22,500,000 readers.

To his co-workers and friends, he was known as Charlie. He could ruffle feathers if he deemed it necessary yet the targets of his outbursts understood that it was a compliment. Charlie never wasted his anger on people not worthy of it. The other side of Charlie was relaxed, humorous, pleasant. Carl Mydans saw him as the calm in the midst of a storm of tempermental artists, territorial writers and crushing deadlines.

Between 1949 and 1959 from the Art Directors Club alone, Tudor won five Club Medals and ten Awards for Distinctive Merit. He continued as a contributing artist to The New Yorker, Town & Country, and Parade magazines. He was a designer for Standard Oil's magazine, The Lamp, and for Vision, a Spanish language magazine. He designed several books; Margit Varga's *Christmas Story* (1946), *American Past* by Roger Butterfield (1947), *LIFE's Picture History of Western Man* (1951), *The World We Live In* (1955), *The World's Great Religions* (1957), *Wonders of Life on Earth* (1960) and *LIFE's Pictorial Atlas of the World* (1961).

In 1961 Tudor was promoted to Director of Quality Control in Corporate Production, responsible for the quality of printing and reproductions in TIME, LIFE and SPORTS ILLUSTRATED. In 1970, five years after retiring, Charles Tudor died. He was 66 years old and had accomplished a great deal.

Ed Thompson, managing editor of LIFE for many years and a friend of Charlie said "(he) taught us all a lot about being an honest human being—the only real kind—and being good journalists, who represent an honorable trade."

HALL OF FAME

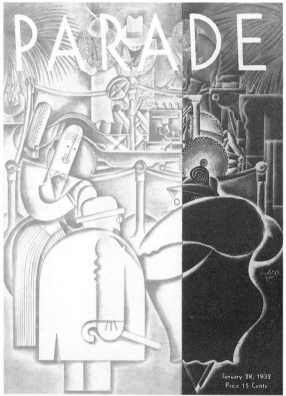

Parade cover, 1932

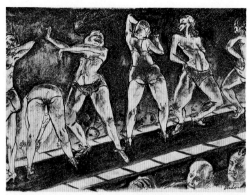

"The Runway," Parade, 1932

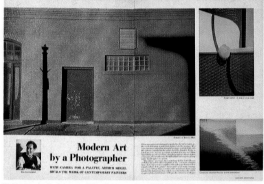

"Modern Art by a Photographer," LIFE, November 1950

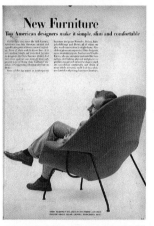

"New Furniture," LIFE, November 1948

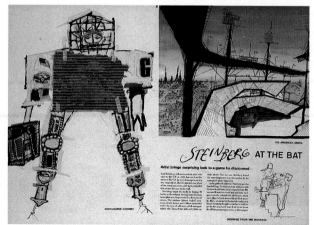

"Steinberg at the Bat," LIFE, July 1955

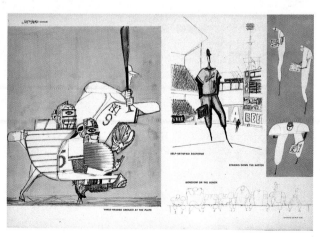

HALL OF FAME

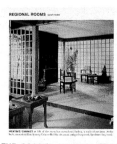

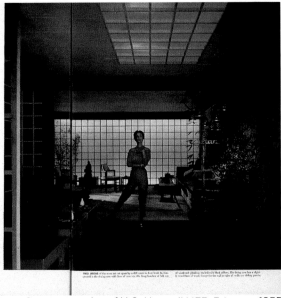

"Cross-Country roundup of U.S. Homes," LIFE, February 1955

"Tudor Gothic" table of contents, LIFE, March 1955

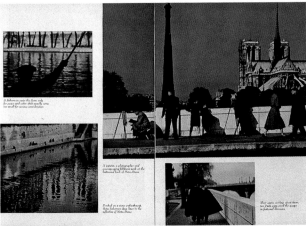

"The Glow of Paris," LIFE, August 1955

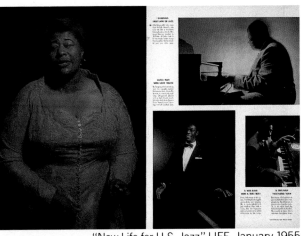

"New Life for U.S. Jazz," LIFE, January 1955

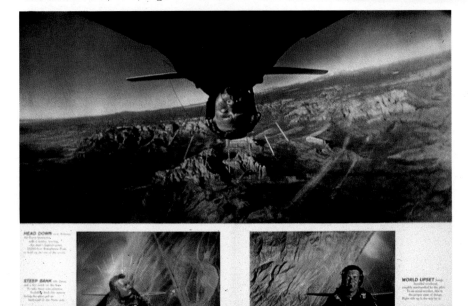

"Man's High New Realm," LIFE, June 1956

Newspaper advertising: Half page or less, b&w
More than half page, b&w
Campaign, b&w
Double page spread or less, color
Campaign, color
Public service
Public service campaign
Political
Section, insert, supplement

Distinctive Merit

Art Director Bob Barrie
Artist Bob Barrie
Writer Phil Hanft
Client The Minnesota Zoo
Agency Fallon McElligott Rice, Minneapolis, MN
Publication Minneapolis Star & Tribune

THE MOST PHYSICAL AUSTRALIAN IMPORT SINCE OLIVIA NEWTON-JOHN.

First they send us Olivia. Then they send us Men at Work and The Man from Snowy River.
Now they want us to take eight Red-necked Wallabies off their hands. Ha. We'll take them. But only
until Labor Day. See them 9:30 AM until 6 PM daily. **The Minnesota Zoo**

2

Art Director	Jeff Laramore
Designer	Jeff Laramore
Artist	Jeff Laramore
Writers	David Jemerson Young, John Young
Client	The Shorewood Corporation
Agency	Young & Laramore, Indianapolis, IN

3

Art Director	Bob Barrie
Photographers	Jim Arndt, Arndt & Berthiaume Photography
Writer	Phil Hanft
Client	Nankin Express
Agency	Fallon McElligott Rice, Minneapolis, MN
Publication	St. Paul Pioneer Press

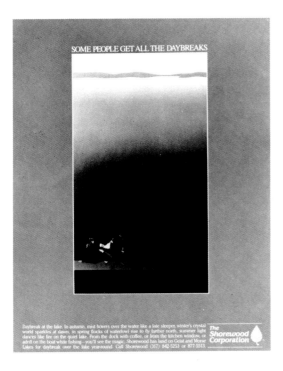

4

Art Director	Mike Murray
Artist	Stan Olson
Writer	Bob Thacker
Client	Rogers Cablesystems
Agency	Chuck Ruhr Advertising, Minneapolis, MN
Publication	Minneapolis Star & Tribune

5

Art Director	Brooke Kenney
Artist	Cindy Berglund
Writer	Mike Dodge
Client	Control Data Corporation
Agency	Dodge and Kenney, Inc., Minneapolis, MN
Publication	Contact

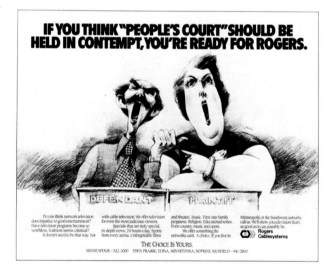

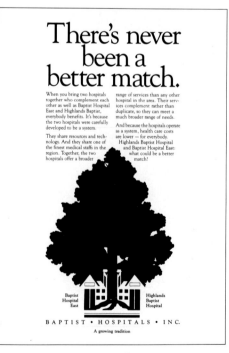

10

Art Director	Mike Murray
Photographer	Jim Arndt
Writer	Bill Johnson
Client	Metropolitan Medical Center
Agency	Chuck Ruhr Advertising, Minneapolis, MN
Publication	Minneapolis Star & Tribune

11

Art Director	Joe Hawkins
Designer	Pat Mollica
Artist	Pat Mollica
Writer	Michael Jones-Kelley
Client	Ramada Renaissance Atlanta
Agency	Evans/Atlanta, Inc., Atlanta, GA
Creative Director	Michael Jones-Kelley,

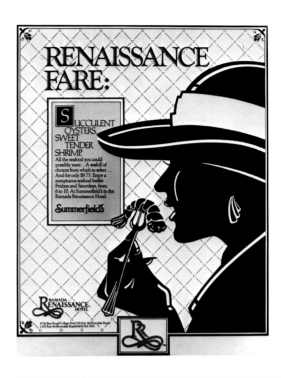

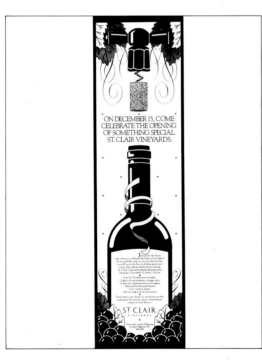

12

Art Director	Rick Vaughn
Designer	Rick Vaughn
Artist	Mark Chamberlain
Writer	Donna Williams
Client	St. Clair Vineyards
Agency	Vaughn/Wedeen Creative, Inc., Albuquerque, NM

13

Art Director	Mike Murray
Artist	Stan Olson
Writer	Bob Thacker
Client	Rogers Cablesystems
Agency	Chuck Ruhr Advertising, Minneapolis, MN
Publication	Minneapolis Star & Tribune

14

Art Director	Jonathan Boughton
Artist	Jonathan Boughton
Writer	Roger Core
Client	Nat Goodwin Clothiers
Agency	Roger Core Advertising, Weston, CT

15

Art Director	Ann Hollingworth
Artists	Terry Shoffner, C. Robitaille
Writer	Viv Tate
Client	Amstel Brewery Canada Limited
Agency	Doyle Dane Bernback Advertising Ltd., Toronto, Canada
Prod. Manager	John Stevenson
Typographer	Hunter Brown Limited

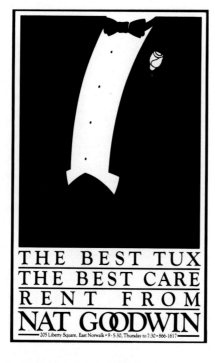

THE BEST TUX
THE BEST CARE
RENT FROM
NAT GOODWIN

205 Liberty Square, East Norwalk • 9 - 5:30, Thursday to 7:30 • 866-1617

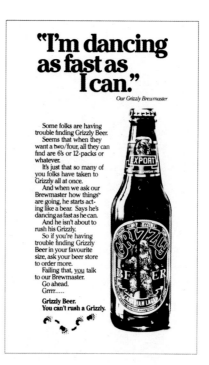

"I'm dancing as fast as I can."

Our Grizzly Brewmaster

Grizzly Beer.
You can't rush a Grizzly.

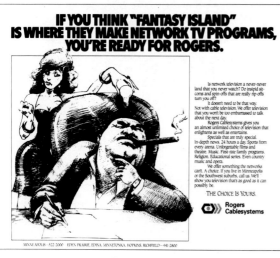

IF YOU THINK "FANTASY ISLAND"
IS WHERE THEY MAKE NETWORK TV PROGRAMS,
YOU'RE READY FOR ROGERS.

Rogers
Cablesystems

REMEMBER
WHAT CLASSICAL
MUSIC DID FOR
BO DEREK?

Come hear the music that made a star as we unveil the magic of Ravel's Bolero. ✽ With Lucas Foss conducting. ✽ Friday, April 13 and Saturday, April 14 at 8 PM. ✽ The Lyric Theatre. ✽ For tickets call 471-7344. ✽

16

Art Director	Mike Murray
Artist	Stan Olson
Writer	Bob Thacker
Client	Rogers Cablesystems
Agency	Chuck Ruhr Advertising, Minneapolis, MN
Publication	Minneapolis Star & Tribune

17

Art Director	Clark Lamm
Artist	Eric Brightfield
Writer	Cal Bruns
Client	Kansas City Symphony
Agency	Valentine-Radford, Inc., Kansas City, MO

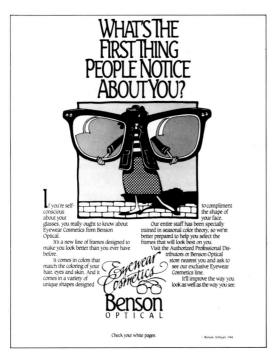

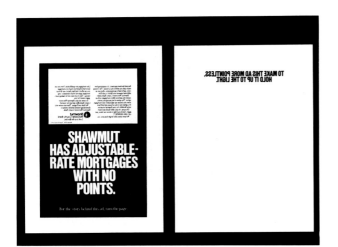

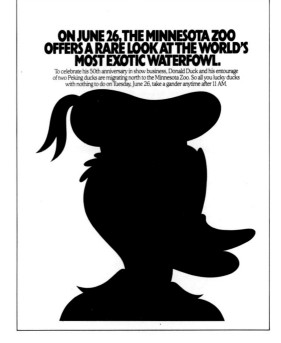

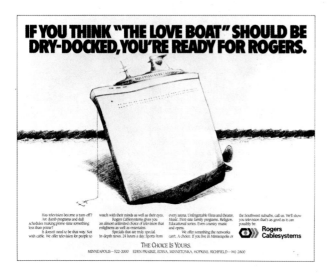

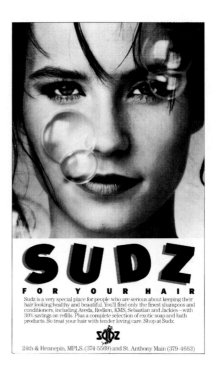

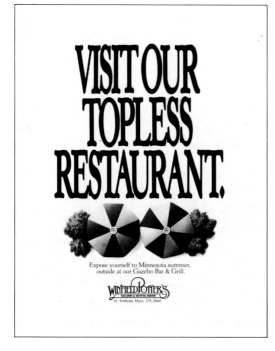

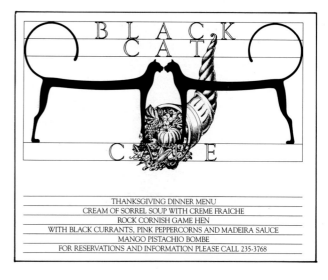

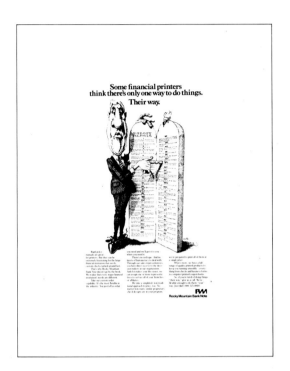

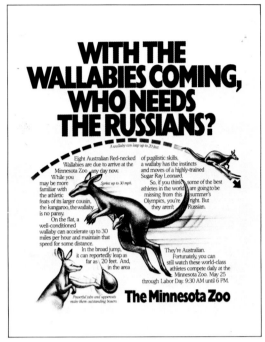

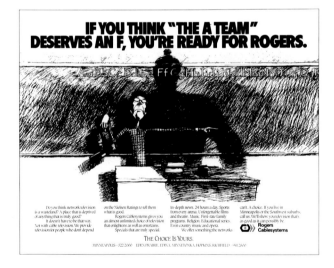

29

Silver Award

Art Director Dean Hanson
Artist Koren
Writer Jarl Olsen
Client ITT Life Insurance Corporation
Agency Fallon McElligott Rice, Minneapolis, MN
Publication Wall Street Journal

Silver Award

Art Director	Bob Barrie
Photographer	Rick Dublin
Writer	Rod Kilpatrick
Client	MedCenters Health Plan
Agency	Fallon McElligott Rice, Minneapolis, MN
Publication	St. Paul Pioneer Press

The Average American Lives 73.7 Years. (Give Or Take A Few.)

Overweight. Subtract 5 Years.

Stress. Subtract 3 Years.

Excessive Drinking. Subtract 5 Years.

Lack Of Sleep. Subtract 2 Years.

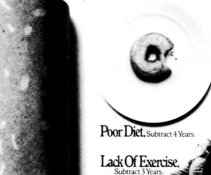

Smoking Subtract 6 Years.

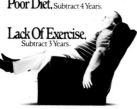

Poor Diet. Subtract 4 Years.

Lack Of Exercise. Subtract 3 Years.

Your life expectancy isn't determined by statistics alone.

It's determined by the decisions you make every day. Decisions about things like smoking. Drinking. Exercise. Diet. Things that can have a profound impact on the length of your life—and on its quality.

At MedCenters, our goal is to keep you as healthy as we possibly can. So when you're sick, we provide you with doctors and medical facilities that are second to none.

More than 400 doctors, in fact, at 41 Twin Cities locations including the Park Nicollet Medical Center.

But we also have a lot to offer when you're not sick. We can help you make some important decisions about your health. And if you choose, we can help you conquer your bad health habits through information, classes, counseling—whatever it takes.

You see, our commitment to your health is more than a matter of thermometers, pills and stethoscopes. It's a matter of principle.

To find out more, ask your employer. Or write MedCenters Health Plan, 4951 Excelsior Boulevard, Minneapolis, MN 55416.

But don't put it off. Life's too short.

MEDCENTERS
HEALTH PLAN

Life expectancy figures are for illustrative purposes only and can vary widely. Consult your doctor.

31

Art Director Bill Murphy
Writer Tony Winch/Vashti Brotherhood
Client The Boston Globe
Agency HHCC, Boston, MA
Publication The Boston Globe

32

Art Director Brian Stewart
Writer Cynthia Miller
Client Pickwick Discount Books
Agency Kauffman-Stewart, Minneapolis, MN

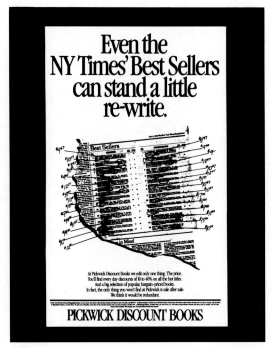

33

Art Director Dom Farrell
Artist Mark Alexander
Writer Chris Rowean
Client Brooks Drugs
Agency Ingalls, Boston, MA

34

Art Directors	Mike Fazende, Clifford Goodenough
Photographer	Ben Saltzman
Writer	Pete Smith
Client	Minneapolis Star & Tribune
Agency	Bozell & Jacobs, Inc., Minneapolis, MN

35

Art Director	John Scavnicky
Designer	John Scavnicky
Photographer	Ladd Trepal
Writer	Scott Mackey
Client	Cleveland Magazine
Agency	Meldrum and Fewsmith, Inc., Cleveland, OH

Is This The Kind Of Care Package Central Americans Really Need?

Foreign Correspondent Frank Wright just spent a month there to find out. He talked to soldiers, peasants, clergy, government officials, and businessmen. He traveled to five countries and logged 3,000 miles.
What's it like to live in a place where death is a way of life? Read Frank Wright's report on Central America, our exclusive seven-part series, all week in the Star and Tribune.

STAR..Tribune

Every Edition's An Extra.

Estrogen will help a bald man grow hair. Unfortunately, that's not all he'll grow.

A little dab of estrogen can do wonders for a man's hairline. And also his bust line.

Men growing breasts is just a sample of what you might find in CLEVELAND Magazine's special healthcare sections. It's your way to check up on all the medical and personal healthcare news, and

its impact in Cleveland.
And every month, CLEVELAND Magazine puts you on top of everything else that matters in Cleveland. Entertainment. Fashion. Finance. The Arts. Dining. And hard-hitting features that take you behind the headlines.
Or, in some cases, the hairlines.

Call 771-2833 today for your subscription.

CLEVELAND
Magazine

We don't just cover Cleveland. We uncover it.

Silver Award

Art Director	Darrell Lomas, Alex Mendoza
Artist	Fred Nelson
Writers	Harry Woods, Steve Stein, Chuck Silverman
Client	Wrather Port Properties
Creative Director	Chuck Silverman
Agency	Cunningham & Walsh, Fountain Valley, CA
Production Manager	Jill Heatherton

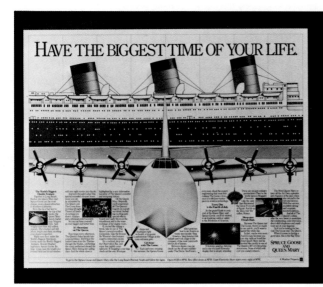
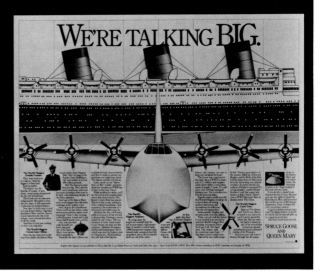

Distinctive Merit

Art Director Pat Burnham
Photographers Harley Hettick, Jay Dusard, John Running
Artist Kai Hsi
Writer Bill Miller
Client US West
Agency Fallon McElligott Rice, Minneapolis, MN
Publication Wall Street Journal

38

Distinctive Merit

Art Director Patricia Hardy
Photographer Bettman Archives
Writer Jonathan Mandell
Client The Bank of Boston
Agency HBM/Creamer, Boston, MA
Publication The Boston Globe

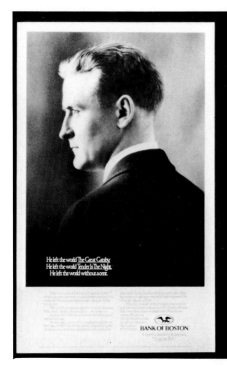
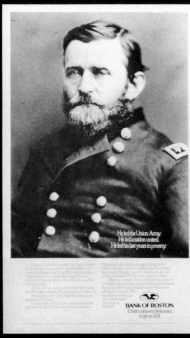
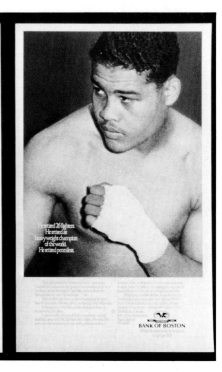

39

Art Director	Brooke Kenney
Photographer	Joe Giannetti
Writer	Mike Dodge
Client	Morgan's Fine Jewelry
Agency	Dodge and Kenney, Inc., Minneapolis, MN
Publication	Minneapolis Star & Tribune

40

Art Director	Harvey Baron
Designer	Harvey Baron
Photographer	Dennis Chalkin
Writer	Diane Rothschild
Client	Cigna
Agency	Doyle Dane Bernbach, New York, NY

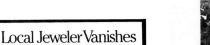

41

Art Director	Skip Mascaro
Designer	Skip Mascaro
Writer	Al Lozano
Client	The Irvine Company
Agency	Diane Moon & Associates, Costa Mesa, CA

42

Art Director	Mark Stockstill
Designer	Mark Stockstill
Artists	Mark Stockstill, Bob Swank, Mike Bonilla
Client	Armco
Director	Bob Cyphers
Agency	Armco, Middletown, OH
Publication	Wall Street Journal
Design Firm	Graphica Inc. Studio

Art Directors	Si Lam, Greg Koorhan
Photographer	David Rawcliffe
Writer	Niel Klein
Client	George Hein, Adventist Health System
Agency	Klein/Richardson, Inc., Beverly Hills, CA

Art Director	Marianne Tombaugh
Designer	Roby Odom
Photographer	Henry Sack
Artist	Kip Lott
Client	Harlan Crow—Trammell Crow Company
Agency	The Hay Agency, Inc., Dallas, TX

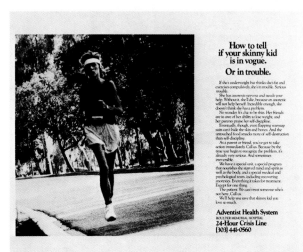

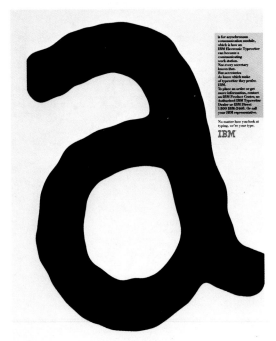

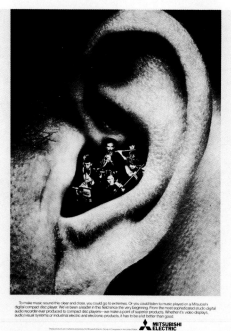

Art Director	Gary Goldsmith
Designer	Gary Goldsmith
Writer	Irwin Warren
Client	IBM
Agency	Doyle Dane Bernbach, New York, NY
Publication	Wall Street Journal

Art Director	Mario Giua
Writer	John Salvati
Client	Mitsubishi Electric America
Director	Chiat/Day
Agency	Chiat/Day Inc., New York, NY

47

Art Director	Bob Barrie
Photographer	Stock
Writer	Mike Lescarbeau
Client	Minnesota North Stars
Agency	Fallon McElligott Rice, Minneapolis, MN
Publication	St. Paul Pioneer Press

48

Art Director	Ann-Marie Light
Designer	Ann-Marie Light
Photographer	Horst
Writers	Richard Raboy, Bob Evans
Client	Barneys New York
Agency	Epstein, Raboy Advertising, Inc., New York, NY
Account Executive	Rhonda Fulton

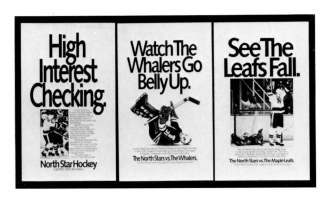

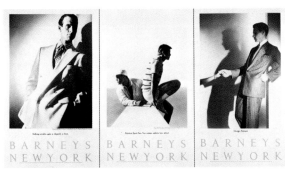

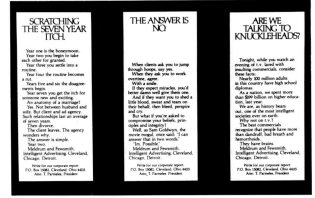

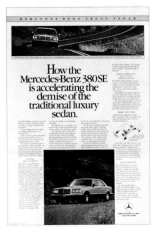

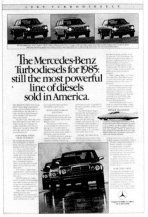

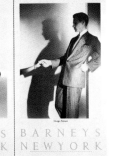

49

Art Director	Bill Schwartz
Designer	Bill Schwartz
Writer	Chris Perry
Client	Meldrum and Fewsmith
Agency	Meldrum and Fewsmith, Cleveland, OH

50

Art Director	Bruce Bennett Kramer
Designer	Bruce Bennett Kramer
Photographers	Brad Miller, Harry Dezitter
Artist	Art Staff Inc.
Writer	Bruce McCall
Client	Mercedes-Benz of North America Inc.
Agency	McCaffrey and McCall Inc., New York, NY

51

Art Director Charlie Clark
Designer Charlie Clark
Artist Alex Murawski
Writer Leslie Trinite Clark
Client Midlothian Enterprises, Inc.
(Evergreen)
Agency Siddall, Matus & Coughter, Inc.,
Richmond, VA
Publication Richmond Times Dispatch

52

Art Directors John Morrison, Dean Hanson, Nancy
Rice
Photographer stock
Writers Rod Kilpatrick, Mike Lescarbeau,
Tom McElligott
Client American Association of Advertising
Agencies
Agency Fallon McElligott Rice, Minneapolis,
MN

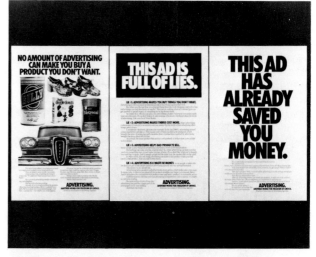

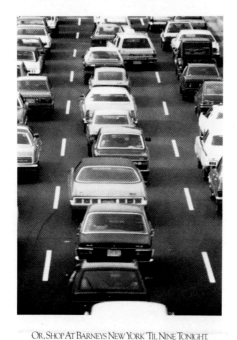

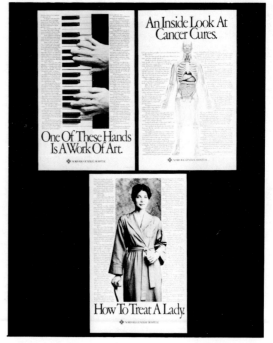

53

Art Director Matt Haligman
Writer Barbara Reynolds
Client Barneys New York
Agency Chiat/Day Inc., New York, NY

54

Art Director Don Harbor
Designer Jeff France
Photographers Jamie Cook, Ronn Maratea
Writer Ken Hines
Client Norfolk General Hospital
Agency Lawler Ballard Advertising, Norfolk,
VA
Type Director Don Woodlan

55

Art Director	Terry Schneider
Photographers	Joe Felzman, Jim Piper
Writer	Barry Pullman
Client	Zell Bros
Agency	Borders, Perrin & Norrander, Inc., Portland, OR

56

Art Directors	Jerry Whitley, Brandt Wilkins, William Hartwell
Designers	Jerry Whitley, Brandt Wilkins, William Hartwell
Photographers	Robert Ammirati, Ernst Hermann Ruth
Writers	Mark Silveira, Joe O'Neill
Client	BMW of North America, Inc.
Agency	Ammirati & Puris, Inc., New York, NY
Publication	Cycle News, On The Level

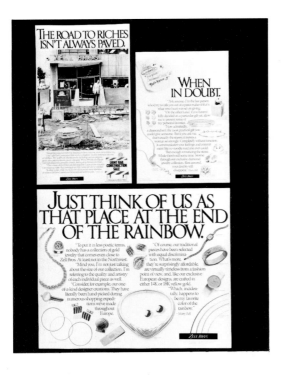

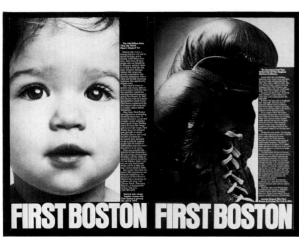

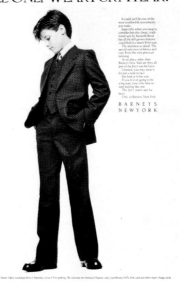

57

Art Director	Paul Basile
Photographers	Jerry Friedman, David Langley
Writer	Jerry Della Femina
Client	First Boston Financial Corp.
Agency	Della Femina Travisano & Partners, New York, NY

58

Art Director	Matt Haligman
Writer	Barbara Reynolds
Client	Barneys New York
Agency	Chiat/Day Inc., New York, NY

59

Art Director Bob Jensen
Artist Ken Westphal
Writer Rob Price
Client Crown Center Redevelopment
Agency Valentine-Radford, Inc., Kansas City, MO

60

Art Director George Fugate
Designer George Fugate
Illustrator Scott Wright
Writers George Fugate, Frank Merriam
Client Fernbrook
Agency Fugate & Ross, Inc., Richmond, VA
Publication Richmond Times Dispatch
Art Director Dick Ross

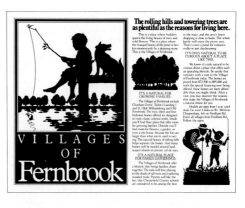

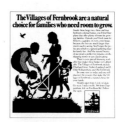

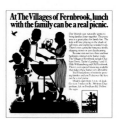

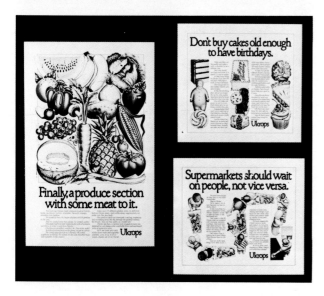

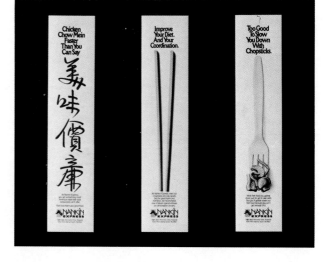

61

Art Directors Carolyn Tye, Wayne Gibson
Artist Reid Icard
Writers Kerry Feuerman, Bill Westbrook
Client Ukrop's Super Markets
Agency Westbrook, Inc., Richmond, VA
Publication Richmond Times-Dispatch & News Leader

62

Art Director Bob Barrie
Photographers Jim Arndt, Arndt & Berthiaume Photography
Writer Phil Hanft
Client Nankin Express
Agency Fallon McElligott Rice, Minneapolis, MN
Publication St. Paul Pioneer Press

63

Art Directors Lila Sternglass, Debbie Peretz
Artist George Stavrinos
Writers Bill Hamilton, Art Winters
Client New York City Opera
Agency Rumrill Hoyt, New York, NY
Publication New York Times

64

Art Director Arthur W. Taylor
Artist James Smith
Writer David Lyday
Client Jon Garner, Labatt Importers, Inc.
Agency Tracy-Locke/BBDO, Dallas, TX
Typography Max Shuppert

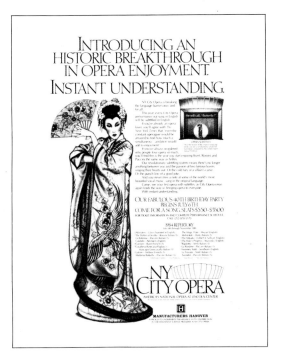

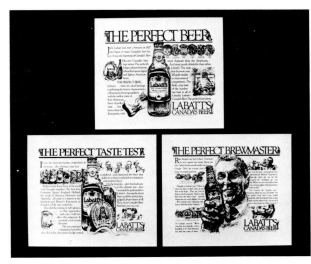

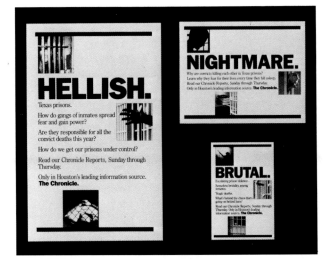

65

Art Director Karen Mann
Designers Karen Mann, Chuck Carlberg
Writer Carol Miller
Client Houston Chronicle
Agency Rives Smith Baldwin Carlberg &
Y&R, Houston, TX
Creative Director Chuck Carlberg

Gold Award

Art Director Mark Fuller
Photographer Bob Jones, Jr.
Writer Mac Calhoun
Client Richmond Metropolitan Authority
Agency Finnegan & Agee, Inc., Richmond, VA
Retouching Charlie Sheffield

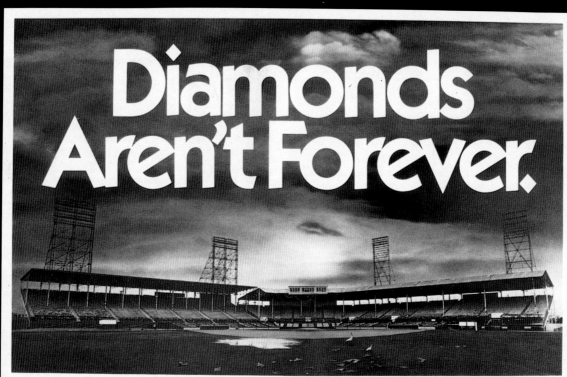

67

Art Director Irwin Goldberg
Writer Evan Stark
Client Phillips-Van Heusen Corporation
Agency Nadler & Larimer, Inc., New York, NY
Publication Daily News Record

68

Art Director Mark Walton
Designer Mark Walton
Artist Julius Ciss
Writer Pamela Frostad
Client Ministry of Agriculture and Food
Agency Case Associates, Toronto, Canada
Publication Globe and Mail Newspaper
Typography Max Brown/Hunter Brown

When Moses Phillips came to America and started selling shirts to coal miners, he never dreamed how far he would go.

*Moses Phillips, Annual Sales, 1881 About $250.
Phillips-Van Heusen Corporation.
Annual Sales, 1983 Over $505,000,000.*

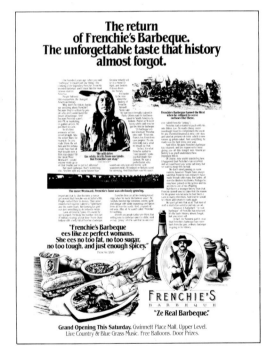

The return
of Frenchie's Barbeque.
The unforgettable taste that history
almost forgot.

"Frenchie's Barbeque
ees like ze perfect womans.
She ees no too fat, no too sugar,
no too tough, and just enough spicey."

FRENCHIE'S
BARBEQUE
"Ze Real Barbeque."

Grand Opening This Saturday. Gwinnett Place Mall, Upper Level.
Live Country & Blue Grass Music. Free Balloons. Door Prizes.

69

Art Director Artie Shardin
Designers Artie Shardin, Norman Grey
Photographer Ed Wolkis/Bettmann Archive
Artist Christy Sheets Mull
Writer Scott Bradford
Client Frenchie's Barbeque, Inc.
Agency Anonymous, Incognito & Smith,
 Atlanta, GA
Publication Gwinnett Daily News
Typographer Type Designs, Inc.

Silver Award

Art Director	Sharon Tooley
Designer	Sharon Tooley
Artist	John Collier
Writer	Paule Sheya Hewlett
Client	Parkway Investments/Texas, Inc.
Agency	Sharon Tooley Design, Houston, TX
Publication	Houston Business Journal

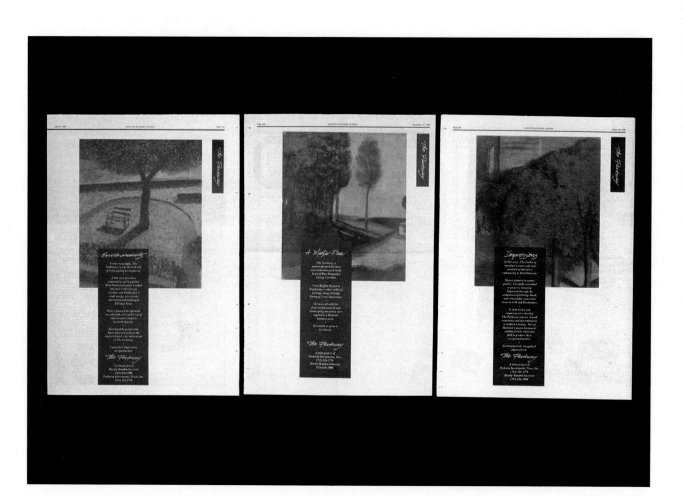

71

Art Director	Roy Trimble
Designer	Lynn Spicer
Artist	Jane Cobb
Writer	Laura Freeman
Client	BellSouth Advertising and Publishing
Agency	Luckie & Forney, Inc., Advertising, Birmingham, AL
Publication	Decatur Daily
Creative Directors	Leo Wright, Roy T. Trimble

72

Art Director	Pat Longan
Artist	Robert Peluce
Writer	Al Buono
Client	John Harris
Agency	McFarland & Drier, Inc., Miami, FL
Publication	Miami Herald
Creative Director	Bill Drier

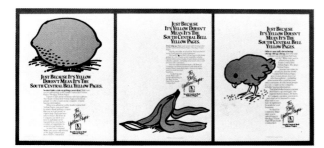

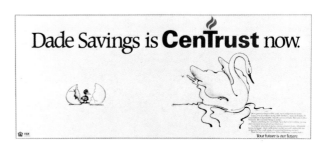

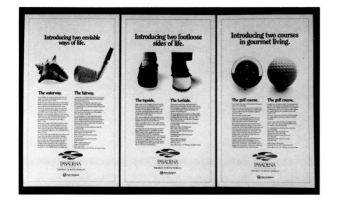

73

Art Director	Robert MaHarry
Designer	Robert MaHarry
Photographer	Curtis Graham
Writer	Sharon Kirk
Client	US Steel Realty Development
Agency	Johannesson, Kirk & MaHarry, Inc., Rochester, NY
Publication	St. Petersburg Times

74

Art Directors	Jeff Jones, Brian Stewart
Illustrator	Tom Larson
Writer	Bruce Hannum
Client	City Pages
Agency	Kauffman-Stewart, Minneapolis, MN

75

Art Director	Dan Scarlotta
Designer	Dan Scarlotta
Photographer	Marty Clark
Writer	Ed Korenstein
Client	Governor's Safety Council
Agency	Pringle Dixon Pringle, Atlanta, GA

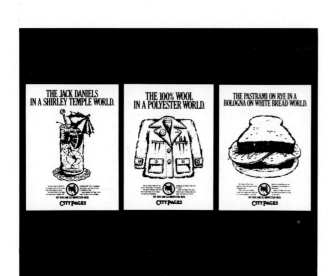

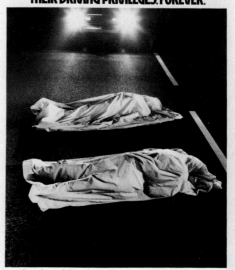

Gold Award

Art Director Jac Coverdale
Photographers Tom Berthiaume, Jim Arndt
Writer Jerry Fury
Client YMCA-Minneapolis
Agency Clarity Coverdale Advertising,
 Minneapolis, MN

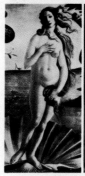

78

Art Directors	Warren Margulies, David Shapiro, Rebecca Cohen
Designers	Warren Margulies, David Shapiro
Photographer	Rick Smith
Writers	Lisa Duke, Benton Sen, Warren Margulies
Client	Untied Way Forsyth County N.C.
Agency	Long, Haymes & Carr, Inc., Winston-Salem, NC
Publication	Winston-Salem Journal

79

Art Director	Gary Greenberg
Designer	Gary Greenberg
Photographer	Lou Goodman
Writer	Peter Seronick
Client	National Head Injury Foundation
Agency	Rossin Greenberg Seronick & Hill, Boston, MA

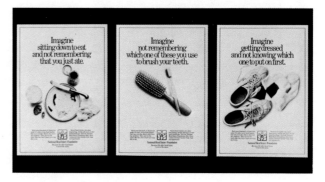

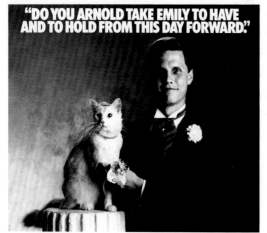

80

Art Directors	Domenick Marino, Mark Drossman
Designer	Domenick Marino
Photographer	Larry Robins—Renaissance Productions
Writers	Neil Drossman, Michael Lichtman
Client	Bide-A-Wee Pet Adoption Centers
Agency	Drossman Lehmann Marino, Inc., New York, NY
Publications	The New York Times, Newsday, Daily News

81

Art Director	Joe DelVecchio
Designer	Joe DelVecchio
Photographer	Allan Luftig
Writer	Jeff Linder
Client	Archdiocese of New York
Agency	Doyle Dane Bernbach, New York, NY
Publications	People Mag, Newsweek, Forbes

Distinctive Merit

Art Director Jill Bell
Artist Brad Holland
Writer David M. Johnson
Client PANE (People Against Nuclear Energy)
Publication The Press and Journal, Middletown, PA

YOU'D BETTER REACT BEFORE THEY DO.

You'd better do something. Right now.

Before they vote to restart Unit One at Three Mile Island.

Help us prepare to take them to court. So we can keep them there. Until they realize a simple fact of life.

We won't stand for the reopening of Unit One. Not by the same corporation that admitted to falsifying records. And actually pleaded guilty to criminal charges.

Make them realize your reaction to all that.

Send a check now. To the Susquehanna Valley Alliance. And help pay for legal research, court costs, and related expenses.

Join us in keeping TMI shut.

Because when it comes to that plant and that company, there's only one nuclear reaction. "No."

Here's my check payable to the Susquehanna Valley Alliance for $_____. Now, get ready to take them to court. And keep them there. For as long as it takes.

NAME_____

ADDRESS_____CITY_____

STATE_____ZIP_____PHONE_____

Please send this coupon and your check to:
Susquehanna Valley Alliance, Box 1012, Lancaster, PA 17604

"NO" IS A NUCLEAR REACTION

83

Art Directors	Jill Bell, Rena Levine
Writer	David M. Johnson
Client	Freeze Voter '84—Downstate NY, Md and Colo.
Publication	Ft. Collins Coloradoan

84

Art Directors	Glenn A. Dady, David Carlson
Photographers	Dennis Murphy, Michael Haynes
Writers	Melinda Marcus, Mike Renfro, Pat Scullin
Client	Democratic Small Business Committee
Agency	The Richards Group, Dallas, TX

THEY INVENTED A MACHINE THAT CAN END THE NUCLEAR ARMS RACE.

On Nov. 6, you get to pull the lever.

PULL FOR THE FREEZE. VOTE MONDALE-FERRARO.

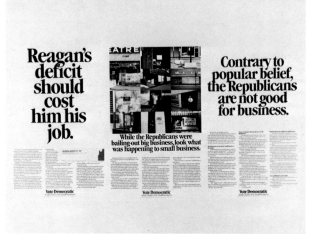

Silver Award

Art Director	Philip Gips
Designer	Philip Gips
Artist	Chuck Wilkinson
Writer	Kate Carroll Cox
Client	St. Andrews/Boca Raton
Agency	Gips & Balkind & Associates, New York, NY

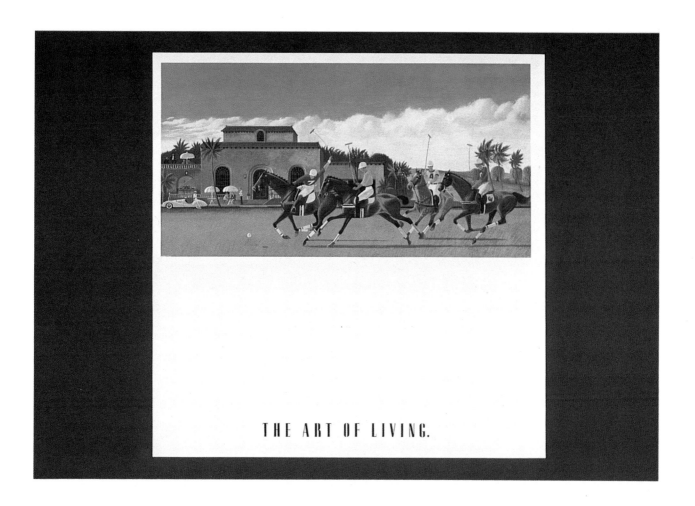

Silver Award

Art Director	Don Sibley
Designer	Don Sibley
Photographer	Geof Kern
Artists	Jerry Jeanmard, Ken Shafer
Writers	Joyce Ross, Jennifer Coleman
Client	Baylor Hospital
Agency	Sibley/Peteet Design, Inc., Dallas, TX

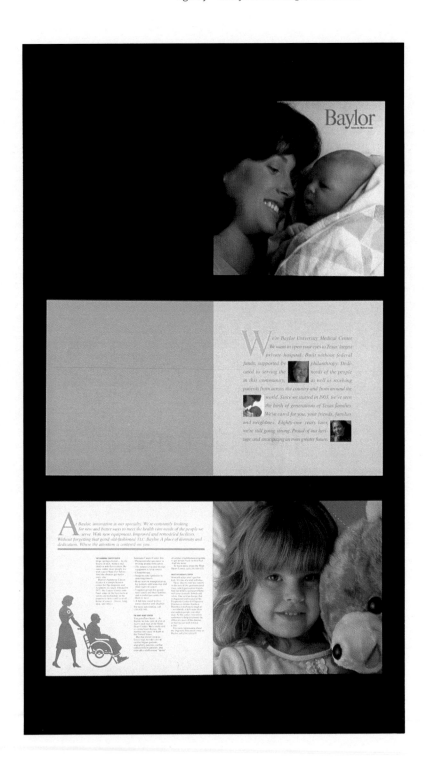

Art Director	Tony Ross
Designer	Tony Ross
Photographer	Robert Prengle
Writer	Luann Haney
Client	Silver Works
Agency	Tony Ross, Wilmington, DE
Printer	Veitch Printing Corporation

Magazine advertising: Consumer, full page, b&w
Consumer, spread, b&w
Consumer, full page, color
Consumer, spread, color
Consumer, less than full page, b&w
Consumer, less than full page, color
Consumer campaign, b&w
Consumer campaign, color
Public service
Public service campaign
Business or trade, full page or less, b&w
Business or trade, spread, b&w
Business or trade, full page or less, color
Business or trade, spread, color
Business or trade campaign, b&w
Business or trade campaign, color
Section, insert, supplement

Distinctive Merit

Art Director Charles Guarino
Photographer Andrew Unangst
Writers Charles Guarino, Cheryl Baron
Client Smithsonian Magazine
Agency Warwick Advertising, New York, NY
Publications Ad Age, Adweek

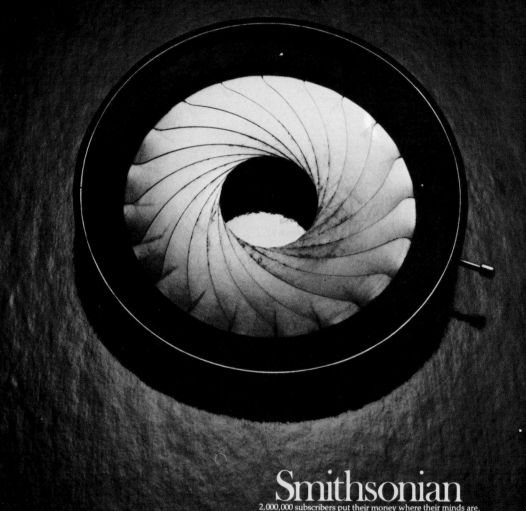

Distinctive Merit

Art Director	Seymon Ostilly
Photographer	Manuel Gonzalez
Writer	Bob Mitchell
Client	IBM Corp.
Agency	Lord, Geller, Federico, Einstein Inc., New York, NY
Publication	Sports & Spokes

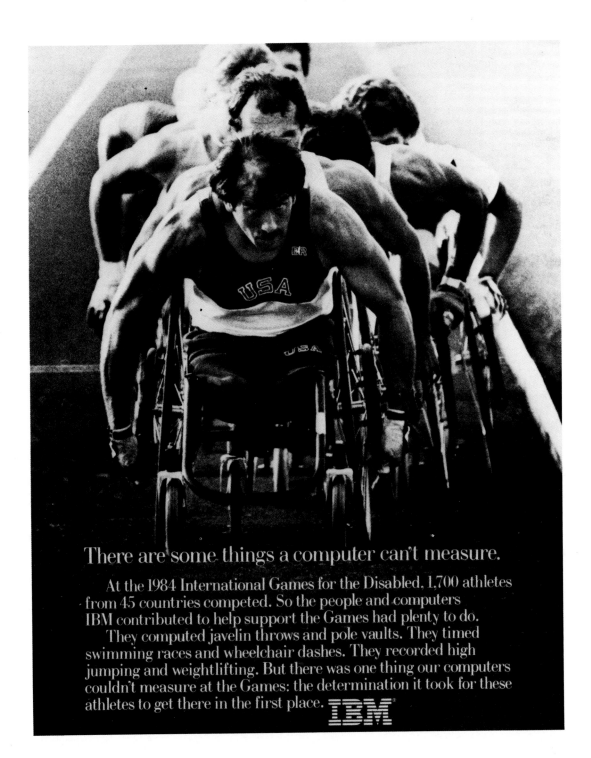

90

Art Director Pat Burnham
Artist Don Biehn Advertising Art
Writer Bill Miller
Client WFLD-TV, Metromedia Chicago
Agency Fallon McElligott Rice, Minneapolis, MN
Publication TV Week (Chicago)

91

Art Director Doreen Cheu-Caldera
Designer Doreen Cheu-Caldera
Photographer Rick Gayle
Writer Donna Vogt
Client Newscenter 10/KTSP-TV, Phoenix, AZ
Director Donna Vogt
Publication TV Guide
Creative Director Donna Vogt
Typography Headquarters Typographics

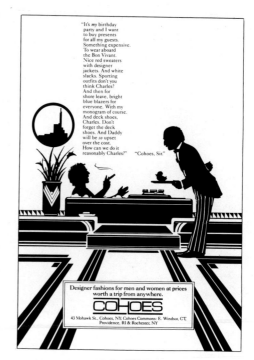

92

Art Director Steven Sessions
Designer Steven Sessions
Artist Regan Dunnick
Writer Steven Sessions
Client Body Beautiful Weight Reduction Studio
Agency Steven Sessions Inc., Houston, TX
Publication Houston Home & Garden

93

Art Director Scott·E. Sager
Designer Scott E. Sager
Artist Bill Mayer
Writer Frank Corkrum
Client Cohoes Specialty Stores, Ltd.
Agency Muller Jordan Weiss, New York, NY
Publication Metroland Magazine

94

Art Director Charles Guarino
Photographer Andrew Unangst
Writers Charles Guarino, Cheryl Baron
Client Smithsonian Magazine
Agency Warwick Advertising, New York, N.Y.
Publications Ad Age, Adweek

95

Art Director Dean Hanson
Artist Koren
Writer Jarl Olsen
Client ITT Life Insurance Corporation
Agency Fallon McElligott Rice, Minneapolis, MN
Publication Sports Illustrated

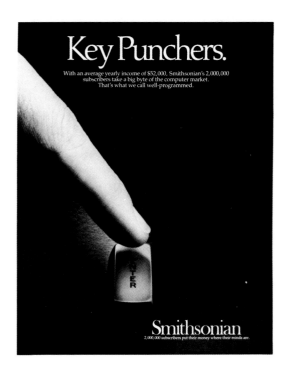

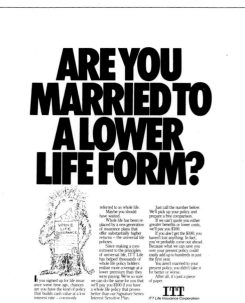

96

Art Director Ellen Ditmanson
Designer Ellen Ditmanson
Artist Ellen Ditmanson
Writer Jan Gray
Client King-TV
Agency King-TV Marketing & Advertising, Seattle, WA

97

Art Director Pat Burnham
Photographer Craig Perman
Artist Jack Krough
Writer Bill Miller
Client WFLD-TV, Metromedia Chicago
Agency Fallon McElligott Rice, Minneapolis, MN
Publication TV Week (Chicago)

98

Art Director Gary Husk
Designers Gary Husk, Melanie Jennings Husk
Photographer Daryl Bunn
Writer Glenn Overman
Client Barnett Bank of Jacksonville, N.A.
Agency Husk Jennings Anderson!,
 Jacksonville, FL
Typographer DG&F Typography

99

Art Director Scott E. Sager
Designer Scott E. Sager
Artist David Fe Bland
Writer Frank Corkrum
Client Cohoes Specialty Stores, Ltd.
Agency Muller Jordan Weiss, New York, NY
Publication Tanglewood Music Festival Program

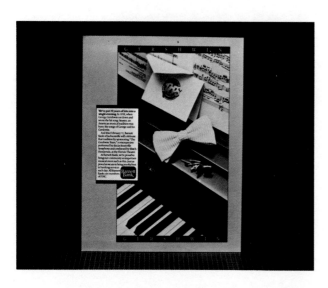

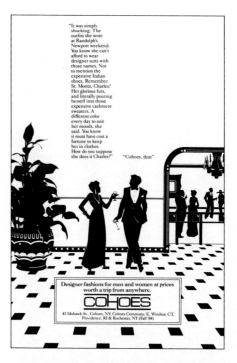

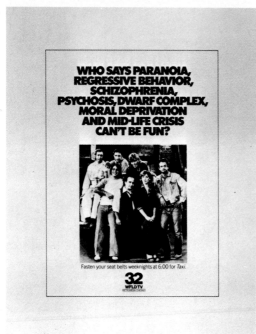

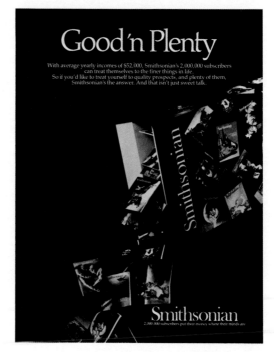

100

Art Director Pat Burnham
Photographer stock
Writer Bill Miller
Client WFLD-TV, Metromedia Chicago
Agency Fallon McElligott Rice, Minneapolis,
 MN
Publication TV Week (Chicago)

101

Art Director Charles Guarino
Photographer Andrew Unangst
Writer Charles Guarino
Client Smithsonian Magazine
Agency Warwick Advertising, New York, N.Y.
Publications Ad Age, Adweek

102

Art Director	Doreen Cheu-Caldera
Designer	Doreen Cheu-Caldera
Photographer	Rick Gayle
Writer	Donna Vogt
Client	Newscenter 10/KTSP-TV, Phoenix, AZ
Director	Donna Vogt
Publication	TV Guide
Creative Director	Donna Vogt
Typography	Headquarters Typographics

103

Art Director	Christopher Garland
Designer	Christopher Garland
Photographer	Tom Vack
Writer	Patricia Garland
Client	City
Agency	Xeno, Chicago, IL
Publication	Interview

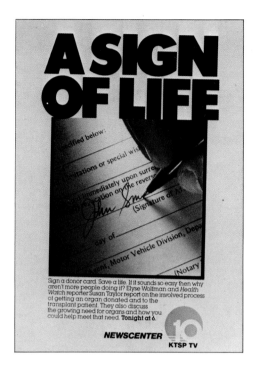

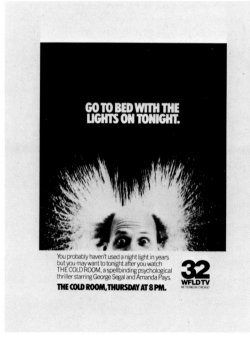

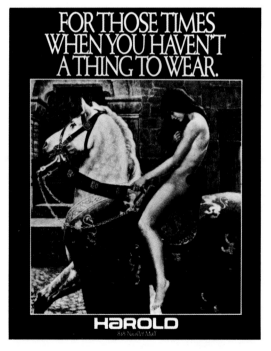

104

Art Director	Pat Burnham
Photographer	Kent Severson
Writer	Bill Miller
Client	WFLD-TV, Metromedia Chicago
Agency	Fallon McElligott Rice, Minneapolis, MN
Publication	TV Week (Chicago)

105

Art Director	Ann Rhodes Riebe
Writer	Bill Johnson
Client	Harold
Agency	Chuck Ruhr Advertising, Minneapolis, MN
Publication	TC Magazine

106

Art Director	Charles Guarino
Photographer	Andrew Unangst
Writers	Charles Guarino, Robert Shaffron
Client	Smithsonian Magazine
Agency	Warwick Advertising, New York, N.Y.
Publications	Adweek, Ad Age

107

Art Director	Christopher Hoppe
Photographer	Tim Schultz
Writer	David Stern
Client	Turtle Wax, Inc.
Agency	Lou Beres & Associates, Inc., Chicago, IL

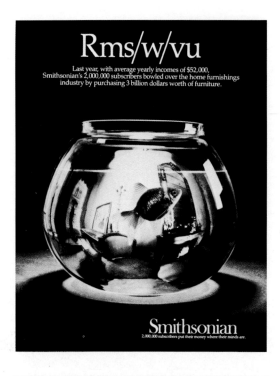

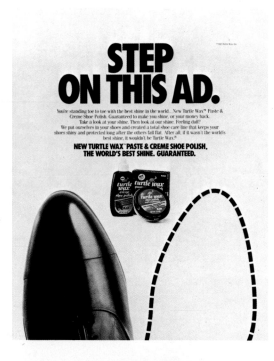

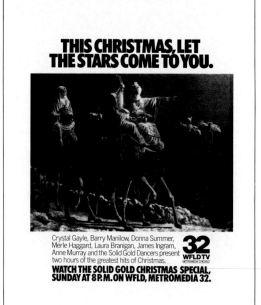

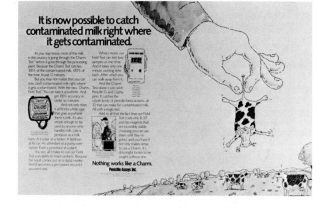

108

Art Director	Dean Hanson
Photographer	stock
Writer	Jarl Olsen
Client	WFLD-TV, Metromedia Chicago
Agency	Fallon McElligott Rice, Minneapolis, MN
Publication	TV Week (Chicago)

109

Art Director	Rob Rich
Artist	Jim Carson
Writer	Don Pogany
Client	Penicillin Assays
Agency	ClarkeGowardFitts, Boston, MA

THE VOLVO TURBO AS MOST COMMONLY VIEWED FROM A BMW 318i.

The posterior of a Volvo Turbo may not be its most attractive feature, but it's the one BMW 318i owners will be seeing a lot of.

In an independent test*of 0 to 60 acceleration, the intercooled Turbo from Volvo beat the 318i by almost two seconds.

Results like this have prompted *Car and Driver* to call the Volvo Turbo "a missile."

And *Road & Track* describes its handling and performance as "Exemplary."

So before you run out and buy the ultimate driving machine, test drive the intercooled Turbo from Volvo.

It could prevent you from becoming one of those BMW owners with 20/20 hindsight.

*Tests of acceleration conducted by *Car and Driver.*

THE TURBO+
By Volvo.

Silver Award

Art Director Wes Keebler
Writer Chuck Silverman
Client Tahiti Tourism Promotion Board/UTA
French Airlines
Creative Director Chuck Silverman
Agency Cunningham & Walsh, Fountain
Valley, CA
Production Manager Jill Heatherton

SORRY, NO McDONALD'S.

I f fast-food and fast living are what you're looking for in a vacation, you'll probably be a bit disappointed with a visit to Tahiti and her islands.

Because taking life slow and easy is what Tahiti is all about. It's a philosophy that envelops you the moment you arrive.

You'll enjoy relaxed sunny days. Warm, crystal-clear lagoons. Cool, green foliage. Waterfalls. Flowers. Exotic scents. Bright blue skies. Secluded beaches. Graceful palms. Breathtaking sunsets. Soft evening breezes. And food that's simply outstanding.

Tahiti has everything you need to forget all of the pressures and problems of day-to-day living. And fully engross yourself in the fine art of doing absolutely nothing.

Granted, there are no towering high-rise hotels in Tahiti. No frantic freeways. No fancy cars or clothes. And alas, there are no Big Mac® or Quarter Pounder® sandwiches, either.

But most of the people who've been here seem to think that it's what Tahiti doesn't have that makes it what it is.

TAHITI VIA UTA

For all the details and FREE color brochures call or write UTA French Airlines, P.O. Box 9000, Van Nuys, CA 91409. Or call your travel agent.

Distinctive Merit

Art Director Charlotte Sherwood
Photographer Andrew Unangst
Writer Murray Klein
Client Johnnie Walker Black Label
Agency Smith/Greenland, Inc., New York, NY
Publication The New Yorker

Distinctive Merit

Art Director	Jack Mariucci
Designer	Jack Mariucci
Photographer	Andy Sugden
Artist	R/V Retouching Studios Inc.
Writer	Barry Greenspon
Client	Michelin Tire Corp
Agency	Doyle Dane Bernbach, New York, NY
Publications	Time, Newsweek, Motor Trend

114

Art Director	Rafael Morales
Photographer	Manuel Gonzalez
Writer	Francesca Blumenthal
Client	Fisher-Price Toys
Agency	Waring & LaRosa, Inc., New York, NY
Publication	Family Circle

115

Art Director	Carol Golden
Photographer	Mike Chesser
Writer	Bob Browand
Client	Ektelon
Agency	Phillips Organisation, San Diego, CA

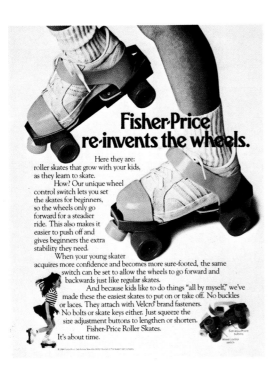

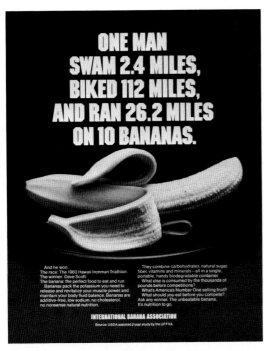

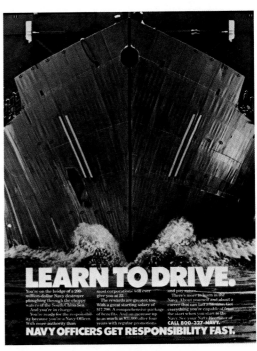

116

Art Director	Anthony Smith
Designer	Anthony Smith
Photographer	Charles Nairn
Writer	Ben White
Client	International Banana Association
Executive Creative Director	Kenneth Dudwick
Creative Director	Craig Mathiesen
Agency	Ketchum Advertising/San Francisco, CA
Publications	Bicycling, Runners World, Triathlon
Production Supervisor	Wayne Wadekamper
Engraver	Kieffer, Nolde-Chicago

117

Art Director	William Heatley
Photographer	Al Satterwhite
Writers	Steve Chaseman and Rob Feakins
Client	U.S. Navy
Agency	Ted Bates/New York, NY

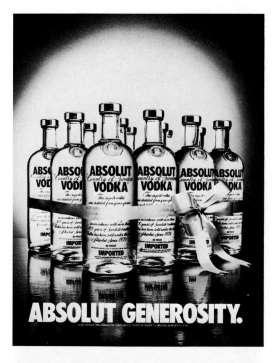

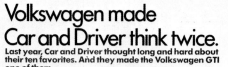

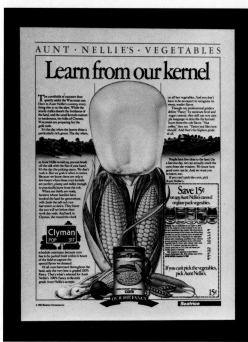

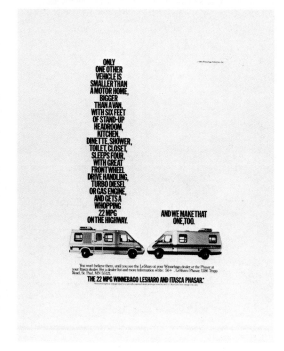

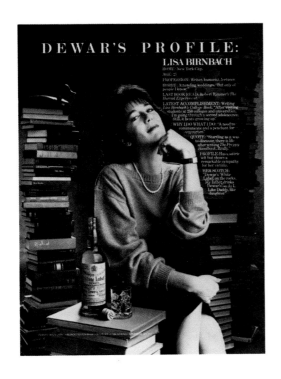

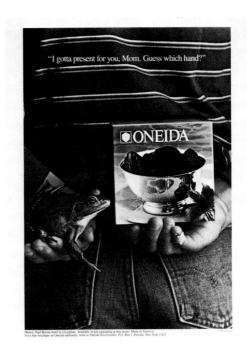

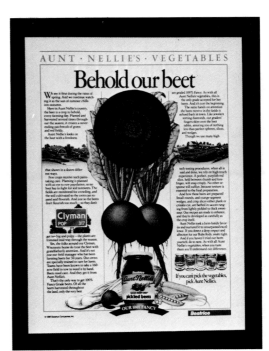

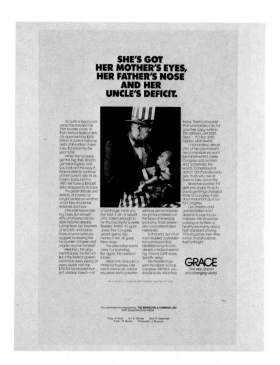

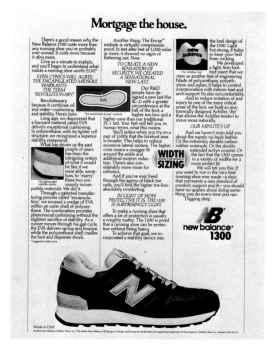

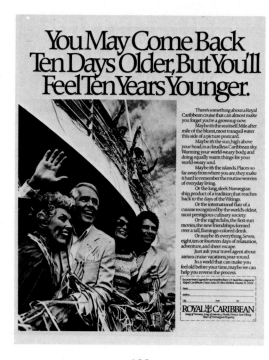

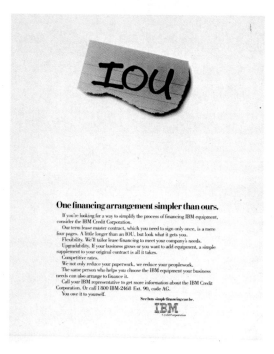

130

Art Director	Michelle Weibman
Designer	Michelle Weibman
Illustrator	Edmund Eng
Writer	Yoni Mozeson
Client	British Tourist Authority
Director	Jay Schulberg
Agency	Ogilvy & Mather Advertising, New York, NY
Publication	Travel Leisure magazine

131

Art Directors	Lary Larsen, Paul Boley
Writer	Richard Rand
Client	Schenley/Dewar's
Agency	Leo Burnett Co., Inc., Chicago, IL

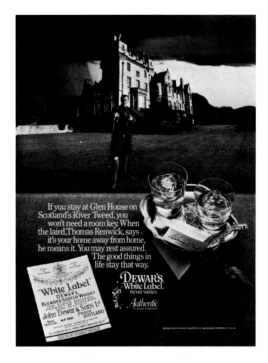

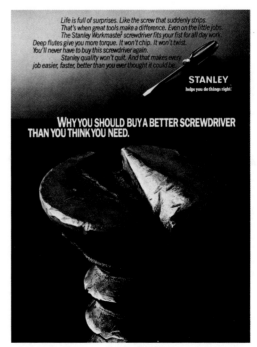

132

Art Director	Kevin Houlihan
Writer	Nina DiSesa
Client	General Foods Corp.—Jell-O Gelatin Pops
Agency	Young & Rubicam, New York, NY
Publication	Better Homes and Gardens
Associate Creative Director	Mike Hampton

133

Art Directors	Bill Boch, Tim Hanrahan
Photographer	Dennis Manarchy
Writers	Chuck Matzell, Michael Ward
Client	Stanley Works
Agency	HBM/Creamer, Boston, MA
Publication	People Magazine

134

Art Director	Mark Hughes
Designer	Mark Hughes
Photographer	Carl Furuta
Writer	Neal Gomberg
Client	Volkswagen
Agency	Doyle Dane Bernbach, New York, NY

135

Art Director	Anthony Smith
Designer	Anthony Smith
Photographer	Charles Nairn
Writer	Ben White
Client	International Banana Association
Executive Creative Director	Kenneth Dudwick
Creative Director	Craig Mathiesen
Agency	Ketchum Advertising, San Francisco, CA
Publications	Family Circle, Ladies Home Journal
Production Manager	Wayne Wadekamper
Engraver	Kieffer, Nolde-Chicago

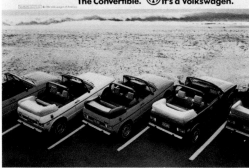

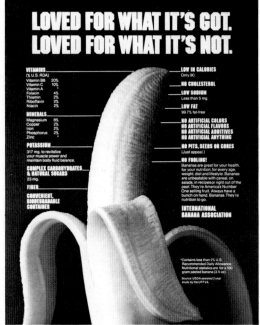

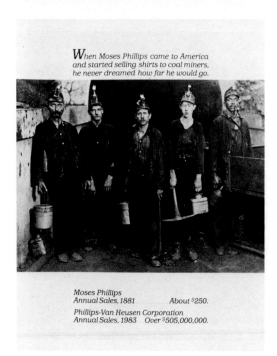

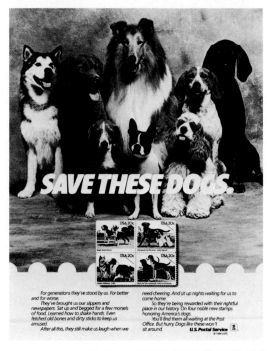

136

Art Director	Irwin Goldberg
Writer	Evan Stark
Client	Phillips-Van Heusen Corporation
Agency	Nadler & Larimer, Inc., New York, NY
Publication	Fortune

137

Art Director	Beverly Okada
Photographer	Carl Fischer
Writer	Ron Burkhardt
Client	U.S. Postal Service
Agency	Young & Rubicam, New York, NY
Publication	Sports Illustrated
Associate Creative Director	Greta Basile

138

Art Director	Barry Stringer
Designer	Barry Stringer
Photographer	Don Miller
Writer	Margo Northcote
Client	Tambrands
Agency	Leo Burnett Company Ltd., Toronto, Canada
Publication	Chatelaine

139

Art Director	Mark Erwin
Photographer	William Coupon
Writer	Bruce Richter
Client	Maxell
Agency	Scali, McCabe, Sloves, New York, NY

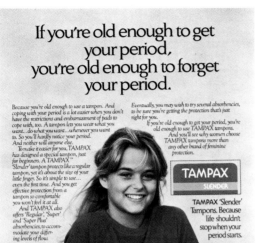

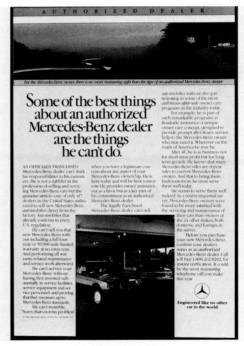

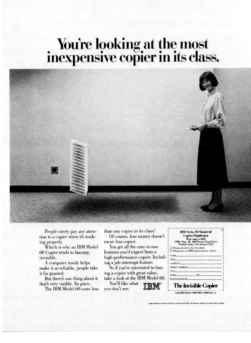

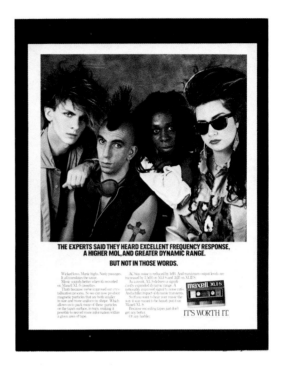

140

Art Director	Rick Elkins
Designer	Rick Elkins
Photographer	Larry Robins
Writer	Rhonda Peck
Client	IBM
Agency	Doyle Dane Bernbach, New York, NY

141

Art Directors	Joe Steele, Bruce Kramer
Designer	Joe Steele
Photographer	Dick Durrance II
Writer	Bruce McCall
Client	Mercedes Benz North America
Agency	McCaffrey & McCall, Inc., New York, N.Y.
Publication	Time Magazine

142

Art Director Charlotte Sherwood
Writer Murray Klein
Client Johnnie Walker Black Label
Agency Smith/Greenland, Inc., New York, N.Y.
Publication The New Yorker

143

Art Director Howard Title
Artist John Collier
Writer Sara Selz
Client Grand Specialties
Agency Waring & LaRosa, Inc., New York, N.Y.
Publication Gourmet

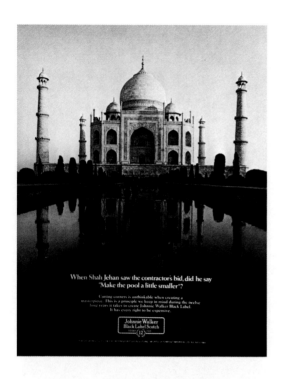

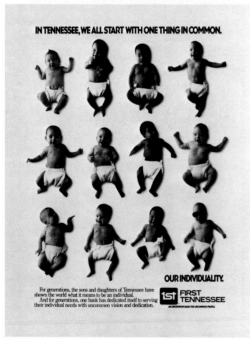

144

Art Director Dean Hanson
Photographer Steve Umland
Writer Phil Hanft
Client First Tennessee Banks
Agency Fallon McElligott Rice, Minneapolis, MN
Publication Memphis Theatre

You put it on with your hands, now take it off with your hands.

By adding Heavyhands to your walking, running or dancing, you can lose 30% to 300% more calories while you tone and strengthen major muscle groups throughout your body. Find out more at your sporting goods store. **Heavyhands™ from AMF.**

Gold Award

Art Director	Seymon Ostilly
Designer	Seymon Ostilly
Artist	Manuel Gonzalez
Writer	Bob Mitchell
Client	IBM Corp.
Agency	Lord, Geller, Federico, Einstein Inc., New York, NY
Publication	Life Magazine

Guess which one will grow up
to be the engineer.

As things stand now, it doesn't take much of a guess.

Because by and large, *he* is encouraged to excel in math and science. *She* isn't.

Whatever the reason for this discrepancy, the cost to society is enormous because it affects women's career choices and limits the contributions they might make.

Only 4% of all engineers are women.

Only 13.6% of all math and science Ph.D.'s are women.

And an encouraging, but still low, 31.3% of all professional computer programmers are women.

In the past ten years, IBM has supported more than 90 programs designed to strengthen women's skills in these and other areas. This support includes small grants for pre-college programs in engineering, major grants for science programs at leading women's colleges, and grants for doctoral fellowships in physics, computer science, mathematics, chemistry, engineering, and materials science.

We intend to continue supporting programs like these.

Because we all have a lot to gain with men and women on equal footing. **IBM**

Gold Award

Art Director. Tom Wolsey
Designer Tom Wolsey
Photographer Henry Wolf
Writer Helayne Spivak
Client Karastan Rug Mills Inc.
Agency Ally & Gargano, Inc., New York, NY
Publication House & Garden

Some of us have more finely developed nesting instincts than others.

Gold Award

Art Director Simon Bowden
Writer Frank Fleizach
Client Volvo
Agency Scali, McCabe, Sloves, New York, N.Y.

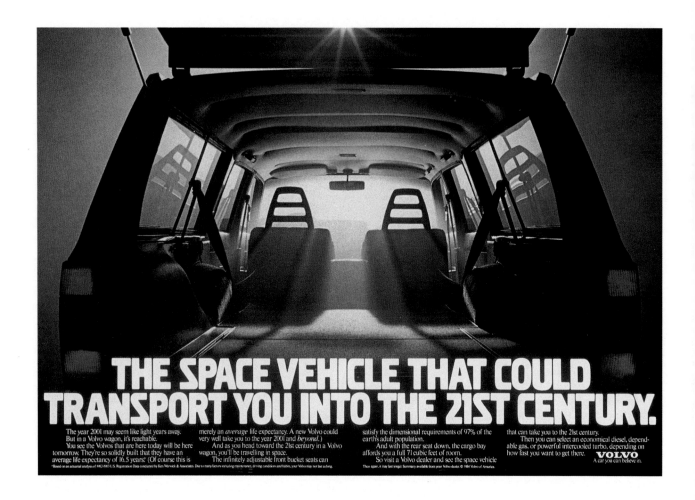

THE SPACE VEHICLE THAT COULD TRANSPORT YOU INTO THE 21ST CENTURY.

Silver Award

Art Director	John Morrison
Photographer	Dennis Manarchy
Writer	Tom McElligott
Client	AMF American
Agency	Fallon McElligott Rice, Minneapolis, MN
Publication	Shape

The best way to subtract 10 lbs. here, is to add 2 lbs. here.

By adding Heavyhands to your walking, running or dancing, you can lose 30% to 300% more calories while you tone and strengthen major muscle groups throughout your body. Find out more at your local sporting goods store. **Heavyhands™ from AMF.**

Distinctive Merit

Art Director Pat Burnham
Photographer Jay Dusard
Writer Bill Miller
Client US West
Agency Fallon McElligott Rice, Minneapolis,
 MN
Publication Pensions & Investment Age

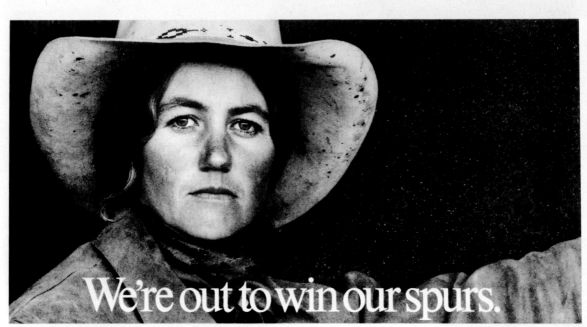

151

Art Director	Tom Wolsey
Designer	Tom Wolsey
Photographer	Henry Wolf
Writer	Helayne Spivak
Client	Karastan Rug Mills Inc.
Agency	Ally & Gargano, Inc., New York, NY
Publication	House & Garden

152

Art Director	Dan Peppler
Designer	Peter Elendt
Photographer	Terry Collier
Writer	Terry Bell
Client	Honda Canada Inc.
Agency	Needham Harper of Canada Ltd., Toronto, Canada
Publications	MacLean's, Time

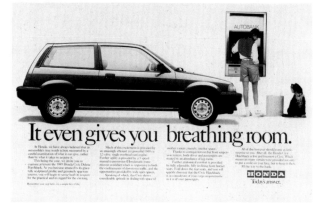

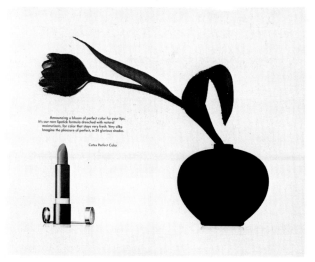

153

Art Director	Len Favara
Designer	Len Favara
Photographer	Andrew Unangst
Client	Judith Leiber
Agency	Peter Rogers Associates, New York, NY
Creative Director	Len Favara

154

Art Directors	Joe LaRosa, Jon Parkinson
Photographer	Michael O'Neill
Writer	Alice Moroz
Client	Cutex Perfect Color for Lips
Agency	Waring & LaRosa, Inc., New York, NY
Publication	Cosmopolitan

155

Art Director	Glen Jacobs
Designer	Glen Jacobs
Photographers	Richard Hochman, David Seidner (inside front cover)
Writer	Christina Thorp
Client	Charles of the Ritz Group, Ltd.
Agency	Advertising To Women, Inc., New York, NY
Printing Consultant	Robert Matricardi

156

Art Director	Don Zimmerman
Photographer	Sarah Moon
Writer	Elin Jacobson
Client	Jeremy Pudney
Agency	NW Ayer Incorporated, New York, NY
Publication	Vogue

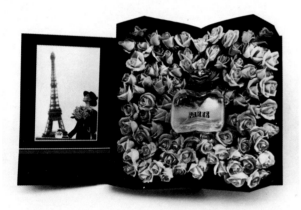

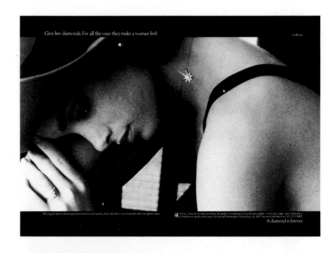

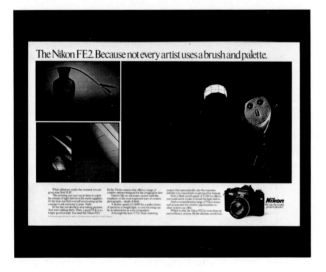

157

Art Director	Amy Schottenfels
Photographer	Michael O'Neill
Writer	Helen Klein
Client	Nikon
Agency	Scali, McCabe, Sloves, New York, NY

158

Art Director	Mark Walton
Photographer	Terry Collier
Writers	Dan Peppler, Terry Bell
Client	Honda Canada Inc.
Agency	Needham Harper of Canada Ltd., Toronto, Canada
Publications	MacLean's, Time

159

Art Director | Tom Wolsey
Designer | Tom Wolsey
Photographer | Henry Wolf
Writer | Helayne Spivak
Client | Karastan Rug Mills Inc.
Agency | Ally & Gargano, Inc., New York, NY
Publication | Architectural Digest

160

Art Director | Pat Burnham
Photographer | Harley Hettick
Writer | Bill Miller
Client | US West
Agency | Fallon McElligott Rice, Minneapolis, MN
Publication | Forbes

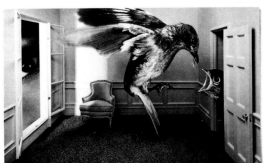

Some of us have more finely developed nesting instincts than others.

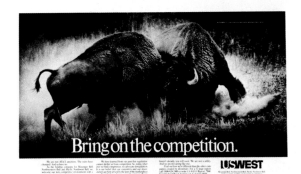

Bring on the competition.

NOW MORE THAN EVER

GoTo Bermuda In A Recreational Vehicle.

161

Art Director | Bob Needleman
Client | Izod
Agency | Scali, McCabe, Sloves, New York, NY

162

Art Director | Larry Bennett
Photographer | Randy Miller
Writer | Harriet Frye
Agency | McKinney, Silver & Rockett, Raleigh, NC

163

Art Director	Tom Schwartz
Designer	Tom Schwartz
Writer	Richard Middendorf
Client	IBM Credit Corporation
Agency	Doyle Dane Bernbach, New York, NY

164

Art Director	Pat Bilger
Designer	Pat Bilger
Photographer	Jerry Cailor
Writer	Margaret Lubalin
Client	WestPoint Pepperell
Agency	Calet, Hirsch & Spector, Inc., New York, NY
Publication	New York Times Magazine

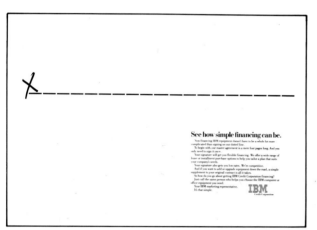

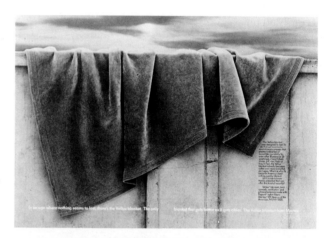

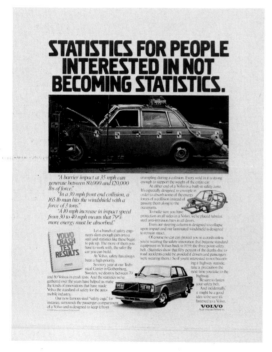

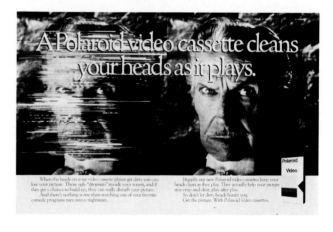

165

Art Director	Simon Bowden
Photographer	Harry DeZitter
Writer	Frank Fleizach
Client	Volvo
Agency	Scali, McCabe, Sloves, New York, NY

166

Art Directors	Thom Higgins and Carole Deitchman
Photographer	Howard Berman
Writer	John Doig
Client	Polaroid
Agency	Ogilvy & Mather Advertising, New York, NY

167

Art Director	Bob Needleman
Writers	Larry Hampel, Ed McCabe
Client	Sperry
Agency	Scali, McCabe, Sloves, New York, NY

168

Art Directors	Frank Perry, Marshall Taylor
Designer	Frank Perry
Photographer	Irv Bahrt
Writer	Hal Friedman
Client	Burger King Corp.
Agency	J. Walter Thompson, New York, NY
Publication	Sports Illustrated

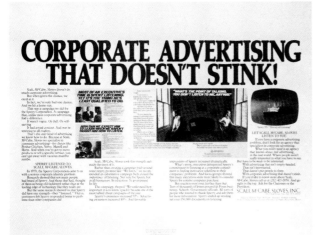

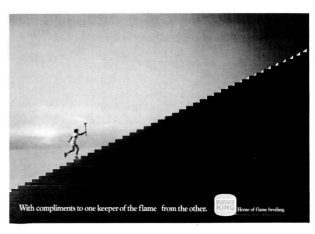

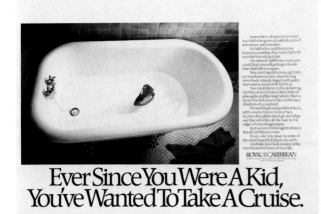

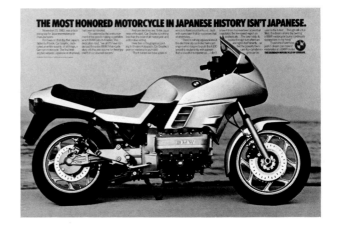

169

Art Director	Larry Bennett
Photographer	Tim Olive
Writer	Harriet Frye
Agency	McKinney, Silver & Rockett, Raleigh, NC

170

Art Director	Jerry Whitley
Designer	Jerry Whitley
Photographer	Ernst Hermann Ruth
Writer	Joe O'Neill
Client	BMW of North America, Inc.
Agency	Ammirati, & Puris Inc., New York, NY
Publication	Autoweek

171

Art Director Pam Cunningham
Photographer Lamb & Hall
Writer Carol Ogden
Client American Honda Motor Company, Inc.
Agency Needham Harper Worldwide/Los Angeles, CA
Publication Major League Baseball World Series Program

172

Art Director John Morrison
Photographer Dennis Manarchy
Writer Tom McElligott
Client AMF American
Agency Fallon McElligott Rice, Minneapolis, MN
Publication Inside Sports

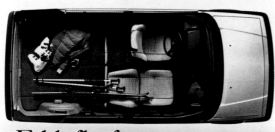

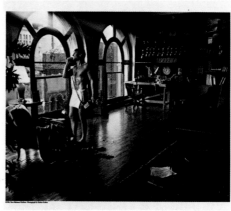

173

Art Director Rick Elkins
Designer Rick Elkins
Photographer Larry Robins
Writer Rhonda Peck
Client IBM
Agency Doyle Dane Bernbach, New York, NY

174

Art Director Alan Sprules
Photographer Robert Farber
Writer Roger Proulx
Client Paco Rabanne Parfums
Agency Ogilvy & Mather Advertising, New York, NY
Creative Director Jay Jasper

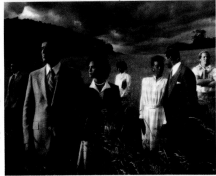

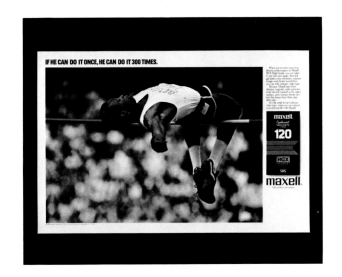

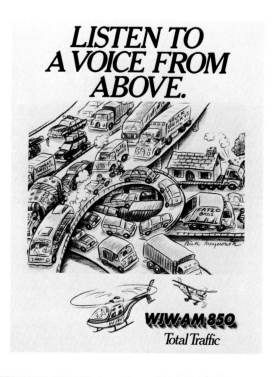

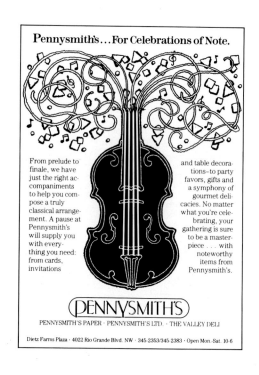

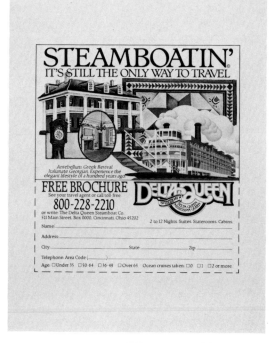

183

Art Director Gary Goldsmith
Designer Gary Goldsmith
Artist Gil Cope
Writer Diane Rothschild
Client Allied Corp
Agency Doyle Dane Bernbach, New York, NY

184

Art Director Dave Gardiner
Photographer Carol Kaplan
Artist Cathleen Toelke
Writer Gail Schoenbrunn
Client Sporto shoes
Agency Ingalls, Boston, MA

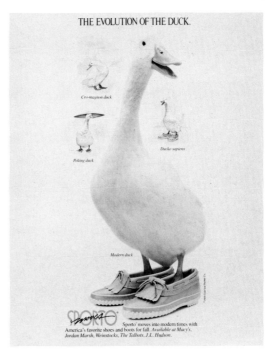

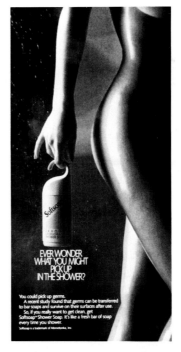

185

Art Directors Bill Hollingshead, Tom Shortlidge
Writer Mike Faems
Client Tupperware International
Agency Young & Rubicam Chicago, Chicago, IL

186

Art Director Jeff Jones
Photographer Dennis Manarchy
Writer Gary LaMaster
Client Minnetonka, Inc.
Agency Bozell & Jacobs, Inc., Minneapolis, MN

187

Art Director	John Morrison
Photographer	Dennis Manarchy
Writer	Tom McElligott
Client	AMF American
Agency	Fallon McElligott Rice, Minneapolis, MN
Publication	Inside Sports

188

Art Director	Sarah A. Macuga
Designer	Sarah A. Macuga
Photographer	Roy Coggin
Writer	Ned Tolmach
Client	Regent of Washington
Agency	Soghigian & Macuga Advertising, Washington, DC

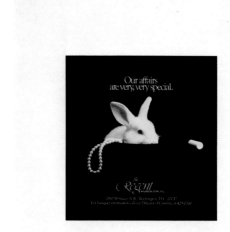

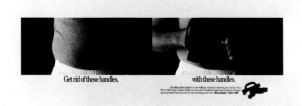

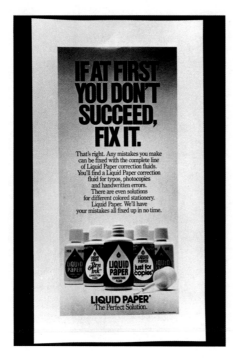

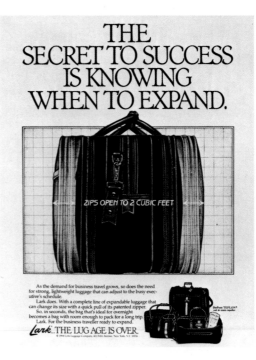

189

Art Directors	Susan Nappe, Patrick Flaherty
Photographer	Steve Marsel
Writer	Vashti Brotherhood
Client	Papermate
Agency	HHCC, Boston, MA

190

Art Director	Joe Loconto
Artist	Kirsten Soderlind
Writer	Terry Gallo
Client	Lark Luggage
Agency	Dancer, Fitzgerald, Sample, Inc., New York, NY
Executive Creative Director	Eric Weber
Associate Creative Director	Stephen Dolleck

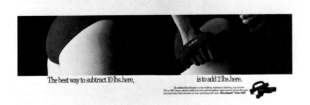

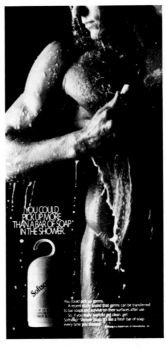

195

Art Director	Steven Wedeen
Designer	Steven Wedeen
Artist	Kevin Tolman
Writer	Donna Williams
Client	Pennysmith's
Agency	Vaughn/Wedeen Creative, Inc., Albuquerque, NM

196

Art Director	Paul Lepelletier
Designer	Paul Lepelletier
Photographer	Charles Gold
Writer	Eli Kramer
Client	Joseph Garneau Co.
Agency	Benton & Bowles, Inc., New York, NY
Publication	Esquire Magazine

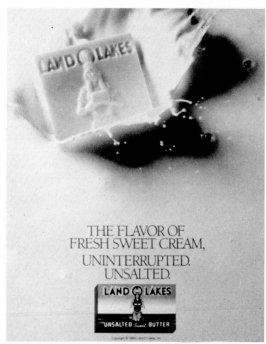

197

Art Director	Scott Frederick
Designer	Scott Frederick
Artist	Wanamakers Art Studio
Writer	Craig Jackson
Client	The Delta Queen Steamboat, Inc.
Agency	Northlich, Stolley, Inc., Cincinnati, OH

198

Art Director	Liz Kell Schupanitz
Designer	Liz Kell Schupanitz
Photographer	Dennis Manarchy
Writer	Laurie Casagrande
Client	Land O'Lakes, Inc. Unsalted Butter
Agency	Campbell-Mithun, Inc., Minneapolis, MN
Publication	Gourmet

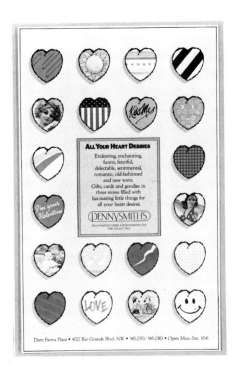

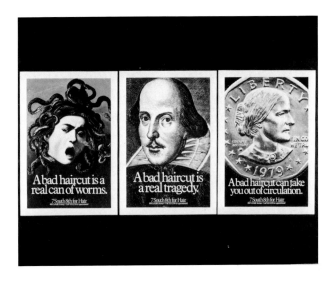

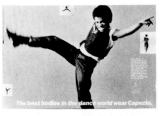

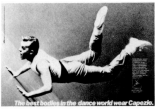

203

Art Director	Tom Stoneham
Photographer	Pete Stone
Writer	Barry Pullman
Client	Gerber Legendary Blades
Agency	Borders, Perrin & Norrander, Inc., Portland OR

204

Art Director	Peter Arnell
Designer	Dinah Coops
Photographer	Duane Michals
Client	To Boot
Agency	Arnell/Bickford Associates, New York, NY
Account Executive	Ted Bickford

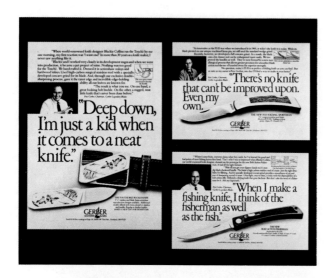

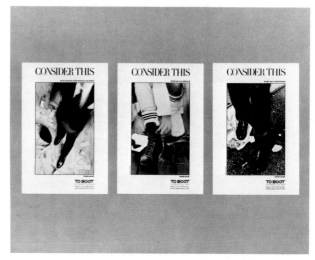

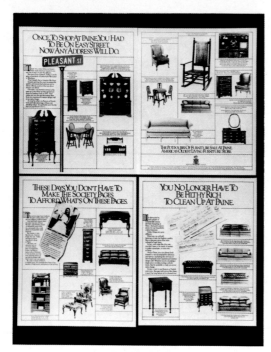

205

Art Director	Bob Kasper
Designer	Bob Kasper
Photographers	John Curtis, Bob Kasper
Writer	Kathy Kiley
Client	Paine Furniture
Agency	HBM/MacDonald, Boston, MA
Publication	Boston Globe Magazine
Creative Director	Terry MacDonald

Gold Award

Art Director	Tom Wolsey
Designer	Tom Wolsey
Photographer	Henry Wolf
Writer	Helayne Spivak
Client	Karastan Rug Mills, Inc.
Agency	Ally & Gargano, Inc., New York, NY
Publications	House & Garden, Architectural Digest

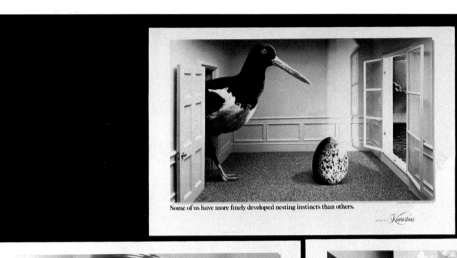

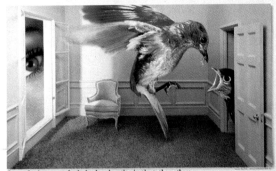

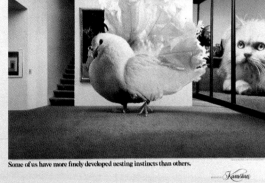

Gold Award

Art Director John Morrison
Photographer Dennis Manarchy
Writer Tom McElligott
Client AMF American
Agency Fallon McElligott Rice, Minneapolis, MN
Publication Gentlemen's Quarterly

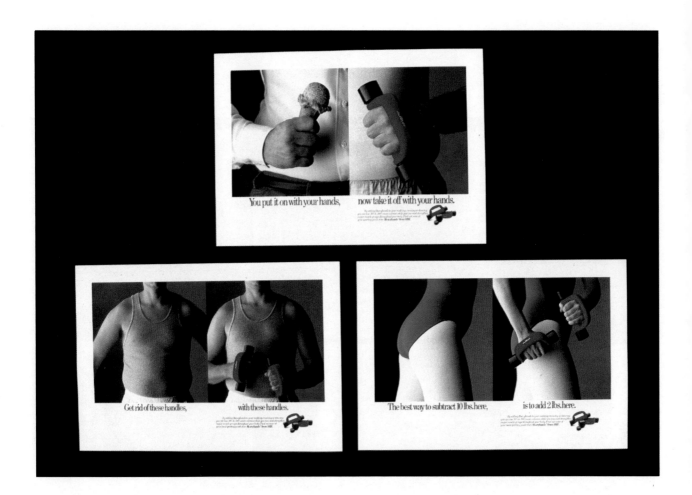

Silver Award

Art Director Gordon Bowman
Designer William Wondriska
Photographer Jay Maisel
Client United Technologies Corporation
Agency United Technologies, In House,
 Hartford, CT

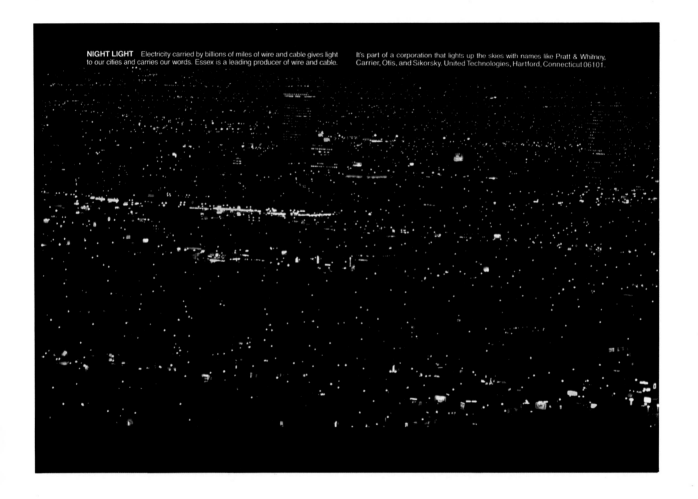

NIGHT LIGHT Electricity carried by billions of miles of wire and cable gives light to our cities and carries our words. Essex is a leading producer of wire and cable.

It's part of a corporation that lights up the skies with names like Pratt & Whitney, Carrier, Otis, and Sikorsky. United Technologies, Hartford, Connecticut 06101.

Art Directors	Seymon Ostilly, Jean Marcellino
Artists	Richard Leung, Larry Ottino, Students of the Children's All Day School
Writers	Barry Hoffman, Kevin O'Neill, John Schmidt
Client	IBM Corp.
Agency	Lord, Geller, Federico, Einstein Inc., New York, NY
Publications	Time, Money, Newsweek

The writer quoted above is a recent kindergarten graduate.

And the words are only a few of many he could read and write for you.

The future laureate, Matthew Howse, was part of a unique educational project. A two-year study of that project, sponsored by IBM, has led to an important new IBM product called the Writing to Read System.

It simply teaches children how to convert sounds they can already say into sounds they can write.

At first, there's little emphasis on spelling and punctuation. (Matthew, for instance, needed help with the word "beautiful.")

The important thing is, children learn to express their own feelings and ideas.

Thousands of kindergartners took part in the project. After one year, their reading ability as a group was significantly higher than the national norm.

What's more, seven out of ten could write words, sentences, even stories. Skills not expected of beginning readers.

To help develop Writing to Read, IBM provided personal computers, Selectric typewriters, workbooks and tape recorders. As well as money to train teachers and underwrite the project.

We think the idea is so beautiful that, well, ask Matthew Howse.

IBM

210

Art Director	Pat Burnham
Photographers	Harley Hettick, Jay Dusard, John Running
Writer	Bill Miller
Client	US West
Agency	Fallon McElligott Rice, Minneapolis, MN
Publication	Forbes

211

Art Director	John Morrison
Photographer	Dennis Manarchy
Writer	Tom McElligott
Client	AMF American
Agency	Fallon McElligott Rice, Minneapolis, MN
Publication	Inside Sports

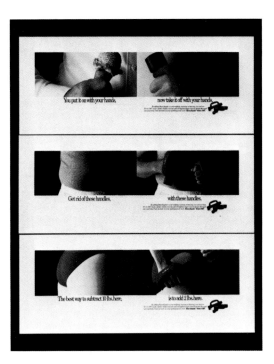

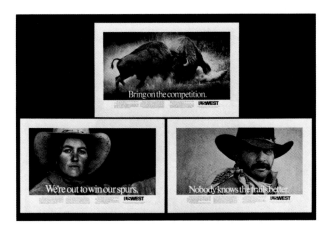

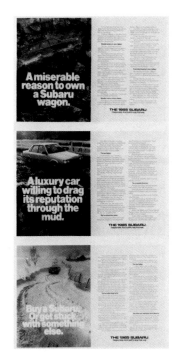

212

Art Director	Tony De Gregorio
Designer	Tony De Gregorio
Photographer	Carl Furuta
Writer	Lee Garfinkel
Client	Subaru
Agency	Levine, Huntley, Schmidt & Beaver, New York, NY

213

Art Director	Eric Anderson
Designer	Eric Anderson
Photographers	Lynn St. John, Jerry Friedman
Writers	Peggy Gregerson, Karen Mallia
Client	Swanson
Directors	Malcolm End, John Doig
Agency	Ogilvy & Mather Advertising, New York, NY
Publications	Bon Appetit, Southern Living, Sports Illustrated

214

Art Director	Wes Keebler
Writers	Chuck Silverman, Steve Kaplan
Client	Tahiti Tourism Promotion Board/ UTA French Airlines
Creative Director	Chuck Silverman
Agency	Cunningham & Walsh, Fountain Valley, CA
Production Manager	Jill Heatherton

215

Art Director	Ray McAnallen
Photographer	Norm Parker
Writer	Mike Fickes
Client	Anheuser-Busch, Inc.-Budweiser
Agency	D'Arcy MacManus Masius, St. Louis, MO
Publications	Red Bird Review, Pro Magazine, Goal Magazine

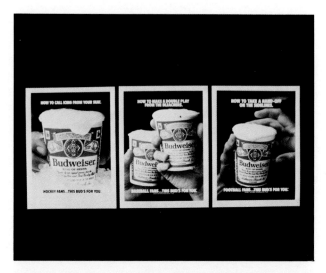

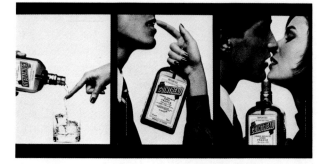

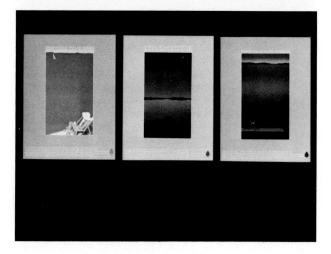

216

Art Directors	Ron Travisano, Rochelle Udell
Photographer	Lothar Schmidt
Writer	Jerry Della Femina
Client	Cointreau
Agency	Michael Meyer/Pat Kuss/Della Femina, Travisano & Partners, Inc., New York, NY

217

Art Directors	Jeff Laramore, David Jemerson Young
Designer	Jeff Laramore
Artist	Jeff Laramore
Writers	David Jemerson Young, John Young
Client	The Shorewood Corporation
Agency	Young & Laramore, Indianapolis, IN

218

Art Director Paul Cade
Photographer Nigel Dickson
Writer Allan Kazmer
Client Quaker Oats Company of Canada
Ltd.
Agency Doyle Dane Bernbach Advertising
Ltd., Toronto, Canada
Production Manager John Stevenson
Typographer Hunter Brown Limited

219

Art Directors Gary Yoshida, Holly Hood
Photographer Lamb and Hall
Writers Bob Coburn, David Morgenstern
Client American Honda Motor Company,
Inc.
Agency Needham Harper Worldwide, Los
Angeles, CA
Publications USA Today, Time, Ms.

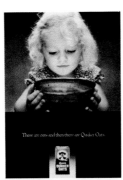

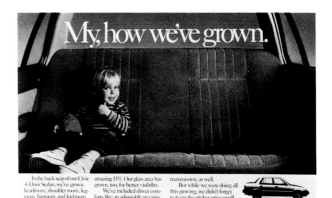

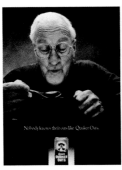

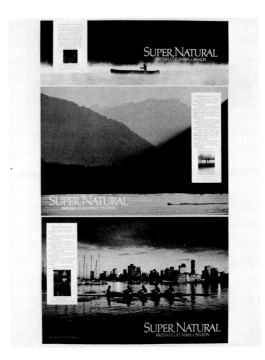

220

Art Director Don Zimmerman
Photographer Sarah Moon
Writer Elin Jacobson
Client Jeremy Pudney
Agency NW Ayer Incorporated, New York, NY
Publication Harper's Bazaar

221

Art Director Bill Cozens
Designer Bill Cozens
Photographers Charles O'Rear, Derik Murray, Image
Finders/Ross Stojko
Writer Alvin Wasserman
Client Tourism British Columbia
Agency McKim Advertising Ltd., Vancouver,
B.C.
Creative Director Alvin Wasserman

222

Art Director	Jerry Whitley
Designer	Jerry Whitley
Photographer	Ernst Hermann Ruth
Writers	Joe O'Neill, Rich Pels
Client	BMW of North America, Inc.
Agency	Ammirati & Puris, Inc., New York, NY
Publications	Autoweek, Rider

223

Art Director	Bryan McPeak
Designer	Bryan McPeak
Photographer	Fred Collins
Artist	John Burgoyne
Writer	David Lubars
Client	Shawmut Banks
Agency	Leonard Monahan Saabye, Providence, RI
Production	Linda Ahearn

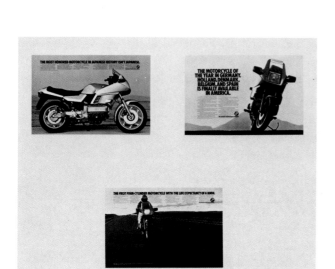

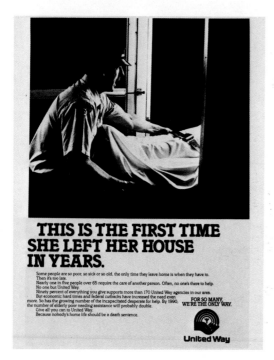

225

Art Director	Dennis Mramor
Designer	Dennis Mramor
Photographer	Carl Fowler
Writer	Tom Amico
Client	United Way Services
Agency	Meldrum and Fewsmith, Cleveland, OH
Retoucher	Paul Dzuroff

226

Art Director	Tom Sexton
Designer	Tom Sexton
Photographer	David Fischer
Writers	Tom Sexton, Elizabeth Dawson
Client	San Francisco Child Abuse Council
Agency	Young and Rubicam, San Francisco, CA
Publication	San Francisco Magazine

227

Art Director	Robert Talarczyk
Designers	Susan Verba, Robert Talarczyk
Writer	Bill Ballard
Client	CIBA-Geigy
Agency	C & G Agency, Summit, NJ

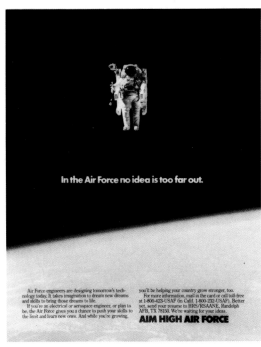

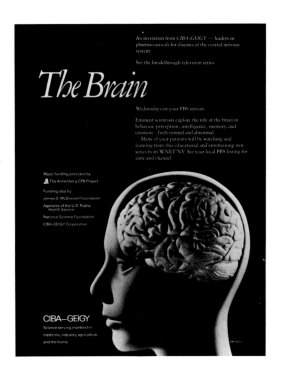

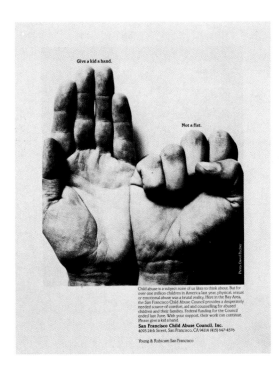

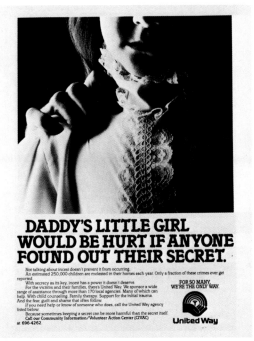

228

Art Director	Stephen Parker
Designer	Stephen Parker
Photographer	NASA
Writers	Chet Lane, Martha Marchesi
Client	United States Air Force
Agency	D'Arcy MacManus Masius, New York, NY
Publication	Byte

229

Art Director	Dennis Mramor
Designer	Dennis Mramor
Photographer	Carl Fowler
Writer	Tom Amico
Client	United Way Services
Agency	Meldrum and Fewsmith, Inc., Ceveland, OH
Retoucher	Paul Dzuroff

230

Art Director	Jack Farmer
Designer	Rick Phillips
Photographer	Richard Petrillo
Writer	Tom Tuerff
Client	Clean Community Systems of Albuquerque
Agency	Boyd Dudley Farmer, Phoenix, AZ

231

Art Director	Eric Ripp
Writer	Andy Mendelsohn
Client	Seagram Distillers
Agency	Warwick Advertising, New York, NY

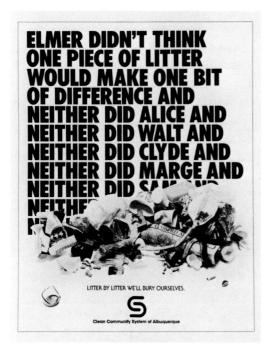

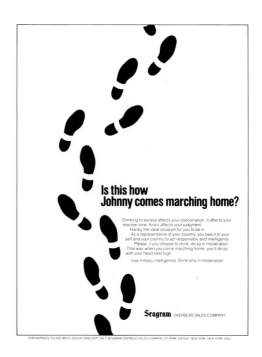

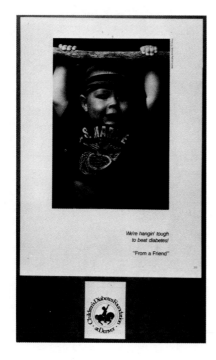

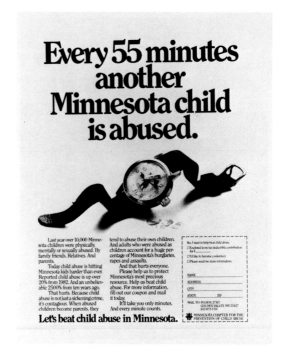

232

Art Director	Nancy Flanders Lockspeiser
Designer	Nancy Flanders Lockspeiser
Photographer	Terrence Patrick Currey
Writer	Terrence Patrick Currey
Client	Children's Diabetes Foundation at Denver
Editor	Christine Lerner
Publisher	Children's Diabetes Foundation at Denver, CO
Advertising Manager	Betsy Noel

233

Art Director	Paul Schupanitz
Designer	Paul Schupanitz
Photographer	Ben Saltzman
Writer	Patrick Hanlon
Client	Minnesota Chapter for the Prevention of Child Abuse
Agency	Campbell-Mithun, Inc., Minneapolis, MN

234

Art Director	Dennis Mramor
Designer	Dennis Mramor
Photographer	Carl Fowler
Writer	Tom Amico
Client	United Way Services
Agency	Meldrum and Fewsmith, Cleveland, OH
Retoucher	Paul Dzuroff

235

Art Director	Ray Stollerman
Photographer	Cosimo Studios
Writer	Betsy Mansfield
Client	Barbara Pesin
Agency	NW Ayer Incorporated, New York, NY
Publication	Time Magazine

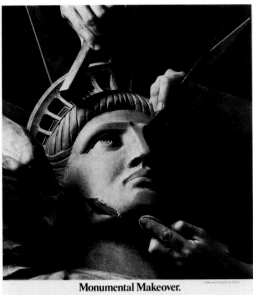

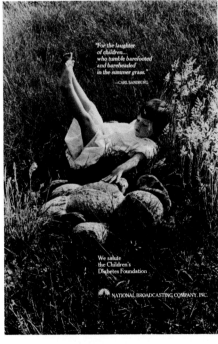

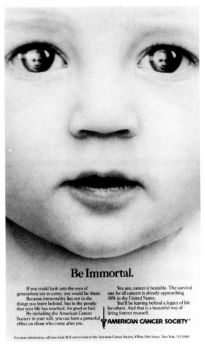

236

Art Director	Dolores Gudzin
Designer	Dolores Gudzin
Photographer	George Gibbon
Writers	Robert Edelstein, Carl Sandburg
Client	National Broadcasting Company, Inc.
Agency	National Broadcasting Company, Inc., New York, NY
Publication	7th Annual Carousel Ball Journal

237

Art Director	Gail Kennedy
Writer	Charles Silbert
Client	American Cancer Society
Agency	Young & Rubicam, New York, NY

Art Director Dennis Mramor
Designer Dennis Mramor
Photographer Carl Fowler
Writer Tom Amico
Client United Way Services
Agency Meldrum and Fewsmith, Cleveland, OH
Retoucher Paul Dzuroff

Art Director Colin Priestley
Artist Henry Fernandez
Writers Marilyn Leitman, Anne Baldwin, Steven Ridley
Client Ontario Ministry of the Attorney General
Agency Camp Associates Advertising, Toronto, Ontario, Canada

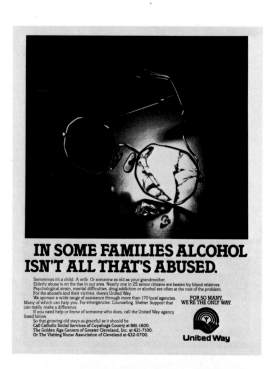

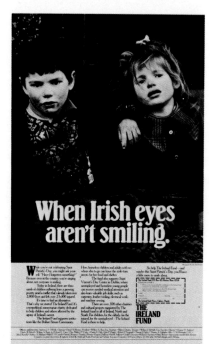

Art Director John Schmidt
Writer John Montgomery
Client The Ireland Fund
Agency Leo Burnett Co., Inc., Chicago, IL

241

Art Director Dennis Mramor
Designer Dennis Mramor
Photographer Carl Fowler
Writer Tom Amico
Client United Way Services
Agency Meldrum and Fewsmith, Cleveland OH
Retoucher Paul Dzuroff

243

Art Director Mike Fazende
Writer Richard M. Coad
Client The Mental Health Association of Greater Chicago
Agency Young & Rubicam Chicago, Chicago, IL

244

Art Director Peter Poulos
Designer Peter Poulos
Photographer Michael Pateman
Writer David Apicella
Client The President's Council on Volunteerism and Independent Sector
Creative Director Jay Schulberg
Agency Ogilvy & Mather Advertising, New York, NY

Silver Award

Art Director John Morrison
Photographer Tom Berthiaume, Arndt &
Berthiaume Photography
Writer Jarl Olsen
Client AMF American
Agency Fallon McElligott Rice, Minneapolis,
MN
Publication Sporting Goods Business

Live off the fat of the land.

You could be in great shape selling one of the hottest new lines of exercise equipment in America. Visit us in booth 1446 at this year's National Sporting Goods Association Convention & Show in Dallas, Texas, January 31 through February 3rd. **AMF**

Silver Award

Art Director	Jerry Whitley
Designer	Jerry Whitley
Photographer	Leon Kuzmanoff
Writer	Joe O'Neill
Client	BMW of North America, Inc.
Agency	Ammirati & Puris, Inc., New York, NY
Publication	On The Level

IN 1968, MALCOLM FORBES FOUND AN INVESTMENT WORTH SITTING ON.

And then, there is his favorite pursuit of all: motorcycle riding. Forbes took it up sixteen years ago at the age of 48.

He now owns two BMW's.

WHY MALCOLM FORBES LIKES BMW'S.

A BMW, writes Cycle magazine, "is perfectly tailored for your basic civilized discriminating blue-blooded rider who understands the difference between a one-dimensional motorcycle and one with character."

Malcolm understands the difference.

He has toured the United States, Europe, Russia, Asia and Africa. Encountering every kind of terrain, from ice-encrusted Siberian highways to sand-swept Moroccan desert roads. And "Malcolm's favorite pace," according to Cycle magazine, "is brisk."

There's no motorcycle better equipped to handle that pace, mile after mile, year after year than a BMW.

Its opposed-twin power plant runs at "the kind of engine speeds that lead to a long and trouble-free life" (Touring Bike). Enabling BMW's to not only attain high speeds, but sustain them. Without exhausting themselves or their riders in the process.

Indeed, because of the twin's exceptionally low center of gravity, BMW's are, according to Forbes, "responsive, light and thoroughly comfortable for cruising," where they can be flicked as opposed to wrestled through turn after turn.

Nor is any other motorcycle as likely to make a rider's hard-earned dollars go as far. BMW's are warranted for 3 years and an unlimited number of miles; 3 times longer than virtually any other bike.*

Is a motorcycle warranty really important to a man of Malcolm's means?

"My father preached a respect for money, in the sense of a penny saved is a penny earned. Whenever we left the living room to go to dinner we were taught to turn out the lights on the way."

Those interested in sitting on an investment vehicle as opposed to just a motorcycle should see their BMW dealer.

Malcolm Forbes has never been given to doing things halfway.

In 1941, he borrowed enough money to become the publisher of not one, but two Ohio newspapers. He was 22 at the time.

In 1951, he purchased his first piece of artwork by the fabled Russian jeweler, Fabergé.

Today the Forbes magazine's collection is rivaled only by the Kremlin's.

A few years ago, he took his very first ride in a hot-air balloon. Fifteen months later, he set six world records en route to becoming the first person in history to soar coast to coast across North America.

THE LEGENDARY MOTORCYCLES OF GERMANY.

Distinctive Merit

Art Director	David Garcia
Designer	David Garcia
Photographer	Sean Eagar
Writer	Mike Rogers
Client	Michelin Tire Corporation
Agency	Doyle Dane Bernbach, New York, NY
Publications	Modern Tire Dealer, Tire Review, Fleet Owner

HOW TO PREVENT PREMATURE BALDNESS.

Perhaps no group suffers more from premature baldness than loggers.

What with the Herculean loads you carry and the treacherous terrain you traverse, it's no wonder your tires wear out so quickly.

Which is an out-and-out shame. Because there is a solution. One that can reduce your tire costs significantly.

The Michelin XDL radial traction tire.

It has 40% more tread than our highway drive axle traction tires. And more tread—especially more Michelin tread—means more mileage. To say nothing of more protection.

The Michelin XDL is also reinforced with steel belts under the tread which help guard against punctures.

Since the shoulder of any traction tire shoulders the blame for a lot of damage, we beefed it up with ribs. And added a special cut-resistant compound to the sidewall.

What's more, since the XDL's sidewall is more flexible, when it hits a sharp object, it gives. Helping to resist damage.

Because of its special tread compound and deep aggressive tread design, the XDL also provides outstanding traction in mud and rock.

Of course, you may have to pay a little more for the Michelin XDL initially.

But because it outperforms and outlasts standard traction tires, the XDL actually ends up saving you money.

MICHELIN. BECAUSE SO MUCH IS RIDING ON YOUR TIRES.

248

Art Director	Tom Varisco
Designer	Tom Varisco
Writer	Tom Varisco
Client	Paragraphics, Inc.
Design Firm	Tom Varisco Graphic Designs, Inc., New Orleans, LA

249

Art Director	Phil Willet
Designer	Phil Willet
Photographer	Dan Mullen
Writer	Hy Abady
Client	Ricoh
Agency	Calet, Hirsch & Spector, Inc., New York, NY
Publication	Photo Marketing

DON'T FORGET TO FLUSH.

Paragraphics
Your Typographic Studio
6901 Pritchard Pl., New Orleans, LA 70125
504/866-8816 Telecopier 866-8810

THE RICOH KR-10 SUPER. CAMERA DEALERS LOOK AT IT THIS WAY.

Amazing advertising discovery.
Man has a brain.

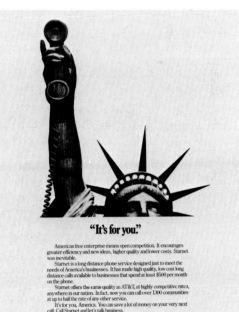

"It's for you."

250

Art Director	Jim Fitts
Artist	Don Martin
Writer	Jon Goward
Client	ClarkeGowardFitts
Agency	ClarkeGowardFitts, Boston, MA

251

Art Director	John Vitro
Photographers	Peter Kaplan, Marshall Harrington
Artist	Richard Malfara
Writer	Martha Shaw
Client	Starnet
Agency	Knoth & Meads, San Diego, CA
Account Executive	Gary Meads

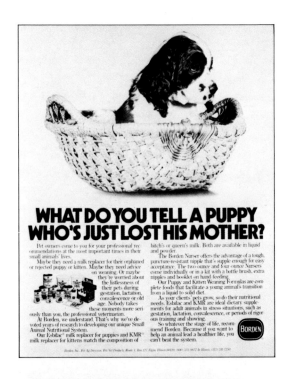
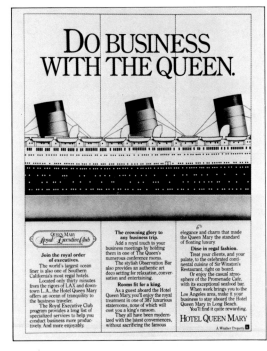
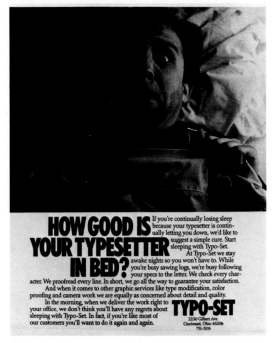

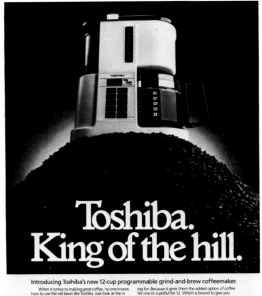

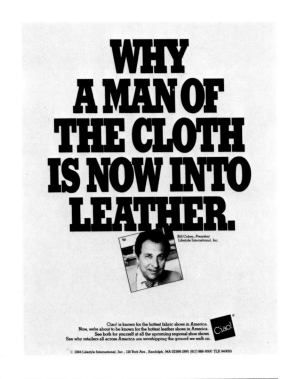

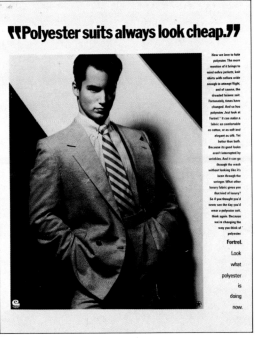

260

Art Director	Harris Milligan
Photographer	Allen Matthews
Writer	Bob Morrison
Client	Cargill, Wilson & Acree
Agency	Cargill, Wilson & Acree, Atlanta, GA
Publication	Northside Neighbor

261

Art Director	Gary Greenberg
Designer	Gary Greenberg
Photographer	UPI
Writer	Peter Seronick
Client	Dexter Shoe Company
Agency	Rossin Greenberg Seronick & Hill Inc., Boston, MA
Publication	Footwear News

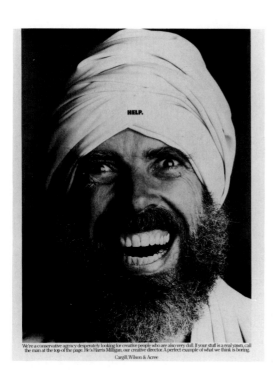

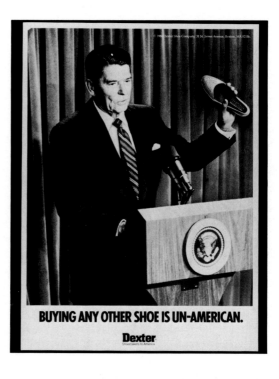

Silver Award

Art Director Bob Barrie
Photographer Jim Arndt, Arndt & Berthiaume
 Photography
Writer Phil Hanft
Client Control Data Business Advisors
Agency Fallon McElligott Rice, Minneapolis,
 MN
Publication Maryland Business & Living

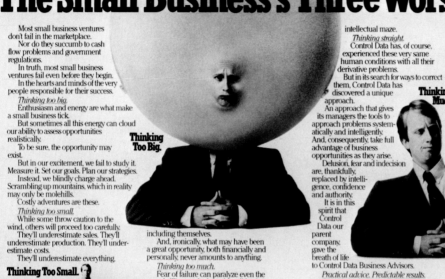

The Small Business's Three Worst Enemies.

Most small business ventures don't fail in the marketplace.

Nor do they succumb to cash flow problems and government regulations.

In truth, most small business ventures fail even before they begin.

In the hearts and minds of the very people responsible for their success.

Thinking too big.

Enthusiasm and energy are what make a small business tick.

But sometimes all this energy can cloud our ability to assess opportunities realistically.

To be sure, the opportunity may exist.

But in our excitement, we fail to study it. Measure it. Set our goals. Plan our strategies. Instead, we blindly charge ahead. Scrambling up mountains, which in reality may only be molehills.

Costly adventures are these.

Thinking too small.

While some throw caution to the wind, others will proceed too carefully. They'll underestimate sales. They'll underestimate production. They'll underestimate costs.

They'll underestimate everything.

Thinking Too Small.

including themselves.

And, ironically, what may have been a great opportunity, both financially and personally, never amounts to anything.

Thinking too much.

Fear of failure can paralyze even the most brilliant and talented small business operators.

They'll tediously examine, re-examine, cross-examine, analyze and trivialize every detail. Endlessly meeting and discussing every possible option with all its ramifications.

Ultimately, what may have been a simple and exciting idea becomes lost in a dull,

intellectual maze.

Thinking straight.

Control Data has, of course, experienced these very same human conditions with all their derivative problems.

But in its search for ways to correct them, Control Data has discovered a unique approach.

An approach that gives its managers the tools to approach problems systematically and intelligently. And, consequently, take full advantage of business opportunities as they arise.

Delusion, fear and indecision are, thankfully, replaced by intelligence, confidence and authority.

It is in this spirit that Control Data our parent company, gave the breath of life to Control Data Business Advisors.

Practical advice. Predictable results.

Our charter is simple. To bring to you the excitement and challenge of making your business run your way.

Our technique is equally simple.

We give you the tools. And let you use them.

Unlike most traditional consultants, the people you will work with have experienced the very same problems you are experiencing now.

Unlike most traditional consultants, the techniques for solving these problems are the techniques we ourselves have used successfully. In real business situations.

At Control Data Business Advisors, we don't propose to solve your problems for you. But, rather, teach you to take control and solve them yourself. Confidently. Intelligently. Efficiently. And, most importantly, correctly.

Mail the coupon for an invitation to our free introductory seminar.

Or, if you prefer, a free personal consultation, including program recommendation and costs.

Better yet, call 800-382-7070 toll free right now.

It may be the most courageous business decision you'll ever make.

Thinking Too Big.

Thinking Too Much.

Help. I have seen the enemy. And he is me.

☐ Please have one of your staff call to make an appointment for a free consultation.
☐ I'd like to attend your free seminar.

Name
Company
Address
City State Zip
Phone ()

CONTROL DATA BUSINESS ADVISORS
Box 0-MNB07S, Minneapolis, MN 55440

263
Distinctive Merit

Art Director	Ron Louie
Designer	Ron Louie
Photographer	Jim Young
Writer	Mike Rogers
Client	Michelin
Agency	Doyle Dane Bernbach, New York, NY
Publication	Fleet Owner

"IT'S JUST AS GOOD AS A MICHELIN. AND $30 CHEAPER."

Everyone and his uncle is comparing himself to Michelin these days.

It lasts as long as a Michelin. It handles as well as a Michelin.

And just in case no one has said it to you today, let us be the first: it's cheaper than a Michelin.

While comparison may be one of the sincerest forms of flattery, we'd like to point out what many users have learned at the hands of the best, if not the kindest teacher, experience.

It's only as good as a Michelin when it's a Michelin. That's particularly true of the Michelin Pilot XDA low-profile radial.

For openers, this extraordinary drive axle tire delivers up to 25% more mileage than standard radials. (That offsets the lower initial price of many standard radials right off the bat.)

The Michelin XDA also makes your biggest operating cost—fuel—less costly.

It minimizes rolling resistance significantly. And in doing so reduces fuel consumption up to 4% compared to standard radial tires.

And 4% over an expected original tread life of 200,000 miles is a mint of money. That stays in a very popular place.

Your pocket.

The Michelin XDA drive axle low-profile radial also gives you excellent retreadability. And outstanding casing life and value. Even after 200,000 miles the casing is usually worth in the neighborhood of $90 to you or a retreader.

And since the XDA weighs less than standard radials, it not only enables you to carry more cargo.

It reduces your taxes by up to $13.47 per tire.

And it goes almost without saying that the XDA offers exceptional traction. On dry, wet, even snowy roads.

So why settle for a cheaper tire that isn't as good as a Michelin, when it's more cost-effective to get the one tire that really is as good as a Michelin.

A Michelin.

MICHELIN. BECAUSE SO MUCH IS RIDING ON YOUR TIRES.

264

Art Director Peter Cohen
Photographer Jerry Calamari
Writer Martin Kaufman
Client Nikon
Agency Scali, McCabe, Sloves, New York, NY

265

Art Director Rene Vidmer
Photographer Alen MacWeeney
Writers Eve Hartman, Ken Baron
Client Stuffed Shirt
Agency Baron & Zaretsky Advertising, New York, NY

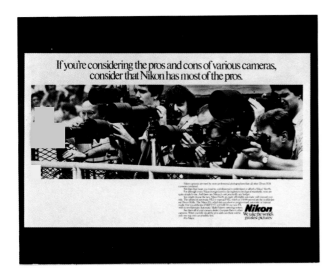

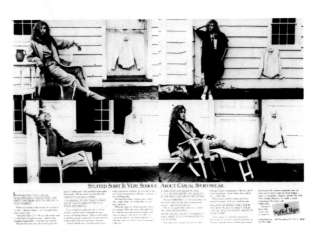

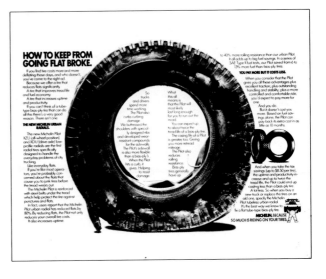

266

Art Director Bob Barrie
Artist Bob Barrie
Writer Phil Hanft
Client Dalmations by Golly
Agency Fallon McElligott Rice, Minneapolis, MN
Publication Canine Chronicles

267

Art Director David Garcia
Designer David Garcia
Photographer Jim Young
Writer Mike Rogers
Client Michelin Tire Corporation
Agency Doyle Dane Bernbach, New York, NY
Publications Modern Tire Dealer, Tire Review, Fleet Owner

268

Art Director Robert Giaimo
Designer Robert Giaimo
Artist Joel Pahn
Writer Tom Molitor
Client Grey Advertising, Los Angeles
Agency Grey Advertising, Los Angeles, CA
Creative Director Alan Kupchick

269

Art Director Bob Barrie
Photographer Jim Arndt, Arndt & Berthiaume
Photography
Writer Phil Hanft
Client Control Data Business Advisors
Agency Fallon McElligott Rice, Minneapolis,
MN
Publication Minnesota Business Journal

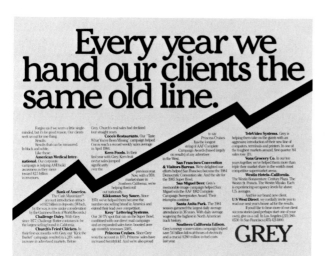

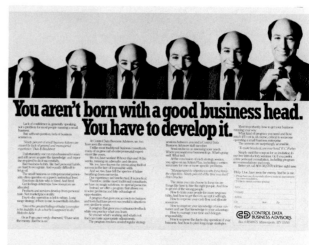

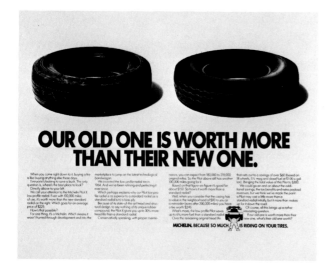

270

Art Director Ron Louie
Designer Ron Louie
Photographer Jim Young
Writer Mike Rogers
Client Michelin
Agency Doyle Dane Bernbach, New York, NY
Publication Refrigerated Transporter

271

Art Director	John Morrison
Photographer	Steve Steigman
Writer	Tom McElligott, Mike Lescarbeau
Client	Micro Business Applications
Agency	Fallon McElligott Rice, Minneapolis, MN
Publication	Corporate Report

272

Art Director	Dean Hanson
Photographer	stock
Writer	Rod Kilpatrick
Client	ITT Life Insurance Corporation
Agency	Fallon McElligott Rice, Minneapolis, MN
Publication	Best's Review

Something is wrong when your sales are up 300% and the word on the street is that you're in trouble.

IN 1986, WE'LL HAVE MORE AGENTS IN HONG KONG THAN THE C.I.A. AND THE K.G.B. COMBINED.

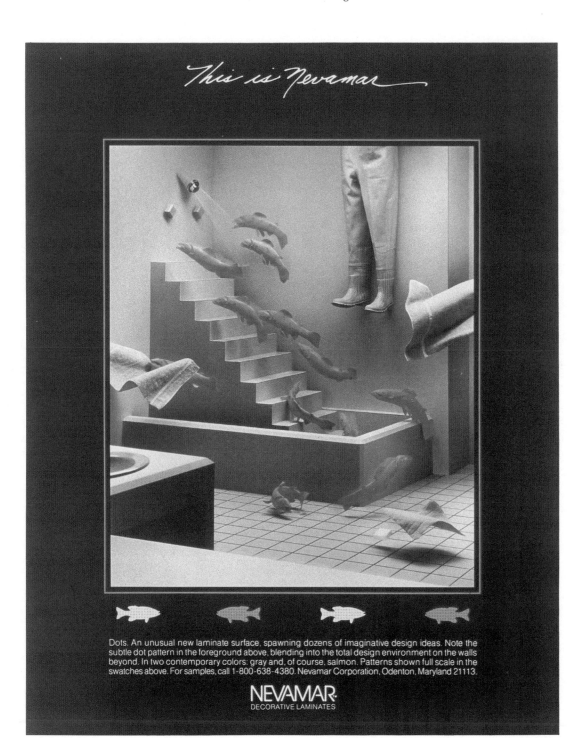

Silver Award

Art Director David Nathanson
Designer David Nathanson
Photographer Larry Robins
Writer Jane Talcott
Client Cigna Corporation
Agency Doyle Dane Bernbach, New York, NY
Publication Business Insurance

A FEW WORDS ABOUT OVERTREATMENT.

Sometimes it seems that there are more tonsillectomies in this world than tonsils.

It would be laughable except that overtreatment helps drive up medical costs, which, as any employee benefit manager knows, is no laughing matter.

At Connecticut General, a CIGNA company, we're not simply wringing our hands and raising our rates. We're doing something to help contain costs.

Our Medical Management Information system pinpoints overtreatment through DRG-based analysis. For example, are your employees exceeding the expected length hospital stay for their diagnosis? Which providers routinely admit on Friday for Monday surgery? Is there an excess of short hospitalizations that could have been outpatient procedures?

Information like this, along with utilization review programs and employee education, helps our clients hold down their costs. We have instituted a hospital pre-admission certification program in many areas around the country, with more on the way. That's a great step in cost containment because we are examining treatment plans before charges are incurred.

If you'd like to know how we can help reduce your company's costs or want more information, call your broker, your local Connecticut General representative, or call Chip Sharkey, Marketing Vice President, at (203) 726-8500.

Benefit costs won't be contained by providing bigger and bigger bandages, but by finding the correct programs for your company's needs.

Connecticut General Life Insurance Company
a CIGNA company

275

Art Director Michael Grout
Designer Michael Grout
Artist Ernie Norcia
Writer Terrance L. Flynn
Client Howard Paper Mills
Agency Kircher, Helton & Collett, Inc. Dayton, OH
Publication Graphic Design U.S.A.

276

Art Director Eddie Tucker
Designer Eddie Tucker
Artist Eddie Tucker
Writers Joy Blair, Eddie Tucker
Client Boyle Investment Company
Agency Ward Archer & Associates, Memphis, TN

277

Art Director Bruce Mayo
Designer Bruce Mayo
Writer Lynda Lawrence
Client Microlife America
Agency Mayo, Brogan Advertising, Inc., Costa Mesa, CA
Publication Computer Retail News

278

Art Directors Doug Fisher, Bob Bender
Designers Dough Fisher, Bob Bender
Photographer Hickson-Bender
Writer Ron Etter
Client Nevamar Corporation
Agency Lord, Sullivan & Yoder, Marion, OH
Publication Interior Design

279

Art Director	Gary Goldsmith
Designer	Gary Goldsmith
Artist	Gil Cope
Writer	Diane Rothschild
Client	Allied Corp
Agency	Doyle Dane Bernbach, New York, NY

280

Art Director	Fernando Lecca
Designer	Fernando Lecca
Photographer	Myers Studios, Inc.
Writer	Michael N. Smith
Client	Pennwalt Flour Service
Agency	Faller, Klenk & Quinlan, Inc., Buffalo, NY
Publications	Cereal Foods World; Milling and Baking News

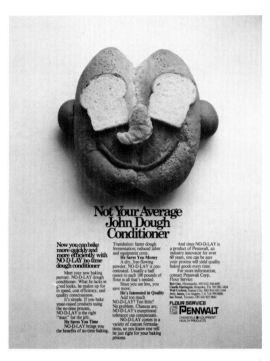

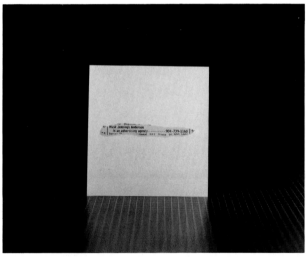

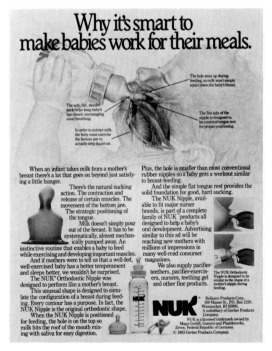

281

Art Director	Michael Parkes
Designer	Michael Parkes
Writer	Melanie Jennings Husk
Agency	Husk Jennings Anderson!, Jacksonville, FL

282

Art Director	Bryan McPeak
Photographer	Myron
Artists	John Burgoyne, Peter Hall
Writer	Tom Monahan
Client	Reliance Products Corp.
Agency	Leonard Monahan Saabye, Providence, RI
Production	Linda Ahearn

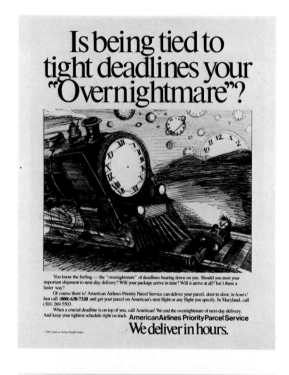

291

Art Director	Deborah Lucke
Designer	Deborah Lucke
Photographer	John Holt
Writer	Jeff Abbott
Client	Siebe North
Agency	Leonard Monahan Saabye, Providence, RI
Production	Linda Ahearn

292

Art Director	Andria Arnovitz
Designer	Andria Arnovitz
Photographer	Michael Pruzan
Writer	Michael LaMonica
Client	Owens-Corning Fiberglas
Publisher	Insulation Outlook/Insulation Guide
Director	Malcolm End
Agency	Ogilvy & Mather Advertising, New York, NY

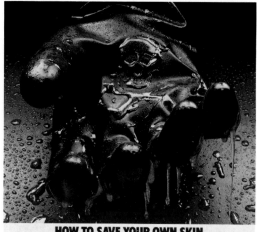

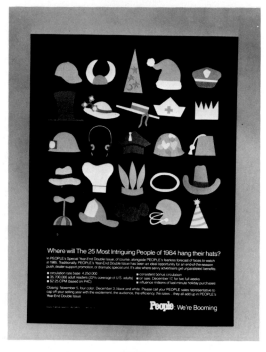

293

Art Directors	Liza Greene, Dick Martell
Designer	Liza Greene
Artist	Liza Greene
Writer	Alan Tuckerman
Client	People Magazine
Agency	People Promotion, New York, NY
Publications	Ad Age, Advertising Week

294

Art Director	Don Sibley
Designer	Don Sibley
Photographer	Neil Whitlock, The Photographers, Inc.
Writer	Don Sibley
Client	The Photographers, Inc.
Agency	Sibley/Peteet Design, Inc., Dallas, TX

295

Art Director	Amy Levitan
Designer	Amy Levitan
Artist	A.B. Silverman
Writer	Richard Middendorf
Client	IBM
Agency	Doyle Dane Bernbach, New York, NY
Publication	New York Times Magazine

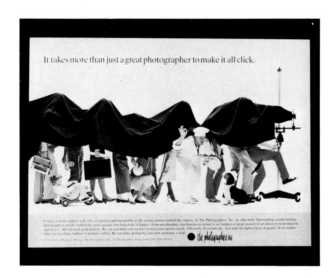

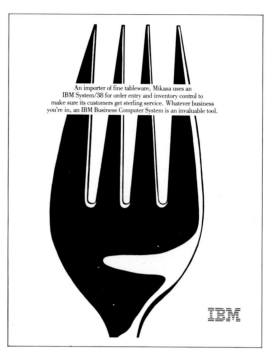

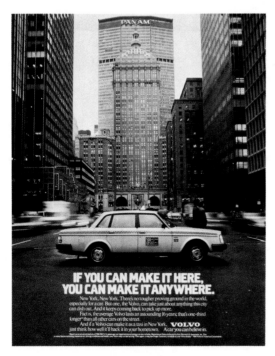

296

Art Director	Peter Cohen
Photographer	Jake Rajes
Writer	Jeffery Epstein
Client	Volvo
Agency	Scali, McCabe, Sloves, New York, NY
Publication	Los Angeles Times

297
Gold Award

Art Director	John Morrison
Photographer	Dennis Manarchy
Writer	Tcm McElligott
Client	AMF American
Agency	Fallon McElligott Rice, Minneapolis, MN
Publication	Sporting Goods Business

Make money hand over fist.

Last Christmas season, Heavyhands were the best selling new fitness product on the market.

Unfortunately, some retailers underestimated the demand and were caught in out-of-stock situations.

This year, the combination of more and better advertising, plus word-of-mouth endorsements from thousands of current Heavyhands users, promises another record breaking year.

And as if that weren't enough, Heavyhands will be offering a $2.00 off coupon to over 26 million AT&T customers this Fall.

So don't wait.

Order Heavyhands now, (with payment delayed until January 10, 1985), and begin putting a profitable Christmas within your grasp.

Heavyhands from AMF.

Silver Award

Art Director David Nathanson
Designer David Nathanson
Photographer Larry Robins
Writer Jane Talcott
Client Cigna Corporation
Agency Doyle Dane Bernbach, New York, NY
Publication Business Insurance

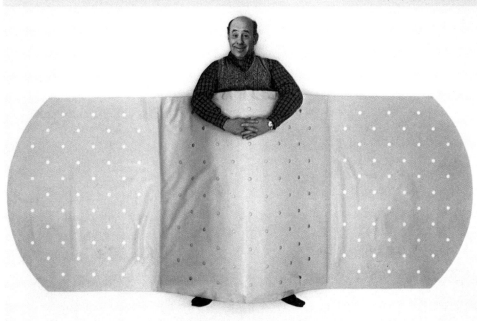

A FEW WORDS ABOUT OVERTREATMENT.

Sometimes it seems that there are more tonsillectomies in this world than tonsils.

It would be laughable except that overtreatment helps drive up medical costs, which, as any employee benefit manager knows, is no laughing matter.

At Connecticut General, a CIGNA company, we're not simply wringing our hands and raising our rates. We're doing something to help contain costs.

Our Medical Management Information system pinpoints overtreatment through DRG-based analysis. For example, are your employees exceeding the expected length hospital stay for their diagnosis? Which providers routinely admit on Friday for Monday surgery? Is there an excess of short hospitalizations that could have been outpatient procedures?

Information like this, along with utilization review programs and employee education, helps our clients hold down their costs. We have instituted a hospital pre-admission certification program in many areas around the country, with more on the way. That's a great step in cost containment because we are examining treatment plans before charges are incurred.

If you'd like to know how we can help reduce your company's costs or want more information, call your broker, your local Connecticut General representative, or call Chip Sharkey, Marketing Vice President, at (203) 726-8500.

Benefit costs won't be contained by providing bigger and bigger bandages, but by finding the correct programs for your company's needs.

Connecticut General Life Insurance Company
a CIGNA company

299

Silver Award

Art Director Ron Louie
Designer Ron Louie
Photographer Harry DeZitter
Writer Chuck Gessner
Client National Federation of Coffee
Growers of Colombia
Agency Doyle Dane Bernbach, New York, NY
Publication World Coffee & Tea

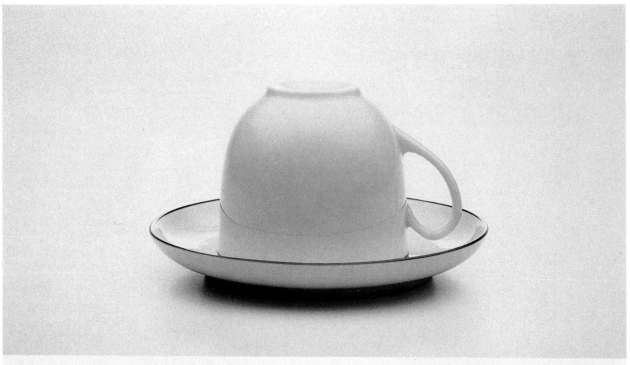

The only alternative to 100% Colombian Coffee.

To a lot of people, it's 100% Colombian Coffee—or nothing.

In fact, almost sixty percent of America's coffee drinkers now believe that 100% Colombian is the best. What's more, most of them are willing to pay a premium for it.

Combine this with our aggressive marketing program featuring Juan Valdez® and you'll realize this is one product a roaster shouldn't overlook.

For more information call toll free: 1-800-223-3101 or write: 100% Colombian Coffee Program, Post Office Box 8545, New York, N.Y. 10150.

100% Colombian Coffee. There's nothing like it.

Silver Award

Art Director John Morrison
Photographer Steve Umland
Writer Jarl Olsen
Client Shade Information Systems
Agency Fallon McElligott Rice, Minneapolis, MN
Publication The Office

The entire Eastern Seaboard was just wiped out by a single cup of coffee.

It can take hundreds of hours to fill up the memory on a computer diskette. And just a second to erase it.

That's why Shade offers their high-quality diskettes in a rigid plastic carton.

For just a little more, you get a permanent storage library for ten 5¼" diskettes.

When your precious memories are in the carton, they aren't being bashed with notebooks. Or drowned with coffee. Or scorched with cigarette ashes. And they aren't being lost.

Call us at 1-800-742-3475 and we'll tell you how you can order Shade diskettes in the plastic carton. Do it today.

Before you're wiped out by a paperweight.

301
Distinctive Merit

Art Director	Bob Barrie
Photographer	Steve Steigman
Writer	Rod Kilpatrick
Client	Interline Communication Services Inc.
Agency	Fallon McElligott Rice, Minneapolis, MN
Publication	Communications Week

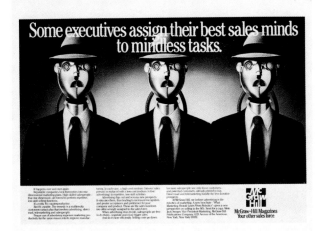

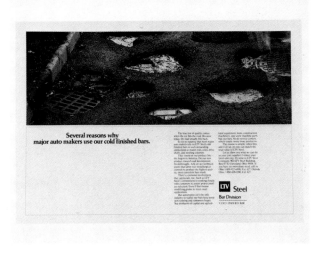

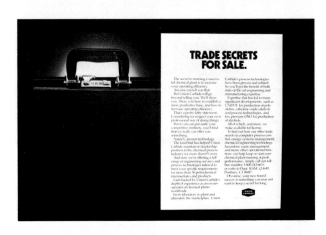

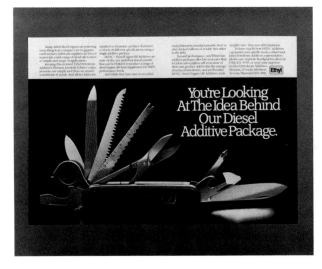

306

Art Director	Paul LaBarbera
Photographer	Steve Myers
Writer	Ann Hayden
Client	Eastman Kodak Company
Agency	Rumrill-Hoyt, Inc., Rochester, NY
Creative Group Manager	Kenn Jacobs

307

Art Director	Dave Clar
Designer	Dave Clar
Photographer	Mark Kozlowski
Writer	Bob Haefner
Client	Mobil Chemical
Agency	Hutchins/Young & Rubicam, Rochester, NY

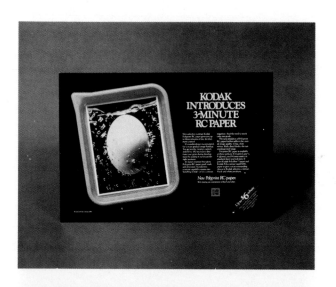

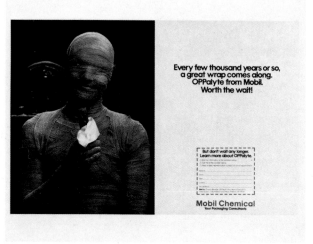

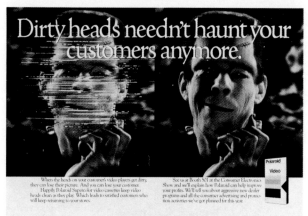

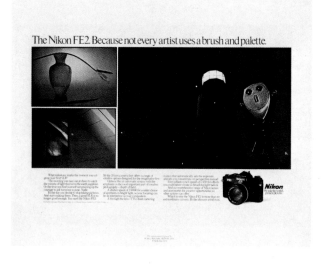

308

Art Directors	Thom Higgins and Carole Deitchman
Photographer	Howard Berman
Writer	John Doig
Client	Polaroid
Agency	Ogilvy & Mather Advertising, New York, NY

309

Art Director	Amy Schottenfels
Photographer	Michael O'Neil
Writer	Helen Klein
Client	Nikon
Agency	Scali, McCabe, Sloves, New York, NY

310

Art Directors | Stavros Cosmopulos, Tom Demeter
Designer | Stavros Cosmopulos
Artist | Ken Maryanski
Writer | Sam Bregande
Client | Allendale Insurance Co.
Agency | Cosmopulos, Crowley & Daly, Inc., Boston, MA
Typesetter | Arrow Comp./Boston

311

Art Director | George Zipparo
Photographer | Gary Feinstein
Writer | Tim McGraw
Client | McGraw-Hill Publications Co.
Agency | HCM, New York, NY

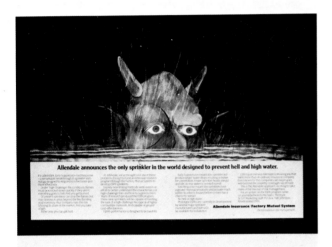

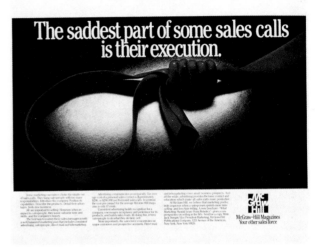

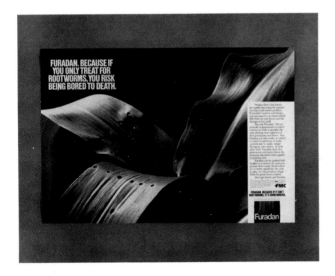

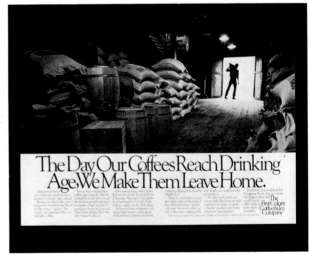

312

Art Director | Diane Cook Tench
Designer | Diane Cook Tench
Photographer | Gerald Zanetti
Writer | Daniel Russ
Client | FMC
Agency | The Martin Agency, Richmond, VA
Creative Supervisor | Mike Hughes

313

Art Director | Mark Fuller
Photographer | Ralph Holland
Writers | Ed Jones, Allen Wimettt
Client | The First Colony Coffee & Tea Co.
Agency | Finnegan & Agee, Inc., Richmond, VA

314

Art Director	Raymond Powell
Photographer	James Wood
Writer	Jim Cole
Client	The Ritz-Carlton, Naples
Agency	Cole Henderson Drake, Inc., Atlanta, GA

315

Art Director	Bridget DeSocio
Designer	Bridget DeSocio
Photographer	Bill White
Client	Stendig International, Inc., New York, NY
Printer	Sterling Roman Press
Director of Stendig Textiles	Ursula Dayenian

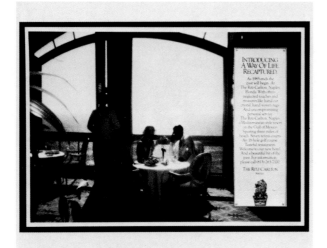

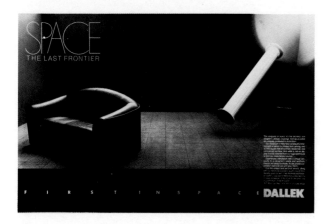

316

Art Director	Mary Anne Christopher
Photographers	Cailor/Resnick
Writer	Steve Brophy
Client	Dallek Office Furniture
Agency	Smith/Greenland, Inc., New York, NY
Publication	Interior Design

317

Art Director	Alice E. Meliere
Photographer	Gerald Zanetti
Writers	Dick Calderhead, Anne Reilly
Client	The Creative Black Book
Agency	Calderhead & Phin, New York, NY

318

Art Director Carol Franklin
Designer Carol Franklin
Photographer Larry Robins
Writer Marcia Lusk
Client A.I.G.
Agency Needham Harper Worldwide, Inc.,
New York, NY
Publication Business Insurance

319

Art Director Steve Singer
Designer Steve Singer
Photographer James Salzano
Writers Michael Robertson; Anders Rich
Client RCA
Agency Needham Harper Worldwide, Inc.,
New York, NY
Publication Business Week North America

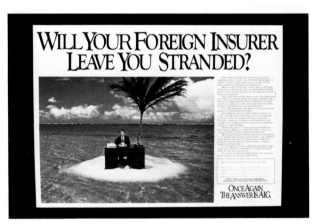

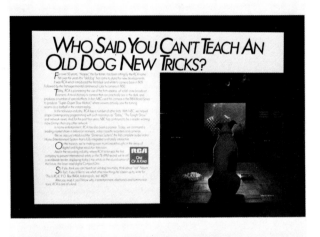

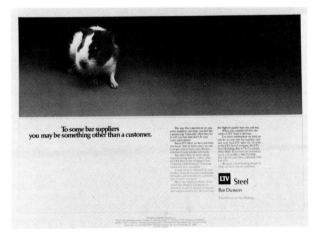

320

Art Director Christina Howe
Photographer Michael Furman
Writer Jack Soos
Client Strathmore Paper Company
Agency Keiler Advertising, Farmington, CT
Advertising Manager Murray Grant
Production Mary Morris

321

Art Director John Scavnicky
Designer John Scavnicky
Photographer Charlie Coppins
Writer Scott Mackey
Client LTV Steel Company
Client Meldrum and Fewsmith, Inc.,
Cleveland, OH
Art Studio Falcon Advertising

322

Art Directors	Steve Frykholm, Ivan Chermayeff
Designers	Ivan Chermayeff, Steve Jenkins
Photographer	Francois Robert
Writer	Ralph Caplan
Client	Herman Miller Inc.
Agency	Chermayeff & Geismar Associates, New York, NY
Publication	Progressive Architecture

323

Art Director	Jerry Gentemann
Photographer	Terry Heffernan
Writers	Lloyd Fabri, Judy Bean
Client	McCann-Erickson
Agency	McCann Erickson, Atlanta/New York
Publication	Fortune Magazine

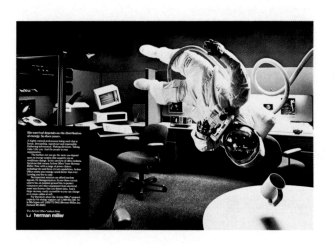

Silver Award

Art Director	Bridget DeSocio
Designer	Bridget DeSocio
Photographer	Bill White
Client	Stendig International, Inc., New York, NY
Production	William Tucker
Typographers	Nassau Type
Printer	Sterling Roman Press
Publication	Progressive Architecture Magazine
Vice-President of Marketing	Larry Pond, Stendig International

325
Distinctive Merit

Art Directors Dean Hanson, John Morrison
Photographers Rick Dublin, stock, Kent Severson
Writers Jarl Olsen, Rod Kilpatrick
Client ITT Life Insurance Corporation
Agency Fallon McElligott Rice, Minneapolis, MN
Publication Life Insurance Selling

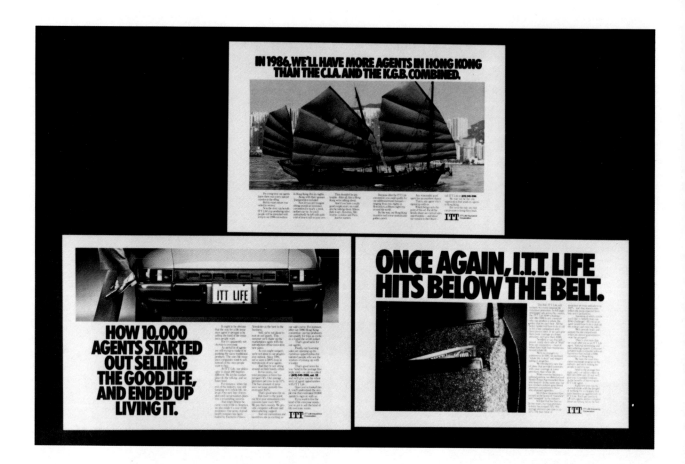

326

Art Director	Bob Barrie
Photographer	Jim Arndt, Arndt & Berthiaume Photography
Writer	Phil Hanft
Client	Control Data Business Advisors
Agency	Fallon McElligott Rice, Minneapolis, MN
Publication	Minnesota Business Journal

327

Art Directors	Dick Henderson, Coy Berry
Photographer	Eric Henderson
Writer	Tommy Thompson
Client	Harvey W. Watt & Co.
Agency	Cole Henderson Drake, Inc., Atlanta, GA

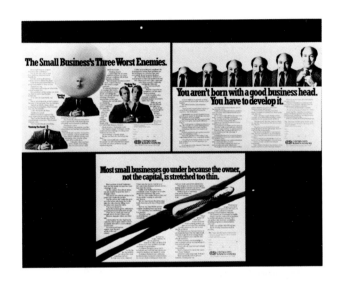

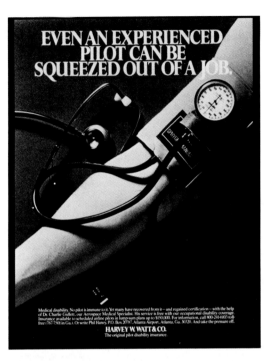

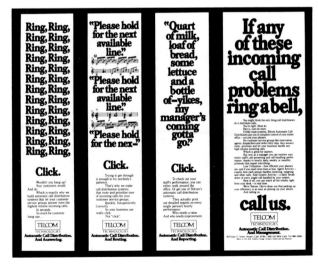

328

Art Director	Bruce Logan
Writer	Greg Voornas
Client	Telcom Technologies
Agency	LeAnce/Herbert/Bowers, Newport Beach, CA
Publication	Telecommunications Products & Technologies
Creative Director	Glenn Herbert

329

Art Director	Theodore Plair
Photographer	Thomas Victor
Writer	Robert Phillips
Client	Eastman Kodak Company
Agency	J. Walter Thompson U.S.A., New York, NY
Publication	Film Journal

331

Gold Award

Art Director Cheryl Heller
Designer Cheryl Heller
Photographers Clint Clemens, Bruno Joachim,
Bruce Pendleton, Ron Scott
Writer Peter Caroline
Client S.D. Warren Paper Co.
Agency The Design Group, HBM/Creamer
Inc., Boston, MA

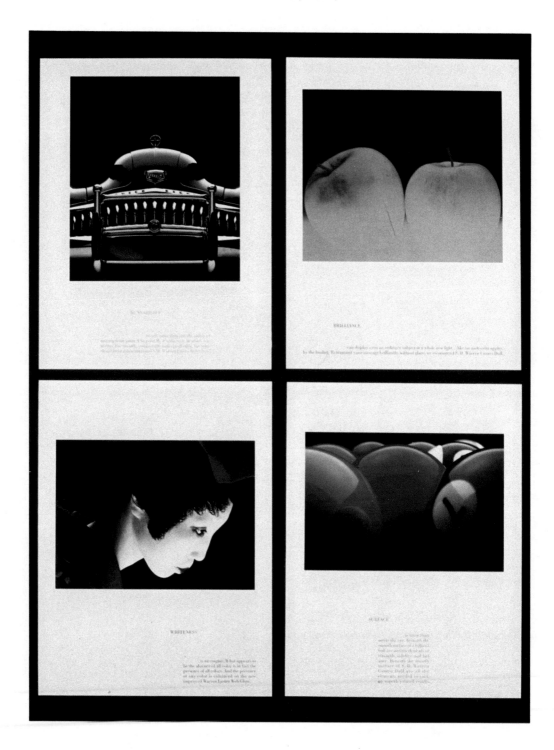

Silver Award

Art Director	Christina Howe
Photographer	Michael Furman; Myron
Writer	Jack Soos
Client	Strathmore Paper Company
Agency	Keiler Advertising, Farmington, CT
Advertising Manager	Murray Grant
Production	Mary Morris

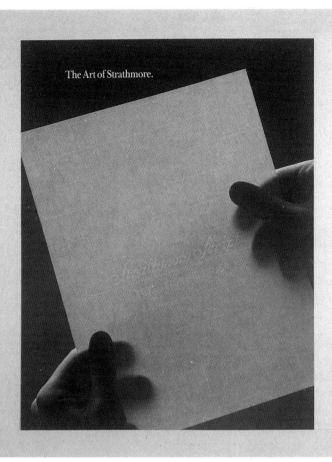

The Art of Strathmore.

The Science of Strathmore.

Throughout more than ninety years of papermaking at Strathmore, there has been much innovation, yet very little change. We now use sophisticated equipment to monitor and govern much of the papermaking process, but we have never forgotten the most important ingredient in fine paper. People.

It is our machine tenders, not our machines, that can detect flaws in a watermark traveling at more than a thousand feet a minute. And the most precise electronic color analyzer cannot match the sensitivity of the experienced human eye coupled with the instincts of the mind.

We understand that automation would allow us to make our papers more quickly, but it would not allow us to make them as well.

At Strathmore, people make our papers. And that we will never change.

Strathmore. Because paper is part of the picture.

Strathmore Paper Company
Westfield, Massachusetts ©1985

Silver Award

Art Director	John Morrison
Photographer	Steve Umland
Writer	Jarl Olsen
Client	Shade Information Systems
Agency	Fallon McElligott Rice, Minneapolis, MN
Publication	Modern Office Technology

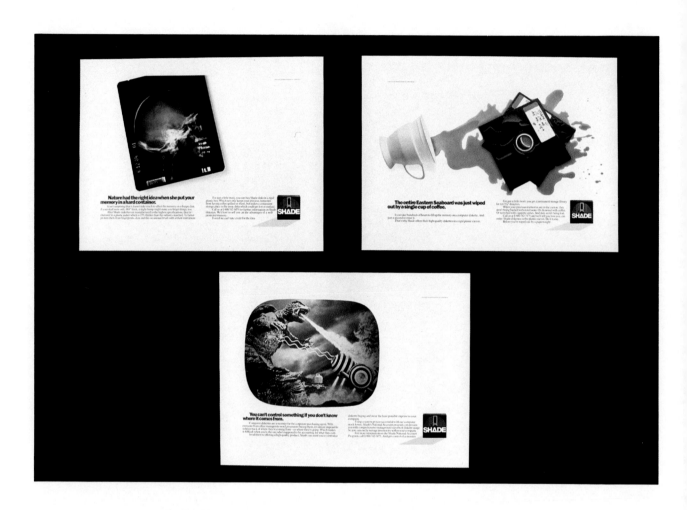

Distinctive Merit

Art Directors	Doug Fisher, Bob Bender
Designers	Doug Fisher, Bob Bender
Photographer	Hickson-Bender
Writer	Ron Etter
Client	Nevamar Corporation
Agency	Lord, Sullivan & Yoder, Marion, OH
Publication	Interior Design

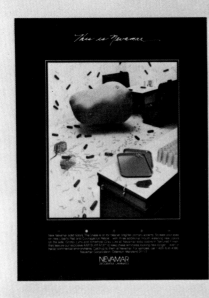 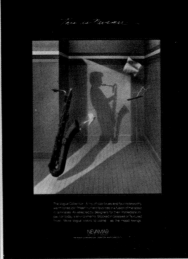 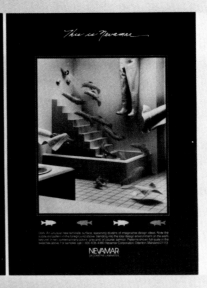

335

Art Director	Jerry Berman
Designer	Jerry Berman
Photographer	Nikolay Zurek
Writer	Jerry Berman
Client	Nikolay Zurek
Design Firm	Sidjakov Berman & Gomez, San Francisco, CA

336

Art Director	Gene Powers
Photographer	Jamie Cook
Writers	Jennifer Cresimore Lemay, Dave Nelson
Client	Kimberly-Clark Technical Paper & Specialty Products Group
Agency	Cargill, Wilson & Acree, Inc., Atlanta, GA
Publications	Print, Graphic Design, CA

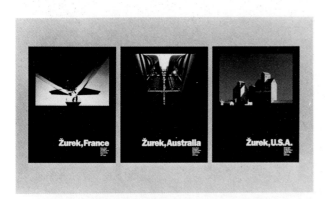

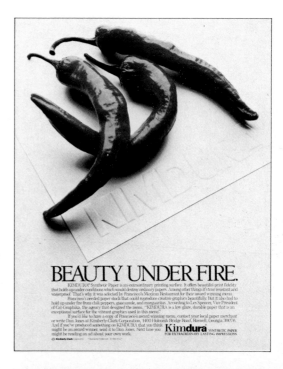

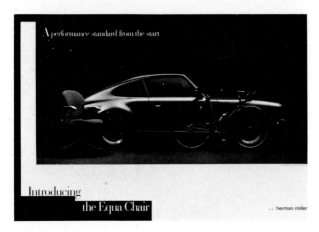

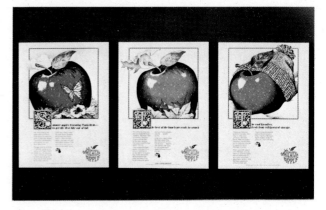

337

Designer	John Casado
Photographer	Rudi Legname
Writer	Michael Wright
Client	Herman Miller, Inc., Zeeland, MI

338

Art Directors	Diane Chencharick, Mike Morgan
Designer	Diane Chencharick
Artist	Chuck Mikolaycak
Writer	Cynthia Hewa
Client	Michigan Apple Committee
Agency	Baker, Abbs, Cunningham & Klepinger, Inc., Birmingham, MI

339

Art Director	Woody Kay
Designer	Woody Kay
Photographer	Myron
Writers	Tom Monahan, Melissa Mirarchi
Client	Wright Line Inc.
Agency	Leonard Monahan Saabye, Providence, RI
Production	Carl Swanson

340

Art Directors	Christine Owens, Janet Picchi-Fogg
Designer	Christine Owens
Photographer	Tom Tracy
Writers	Christine Owens, Susan Lutter
Client	Ultratech Photomask
Agency	Owens/Lutter, Santa Clara, CA

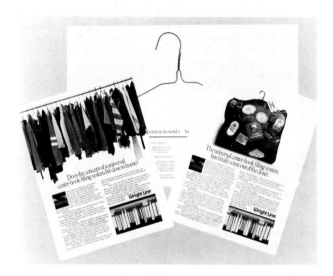

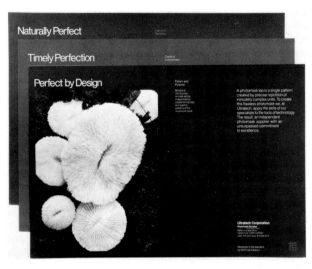

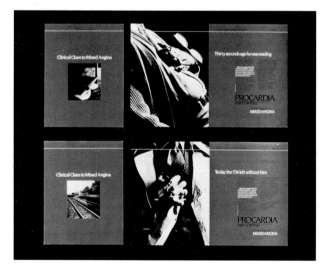

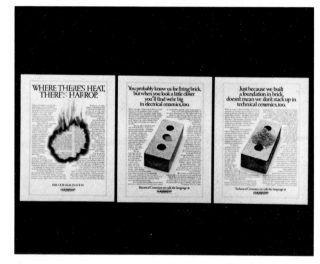

341

Art Director	Tom Velardi
Photographer	Bob Walsh
Writer	Carol Shepko
Client	Pfizer Laboratories
Agency	Dorritie & Lyons, New York, NY

342

Art Director	Axel Von Kaenel
Designer	Axel Von Kaenel
Photographer	Hickson-Bender
Writer	Terry Burris
Client	Harrop Industries, Inc.
Agency	Lord, Sullivan & Yoder, Marion, OH
Publications	Brick & Clay—ACS Bulletin, Ceramic Industries

343

Art Director	Dick Henderson
Photographer	stock
Writer	Jim Cole
Client	C.H. Masland & Sons
Agency	Cole Henderson Drake, Inc., Atlanta, GA

344

Designer	John Casado
Artist	Casado Design
Writer	Michael Wright
Client	Herman Miller, Inc., Zeeland, MI

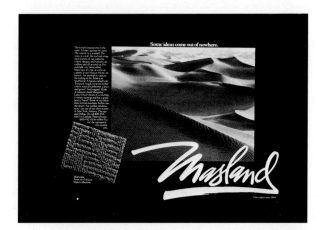

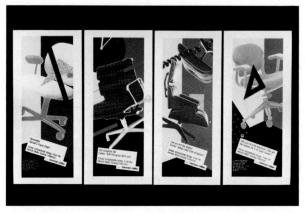

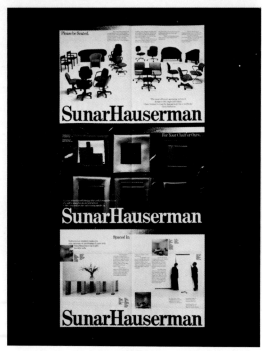

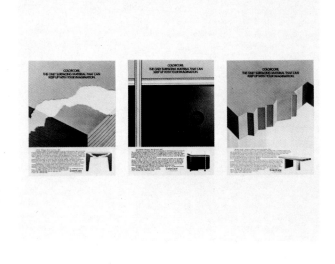

345

Art Director	Wilburn Bonnell III
Designer	Richard Beidel
Photographers	Bill Kontzias, Rudolph Janu, Idaka
Writer	Christine Rae
Client	Sunar Hauserman
Editor	Christine Rae
Publisher	Sunar Hauserman
Agency	Bonnell Design Associates Inc., New York, NY

346

Art Director	Tom Wai-Shek
Designer	Tom Wai-Shek
Photographers	Bob Harr/Hedrich-Blessing
Writer	Larry Vine
Client	Formica Corporation
Agency	Geers Gross Advertising, New York, NY

347

Art Directors	Marty Neumeier, Kathleen Joynes
Designers	Kathleen Joynes, Marty Neumeier, Sandra Higashi
Photographers	Tom Ploch and various stock photography
Writer	Marty Neumeier
Client	Precision Monolithics Inc.
Agency	Neumeier Design Team, Atherton, CA

348

Art Director	John Clark
Designer	John Clark
Photographer	Carrie Branovan
Agency	Jason Grant Associates, Providence, RI
Stylist	Cheryl Katz, C & J Katz Studio

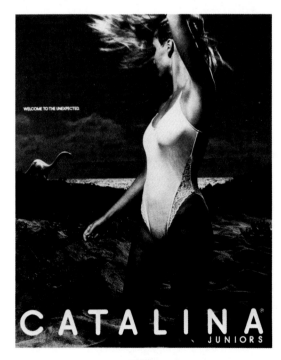

349

Art Director	Jim Benedict
Designer	Jim Benedict
Photographer	Norman Seeff
Writer	Peggy Foran
Client	Catalina
Agency	Grey Advertising, Los Angeles, CA
Creative Director	Alan Kupchick

350

Art Director	Axel Von Kaenel
Designer	Axel Von Kaenel
Artist	Dale Dalton
Writers	Ron Etter/Carroll Conklin
Client	Peabody Galion
Agency	Lord, Sullivan & Yoder, Marion, OH
Publications	Construction Equipment, Waste Age

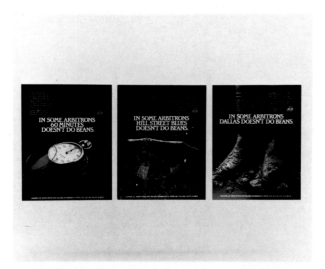

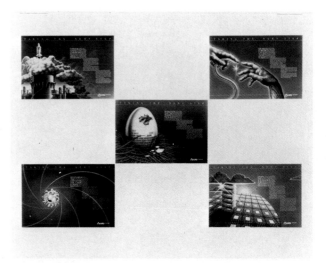

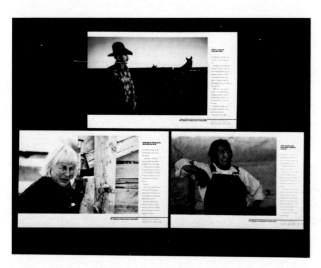

355

Art Director	Carol Franklin
Photographer	Steve Brunstein
Illustrator	Brian Zick
Writer	Marcia Lusk
Client	Union Carbide
Agency	Needham Harper Worldwide, Inc., New York, NY
Publication	Modern Paint & Coatings Journal

356

Art Director	Steve Stone
Designer	Steve Stone
Illustrator	Jennifer Beekman
Writer	Galen Wright
Client	Ciba-Geigy Corporation
Executive Creative Director	Kenneth Dudwick
Creative Director	Craig Mathiesen
Associate Creative Director	Tony Smith
Agency	Ketchum Advertising, San Francisco, CA
Publications	American Nurseryman, Grands Maintenance, Weeds, Trees & Turf
Production Supervisor	Dena Raffel
Engraver	Balzer Shopes

357

Art Director	Chuck Mumah
Designer	Chuck Mumah
Photographer	Neal Higgins
Artist	Rick Lovell
Writer	Mike Kane
Client	American Cyanamid-Prowl® Herbicide
Agency	Tucker Wayne & Company, Atlanta, GA
Publication	Farm Publications

358

Art Directors	Susan Slover, Susan Huyser
Designer	Susan Slover
Photographer	Niwa-Ogrudek
Client	The Paristyle Group
Director	Patrick O'Dea
Agency	Susan Slover Design, New York, NY
Publication	Accessories Magazine

359

Art Director	Ken Renczenski
Designer	Paul J. Cowley
Photographer	James Scherzi
Writer	Mike Greenstein
Client	Eastern Microwave, Inc.
Agency	Paul J. Cowley & Associates, Inc., Syracuse, New York

360

Art Directors	Diane Meier, Darcey Lund
Designers	Diane Meier, Darcey Lund
Photographer	Erica Lennard
Writer	Diane Meier
Client	Cambridge Dry Goods
Agency	Meier Advertising, New York, NY
Publication	WWD

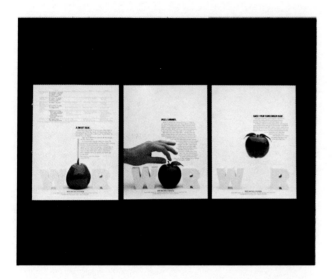

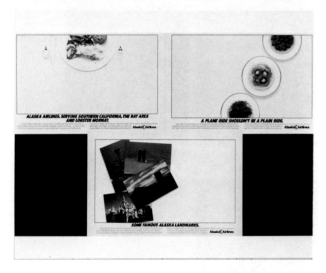

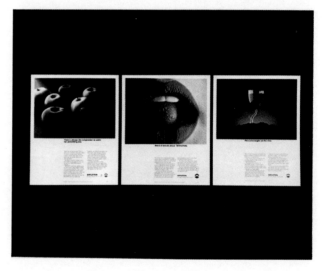

361

Art Director	Geoffrey B. Roche
Designer	Geoffrey B. Roche
Photographers	Lobster & Tarts: Terry Heffernan Postcards: S.F. & Seattle: Harold Sund/Portland: C. Bruce Foster/ Disneyland: stock
Writer	Jim Copacino
Client	Alaska Arilines
Agency	Livingston & Co., Seattle, WA

362

Art Director	Bob Jensen
Photographer	Glen Wans
Writer	Tom Hansen
Client	Mobay Chemical Corp.
Agency	Valentine-Radford, Inc., Kansas City, MO

363

Art Director	Marijo Bianco
Photographer	Rick Gould
Writer	Donn Carstens
Client	Sachs Properties
Agency	Bartels & Carstens, Inc., St. Louis, MO

364

Art Director	Ted Barton
Designer	Ted Barton
Photographer	Dennis Manarchy
Artists	Lawrence W. Duke, Robert Weber
Writer	Arthur Hofmayer
Client	Southern Pacific Transportation Co.
Agency	Ogilvy & Mather, San Francisco, CA

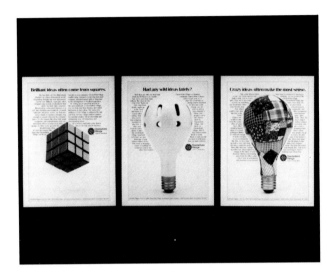

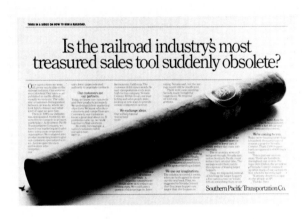

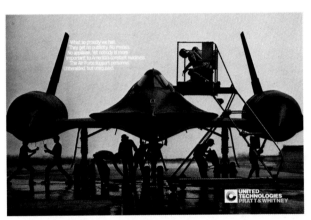

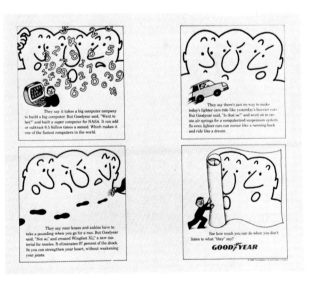

365

Art Director	Joe Goldberg
Photographer	Mark Meyer
Writer	Tim McGraw
Client	Pratt & Whitney
Agency	HCM, New York, NY

366

Art Director	Shelley Doppelt
Artist	Hal Silvermintz
Writer	Dick Evans
Agency	Brouillard Communications, New York, NY

367

Art Director	David Jemerson Young
Designer	David Jemerson Young
Artists	David Jemerson Young, Jeff Laramore, David Lesh
Writers	John Young, David Jemerson Young
Client	Arthur Young Agency
Agency	Young & Laramore, Indianapolis, IN

368

Art Director	Gene Federico
Photographers	Jaques Dirand, Bruce Wolf, Joe Standart
Artist	Helen Federico
Writer	George Soter
Client	F. Schumacher & Co.
Agency	Lord, Geller, Federico, Einstein Inc., New York, NY

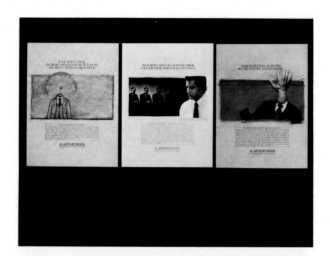

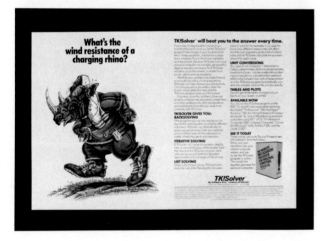

369

Art Directors	Stavros Cosmopulos, Richard Hydren
Designer	Stavros Cosmopulos
Artist	Ed Parker
Writers	Stavros Cosmopulos, Sam Bregande
Client	Software Arts, Inc.
Agency	Cosmopulos, Crowley & Daly, Inc., Boston, MA
Typesetter	Arrow Comp./Boston
Creative Director	Stavros Cosmopulos

370

Art Director	Richard Yeager
Designer	Peter Volz
Photographer	Richard Yeager
Writer	Burt Ritchie
Client	PermaGrain Products, Inc.
Agency	Richard Yeager Associates, Moorestown, NJ

371

Art Director Clifford Goodenough
Photographer Mark Hauser
Writer Bert Gardner
Client FirsTel Information Systems
Agency Bozell & Jacobs, Inc., Minneapolis, MN

372

Art Director Roy Grace
Designer Roy Grace
Photographers Stock Photo, Bill Farrell
Writers Tom Yobbagy, Jim McKennan
Client IBM-Information Systems Group
Agency Doyle Dane Bernbach, New York, NY
Publication Forbes

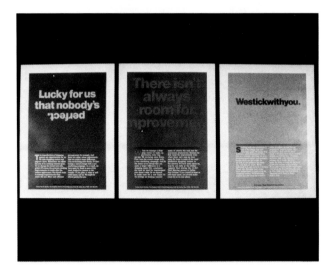

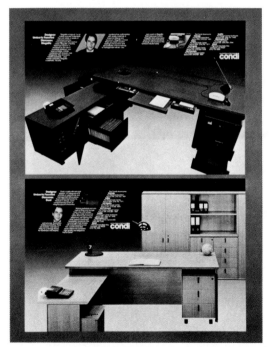

373

Art Director Chris Rovillo
Designer Chris Rovillo
Writer Mark Perkins
Client Schroder Center Management, Inc.
Agency Richards, Brock, Miller, Mitchell, & Assoc./The Richards Group, Dallas, TX

374

Art Director Marcia Loots-Serna
Writer Ted Luciani
Client Condi
Production Manager Allen Williams
Creative Director Cheri Ramey
Agency Ramey Communications, Los Angeles, CA
Publication Contract Magazine
Color Separations John Adams & Son

375

Art Director Arnie Blumberg
Photographer Abe Seltzer
Writer Bill Hentz
Client CBN Cable Network
Agency Foote, Cone & Belding, New York, NY
Publication Cable Age

376

Art Director George Zipparo
Photographers Henry Wolf, Gary Feinstein
Writer Tim McGraw
Client McGraw-Hill Publications Company
Agency HCM, New York, NY

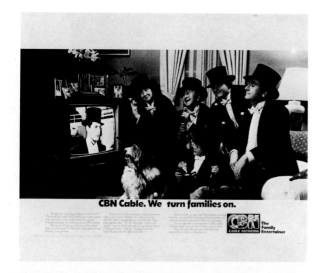

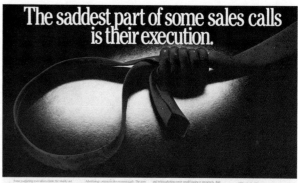

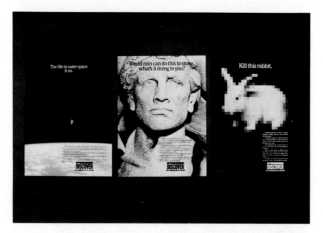

377

Art Director Bob Czernysz
Artist Frank Tedesco
Writer Dick Olmsted
Client Time, Inc.—Discover Magazine
Agency Young & Rubicam, New York, NY
Publications Adweek, Advertising Age
Associate Creative Director John Rindlaub

378

Art Director	Brian Harrod
Artist	Roger Hill
Writer	Ian Mirlin
Client	Chatelaine Promotions
Agency	McCann-Erickson, Toronto, Canada
Publication	Marketing Magazine
Creative Director	Stu Eaton
Mechanical Artist	Janette Sobczok

379

Art Directors	Stavros Cosmopulos, Tom Demeter
Designer	Stavros Cosmopulos
Artist	Ken Maryanski
Writer	Sam Bregande
Client	Allendale Insurance Co.
Agency	Cosmopulos, Crowley & Daly, Inc., Boston, MA
Typesetter	Arrow Comp./Boston

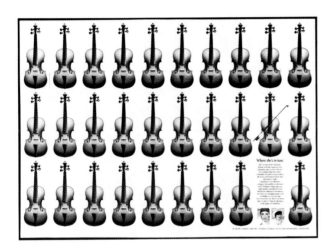

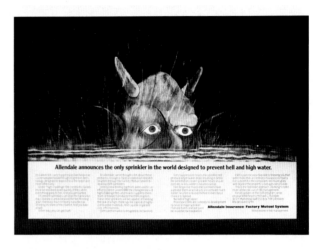

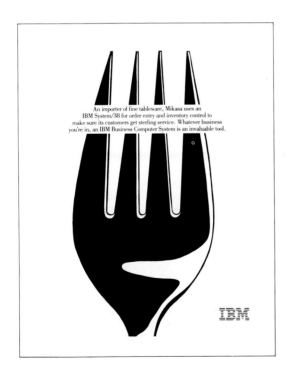

380

Art Director	Amy Levitan
Designer	Amy Levitan
Artist	A.B. Silverman
Writer	Richard Middendorf
Client	IBM
Agency	Doyle Dane Bernbach, New York, NY
Publication	New York Times Magazine

381

Art Director	Roy T. Trimble
Designers	Martha Urban, Martin Buchanan
Photographers	Robert Latorre, Arington Hendley
Artist	Spano-Roccanova/Retouching
Writer	Buddy Colvin
Client	South Central Bell
Agency	Luckie & Forney, Inc., Advertising, Birmingham, AL
Publication	Forbes
Creative Directors	Leo Wright, Roy T. Trimble

382

Art Director	Gary Goldsmith
Designer	Gary Goldsmith
Writer	Irwin Warren
Client	IBM
Agency	Doyle Dane Bernbach, New York, NY
Publications	Times, US News, Black Enterprise

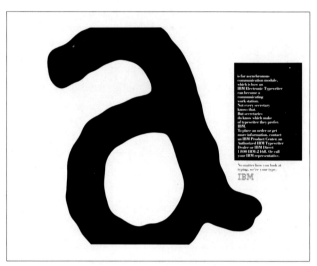

383

Art Director	Carl Stewart
Writers	Joy Golden, Betty Green
Client	Gourmet Magazine
Agency	TBWA Advertising, Inc., New York, NY
Publication	Advertising Age

Silver Award

Art Directors	David Edelstein, Nancy Edelstein, Lanny French
Designers	David Edelstein, Nancy Edelstein, Lanny French
Photographer	Jim Cummins
Artist	Cynthia Langwell, Norman Hathaway
Writer	David Edelstein
Client	Generra Sportswear
Agency	Edelstein Associates, Seattle, WA

Distinctive Merit

Art Director	Ken Duskin
Designer	Ken Duskin
Photographers	Earnst Haas, Brad Miller
Writer	Alan Mond
Client	Chrysler Corporation
Agency	Kenyon & Eckhardt, Inc., New York, NY
Publication	Life Magazine
Creative Director	Ken Duskin

Distinctive Merit

Art Directors Ellen Burnie, Sandy Carlson
Photographer Bruce Weber
Writer Ilene Cohn-Tanen
Client Polo/Ralph Lauren
Agency Geers Gross Advertising, New York,
NY

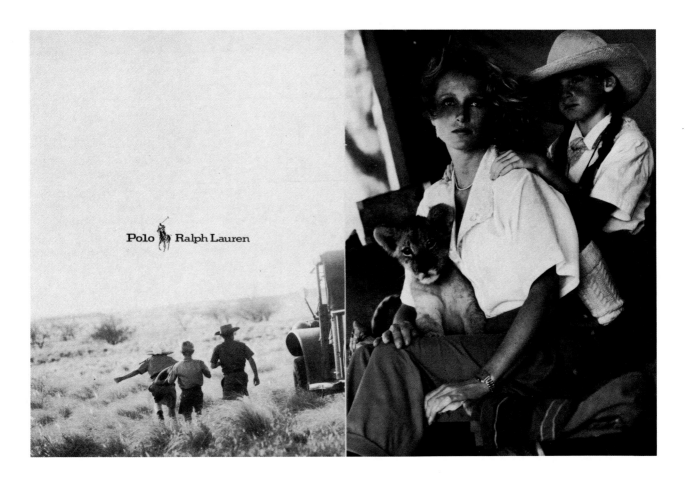

387

Art Director	Doug Malott
Designer	Doug Malott
Photographer	Cosby-Bowyer Inc.
Writer	Dick Grant
Client	Stihl Incorporated
Agency	Stuart Ford Incorporated, Richmond, VA
Publication	Chain Saw Age
Production Manager	Jenny Schoenherr

388

Art Directors	Tom Stoneham, Terry Schneider
Photographer	Pete Stone
Writer	Barry Pullman
Client	Metheus-Computervision
Agency	Borders, Perrin & Norrander, Inc., Portland, OR

389

Art Director	Tom Van Steenbergh
Photographer	Will Ryan
Writers	John Weiss, Jane Adamo
Client	Rémy Martin Amerique, Inc.
Agency	Margeotes Fertitta & Weiss, Inc., New York, NY
Creative Director	John Margeotes

390

Art Director	Glen Jacobs
Designer	Glen Jacobs
Photographers	Richard Hochman, David Seidner (Inside Front Cover)
Writer	Christina Thorp
Client	Charles of the Ritz Group, Ltd.
Agency	Advertising to Women, Inc., New York, NY
Printing Consultant	Robert Matricardi

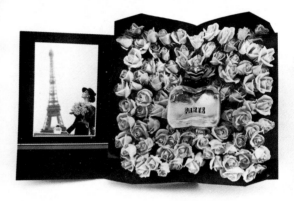

Newspaper editorial: Full page, color
Full page, b&w
Less than full page, b&w or color
Multi-page section
Magazine editorial: Sunday Magazine or supplement
Consumer, spread, b&w
Consumer, full page, color
Consumer, spread, color
Consumer, multiple pages, single story, b&w
Consumer, multiple pages, single story, color
Consumer cover
Business, trade or house organ, full page, b&w
Business, trade or house organ, spread, b&w
Business, trade or house organ, full page or spread, color
Business, trade or house organ, multiple pages, single story, b&w
Business, trade or house organ, multiple pages, single story, color
Business, trade or house organ, cover
Consumer or business magazine full issue
House organ full issue

Distinctive Merit

Art Director	Veronique Vienne
Artist	Dugald Stermer
Publisher	Mercury News, San Jose, CA
Publication	West Magazine

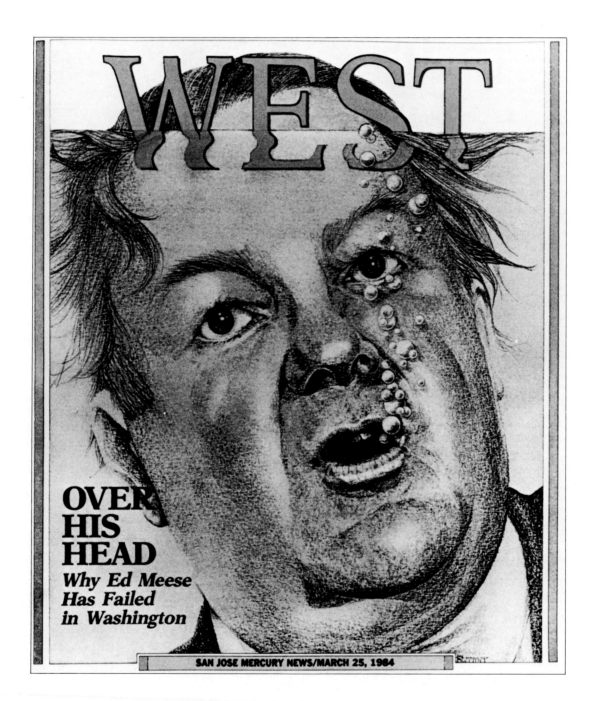

392

Art Director David Hadley
Designer David Hadley
Artist Tom Foty
Editor Terrie Blair
Publisher Minneapolis Star and Tribune,
 Minneapolis, MN
Publication Minnesota Guide

393

Art Director Greg Paul
Artist Merle Nacht
Editor John Parkyn
Publication Sunshine Magazine, Fort
 Lauderdale, FL

394

Art Director Greg Paul
Artist Anita Kunz
Editor John Parkyn
Publication Sunshine Magazine, Fort
 Lauderdale, FL

395

Art Director Broc Sears
Designer Deborah Withey-Culp
Artist Deborah Withey-Culp
Editor Candy Sagon
Publisher The Dallas Times Herald, Dallas, TX
Publication The Dallas Times Herald Taste
 Section

396

Art Director Greg Paul
Artist Mark Chickinelli
Editor John Parkyn
Publication Sunshine Magazine, Fort
Lauderdale, FL

397

Art Director Broc Sears
Designer Broc Sears
Artist Broc Sears
Writer Broc Sears
Editor Charles Redden
Publisher Dallas Times Herald, Dallas, TX
Publication Dallas Times Herald

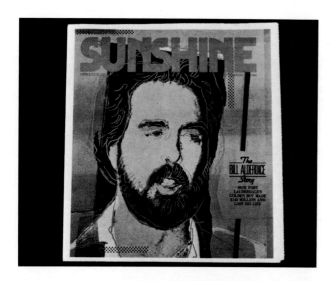

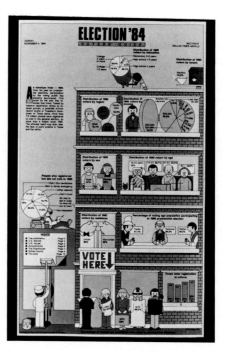

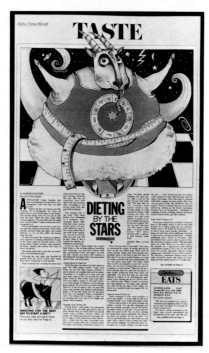

398

Art Director Broc Sears
Designer Deborah Withey-Culp
Artist Deborah Withey-Culp
Editor Candy Sagon
Publisher Dallas Times Herald, Dallas, TX
Publication The Dallas Times Herald Taste
Section

399

Art Director Greg Paul
Artist Matt Mahurin
Editor John Parkyn
Publication Sunshine Magazine, Fort Lauderdale, FL

400

Art Director David Hadley
Designer David Hadley
Artist Steve Johnson
Editor Terrie Blair
Publisher Minneapolis Star and Tribune, Minneapolis, MN
Publication Minnesota Guide

401

Art Director Broc Sears
Designer Deborah Withey-Culp
Artist Deborah Withey-Culp
Editor Candy Sagon
Publisher Dallas Times Herald, Dallas, TX
Publication The Dallas Times Herald Taste Section

402

Art Director Greg Paul
Artist Patricia Dryden
Editor John Parkyn
Publication Sunshine Magazine, Fort
Lauderdale, FL

403

Art Director Veronique Vienne
Artist J.T. Morrow
Publisher Mercury News, San Jose, CA
Publication West Magazine

404

Art Director Nanette Bisher
Designer Nanette Bisher
Artist Larry Taugher
Writer Frank O'Donnell
Editor Richard Cheverton
Publisher Dave Threshie
Publication The Orange County Register, Santa
Ana, CA

405

Distinctive Merit

Art Director Linda Brewer
Designer Linda Brewer
Artist Mitzura Salgian
Client The New York Times Travel Section
Editor Michael Leahy
Publisher The New York Times, New York, NY
Publication The New York Times Travel Section

The New York Times

Sunday, December 23, 1984

Travel

Copyright © 1984 The New York Times

Section **10**

Searching for Christmas

Midnight mass at the Church of St. Catherine's in Bethlehem.

Drawings by Mitzura Salgian

HE single guiding star has been shattered by time into a carnival of glittering lights, but the pilgrims still tread the road to Bethlehem in search of the miracle of Christ's birth. The difference between what is nurtured in our imaginations and what is offered up to us in reality is nowhere more stark than in this biblical town. Christmas in Bethlehem. The ancient dream: a cold clear night made brilliant by a glorious star, the smell of incense, shepherds and wise men falling to their knees in adoration of the sweet baby, the incarnation of perfect love. This simple tableau is so rich with meaning that whether represented on the mantelpiece or in the mind, it seems suspended, complete unto itself, somewhere in eternity. **BETHLEHEM. BY LUCINDA FRANKS. PAGE 9.**

 O sit on the steps of the Damascus Gate is to watch the world go by. In five minutes outside this gray-stoned entryway to Jerusalem's Old City, you'll see red-turbaned Arab coffee sellers, Palestinian students swathed in black checked keffiyahs, Hasidim bedecked with 16th-century Polish fur hats and Yemenites wearing yarmulkes. You'll see Swedish tourists in cutoff shorts, hooded monks shrouded in black and Bedouin women in embroidered robes. They're all here, bumping into each other, excusing themselves in different tongues, motioning at the ancient ramparts of the walled city and generally creating one of the world's most colorful human kaleidoscopes. **JERUSALEM. BY THOMAS L. FRIEDMAN. PAGE 8.**

 EDIEVAL Byzantium was an awesome blend of dream and power. A shipload of Frankish soldiers who saw it for the first time, spread out above the Sea of Marmara, "looked upon it very earnestly," their chronicler recorded in 1204, "for when they saw the high walls and magnificent towers that closed it round about, the rich palaces and mighty churches, of which there were so many, no one would have believed it had he not seen it with his own eyes." **ISTANBUL. BY FERGUS M. BORDEWICH. PAGE 13.**

Distinctive Merit

Art Director	Steven Heller
Designer	Steven Heller
Artist	Michael Bartalos
Client	The New York Times
Editor	Mitchell Levitas
Publisher	The New York Times
Publication	The New York Times, New York, NY

The New York Times

Book Review

December 2, 1984

CHRISTMAS BOOKS

WHY ARE THESE PEOPLE READING?
— SEE PAGE 3

Our choice of the 15 best books of 1984 Richard Gilman on religion
in fiction ☆ John Updike on "The Gardener's Year" What character
in fiction or nonfiction would you most like to be?
Replies from Margaret Atwood, Vladimir Horowitz, Italo Calvino,
Woody Allen, Carol Channing, Carlos Fuentes and others
James Atlas on New York's special bookstores John Julius Norwich
on a lavish book about the mosaics of San Marco Nora Ephron on
"The Estates of Beverly Hills" Gift books: art by John Russell, travel
and nature by George Plimpton, cookbooks by Marian Burros, photography
by Andy Grundberg, architecture and design by Paul Goldberger
Together with an annotated list of 200 notable books of the year

Section 7 © 1984 The New York Times

407

Art Director	Gary Rogers
Designer	Gary Rogers
Photographer	Bob Luckey
Writer	George Dewan
Client	Newsday-Part II
Editor	Roy Hanson
Publisher	Newsday, Melville, NY
Publication	Newsday

408

Art Director	Ernest Lynk
Designer	Ernest Lynk
Photographer	Chuck Stewart
Editor	Gary Giddins
Publisher	The Village Voice, New York, NY
Publication	The Village Voice

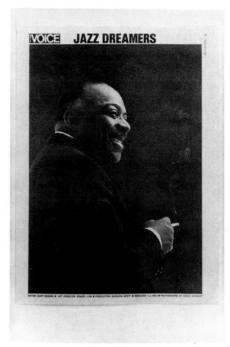

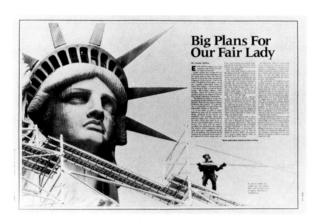

409

Art Director	Richard Aloisio
Designer	Richard Aloisio
Photographer	Thomas Victor (bottom photo)
Artists	Colos, Scott MacNeill
Client	The New York Times
Editor	Soma Golden
Publisher	The New York Times, New York, NY
Publication	The New York Times

410

Art Director	Tom Bodkin
Designer	Tom Bodkin
Client	The New York Times
Editor	Michael Leahy
Publisher	The New York Times, New York, NY
Publication	The New York Times Travel Section

411

Art Director	Donna Albano
Designer	Donna Albano
Photographer	Eric Kvalsvik
Writer	Carleton Jones
Client	The Baltimore Sun
Editor	Elizabeth Large
Publisher	A.S. Abell
Publication	The Baltimore Sun, Baltimore, MD

Silver Award

Art Director Frances Tanabe
Artist Michael David Brown
Client Washington Post Bookworld
Agency Michael David Brown, Rockville, MD

413

Art Director	Robert Barkin
Designer	Alice Kresse
Artist	Alice Kresse
Writer	Phyllis Chasanow-Richman
Client	The Washington Post
Editor	Phyllis Chasanow-Richman
Publisher	The Washington Post, Washington, DC
Publication	The Washington Post

414

Art Director	Gary Cosimini
Designer	Gary Cosimini
Artist	Michael Bartalos
Writer	Ari L. Goldman
Client	The New York Times
Editor	Annette Grant
Publisher	The New York Times, New York, NY
Publication	The New York Times

Gold Award

Art Director	George Benge
Designer	Doug Stanley
Photographer	David Leeson
Artists	Jan Brunson, Dan Clifford, Ken Marshall, Mark Smith
Writer	Bruce Tomaso
Editor	Howard Swindle
Publisher	Dallas Morning News
Publication	Dallas Morning News, Dallas, TX

Silver Award

Art Director	Lucy Bartholomay
Designer	Lucy Bartholomay
Photographer	Stan Grossfeld
Writer	Colin Nickerson
Client	The Boston Globe
Publisher	The Boston Globe, Boston, MA
Publication	The Boston Globe

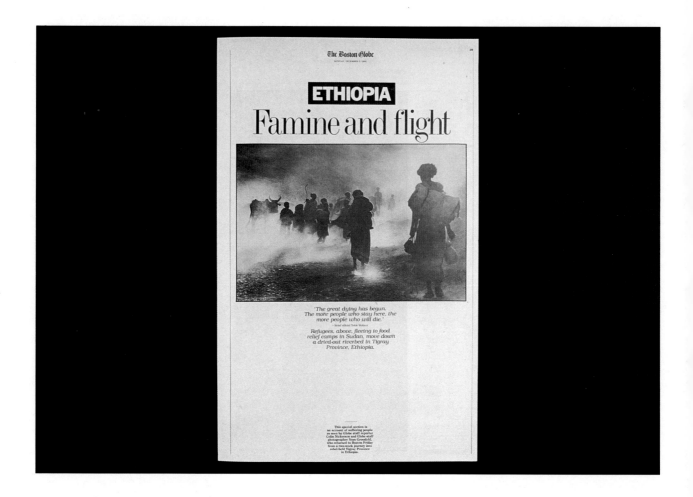

417

Art Director	Keith Branscombe
Designer	Greg Butler
Artist	Clive Dobson
Writer	Patricia Orwen
Editor	Vian Ewart
Publisher	The Toronto Star
Publication	The Saturday Star, Toronto, Canada

418

Art Director	Alice Kresse
Designer	Alice Kresse
Photographer	The Washington Post Staff
Artist	Alice Kresse
Client	The Washington Post
Editors	Ron Shaffer, Frank Gaffney, Diana Pabst
Publication	The Washington Post, Washington, DC

419

Art Director	Ian Somerville
Artist	Patrick Corrigan
Writer	Diane Francis
Client	Business Today
Editor	Ellen Moorhouse
Publisher	The Toronto Star
Publication	The Sunday Star, Toronto, Canada

Gold Award

Art Director Tom Bodkin
Designer Tom Bodkin
Photographers Cover photo: Geoffrey Clifford, Black
Star, and various photographers
Client The New York Times
Editor Marv Siegel
Publisher The New York Times, New York, NY
Publication The New York Times "World of New
York" Magazine

Silver Award

Art Director	Tom Bodkin
Designer	Tom Bodkin
Photographer	Various
Artist	Cover: Nancy Stahl
Client	The New York Times
Editor	Michael Leahy
Publisher	The New York Times, New York, NY
Publication	The New York Times "Sophisticated Traveler" Magazine

422

Art Directors — Tom Ruis, Janet Froelich
Photographer — Tom Arma
Writer — Eric Nadler
Publication — Daily News Sunday Magazine, New York, NY

423

Art Director — Jann Alexander
Designer — Jann Alexander
Photographer — Margaret Thomas (cover & cover story)
Writer — Emily Yoffe (cover story)
Editor — Stephen Petranek
Publisher — Washington Post Co.
Publication — Washington Post Magazine, Washington, DC

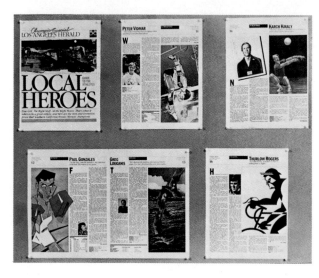

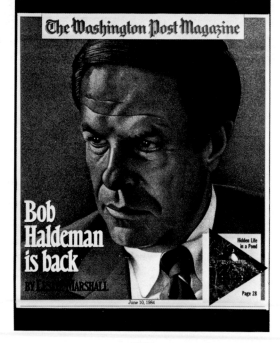

424

Art Director — Michael Keegan
Designer — Julianna White
Photographers — Anne Knudsen, Paul Chinn, Leo Jarzomb, James Ruebsamen, Mike Mullen
Client — Los Angeles Herald Examiner
Editor — Leslie Ward
Publisher — Los Angeles Herald Examiner
Publication — Los Angeles Herald Examiner, Los Angeles, CA
Graphics & Systems Editor — Saul Daniels

425

Art Director — Jann Alexander
Designer — Jann Alexander
Photographer — Mimi Levine (cover story)
Artist — Bill Nelson (cover)
Writer — Leslie Marshall (cover story)
Editor — Stephen Petranek
Publisher — Washington Post Co.
Publication — Washington Post Magazine, Washington, DC

426

Art Directors Tom Ruis, Janet Froelich
Photographer Marcia Resnick, Roy Morsch, David
 Alexander
Writer John Lombardi
Publication Daily News Sunday Magazine, New
 York, NY

427

Art Director Estelle Walpin
Artist Susan Huggins, New York, NY
Clients Suburbia Today, Gannett Rockland
 Newspapers

WHO KILLED JOHN BELUSHI?

BY JOHN LOMBARDI

PART I: SEX & DOPE

DUSTIN HOFFMAN'S 'SALESMAN'

428

Art Director Jann Alexander
Designer Jann Alexander
Artists Milton Glaser (cover), Kenneth
 Krafchek, Bobbi Tull, Dana
 Verkouteren
Writers Joyce Carol Oates; Philip Graham;
 Anne Tyler
Clients Stephen Petranek, Jeanne McManus
Publisher Washington Post Co.
Publication Washington Post Magazine,
 Washington, DC

429

Art Director Roger Black
Designer Martine Winter
Photographer William Coupon
Client The New York Times Magazine
Editor Ed Klein
Publisher The New York Times, New York, NY
Publication The New York Times Magazine

430

Art Director	Louise Sandhaus
Designer	Louise Sandhaus
Photographer	Gertrude Blom
Writer	Victor Perera
Client	East West Journal
Editor	Mark Mayell
Publisher	Leonard Jacobs
Publication	East West Journal, Brookline Village, MA

431

Art Director	Ken Kendrick
Designer	Martine Winter
Photographer	Hiro
Client	The New York Times Magazine
Editor	Ed Klein
Publisher	The New York Times, New York, NY
Publication	The New York Times

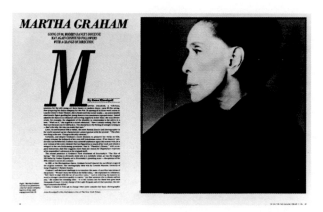

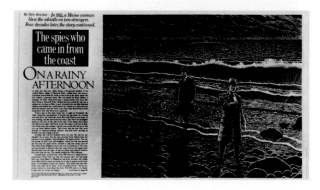

432

Art Director	Ronn Campisi
Designer	Ronn Campisi
Artist	Doug Smith
Client	The Boston Globe
Editor	Michael Larkin
Publisher	The Boston Globe, Boston, MA
Publication	The Boston Globe Magazine

433

Art Director	Louise Sandhaus
Designer	Deborah A. Bowman
Photographer	Gordon Munro
Writer	Ronald E. Kotzsch
Client	East West Journal
Editor	Mark Mayell
Publisher	Leonard Jacobs
Publication	East West Journal, Brookline Village, MA

434

Art Director	Ken Kendrick
Designer	Martine Winter
Photographer	Marion Ettlinger
Client	The New York Times
Editor	Ed Klein
Publisher	The New York Times, New York, NY
Publication	The New York Times Magazine

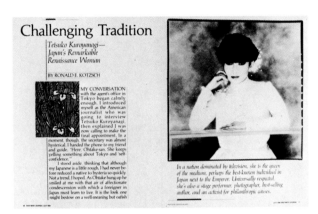

435

Art Director	Miriam Smith
Designer	Miriam Smith
Artist	Andrzej Dudzinski
Client	The Newsday Magazine
Editor	John Montorio
Publisher	Newsday, Melville, NY
Publication	The Newsday Magazine

436

Art Director	Kiyoshi Kanai
Designer	Kiyoshi Kanai
Photographer	Malcom Baron
Writer	Barbara Butt
Client	Mobil Corporation
Editor	Barbara Butt
Publisher	Mobil Corporation
Agency	Kiyoshi Kanai, Inc., New York, NY

437

Art Director	David W. Bird II
Photographer	Leslie L. Bird
Publication	Automobile Quarterly Magazine, Princeton, NJ
Sculpture	From the Collection of Ray Holland

438

Art Director	Brad Pallas
Designer	Wesley Hall
Photographer	Ben Calvo
Writer	Barbara Bernal
Client	Woman's Day Magazine
Editors	Karin Lidbeck, Theresa Capuana
Publisher	Thomas M. Kenney
Publication	Woman's Day Magazine, New York, NY
Editor in Chief	Ellen R. Levine

439
Distinctive Merit

Art Director	Lloyd Ziff
Designer	Lloyd Ziff
Photographer	Kenneth McGowan
Writer	Brooke Hayward
Editor	Shelley Wanger
Publisher	The Conde Nast Publications, Inc., New York, NY
Publication	House & Garden

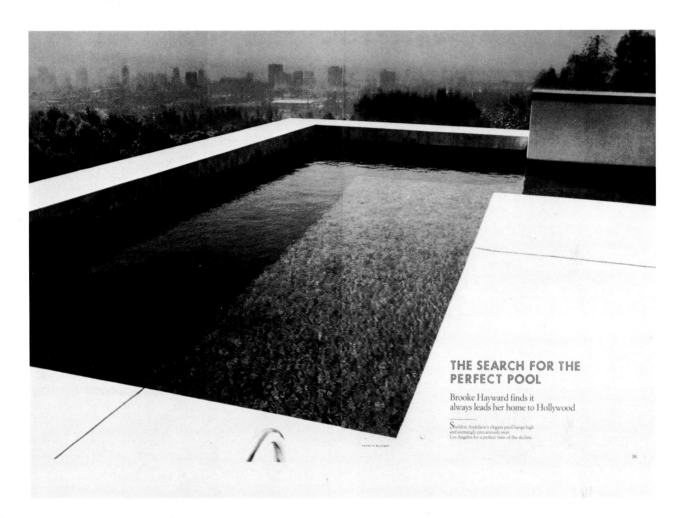

THE SEARCH FOR THE
PERFECT POOL

Brooke Hayward finds it
always leads her home to Hollywood

Sheldon Andelson's elegant pool hangs high
and seemingly precariously over
Los Angeles for a perfect view of the skyline.

440

Art Director	John Tom Cohoe
Designer	Frank Tagariello
Photographer	Jill Freedman
Writer	Nancy Lyon
Editor	Kevin Buckley
Publisher	Knapp Communications, New York, NY
Publication	GEO

441

Art Director	Al Braverman
Designer	David Taub
Photographer	Charles LeMieux
Writer	Charles LeMieux
Editor	Peter A. Janssen
Publisher	Robert J. O'Conner
Publication	Motor Boating & Sailing, New York, NY

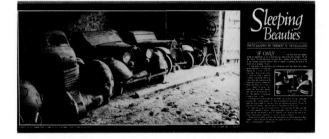

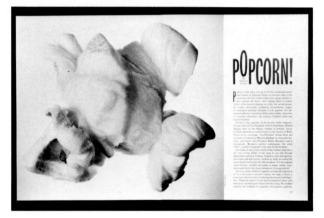

442

Art Director	Michael Pardo
Photographer	Herbert W. Hesselmann
Editor	Lowell C. Paddock
Publisher	L. Scott Bailey
Publication	Automobile Quarterly, Princeton, NJ

443

Art Director	Melissa Tardiff
Designer	Richard Turtletaub
Photographer	Tom Hollyman
Publication	Town & Country, New York, NY

444

Art Director Derek Ungless
Designer Rosemarie Sohmer
Photo Editor Laurie Kratochvil
Photographer E.J. Camp
Publication Rolling Stone Magazine, New York, NY

445

Art Director Michael Valenti
Designer Michael Valenti
Photographer Manfred Hamm
Editor Oliver S. Moore III
Publisher Hearst Publications
Publication Science Digest Magazine, New York, NY

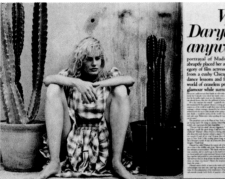

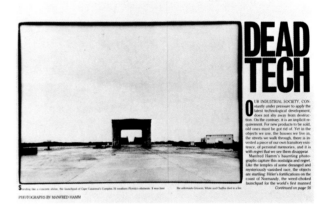

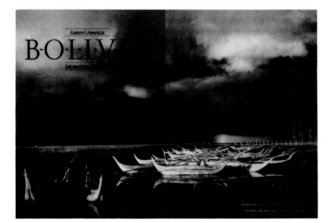

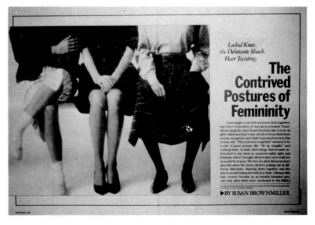

446

Art Director Nina Ovryn
Designer Nina Ovryn
Photographer Loren McIntyre
Editor Donald Dewey
Publisher East West Network, New York, NY
Publication Review Magazine

447

Art Director Phyllis Schefer
Designer Phyllis Schefer
Photographer Jennifer Baumann
Publication Ms. Magazine, New York, NY

448

Art Director	Kurt Peck
Artist	Eric Sloane (1905-1985)
Writer	Susan Hallsten McGarry
Publisher	Southwest Art Inc., Houston, TX
Quality Control	Rick O. Sweval

449

Art Director	Christopher Austopchuk
Designer	Christopher Austopchuk
Photographer	Kei Ogata
Client	Condé Nast Publications, New York, NY
Editor	Phyllis Starr Wilson
Publisher	Kevin Madden
Publication	Self Magazine

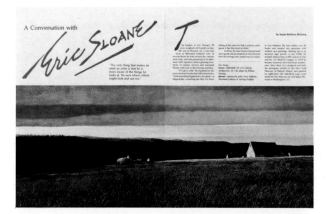

450

Art Director	Roger Gorman
Designer	Frances Reinfeld
Writer	Germano Celant
Client	Artforum Magazine
Editor	Ingrid Sischy
Publishers	Anthony Korner, Amy Baker Sandback
Agency	Reiner Design Consultants, Inc., New York, NY
Publication	Artforum Magazine

451

Art Director	Gary Gretter
Designer	Carol Rheuban
Photographer	Karen Krause
Publication	Sports Afield Magazine, New York, NY

452

Art Director Michael Brock
Designer Michael Brock
Photographer Robert Peak
Writer Roger Kahn
Client Los Angeles Olympic Organizing
 Committee, Sports Illustrated
Editor Steve Gelman
Publisher Sports Illustrated
Design Firm Michael Brock Design, Los Angeles,
 CA
Publication Official Olympic Souvenir Program

453

Art Director Phyllis Schefer
Designer Gary Mele
Photographer Marcia Lippman
Publication Ms. Magazine, New York, NY

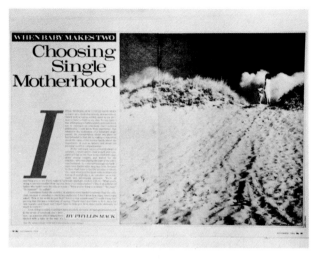

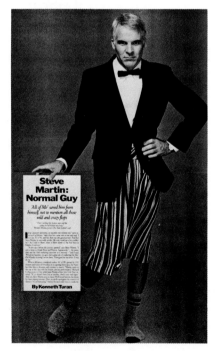

454

Art Director Derek Ungless
Designer Elizabeth Williams
Photographer Bonnie Schiffman
Photo Editor Laurie Kratochvil
Publication Rolling Stone Magazine, New York,
 NY

455

Art Directors Del Harrod, Joseph Swanson
Designer Del Harrod
Artist Alex Lewis
Client New Perspectives Magazine
Editor Linda Chavez
Agency U.S. Commission on Civil Rights,
 Washington, DC

456

Art Director — Bill Jensen
Artist — Greg Spalenka
Writer — Noel J. Boulanger
Editor — Patrick Kenealy
Publisher — Ziff-Davis Publishing, New York, NY
Publication — Digital Review

457

Art Director — Wayne Fitzpatrick
Designer — Wayne Fitzpatrick
Writer — Timothy Ferris
Client — Science 84 Magazine, American Association for the Advancement of Science
Editor — Allen Hammond
Publisher — William Carey
Publication — Science 84 Magazine, Washington, DC
Photo Editor — Margo Crabtree

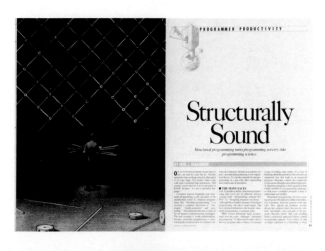

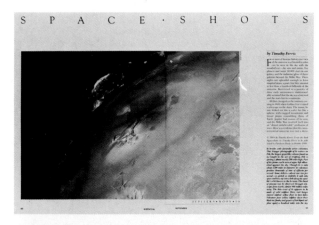

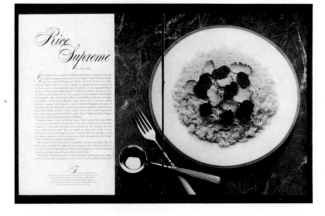

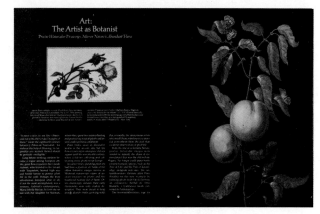

458

Art Director — Melissa Tardiff
Designer — Mary Rosen
Photographer — Matthew Klein
Publication — Town & Country, New York, NY

459

Art Director — Charles Ross
Writer — Kenneth Baker
Editor — Don G. Erickson
Publication — Architectural Digest, Los Angeles, CA

460

Art Director	Ronn Campisi
Designer	Ronn Campisi
Artist	Rafal Olbinski
Client	The Boston Globe
Editor	Michael Larkin
Publisher	The Boston Globe, Boston, MA
Publication	The Boston Globe Magazine

461

Art Director	Michael Brock
Designer	Michael Brock
Photographer	Tom Keller
Writer	Jack Newcombe
Client	Los Angeles Olympic Organizing Committee/Sports Illustrated
Editor	Steve Gelman
Publisher	Sports Illustrated
Design Firm	Michael Brock Design, Los Angeles, CA
Publication	Official Olympic Souvenir Program

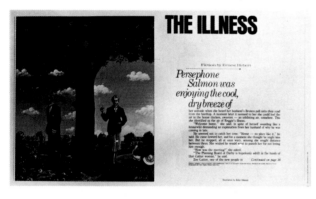

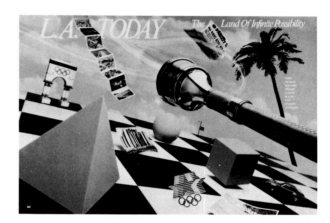

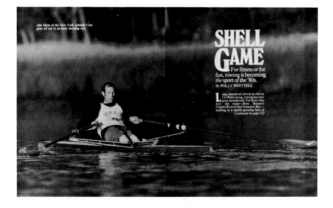

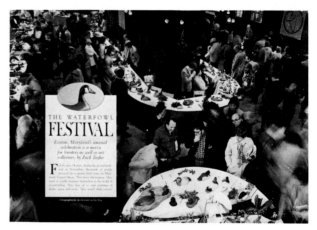

462

Art Director	Al Braverman
Designer	Dave Taub
Photographer	Dan Nerney
Writer	Polly Whittell
Editor	Peter A. Janssen
Publisher	Robert J. O'Conner
Publication	Motor Boating & Sailing, New York, NY

463

Art Director	Gary Gretter
Designer	Robert Gray
Photographer	Don Gray
Publication	Sports Afield Magazine, New York, NY

464

Art Director Melissa Tardiff
Designer Richard Turtletaub
Photographer Lee Boltin
Publication Town & Country Magazine, New York,
NY

465

Art Director Fo Wilson
Designer Fo Wilson
Photographer Anthony Barboza
Client Essence Communications, Inc.
Publication Essence Magazine, New York, NY
Editor-in-Cheif Susan L. Taylor

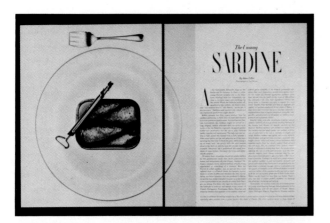

466

Art Director Fo Wilson
Designer Fo Wilson
Photographer Chris Callis
Client Essence Communications Inc.
Publication Essence Magazine, New York, NY
Editor-in-Cheif Susan L. Taylor

467

Art Director J Porter
Designer J Porter
Writer Pat Leonard
Editors John Pierce and Judson Hale
Publisher Rob Trowbridge
Publication Yankee Magazine, Dublin, NH
Lettering Erick Ingraham

468

Art Director	Al Braverman
Designer	David Taub
Photographer	J. Guichard/Sygma
Writer	Bill Homewood
Editor	Peter A. Janssen
Publisher	Robert J. O'Conner
Publication	Motor Boating & Sailing, New York, NY

469

Art Director	Norman S. Hotz
Designer	Norman S. Hotz
Artist	Christopher Magadini
Writers	Emily and Per Ola D'Aulaire
Client	The Reader's Digest
Editor	Nina Bell Allen
Publisher	The Reader's Digest Assoc., Pleasantville, NY
Publication	Reader's Digest
Editor-in-Chief	Kenneth O. Gilmore

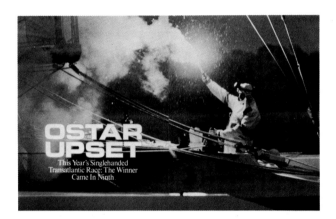

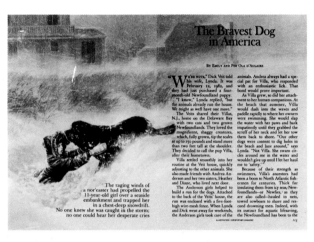

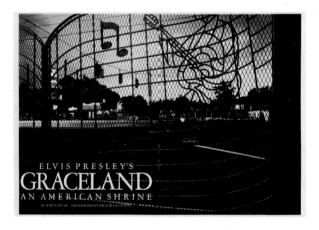

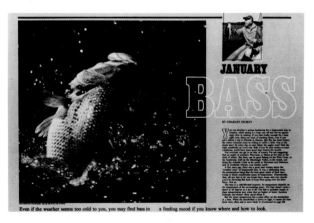

470

Art Director	Lloyd Ziff
Designer	Lloyd Ziff
Photographer	William Eggleston
Writer	Martin Filler
Editor	Martin Filler
Publisher	The Conde Nast Publications, Inc., New York, NY
Publication	House & Garden

471

Art Director	Victor J. Closi
Designer	Victor J. Closi
Photographers	Lynn Rogers, Charley Dickey
Writer	Charley Dickey
Client	Field & Stream Magazine
Editor	Duncan Barnes
Publisher	CBS Magazines, New York, NY
Publication	Field & Stream Magazine

472

Art Director	Al Braverman
Designer	Dave Taub
Photographer	Bonnie Waitzkin
Writer	Bonnie Waitzkin
Editor	Peter A. Janssen
Publisher	Robert J. O'Conner
Publication	Motor Boating & Sailing, New York, NY

474

Art Director	Derek Ungless
Designer	Derek Ungless
Photographers	Minneapolis Star & Tribune and Ken Regan/Camera 5
Photo Editor	Laurie Kratochvil
Publication	Rolling Stone Magazine, New York, NY

473

Art Director	Michael Pardo
Artist	David Kimble
Publisher	L. Scott Bailey
Publication	Automobile Quarterly Magazine, Princeton, NJ

475

Art Director	Ronn Campisi
Designer	Ronn Campisi
Artist	Cathy Barancik
Client	The Boston Globe
Editor	Michael Larkin
Publisher	The Boston Globe, Boston, MA
Publication	The Boston Globe Magazine

476

Art Director	Emilie Whitcomb
Publication	New Age Journal, Brighton, MA

477

Art Director	Al Braverman
Designer	Dave Taub
Writer	John Clemans
Editor	Peter A. Janssen
Publisher	Robert J. O'Conner
Publication	Moror Boating & Sailing, New York, NY

480

Art Director	Bob Ciano
Designer	Bob Ciano
Reporter	Doris Kinney
Editors	Richard Stolley, Mary Steinbauer
Publisher	Life Magazine

Silver Award

Art Director	Louis F. Cruz
Designer	Louis F. Cruz
Photographers	Various
Writer	Kathryn E. Livingston
Client	USAir Magazine
Editor	Richard Busch
Publisher	East/West Network Inc.
Director	Bob Cato
Agency	Cruz Graphic Design, Brooklyn, NY
Publication	USAir Magazine

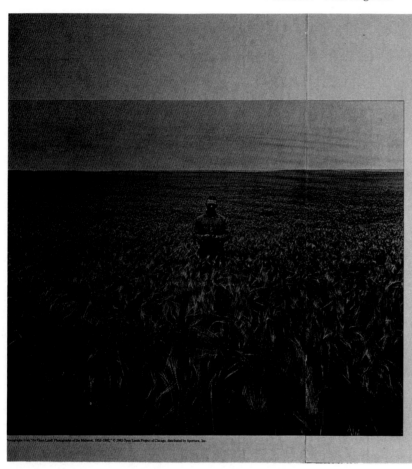

An Open Land

Photographs of the Midwest, 1852-1982

To make a prairie, Emily Dickinson once wrote, all that is needed is "one clover, and a bee, and revery." In fact, mused the wise poetess, "the revery alone will do." A sense of revery is what "An Open Land: Photographs of the Midwest, 1852-1982" is really all about. The exhibition, which opened at the Art Institute of Chicago last spring and has since traveled to other art centers, is a lush, nostalgic journey through the bountiful farmlands of the Midwest. Including more than 100 historical and contemporary images, this is the first major survey of landscape photography exclusively devoted to the often underrated beauty of midwestern America. In a book recently published by Aperture ($19.50), 60 of the photographs are reproduced, accompanied by prose and poetry as well as informative essays written by several of the exhibition's organizers.

Curated by Rhondel McKinney, a photographer who grew up in rural Illinois, this comprehensive photographic survey was sponsored by the Open Lands Project, a group dedicated to the preservation of midwestern natural lands. McKinney spent a year culling pictures from historical societies, museums, university archives, and personal collections that tell the story of the discovery and settlement of the nation's heartland.

McKinney's abiding affection for his homeland and his remarkable ability to seek out photographs that communicate the prairie's particular beauty make this collection more than a random gathering of images dealing with a common subject. In his introductory text McKinney recalls his childhood memory of bumping along back roads in his father's pickup truck, searching for places to hunt quail or to fish, wondering what his silent, tobacco-chewing dad seemed to be marveling at. One day, says McKinney, "I stopped wondering and started looking myself, and eventually I learned to see what he saw, to love what he loved."

McKinney's own pictures capture the prairie sun setting over an open field or an approaching storm darkening a horizon, and he has selected pic-

◄
Anonymous
Man Standing in Center of Wheatfield

W.C. Persons
Threshing Scene, 1920
►

Photographs from "An Open Land: Photographs of the Midwest, 1852-1982," © 1982 Open Lands Project of Chicago, distributed by Aperture, Inc.

Distinctive Merit

Art Director	Bob Ciano
Designer	Bob Ciano
Photographer	Mary Ellen Mark
Writer	Cheryl McCall
Editor	Richard Stolley
Publisher	Life Magazine

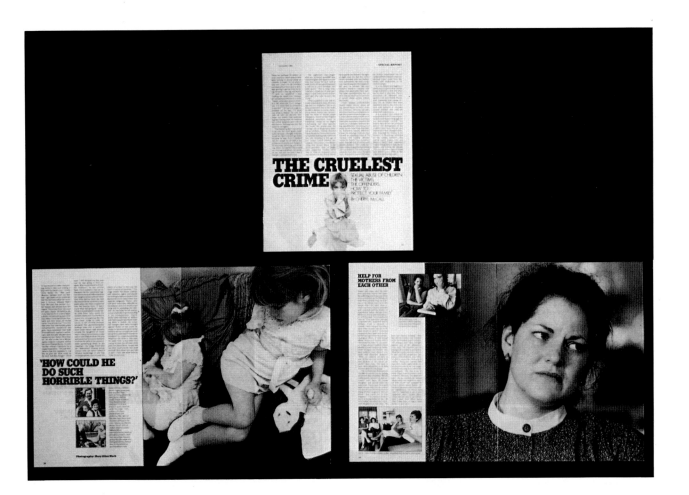

Gold Award

Art Director	Mary K. Baumann
Designer	Mary K. Baumann
Photographer	Susan Wood
Writer	Stephen Brewer
Editor	David Maxey
Publisher	Knapp Publications, New York, NY
Publication	GEO
Hand Lettering	Tom Carnase

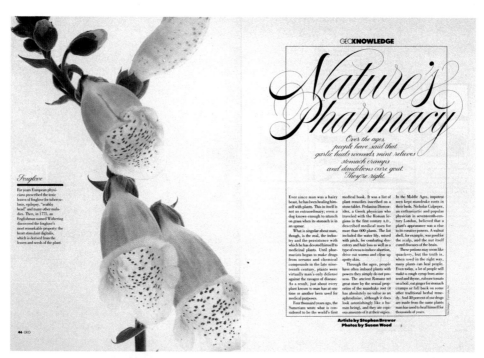

GEO**KNOWLEDGE**

Nature's Pharmacy

*Over the ages,
people have said that
garlic heals wounds, mint relieves
stomach cramps
and dandelions cure gout.
They're right.*

Ever since man was a hairy beast, he has been healing himself with plants. This in itself is not so extraordinary; even a dog knows enough to munch on grass when its stomach is in an uproar.

What is singular about man, though, is the zeal, the industry and the persistence with which he has devoted himself to medicinal plants. Until pharmacists began to make drugs from serums and chemical compounds in the late nineteenth century, plants were virtually man's only defense against the ravages of disease. As a result, just about every plant known to man has at one time or another been used for medical purposes.

Four thousand years ago, the Sumerians wrote what is considered to be the world's first medical book. It was a list of plant remedies inscribed on a stone tablet. Pedanius Dioscorides, a Greek physician who traveled with the Roman legions in the first century A.D., described medical uses for more than 600 plants. The list included the water lily, mixed with pitch, for combating dysentery and hair loss as well as a type of cress to induce abortion, drive out worms and clear up spotty skin.

Through the ages, people have often imbued plants with powers they simply do not possess. The ancient Romans set great store by the sexual properties of the mandrake root (it has absolutely no value as an aphrodisiac, although it does look astonishingly like a human being), and they ate copious amounts of it at their orgies.

In the Middle Ages, impotent men kept mandrake roots in their beds. Nicholas Culpeper, an enthusiastic and popular physician in seventeenth-century London, believed that a plant's appearance was a clue to its curative powers. A walnut shell, for example, was good for the scalp, and the nut itself cured diseases of the brain.

These potions may seem like quackery, but the truth is, when used in the right way, many plants can heal people. Even today, a lot of people will make a cough syrup from anise seed and thyme, rub raw tomato on a boil, eat ginger for stomach cramps or fall back on some other traditional herbal remedy. And 30 percent of our drugs are made from the same plants man has used to heal himself for thousands of years.

**Article by Stephen Brewer
Photos by Susan Wood**

Foxglove

For years European physicians prescribed the toxic leaves of foxglove for tuberculosis, epilepsy, "scabby head" and many other maladies. Then, in 1775, an Englishman named Withering discovered the foxglove's most remarkable property: the heart stimulant digitalis, which is derived from the leaves and seeds of the plant.

46 GEO

Silver Award

Art Director	Mary K. Baumann
Designer	Mary K. Baumann
Photographer	Evelyn Hoffer
Writer	Jeffrey Simpson
Editor	David Maxey
Publisher	Knapp Communications, New York, NY
Publication	GEO

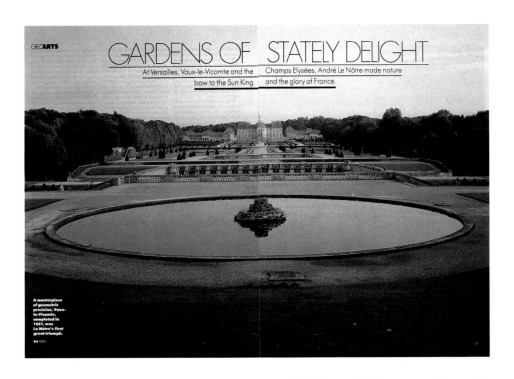

GEOARTS

GARDENS OF STATELY DELIGHT

At Versailles, Vaux-le-Vicomte and the bow to the Sun King

Champs Elysées, André Le Nôtre made nature and the glory of France.

A masterpiece of geometric precision, Vaux-le-Vicomte, completed in 1661, was Le Nôtre's first great triumph.

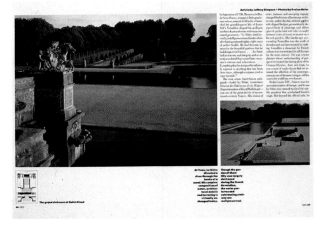

The grand staircase at Saint-Cloud

At Vaux, Le Nôtre devised a river through the banks of a canal. His complex composition of water, architectural details and terracing is virtually unchanged today.

Through the gardens of Chantilly was largely destroyed during the French Revolution, the water parterres and watering staircase are well preserved.

The formality of the gardens at Saint-Cloud is softened by tree-lined paths, or allées. Intimate in scale, these walkways are often accented with statuary.

484

Art Director	Wm. A. Motta
Designer	Richard M. Baron
Photographer	John Lamm
Writer	Dean Batchelor
Editor	John Dinkel
Publisher	CBS Magazines, Newport Beach, CA
Publication	Road & Track

485

Art Director	Lloyd Ziff
Designer	Lloyd Ziff
Photographer	Jacques Henri Lartigue
Editor	Denise Otis
Publisher	The Conde Nast Publications, Inc., New York, NY
Publication	House & Garden

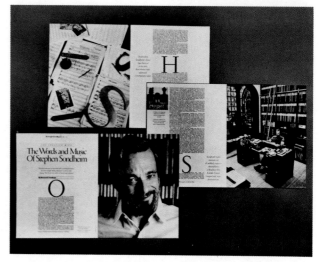

486

Art Director	Fred Woodward
Designers	Fred Woodward, David Kampa
Photographers	Various
Editor	Gregory Curtis
Publisher	Michael Levy
Agency	Texas Monthly
Publication	Texas Monthly, Austin, TX

487

Art Director	Ken Kendrick
Designer	Diana LaGuardia
Photographer	Barbra Walz
Client	The New York Times Magazine
Editor	Ed Klein
Publisher	The New York Times, New York, NY
Publication	The New York Times

488

Art Director	Shinichiro Tora
Designer	Shinichiro Tora
Photographer	Giorgio Lotti
Writer	Steve Pollock
Client	Popular Photography
Editor	Steve Pollock
Publisher	CBS Magazine
Publication	Popular Photography, New York, NY

489

Art Director	Mary K. Baumann
Designer	Mary K. Baumann
Photographers	Various
Writer	L.J. Davis
Editor	David Maxey
Publisher	Knapp Communications, New York, NY
Publication	GEO

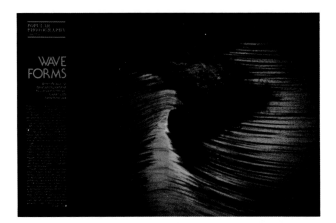

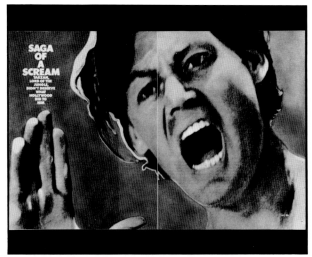

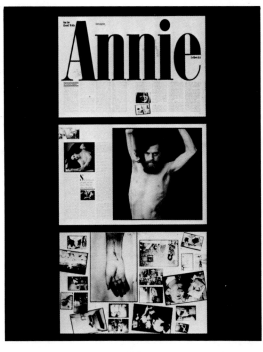

490

Art Director	Will Hopkins
Designer	Will Hopkins
Photographer	Annie Leibovitz
Editor	Sean Calahan
Publisher	CBS
Agency	Will Hopkins, New York, NY
Publication	American Photographer

491

Art Director	Fred Woodward
Designers	Fred Woodward, DAvid Kampa
Artists	Various
Editor	Gregory Curtis
Publisher	Michael Levy
Agency	Texas Monthly
Publication	Texas Monthly, Austin, TX

492

Art Director	Carla Barr
Designer	Carla Barr
Photographer	Alen MacWeeney
Writer	Anita Shreve
Client	Connoisseur Magazine
Editor	Thomas Hoving
Publisher	Hearst Corp.
Publication	Connoisseur Magazine, New York, NY

493

Art Directors	Rodney Williams, Mary Challinor
Designer	Mary Challinor
Artist	Brad Holland
Writer	Barbara Burke
Client	Science 84
Publication	Science 84, Washington, DC

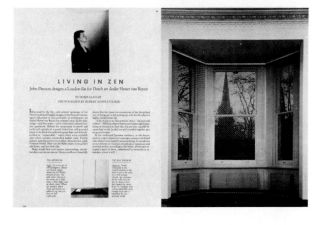

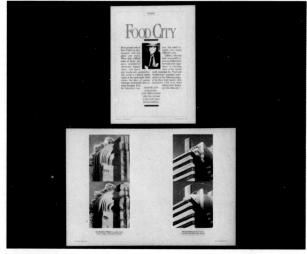

494

Art Director	Lloyd Ziff
Designer	Lloyd Ziff
Photographer	Robert Mapplethorpe
Writer	Doris Saatchi
Editors	Denise Otis, Lloyd Ziff
Publisher	The Conde Nast Publications, Inc., New York, NY
Publication	House & Garden

495

Art Director	Nina Ovryn
Designer	Nina Ovryn
Artist	Judy Clifford
Editor	Donald Dewey
Publisher	East West Network, New York, NY
Publication	Review Magazine

496

Art Director	Mary K. Baumann
Designer	Mary K. Baumann
Photographer	Michael O'Neal
Writer	Elizabeth Hall
Editor	Kevin Buckley
Publisher	Knapp Communications, New York, NY
Publication	GEO

497

Art Director	Nina Ovryn
Designer	Nina Ovryn
Photographers	Andrew Unangst, John Paul Endress, Roy Coggin, Lynn St. John, Cy Gross, Constance Hansen, Dick Frank, Henry Wolf,, Michel Tcherevkoff, Matthew Klein
Editor	Donald Dewey
Publisher	Eastwest Network, New York, NY
Publication	Review Magazine

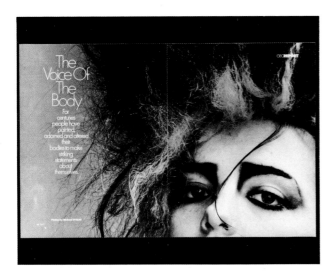

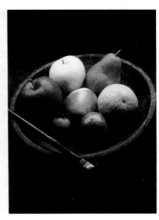

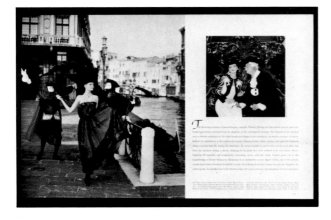

498

Art Director	Melissa Tardiff
Designer	Mary Rosen
Photographer	Norman Parkinson
Publication	Town & Country, New York, NY

499

Art Directors	Fred Woodward, Nancy E. McMillen
Designers	Nancy E. McMillen, Fred Woodward
Artist	Mark Kseniak
Editor	Gregory Curtis
Publisher	Michael Levy
Agency	Texas Monthly
Publication	Texas Monthly, Austin, TX

500

Art Director	Shinichiro Tora
Designer	Shinichiro Tora
Photographer	Daniel Pons
Writer	Arthur Goldsmith
Client	Popular Photography
Editor	Arthur Goldsmith
Publisher	CBS Magazine
Publication	Popular Photography, New York, NY

501

Art Director	Mary K. Baumann
Designer	Miriam Weinberg
Editor	David Maxey
Publisher	Knapp Communications, New York, NY
Publication	GEO

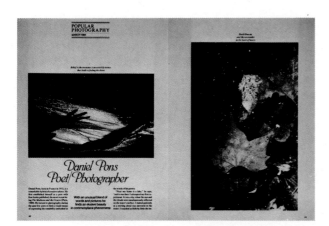

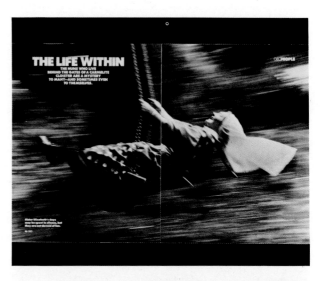

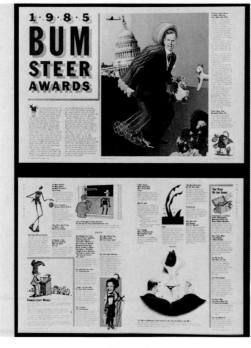

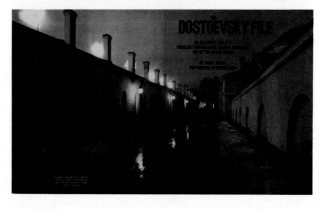

502

Art Director	Fred Woodward
Designers	Fred Woodward, David Kampa
Illustrators	Various
Editor	Gregory Curtis
Publisher	Michael Levy
Agency	Texas Monthly
Publication	Texas Monthly, Austin, TX

503

Art Director	Carla Barr
Designer	Carla Barr
Photographer	Edward Gorn
Writer	Susan Jacoby
Client	Connoisseur Magazine
Editor	Thomas Hoving
Publisher	Hearst Corp.
Publication	Connoisseur Magazine, New York, NY

504

Art Director Michael Pardo
Photographer Herbert W. Hesselmann
Publisher L. Scott Bailey
Publication Automobile Quarterly Magazine,
Princeton, NJ

505

Art Director Will Hopkins
Designer Will Hopkins
Photographer Irving Penn
Editor Sean Callahan
Publisher CBS
Agency Will Hopkins, New York, NY
Publication American Photographer

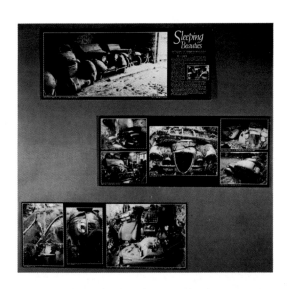

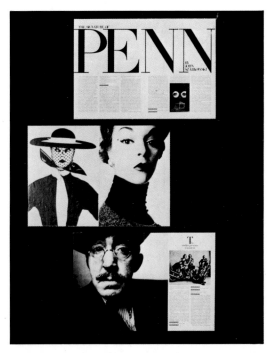

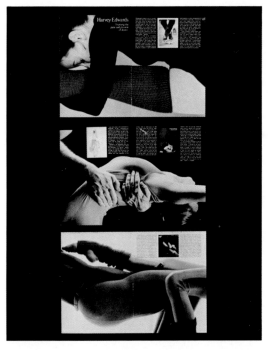

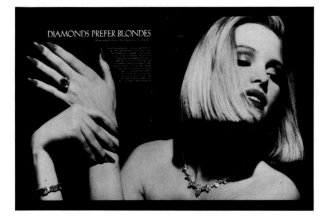

506

Art Director Will Hopkins
Designer Will Hopkins
Photographer Harvey Edwards
Editor Sean Callahan
Publisher CBS
Agency Will Hopkins, New York, NY
Publication American Photographer

507

Art Director Melissa Tardiff
Designer Melissa Tardiff
Photographer Skrebneski
Publication Town & Country Magazine, New York,
NY

508

Art Director Fred Woodward
Designers Fred Woodward, David Kampa
Photographer Geof Winningham
Client Texas Monthly
Editor Gregory Curtis
Publisher Michael Levy
Publication Texas Monthly, Austin, TX

509

Art Director Lloyd Ziff
Designer Karen Lee Grant
Photographer Francois Halard
Writer William Howard Adams
Editor Denise Otis
Publisher The Conde Nast Publications, Inc.,
 New York, NY
Publication House & Garden

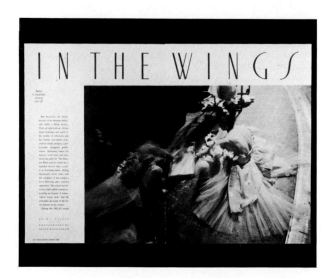

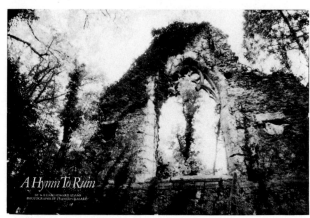

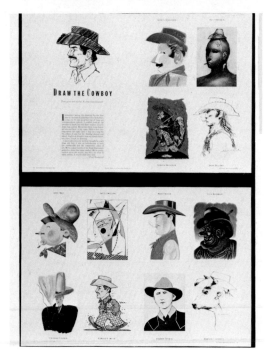

510

Art Director Fred Woodward
Designers Fred Woodward, David Kampa
Illustrators Various
Editor Gregory Curtis
Publisher Michael Levy
Agency Texas Monthly
Publication Texas Monthly, Austin, TX

511

Art Director Will Hopkins
Designer Will Hopkins
Photographers Various
Editor Sean Callahan
Director CBS
Agency Will Hopkins, New York, NY
Publication American Photographer

512

Art Director Melissa Tardiff
Designer Melissa Tardiff
Photographer Skrebneski
Publication Town & Country, New York, NY

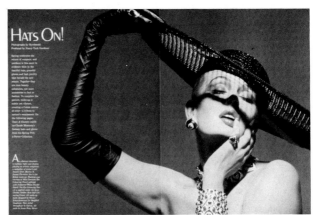

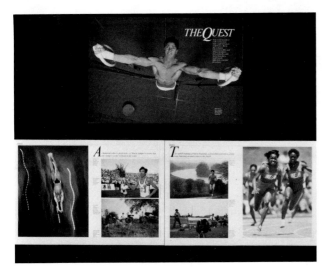

513

Art Director Michael Brock
Designer Michael Brock
Photographers Various
Writer Jack Newcombe
Client Los Angeles Olympic Organizing
 Committee/Sports Illustrated
Editor Steve Gelman
Publisher Sports Illustrated
Design Firm Michael Brock Design, Los Angeles,
 CA
Publication Official Olympic Souvenir Program

Gold Award

Art Director Bob Ciano
Designer Bob Ciano
Photographer Al Freni
Reporter Linda Gomez
Editors Richard Stolley, Mary Steinbauer
Publisher Life Magazine

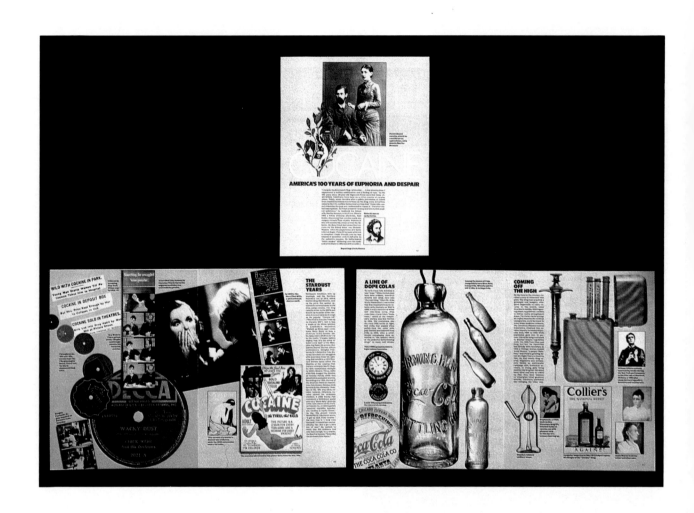

Gold Award

Art Director Bob Ciano
Designer Bob Ciano
Photographer Co Rentmeester
Reporter Victoria Kohn
Editors Richard Stolley, Steve Robinson,
 Mary Steinbauer
Publisher Life Magazine

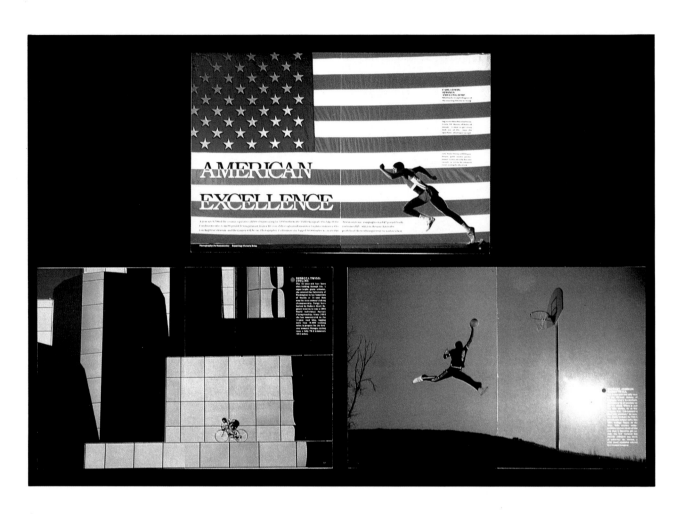

Distinctive Merit

Art Director Bob Ciano
Designer Charles Pates
Photographer William Albert Allard
Reporter Margot Dougherty
Editors Richard Stolley, Steve Robinson
Publisher Life Magazine

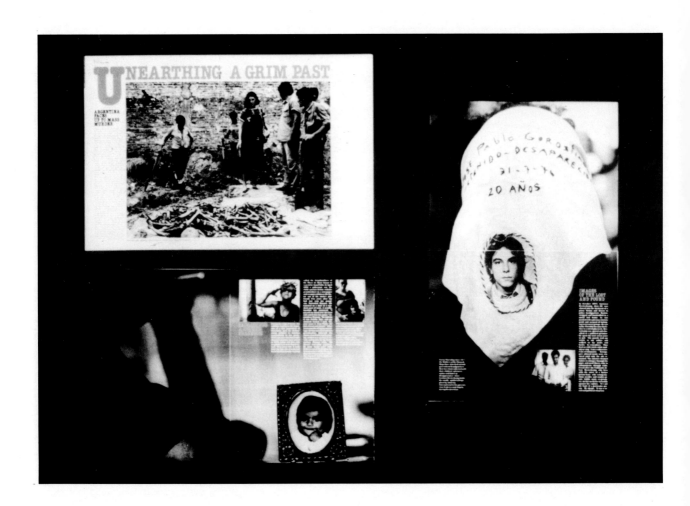

Distinctive Merit

Art Director	Bob Ciano
Designer	Bob Ciano
Photographer	Harry Benson
Reporters	Ludmilla Thorne, David Friend
Editors	Richard Stolley, Steve Robinson
Publisher	Life Magazine

518

Art Director	Bob Ciano
Designer	Bob Ciano
Reporter	Sue Allison
Editors	Richard Stolley, Mary Steinbauer, Steve Robinson
Publisher	Life Magazine

519

Art Director	Bob Ciano
Designer	Nora Sheehan
Photographer	Uli Rose
Reporter	Tonne Goodman
Editors	Richard Stolley, Mary Steinbauer
Publisher	Life Magazine

520

Art Director	Bob Ciano
Designer	Nora Sheehan
Photographer	Starr Ockenga
Reporters	Rosemarie Robotham, David Craig
Editors	Richard Stoley, Mary Steinbauer
Publisher	Life Magazine

521

Art Director	Bob Ciano
Designer	Charles Pates
Photographers	Heinz Kluetmeier, Co Rentmeester, Professor & Mrs. J. Wilson Meyers
Editors	Richard Stolley, Mary Steinbauer, Steve Robinson
Publisher	Life Magazine

522

Art Director	Bob Ciano
Designer	Bob Ciano
Photographers	John Zimmerman, Walter Looss Jr., Bruce Chambers
Editors	Richard Stolley, Mary Steinbauer
Publisher	Life Magazine

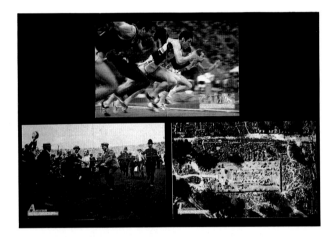

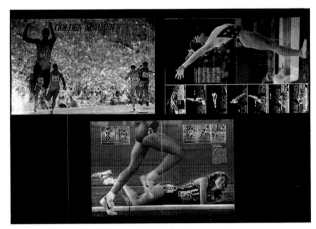

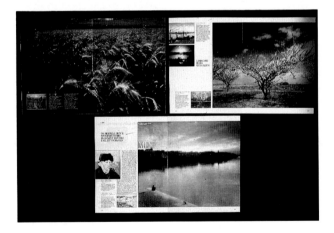

523

Art Director	Bob Ciano
Designer	Nora Sheehan
Photographer	Denis Waugh
Writer	Mary Simons
Editors	Richard Stolley, Mary Simons
Publisher	Life Magazine

524

Art Director	Bob Ciano
Designers	Nora Sheehan, Charles Pates
Photographers	Bill Epperidge, Peter Tenzer, Michael Melford
Reporters	Nancy Griffin, Gail Wescott, Naomi Cutner
Editor	Richard Stolley, James Watters
Publisher	Life Magazine

525

Art Director	Bob Ciano
Designer	Charles Pates
Photographers	Mark Sennet, Theo Westenberger, Deborah Feingold, Barbara Walz
Reporter	Rosemarie Robotham
Editors	Richard Stolley, Mary Steinbauer
Publisher	Life Magazine

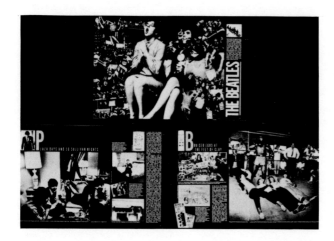

526

Art Director	Bob Ciano
Designer	Nora Sheehan
Photographers	Bill Ling, Lynn Goldsmith, Gordon Munro, Norman Parkinson, Nancy Bundt
Reporter	Naomi Cutner
Editors	Richard Stolley, Mary Steinbauer, James Watters
Publisher	Life Magazine

526A

Art Director	Bob Ciano
Designers	Charles Pates, Robin Brown
Photographers	Horst, John Ellis, Henry Waxman
Reporters	James Watter
Editors	Richard Stolley, James Watters, Mary Steinbauer
Publisher	Life Magazine

Silver Award

Art Director Ken Kendrick
Designer Ken Kendrick
Artist Matt Mahurin
Client The New York Times Magazine
Editor Ed Klein
Publisher The New York Times
Publication The New York Times, New York, NY

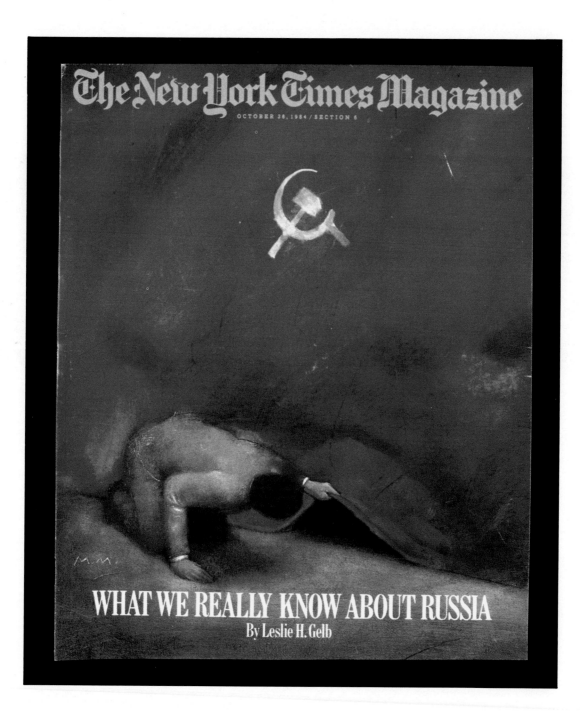

528

Distinctive Merit

Art Directors Will Hopkins, Louis F. Cruz
Designers Will Hopkins, Louis F. Cruz
Photographer Walter Looss, Jr.
Client American Photographer Magazine
Editor Sean Callahan
Publisher CBS Magazines
Agency American Photographer Magazine,
 New York, NY
Publication American Photographer Magazine

529

Art Director	Carla Barr
Designer	Carla Barr
Photographer	Alen MacWeeney
Client	Connoisseur Magazine
Editor	Thomas Hoving
Publisher	Hearst Corp.
Publication	Connoisseur Magazine, New York, NY

530

Art Director	Rudy Hoglund
Artist	Mario Donizetti
Client	Time Magazine
Publisher	Time Incorporated
Publication	Time Magazine, New York, NY

531

Art Director	Roger Gorman
Designer	Frances Reinfeld
Writer	Germano Celant
Client	Artforum Magazine
Editor	Ingrid Sischy
Publishers	Anthony Korner, Amy Baker Sandback
Agency	Reiner Design Consultants, Inc., New York, NY
Publication	Artforum Magazine

532

Art Director	Louise Kollenbaum
Designer	Dian-Aziza Ooka
Photographer	Norman Seeff
Publisher	Mother Jones Magazine, San Francisco, CA
Publication	Mother Jones

533

Art Director	Ken Kendrick
Designer	Ken Kendrick
Photographer	Dilip Mehta/Contact
Client	The New York Times Magazine
Editor	Ed Klein
Publisher	The New York Times, New York, NY
Publication	The New York Times Magazine

534

Art Director	Will Hopkins
Designer	Will Hopkins
Photographer	Co Rentmeester
Editor	Sean Callahan
Publisher	CBS
Agency	Will Hopkins, New York, NY
Publication	American Photographer

535

Art Director	Lloyd Ziff
Designer	Karen Lee Grant
Photographer	Jacques Dirand
Editor	Louis O. Gropp
Publisher	The Conde Nast Publications, Inc., New York, NY
Publication	House & Garden

536

Art Director	Owen Hartley
Photographer	Amy Meadow
Publisher	Fairchild Publications, New York, NY
Publication	M Magazine

537

Art Directors	Ira Yoffe, Christopher Austopchuk
Designers	Ira Yoffe, Christopher Austopchuk
Photographer	Gil Kenny
Writer	David Halberstam
Client	Parade Magazine
Editor	Walter Anderson
Publisher	Carlo Vittorini
Publication	Parade Magazine, New York, NY

538

Art Director	Will Hopkins
Designer	Will Hopkins
Artist	Richard Avedon
Editor	Sean Callahan
Publisher	CBS
Agency	Will Hopkins, New York, NY
Publication	American Photographer

539

Art Director	Fernando Manuel Martinez
Designer	Fernando Manuel Martinez
Photographer	Kimball/Nanessence
Agency	Fernando Manuel Martinez, San Diego, CA
Publication	San Diego Home/Garden, San Diego, CA
Production	Joan M. Hubert

540

Art Director	Janie Taylor
Photographer	Sheila Metzner
Editor	Tedd A. Cohen
Publisher	Ultra Magazine, Houston, TX

541

Art Director Owen Hartley
Photographer Harry Benson
Publisher Fairchild Publications, New York, NY
Publication M Magazine

542

Art Director Will Hopkins
Designer Will Hopkins
Photographer Kathie McGinty
Editor Sean Callahan
Publisher CBS
Agency Will Hopkins, New York, NY

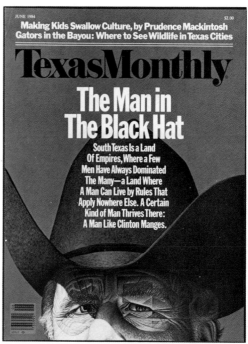

543

Art Director John Tom Cohoe
Designers John Tom Cohoe, Philip Kaplan
Photographer Robert Azzi
Editor Kevin Buckley
Publisher Knapp Communications, New York, NY
Publication GEO

544

Art Director Fred Woodward
Designer Fred Woodward
Artist Sean Earley
Editor Gregory Curtis
Publisher Michael Levy
Agency Texas Monthly
Publication Texas Monthly, Austin, TX

545

Art Director Will Hopkins
Designer Will Hopkins
Editor Sean Callahan
Publisher CBS
Agency Will Hopkins, New York, NY
Publication American Photographer

546

Art Director Robert J. Post
Designer Robert J. Post
Photographer Von
Publisher WFMT, Inc.
Publication Chicago Magazine, Chicago, IL

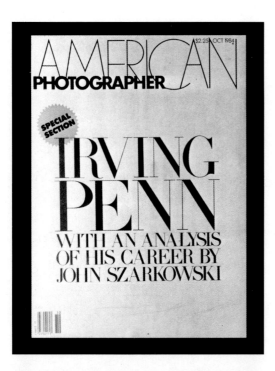

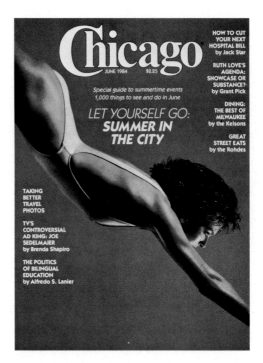

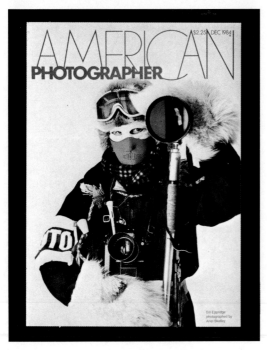

547

Art Director Will Hopkins
Designer Will Hopkins
Photographer Ariel Skelley
Editor Sean Callahan
Publisher CBS
Agency Will Hopkins, New York, NY

548

Art Director Carla Barr
Designer Carla Barr
Photographer Tomas Sennett
Client Connoisseur Magazine
Editor Thomas Hoving
Publisher Hearst Corp.
Publication Connoisseur Magazine, New York, NY

549

Art Director Ronn Campisi
Designer Ronn Campisi
Client The Boston Globe
Editor Michael Larkin
Publisher The Boston Globe, Boston, MA
Publication The Boston Globe Magazine

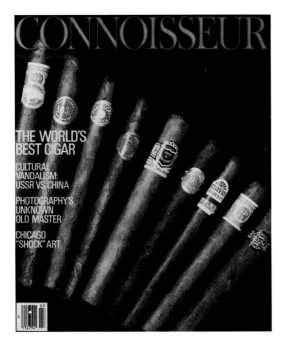

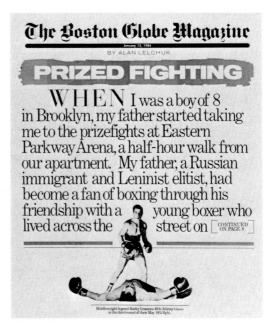

550

Art Director Al Beck
Photographer Mike Chesser
Writer Tom Johnson
Client L.A. Times/Home Magazine
Editor Wallis Guenther
Publisher Los Angeles Times, Los Angeles, CA

551

Art Director Frances Reinfeld
Designer Roger Gorman
Writer Thomas McEvilley
Client Artforum Magazine
Editor Ingrid Sischy
Publishers Anthony Korner, Amy Baker
Sandback
Agency Reiner Design Consultants, Inc.,
New York, NY
Publication Artforum Magazine

552

Art Director Kurt Peck
Artist Alan Bean
Editor Susan Hallsten McGarry
Publisher Southwest Art, Inc., Houston, TX
Quality Control Rick O. Sweval

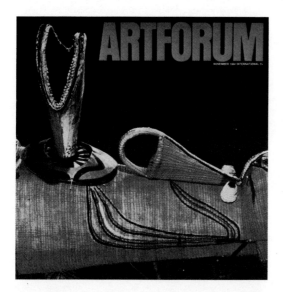

553

Art Director Bob Ciano
Designer Bob Ciano
Artist Garry Trudeau
Writer Garry Trudeau
Editor Richard Stolley
Publisher Life Magazine

554

Art Director B. Martin Pedersen
Designer B. Martin Pedersen
Client Upper & Lower Case
Editor Edward Gottschall
Publisher Upper & Lower Case
Director Ilene Mehl
Agency Jonson Pedersen Hinrichs & Shakery
Inc., New York, NY

555

Gold Award

Art Director B. Martin Pedersen
Designer B. Martin Pedersen
Client Upper & Lower Case
Editor Edward Gottschall
Director Ilene Mehl
Agency Jonson Pedersen Hinrichs & Shakery
Inc., New York, NY

MEET SPACE EXPLORER

IGARASHI

ture, or inside it, and experience the space and volume fully." For that reason, he refers to his alphabet forms not just as sculpture to be looked at, but as architectural environments.

An entire Igarashi alphabet was exhibited recently at the Reinhold-Brown

Mostly we think of graphic designers as just earthbound creatures, permanently trapped in 2-dimensional space. Now we'll have to alter that concept. Here is the work of Takenobu Igarashi, Japanese designer, whose posters, logos, corporate identity graphics and writings have made him a trendsetter in his native Japan, and internationally, as well.

But, as you can see from his designs, there is no confining him to the printed page. He started this 3-dimensional alphabet with drawings of simple, minimal letterforms, then proceeded to enlarge and extrapolate each character into a complex, multi-leveled, multifaceted piece of sculpture.

"I want to make letters on a mammoth scale," explains Igarashi, "so people can climb on top of the sculp-

Gallery in New York City. The letters were fabricated in brushed aluminum, but he has also worked with brass, chrome, wood, cast concrete, plastic and marble. Though these pieces were small in scale (approximately 5½ inches tall) some of his giant letters are 13 feet high and 20 feet wide, and are intended for public or corporate environments, indoors or out.

According to Igarashi, the alphabet is an appealing design project, because "it is a universally understood sign system." However, with or without the recognizable symbolism, let-

terforms make unexpectedly beautiful abstract designs in space.

Igarashi is a graduate of Tama University of Fine Arts in Tokyo, and he received his Master's Degree in Design from the University of California, Los Angeles. He established his own studio, Takenobu Igarashi Design, in Tokyo, in 1970. His posters, logos, corporate graphics and signage are recognized and admired internationally. The Museum of Modern Art in New York City has a permanent collection of his posters, and he has been commissioned to design their 1985 calendar, as well. He has international clients and has taught and lectured worldwide. Both Graphis and Idea magazines have honored him with special feature articles, and he is the recipient of numerous awards. His most recent contribution to the field of graphic

design is his own book, Igarashi Space Graphics, which encompasses three major areas: Architectural Graphics, Communication Graphics and Pure Graphics. It is an intelligent and highly intelligible work with illuminating insights into how he thinks and how he works. Available from Reinhold-Brown Gallery, 26 East 78th Street, New York, NY 10021. Marion Muller

A. The H photographed on the beach makes a grand portal to the sea. In ABS resin with lacquer coating. Actual size: 300 x 300 x 100 mm.
B. B in Indian sandstone is reminiscent of ancient Egyptian temple thrones. Actual size: 220 x 300 x 170 mm.
C. A in gleaming solid aluminum. Actual size: 380 x 310 x 180 mm.
D. Reaching toward the heavens, an inspirational X, in lacquered brass. Actual size: 300 x 240 x 460 mm.

PHOTOS: NOBUO ADACHI

556

Silver Award

Art Director	B. Martin Pedersen
Designer	B. Martin Pedersen
Writer	Marion Muller
Client	Upper & Lower Case
Editor	Edward Gottschall
Publisher	Upper & Lower Case
Director	Ilene Mehl
Agency	Jonson Pedersen Hinrichs & Shakery, Inc., New York, NY

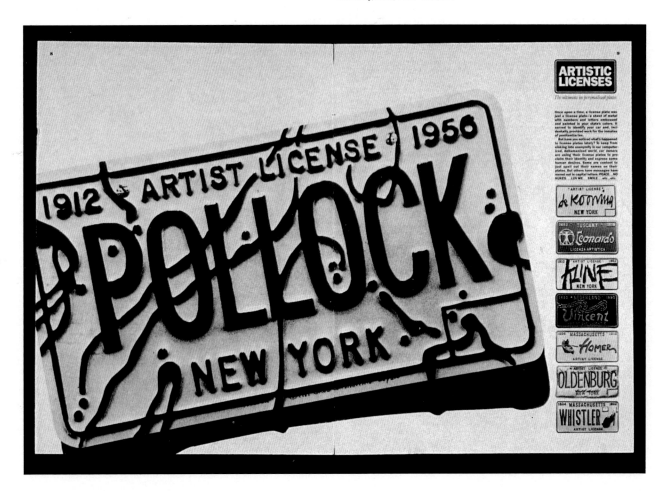

Distinctive Merit

Art Director	B. Martin Pedersen
Designer	B. Martin Pedersen
Photographer	Reprinted from "The Carousel Animal" Zyphyr Press
Client	Upper & Lower Case
Editor	Edward Gottschall
Publisher	Upper & Lower Case
Director	Ilene Mehl
Agency	Jonson Pedersen Hinrichs & Shakery, New York, NY

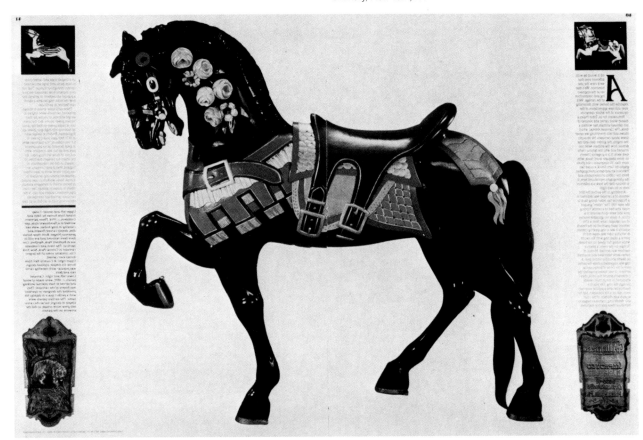

557

Art Director Joan Dworkin
Designer Michael Delia
Writer James E. Peters
Editor Tony Lisanti
Publication Restaurant Business Magazine, New York, NY

559

Art Director Gary Koepke
Designer Gary Koepke
Photographer David Gahr
Writer Tom Moon
Editor Jock Baird
Publisher Gordon Baird
Publication Musician Magazine, Gloucester, MA

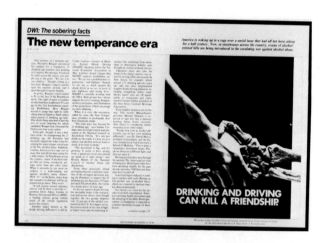

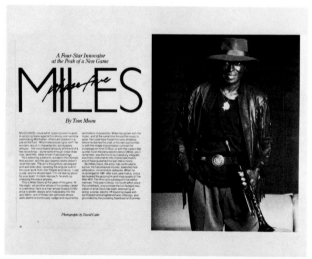

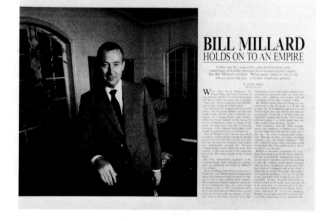

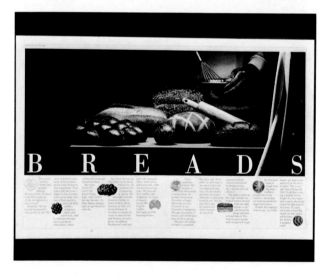

560

Art Director Ann Elizabeth Bartolotti
Photographer Sharon Hall
Writer Deidre Depke
Publisher Tom Casalegno
Publication Micro Marketworld, Framingham, MA

561

Art Director Kit Hinrichs
Designers Kit Hinrichs, Karen Berndt
Photographer Terry Heffernan
Writer Jim Dodge, Peterson & Dodge
Client Royal Viking Line
Editor George Cruys, Royal Viking Line
Agency Jonson Pedersen Hinrichs & Shakery, San Francisco, CA
Publication Royal Viking Skald—Premier issue

562

Art Director Rosslyn A. Frick
Designer Rosslyn A. Frick
Photographer Paul Avis
Writer Ezra Shapiro
Editor Philip Lemmons
Publisher Harry L. Brown
Publication BYTE Magazine, McGraw-Hill,
 Peterborough, NH

563

Art Director John C. Isely
Designer John C. Isely
Artist Donna Pacinella
Writers Joyce Strom-Paikin, MS, RNC;
 Margaret Knickerbocker, RN; Sandra
 Lambdin, RN
Editors Loy Wiley, MBA; Maryanne Wagner
Publisher Springhouse Corporation,
 Springhouse, PA
Publication NursingLife

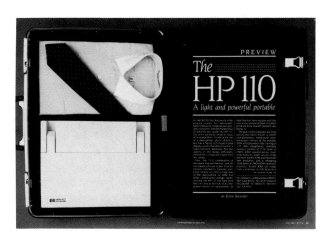

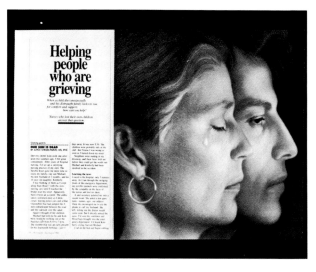

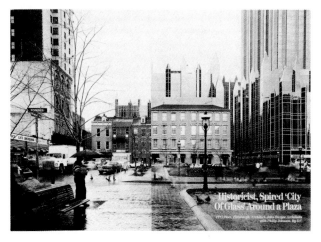

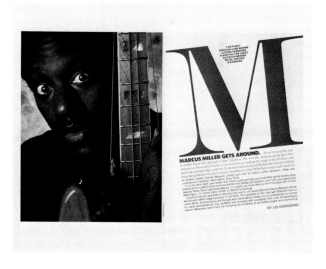

564

Art Director Carole J. Palmer
Designer Carole J. Palmer
Photographer Brian Rose
Editor Donald Canty
Publisher The American Institute of Architects,
 Washington, D.C.

565

Art Director Gary Koepke
Designer Gary Koepke
Photographer Deborah Feingold
Writer J.D. Considine
Editor Jock Baird
Publisher Gordon Baird
Publication Musician Magazine, Gloucester, MA

566

Art Director B. Martin Pedersen
Designer B. Martin Pedersen
Photographer From "The Carousel Animal"
Published by Zephyr Press
Writer Marion Muller
Client Upper & Lower Case
Editor Edward Gottschall
Publisher Upper & Lower Case
Director Ilene Mehl
Agency Jonson Pedersen Hinrichs &
Shakery, Inc., New York, NY

567

Art Director Al Foti
Designer Sydney Rowan
Publisher MD Publications, Inc., New York, NY
Publication MD Magazine

568

Art Director Edward W. Rosanio
Designer Edward W. Rosanio
Artist Robert Jones
Writer Carol A. Foster, RN, MSN
Editor Marylou Webster
Publisher Springhouse Corporation,
Springhouse, PA
Publication Nursing84

569

Art Director Jim Jacobs
Designer Jim Jacobs
Artist Jim Jacobs
Writer Katherine Sheehy Hussey
Client Legal Assistant Today Magazine
Editor Enika H. Pearson
Publisher Legal Assistant Today
Agency Jim Jacobs Studio, Dallas, TX
Publication Legal Assistant Today

570

Art Director Gary Koepke
Designer Gary Koepke
Photographer Deborah Feingold
Artist Michael Thoresen
Writer Jerome Reece
Editor Jock Baird
Publisher Gordon Baird
Publication Musician Magazine, Gloucester, MA

571

Art Directors Harry Knox, Jeffrey Dever
Designer Jeffrey Dever
Illustrator Kenneth Krafchek
Editor Roland R. Hegstad
Agency Harry Knox & Associates, Glendale, MD
Publication Liberty Magazine

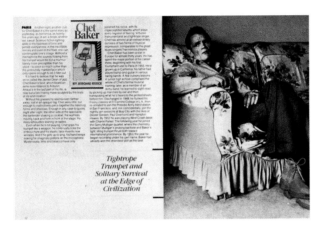

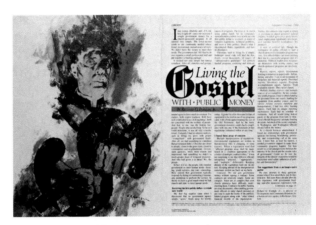

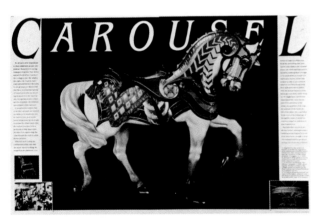

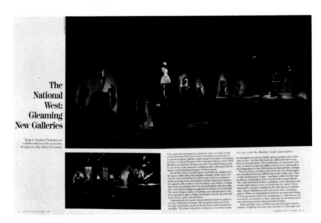

572

Art Director B. Martin Pedersen
Designer B. Martin Pedersen
Photographer Reprinted from "The Carousel Animal" Zyphyr Press
Client Upper & Lower Case
Editor Edward Gottschall
Publisher Upper & Lower Case
Director Ilene Mehl
Agency Jonson Pedersen Hinrichs & Shakery, Inc., New York, NY

573

Art Director Carole J. Palmer
Designer Carole J. Palmer
Photographer Allen Freeman
Editor Donald Canty
Publisher The American Institute of Architects/ SC, Washington, D.C.

574

Art Director Valerie Greenhouse
Designer Valerie Greenhouse
Artist Byron Peck
Client Mortgage Bankers Assoc. of America
Editor Margaret Yao
Agency Harrison Communications,
 Washington, DC
Publication Mortgage Banking

575

Art Director Mare Earley
Designer Darryl Turner
Photographer Bob Murray
Writer Beth Sherman
Editor Tim Simmons
Publisher Fairchild Publications, New York, NY
Publication HFD
Selection Editor Shelly Garcia

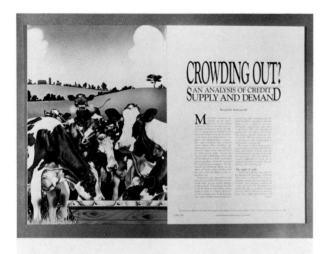

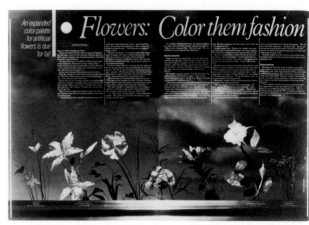

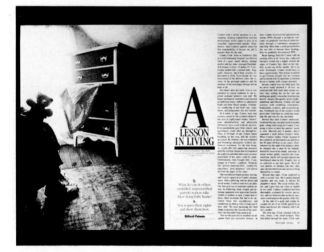

576

Art Director Edward W. Rosanio
Designer Edward W. Rosanio
Photographer Peggy Fox
Writer Linda Chitwood, RN, BSN
Editor Margie English
Publisher Springhouse Corporation,
 Springhouse, PA
Publication Nursing84

577

Art Director	Joseph R. Morgan
Designer	Sam Burlockoff
Photographer	William Albert Allard
Editor	Albert Roland
Publisher	U.S. Information Agency, Washington, DC
Publication	Dialogue Magazine
Picture Editor	Ellen F. Toomey

578

Art Director	David Brier
Designer	David Brier
Artist	Barry Root
Writer	David Ames
Client	David Brier Design Works, Inc.
Publisher	David Brier, East Rutherford, NJ
Publication	Graphic Relief
Handlettering	David Brier

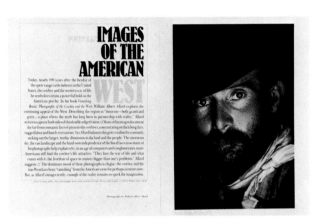

579

Art Director	Kit Hinrichs
Designers	Kit Hinrichs, Karen Berndt
Photographer	Terry Heffernan
Writers	Linda Evans, Lawrence Selman
Client	Royal Viking Line
Editor	George Cruys
Agency	Jonson Pedersen Hinrichs & Shakery, San Francisco, CA

580

Art Director William Kircher III
Designer Bobbie Lee
Artist Glenn Heitz
Client National Education Association
Agency William Kircher & Associates,
Washington, DC

581

Art Director Deborah J. Todd
Publication The Professional Photographer, Des
Plaines, IL

582

Art Director Ann Elizabeth Bartolotti
Photographer John Owens
Writer Patricia Keefe
Publisher Tom Casalegno
Publication Micro Marketworld, Framingham,
MA

Gold Award

Art Director	B. Martin Pedersen
Designer	B. Martin Pedersen
Client	Upper & Lower Case
Editor	Edward Gottschall
Publisher	Upper & Lower Case
Director	Ilene Mehl
Agency	Jonson Pedersen Hinrichs & Shakery, Inc., New York, NY

584
Silver Award

Art Director	Kenneth Windsor
Designer	Kenneth Windsor
Publication	Progressive Architecture, Stamford, CT

Great revivals

Although trained as a painter, Richard Riemerschmid moved quickly into the applied arts, playing a major role in the 1907 formation of the Deutscher Werkbund. His Music Room Chair, reissued this year by Jack Lenor Larsen, was first shown at the Dresden Exhibition of 1899. Its striking diagonal cross brace, slightly curved, is an elegant, organic solution to the problem of stabilization. The chair is available in golden natural or ebonized beechwood and studded seat cushions.

Some furniture, like some fashion, never goes out of style. Demand for Le Corbusier's chaise longue, Marcel Breuer's Wassily chair and his ever-popular Cesca, and even Mies van der Rohe's pricey Barcelona chair seems only to increase with the passage of time. These classics are, however, only the core of a general revival of early 20th-Century furniture which has gained considerable momentum over the past several years. Shown on these pages are some of the more recent offerings, an eclectic portfolio ranging from the organic art furniture of Erik Gunnar Asplund to the rationalist work of Giuseppe Terragni.

While these nine pieces are significant in and of themselves, each also represents a broader commitment on the part of manufacturers and distributors to make available not just the odd collector's item but a whole series of works by a given designer. The Breuer couch is only the latest in a long line of Breuer pieces reproduced by Thonet over the years. ICF expects to add to its collection of furniture by Eliel Saarinen on a yearly basis, while Jack Lenor Larsen's introduction of the Riemerschmid Music Room Chair follows last year's Armchair. Atelier International has reintroduced three Asplund designs, and Furniture of the Twentieth Century carries a total of six pieces by Terragni.

Herman Miller has begun to reproduce Isamu Noguchi's 1947 organic coffeetable (below) as part of a whole program of reissued classics by Noguchi, George Nelson, and Charles Eames, whose last work, a posthumously manufactured leather sofa with padded arms, was also reintroduced this year. The Noguchi table, which balances a heavy plate-glass top on two identical members carved from solid wood, has been out of production only since 1973. Its return is a welcome sign of the times. [DARALICE D. BOLES] ■

Art Director Kenneth Windsor
Designer Kenneth Windsor
Photographers Masao Ari, Shinkenchiku
Writer Bruno J. Hubert
Publication Progressive Architecture, Stamford,
CT

Kahn's epilogue

National Capital
Dacca, Bangladesh

In 1947, the British India Empire collapsed. The resulting partition produced India and Pakistan, the latter composed of two territorial units separated by 1500 miles. Autonomous movements sprang up quickly in the eastern half, challenging the domination of West Pakistan. In 1970, terrible floods devastated the eastern territory, and in the face of West Pakistan's complete passivity, agitation for independence increased, culminating in the civil war of 1971. With the support of India, East Pakistan acquired some semblance of independence, although the newly named Bangladesh remained under the tutelage of India for some

With the completion this year of the Assembly Building, Kahn's last work—The National Capital of Bangladesh— is finished.

time. The most densely populated country in the world as well as one of the poorest, Bangladesh is today dependent on other countries for its very survival.

In 1962, Louis Kahn was called upon to design what inhabitants of Dacca still call the "second capital" or Capital of East Pakistan. From the beginning, the complex was to be a symbol of modernization, looking towards western prototypes, construction techniques and work methods. Construction commenced in 1966, but stopped in 1971 when civil war intervened. The Assembly complex, then about 75 percent complete, was converted to use as a temporary military camp.

"Because this is delta country," wrote Kahn of the National Capital of Bangladesh, "buildings are placed on mounds to protect them from flood. The lake was meant to encompass the hostels and the assembly and to act as a dimensional control. The assembly, hostels, and supreme court belong to the Citadel of Assembly, suggesting a completeness causing other buildings to take their distance." (JA Journal, June 1973). The National Assembly Building (above and facing page) is almost completely surrounded by water; the north façade (overleaf) fronts a large, ceremonial plaza.

586

Art Director	Peter Morance
Designer	Peter Morance
Photographer	various
Writer	William Marlin
Client	Mercedes-Benz of North America, Inc.
Editor	Thomas P. Parrett
Publisher	Mercedes-Benz of North America, Inc.
Agency	McCaffrey and McCall, Inc., New York, NY
Publication	Mercedes XIII

587

Art Director	B. Martin Pedersen
Designer	B. Martin Pedersen
Photographer	From "The Carousel Animal" Published by Zephyr Press
Writer	Marion Muller
Client	Upper & Lower Case
Editor	Edward Gottschall
Publisher	Upper & Lower Case
Director	Ilene Mehl
Agency	Jonson Pedersen Hinrichs & Shakery, Inc., New York, NY

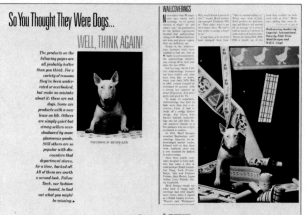

588

Art Director	Al Foti
Designer	Al Foti
Publisher	MD Publications, Inc., New York, NY
Publication	MD Magazine

589

Art Director	Doris Downes-Jewett
Designer	Doris Downes-Jewett
Photographer	Matthew Klein
Writers	Francy Searles, Jeff Prine, Mary Connors
Editor	Francy Searles
Publisher	Fairchild Publications, New York, NY
Publication	Home Fashions Textiles

590

Art Director	Kenneth Windsor
Designer	Kenneth Windsor
Photographer	Norman McGrath
Publication	Progressive Architecture, Stamford, CT

591

Art Director	B. Martin Pedersen
Designer	B. Martin Pedersen
Client	Upper & Lower Case
Editor	Edward Gottschall
Publisher	Upper & Lower Case
Director	Ilene Mehl
Agency	Jonson Pedersen Hinrichs & Shakery, Inc., New York, NY

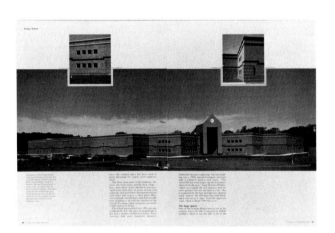

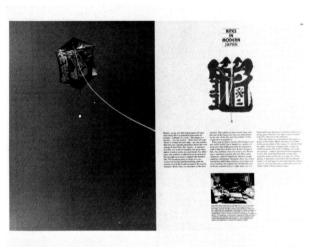

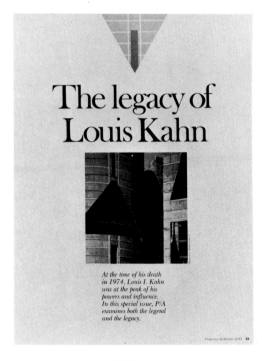

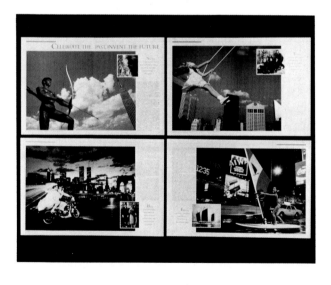

592

Art Director	Kenneth Windsor
Designer	Kenneth Windsor
Photographer	John Christopher Knowles
Publication	Progressive Architecture, Stamford, CT

593

Art Director	John C. Jay
Designers	Steve Hoffman, John C. Jay
Photographer	Sal Corbo
Client	Guest Informant
Director	Haines Wilkerson
Agency	John Jay Design, New York, NY
Publication	Guest Informant

594

Art Director Kenneth Windsor
Designer Kenneth Windsor
Photographer Richard Bryant
Publication Progressive Architecture, Stamford, CT

595

Art Director Kenneth Windsor
Designer Kenneth Windsor
Publication Progressive Architecture, Stamford, CT

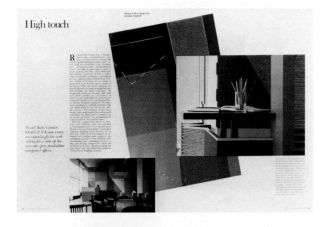

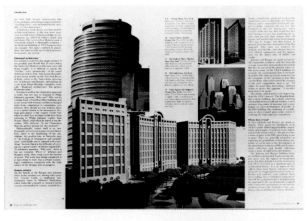

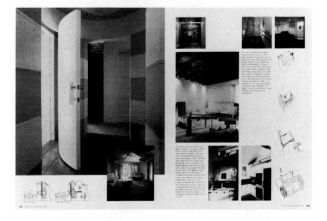

596

Art Director Kenneth Windsor
Designer Kenneth Windsor
Photographer Tim Street-Porter
Publication Progressive Architecture, Stamford, CT

597

Art Director Kenneth Windsor
Designer Kenneth Windsor
Photographer Patricia Layman Bazelon
Publication Progressive Architecture, Stamford, CT

598

Gold Award

Art Director Andrew Kner
Artist Matt Mahurin
Client RC Publications
Editor Martin Fox
Publisher Howard Cadel
Publication Print Magazine, New York, NY

Silver Award

Art Director	Daniel J. McClain
Designer	Daniel J. McClain
Photographer	Charles Krebs
Client	National Audubon Society
Editor	Les Line
Publisher	National Audubon Society, New York, NY
Publication	Audubon
Picture Editor	Martha Hill

600

Silver Award

Art Directors	James Cross, Andrew Kner
Designer	Michael Mescall
Publisher	Print Magazine
Agency	Cross Associates, Los Angeles, CA

601

Distinctive Merit

Art Director Jack Lefkowitz
Designer Jack Lefkowitz
Artist Virginia Strnad
Writer David Ritchey
Client Industrial Launderer
Editor David Ritchey
Publisher Institute of Industrial Launderers
Agency Jack Lefkowitz Inc., Leesburg, VA
Publication Industrial Launderer

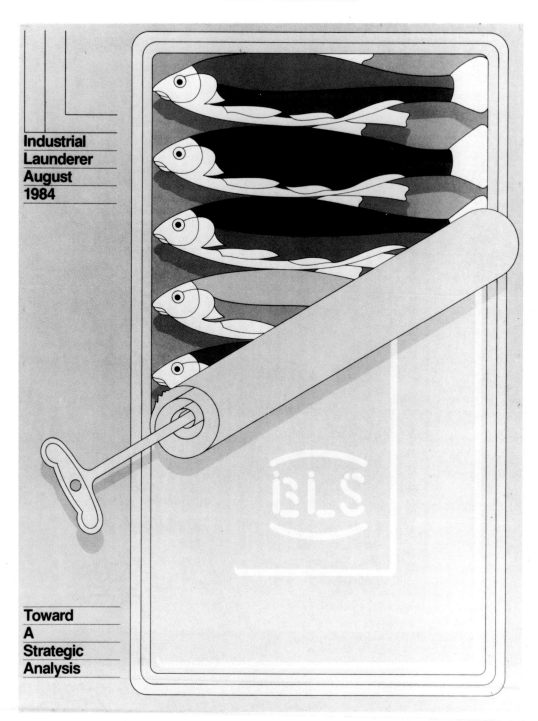

602

Distinctive Merit

Art Director Don Johnson
Designer Bonnie Berish
Artist Mary Ann Lasher
Writer Dana Lee Wood
Client Nabisco Brands Inc.
Agency Johnson & Simpson Graphic Designers, Newark, NJ
Publication NBEYE

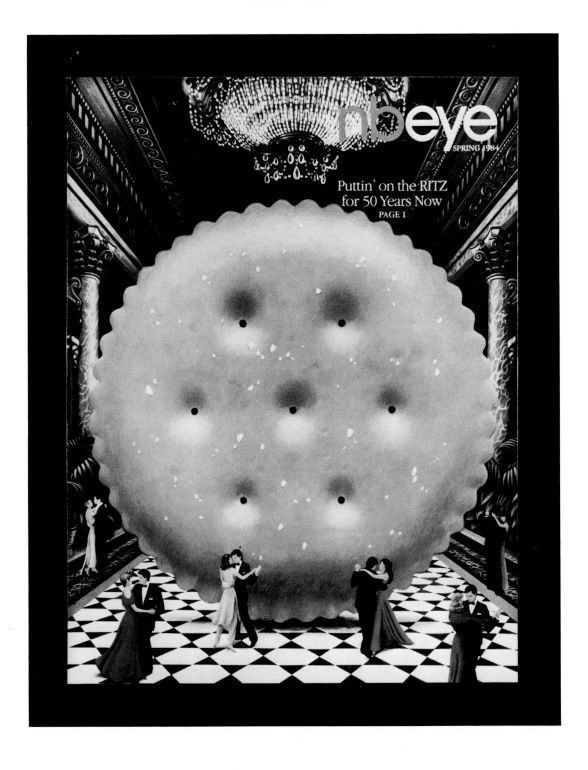

603

Art Directors Michael David Brown, Dorothy Wickerden
Artist Michael David Brown
Client The New Republic
Agency Michael David Brown, Rockville, MD

604

Art Director Peter Morance
Designer Peter Morance
Photographer John Lamm
Client Mercedes-Benz of North America, Inc.
Editor Thomas P. Parrett
Publisher Mercedes-Benz of North America, Inc.
Agency McCaffrey and McCall, Inc., New York, NY
Publication Mercedes XII

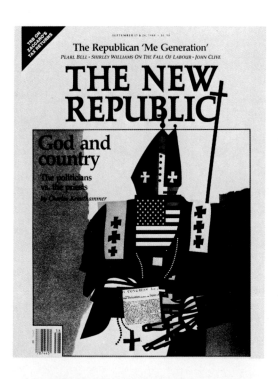

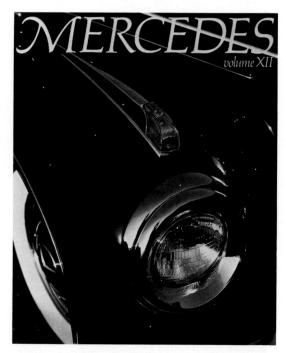

605

Art Directors Janice Fudyma & Craig Bernhardt
Artist Judy Pedersen
Client Maxwell House Messenger
Publisher General Foods Corporation
Agency Bernhardt-Fudyma Design, New York, NY

606

Art Director	Andrew Kner
Designer	Rafal Olbinski
Artist	Rafal Olbinski
Writer	Martin Fox
Client	RC Publications
Editor	Martin Fox
Publisher	Howard Cadel
Publication	Print Magazine, New York, NY

607

Art Director	Jack Lefkowitz
Designer	Jack Lefkowitz
Artist	Virginia Strnad
Writer	David Ritchey
Client	Industrial Launderer
Editor	David Ritchey
Publisher	Institute of Industrial Launderers
Agency	Jack Lefkowitz Inc, Leesburg, VA
Publication	Industrial Launderer

608

Art Director	Bruno Ruegg
Designer	Bruno Ruegg
Photographer	Francois Robert
Artist	Photo of Thermogram courtesy Andrew A. Fischer MD PhD
Writer	Editorial
Client	Sandoz Laboratories
Editor	Karen Izui
Publisher	Sieber & McIntyre Publishing Div.
Agency	Sieber & McIntyre, Chicago, IL
Publication	Single Sponsor Medical

609

Art Director Tim McKeen
Designer Kathryn L. Wityk
Design Director John Newcomb
Photographer Stephen E. Munz
Artist Asdur Takakjian
Writer Margo Quinlan, RN, MS
Client RN Magazine
Editor James A. Reynolds
Publisher Medical Economics Co., Inc.
Publication RN Magazine, Oradell, NJ

610

Art Director Carole J. Palmer
Designer Carole J. Palmer
Photographer Jet Lowe - HABS/HAER
Editor Donald Canty
Publisher The American Institute of Architects, SC, Washington, D.C.

611

Art Director Greg Simpson
Designer Greg Simpson
Photographer Craig Cutler
Artist The Manhattan Model Shop
Client Mercedes-Benz of North Amrica, Inc.
Editor Thomas P. Parrett
Publisher Mercedes-Benz of North America, Inc.
Agency McCaffrey and McCall, Inc., New York, NY
Publication Sales Management Journal

612

Art Director Brenda Suler
Designer Brenda Suler
Artist Sandy Huffaker
Client Madison Avenue Magazine Publishing Company
Editor Stuart Emmrich
Publisher Walter Weidenbaum
Publication Madison Avenue Magazine, New York, NY

613

Art Director	Craig Bernhardt
Designer	Ron Shankweiler
Artist	Nancy Stahl
Editor	Nan Haley Redmond
Agency	Bernhardt Fudyma Design Group, New York, NY

614

Art Directors	Joanne Zamore, Beth Singer
Designer	Joanne Zamore
Artist	James Yang
Client	IBM, Federal Systems Division
Agency	Design Communication, Inc., Washington, DC

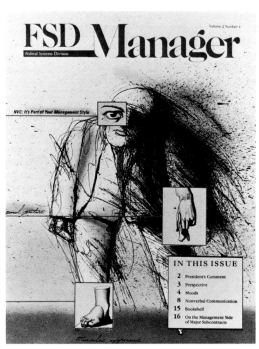

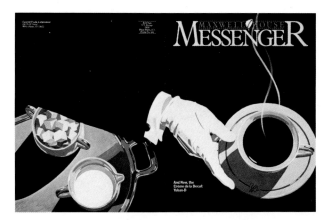

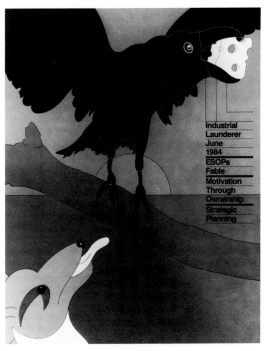

615

Art Director	Jack Lefkowitz
Designer	Jack Lefkowitz
Artist	Virginia Strnad
Writer	David Ritchey
Client	Industrial Launderer
Editor	David Ritchey
Publisher	Institute of Industrial Launderers
Agency	Jack Lefkowitz Inc., Leesburg, VA
Publication	Industrial Launderer

Art Director	Kit Hinrichs
Designers	Kit Hinrichs, Karen Berndt
Photographer	various
Artist	various
Writer	various
Client	Royal Viking Line
Editor	George Cruys
Agency	Jonson Pedersen Hinrichs & Shakery, San Francisco, CA

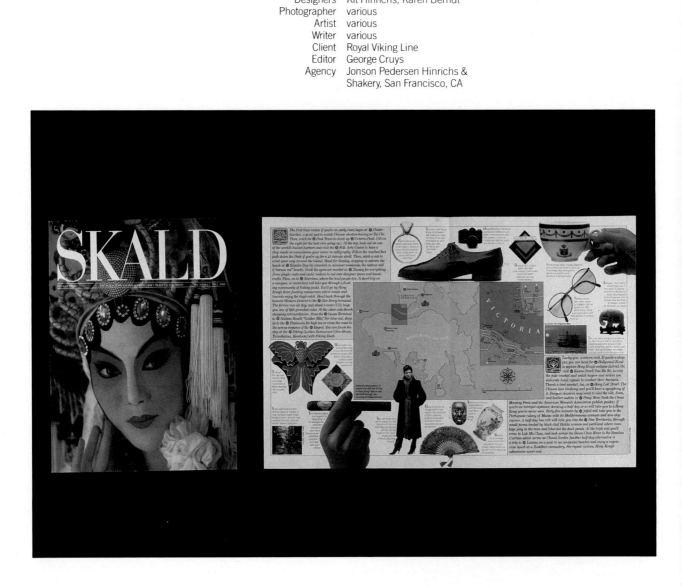

Silver Award

Art Director Marilyn Rose
Designer Marilyn Rose
Photographer various
Editor Joseph Gribbins
Publisher Donald C. McGraw, Jr.
Publication Nautical Quarterly, New York, NY

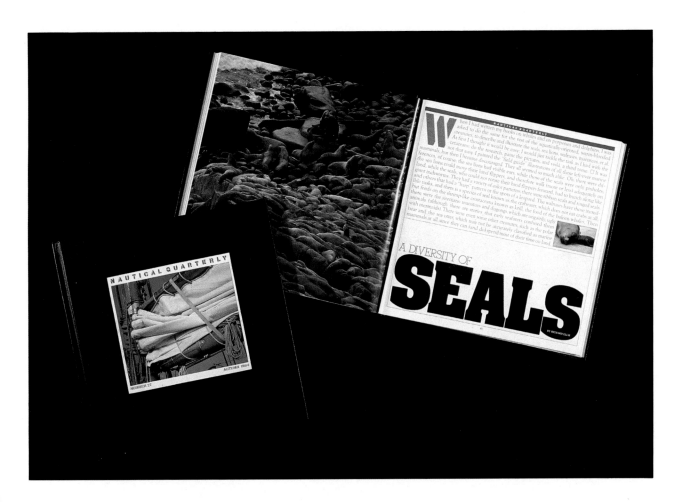

618

Distinctive Merit

Art Director John Tom Cohoe
Designers John Tom Cohoe, Frank Tagariello,
 Miriam Weinberg
Editor Kevin Buckley
Publisher Knapp Communications, New York,
 NY
Publication GEO

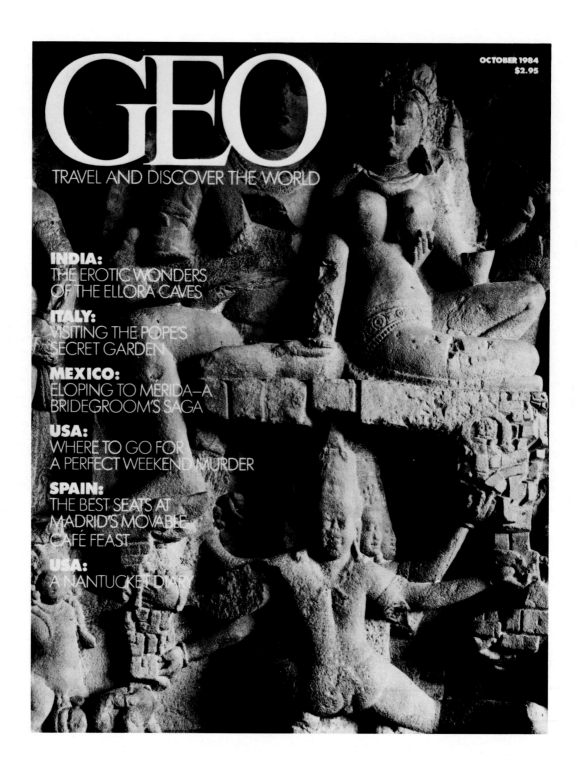

619

Art Director Fred Bechlen
Designer Fred Bechlen
Photographer Various
Client Minolta Camera Co., Ltd.
Editor Richard V. Bryant
Publisher K. Nakamura
Agency Dentsu Inc., Osaka, Japan

620

Art Director Derek Ungless
Designer Elizabeth Williams
Assistant Designer Rosemarie Sohmer
Photo Editor Laurie Kratochvil
Publication Rolling Stone Magazine, New York, NY

621

Art Director Carole J. Palmer
Designer Carole J. Palmer
Photographer Jet Lowe-HABS, HAER
Editor Donald Canty
Publisher The American Institute of Architects, SC, Washington, DC

622

Art Director John Tom Cohoe
Designers John Tom Cohoe, Frank Tagariello,
 Miriam Weinberg
Publisher Knapp Communications, New York,
 NY
Publication GEO

623

Art Director Derek Ungless
Designer Elizabeth Williams
Assistant Designer Tracey Glick
Photo Editor Laurie Kratochvil
Publication Rolling Stone Magazine, New York,
 NY

Gold Award

Art Directors	Robert Meyer, Julia Wyant
Designer	Julia Wyant
Photographer	Nicholas Muray
Writer	Michael Hager
Client	International Musuem of Photography at George Eastman House
Editor	Robert Mayer
Agency	Robert Meyer Design, Inc., Rochester, NY
Publication	IMAGE
Printer	Canfield & Tack, Inc.

Gold Award

Art Director Kit Hinrichs
Designers Kit Hinrichs, Lenore Bartz
Photographers Paul Fusco, Henrik Kam
Artists Justin Carroll, David Stevenson
Client Potlatch Corporation
Editor Delphine Hirasuna
Agency Jonson Pedersen Hinrichs &
 Shakery, San Francisco, CA

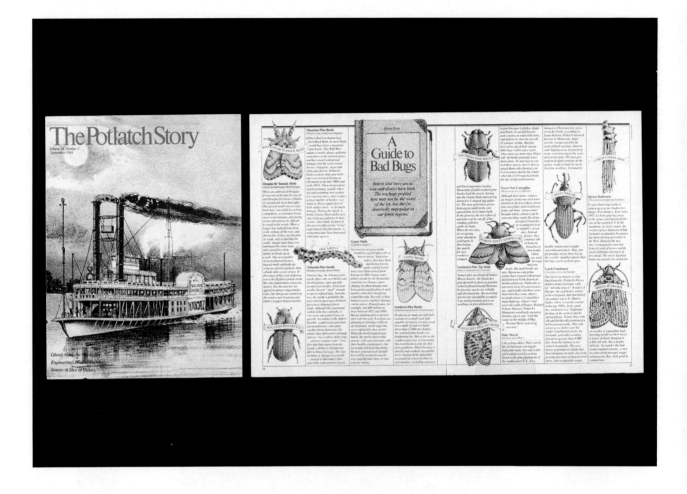

Silver Award

Art Director	Wilburn Bonnell III
Designer	Richard Beidel
Photographers	Bill Kontzias, Rudolph Janu, Idaka
Writer	Christine Rae
Client	Sunar Hauserman
Editor	Christine Rae
Publisher	Sunar Hauserman
Agency	Bonnell Design Associates Inc., New York, NY

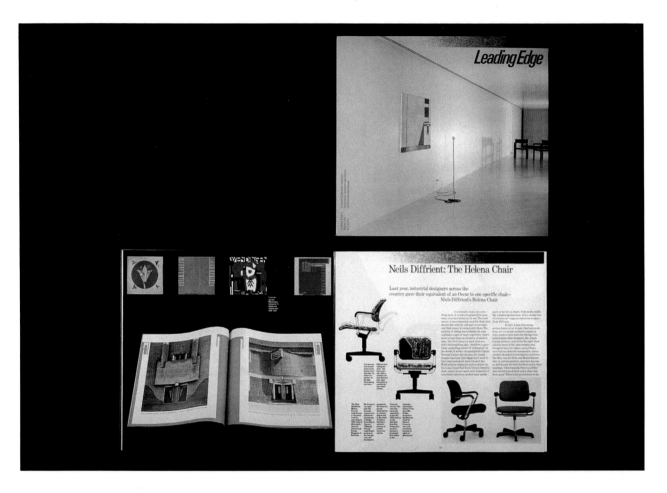

Silver Award

Art Director	Kit Hinrichs
Designers	Kit Hinrichs, Lenore Bartz
Photographer	various
Artist	various
Client	Potlatch Corporation
Editor	Delphine Hirasuna
Agency	Jonson Pedersen Hinrichs & Shakery, San Francisco, CA

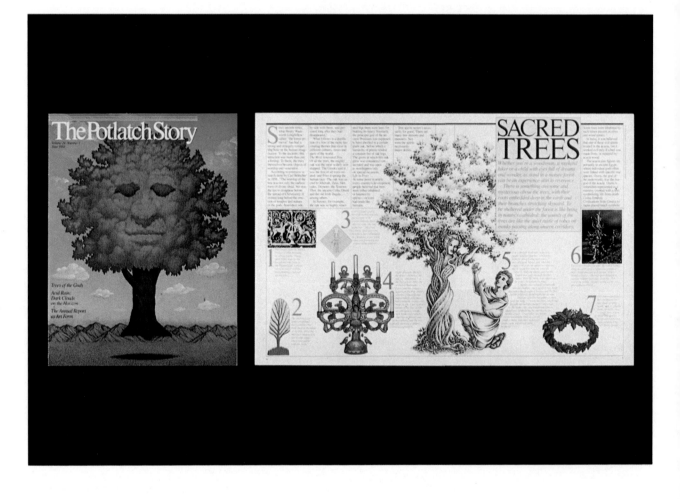

628

Art Director Don Kubly
Designer John Vince
Writer Harry Smallenberg
Client Art Center College of Design,
 Pasadena, CA
Editor Harry Smallenberg

629

Art Director Asger Jerrild
Designer Asger Jerrild
Photographer George Giusti
Artist George Giusti, West Redding, CT
Client Price Waterhouse
Printer Steelograph Co. Inc.

630

Art Director Anthony Russell
Designer Casey Clark
Photographers Stephen Wilkes, Gloria Baker, Paul
 Fusco, Burk Uzzle
Artist Susannah Kelly
Client Peat Marwick
Editor Jerry G. Bowles
Associate Editor John K. Smalley
Director of Publications Gerald J. Barry
Agency Anthony Russell, Inc., New York, NY

631

Art Director Wilburn Bonnell III
Designer Richard Beidel
Photographers Bill Kontzias, Rudolph Janu, Idaka
Writer Christine Rae
Client Sunar Hauserman
Editor Christine Rae
Publisher Sunar Hauserman
Agency Bonnell Design Associates Inc., New
 York, NY

632

Art Director	Kit Hinrichs
Designers	Kit Hinrichs, Lenore Bartz
Photographers	Henrik Kam, Terry Heffernan, Clark Kinsey, Tom Tracy
Artists	John Hyatt, Justin Carroll
Client	Potlatch Corporation
Editor	Delphine Hirasuna
Agency	Jonson Pederson Hinrichs & Shakery, San Francisco, CA

633

Art Director	Julia Wyant
Designer	Julia Wyant
Writer	Robert A. Mayer
Client	International Museum of Photography at George Eastman House
Agency	Robert Meyer Design, Inc., Rochester, NY
Printer	Canfield & Tack, Inc.

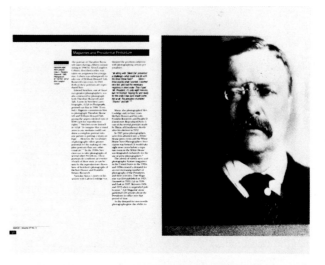

634

Art Director	Peter Deutsch
Designer	Jan McNeil
Photographers	Camille Vickers, Ziggy Kaluzny
Artists	Tim Lewis, Mark Ulrich
Writer	Various
Client	Allied Corporation
Editor	Timothy D. Patterson
Director	Patricia F. Lauber
Agency	Anthony Russell, Inc., New York, NY
Publication	OMNIA

635

Art Directors	Wynn Medinger, Jones Medinger Kindschi Inc.
Designers	Wynne Patterson, Jones Medinger Kindschi Inc.
Photographer	Various
Artist	Various
Writer	Various
Client	IBM Corporation
Editor	Lloyd Banquer, IBM
Director	John Morris, IBM
Agency	Jones Medinger Kindschi Inc., North Salem, NY

636

Art Director	Wilburn Bonnell III
Designer	Richard Beidel
Photographers	Bill Kontzias, Rudolph Janu, Idaka
Writer	Christine Rae
Client	Sunar Hauserman
Editor	Christine Rae
Publisher	Sunar Hauserman
Agency	Bonnell Design Associates Inc., New York, NY

637

Art Director	Julia Wyant
Designer	Julia Wyant
Photographer	various
Client	International Museum of Photography at George Eastman House
Agency	Robert Meyer Design, Inc., Rochester, NY
Printer	Canfield & Tack, Inc.

638

Art Director	Anthony Russell
Designer	Mark Ulrich
Photographer	Various
Artist	Various
Writer	Various
Client	Squibb Corporation
Editor	Gail Sokolowski
Agency	Anthony Russell, Inc., New York, NY
Publication	Squibbline

Promotion and Graphic Design: Annual report
Booklet, folder, brochure
Sales kit
Direct mail piece
Record album
Package, bottle, carton, can
Calendar
Menu, card, announcement
Letterhead, envelope & business card
Trademark, logo
P.O.P. design, display

Campaign entries: Booklets, folders, brochures
Sales kits
Direct mail
Packages, cartons, bottles, cans
Cards, menus, announcements
P.O.P. designs, displays
Corporate identity program

Gold Award

Art Director	Ernie Perich
Designers	Jeanette Dyer, Wayne Pederson
Photographer	Ann DeLaVergne
Writer	Mathew Thornton
Client	Domino's Pizza, Inc.
Agency	Group 243 Design, Inc., Ann Arbor, MI

Silver Award

Art Director	Bennett Robinson
Designers	Bennett Robinson, Paula Zographos
Photographers	Bill Hayward, Ron & Peggy Barnett
Writer	Oscar Shefler-H J Heinz Co.
Client	Thomas H. McIntosh-H J Heinz Co.
Agency	Corporate Graphics Inc., New York, NY
Printer	The Hennegan Company

Silver Award

Art Director	Janis Koy
Designer	Janis Koy
Photographer	Steve Brady
Writer	Steve Barnhill & Company
Client	Luby's Cafeterias, Inc.
Retouching	Raphaële
Production	Ken Howell
Typography	ProType of San Antonio
Agency	Koy Design, Inc., San Antonio, TX
Printer	Heritage Press, Dallas

Distinctive Merit

Art Director Milton Glaser
Designer Karen Skelton
Illustrator Jim McMullan
Writer Schlumberger, Ltd.
Client Schlumberger, Ltd.
Publisher Schlumberger, Ltd.
Studio Milton Glaser Inc., New York, NY

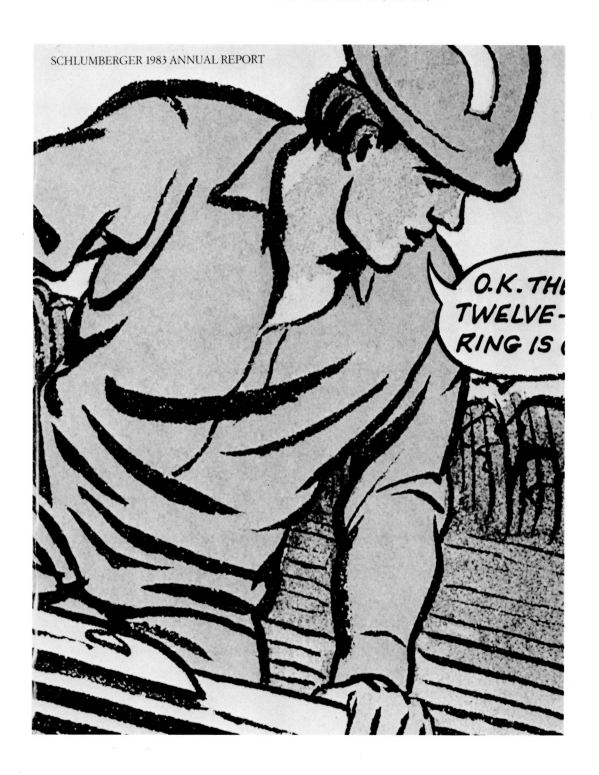

643

Art Director	Jim Berte
Designer	Jim Berte
Photographer	Mark Joseph
Client	Litton Industries
Agency	Robert Miles Runyan & Associates
	Playa del Rey, CA

644

Art Director	Roslyn Eskind
Designers	Roslyn Eskind, Christine Ullett
Photographer	John Harquail
Writer	Susan M. de Stein
Client	The Toronto-Dominion Bank
Editor	Susan M. de Stein
Publisher	The Toronto-Dominion Bank
Agency	Eskind Waddell, Toronto, Canada

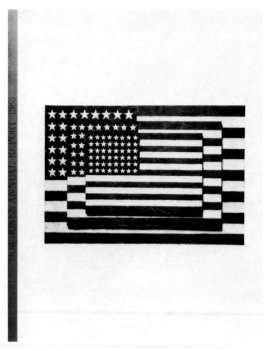

645

Art Director	D.J. Stout
Designer	D.J. Stout
Photographer	Robert Latorre
Writer	Larry Sisson
Client	Texas Industries, Inc.
Agency	Robert A. Wilson Assoc. Inc., Dallas, TX

646

Art Director	B. Martin Pedersen
Designers	Adrian Pulfer, B. Martin Pedersen
Writer	Larry Armour
Client	Dow Jones Company
Director	Larry Armour
Agency	Jonson Pedersen Hinrichs & Shakery, Inc., New York, NY
Publication	Annual Report

647

Art Director	Tyler Smith
Designers	Tyler Smith, Susan Snitzer
Photographer	Graeme Outerbridge
Client	Hopewell Insurance Co.
Studio	Tyler Smith, Art Direction Inc., Providence, RI

648

Art Directors	Douglas Oliver, Emmett Morava
Designer	Douglas Oliver
Photographer	Rick Golt
Illustrator	Dusty Deyo
Writer	Andrea Simpson
Client	Pacific Resources, Inc.
Agency	Morava & Oliver Design Office, Santa Monica, CA

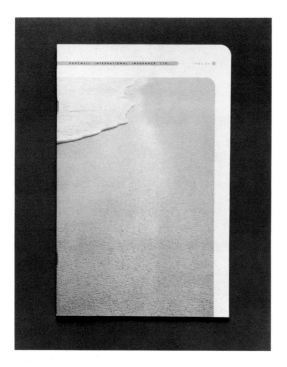

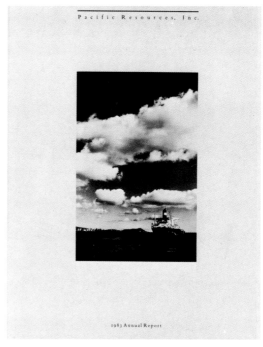

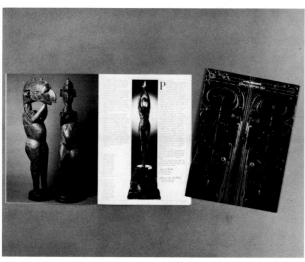

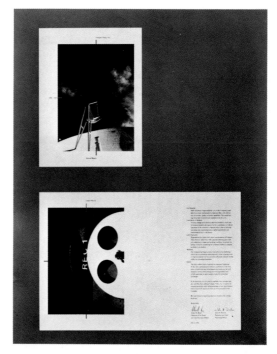

649

Art Director	Lawrence Bender
Designer	Lawrence Bender
Photographers	various
Writer	John Straubel
Client	W.A. Krueger Co.
Agency	Lawrence Bender & Associates, Palo Alto, CA

650

Art Director	Jim Berte
Designer	Jim Berte
Photographer	Burton Pritzker
Client	Compact Video, Inc.
Agency	Robert Miles Runyan & Assoc. Playa del Rey, CA

651

Art Director	Wilburn Bonnell III
Designer	Wilburn Bonnell III, Ingrid Nagin
Photographer	Rudolph Janu
Client	Sunar Hauserman
Editor	Christine Rae
Publisher	Sunar Hauserman
Agency	Bonnell Design Associates Inc., New York, NY

652

Art Director	John Van Dyke
Designer	John Van Dyke
Photographers	David Watanabe, Steve Firebaugh, Steve Welsh
Writer	Tom Ambrose
Client	Weyerhaeuser Company
Director	John Van Dyke
Agency	Van Dyke Company, Seattle, WA

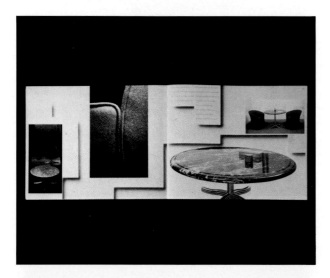

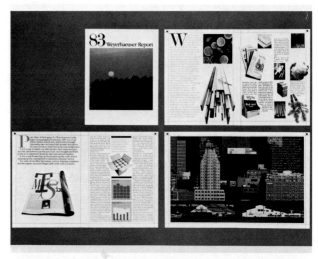

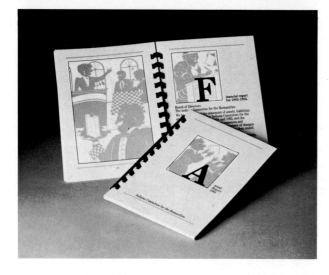

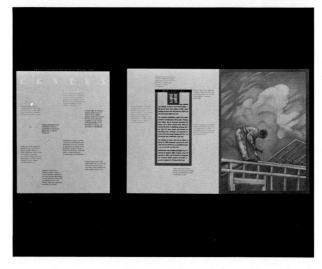

653

Art Director	Susan J. Kovatch
Designer	Susan J. Kovatch
Artist	Andrea Eberbach
Writer	Dorane Fredland
Client	Indiana Committee for the Humanities
Agency	DesignMark Inc., Indianapolis, IN

654

Art Director	Woody Pirtle
Designer	Woody Pirtle
Illustrator	Gary Kelley
Writer	Centex Corporation
Client	Centex Corporation
Agency	Pirtle Design, Dallas, TX
Creative Director	Woody Pirtle

655

Art Director Robert Miles Runyan
Designer Doug Joseph
Photographer Neil Slavin
Clients Bateman Eichler, Hill Richards
Agency Robert Miles Runyan & Assoc. Playa del Rey, CA

656

Art Director Janet Nebel
Designers Janet Nebel, Peggy Pugh
Photographer Neal Slavin
Writer Louise Hayman
Client Union Trust Bancorp
Agency The Woods Group, Inc., Baltimore, MD

657

Art Director James Stanton
Designer James Stanton
Photographer Ben Rosenthal
Writer Jan Van Meter
Client Hill and Knowlton, Inc.
Agency Hill and Knowlton, Inc., New York, NY

658

Art Director Diana Graham
Designers Diana Graham, Michelle Aranda
Photographer John Hill
Writer Francis X. Piderit
Client Macmillan, Inc.
Agency Gips + Balkind + Associates, New York, NY

659

Art Director	Robert Miles Runyan
Designer	Rik Besser
Photographer	William James Warren
Writer	Debra Coyman
Client	Agrigenetics Corporation
Agency	Robert Miles Runyan & Associates, Los Angeles, CA
Printer	Lithographix, Inc.

660

Art Director	John Van Dyke
Designer	John Van Dyke
Photographer	Bob Peterson
Writer	Tom McCarthy
Client	Boy Scouts of America
Director	John Van Dyke
Agency	Van Dyke Company, Seattle, WA

661

Art Directors	Vartus Artinian, Michael Benes
Designers	Vartus Artinian, Michael Benes
Photographers	Ed Holcomb, Russ Schleipman, Bowl, Marsel Studio
Writers	Sam Yanes, Gordon Lewis
Client	Polaroid Corporation, Cambridge, MA
Publisher	Acme Printing Co.

662

Art Director	Kit Hinrichs
Designers	Kit Hinrichs, Lenore Bartz
Photographers	Paul Ambrose, Gary Beydler, John Blaustein, Charly Franklin, Rudi Legname, Tom Tracy
Client	Crocker National Corporation
Editor	Dave Sanson
Agency	Jonson Pedersen Hinrichs & Shakery, San Francisco, CA

663

Art Director	Dick Sheaff
Designer	Dick Sheaff
Writer	Robert Meisel
Client	The Mitre Corporation
Editor	Alan Erskine
Agency	Sheaff Design, Inc., Needham Heights, MA
Executive Vice President	Charles A. Zraket

664

Art Director	Infield + D'Astolfo
Designer	Infield + D'Astolfo
Photographer	James Wojcik
Writer	Jack Galub
Client	Marubeni America Corporation
Editor	Frank Fucito
Agency	Infield & D'Astolfo, New York, NY

665

Art Director	Woody Pirtle
Designers	Woody Pirtle, Kenny Garrison
Photographer	Arthur Meyerson
Writer	National Gypsum Company
Client	National Gypsum Company
Agency	Pirtle Design, Dallas, TX
Creative Director	Woody Pirtle

666

Art Director	Aubrey Balkind
Designer	Diana Graham
Artist	Serban Epure
Writer	Francis X. Piderit
Client	VNU Amvest (Holland)
Agency	Gips + Balkind + Associates, New York, NY

667

Art Director	Kit Hinrichs
Designers	Kit Hinrichs, Nancy Koc
Photographer	Tom Tracy
Artists	Justin Carroll, Will Nelson, Colleen Quinn
Client	Potlatch Corporation
Editor	Delphine Hirasuna
Agency	Jonson Pedersen Hinrichs & Shakery, San Francisco, CA

668

Art Director	Andree' Cordella
Designer	Andree' Cordella
Photographer	Myron/Stock Photography
Artists	Gene Lemery, John Gatie
Writer	Jayne Schaffer
Client	Arkwright Boston Insurance Company
Editor	Jayne Schaffer
Studio	Gunn Associates, Boston, MA
Publication	Annual Report
Printer	Sanders Printing, New York

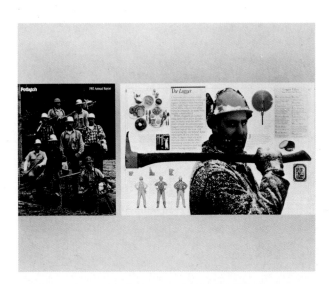

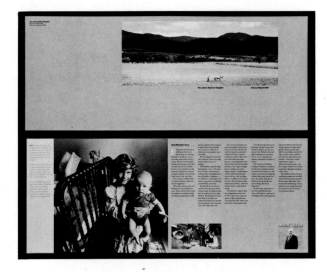

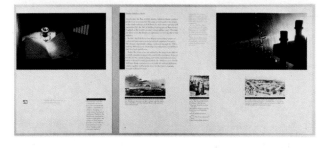

669

Art Director	Anthony Rutka
Designer	Anthony Rutka
Photographer	Jed Kirschbaum
Writer	Jo Clendenon
Client	The John Hopkins Medical Institutions
Agency	Rutka Weadock, Baltimore, MD

670

Art Director	Bob Newman
Designer	Bob Newman
Photographer	Gabe Palmer
Writer	Paul Diesel
Client	Multibank Financial Corp.
Agency	Newman Design Associates, New York, NY

671

Art Directors	Deborah Gallin, Michael P. Cronan
Designer	Michael Cronan
Photographer	John Blaustein
Artist	Michael Cronan
Writer	Deborah Gallin
Client	Farmers Savings Bank
Agency	Deborah Gallin Associates, San Francisco, CA

672

Art Director	John Waters
Designer	John Waters
Artist	Ed Walter
Writer	John C. Waddell
Client	Arrow Electronics, Inc.
Agency	John Waters Associates, Inc., New York, NY

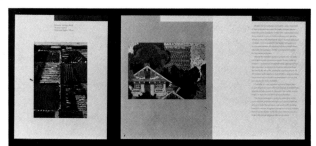

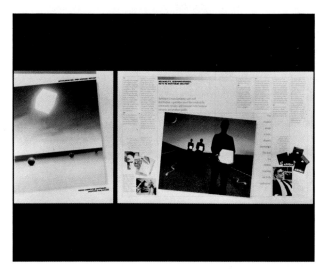

673

Art Director	Linda Hinrichs
Designers	Linda Hinrichs, Carol Kramer
Photographer	Charly Franklin
Writer	Rjck Barba
Client	Activision Inc.
Agency	Jonson Pedersen Hinrichs & Shakery, San Francisco, CA

674

Art Director	Stephen Miller
Designer	Stephen Miller
Photographer	Greg Booth
Artist	Jack Unruh
Writers	Mark Perkins, Jess Hay
Client	Lomas & Nettleton Mortgage Investor
Agency	Richards Brock Miller Mitchell & Associates, Dallas, TX

677

Gold Award

Art Director B. Martin Pedersen
Designer B. Martin Pedersen
Artist Ms Hama Hotta (Calligraphy)
Writer Bill Littlefield
Client Rolf Sauer, IBM
Agency Jonson Pedersen Hinrichs &
Shakery, Inc., New York, NY

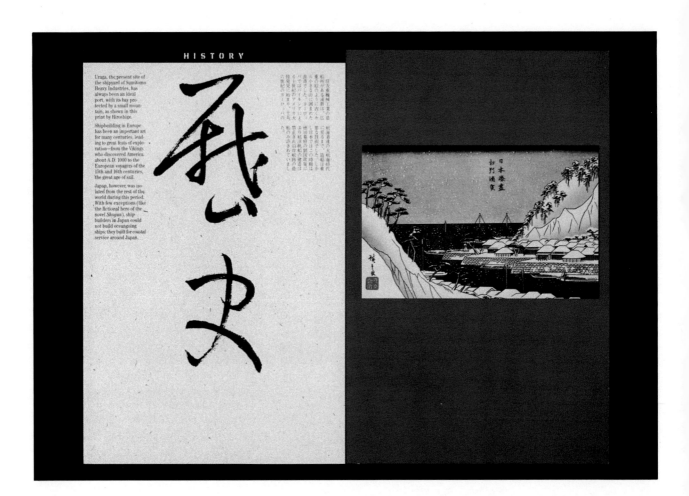

Silver Award

Art Director	Kit Hinrichs
Designers	Kit Hinrichs, Lenore Bartz
Photographer	Various
Artist	Various
Writer	Delphine Hirasuna
Client	Northwest Paper Company
Agency	Jonson Pedersen Hinrichs & Shakery, San Francisco, CA

Silver Award

Art Director	Cheryl Heller
Designer	Cheryl Heller
Photographer	Clint Clemens
Writer	Peter Caroline
Client	S.D. Warren Paper Co.
Agency	The Design Group, HBM/Creamer Inc., Boston, MA

Distinctive Merit

Art Director	Rex Peteet
Designer	Rex Peteet
Photographers	John Wong, Greg Booth & Associates
Artists	Rex Peteet, Jerry Jeanmard, Michael Schwab, Louis Escobedo
Writers	Mark Perkins, Rex Peteet
Client	International Paper Co.
Agency	Sibley/Peteet Design, Inc., Dallas, TX

681

Art Director	Woody Kay
Designer	Woody Kay
Writer	Tom Monahan
Client	Wright Line Inc.
Agency	Leonard Monahan Saabye, Providence, RI
Production	Carl Swanson

682

Art Director	Lowell Williams
Designers	Lowell Williams, Bill Carson
Artist	Sandy Kinnee
Writer	Lee Herrick
Client	Towne Club
Agency	Lowell Williams Design, Inc., Houston, TX

683

Art Director	Gary Husk
Designers	Gary Husk, Melanie Jennings Husk, Hollis Anderson
Photographer	Daryl Bunn
Writers	Melanie Jennings Husk, Jane Jordan
Client	Barnett Bank of Jacksonville, N.A.
Agency	Husk Jennings Anderson!, Jacksonville, FL
Typographer	DG&F Typographer

684

Art Director	Susan Adamson
Designer	Susan Adamson
Photographer	Phil Porcella
Writer	Steve Holzman
Client	Honeywell Information Systems
Agency	Cipriani Advertising, Inc., Boston, MA
Printer	Nimrod Press

685

Art Directors	Stan Reed, Jim Sendecke
Designer	Bill Shaffer
Writer	Frank Oswald
Client	Kohler Company
Agency	Reed Design Associates, Madison, WI

686

Art Director	Sherry McAllister
Designers	Sherry McAllister, Cathy Yates
Photographer	Cathy Yates
Artist	Nicholas Klise
Writer	Dick Jolly
Client	The Walters Art Gallery
Agency	Shub, Dirksen, Yates & McAllister, Inc., Baltimore, MD

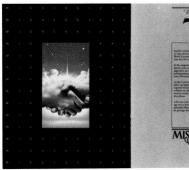

687

Art Director	Paul Ciavarra
Designer	Paul Ciavarra
Artist	Oren Sherman
Client	Urban Investment & Development Company
Agency	Ingalls Design Group, Boston, MA

688

Art Director	Wayne Saylor
Designer	Al Evans
Artist	Rudy Laslo
Writers	Steve Tadlock, Mary Sumners
Client	Mississippi
Agency	Maris, West and Baker
Design Firm	Skidmore Saharation, Troy, MI

689

Art Director	Michael Gunselman
Designer	Michael Gunselman
Photographers	Roger Ritchie, Paul Bowen, Kevin Bender
Artists	Richard Leech, Ralph Billings
Writer	Barry Tully
Client	Roger Ritchie, Atlantic Aviation Corporation, Wilmington, DE
Printer	Lebanon Valley Offset

690

Art Directors	Diane Meier, Darcey Lund
Designers	Diane Meier, Darcey Lund
Photographer	Erica Lennard
Artist	Grant Wood
Writer	Diane Meier
Client	Cambridge Dry Goods
Agency	Meier Advertising, New York, NY

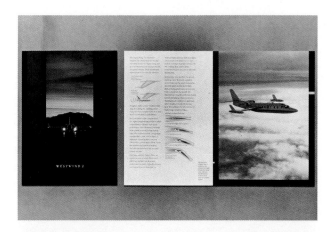

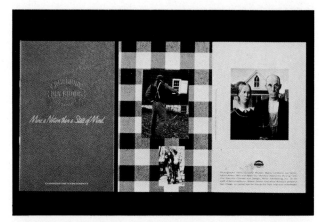

691

Art Director	Frank Gabriele
Photographer	Lasse Lie
Artist	Eric Gronlund
Writer	Steve Trygg
Client	Anderson & Lembke
Agency	Anderson & Lembke, Stamford, CT
Client Supervisor	Bengt Anderson

692

Art Director	Infield + D'Astolfo
Designer	Infield + D'Astolfo
Writer	Ayn Carey
Client	Citibank International Financial Institutions Group
Editor	Ayn Carey
Agency	Infield + D'Astolfo, New York, NY

693

Art Director	Jim Huckabay
Designers	Jim Huckabay, John Walker
Photographer	Tim Harper
Artist	Jim Huckabay
Writer	Dan Baldwin
Client	U.L. Coleman Companies
Agency	Focus Design Group, Inc., Shreveport, LA

694

Art Director	Mark Kent
Designer	Mark Kent
Photographer	Al Fisher
Artists	Calderwood and Preg
Writer	Brian Flood
Client	Cole-Haan
Agency	Cipriani Advertising, Inc., Boston, MA
Printer	Nimrod Press

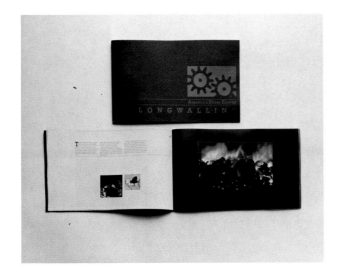

695

Art Directors	Robert A. Adam, Dennis Morabito
Designers	Robert A. Adam, Ralph Russini, Rick Madison, Dennis Moran
Client	Eickhoff Corporation/Burson Marsteller
Agency	Adam, Filippo & Moran, Inc., Pittsburgh, PA
Publication	Longwalling Brochure

696

Art Directors	James Cross, Emmett Morava
Designers	Heidi-Marie Blackwell, Cover: Ken Rang
Client	Simpson Paper Company
Agency	Cross Associates, Los Angeles, CA
Printer	Gardner/Fulmer Lithograph

697

Art Director Lowell Williams
Designers Lowell Williams, Bill Carson
Photographer Various
Writer Lee Herrick
Client Cadillac Fairview
Agency Lowell Williams Design, Inc.,
Houston, TX
Chrome Retouching Raphaele, (Raphaele, Inc.)

698

Art Director Marianne Tombaugh
Designer Michael Landon
Artist Michael Landon
Writer Lyda Workman
Client Ann D'Amico - Valley View Center
Agency The Hay Agency, Inc., Dallas, TX

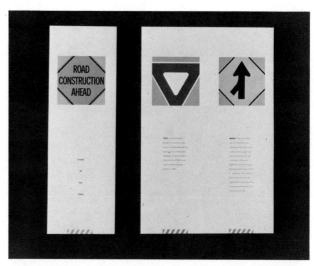

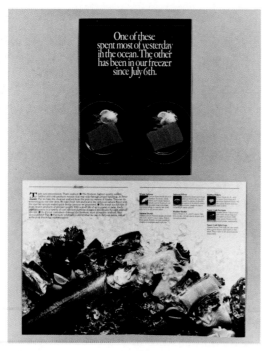

699

Art Director Peter Richards
Designer Peter Richards
Photographer Fred Milkie
Artist Scott McDougall
Writer Hugh Saffel
Client Peter Pan Seafoods
Agency Cole & Weber, Inc., Seattle, WA

700

Art Directors Diane Meier, Darcey Lund
Designers Diane Meier, Darcey Lund
Photographers Erica Lennard, Frederick L. Hamilton
Artist Fernand Khnopff
Writer Diane Meier
Client Cambridge Dry Goods
Agency Meier Advertising, New York, NY

701

Art Director	Brian Boyd
Designer	Brian Boyd
Photographer	Jim Sims
Writer	Owen Page
Client	Circle 10/Boy Scouts
Publisher	Williamson Printing Corporation
Agency	Richards Brock Miller Mitchell & Associates, Dallas, TX

702

Art Director	Bob Salpeter
Designer	Bob Salpeter
Artist	Old Prints
Client	IBM A/FE
Director	Rolf Sauer
Agency	Salpeter Paganucci, Inc., New York, NY

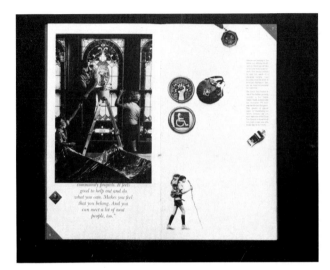

703

Art Director	James Cross
Designer	Steve Martin
Calligrapher	William Schoenberger
Client	Simpson Paper Company
Agency	Cross Associates, Los Angeles, CA
Printer	Welsh Graphics

704

Art Director	Robert Cipriani
Designer	Robert Cipriani
Photographers	Brian Newdorfer, Bill Gallery, Steve Dunwell, others
Writers	Carol Lasky, Paul Wesel
Client	Four Seasons Place
Agency	Cipriani Advertising, Inc., Boston, MA
Printer	Nimrod Press

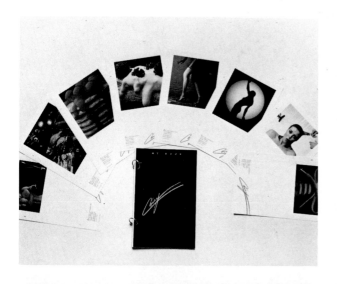

709

Art Director	George E. Turnbull
Designers	Eddie Lee, Deborah Chandler
Artist	Bruce Saunders
Writer	Dan O'Brien
Client	Scribe Data Systems
Publisher	Scribe Data Systems
Agency	Turnbull & Company, Cambridge, MA

710

Art Directors	Grace Melillo, Dale Glasser
Designer	Dale Glasser
Photographer	Robert Wagoner
Writers	Grace Melillo, Joyce Lambert
Client	Fieldcrest Mills, Inc.
Agency	Dale Glasser Graphics, New York, NY
Printer	Print Technical Group

711

Art Director	Mark Kent
Designer	Mark Kent
Photographer	Al Fisher
Artists	Calderwood and Preg
Writer	Brian Flood
Client	Cole-Haan
Agency	Cipriani Advertising, Inc., Boston, MA
Printer	Nimrod Press

712

Art Director	Loren Weeks
Designer	Loren Weeks
Photographer	Kolsky-Rose
Artist	Lukas Auto Body
Writers	Tim Leigh, Jane Glasser
Client	Comprehensive Rehabilitation Services
Agency	Bronson Leigh Weeks, Portland, OR

713

Art Director	Brian Boyd
Designer	Brian Boyd
Photographer	Jim Sims
Writer	Lee Ballard
Client	Criterion Financial Corporation
Publisher	Brodnax Printing Company
Agency	Richards Brock Miller Mitchell & Associates, Dallas, TX

714

Art Director	Claude Skelton
Designers	Gigi Gold, Robin Soltis
Photographer	Barry Holniker
Writer	David Treadwell
Client	Rosemont College
Agency	The Barton-Gillet Co., Baltimore, MD

715

Art Director	David Stahl
Photographer	Anderson Studios
Writer	John McCaig
Client	Sweet & Company
Agency	Quinlan Advertising, Indianapolis, IN

716

Art Director	Loren Weeks
Designer	Eric Spillman
Photographer	Jerry Hart
Writer	Tim Leigh
Client	Bronson Leigh Weeks
Agency	Bronson Leigh Weeks, Portland, OR

717

Art Director — Randall Hensley
Designers — Randall Hensley, Diana DeLucia, Nancy Stock Allen, Debbie Hahn
Photographers — Various
Writer — Dan Shepard
Client — Sperry Corporation
Agency — Muir Cornelius Moore, New York, NY

718

Art Director — Mark Kent
Designer — Mark Kent
Photographer — Al Fisher
Artists — Calderwood and Preg
Writer — Brian Flood
Client — Cole-Haan
Agency — Cipriani Advertising, Inc., Boston, MA
Printer — Nimrod Press

719

Art Director — Dick Mitchell
Designer — Dick Mitchell
Photographer — Gerry Kano
Writer — Mark Perkins
Client — Luedtke Aldridge Partnership
Agency — Richards Brock Miller Mitchell & Associates, Dallas, TX

720

Art Director — James Cross
Designer — Michael Mescall
Photographers — Various
Artist — Cover Illustration: Woody Pirtle
Writer — Simpson Paper Company
Client — Simpson Paper Company
Agency — Cross Associates, Los Angeles, CA
Printer — George Rice & Sons

721

Art Director	Sam Alexander
Designer	Sam Alexander
Photographers	Stefan Findel, Arni Katz, Mike Granberry, Bernard Cohen, Ross Anderson, Jim Ayres, Don DaLee, Eileen Tantillo
Writer	John Stanley
Client	National Graphics, Inc., Decatur, GA

722

Art Director	Philip Gips
Designers	Philip Gips, Christine Car
Photographer	Layman-Newman
Artists	Dung Nguyen, Gina Stone, Michelle Aranda, Christine Car
Writer	Harriett Levin
Client	Mobil Corporation
Agency	Gips + Balkind + Associates, New York, NY

723

Art Director	Jackson Boelts
Designer	Jackson Boelts
Artist	Jackson Boelts
Clients	Estes Homes, Rodger Karber
Editor	Rodger Karber
Publisher	Arizona Lithography
Agency	Bird Graphic Design, Tucson, AZ

724

Art Director	Takaaki Matsumoto
Designers	Takaaki Matsumoto, Amy Reichert
Photographer	Masao Ueda
Client	Gallery 91 N.Y.
Agency	Takaaki Matsumoto, New York, NY

725

Art Director Craig Fuller
Designer Craig Fuller
Photographer Marshall Harrington
Artist Pak Sing Chan
Writer Carolyn Dreyer
Client The Meridian Company, Ltd.
Studio Crouch + Fuller, Inc., Del Mar, CA

726

Art Directors Tetsuya Matsuura, Charles Blake
Designer Tetsuya Matsuura
Artist Tetsuya Matsuura
Writer Barry Goodman
Client NBC Sales Marketing, New York, NY

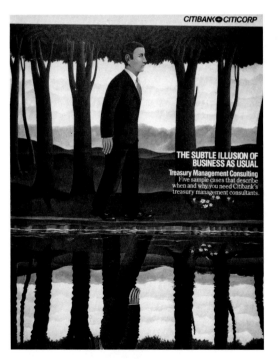

727

Art Director Amy Falk
Designer Amy Falk
Photographer Mitchel Grey
Writer Leslie Goldman
Client Joseph & Feiss—Geoffrey Beene
Agency Sacks & Rosen, New York, NY

728

Art Directors Craig Bernhardt, Janice Fudyma
Designer Jane Sobczak
Artist Richard Hess
Client Citibank/Citicorp
Agency Bernhardt Fudyma Design Group,
New York, NY

729

Art Director	Audrey Satterwhite
Client	T.J. Martell Foundation for Leukemia & Cancer Research
Agency	White Ink, Inc., New York, NY
Typography	John Pistilli

730

Art Director	Susan Adamson
Designer	Susan Adamson
Photographer	Bruno Joachim
Artist	Cheryl Roberts
Writer	Steve Romano
Client	Honeywell Information Systems
Agency	Cipriani Adertising, Inc., Boston, MA
Printer	Dynagraf Printing

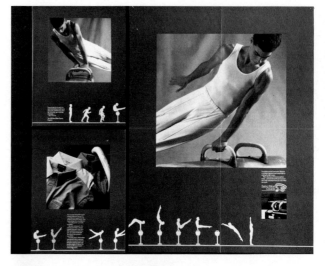

731

Art Director	Tyler Smith
Designer	Tyler Smith
Photographer	Myron
Writer	Richard Dunn
Client	Tell Tool
Studio	Tyler Smith Art Direction Inc., Providence, RI

732

Art Director	Alan Taylor
Designer	Alan Taylor
Photographer	Doug Doering
Writer	Bebra Tidwell
Client	Chakos Zentner Marcum Architects AIA
Agency	Alan Taylor Design, Dallas, TX

733

Art Director	John Van Dyke
Designer	John Van Dyke
Photographer	David Watanabe
Artist	Alice Hung
Writer	Elaine Kraft
Client	Weyerhaeuser Company
Director	John Van Dyke
Agency	Van Dyke Company, Seattle, WA

734

Art Director	Brian D. Fox
Designer	Ron Brant
Writer	Marshall Drazen
Client	Embassy Pictures, Marc Gerber
Agency	B.D. Fox & Friends Advertising, Inc., Los Angeles, CA

735

Art Director	Taylor & Browning Design Associates
Designer	Taylor & Browning Design Associates
Photographer	Pat La Croix, The Brant Group
Writer	David Parry Ltd.
Client	Kinetics, Rexdale, Ontario, Canada
Printing	Matthews Ingham & Lake Inc.

736

Art Director	Frank Young
Photographer	Andrea Blanch
Writer	Regina Ovesey
Client	Capezio by Ballet Makers, Inc.
Agency	Ovesey & Co., Inc., New York, NY
Creative Director	Regina Ovesey

737

Art Director	Vance Jonson
Designers	Vance Jonson, Scott Paramski
Photographer	Robert Reichert
Writer	Gordon C. Hamilton
Client	Texaco
Editor	Frank Dougherty
Publisher	Texaco
Agency	Jonson Pedersen Hinrichs & Shakery, Rowayton, CT

738

Art Directors	Diane Butler, Karen Abney
Designer	Karen Abney
Writer	Frances Boswell
Client	Trammell Crow Company
Agency	Diane Butler & Associates, Houston, TX

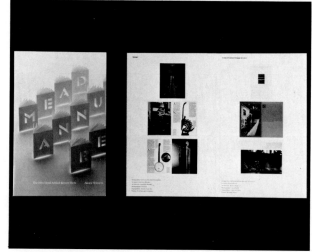

739

Art Director	Ronald R. Manzke
Designer	Barb Koehn
Photographer	Susan Wides
Writer	David Borstin
Agency	Manzke Associates, Stamford, CT

740

Art Director	Robert Cipriani
Designer	Robert Cipriani
Photographer	Clint Clemens
Writer	Janet Wright
Client	Mead Paper Corporation
Agency	Cipriani Advertising, Inc., Boston, MA
Printer	Lebanon Valley Offset

741

Art Director Jack Anderson
Designers Cliff Chung, Jack Anderson
Writer Rachel Bard
Client Sunstone Software
Agency Hornall Anderson Design Works,
Seattle, WA

742

Art Director Walter Horton
Designer Walter Horton
Photographers Various
Writer Ann Eklund Phillips
Client Moonlight Beach Development
Agency Sibley/Peteet Design, Inc., Dallas, TX

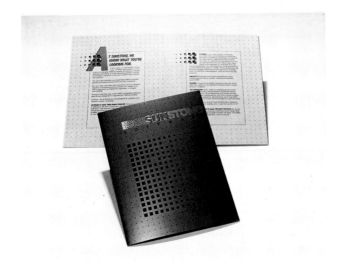

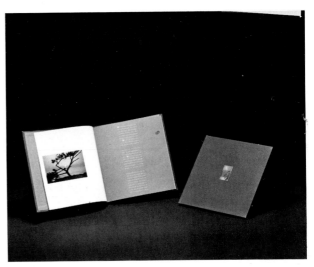

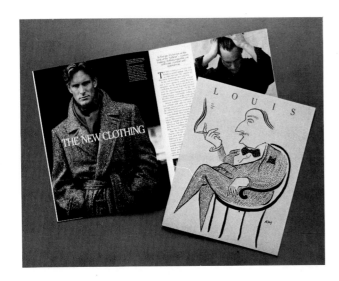

743

Art Director Tyler Smith
Designer Tyler Smith
Photographers Myron, Chris Brotherton
Artist Ken Maryanski
Writer Geoff Currier
Client Louis
Studio Tyler Smith Art Direction Inc.,
Providence, RI

744

Art Director Mark Kent
Designer Mark Kent
Photographer Al Fisher
Artist Calderwood and Preg
Writer Brian Flood
Client Cole-Haan
Agency Cipriani Advertising, Inc., Boston,
MA
Printer Nimrod Press

745

Art Director	Lois Carlo
Designer	Lois Carlo
Photographer	Lizzie Himmel
Writer	Patrice Kelly
Clients	Canon Mills (Christiane Michaels, Amy Walters, Wayne Little)
Agency	Carlo Associates, New York, NY
Printer	LaSalle

746

Art Director	James Sebastian
Designers	James Sebastian, Jim Hinchee
Photographer	Bruce Wolf
Client	Martex/West Point Pepperell
Design Studio	Designframe, Inc., New York, NY
Interior Designer	Bill Walter

747

Art Director	Don Trousdell
Designer	Don Trousdell
Artist	One Up Studio, Atlanta, GA
Writer	Rich Maender
Client	Turner Broadcasting Systems

748

Art Directors	Chris Hill, Sam Badger
Designers	Chris Hill, Joe Rattan, Mike Schneps
Photographer	Mike Schneps
Writer	Lee Herrick
Client	Fidelity Capital Corp.
Publisher	Heritage Press
Agency	Hill/A Marketing Design Group, Houston, TX

749

Art Directors	Bryan McPeak, Doreen Velmer
Designers	Bryan McPeak, Doreen Velmer
Photographers	David Wade, Warren Jagger
Writer	Ernie Schenck
Client	Shawmut Banks
Agency	Leonard Monahan Saabye, Providence, RI
Printer	United Printing
Production	Carl Swanson

750

Art Director	Tyler Smith
Designer	Tyler Smith
Photographer	Myron
Writer	Geoff Currier
Client	Louis
Studio	Tyler Smith Art Direction Inc., Providence, RI

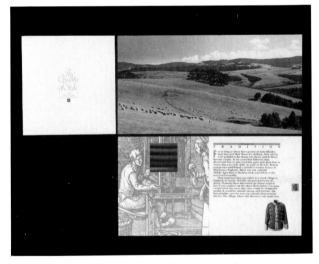

751

Art Director	Lowell Williams
Designers	Lowell Williams, Bill Carson
Photographer	Arthur Meyerson
Writer	Lee Herrick
Client	Heritage Press
Agency	Lowell Williams Design, Inc., Houston, TX

752

Art Director	Vásken Kalayjian
Designers	Vásken Kalayjian, Ted Matsuura
Photographers	Various
Writer	Jaime Laughridge
Client	Burlington Industries
Publisher	Burlington Industries
Director	Cye Jacobson
Agency	Glazer & Kalayjian, Inc., New York, NY
Publication	Quality of Style

753

Art Director Rodger Browder
Designer Rodger Browder
Photographers Hero Drent, Tim Harper
Writer Henny Abrams
Client Freddie Spencer Racing, Inc.
Printer Mid South Press, Inc.
Agency Dolph Miller & Associates, Inc.,
 Shreveport, LA
Typography O D Graphics

754

Art Director Scott Eggers
Designer Scott Eggers
Photographer Jim Sims
Writer Janet Long
Client Paragon Group
Agency Richards Brock Miller Mitchell &
 Assoc., Dallas, TX
Printer Brodnax Printing

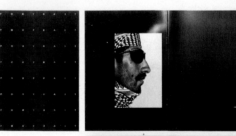

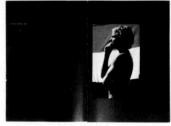

755

Art Director Francene Parco Christianson
Designer Francene Parco Christianson
Photographer Paul Kiesow
Writer JoEllen Zumberge
Client Westin Bonaventure Hotel
Agency Grey Advertising, Los Angeles, CA

756

Art Directors Chris Hill, Dan Daues
Designers Chris Hill, Joe Rattan, Dan Daues
Photographer Joe Baraban
Writer Mary Langridge
Client The Olivet Group
Publisher The Olivet Group
Agency Hill/A Marketing Design Group,
 Houston, TX

757

Art Director Tyler Smith
Designer Tyler Smith
Photographer Clint Clemens
Artist Sergio Bustamante
Writer Geoff Currier
Client Sergio Bustamante
Studio Tyler Smith, Art Direction,
 Providence, RI

758

Art Director Loren Weeks
Designer Loren Weeks
Photographer Gary Nolton
Artists John Field, Peter Cook, Lance
 Hitchings
Writers Jane Glasser, Tim Leigh
Client Logiplex
Agency Bronson Leigh Weeks, Portland, OR

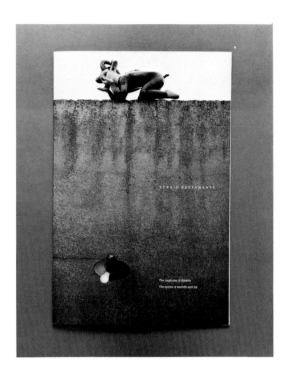

759

Art Director Jennie Pugh, IBD
Designer Ken Pugh
Artist Ken Pugh
Writer Ken Pugh
Client Yaquinto Printing
Agency Pugh and Company, Dallas, TX

760

Art Director Alan Peckolick
Designer Alan Peckolick
Client Kaufman Astoria Studios
Design Firm Pushpin Lubalin Peckolick, Inc.,
 New York, NY
Printer Intelligencer Printing
Binder Loporto Bindery
Typesetting Cardinal Type Service

761

Art Director	Woody Kay
Designers	Woody Kay, Judy Maddock
Photographer	Myron
Artist	Sarah Oliphant Backdrops
Writers	Melissa Mirarchi, Jeff Abbott
Client	Wright Line Inc.
Agency	Leonard Monahan Saabye, Providence, RI
Typography	Rand
Production	Carl Swanson

762

Art Director	Chuck Bennett
Artist	Bonnie Timmons
Writers	Gale Litt, Stan Mallis
Client	Central Bank of Denver
Agency	Evans & Bartholomew, Denver, CO

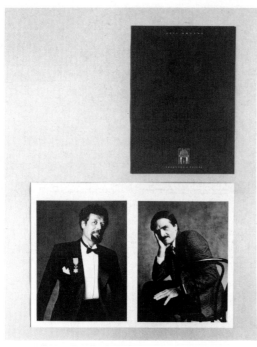

763

Art Director	Arnold Goodwin
Designer	Arnold Goodwin
Photographer	Jean Moss
Writer	Jerry Fields
Client	Bigsby + Kruthers, Gene Silverberg
Director	Gene Silverberg
Agency	Arnold Goodwin Graphic Communications, Chicago, IL

764

Art Director	Bob Paganucci
Designer	Bob Paganucci
Artist	Alex Tiani
Writer	Bill Littlefield
Client	IBM
Agency	Salpeter Paganucci, Inc., New York, NY
Project Mgr.	Rolf Sauer

765

Art Director	Jim Huckabay
Designer	Jim Huckabay
Photographers	Tim Harper, Neil Johnson, Terry Atwood
Artist	Jim Huckabay
Writer	Dan Baldwin
Client	Downtown Development Authority
Agency	Focus Design Group, Inc., Shreveport, LA

766

Art Director	John Clark
Designer	John Clark
Photographers	Chuck Baker, Eric Schweikardt, Myron
Writer	Dick Dunn
Agency	Jason Grant Associates, Providence, RI

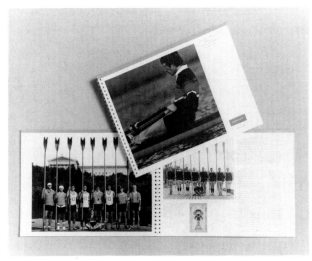

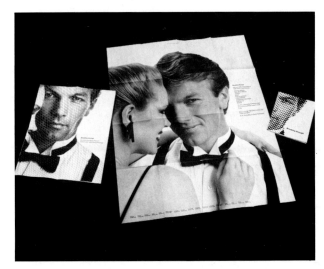

767

Art Director	Ron Hanagriff
Designer	Ron Hanagriff
Photographers	Nash Baker, Fred Carr, Damian Hevia, Tom Payne, Bryan Smothers
Writer	Phyllis Libowsky
Client	Clampitt Paper Co.
Agency	Baxter + Korge Inc., Houston, TX
Stylist	Suzanne Starr

768

Art Director	Gordon Hochhalter
Designer	Fred Bernie-Vischer
Photographer	Jerry Dunne
Writer	Gordon Hochhalter
Client	R.R Donnelley & Sons Company
Agency	R.R. Donnelley & Sons Company, Chicago, IL
Studio	O'Grady Advertising Arts

769

Art Director	John Rieben
Designer	John Rieben
Artist	Benoit B. Mandelbrot from the book "The Fractal Geometry of Nature"
Writer	Jacquelyn Lloyd
Client	Ameritech Development Corporation
Agency	Mobium Corp for Design, Chicago, IL

770

Art Director	Jim Jacobs
Designer	Danny Kamerath
Photographer	Jim Olvera
Writer	Mark Perkins
Client	Southern Methodist University
Publisher	Southern Methodist University
Agency	Jim Jacobs Studio, Dallas, TX

771

Art Director	Dick Sheaff
Designer	Dick Sheaff
Photographers	Robert Schlowsky, Walter Bibikow
Writer	Christopher Tilghman
Client	The Analytic Sciences Corporation
Editor	Dr. Arthur Gelb
Agency	Sheaff Design, Inc., Needham Heights, MA
Coordinator	Lloyd Sidney

772

Art Director	Greg Samata
Designers	Pat & Greg Samata
Photographer	Mark Joseph
Artist	George Sawa
Writers	Robert A. Bassi, Pat Stahl
Client	Chicago Board of Options Exchange
Editor	Robert A. Bassi
Printer	F.C.L. Graphics, Inc.
Director	William G. Kobos, Account Executive
Agency	Samata & Associates, West Dundee, IL

773

Art Directors	Mark Judson, Blake Miller
Designer	Blake Miller
Photographer	Jim Sims, Sims Boynton Photography
Writer	JoAnn Stone
Client	J. L. Watson
Agencies	Miller Judson and Ford, Inc., Boswell Byers and Stone, Inc., Houston, TX

774

Art Director	Bennett Robinson
Designer	Bennett Robinson
Writer	Maxwell Arnold, Simpson Paper Company
Client	Keith Anderson, Simpson Paper Company
Agency	Corporate Graphics Inc., New York, NY
Printer	Bob Pearson, Graphic Arts Center, Portland, OR

775

Art Director	John Vitro, La Jolla, CA
Photographer	Marshall Harrington
Client	Marshall Harrington Photography
Production	Tom Welch
Stylist	Pam Smith

776

Art Director	John Vitro, La Jolla, CA
Photographer	Marshall Harrington
Client	Marshall Harrington Photography
Production	Tom Welch
Stylist	Pam Smith

777

Art Directors	Harold Matossian, Takaaki Matsumoto
Designer	Takaaki Matsumoto
Photographer	Mario Carrieri, Italy
Client	Knoll International
Agency	Knoll Graphics, New York, NY
Typography	Susan Schechter

778

Art Director	Dennis Russo
Designer	Dennis Russo
Artist	Dennis Russo
Writer	Mallory Mercaldi
Client	University of Hartford
Editor	James Kurish
Publisher	University of Hartford
Director	Walter McCann
Agency	Wondriska Associates Inc., Farmington, CT
Publication	University of Hartford
Printer	Allied Printing Services Inc.

779

Art Director	Mike Parsons
Designer	Mike Parsons
Photographer	Leo Karr
Writer	Joe Helgert
Client	McGary/Skinner
Editor	Joe Helgert
Agency	Parsons Design, Scottsdale, AZ

780

Art Director	Hinsche + Associates
Designer	Hinsche + Associates
Photographer	Steve Hulen
Artist	Hinsche + Associates
Client	Clarion Corporation of America
Agency	Marsteller, Inc., Los Angeles, CA

781

Art Director	Kate Keating
Designers	Kate Keating, Lisa Nelson
Artist	Mercedes McDonald
Writer	Cynthia Schramm
Client	Pacific Gas & Electric Company
Agency	Kate Keating Associates, San Francisco, CA
Printer	James H. Barry Company

782

Art Director	Steven Wedeen
Designer	Steve Wedeen
Artist	Steven Wedeen
Writer	Lynn Villella
Client	Presbyterian Hospital
Agency	Vaughn/Wedeen Creative, Inc., Albuquerque, NM

783

Art Director	Blake Miller
Designer	Blake Miller
Photographer	Wayne Jesperson
Artist	Blake Miller
Writer	Denise Zwicker
Client	Jesperson Construction, Inc.
Agency	Miller Judson and Ford, Inc., Houston, TX

784

Art Directors	Blake Miller, Mark Judson
Designer	Blake Miller
Artists	Richard Sparks, Richard McCarley
Writers	Lee Herrick, JoAnn Stone
Client	Boswell Byers and Stone, Inc.,/ Houston Tealstone Venture
Agency	Miller Judson and Ford, Inc., Houston, TX

785

Art Director	Jonathan Kirk, Ardmore, Pa.
Designer	Jonathan Kirk
Artist	Jonathan Kirk
Writer	Jonathan Kirk

786

Art Directors	Jeff Laramore, David Jemerson Young
Designer	Jeff Laramore
Photographer	Dick Spahr
Writer	John Young
Client	Sunbeam Development Corporation
Agency	Young & Laramore, Indianapolis, IN

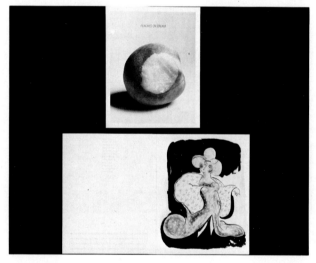

787

Art Directors	David Edelstein, Nancy Edelstein, Lanny French
Designers	David Edelstein, Nancy Edelstein, Lanny French, Norman Hathaway
Photographers	Jim Cummins, Peter Gravelle
Writer	David Edelstein
Client	Generra Sportswear
Agency	Edelstein Associates, Seattle, WA

788

Art Director	Cheryl Heller
Designer	Cheryl Heller
Photographers	Various
Artists	Various
Writer	Peter Caroline
Client	S.D. Warren Paper Co.
Agency	The Design Group, HBM/Creamer Inc., Boston, MA

789

Art Director	Lois Carlo
Designers	Lois Carlo, Hillary Mager, David T. Jones
Photographers	David Riley, Carin Riley
Writer	Patrice Kelly
Clients	Cannon Mills (Christiane Michaels, Amy Walters, Wayne Little)
Agency	Carlo Associates, New York, NY
Printer	Jack Eisen/Seybert Nicholas

790

Art Directors	Harold Matossian, Takaaki Matsumoto
Designers	Takaaki Matsumoto, Bernard Reynoso
Photographers	Mikio Sekita, Susan Wedas
Client	Knoll International
Agency	Knoll Graphics, New York, NY
Typographer	Susan Schechter

791

Art Directors	Rick Vaughn, Steven Wedeen
Designer	Rick Vaughn
Photographers	Stephen Marks, Bryan Peterson, Dick Kent
Writer	Susan Blumenthal
Client	Summit Construction, Inc.
Agency	Vaughn/Wedeen Creative, Inc., Albuquerque, NM

792

Art Directors	Susan Knox, Art Chantry
Designer	Art Chantry
Photographer	Tom Collicott
Client	Safeco Insurance Companies
Agency	Art Chantry Design, Seattle, WA
Printer	Unicraft

793

Art Director	Cheryl Heller
Designer	Cheryl Heller
Photographers	Chuck Baker, Al Fisher
Writer	Dave Wecal
Client	Stride Rite Shoe Corporation
Agency	The Design Group, HBM/Creamer Inc., Boston, MA

794

Art Director	Lois Carlo
Designer	Lois Carlo
Photographer	Beth Galton
Writer	Patrice Kelly
Clients	Cannon Mills, Christine Michaels, Amy Walters, Wayne Little
Agency	Carlo Associates, New York, NY
Printer	LaSalle

795

Art Director	Robert J. Barthelmes
Designer	Alice Kenny
Photograhers	Various
Artists	Various
Writer	Daniel D'Arezzo
Client	The Condé Nast Publications Inc.
Editors	Deirdre Oakley, Linda Kulman
Publisher	David O'Brasky
Agency	Vanity Fair, New York, NY
Publication	Vanity Fair
Production	Thomas Hefferman
Editor in Chief	Tina Brown

796

Art Director	Bruce Nichols
Designer	Bruce Nichols
Photographer	Russ Schliepman
Writer	Kenneth Putney
Client	Repligen Corporation
Studio	Gunn Associates

797

Art Director Stephen Goldstein
Designer Stephen Goldstein
Artist Mark Fisher
Writer Michael Ward & Associates
Client New Medico Associates, Inc.
Agency Good Graphics Studio, Boston, MA

798

Art Director Stavros Cosmopulos
Designer Stavros Cosmopulos
Artist Stavros Cosmopulos
Writer Stavros Cosmopulos
Client Cosmopulos, Crowley & Daly, Inc. Boston
Agency Cosmopulos, Crowley & Daly, Inc., Boston, MA
Printer Dynagraf/Boston
Typesetter Arrow Comp/Boston

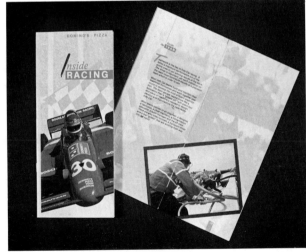

799

Art Director John Muller
Designer Mark Sackett
Writer Moore Hoch & Assoc.
Client Folly Theatre
Agencies John Muller & Co., Inc., Moore Hoch & Assoc., Kansas City, MO

800

Art Director Ernie Perich
Designer Chris Purcell
Photographer Ann DeLaVergne
Writer Mathew Thornton
Client Domino's Pizza, Inc.
Agency Group 243 Design, Inc., Ann Arbor, MI
Typography Michele Montour

801

Art Director	Barbara J. Loveland
Designer	Barbara J. Loveland
Artists	Alan Cober, Vivienne Flesher, Robert Heindel, Lonni Sue Johnson, Ed Lindlof, Masami Hirokawa, Barbara Nessim, Fred Otnes, Dagmar Frinta
Writer	Ralph Caplan
Client	Herman Miller, Inc., Zeeland, MI

802

Art Director	John Muller
Designer	John Muller
Photographers	R.C. Nible, Gary Sutton
Writer	Val Alexander
Client	K.C. Art Institute
Editor	Willem Volkersz
Agency	John Muller & Co., Inc., Kansas City, MO

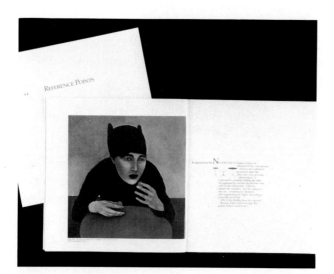

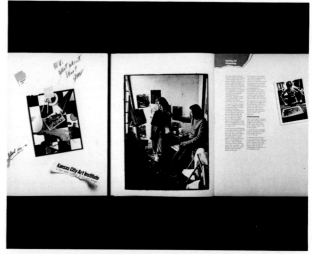

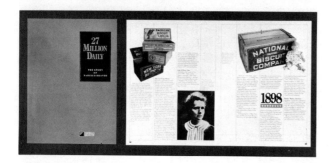

803

Art Director	Don Johnson
Designer	Bonnie Berish
Writer	Dana Lee Wood
Client	Nabisco Brands Inc.
Agency	Johnson & Simpson Graphic Designers, Newark, NJ
Publication	27 Million Daily—The Story of Nabisco Brands

804

Art Director	McRay Magleby
Designer	McRay Magleby
Photographer	John P. Snyder
Writer	Norman A. Darais
Client	Brigham Young University, President's Office
Agency	BYU Graphics, Provo, UT

805

Art Directors	Vic Cevoli, John Avery
Designer	John Avery
Photographer	Walter Bibikow
Artist	John Burgoyne
Client	Cheverie & Co.
Agency	HHCC, Boston, MA

806

Art Director	Bridget DeSocio
Photographer	Henry Wolf, New York, NY
Client	Stendig International Inc.

807

Art Directors	Martha Rowe, Dan Glidden
Designers	Dan Glidden, Rich Doty
Artist	Dan Glidden
Writer	Martha Rowe
Client	South Main Center Association
Agency	Flat Lizard Graphics, Houston, TX

808

Art Director	Woody Pirtle
Designer	Woody Pirtle
Photographers	Various
Artists	Various
Writer	Bud Arnold
Client	Simpson Paper Company
Agency	Pirtle Design, Dallas, TX
Creative Director	Woody Pirtle

809

Art Director	Lois Carlo
Designer	Lois Carlo, Hillary Mager, David T. Jones
Photographer	Raeanne Giovanni
Writer	Patrice Kelly
Clients	Cannon Mills (Christiane Michaels, Amy Walters, Wayne Little)
Agency	Carlo Associates, New York, NY
Printer	A. Colish

810

Art Director	Cheryl Heller
Designer	Cheryl Heller
Photographers	Chuck Baker, Myron
Writer	Jeff Billig
Client	Stride Rite Shoe Corporation
Agency	The Design Group, HBM/Creamer Inc., Boston, MA

811

Art Directors	David Edelstein, Nancy Edelstein, Lanny French
Designers	David Edelstein, Nancy Edelstein, Lanny French, Wilkins & Peterson
Photographer	Jim Cummins
Writers	David Edelstein, Douglas Edelstein
Client	Generra Sportswear
Agency	Edelstein Associates, Seattle, WA

812

Art Director	Ellen Ziegler
Designer	Ellen Ziegler
Illustrators	Don Baker, Art Chantry, Gary Jacobsen, Yutaka Sasaki
Writer	Debbie Tonkovitch
Client	Harbor Properties, Inc.
Agency	Ellen Ziegler/Designers, Seattle, WA

817

Art Directors	Richard Ostroff, Ted McNeil
Photographers	Robert Huntzinger, Tosh Matsumoto
Writer	Patti Goldberg
Client	Alfa Romeo
Agency	HCM, New York, NY
Creative Director	Paul Levett

818

Art Director	Cheryl Heller
Designer	Cheryl Heller
Photographers	Chuck Baker, Myron
Writer	Jeff Billig
Client	Stride Rite Shoe Corporation
Agency	The Design Group, HBM/Creamer Inc., Boston, MA

819

Art Director	James Cross
Designer	James Cross
Client	Simpson Paper Company
Agency	Cross Associates, Los Angeles, CA
Printer	Hickey & Hepler Graphics, Inc.

820

Art Directors	B. Martin Pedersen, Adrian Pulfer
Designer	Adrian Pulfer
Writer	David Konigsberg
Client	Georgia Pacific Corp.
Editor	David Konigsberg
Director	Susan Whalen
Agency	Jonson Pedersen Hinrichs & Shakery, New York, NY

821

Art Director	Carl Lehmann-Haupt, New York, NY
Designer	Ann Kwong
Client	The Bettmann Archive

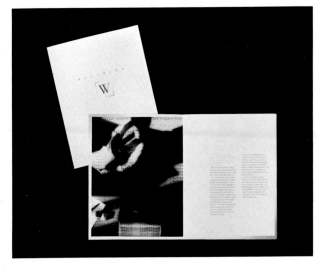

822

Art Director	Michael Mabry
Designer	Michael Mabry
Photographer	Michael Utterback
Artist	Margie Eng-Chu
Writer	Brigitte LeBlanc
Client	Wilshire Associates
Editor	Dana Dakin & Associates
Agency	Dana Dakin & Associates, Sausalito, CA
Printer	Interprint

823

Art Director	Andreé Cordella
Designer	Andreé Cordella
Photographer	Myron
Artist	Andreé Cordella
Writer	Steve Holzman
Client	Honeywell Information Systems
Editor	Honeywell
Studio	Gunn Associates, Boston, MA
Printer	Nimrod Press, Boston, MA

824

Designer	Ann Marra
Photographer	Edward Gowans
Artists	Alana Dills, Ann Marra
Writer	Joann Lunt
Client	Boise Cascade Paper Group
Agency	Young & Roehr Advertising, Inc., Portland, OR
Printer	Schultz, Wack, Weir

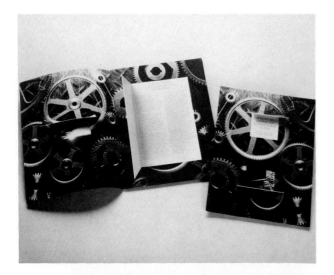

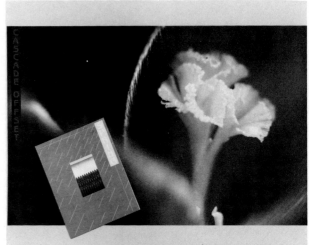

825

Art Directors	B. Martin Pedersen, Adrian Pulfer
Designer	Adrian Pulfer
Writer	David Konigsberg
Client	Georgia Pacific
Editor	David Konigsberg
Director	Susan Whalen
Agency	Jonson Pedersen Hinrichs & Shakery, New York, NY

826

Art Director	Georgia Deaver
Designer	Georgia Deaver
Client	Georgia Deaver—self promotion
Design Firm	Georgia Deaver Calligraphy, San Francisco, CA
Calligrapher	Georgia Deaver

827

Art Director	Georgia Deaver
Designer	Georgia Deaver
Client	Georgia Deaver—self promotion
Design Firm	Georgia Deaver Calligraphy, San Francisco, CA
Calligrapher	Georgia Deaver

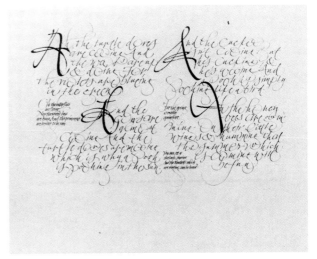

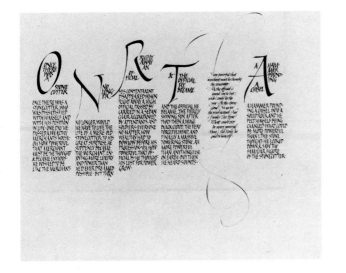

828

Art Director	Georgia Deaver
Designer	Georgia Deaver
Client	Georgia Deaver
Design Firm	Georgia Deaver Calligraphy, San Francisco, CA
Calligrapher	Georgia Deaver

Art Director	Mike Guillory
Designer	Mike Guillory
Photographer	Bryan Smothers/The Image Bank
Artists	Bob Lapsley, Mike Guillory
Writer	Greg Bolton
Client	Riverside Press
Agency	Graphic Designer's Group, Houston, TX

Silver Award

Art Director	Rex Peteet
Designer	Rex Peteet
Artist	Rex Peteet
Writers	Ann Eklund Phillips, Rex Peteet
Client	The Herring Group/Alexandria Mall
Agency	Sibley/Peteet Design, Inc., Dallas, TX

831

Silver Award

Art Director	Kiyoshi Kanai
Designer	Kiyoshi Kanai
Photographer	Oberto Gili
Writer	Patrice Kelly
Client	Cannon Mills
Publisher	Cannon Mills
Director	Christiane Michaels
Agency	Kiyoshi Kanai, Inc., New York, NY

Distinctive Merit

Art Director	William Paullin
Designer	Don Trousdell
Photographer	Michael Granberry
Writer	Ceil Mattingly
Client	Coca-Cola USA, Dick Dana
Publisher	Litho-Krome
Agency	Selling Solutions, Inc., Atlanta, GA
Finishing	Herb Haralson

833

Art Director	Notovitz & Perrault Design, Inc.
Designer	Notovitz & Perrault Design, Inc.
Photographers	Jay Brenner, Joe Marvullo
Artist	Tony DiSpigna
Writer	Rick Young
Client	United States Banknote Corporation
Agency	Notovitz & Perrault Design, New York, NY
Publication	Portfolio of Security and Craftsmanship

834

Art Director	Kevin B. Kuester
Designer	Madsen and Kuester, Inc., Minneapolis, MN
Photographer	Arthur Meyerson
Client	The Griffin Companies

835

Art Director	Joseph Weidert
Designer	Joseph Weidert
Photographer	John Lewis
Artist	Jeff Hargreaves
Writer	Joseph Weidert
Client	Fox River Paper Company
Agency	Weidert Grapentin Advertising Inc., Appleton, WI

836

Art Director	Rex Peteet
Designers	Rex Peteet, Walter Horton
Artists	Walter Horton, Rex Peteet
Writer	Rex Peteet
Client	International Paper Co.
Agency	Sibley/Peteet Design, Inc., Dallas, TX

837

Art Director	Bridget DeSocio
Designer	Bridget DeSocio
Photographer	Bill White
Writer	Judith Nasatir
Client	Stendig International, Inc., New York, NY
Editor	Elaine Caldwell
Typographer	Nassau Type
Printer	Sterling Roman Press
Production	Julie Bernatz

838

Art Director	Taylor & Browning Design Associates
Designer	Taylor & Browning Design Associates
Photographer	Pat La Croix, The Brant Group
Writer	David Parry Ltd.
Client	Kinetics, Rexdale, Ontario, Canada
Printing	Matthews Ingham & Lake Inc.

839

Art Director	Amy Fread
Designer	Nancy Merish
Artist	Dennis Ziemienski
Writer	Paul Smolarcik
Client	Incentive World
Publisher	Al Luthy/Ziff-Davis Publishing Company, New York, NY
Director	Martin Broder
Agency	In-house Promotion Department/ Business Publications Division

840

Art Directors	David November, Marie-Christine Lawrence
Designers	D. November, M.C. Lawrence, Edith Scudellari, Wan Pak
Artist	Edith Scudellari
Client	CBS Entertainment Division Press Information
Agency	CBS Entertainment, New York, NY
Lettering	Wan Pak

841

Art Director	Amy Fread
Designer	Francesca Pardo
Photographers	David Spindel, Various
Writer	Paul Smolarcik
Client	Photo/Design
Editor	Michael O'Conner
Publisher	Jerry Landress, Ziff-Davis Publishing Company
Director	Martin Broder
Agency	Ziff-Davis BPD Promotional Department, New York, NY
Creative Director	Steven Weininger

842

Art Director	Homans/Salsgiver
Writer	Mill Roseman
Client	Paper Sources, International
Agency	Homans/Salsgiver, New York, NY
Publication	Fred Weidener and Sons

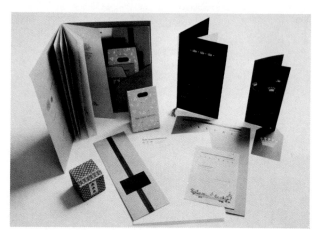

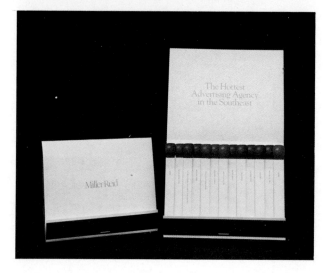

843

Art Director	Mark Wood
Designer	Jim Aplin
Photographer	Bill Parsons
Artist	Jeff Cole
Writer	Lance Porter
Client	Miller-Reid, Inc.
Agency	Miller-Reid, Chattanooga, TN

844

Art Director	Jim Jacobs
Designer	Danny Kamerath
Photographer	Kent Kirkley
Client	R. Jones & Associates
Agency	Jim Jacobs Studio, Dallas, TX

845

Art Director	Stephen J. Pena
Designer	Stephen J. Pena
Artist	Stephen J. Pena
Client	The Boston Globe
Publisher	The Boston Globe
Agency	The Boston Globe, Boston, MA
Printer	Chadis Printing

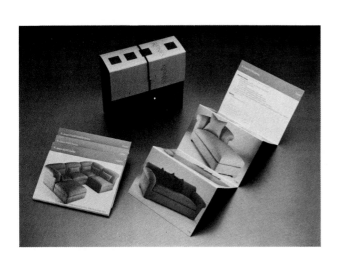

846

Art Directors	Christine Owens, Janet Picchi-Fogg
Designers	Janet Picchi-Fogg, Christine Owens
Artist	Gretchen Shields
Writers	Fred Morfit, Susan Lutter
Client	Diablo Systems
Agency	Owens/Lutter, Santa Clara, CA

Gold Award

Art Director	Chris Hill
Designers	Chris Hill, Jeff McKay, Mary Langridge
Writer	Mary Langridge
Client	Art Directors Club of Houston
Publisher	Printing Resources
Agency	Hill/A Marketing Design Group, Houston, TX

849

Silver Award

Art Directors Harold Matossian, Takaaki
Matsumoto
Designers Leslie Ladds, Takaaki, Matsumoto
Photographer Mikio Sekita
Client Knoll International
Agency Knoll Graphics, New York, NY
Typography Susan Schechter

Distinctive Merit

Art Director	Frank Schulwolf
Artists	Frank Schulwolf, Bill James, Ted Lodigensky, Daniel Schwartz, Robert Altemus, Arthur Low
Client	Aviation Sales Company, Inc., A division of Ryder System
Agency	Susan Gilbert & Company, Inc., Coral Gables, FL

851

Art Director Tom Smith
Designer Tom Smith
Artists Ramiro Salazar, Rasic Art
Writer Joan Kriikku
Client Leaseway Transportation
Agency Wyse Advertising, Cleveland, OH

852

Art Director Danny Boone
Designer Danny Boone
Writer Barbara Ford
Client Barnett Banks of Florida
Agency The Martin Agency, Richmond, VA
Creative Director Harry Jacobs

853

Art Director Jennie Pugh, IBD
Designers Ken Pugh, Jennie Pugh, IBD
Artist Ken Pugh
Writers Liz Oliphant, Ken Pugh
Client Adam Whitney Interior Plants
Agency Pugh and Company, Dallas, TX
Printer Yaquinto Printing

854

Art Directors Ron Miriello, Kimball/Nanessence
Designer Ron Miriello
Photographer Kimball/Nanessence
Client ASMP, San Diego, CA
Publisher Gardner-Fulmer Lithography

855

Art Directors	Terry Lesniewicz, Al Navarre
Designers	Terry Lesniewicz, Al Navarre
Photographer	Bob Williams/Owens-Corning Photographic Services
Writer	Lesniewicz/Navarre
Client	Owens-Corning Fiberglas Corporation/Residential Commercial Insulation Division
Agency	Lesniewicz/Navarre, Toledo, OH

856

Art Director	Mark Fristad
Designer	Ann Marra
Writers	George Taylor, Todd Duvall
Client	Rono Graphic Communications Co.
Agency	Turtledove Clemens, Inc., Portland, OR

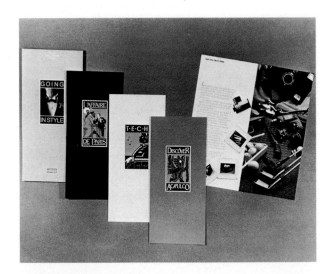

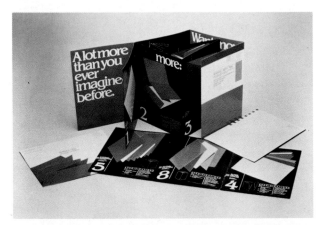

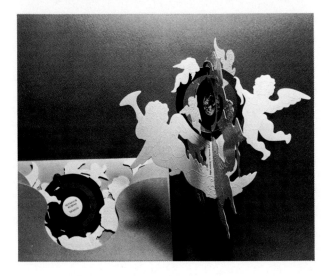

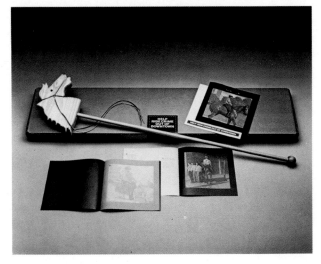

857

Art Director	Seymour Robins, Sheffield, MA
Designer	Seymour Robins
Artists	Seymour Robins, Karole Svingala
Client	Seymour Robins
Printer	Pond-Ekberg Co.

858

Art Director	Mark Sloneker
Designer	Mark Sloneker
Illustrator	John Collier
Woodcraftsman	Pat Dawson
Writer	Lisa Turner
Client	Central Houston Inc./Houston Mounted Police
Agency	Bozell & Jacobs/Houston, Houston, TX
Creative Director	Ron Spataro

859

Art Director Mona Fitzgerald
Designer Mona Fitzgerald
Photographer Craig Stewart
Artist Mona Fitzgerald
Writer Mary Langridge
Client The Shade Shop
Agency Goswick & Associates, Houston, TX

860

Art Director Jann Church
Designer Jann Church
Client Koll Company
Agency Jann Church Partners, Marketing &
Graphic Design, Inc. Newport
Beach, CA

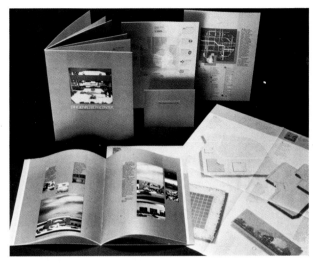

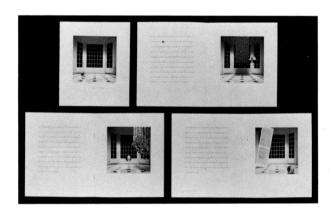

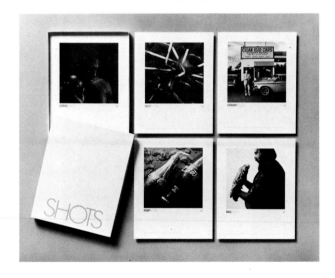

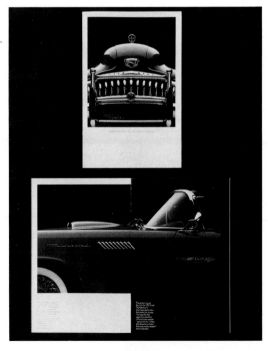

861

Art Director John Vitro, La Jolla, CA
Photographer Marshall Harrington
Client Marshall Harrington Photography
Production Tom Welch
Stylist Pam Smith

862

Art Director Cheryl Heller
Designer Cheryl Heller
Photographer Clint Clemens
Writer Peter Caroline
Client S.D. Warren Paper Co.
Agency The Design Group, HBM/Creamer
Inc., Boston, MA

863

Art Directors	Paula Savage, Julia Pepper
Designers	Julia Pepper, Paula Savage
Writers	Steve Barnhill & Company, Inc., Paula Savage
Client	Savage Design Group, Inc.
Agency	Savage Design Group, Inc., Houston, TX

864

Art Director	Robert Cipriani
Designer	Robert Cipriani
Photographer	Clint Clemens
Writer	Janet Wright
Client	Mead Paper Corporation
Agency	Cipriani Advertising, Inc., Boston, MA
Printer	Lebanon Valley Offset

865

Art Director	Kerry Walsh
Designer	Kerry Walsh
Writer	Linda Lambert
Client	Operation Aware of Oklahoma, Inc.
Agency	Phillips Knight Walsh, Inc., Tulsa, OK

866

Art Director	Graphis One
Designer	Mark Tweed
Artist	Barry Zaid
Writer	Lisa McMath
Client	Colorado School of Mines
Agency	Graphis One Inc., Boulder, CO
Printer	March Press

867

Art Director Julia Pepper
Designer Julia Pepper
Artist Regan Dunnick
Writer Rebecca Parker
Client Clampitt Paper Company
Agency Savage Design Group, Inc., Houston, TX

868

Art Director Michael Mabry
Designers Michael Mabry, Margie Eng-Chu
Artist Georgia Deaver
Writers Judy Rapp Smith, Wayne Rood
Client Pacific School of Religion
Editor Judy Rapp Smith
Publisher Pacific School of Religion, Berkeley, CA

869

Art Director John Vitro, La Jolla, CA
Photographer Marshall Harrington
Client Commercial Press
Production Tom Welch

870

Art Director Tom Roth
Designer Gina Federico
Artist Gina Federico
Writers Steve Trygg, Maryann Stein
Client Landon Associates
Agency Anderson & Lembke, Stamford, CT

871

Art Director Martha Dillon
Designer Martha Dillon
Client School of Architecture
Agency University of Texas at Austin, Office
of Publications, Austin, TX

872

Art Director Frank Metz
Designer Robert Anthony
Photographer Anthony Loew
Client American Institute of Graphic Arts
Agency Robert Anthony, Inc., New York, NY

873

Art Director Woody Pirtle
Designer Woody Pirtle
Photographers various
Artists various
Writer Bud Arnold
Client Simpson Paper Company
Agency Pirtle Design, Dallas, TX
Creative Director Woody Pirtle

874
Art Director Frank Schulwolf
Artists Ted Lodigensky, Cheryl Nathan, Bill James
Writer Arthur Low
Client Aviation Sales Company, Inc., A division of Ryder System
Agency Susan Gilbert & Company, Inc., Coral Gables, FL

875
Art Directors Chris Hill, Jeff McKay
Designers Chris Hill, Jeff McKay, Regan Dunnick, Catherine Hennes
Artist Regan Dunnick
Client Cal Poly University
Publisher Printing Resources
Agency Hill/A Marketing Design Group, Houston, TX

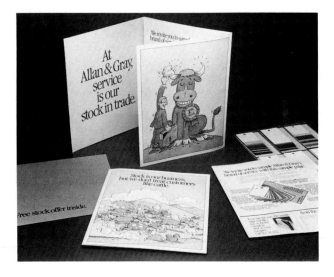

876
Art Director Tina Cohoe
Artist Elwood Smith
Writer Leila Vuorenmaa
Client Allan & Gray Corporation
Agency O & M Direct, New York, NY

877
Art Director Woody Kay
Designer Woody Kay
Writer Tom Monahan
Client Wright Line Inc.
Agency Leonard Monahan Saabye, Providence, RI
Production Carl Swanson

878

Art Directors Paul Huber, C. Randall Sherman
Designer Paul Huber
Writer Paul Huber
Client Brandt & Lawson, Inc.
Agency Loucks Atelier, Inc., Houston, TX

879

Art Director Frank Schulwolf
Artists Ted Lodigensky, Bill James, Kimberly Smith
Writer Arthur Low
Client Aviation Sales Company, Inc., A division of Ryder System
Agency Susan Gilbert & Company, Inc., Coral Gables, FL

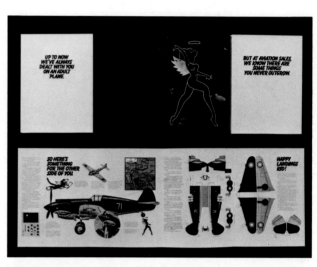

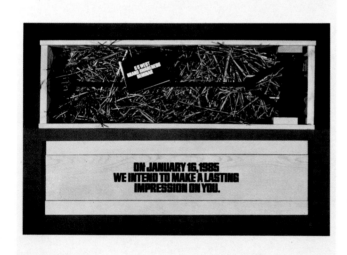

880

Art Director Pat Burnham
Writer Bill Miller
Client US West
Agency Fallon McElligott Rice, Minneapolis, MN

881

Art Director Bob Dennard
Designer Pam Wendland
Writer Bob Dennard
Client The Herring Group
Agency Dennard Creative, Inc., Dallas, TX

882

Art Director David Withers
Writer Greg Engel
Client Farley's Industrial Laundry
Agency Engel and Tirak Advertising and
Public Relations, Erie, PA

884

Art Director Carol Friedman
Designer Carin Goldberg
Artist Carol Friedman
Agency Elektra Records, New York, NY
Producer Lenny Kaye

885

Art Director John Berg
Photographer Gilles Larrain
Client CBS, Inc., New York, NY

886

Art Director Audrey Satterwhite
Designer Audrey Satterwhite
Photographer Patrice Casanova
Client David Sonenberg
Agency White Ink, Inc., New York, NY
Makeup/Body Design Helene Guetary

887

Art Directors Tony Lane, Nancy Donald
Photographer Dennis Keeley
Client CBS, Inc., Century City, CA

888

Art Directors Mariko Iida, Kazuhide Yamazaki
Designer Mariko Iida
Artist Kazuhide Yamazaki
Client Wackie's House of Music
Agency Mariko Iida/Design, New York, NY

889

Art Director Robert Forsbach
Designer Diana McKnight
Artist Robert Forsbach
Writer Ron Chapman
Client KVIL Radio
Agency Richards, Brock, Miller, Mitchell &
Associates, Dallas, TX

890

Art Director Bill Johnson
Designers Bill Johnson, Leslie Cabarga, Virginia
 Team
Artist Leslie Cabarga
Client CBS Records
Agency CBS Records, Nashville, TN

891

Art Director Carol Friedman
Designer Carin Goldberg
Artist Romare Bearden
Agency Elektra Records, New York, NY
Producer Lenny Kaye

892

Art Director Josephine DiDonato
Client CBS, Inc., New York, NY

Silver Award

Art Director	Cal Anderson
Designer	Cal Anderson
Client	Le Champ Cellars
Design Field	Georgia Deaver Calligraphy, San Francisco, CA
Calligrapher	Georgia Deaver

Silver Award

Art Directors	Hal Riney, Jerry Andelin
Designer	Primo Angeli
Artist	Mark Jones
Client	Blitz-Weinhard Brewing Co.
Agency	Primo Angeli Graphics, San Francisco, CA
Illustrator	Ray Honda

Distinctive Merit

Art Directors	John C. Jay, David Au
Designers	Tim Girvin, David Au, John C. Jay
Artist	Tim Girvin
Client	Bloomingdale's, New York, NY
Creative Director	John C. Jay

900

Art Director Thom Marchionna
Designer Thom Marchionna
Artist Thom Marchionna
Client Marc Software International
Agency Carter Callahan, Inc., San Jose, CA

901

Art Director Warren Kass
Designer Warren Kass
Artists Warren Kass, Judy Scheck
Client Ken Bray, Enzo Marino
Agency Kass Communications, New York, NY

902

Art Director Jack Anderson
Designers Raymond Terada, Jack Anderson
Client CDI
Agency Hornall Anderson Design Works, Seattle, WA

903

Art Director Kathleen Campbell
Lettering Chuck Schmidt
Writer Alex Martin
Client Vitex Foods, Inc.
Director Ken Mann
Agency Tom Campbell Design Associates, Inc., Los Angeles, CA

904

Art Director P. Scott Makela
Designers Debra Borowski, Michael Olson
Artists P. Scott Makela, Michael Olson
Client Intuitive Music
Agency Makela Design Works, Minneapolis, MN

905

Art Director Ken DeLor
Designer Ken DeLor
Photographer Michael Brohm
Client Princeton Industries
Agency Signature, Inc., Louisville, KY

906

Designer Chiu Li
Artist Chiu Li, New York, NY
Client Bloomingdale's/Gund, Inc.

907

Art Directors Doug Johnson, Anne Leigh
Designers Doug Johnson, Anne Leigh
Client American Natural Beverage
Design Studio Performing Dogs, New York, NY

908
Art Director Tim Girvin
Designer Tim Girvin
Artist Anton Kimball
Client Bright Blocks
Agency Tim Girvin Design, Inc., Seattle, WA

909
Art Directors Millie Falcaro, Mary Tiegreen
Designer Mary Tiegreen
Client Neiman-Marcus
Agency Falcaro & Tiegreen Ltd., New York, NY

910
Art Director Dennis Gagarin
Designer Dennis Gagarin
Artist Michael Schwab
Writers Jim Stephens, Paula Polley
Client Racal-Vadic
Agency Tycer-Fultz-Bellack, Palo Alto, CA
Packaging Peterson & Strong

911
Art Director Tris Johnson, Peter Kramer
Designer Tris Johnson
Photographers John Still, David Bradshaw
Writers Peter Kramer, Ray Welch
Client Zoom Telephonics, Inc., Boston, MA

912

Art Director Hamid Nowroozi
Designer Karin A. Fickett
Artist David Hannum
Client Wang Laboratories, Inc., Lowell, MA

913

Art Director David Strong
Designers David Strong, Susan Giordano
Artist Rick Gill
Writers Jerald Bookwalter, Helene Smart
Client Bookwalter Winery
Agency David Strong Design Group, Seattle, WA
Printer Heath Northwest

914

Art Director Donna J. Edson
Designer Donna J. Edson
Writer Jon Simpson
Client The Herb Shop
Agency Godfrey Advertising, Inc., Lancaster, PA

915

Art Director Rich Silverstein
Designer Rich Silverstein
Photographer Dennis Gray
Artist Milton Glaser
Writers Andy Berlin, Jeff Goodby
Client Electronic Arts
Agency Goodby, Berlin & Silverstein, San Francisco, CA

916

Art Director	Cheryl Fujii
Designer	Anton C. Kimball
Artist	Anton C. Kimball
Client	Nordstrom
Agency	Nordstrom Advertising, Seattle, WA

917

Art Director	Jim Tesso
Designers	Jim Tesso, Jim Drake
Writers	Don Perdue, Fred Thomas, Irv Kaplan
Client	WBD, INC.
Agency	Saifman, Richards & Associates, Beachwood, OH

918

Art Directors	Nicolas Sidjakov, Jerry Berman
Designer	James Nevins
Photographer	George Brown
Writer	Paul Cuneo
Client	Activision, Inc.
Design Firm	Sidjakov Berman & Gomez, San Francisco, CA

919

Art Director	Kazumasa Nagai
Designer	Kazumasa Nagai
Artist	Kazumasa Nagai
Client	Bloomingdale's
Agency	Kazumasa Nagai, Tokyo, Japan
Creative Director	John C. Jay

920

Art Director	Tibor Kalman
Designer	Tibor Kalman
Client	M&Co.
Agency	M&Co., New York, NY

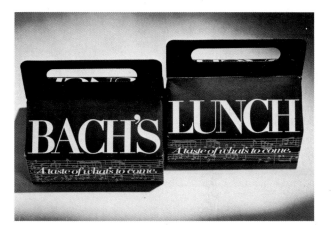

921

Art Directors	Raymond Lee, Peter Baker
Designer	Raymond Lee
Artist	J.S. Bach
Writers	Graziano Palumbo, Jane Forner
Client	CentreStage Music
Agency	Raymond Lee & Associates, Toronto, Canada

Art Director Steve Erenberg
Designer Steve Erenberg
Photographer Stephen Stuart
Client Herlin Press Inc.
Agency Pace Advertising Agency, New York, NY

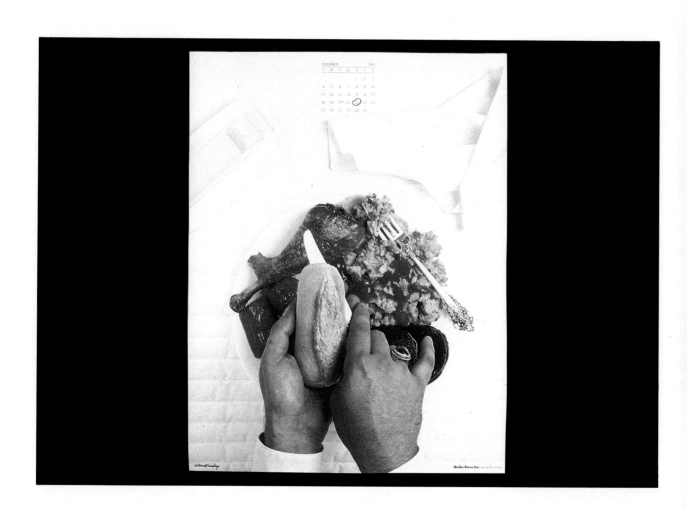

Silver Award

Art Director	Tamotsu Yagi
Designer	Tamotsu Yagi
Photographer	Oliviero Toscani
Writer	Beth LaDove
Client	Esprit De Corp.
Publisher	Esprit De Corp.
Director/Editor	Douglas R. Tompkins
Agency	Esprit Graphic Design Studio, San Francisco, CA
Research	Emiko Kaji, Christine Altieri
Print Production Manager	Hilary Mosberg
Printer	Pacific Litho

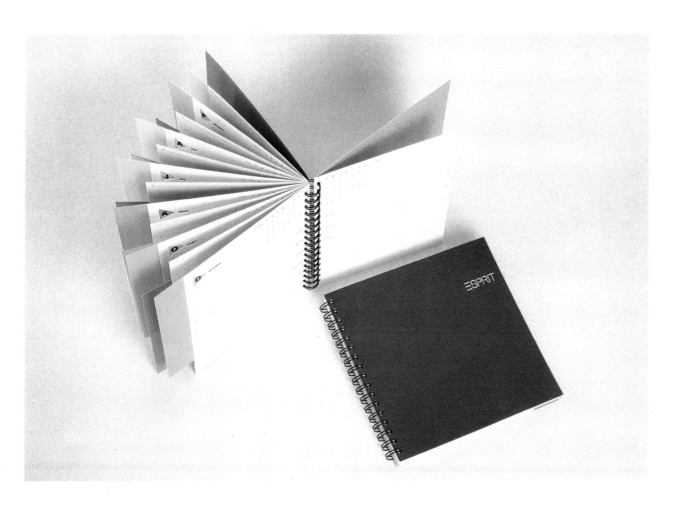

924

Silver Award

Art Directors	Pat Burnham, Glen Smith
Designer	Glen Smith
Photographer	William Albert Allard
Writer	Bill Miller
Client	US West
Agency	Fallon McElligott Rice, Minneapolis, MN

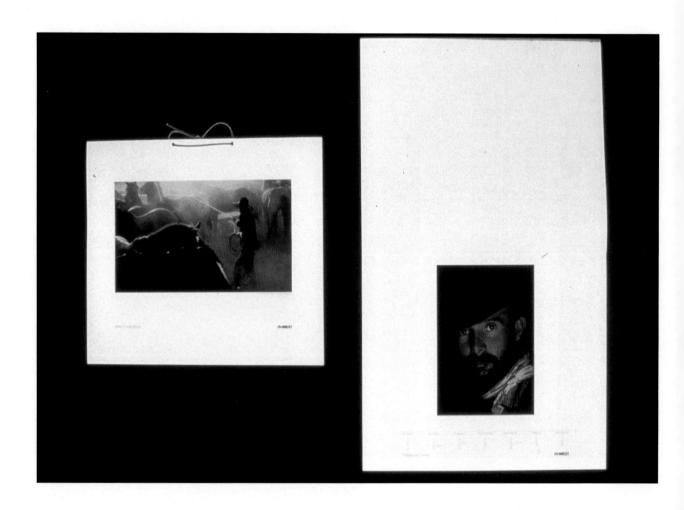

Distinctive Merit

Art Director	Minoru Morita
Designer	Minoru Morita
Photographers	Kyunghun Koh, Dale Whyte
Client	Creative Center Inc.
Agency	Creative Center Inc., New York, NY

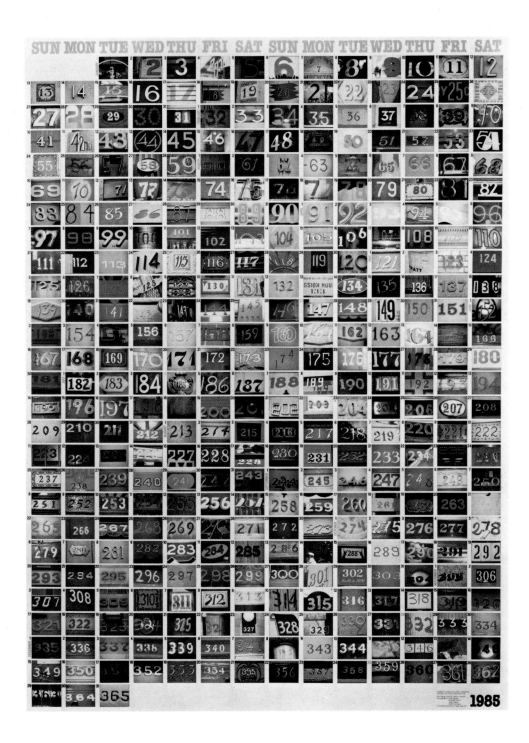

Art Director Michael Mabry
Designers Michael Mabry, Noreen Fukumori
Photographers various
Client Overseas Printing
Publisher Hal Belmont, Graphics Etc.
Agency Michael Mabry Design, San
 Francisco, CA
Typography Petrographics Typeworld

927

Art Director	James Cross
Designer	Steve Martin
Photographer	Lonnie Duka
Writer	Jan Lansing
Client	Fluor Corporation
Agency	Cross Associates, Los Angeles, CA
Printer	Gardner/Fulmer Lithograph

928

Art Director	Vance Jonson
Designers	Vance Jonson, Kim Capone
Photographer	Ross Elmi
Artist	Vance Jonson
Writer	Vance Jonson
Client	Baronet Litho
Agency	Jonson Pedersen Hinrichs & Shakery, Rowayton, CT

929

Art Directors	Al Gluth, John Weaver
Designer	Al Gluth
Photographer	Bob Werre
Client	Grover Printing
Agency	Gluth Weaver Design, Houston, TX

930

Art Director	Mike Guillory
Designer	Mike Guillory
Photographer	Bryan Smothers, The Image Bank
Artists	Bob Lapsley, Mike Guillory
Writer	Greg Bolton
Client	Riverside Press
Agency	Graphic Designer's Group, Houston, TX

931

Art Director	Bud Linschoten
Designer	Bud Linschoten
Artists	Carol M. Hasegawa, Grant Kagimoto
Writer	Pamela Wilk
Client	Cane Haul Road, Ltd.
Publisher	Cane Haul Road, Ltd.
Agency	Linschoten & Associates, Inc., Honolulu, HI
Printer	American Printing Company

932

Art Director	Marilyn Rose, Weehawken, NJ
Designer	Marilyn Rose
Writer	Margaret Wagner
Client	Library of Congress Publishing Office, Dana Pratt, Director
Editor	Maureen McNeil
Publisher	GMG Publishing
Director	Gerald Galison

933

Art Director	Woody Pirtle
Designers	Woody Pirtle, Kenny Garrison
Photographers	Various
Artists	Various
Writer	Woody Pirtle
Client	Pirtle Design
Agency	Pirtle Design, Dallas, TX
Creative Director	Woody Pirtle

934

Art Directors	Roger Cook, Don Shanosky
Designers	Roger Cook, Don Shanosky
Photographers	Melchior DiGiamcomo, L.A.-Prosports
Client	Self-Promotion
Agency	Cook & Shanosky Assoc., Inc., Princeton, NJ
Printer	S.D. Scott Printing, Co., Inc.

935

Art Director	Michael Mabry
Designers	Michael Mabry, Margie Eng-Chu
Photographers	Various
Client	Overseas Printing
Publisher	Hal Belmont, Graphics Etc.
Agency	Michael Mabry Design, San Francisco, CA
Typography	Petrographics Typeworld

936

Art Director	Harris Lewine
Designer	Paul Gamarello
Writer	Harris Lewine
Client	Mercedes-Benz of North America/ National Multiple Sclerosis Society
Editor	Leo Levine
Agency	Eyetooth Design Inc., New York, NY
Printer	The Chaucer Press

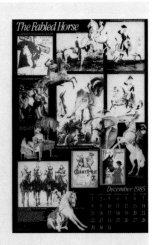

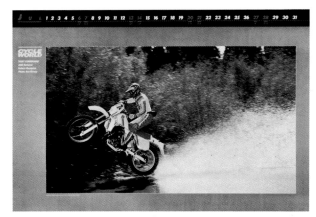

937

Art Director	Marilyn Rose, Weehawken, NJ
Designer	Marilyn Rose
Artist	Simms Taback
Writer	Smithsonian Family Learning Project—John Falk, Director
Publisher	GMG Publishing
Director	Gerald Galison

938

Art Director	Paul W. Zeek
Designer	William Fletcher
Photographers	Ron Hussey, Rich Chenet, Michael Pons, George Olson
Writer	Ron Hussey
Client	Cycle World Magazine, a unit of CBS, Inc.
Publisher	Jim Hassen, CBS, Inc.
Director	Paul W. Zeek
Agency	Zeek Design & Associates, San Juan Capistrano, CA
Publication	Cycle World Magazine

939

Designer Malcolm Waddell
Photographer Yuri Dojc
Publishers Yuri Dojc, Eskind Waddell, Cooper &
 Beatty, Ltd., Empress Litho Plate
 Ltd., Arthurs-Jones Lithographing
 Ltd.
Agency Eskind Waddell, Toronto, Canada

940

Art Director Kit Hinrichs
Designers Kit Hinrichs, Pam Shaver
Photographers Terry Heffernan, Light Language
Client American President Lines
Agency Jonson Pedersen Hinrichs &
 Shakery, San Francisco, CA

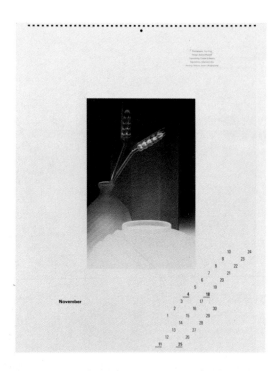

941

Art Director Scott A. Mednick
Designers Scott A. Mednick, Lisa Pogue
Artist Bryan Honkawa
Client Gore Graphics
Publisher Gore Graphics
Agency Douglas Boyd Design, Los Angeles,
 CA

942

Art Director Jack Anderson
Designers Greg Walters, Jack Anderson
Photographer Jim Laser
Client Callison Partnership
Agency Hornall Anderson Design Works,
 Seattle, WA

Art Director Rex Peteet
Designer Rex Peteet
Artists Jerry Jeanmard, Rex Peteet, Don Sibley, Ken Shafer
Client Good Earth Restaurants
Agency Sibley, Peteet Design, Inc., Dallas, TX

945

Silver Award

Art Director	Gordon Hochhalter
Designer	Bob Meyer
Artist	Bob Meyer
Writer	Gordon Hochhalter
Client	R.R. Donnelley & Sons Company
Agency	R.R. Donnelley & Sons Company, Chicago, IL
Studio	O'Grady Advertising Arts

946
Distinctive Merit

Art Director Susan J. Kovatch
Designer Susan J. Kovatch
Artist Susan J. Kovatch
Writer Susan J. Kovatch
Client Susan J. Kovatch
Agency DesignMark Inc., Indianapolis, IN

Distinctive Merit

Art Director	Don Sibley
Designer	Don Sibley
Artists	Jerry Jeanmard, Don Sibley
Writer	Mary Sumners
Client	Neiman-Marcus
Agency	Sibley/Peteet Design, Inc., Dallas, TX

948

Art Director Bruce Hirshfield
Writer Bruce Hirshfield
Client The Advertizing Agency
Agency The Advertizing Agency, Charlotte, NC

949

Art Director Woody Pirtle
Designer Kenny Garrison
Artist Kenny Garrison
Client Shepherd & Boyd
Agency Pirtle Design, Dallas, TX
Creative Director Woody Pirtle

950

Art Director James A. Stygar
Designer James A. Stygar
Writer Penelope H. Stygar
Client Advertising Club of Richmond
Agency Folio2, Inc., Richmond, VA

951

Art Director Don Kubly
Designers Il Chung and Dan Ashcraft
Writer Richard Edler
Clients Art Center College of Design and Doyle Dane Bernbach, Pasadena, CA

952

Art Director	Chris Hill
Designers	Chris Hill, Joe Rattan
Client	The Art Directors Club of New York
Publisher	Heritage Press
Agency	Hill, A Marketing Design Group, Houston, TX

953

Art Directors	Ken White, Lisa Pogue
Designer	Sylvia Zimmerman
Artist	Sylvia Zimmerman
Writer	Michelle Martino
Client	White + Associates
Agency	White + Associates, Los Angeles, CA

954

Art Director	Agnew Moyer Smith Inc.
Designer	Norm Goldberg
Client	Agnew Moyer Smith Inc.
Agency	Agnew Moyer Smith Inc., Pittsburgh, PA

955

Art Directors	Bob Dennard, Vikki Foster
Designer	Vikki Foster
Artist	Vikki Foster
Client	Yaquinto Printing
Agency	Dennard Creative, Inc., Dallas, TX

956

Art Director	George Chadwick
Designer	George Chadwick
Artist	Kim Vogel
Writer	Jim Stephens
Client	In-house
Agency	Tycer-Fultz-Bellack, Palo Alto, CA
Typographer	Brekas Type & Graphics
Printer	Graphic Center

957

Art Director	Steven Wedeen
Designer	Steven Wedeen
Artist	Steven Wedeen
Writers	Donna Williams, Susan Blumenthal
Client	The Valley Deli
Agency	Vaughn, Wedeen Creative, Inc., Albuquerque, NM

958

Art Director	Gordon Hochhalter
Designer	Georgene Sainati
Photographer	Jerry Dunne
Writer	Gordon Hochhalter
Client	R.R. Donnelley & Sons Company
Agency	R.R. Donnelley & Sons Company, Chicago, IL
Studio	O'Grady Advertising Arts

959

Art Director	Andrew Kramer
Designer	Andrew Kramer
Artist	Aaron Breinberg
Client	F.G. Bodner
Agency	Kramer Associates, Inc., New York, NY
Printer	Trilon Color Lithographers Ltd.

960

Art Director	Larry Yang
Designer	Larry Yang
Photographer	Amos T.S. Chan
Artist	Jim Evanson
Clients	Ivy Ross, Jim Evanson
Agency	Weisz + Yang, Inc., Westport, CT

961

Art Director	David Wesko
Designer	David Wesko
Artist	David Wesko
Writer	David Wesko
Client	Apple Graphics
Agency	Apple Graphics, Dallas, TX

962

Art Directors	Mark Gelotte, Nancy Spicer
Designer	Tom Newton, Mark Gelotte
Photographer	Robert LaTorre
Writer	JoLynn Rogers
Client	Hines Industrial
Agency	Collaboration Inc., Houston, TX

963

Art Director	Kenny Garrison
Designer	Kenny Garrison
Artist	Kenny Garrison
Writer	Kenny Garrison
Client	Dan & Linda Scoggins
Agency	Pirtle Design, Dallas, TX
Creative Director	Woody Pirtle

964

Art Director	Rick Gavos
Designer	Rick Gavos
Artist	Rick Gavos
Writer	Rick Gavos
Client	Lively, Gavos and Associates
Agency	Lively, Gavos and Associates, Dallas, TX
Printer	Heritage Press, Dallas

965

Art Director	Mark Steele
Designer	Mark Steele
Writer	Lori Zimring
Client	Dallas Times Herald
Agency	Dallas Times Herald Promotion Art, Dallas, TX

966

Art Director	Dick Mitchell
Designer	Dick Mitchell
Artist	Dick Mitchell
Writer	Melinda Marcus
Client	Pan American Association of Opthamology
Agency	Richards Brock Miller Mitchell & Associates, Dallas, TX

967

Art Directors	Michael Rogalski, Bill Smith, Jr., Bob Warkulwiz
Designers	Michael Rogalski, Bill Smith, Jr., Bob Warkulwiz
Client	Alling & Cory Philadelphia, Cathy Glazer
Agency	Warkulwiz Design Associates, Philadelphia, PA

968

Art Director	Gina Hooten Popp
Designer	Gina Hooten Popp
Artists	David Gillespie, Pat Jones
Writer	Gina Hooten Popp
Client	Rosenberg & Co., Inc.
Directors	Ron Hudson, David Gillespie
Agency	Rosenberg & Co., Inc., Dallas, TX

969

Art Directors	Bob Dennard, Glyn Powell
Designer	Glyn Powell
Artist	Glyn Powell
Writer	Liza Orchard
Client	Natural Resource Management Corporation
Agency	Dennard Creative, Inc., Dallas, TX

970

Art Director	Frank Haggerty
Artist	Hank Nouwen
Writer	Jack Supple
Client	Art Directors, Copywriters Club of Minnesota
Agency	Carmichael-Lynch, Minneapolis, MN

971

Art Director	Peter Baker
Designer	Peter Baker
Artist	Peter Baker
Writer	Peter Baker
Client	Peter Baker, Toronto, Canada

972

Art Director	Rick Gavos
Designer	Rick Gavos
Writer	Les Wells
Client	Citicorp (USA), Inc.
Agency	Lively, Gavos and Associates, Dallas, TX
Public Relations Firm	Hopkins & Associates

973

Art Director	Scott Eggers
Designer	Scott Eggers
Photographers	Andy Post, Greg Booth
Artist	Dick Mitchell
Writer	Melinda Marcus
Client	Cattle Baron's Ball, American Cancer Society
Agency	Richards Brock Miller Mitchell & Assoc., Dallas, TX
Printer	Williamson Printing

974

Art Directors	Forrest & Valerie Richardson
Designers	Forrest & Valerie Richardson
Writer	Forrest & Valerie Richardson
Client	Zachary Livingstone
Agency	Richardson or Richardson, Phoenix, AZ
Production Co.	Steve & Maryann Livingstone

975

Art Director	Mike Schroeder
Designer	Mike Schroeder
Artists	Mike Schroeder, Jeff Weithman
Writer	Mike Schroeder
Client	Interaction Associates Inc.
Agency	Pirtle Design, Dallas, TX
Creative Director	Woody Pirtle

976

Art Director	Jerry Leonhart
Designer	Nicolas Sidjakov
Artist	David Stevenson
Writer	Jack Reeves
Client	Livingston/Sirutis-Livingston/Kane Public Relations
Agency	Livingston/Sirutis Advertising & Livingston/Kane Public Relaltions, Belmont, CA
Design Firm	Sidjakov Berman & Gomez, San Francisco, CA

977

Art Director	Port Miolla Associates, Inc.
Designer	Aileen Natrella
Artists	Paul Port, Ralph Miolla, Aileen Natrella, Patricia Halbert, Nanette Gamache
Writer	Port Miolla Associates
Client	Port Miolla Associates, Stamford, CT

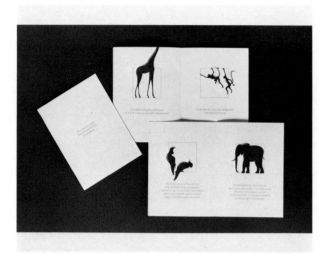

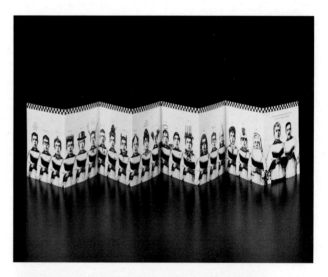

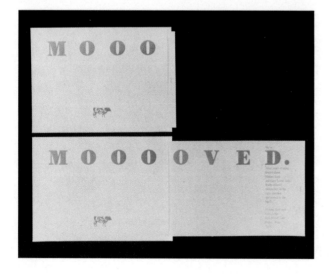

978

Art Director	Gary LoBue, Jr., Dallas, TX
Designer	Miriam Bush-LoBue
Writers	Gary LoBue, Jr., Miriam Bush-LoBue
Clients	Gary LoBue, Jr., Miriam Bush-LoBue

979

Art Director	Ron Louie, Scarsdale, NY
Designer	Ron Louie
Artist	Ron Louie
Writer	Ann Louie
Client	Ann Louie

980

Art Director Scott Paramski
Designer Scott Paramski
Artist Scott Paramski
Writers Owen Page, Robin Ayers
Client Padgett Printing Corporation
Agency The Richards Group, Dallas, TX

981

Art Directors Harold Matossian,
 Takaaki Matsumoto
Designer Takaaki Matsumoto
Artist Robert Venturi
Client Knoll International
Agency Knoll Graphics, New York, NY
Typographer Susan Schechter

982

Art Director Tom Geismar
Designer Tom Geismar
Client Restaurant Associates
Agency Chermayeff & Geismar Associates,
 New York, NY

983

Art Directors Bob Dennard, Glyn Powell
Designer Glyn Powell
Writer Bob Dennard
Client The Herring Group
Agency Dennard Creative, Inc., Dallas, TX

984

Art Director	Danny Sadler
Designer	Danny Sadler
Writer	Betsy England
Client	American Theatre Company
Agency	Brown Bloyed & Associates, Tulsa, OK

985

Art Director	Mr. Hoi L. Chu
Designer	Mr. Hoi L. Chu
Client	H. L. Chu & Company, Ltd.
Agency	H. L. Chu & Company, Ltd., New York, NY

986

Art Director	David Wesko
Designer	David Wesko
Artist	David Wesko
Writer	David Wesko
Client	Apple Graphics
Agency	Apple Graphics, Dallas, TX

987

Art Director	Nick Manganiello
Designer	Nick Manganiello
Writer	Nort Bramesco
Client	Sutton Communications
Agency	Sutton Communications, New York, NY

988

Art Directors	Alison Klassen, Mary Jarowitz
Designers	Mary Jarowitz, Ann Pearson
Artist	Ann Pearson
Writer	Cathryn Dorsey
Client	Cathryn Dorsey Communications, R. Robinson & Assoc., Inc.
Agency	Klassen Graphic Designs, Austin, TX

989

Art Director	Steven Wedeen
Designer	Steven Wedeen
Artist	Mark Chamberlain
Writer	Lynn Villella
Client	Presbyterian Hospital
Agency	Vaughn/Wedeen Creative, Inc., Albuquerque, NM

990

Art Director	Pat Hansen
Designers	Jesse Doquilo, Pat Hansen
Writer	Beth Brosseau
Client	Pat Hansen Design
Agency	Pat Hansen Design, Seattle, WA

991

Art Director	Barbara Wasserman Vinson
Designer	David Bates
Artist	Carl Kock
Writer	David Bates
Client	American Hospital Supply Corporation, Evanston, IL
Editor	Anne Hinman

992

Art Director	Walter Horton
Designer	Walter Horton
Artist	Walter Horton
Writer	Walter Horton
Clients	Joan McClendon, Donnie Schmidt
Agency	Sibley/Peteet Design, Inc., Dallas, TX

993

Art Director	Glenn A. Dady
Designer	Glenn A. Dady
Writer	Melinda Marcus
Client	The Richards Group
Agency	The Richards Group, Dallas, TX
Printer	Padgett Printing

994

Art Director	Bob Paganucci
Designer	Bob Paganucci
Artists	Bob Paganucci, Diana Vasquez, Bob Smith
Client	IBM
Agency	Salpeter Paganucci, Inc., New York, NY
Project Mgr	Frank Franco

995

Art Director David Gauger
Writer Hanns Kaniz
Client Hanns Kainz & Associates, AIA
Agency Gauger Sparks Silva, Inc.,
San Francisco, CA

996

Art Director Kathy White-Whitley
Designers Kathy White-Whitley, Gerry Simons
Writer Gerry Simons
Agency The Simons Group, Inc., Austin, TX

997

Art Directors Dann Wilson, Scott Mayeda
Designers Scott Mayeda, Dann Wilson
Photographer Marshall Harrington
Writers Scott Mayeda, Dann Wilson
Client Knoth & Meads
Agency Knoth & Meads, San Diego, CA

998

Art Director	David Wells
Designer	Bernardo Pebenito
Artist	Bernardo Pebenito
Writer	Sonja Riveland
Client	KIRO Newsradio 71
Agency	KIRO, Inc., Seattle, WA
In-House Agency	KIRO-TV Graphics, Seattle, WA

999

Art Director	Linda Chirby
Designer	Linda Chirby
Writer	Dennis Clark
Client	Marty and Dennis Clark
Printer	Dickson's Inc.
Typesetting	TypoGraphics Atlanta
Agency	Linda Chirby Design, Atlanta, GA

1000

Art Director	Raymond Nichols, Martha Carothers
Designers	Raymond Nichols, Jill Cypher
Writers	Raymond Nichols, Martha Carothers, Bill Derring,
Client	Visual Communications Group
Agency	DEsigners, Visual Communications Group, University of Delaware, Newark, DE

Gold Award

Art Director	Julian Naranjo
Designer	Julian Naranjo
Artist	Julian Naranjo
Client	Vosburgh Productions
Agency	Carol Kerr Graphic Design, San Diego, CA

1002

Silver Award

Art Directors	Walter McCord, Julius Friedman
Designers	Walter McCord, Julius Friedman
Client	Portland Museum
Agency	Images, Louisville, KY

Art Director John Clark
Designer John Clark
Photographer Roger Birn
Client Studio John Clark, Providence, RI
Typography Typographic House

1004

Art Directors	Susan Cummings, Norma O'Neill
Designer	Norma O'Neill
Artist	Norma O'Neill
Client	Ziggurat Exotic Flower Store
Agency	Zarkades + Cummings, Seattle, WA
Printer	Robert Horsley Printers

1005

Art Director	Javier Romero
Designer	Javier Romero
Client	Javier Romero Design
Agency	Javier Romero Design, New York, NY

1006

Art Director	Alan Colvin
Designer	Alan Colvin
Artist	Alan Colvin
Client	David C. Baldwin Inc.
Agency	Pirtle Design, Dallas, TX
Creative Director	Woody Pirtle

1007

Art Director	Julian Naranjo
Designer	Brenda Bodney
Artist	Julian Naranjo
Client	Jay Jacobson
Agency	Julian Naranjo Graphic Design, San Diego, CA

Art Director Kurt Meinecke
Client Charles Shotwell Photography
Agency Group/Chicago, Chicago, IL

1010

Art Director Kurt Meinecke
Client Daun International
Agency Group/Chicago, Chicago, IL

1011

Art Director Paul Davis
Designers Jose Conde, Paul Davis Studio
Client Myrna Davis
Agency Paul Davis Studio, New York, NY
Printer Peerless Ruling Co.

1012

Art Director Paul Gamarello
Designer Paul Gamarello
Client Eyetooth Design, Inc., New York, NY

1013

Art Director Maggie Macnab
Designer Maggie Macnab
Client Virginia Stanley
Agency Macnab Design, Albuquerque, NM
Printer Starline Creative Printing

1014

Art Director Jack Anderson
Designers, Raymond Terada, Jack Anderson
Client Fred Housel, Photographer
Agency Hornall Anderson Design Works,
Seattle, WA

Art Director Sherry Myres
Designer Franklin Nichols
Artist Franklin Nichols
Client R. Fred Myres
Agency Jim Jacobs Studio, Dallas, TX

Art Director Amelia Bellows
Designer Amelia Bellows
Agency Amelia Bellows Design, New York, NY

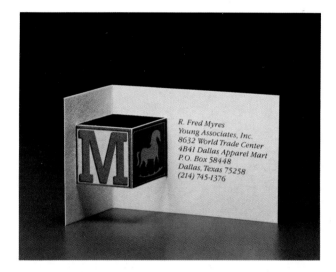

Art Director Walter Horton
Designer Walter Horton
Client Moonlight Beach Development
Agency Sibley/Peteet Design, Inc., Dallas, TX

1018

Art Director	Paige Johnson-Roetter
Designer	Paige Johnson-Roetter
Client	Paige Johnson Design, Inc.
Agency	Paige Johnson Design, Inc., Palo Alto, CA

1019

Art Director	Tamotsu Yagi
Designer	Tamotsu Yagi
Client	Esprit De Corp.
Publisher	Esprit De Corp.
Agency	Esprit Graphic Design Studio, San Francisco, CA
Printer	Nissha, Japan

1020

Art Director	Dan Ruesch
Designer	Dan Ruesch
Client	Holt Communications
Agency	Tandem Studios, Salt Lake City, UT

1021

Gold Award

Art Director Steve Snider
Designer Steve Snider
Client Richman's Zipper Hospital
Agency Rossin Greenberg Seronick & Hill,
Inc., Boston, MA

1022

Silver Award

Art Directors	Steve Kasloff, Kevin Nolan
Designer	Michael Gross
Writer	Steve Kasloff
Client	Ghostbusters
Agency	Columbia Pictures Industries, Inc., Burbank, CA
Creative Director	Steve Kasloff

1023
Distinctive Merit

Art Director Dan Ruesch
Designers Dan Ruesch & Steven Grigg
Client Provo Allergy & Asthma Clinic
Agency Tandem Studios, Salt Lake City, UT

1024

Art Director	John C. Jay
Designers	Tim Girvin, Richard Hsu, John Jay, Paul Koelman
Artist	Tim Girvin
Client	Bloomingdale's
Agency	Bloomingdale's, New York, NY

1025

Art Director	Robert MaHarry
Designers	Robert MaHarry, Ray Dillman
Writer	Sharon Kirk
Client	Missing Children's Help Center
Agency	Johannesson Kirk & MaHarry, Inc., Clearwater, FL

HOPPER PAPERS

1026

Art Director	Scott A. Mednick
Designers	Scott A. Mednick, Randy Momii
Artist	Randy Momii
Client	CBS-TV
Agency	Douglas Boyd Design, Los Angeles, CA

1027

Art Directors	B. Martin Pedersen, Adrian Pulfer
Designer	Adrian Pulfer
Client	Georgia Pacific Corp.
Director	Susan Whalen
Agency	Jonson Pedersen Hinrichs & Shakery, Inc., New York, NY

1028

Art Director	Gordon Mortensen
Designer	Gordon Mortensen
Artist	Gordon Mortensen
Client	National Semiconductor Corporation
Agency	Mortensen Design, Palo Alto, CA
Project Coordinator	Jeanne Stewart

1029

Art·Director	Gayle Monkkonen, Washington, DC
Designer	Gayle Monkkonen
Artist	Gayle Monkkonen
Client	Paragraphics, Inc.

1030

Art Director	Don Trousdell
Designer	Don Trousdell
Artist	Mark Sandlin
Client	One Up Studio, Atlanta, GA

1031

Art Directors	Scott Ray, Arthur Eisenberg
Designer	Scott Ray
Artist	Don Grimes, Calligraphy
Client	The Dallas Ballet
Design Studio	Eisenberg Inc., Dallas, TX

1032

Art Directors Don Arday, Arthur Eisenberg
Designer Don Arday
Artist Don Arday
Client Manhattan Laundry & Dry Cleaning
Design Studio Eisenberg Inc., Dallas, TX

1033

Art Director Willie Baronet, Dallas, TX
Designer Willie Baronet
Artist Willie Baronet
Client Acadiana Symphony Orchestra

1034

Art Director John Wagman
Clients Ellen Designs, Ellen Jaffe
Agency John Wagman Design, Inc., New York, NY

1035

Art Directors Don Arday, Arthur Eisenberg
Designer Don Arday
Artist Don Arday
Client Dallas Central Business District Association
Design Studio Eisenberg Inc., Dallas, TX

1036

Art Directors	Mike Quon, Peter Burke
Designers	Mike Quon, Ann Ceglia, Eileen Fogarty
Artist	Mike Quon
Client	Private Satellite Network, Peter Burke
Agency	Mike Quon Design Office, Inc., New York, NY

1037

Art Director	Blake Miller
Designer	Blake Miller
Artist	Blake Miller
Client	Gloria Arias
Agency	Miller Judson and Ford, Inc., Houston, TX

1038

Art Director	Julian Naranjo
Designer	Julian Naranjo
Artist	Julian Naranjo, David Darrow
Client	Beagle Bros
Agency	Carol Kerr Graphic Design, San Diego, CA

1039

Art Director	Steven Grigg
Designer	Steven Grigg
Artist	Dave Tweed
Client	Robert W. Speirs Plumbing Company
Agency	Tandem Studios, Salt Lake City, UT

1040

Art Director	Jennifer Closner
Designer	Jennifer Closner
Artist	Jennifer Closner
Client	Harvest Classic Horse Show
Agency	Jennifer Closner Design, Minneapolis, MN

1041

Art Director	Lauren Smith
Designer	Lauren Smith
Client	Cinegraphics
Agency	Lauren Smith Design, Mountain View, CA

RON WU PHOTOGRAPHY

1042

Art Director	Robert Petrick
Designer	Robert Petrick
Artist	Robert Petrick
Client	Ron Wu
Publisher	Ron Wu
Agency	Burson Marsteller, Chicago, IL

1043

Art Director	Art Morales
Artist	Art Morales
Client	Sofia
Agency	Pace Advertising Agency, New York, NY

1044

Art Directors	Leonard Walker Torres, Kelly Davenport
Designer	Leonard Walker Torres, John Watson
Client	Southwestern Cable T.V.
Agency	Design Consortium, San Diego, CA

1045

Designer	David Jemerson Young
Artist	David Jemerson Young
Client	Young Letters
Agency	Young & Laramore, Indianapolis, IN

1046

Art Director	Lance Wyman
Designers	Lance Wyman, Rob Roehrick, Mark Fuller
Client	Farr-Jewett & Associates, Inc.
Agency	Lance Wyman, Ltd., New York, NY

1047

Art Director	Primo Angeli
Designer	Jamie Davison
Client	Fono's Ice Creams
Agency	Primo Angeli Graphics, San Francisco, CA

1048

Art Director Art Chantry
Designer Art Chantry
Client Give Peace A Dance
Agency Art Chantry Design, Seattle, WA

1049

Art Director Ken Hegstrom
Designer Ken Hegstrom
Artist Ken Hegstrom
Client Lightning Printing
Agency Hegstrom Design Consultants, San
Jose, CA

1050

Art Director David Jemerson Young
Designer David Jemerson Young
Artist Wayne Watford
Client Netek, Inc.
Agency Young & Laramore, Indianapolis, IN

1051

Art Director Willie Baronet
Designer Willie Baronet
Artist Willie Baronet
Client Dallas Advertising Softball League
Agency Allday & Associates, Dallas, TX

1052

Art Director Keith Bennett
Designer Keith Bennett
Client Face Painters
Agency Adcom Graphics Corp. Design Firm, Chandler, AZ

1053

Art Director Craig Frazier
Designer Craig Frazier
Artist Craig Frazier
Client Levi Strauss & Co.
Design Firm Craig Frazier Design, San Francisco, CA

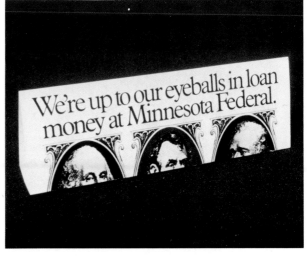

1054

Art Director Scott A. Mednick
Designers Scott A. Mednick, Steve Curry
Artist Brian Sebern
Client Walt Disney Home Video
Agency Douglas Boyd Design, Los Angeles, CA

1055

Art Director Dean Hanson
Artist Bob Blewett
Writer Phil Hanft
Client Minnesota Federal
Agency Fallon McElligott Rice, Minneapolis, MN

1056

Art Director John Norman
Designer John Norman
Artist John Norman
Writers John Norman, Mary Heller
Client Unicorn Design
Agency Design Dimensions, Franktown, CO

1057

Art Director John Norman
Designer John Norman
Artist John Norman
Writer Peggy Gilmore
Client Creative Sources
Agency Design Dimensions, Franktown, CO

1058

Art Director Roger Core
Designer Walter Einsel
Artist Walter Einsel
Client Danbury Savings and Loan
Agency Roger Core Advertising, Weston, CT
Art Production Judith Albin
Marketing Manager James Larivee

1059

Art Directors	Susan Sands, Larry McEntire
Designers	Larry McEntire, Bill Grimes
Artists	Patti J. Bishop, Larry McEntire
Client	Texas Monthly Press
Publisher	Texas Monthly Press
Agency	Lonestar Studio, Austin, TX

1060

Art Director	Joe Duffy
Designer	Joe Duffy
Artist	Joe Duffy
Writer	Bruce Bildsten
Client	Rupert's Night Club
Agency	The Duffy Group, Minneapolis, MN

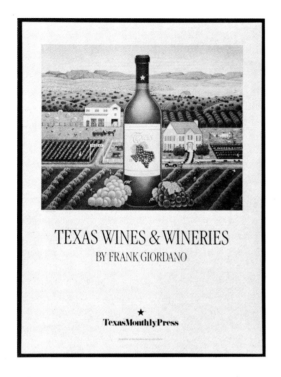

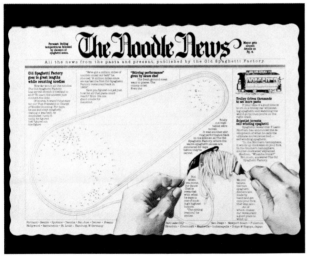

1061

Art Director	Vance Smith
Designer	Vance Smith
Artist	Michael Cacy
Writer	Tom Wiecks
Client	Old Spaghetti Factory
Agency	Wagner, Wiecks, Smith & Lapel, Portland, OR

1062
Gold Award

Art Directors	B. Martin Pedersen, Adrian Pulfer
Designer	Adrian Pulfer
Writer	David Konigsberg
Client	Georgia Pacific
Director	Susan Whelan
Agency	Jonson Pedersen Hinrichs & Shakery, New York, NY

1063

Silver Award

Art Director Peter Harrison
Designer Larry Wolfson
Photographers Len Genschel, Gary Heery
Writer Jerry Bowles
Client Peat Marwick Mitchell & Co.
Design Firm Pentagram Design, Ltd., New York, NY

Distinctive Merit

Art Directors	Bob Dennard, Jan Wilson, Chuck Johnson, Glyn Powell
Designers	Jan Wilson, Chuck Johnson, Glyn Powell
Photographer	Mike McKee
Artist	Various
Writers	Cheryl McCue, David Martin
Client	The Herring Group
Agency	Dennard Creative, Inc., Dallas, TX
Publication	The Herrald

1065

Art Directors	Michael Donovan, Nancye Green
Designer	Peter Galperin
Photographers	Fred Schenk, Andrew Unangst
Client	Brickel Associates, Inc.
Agency	Donovan and Green, New York, NY

1066

Art Director	Henry Brimmer
Designers	Henry Brimmer, Therese Randall, Adelaida Mejia
Agency	Henry Brimmer Design, San Francisco, CA

1067

Art Director	Michael Brock
Designer	Michael Brock
Writer	Terri Fritts, Instant Teller/City National Bank
Client	Lauro Baca, Jr., Instant Teller/City National Bank
Design Firm	Michael Brock Design, Los Angeles, CA
Printer	Alan Lithograph

1068

Art Director	Marianne Tombaugh
Designer	Michael Landon
Artist	Constantin Brancusi
Writer	Marianne Tombaugh
Client	Dedie Rose
Agency	The Hay Agency, Inc., Dallas, TX

1069

Art Director	Stavros Cosmopulos
Designer	Stavros Cosmopulos
Artist	Stavros Cosmopulos
Writer	Stavros Cosmopulos
Client	Cosmopulos, Crowley & Daly, Inc.,
Agency	Cosmopulos, Crowley & Daly, Inc., Boston, MA
Printer	Dynagraf, Boston
Typesetter	Arrow Comp., Boston

1070

Art Director	Gaye Korbet
Designer	Gaye Korbet
Photographer	Steve Korbet
Writer	Michael Ambrosino
Client	Public Broadcasting Associates, Inc.
Editor	Nora Sinclair
Agency	WGBH Design, Boston, MA
Printer	Mercantile Press

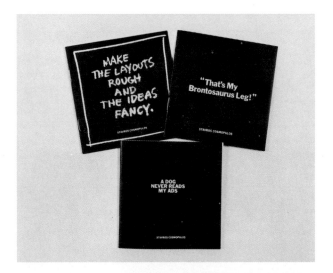

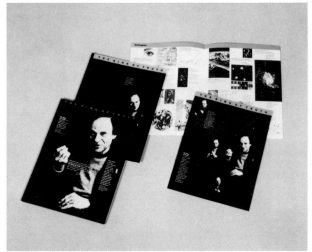

1071

Art Director	Jerry Leonhart
Designer	Nicolas Sidjakov
Photographer	Nikolay Zurek
Artists	David Stevenson, Nicolas Sidjakov
Writers	Tom Livingston, Jack Reeves
Client	ISC Systems Corp.
Agency	Livingston/Sirutis Advertising, Belmont, CA
Design Firm	Sidjakov Berman & Gomez, San Francisco, CA
Printer	George Rice & Sons

1072

Art Director	Michael Blair
Designers	Michael Blair, Steve Carson
Photographers	Dan Rabbe, Dave Hawkins, Jay Silverman, Rick Casemore
Writers	Len Vucci, Fernando Belair
Client	Suzuki
Agency	DYR, Los Angeles, CA
Design Group	Art/West

1073

Art Director	Michael Donovan
Designers	Michael Donovan, Peter Galperin, Margie Chin
Client	International Design Conference in Aspen 1984
Agency	Donovan and Green, New York, NY

1074

Art Director	Bruce Elton
Designers	Bruce Elton, Nina Elton
Artist	Al Lorenz
Client	Citibank
Printing	Seybert/Nicholas
Agency	Elton Design Limited, Garrison, NY
Typesetting	Cardinal Type Service

1075

Art Director	Richard Rogers
Designer	Richard Rogers
Photographers	Melchior DiGiacomo, Alexander Hubrich, Al Satterwhite
Writer	Michael Starks
Client	IBM
Agency	Richard Rogers Inc., New York, NY

1076

Silver Award

Art Director	Rex Peteet
Designer	Rex Peteet
Photographer	John Wong
Artists	Rex Peteet, Walter Horton, Jerry Jeanmard, Michael Schwab, Louis Escobedo
Writer	Mark Perkins, Rex Peteet
Client	International Paper Co.
Agency	Sibley/Peteet Design, Inc., Dallas, TX

1077

Art Directors	Jim Locke, Russell Leong
Designer	Russell K. Leong
Artists	Russell K. Leong, Rick Wong
Writer	Sue Jacoby
Client	Apple Computer Inc.
Agency	Russell Leong Design, Palo Alto, CA

1078

Designers	Barbara Loveland, Linda Powell, Barbara Herman
Writer	Debra Wierenga
Client	Herman Miller, Inc., Zeeland, MI
Production	Deb Keen, Sue Bakker

Art Director Frank Schulwolf
Artists Ted Lodigensky, Bill James,
Kimberly Smith, Cheryl Nathan,
Daniel Schwartz, Robert Altemus,
Frank Schulwolf
Writer Arthur Low
Client Aviation Sales Company, Inc., A
division of Ryder System
Agency Susan Gilbert & Company, Inc.,
Coral Gables, FL

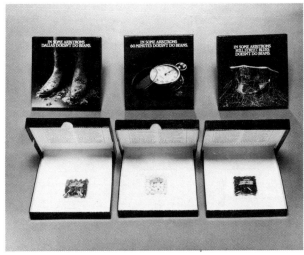

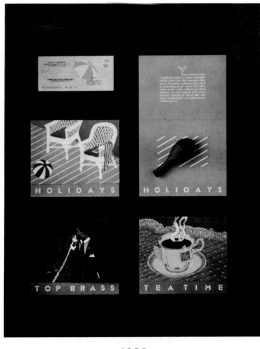

1084

Art Directors — Roger Cook, Don Shanosky
Designers — Roger Cook, Don Shanosky
Writer — Dave Eynon
Client — RH Development Co.
Agency — Cook & Shanosky Assoc., Inc., Princeton, NJ

1085

Art Director — Bob Conge
Designer — Deborah DePasquale
Artist — Bob Conge
Writer — Karen Beadling & Rick Kase
Client — Rochester Society of Communicating Arts
Agency — Conge Design, Rochester, NY
Creative Director — John Massey

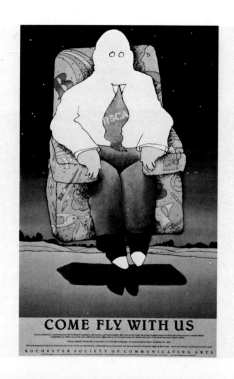

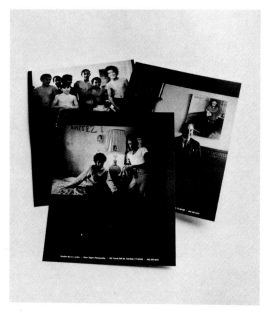

1086

Art Director — Rick Schneider
Designer — Rick Schneider
Photographer — Peter Tepper
Client — Peter Tepper
Agency — Rick Schneider Design, Fairfield, CT
Printer — Craftsmen Litho

1087

Art Director — Sharon Tooley
Designer — Sharon Tooley
Photographer — Frank White
Writer — Paule Sheya Hewlett
Client — Motheral Printing Company
Agency — Sharon Tooley Design, Houston, TX

1088

Art Director — Kenneth G. Hess
Designer — Mark Tweed
Artist — Barry Zaid
Writer — Lisa McMath
Client — Colorado School of Mines
Agency — Graphis One, Inc., Boulder, CO
Printer — March Press

1089

Art Director — Steve Sweitzer
Designer — Steve Sweitzer
Writer — Jim Bergeson
Client — International Minerals &
Chemical Corporation
Agency — Colle & McVoy Advertising,
Minneapolis, MN

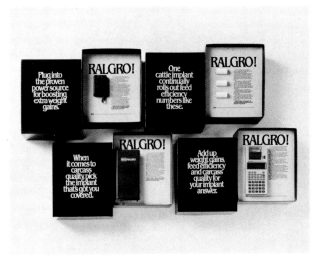

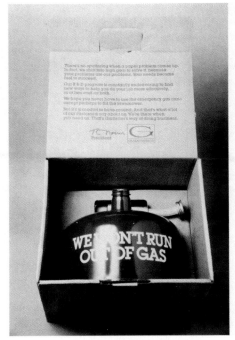

1090

Art Director — David Deutsch
Writer — Brown Hagood
Client — P.H. Glatfelter Paper Company
Agency — David Deutsch Associates,
New York, NY

1091

Art Director Charles Hively
Designer Charles Hively
Writers Julie Harrigan, Laura McCarley
Client Greater Houston Convention &
Visitors Bureau
Agency Metzdorf-Marschalk, Co., Inc.,
Houston, TX

1092

Art Directors Gordon Hochhalter, Bob Meyer
Designer Bob Meyer
Artist Edward Koren
Writer Gordon Hochhalter
Client R.R. Donnelley & Sons Company
Agency R.R. Donnelley & Sons Company,
Chicago, IL
Studio O'Grady Advertising Arts

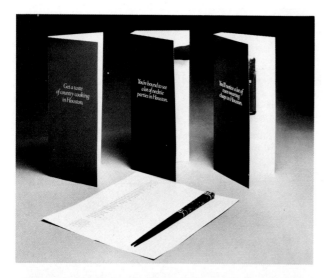

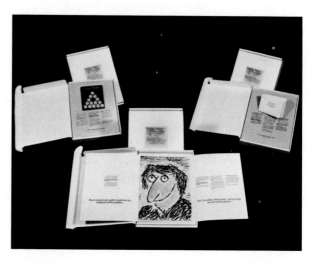

1093

Art Director Steven Voorhees
Designer Steven Voorhees
Artist The Dudycha Group
Writer Ted Horne
Client Dorsey Laboratories
Agency Sieber & McIntyre, Chicago, IL

1094

Silver Award

Art Director	Lou Scolnik
Designer	Glenn Groglio
Photographer	Vincent Lee
Writer	Jon Peterson
Client	Dansk
Agency	Louis Scolnik: Design, Briarcliff Manor, NY

1095
Silver Award

Art Director Larry Long
Designer Alice Hecht
Artist Jean-Michel Folon
Client Corning Medical & Scientific
Agency Weymouth Design, Boston, MA

1096

Art Director Peter Windett
Designer Peter Windett
Artist Rory Kee
Client Lazzaroni (USA)
Agency Peter Windett & Associates,
London, England

1097

Art Director Peter Windett
Designer Peter Windett
Artist Alan Cracknell
Client Crabtree & Evelyn, Ltd.
Agency Peter Windett & Associates,
London, England

1098

Art Director Seymour Chwast
Designer Seymour Chwast
Artist Seymour Chwast
Client Associated Merchandising
Corporation/Doug Bertsch,
Art Director
Studio Pushpin Lubalin Peckolick,
New York, NY

1099

Art Directors Nicolas Sidjakov, Jerry Berman
Designer James Nevins
Artist Gregg Keeling
Client Welch Foods, Inc.
Design Firm Sidjakov Berman & Gomez,
San Francisco, CA

1104

Art Director Warren Eakins
Artist Jerry Haworth
Writer Bill Borders
Client Burgerville USA
Agency Borders, Perrin & Norrander, Inc.,
Portland, OR

1105

Art Director Allen Porter
Designers Lisa Ellert, Allen Porter
Photographer John Payne
Writer Allen Porter
Client Lightning Bug, Ltd.
Design Firm Porter/Matjasich & Associates,
Chicago, IL
Printer Perfect Carton Co.
Color Separator American Litho Arts

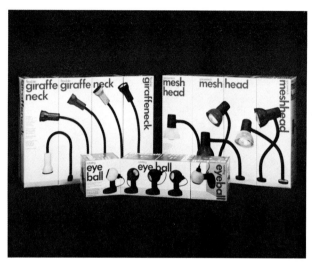

1106

Art Directors Nicolas Sidjakov, Jerry Berman
Designer James Nevins
Illustrator David Stevenson
Artist Jock Campbell
Client Bonner Packing Co.
Design Firm Sidjakov Berman & Gomez, San
Francisco, CA

1107

Art Director Robert P. Gersin
Designers Carol Rhodes, Pamela Virgilio
Artist Angela Staples
Client Government of Jamaica and the United Nations International Development Organization (UNIDO)
Agency Robert P. Gersin Associates Inc., New York, NY

1108

Art Directors Larry Klein, Keith Bright
Designers Ray Wood, Gretchen Goldie, Kimberlee Keswick
Artist (Star in Motion by Robert Miles Runyan & Assocs.)
Client Los Angeles Olympic Organizing Committee
Agency Bright & Associates, Los Angeles, CA

1109

Art Director Alison Woods
Designer Alison Woods
Artist Alison Woods
Writer Paula Polley
Client Atari Inc.
Editor Paula Polley
Agency Woods + Woods, San Francisco, CA

1110

Art Director Art Goodman
Designers Saul Bass, Art Goodman
Photographer Tom Bartone
Artists Mamoru Shimokochi, Karen Lee
Writer Sandy Butchkiss
Client Girl Scouts of the U.S.A.
Agency Saul Bass/Herb Yager & Assoc., Los Angeles, CA
Production Supervisor Nancy Von Lauderback

1111

Art Director Susan Milord
Designer Susan Milord
Artist Sue Thompson
Writer Virginia Anemmers
Client Forest Foods, Inc.
Agency Milord Graphic Design, Suffield, CT

1112

Art Director Robert P. Gersin
Designer Scott Bolestridge
Photographer Philip Koenig
Writer Enid Futterman
Client American Tourister Inc.
Project Director Roland Gebhardt
Agency Robert P. Gersin Associates Inc., New York, NY

1113
Gold Award

Art Director	M. Ray Gedeon
Designer	Philip Gell
Photographer	Marty Stouffer
Client	American Express Travel Related Services Company, Inc.
Agency	Conference Management, Inc., Fairlawn, OH

Silver Award

Art Director Jack Summerford
Designer Jack Summerford
Client Dallas Society of Visual
Communications
Agency Summerford Design, Inc., Dallas, TX

Distinctive Merit

Art Director	Roger Christian
Designer	Roger Christian
Illustrator	Mark Weakley
Client	Southwest Foundation Forum for Biomedical Research
Agency	Roger Christian & Company, Inc., San Antonio, TX
Printer	Paul Anderson Company

1116

Art Director John Cadenhead
Artist SEM
Client Jacqueline Cochran, Inc., New York,
NY

1117

Art Director Richard J. Whelan
Designer James E. Keller
Client Builder Magazine
Director Cary B. Griffin
Agency The Whelan Design Office Inc., New
York, NY

1118

Art Director Woody Pirtle
Designer Woody Pirtle
Artist Woody Pirtle
Writer Dallas Museum of Art
Client Dallas Museum of Art
Agency Pirtle Design, Dallas, TX
Creative Director Woody Pirtle

1119

Art Director	Jann Church
Designer	Jann Church
Client	Monarch Beach
Agency	Jann Church Partners, Marketing & Graphic Design, Inc., Newport Beach, CA

1120

Art Director	Molly Epstein
Designer	Molly Epstein
Artist	Daniel Pelavin
Client	Garan, Inc.
Agency	Shaller, Rubin & Winer, Inc., New York, NY
Creative Director	Peter Noto

1121

Art Director	Vartus Artinian
Designer	Vartus Artinian
Photographers	Various
Writer	Brian Flood
Client	Polaroid Corporation/Rick Colson, Cambridge, MA

1122

Art Directors	Linda Eissler, Arthur Eisenberg
Designer	Linda Eissler
Artists	Linda Eissler, Mark Drury
Client	Chow Catering
Agency	The Oakley Company, Dallas, TX
Design Studio	Eisenberg Inc.

1123

Art Director	Jeffrey A. Spear
Designer	Jeffrey A. Spear
Client	Prune Products, Inc.
Agency	Jeffrey A. Spear/Graphic Design, Santa Monica, CA

1124

Art Director	Paul LaBarbera
Photographer	Steve Myers
Writer	Ann Hayden
Client	Eastman Kodak Co.
Agency	Rumrill-Hoyt, Inc., Rochester, NY
Creative Group Manager	Kenn Jacobs

1125

Art Directors	Don Sibley, Steve Gibbs
Designer	Steve Gibbs
Artist	Steve Gibbs
Client	Neiman-Marcus
Agency	Sibley/Peteet Design, Inc., Dallas, TX

1127

Art Directors	Henry Brimmer, Therese Randall
Designers	Henry Brimmer, Therese Randall
Client	Pedersen Associates
Agency	Henry Brimmer Design, San Francisco, CA

1128

Art Directors	Linda Pierro, Joseph Coleman, Betsy Halliday
Designers	Linda Pierro, Joseph Coleman, Betsy Halliday
Client	Sony Consumer Products Company
Agency	Halliday/Herrmann, Inc., New York, NY

1129

Art Director	Michael Orr
Designers	Michael Orr, Robert K. Cassetti, Peggy Personius
Client	Buschner & Faust Studios, Incorporated
Agency	Michael Orr + Associates, Inc., Corning, New York
Printer	Ayer + Streb, Oser Press

1130

Art Directors	Harold Matossian, Takaaki Matsumoto
Designer	Takaaki Matsumoto
Client	Knoll International
Agency	Knoll Graphics, New York, NY
Typographer	Susan Schechter

Book and jackets: General trade book (primarily text)
Special trade book (primarily art/photography)
Juvenile book
Text or reference book
Book jacket: trade, text, reference or juvenile
Book campaign: trade, text, reference or juvenile
Book jacket campaign: trade, text, reference or juvenile

1131

Silver Award

Art Director	Steve Freeman
Designer	Steve Freeman
Artist	Nelson Shipman
Writer	Gary Powell
Publisher	PSP Records
Agency	Graphic Solutions, Austin, TX

1132

Distinctive Merit

Art Director Martin Solomon
Designer Martin Solomon
Artist Isadore Seltzer
Writer William Shakespeare
Client Royal Composing Room, Inc., New York, NY
Typographer Royal Composing Room, Inc.

1133

Distinctive Merit

Art Director Marie Raperto
Designer Karen Bloom
Client Westvaco
Publisher Westvaco
Typographer Finn Typography
Agency Westvaco—In House, New York, NY
Printer Meriden-Stinehour

1134

Art Director	Sally Eddy
Designer	Will Underwood
Photographer	New York State Historical Association, Cooperstown
Writer	Isabel Thompson Kelsay
Editor	Walda Metcalf
Publisher	Syracuse University Press, Syracuse, NY
Director	Arpena Mesrobian

1135

Art Director	Stan Gellman
Designer	Stan Gellman
Photographer	Robert C. Pettus
Artist	Pat Hays Baer
Writers	Carolyn Hewes Toft, Jane Molloy Porter
Client	Landmarks Association of St. Louis, Inc.
Publisher	Landmarks Association of St. Louis
Agency	Stan Gellman Graphic Design, St. Louis, MO

1136

Art Director	Robert Gould
Designers	Robert Gould, Alex Jay
Artists	Michael Wm. Kaluta, Robert Gould, David Johnson, Alex Nino et al
Writer	Philip Jose Farmer
Client	Byron Preiss Visual Publications, Inc.
Editor	Byron Preiss
Publisher	Berkley Books
Production	Studio J, New York, NY

1137

Art Director	Tim Kenney
Designers	Vicki Valentine, Tim Kenney
Photographers	Various
Artists	Vicki Valentine, Tim Kenney
Client	The Roosevelt Center
Editor	Larry Hansen
Agency	Tim Kenney Design, Washington, DC

1138
Gold Award

Art Directors Debra McQuiston, Don McQuiston
Designer Debra McQuiston
Photographer Pat O'Hara
Writer Tim McNulty
Client Woodlands Press
Publisher Woodlands Press
Agency McQuiston & Daughter, Inc., Del Mar, CA
Publication Olympic National Park: Where the Mountain Meets the Sea

Gold Award

Art Director	Swami Jivan Mahasubh
Designers	Swami Jivan Mahasubh, Paul Mort
Photographer	Christopher Newbert
Writer	Christopher Newbert
Client	Beyond Words
Editor	Paul Berry
Publisher	Beyond Words
Agency	Rickabaugh Design, Portland, OR
Calligraphy	Tim Girvin

Silver Award

Art Director	Michael Pardo
Photographer	Roy D. Query
Writer	Griffith Borgeson
Client	Automobile Quarterly Publications, Princeton, NJ
Editor	Marguerite Kelly
Publisher	L. Scott Bailey
Color Separators	Lincoln Graphics
Printer	Kutztown Publishing
Binder	A. Horowitz & Sons

Distinctive Merit

Art Director	R. D. Scudellari
Designer	Robert Anthony
Photographers	Various
Writer	Dick Schaap
Client	Random House
Editor	Ashbel Green
Publisher	Random House, New York, NY

1142
Distinctive Merit

Art Director Samuel N. Antupit
Designer Samuel N. Antupit
Photographer Henry Wolf
Artist Various
Writers Gerald Silk, Angelo Tito Anselmi,
Henry Flood Robert Jr., Strother
MacMinn
Editor Joan E. Fisher
Publisher Harry N. Abrams, Inc., New York, NY

Distinctive Merit

Art Directors	Debra McQuiston, Don McQuiston
Designer	Debra McQuiston
Photographer	Yoshiaki Nagashima
Writers	Robert White, Koichi Shimazu, John Jones
Client	ARC International Ltd.
Publisher	ARC International Ltd.
Agency	McQuiston & Daughter, Inc., Del Mar, CA
Publication	One World, One People

1144

Art Director	Chris Hill
Designers	Chris Hill, Jon Flaming, Amy Goldman, Amy Leigh, Jeff McKay, Joe Rattan
Photographers	Steve Chenn, Various
Client	Art Directors Club of New York
Agency	Hill/A Marketing Design Group, Houston, TX

1145

Art Director	Roger Ferriter
Designer	Roger Ferriter
Writer	Roger Ferriter
Editor	Judy Cook
Publisher	Communication Arts, New York, NY

1146

Art Director	R.D. Scudellari
Designer	R.D. Scudellari
Photographer	Elliott Erwitt
Writer	Mary Jane Pool
Client	Alfred A. Knopf
Editor	Susan Ralston
Publisher	Alfred A. Knopf/Random House, New York, NY

1147

Art Director	John Newcomb, Stamford, CT
Designer	John Newcomb
Writer	John Newcomb
Client	The R.R. Bowker Company (Xerox, Inc.)
Editor	Betty Sun
Publisher	The R.R. Bowker Company (Xerox, Inc.)

1148

Art Director	Gael Dillon
Designers	Tim Girvin, Phil Archibald
Photographer	Marsha Burns
Artists	Marsha Burns, Tim Girvin
Writer	Michele Durkson Clise
Client	Clarkson Potter
Publisher	Clarkson Potter
Agency	Tim Girvin Design, Inc., Seattle, WA

1149

Art Director	Samuel N. Antupit
Designer	Samuel N. Antupit
Writers	Various.
Photo Editors	John Rewald, Frances Weitzenhoffer
Editor	Beverly Fazio
Publisher	Harry N. Abrams, Inc., New York, NY

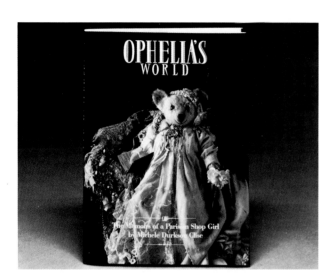

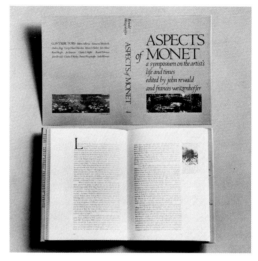

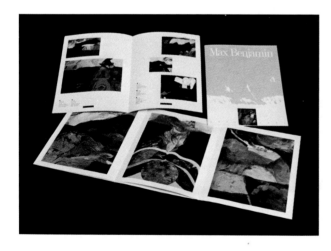

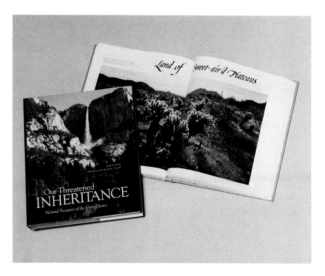

1150

Art Director	W. Joseph Gagnon
Designers	W. Joseph Gagnon, Carol Davidson, Brendan Potash
Photographer	Chris Eden
Writer	Matthew Kangas
Client	Bellevue Art Museum
Editors	Joan Kotker, John Olbrantz
Publisher	Bellevue Art Museum
Agency	W. Joseph Gagnon Design Associates, Seattle, WA
Printer	Atomic Press

1151

Art Director	Jody Bolt
Photographer	James P. Blair
Picture Editor	John G. Agnone
Calligrapher	Eleni Constantopoulos
Illustrator	George Founds
Author	Ron Fisher
Managing Editor	Margery G. Dunn
Publication	Our Threatened Inheritance
Publisher	Special Publications Division, National Geographic Society, Washington, DC

1152

Art Directors	Douglas Oliver, Emmett Morava
Designer	Douglas Oliver
Photographers	Randolph Harrison, Baron Wolman
Writers	Charles Lockwood, Jeff Hyland
Client	Beverly Park Estates
Publisher	Margrant Publishing Company
Agency	Morava & Oliver Design Office, Santa Monica, CA
Production Art	Keith Axelson & Associates

1153

Art Director	Edward D. King
Designer	Edward D. King
Photographer	Oliver Schuchard
Writer	Steve Kohler
Editor	Tim Parshall
Publisher	University of Missouri Press, Columbia, MO
Director	Edward D. King
Printer	Dai Nippon

1154

Art Directors	Stephen Doyle, Thomas Kluepfel
Designers	Stephen Doyle, Thomas Kluepfel
Photographer	Neil Selkirk (cover)
Artists	Various
Curator	Kynaston McShine
Client	The Museum of Modern Art
Editor	Harriet Bee
Publisher	The Museum of Modern Art
Agency	M & Co., New York, NY
Production Manager	Nan Jernigan

1155

Art Director	Swami Jivan Mahasubh
Designers	Swami Jivan Mahasubh, Don Rood, Jerry Soga
Photographer	Richard A. Cooke III
Writers	Richard A. Cooke III, Bronwyn A. Cooke
Client	Beyond Words
Editors	Liz Foster, Paul Berry
Publisher	Beyond Words
Agency	Rickabaugh Design, Portland, OR
Calligraphy	Tim Girvin

1156

Art Director Gael Dillon
Designer Paul Hardy
Agency Paul Hardy Editorial Design, New
York, NY

1157

Art Director Richard Eckersley
Designer Richard Eckersley
Photographer Malcolm Varron, NY
Editors David C. Hunt, Marsha V. Gallagher,
William H. Goetzmann, William J.
Orr
Publishers University of Nebraska Press, Joslyn
Art Museum, Lincoln, NE
Typesetter G & S Typesetters, Inc., Austin, TX
Printer/Binder Dai Nippon Printing Co., Ltd., Japan
Production Manager Debra K. Turner

1158

Art Director Samuel N. Antupit
Designer Bob McKee
Photographer Kevin Fleming
Artist Marley Amstutz (maps)
Writers Jane Vessels (text), Carol E.
Hoffecker (introduction)
Editor Darlene Geis
Publisher Harry N. Abrams, Inc., New York, NY

1159

Art Director	Douglas Turschen
Photographer	Kari Haavisto
Writer	Elizabeth Gaynor
Publisher	Gianfranco Monacelli, Rizzoli, New York, NY

1160

Art Director	Alvin Grossman
Designer	Alvin Grossman
Writer	Barbara Burn
Client	Metropolitan Museum of Art
Editor	John P. O'Neill
Publisher	Harry N. Abrams, Inc., New York, NY

1161

Art Director	Kiyoshi Kanai
Designer	Kiyoshi Kanai
Photographer	Various
Writer	Richard Snow
Client	Brightwaters Press
Editor	Laurance Wieder
Publisher	Brightwaters Press
Director	Laurance Wieder
Agency	Kiyoshi Kanai, Inc., New Yorjk, NY

1162

Art Directors	Bill Fong, Leo Gonzalez
Designers	Bill Fong, Leo Gonzalez, Pam Suzuki
Writer	Ronn Ronck
Photographers	Various
Client	Mutual Publishing Company of Honolulu
Editor	Ronn Ronck
Publisher	Mutual Publishing Company of Honolulu
Agency	The Art Directors, Inc., Honolulu, HI
Printer	Toppan Printing Company, Tokyo, Japan

1163

Art Director	Samuel N. Antupit
Designer	Raymond P. Hooper
Photographers	Various
Writer	Tony Thomas
Editors	Margaret L. Kaplan, Lory Frankel
Publisher	Harry N. Abrams, Inc., New York, NY

1164

Art Director	Robert Anthony
Designer	Robert Anthony
Client	Society of Illustrators, Inc.
Editor	Art Weithas
Publisher	Madison Square Press, Inc., New York, NY
Publication	The Society of Illustrators 25th Annual of American Illustration

1165

Art Director	Don Weller
Designer	Don Weller
Photographers	Pat McDowell, Nick Nass, Neil Rossmiller, Tom Shaner, Don Weller
Artist	Don Weller
Writer	Katherine Reynolds
Client	The Weller Institute for the Cure of Design, Inc.
Editor	John Weibusch
Publisher	The Weller Institute for the Cure of Design, Inc.
Director	Don Weller
Agency	The Weller Institute for the Cure of Design, Inc., Los Angeles, CA
Publication	Park City

1166

Art Director	David M. Seager
Designer	David M. Seager
Photographer	David Muench (Cover)
Client	National Geographic Society
Editor	Margaret Sedeen
Publisher	National Geographic Society, Washington, DC
Picture Editor	Linda B. Meyerriecks

1167

Art Director	William Wondriska
Designer	Betsy Hoople
Client	David Bermant
Editor	Sally Williams
Publisher	Wadsworth Atheneum
Director	Tracy Atkinson
Agency	Wondriska Associates Inc., Farmington, CT
Publication	Wadsworth Atheneum
Printer	Finlay Brothers, Inc.

1168

Art Director	Bill Fong
Designers	Leo Gonzalez, Gregg Ichiki
Photographers	Jack Rankin, Ray Jerome Baker
Writer	Ronn Ronck
Client	Mutual Publishing Company of Honolulu
Editor	Ronn Ronck
Publisher	Mutual Publishing Company of Honolulu
Director	Yoh Jinno
Agency	The Art Directors, Inc., Honolulu, HI
Printer	Samhwa Printing Company, Korea

1169

Art Director	Ed Marquand
Designer	Ed Marquand
Photographers	Ralph Marshall, Paul Macapia
Writer	Pam McClusky
Client	Seattle Art Museum
Editor	Lorna Price
Publisher	Seattle Art Museum, Seattle, WA

1170

Art Director	Jean-Francois Podevin
Designers	John Coy, Jean-Francois Podevin, Laura Handler
Artist	Jean-Francois Podevin
Writer	Sheldon Renan
Client	Renan Productions, Intravision
Editor	Jim Frost
Publisher	Warner Books/Intravision
Director	Rory Nugent/Intravision
Agency	Renan Productions, Los Angeles, CA

1171

Art Director	Ken Sansone
Designer	George Corsillo
Photographer	Tim Street-Porter
Writer	Cara Greenberg
Editor	Harriet Bell
Publisher	Harmony Books, a division of Crown Publishers, Inc., New York, NY
Production	Murray Schwartz

1172

Art Director	Carol Hare Beehler
Designer	Carol Hare Beehler
Artists	Joseph Prestele and sons
Writer	Charles van Ravenswaay
Editor	Jeanne M. Sexton
Publisher	Smithsonian Institution Press, Washington, DC
Publication	Drawn from Nature: The Botonical Art of Joseph Prestele and His Sons

1173

Art Director	David M. Seager
Designer	David M. Seager
Artist	Gerard Huerta (Cover)
Writer	John Anthony Scott
Client	National Geographic Society
Editor	Elizabeth L. Newhouse
Publisher	National Geographic Society, Washington, DC
Illustrations Editor	Linda B. Meyerriecks

1174

Art Director	Samuel N. Antupit
Designer	Carol Robson
Writer	Denise Domergue
Editor	Anne Yarowsky
Publisher	Harry N. Abrams, Inc., New York, NY

1175

Art Director	Betty Anderson
Designer	Dorothy Schmiderer
Writer	Vaulentine Lawford
Client	Alfred A. Knopf
Editor	Victoria Wilson
Publisher	Alfred A. Knopf/Random House, New York, NY

1176

Art Director	Joseph Michael Essex
Designers	Joseph Michael Essex, Wendy Pressley-Jacobs
Photographers	Tom Vack, Cory Pfister
Artist	The 27 Chicago Designers Membership
Writer	Rhodes Patterson
Client	The 27 Chicago Designers
Editor	Joseph Michael Essex
Publisher	The 27 Chicago Designers
Agency	Burson-Marsteller/Americas, Chicago, IL

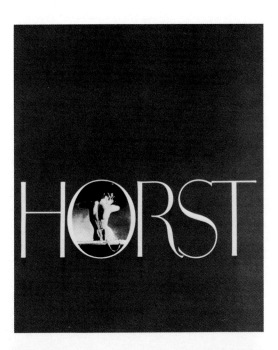

1177

Art Director	Fred Bechlen
Designer	Fred Bechlen
Writer	Leonard Lueras
Client	Emphasis International (HK) Ltd.
Editor	Leonard Lueras
Publisher	Emphasis International and Workman Publishing Co., New York, NY
Printer	Toppan Printing Company (HK) Ltd.

1178

Art Director	Ulrich Ruchti
Designers	Ulrich Ruchti, Robert C. Morrow
Photographers	David Finn, In-flight Photography, Paul Bowen
Writer	David Finn
Client	George Ablah
Editor	Caroline Goldsmith
Publisher	George Ablah
Agency	RF&R Design, New York, NY

1179

Art Director	Louise Fili, New York, NY
Designer	Louise Fili
Artist	John Heartfield
Writers	James Fraser, Steven Heller
Client	Fairleigh Dickinson University
Printer	Red Ink Productions

1180

Art Director	Bob Ciano
Designer	Bob Ciano
Photographer	Horst
Writer	James Watters
Editor	Carol Southern
Publisher	Clarkson Potter

1185
Gold Award

Art Director	Michael Frith
Designer	Marc Cheshire
Photographer	John E. Barrett
Writer	Henry Beard
Editors	Marc Cheshire, Jane Leventhal
Publisher	Holt, Rinehart and Winston, New York, NY
Production Manager	Karen Gillis

1186

Gold Award

Art Directors	Beau Gardner, Shelley Creech
Designer	Beau Gardner
Artists	Beau Gardner, Shelley Creech
Writer	Beau Gardner
Client	Beau Gardner
Editor	Dorothy Briley
Publisher	Lothrop Lee & Shephard, New York, NY

Silver Award

Art Director	Ken Sansone
Designer	Ken Sansone
Artist	Maurice Sendak
Writer	E.T.A. Hoffmann
Editor	Bruce Harris
Publisher	Crown Publishers, Inc., New York, NY
Production	Rusty Porter and Edward Otto

Distinctive Merit

Art Director	Karen Breslin
Designers	Karen Breslin, Craig Walden
Artist	Craig Walden
Writer	Hugh Saffel
Client	Roman Meal Company
Agency	Cole & Weber, Inc., Seattle WA

1189

Art Director Marc Cheshire
Designer Marc Cheshire
Artist Michael Hague
Editor Marc Cheshire
Publisher Holt, Rinehart and Winston,
New York, NY
Production Manager Karen Gillis

1190

Art Director Jeff Clark
Artist Fred Schrier
Writer Pat Kempton
Agency Special Project Services,
Kirtland, OH

1191

Art Director Carol Goldenberg
Designers Carol Goldenberg, Diane deGroat
Artist Diane deGroat
Writers Barbara Isenberg, Marjorie Jaffe
Editor James Giblin
Publisher Clarion Books, New York, NY
Publication Albert the Running Bear's
Exercise Book

1192

Art Director	Ursula P. Vosseler
Designer	Mary Elizabeth Molloy
Picture Editor	Charles E. Herron
Artist	John Huehnergarth
Client	Books For World Explorers
Editor	Ross Bankson
Publisher	National Geographic Society, Washington, DC
Director	Donald J. Crump
Publication	Small Inventions That Make A Big Difference

1193

Art Director	Marc Cheshire
Designer	Marc Cheshire
Artist	Michael Hague
Writer	Kathleen Hague
Editor	Marc Cheshire
Publisher	Holt, Rinehart and Winston, New York, NY
Production Manager	Karen Gillis

1194

Art Director	Rubin Pfeffer
Designer	Joy Chu
Artist	tomie dePaola
Writer	Valentine Davies
Editor	Kathleen Krull
Publisher	Harcourt Brace Jovanovich, Inc., San Diego, CA
Production Spvsr	Warren Wallerstein

1195
Gold Award

Art Directors Charles R. Gailis, Donald C. Lynn
Designers Charles R. Gailis, Kathleen Wilmes Herring
Artist Michael David Brown
Writer IRS Technical Publications Branch
Client IRS Taxpayer Service Division
Editor IRS Tax Forms and Publications Division
Publisher IRS Publishing Services Branch, Washington, DC

Silver Award

Art Director Carol Nehring
Designer Massimo Vignelli
Photographer Rosmarie Hausherr
Writer Donald Fennimore
Editor-in-Chief Gudrun Buettner
Publisher Alfred A. Knopf
Producer Chanticleer Press, Inc., New York, NY

★★★★The Knopf Collectors' Guides to American Antiques

SILVER & PEWTER

For collectors of all types of American silver, silver plate, and pewter made from Colonial times to the present. Color photographs and full descriptions of more than 450 representative objects, along with collecting tips, a price guide, and much more.
By Donald L. Fennimore

"The best guides on the market"
—*Scudder Smith*, Antiques and the Arts Weekly

Silver Award

Art Director Kay Michael Kramer
Designer William A. Seabright
Artist William C. Ober, M.D.
Client Times Mirror/Mosby College
 Publishing, St. Louis, MO
Editor Diane L. Bowen
Publisher Glenn Turner
Publication Integrated Principles of Zoology,
 Seventh Edition

1198

Silver Award

Art Director	Carol Nehring
Designer	Massimo Vignelli
Photographer	Schecter Me Sun Lee
Writer	Blair Whitton
Editor-in-Chief	Gudrun Buettner
Publisher	Alfred A. Knopf
Producer	Chanticleer Press, Inc., New York, NY

★★★★The Knopf Collectors' Guides to American Antiques

TOYS

For collectors of all types of American toys made from the mid-19th century to the present, as well as European and Japanese toys widely sold in America. Color photographs and full descriptions of 397 representative examples, along with collecting tips, a price guide, and much more.

By Blair Whitton

"The best guides on the market"

—Scudder Smith, Antiques and the Arts Weekly

1199

Art Director	Louise Hutchison
Designer	Louise Hutchison
Client	NTID at RIT Computer Science Support Department
Editors	Michael Steve, Myra Wein
Publisher	National Technical Institute for the Deaf/RIT
Agency	NTID Media Production Department, Rochester, NY
Phototypographer	Sarah Perkins

1200

Art Director	Frank Marshall
Designers	Frank Marshall, Jean Taylor
Photographer	Joe Blackburn
Client	IBM Corp.
Agency	Muir Cornelius Moore, New York, NY

1201

Art Director	Anthony L. Saizon
Designer	Anthony L. Saizon; Boston, MA
Photographer	James Scherer (Cover)
Authors	William M. Pride, O. C. Ferrell
Client	Houghton Mifflin Company, College Division
Editor	Joanne Dauksewicz
Publisher	Houghton Mifflin Company, College Division
Publication	Marketing, Basic Concepts and Decisions, Fourth Edition
Production Coordinator	Leslie K. Olney

1202

Art Director/Designer	Karen Tureck
Cover Co-designer	Renee Kilbride Edelman
Cover Photographer	Karen Leeds
Interior Photography	Michael Heron
Photo Editor	Mary Ann Drury
Publisher	McGraw-Hill Book Company, Gregg Division, New York, NY

1203

Art Director	Kay Michael Kramer
Designer	William A. Seabright
Artist	Sue Solomon Seif
Client	Times Mirror/Mosby College Publishing, St. Louis, MO
Editor	Diane L. Bowen
Publisher	Glenn Turner
Publication	General Microbiology

Gold Award

Art Directors	Julio Blanco, Al Blanco
Designer	Michael Fineman
Photographer	Michael Fineman
Writer	Julio Blanco
Publisher	Al Garcia-Serra
Agency	Garcia-Serra & Blanco Advertising, Coral Gables, FL

Art Director Louise Fili
Designer Louise Fili
Client Pantheon Books
Editor Sara Bershtel
Publisher Pantheon Books, New York, NY

1206
Silver Award

Art Director	Tamar Cohen
Designer	Tamar Cohen
Client	Ex Libris, New York, NY
Printer	Red Ink

1207

Art Director	Swami Jivan Mahasubh
Designers	Swami Jivan Mahasubh, Don Rood
Photographer	Christopher Newbert
Client	Beyond Words
Publisher	Beyond Words
Agency	Rickabaugh Design, Portland, OR
Calligraphy	Tim Girvin

1208

Art Director	Sara Eisenman
Designer	Sara Eisenman
Photographer	Horst
Writer	Valentine Lawford
Client	Alfred A. Knopf
Editor	Victoria Wilson
Publisher	Alfred A. Knopf, New York, NY

1209

Art Director	Jackie Merri Meyer, New York, NY
Designer	Jackie Merri Meyer
Artist	John James Audubon
Publisher	Macmillan Publishing Company
Calligrapher	Bernard Maisner

1210

Art Director	Robert Anthony
Designer	Robert Anthony
Artist	James E. Tennison
Client	Society of Illustrators, Inc.
Editor	Art Weithas
Publisher	Madison Square Press, Inc., New York, NY
Publication	The Society of Illustrators 25th Annual of American Illustration

1211

Art Director Robert Reed
Designer Robert Anthony
Photographer Charles Gatewood, Magnum
Client Holt, Rinehart and Winston
Publisher Holt, Rinehart and Winston
Agency Robert Anthony, Inc., New York, NY

1212

Art Director Gael Dillon
Designer Paul Hardy
Agency Paul Hardy Editorial Design,
New York, NY

1213

Art Director Samuel N. Antupit
Designer Raymond P. Hooper
Writer Tony Thomas
Editors Margaret L. Kaplan, Lory Frankel
Publisher Harry N. Abrams, Inc., New York, NY

1214

Art Director Neil Stuart
Designer Neil Stuart
Publisher Viking/Penguin, New York, NY

1215

Art Director	Barbara J. Schneider
Designer	Russell Schneck
Editors	Jane Steinmann, John Nolan
Publisher	Scott, Foresman and Company, Glenview, IL

1216

Art Directors	Andy Carpenter, Lee Wade
Artist	Michael Sabanosh
Writer	Susannah Kells
Client	St. Martin's Press
Editor	Hope Dellon
Publisher	St. Martin's Press, New York, NY

1217

Art Directors	Kiyoshi Kanai, Gael Dillon
Designer	Kiyoshi Kanai
Photographer	Malcolm Baron
Writer	Inger McCabe Elliot
Client	Clarkson & Potter
Editor	Carol Southern
Publisher	Clarkson & Potter
Agency	Kiyoshi Kanai, Inc., New York, NY

1218

Art Director	Marc Alain Meadows
Designers	Marc Meadows, Robert Wiser
Artist	Robert Wiser
Writer	William Lebovich/Historic American Buildings Survey
Client	Preservation Press/National Trust for Historic Preservation
Editors	Diane Maddex, Gretchen Smith
Publisher	Preservation Press
Agency	Meadows & Wiser, Washington, DC

1219

Art Director	Frank Metz
Designer	Robert Anthony
Photographer	Anthony Loew
Client	Simon and Schuster
Publisher	Simon and Schuster
Agency	Robert Anthony, Inc., New York, NY

1220

Art Directors	Debra McQuiston, Don McQuiston
Designer	Debra McQuiston
Photographer	Pat O'Hara
Writer	Tim McNulty
Client	Woodlands Press
Publisher	Woodlands Press
Agency	McQuiston & Daughter, Inc., Del Mar, CA
Publication	Olympic National Park: Where the Mountain Meets the Sea

1221

Art Director	Ronald Kovach
Designer	Paul De Lapa
Photographer	Richard Izui
Artist	Jacqueline Motooka
Writer	Kathleen Casper
Client	Alexander Communications
Editor	Kathleen Casper
Publisher	Paul A. Casper
Agency	Kovach Associates, Inc., Chicago, IL
Publication	Chicago Flash/The Annual Report

1222

Art Director	Louise Fili
Designer	Louise Fili
Photographer	Cindy Siterman
Client	Pantheon Books
Editor	Nan Graham
Publisher	Pantheon Books, New York, NY

1223

Art Director Tamar Cohen
Designer Tamar Cohen
Photographer Tamar Cohen
Client Ex Libris, New York
Printer Red Ink

1224

Art Director Michael David Brown
Designers Michael David Brown, Barbara Raab
Artist Michael David Brown
Client ASHE-ERIC
Agency Michael David Brown, Rockville, MD

1225

Art Director Dorothy Wachtenheim
Designer Robert Anthony
Photographer Anthony Loew
Client Arbor House
Publisher Arbor House
Agency Robert Anthony, Inc., New York, NY

1226

Art Director Neil Stuart
Designer Neil Stuart
Artist Robert Shine
Publisher Viking/Penguin, New York, N.Y.

1227

Art Director Andy Carpenter
Designer Brad Clarke
Artist Brad Clarke
Writer Graham Masterton
Client St. Martin's Press
Editor Tom McCormack
Publisher St. Martin's Press, New York, NY

1228

Art Directors Marc Alain Meadows, Robert L.
 Wiser
Designer Marc Alain Meadows
Artist Robert Wiser
Writer Andrew Gulliford
Client Preservation Press/National Trust for
 Historic Preservation
Editors Diane Maddex, Gretchen Smith
Publisher Preservation Press
Agency Meadows & Wiser, Washington, D.C.

1229

Art Director Peter G. Millward
Designers Ruth G. Millward, Jaap Drost
Photographer Louisiana Department of Culture,
 Recreation and Tourism
Client Louisiana Association of Museums
Editor D. Kay Evans Casey
Agency Millward and Millward Graphic
 Design, Baton Rouge, LA

1230

Art Director Steven Hoffman, New York, N.Y.
Designer Steven Hoffman
Writer Marguerite Yourcenar
Client PAJ Publications
Editor Bonnie Marranca
Publisher Gautam Dasgupta

1231

Art Director Neil Stuart
Designer Neil Stuart
Photographer Jim McGuare
Publisher Viking/Penguin, New York, N.Y.
Type Mark Cohen

1232

Art Director Robert Anthony
Designer Robert Anthony
Artist Norman Rockwell
Client Dr. David Stoltz and Marshall Stoltz
Editor Arpi Ermoyan
Publisher Madison Square Press, Inc.,
New York, N.Y.
Publication The Advertising World of Norman
Rockwell

1233

Art Director Dorothy Wachtenheim
Designer Dorothy Wachtenheim
Artist Viido Polikarpus
Publisher Arbor House, New York, NY

1234

Art Director Louise Fili
Designer Louise Fili
Photographer Irwin Horowitz
Client Pantheon Books
Editor Sara Bershtel
Publisher Pantheon Books, New York, NY

1235

Art Director Susan Sands
Designers Larry McEntire, Bill Grimes
Artists Patti J. Bishop, Larry McEntire
Writer Frank Giordano
Client Texas Monthly Press
Publisher Texas Monthly Press
Agency Lonestar Studio, Austin, TX

1236

Art Director Dorothy Wachtenheim
Type Designer Dick Smith
Artist Roxie Munro
Publisher Arbor House, New York, N.Y.

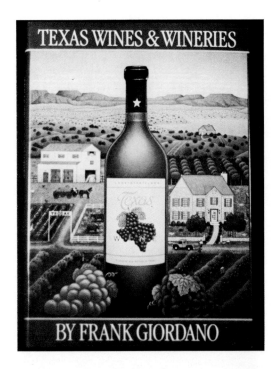

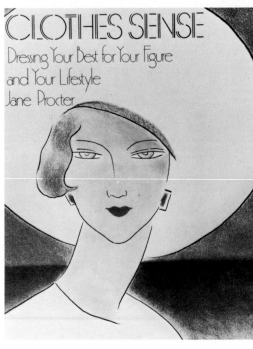

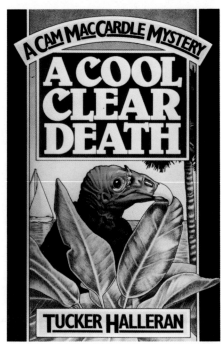

1237

Art Director Alex Gotfryd
Artist Leland Neff
Editor Anne Sweeney
Publisher Doubleday & Co. Inc., New York, NY
Publication Clothes Sense
Typographic Design Casey Koh

1238

Art Director Andy Carpenter
Designer Tom McKeveny
Artist Tom McKeveny
Writer Tucker Halloran
Client St. Martin's Press
Editor Tom Dunne
Publisher St. Martin's Press, New York, NY

1239

Art Director Judith Loeser
Designer Nicholas Gaetano
Artist Nicholas Gaetano
Client Vintage Books
Editor Anne Freegood
Publisher Random House, New York, NY

1240

Designer Ann Marra
Artist Ann Marra
Client Colin Dobson, Ensemble
Publications, Inc.
Agency Marra & Associates Graphic Design,
Portland, OR

1241

Art Director Ronald S. Waife
Designer Cheryl Heller
Publisher Codex Corporation, Mansfield, MA
Agency HBM/Creamer

1242

Art Director Michael Mabry
Designers Michael Mabry & Peter Soe Jr.
Artist Michael Mabry
Client Citizens Utilities Company of
California
Agency Michael Mabry Design,
San Francisco, CA

1243

Art Director Jessica Weber
Artist Joan Hall
Client Martin, Asher, Director Quality
Paperback Book Club
Editor Alice van Straalen, Director Special
Projects
Publisher Book-of-the-Month-Club, Inc.,
New York, NY

1244

Art Director Judith Loeser
Designer Nicholas Gaetano
Artist Nicholas Gaetano
Client Vintage Books
Editor Anne Freedgood
Publisher Random House, New York, NY

1245

Art Director J Porter
Designer J Porter
Photographer Ulrike Welsch
Writer Ulrike Welsch
Client Yankee Books, Dublin, NH
Editor Sharon Smith
Publisher Richard Heckman

1246

Art Director Tom Poth
Designer Melinda Williams
Photographer Tomas Pantin
Client Texas Monthly Press
Agency HIXO, Inc., Austin, TX

1247

Art Director	Frank Metz
Designers	John Condon, Mary Condon
Publisher	Simon & Schuster
Agency	J & M Condon, Inc., New York, NY
Publication	Hitchock/Truffaut

1248

Art Directors	Bill Fong, Leo Gonzalez
Designer	Leo Gonzalez
Photographer	Douglas Peebles
Artist	Ron Hudson (airbursh)
Writer	Ronn Ronck
Client	Mutual Publishing Company of Honolulu
Publisher	Mutual Publishing Company of Honolulu
Agency	The Art Directors, Inc., Honolulu, HI
Calligraphy	Leo Gonzalez
Printer	Toppan Printing Co., Tokyo

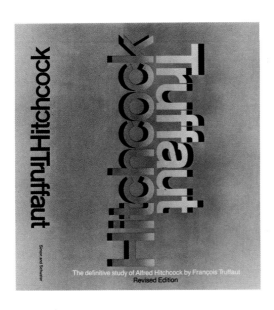

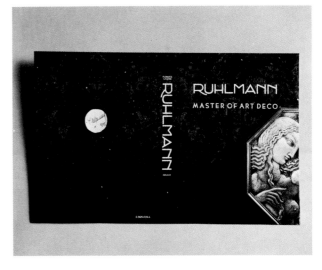

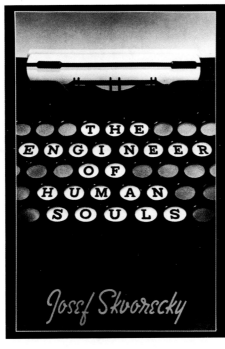

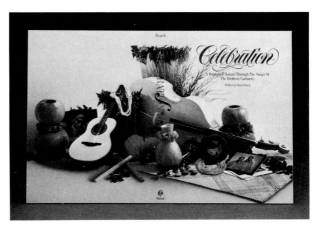

1249

Art Director	Sara Eisenman
Designer	Fred Marcellino
Artist	Fred Marcellino
Writer	Josef Skvorecky
Client	Alfred A. Knopf
Editor	Barbara Bristol
Publisher	Alfred A. Knopf, New York, NY

1250

Designer	Samuel N. Antupit
Writer	Florence Camard
Editors	Nora Beeson, Marti Malovany
Publisher	Harry N. Abrams, Inc., New York, NY

1251

Art Director	Rubin Pfeffer
Designer	Paul Gamarello
Editor	Julian Muller
Publisher	Harcourt Brace Jovanovich, Inc., San Diego, CA

1252

Art Director	John Newcomb, Stamford, CT
Designer	John Newcomb
Photographer	Carol Sollecito
Writer	John Newcomb
Client	The R.R. Bowker Company (Xerox, Inc.)
Editor	Betty Sun
Publisher	The R.R. Bowker Company (Xerox, Inc.)

1253

Art Director	Judith Loeser
Designer	Nicholas Gaetano
Artist	Nicholas Gaetano
Client	Vintage Books
Editor	Anne Freedgood
Publisher	Random House, New York, NY

1254

Art Director	Randall Hensley
Designers	Randall Hensley, Debbie Hahn
Clients	Lee Green, Gary Conrad—IBM Corp, Entry Systems Division
Agency	Muir Cornelius Moore, New York, NY

Art Directors Philip Waugh, Arthur Eisenberg
Designer Philip Waugh
Artist Jim Darnell
Client Dr Pepper
Agency Pharr Cox Communications,
Dallas, TX
Design Studio Eisenberg Inc., Dallas, TX

Art Director John Sposato
Designer John Sposato
Photographer Rick Davis
Client Villard Books
Publisher Villard Books
Agency John Sposato, New York, NY

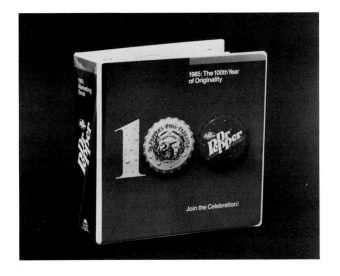

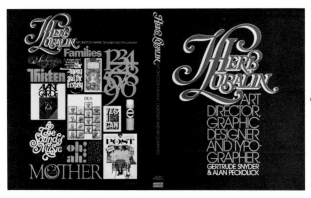

1257

Art Director Jim Davis
Photographer Susan Wood
Client Crown Books, New York, NY

1258

Art Director Alan Peckolick
Designer Alan Peckolick
Writers Gertrude Snyder, Alan Peckolick
Publisher American Showcase, New York, NY

1259

Art Director R.D. Scudellari
Designer R.D. Scudellari
Writer Gennady Smakov
Client Alfred A. Knopf
Editor Susan Ralston
Publisher Alfred A. Knopf/Random House,
New York, NY
Calligraphy Vladimir Yevtikhiev

1260

Art Director R.D. Scudellari
Designer R.D. Scudellari
Writer John Rockwell
Client Random House
Editor Erroll McDonald
Publisher Random House, New York, NY
Lettering Vladimir Yevtikhiev

1262

Art Director Karen Tureck
Designer Nancy Axelrod Sharkey
Photographer Robert Wolfson
Publisher McGraw-Hill Book Company, Gregg
Division, New York, NY

Distinctive Merit

Art Director Simms Taback
Designer Simms Taback
Artist Simms Taback
Writer Harriet Ziefert
Client Grosset & Dunlap
Editor Bernette Ford
Publisher Grosset & Dunlap/Putnam
Publishing Group, New York, NY

1263

Gold Award

Art Director Andrew Kner
Designer Andrew Kner
Artist Judy Pedersen
Writers Teresa Reese, Edward K. Carpenter,
Tom Goss
Client RC Publications
Editor Martin Fox
Publisher Howard Cadel
Publication Print Casebooks 6, New York, NY

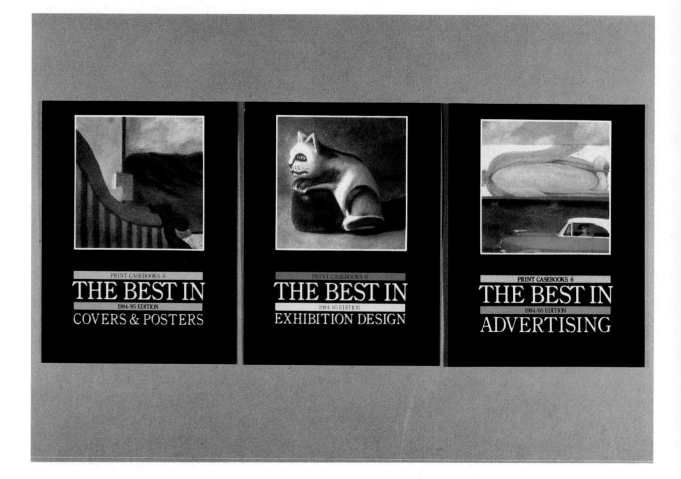

1264
Gold Award

Art Director	Judith Loeser
Designer	Nicholas Gaetano
Artist	Nicholas Gaetano
Publisher	Vintage/Random House, New York, NY
Agency	Nicholas Gaetano
Printer	Longacre Press

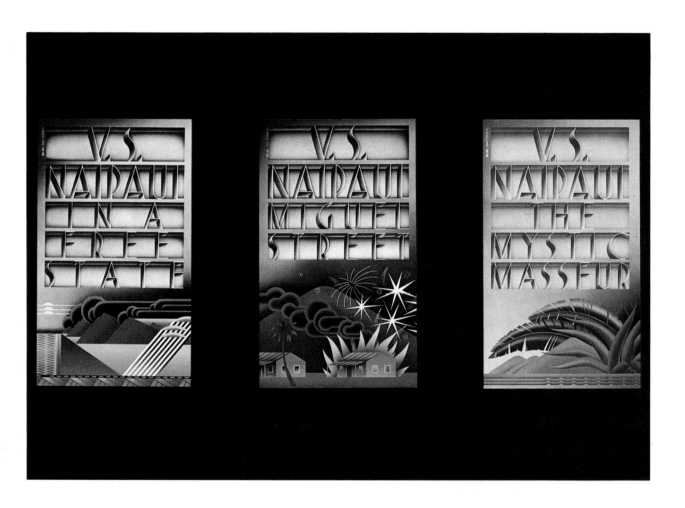

1265

Art Director Louise Fili
Designer Louise Fili
Photographer Christine Rodin
Client Pantheon Books
Editor Helena Franklin
Publisher Pantheon Books, New York, NY

1266

Art Director Milton Charles
Designers John Condon, Mary Condon
Artist David FeBland
Publisher Pocketbooks Inc., New York, NY

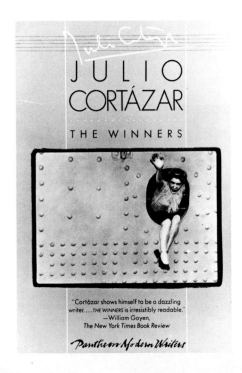

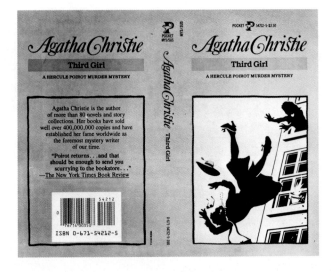

1267

Art Director Rubin Pfeffer
Designer Paul Gamarello
Client Harcourt Brace Jovanovich
Publisher Harcourt Brace Jovanovich
Agency Eyetooth Design Inc., New York, NY

1268

Art Directors	Mike Stromberg, Frank Kozelek
Designer	Mike Stromberg
Photographer	Cosimo Sciana
Artist	James Lebbad
Client	Berkley Books
Publisher	Berkley Books, New York, NY

1269

Art Director	R.D. Scudellari
Designer	R.D. Scudellari
Artist	Stephen Alcorn
Writers	Lord Byron, Gore Vidal, Anatole France
Client	Modern Library, Random House
Editor	John Glusman
Publisher	Modern Library, Random House, New York, NY

Posters (single entries): Outdoor (billboard)
Transit (bus, subway or shelter)
Public service or political
In-store, promotional, etc.
Campaign entries: Outdoor campaign
Transit campaign
Public service or political campaign
In-store, promotional campaign

1270

Gold Award

Art Director	Wes Keebler
Writer	Chuck Silverman
Client	Tahiti Tourism Promotion Board/UTA
	French Airlines
Creative Director	Chuck Siverman
Agency	Cunningham & Walsh, Fountain
	Valley, CA
Production Manager	Jill Heatherton

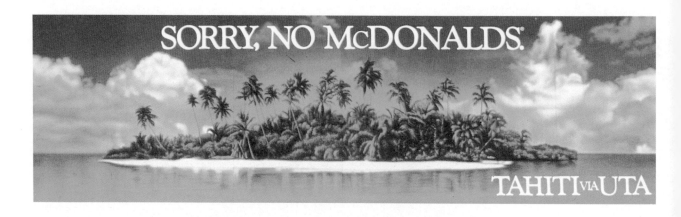

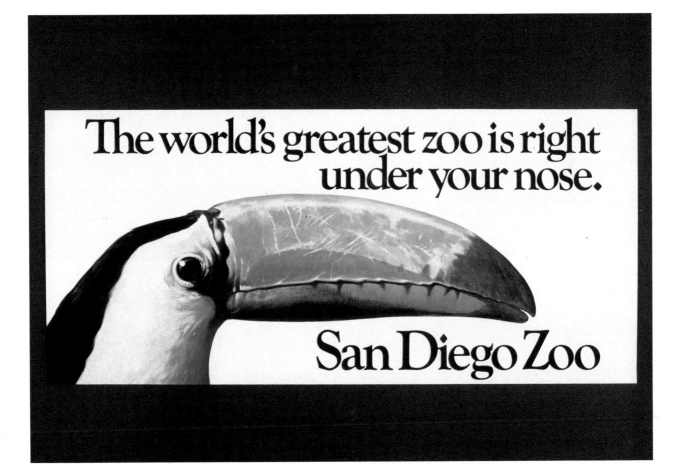

1272

Art Director	Dick Behm
Designer	Dick Behm
Photographer	Feldkamp-Malloy
Writer	John Brinkerhoff
Client	LK Restaurants & Motels
Agency	Lord, Sullivan & Yoder, Marion, OH

1273

Art Director	Peter Weir
Photographer	Al Satterwhite
Writer	Pat Hudson
Client	American Express
Agency	Ogilvy & Mather Advertising, New York, NY
Creative Director	Tom Rost

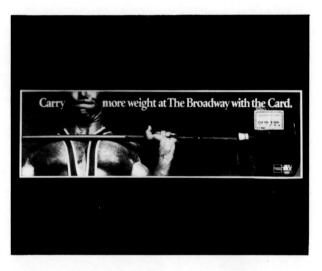

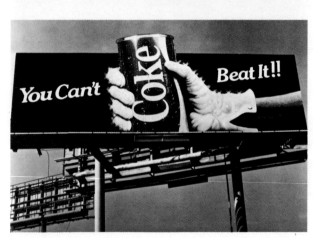

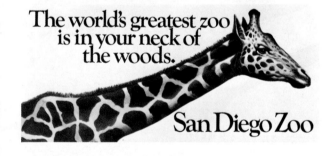

1274

Art Director	Mark Wood
Designer	Jim Wood
Artist	Jack Jones
Writer	James O. Kennedy
Client	Houston Coca-Cola Bottling Company
Agency	Miller-Reid, Inc., Chattanooga, TN

1275

Art Director	Bob Kwait
Designer	Bob Kwait
Artist	Darrel Millsap
Writer	Bob Kwait
Client	The San Diego Zoo
Agency	Phillips-Ramsey, San Diego, CA
Production Artist	Ronnie Van Buskirk

1276

Art Director Danny Boone
Designer Danny Boone
Artist Teresa Fasolino
Writer Mike Hughes
Client Barnett Banks of Florida
Agency The Martin Agency, Richmond, VA
Creative Director Harry Jacobs

1277

Art Director Audrey Satterwhite
Designer Audrey Satterwhite
Photographer Patrice Casanova
Client David Sonenberg
Agency White Ink, Inc., New York, NY
Makeup/Body Design Helene Guetary

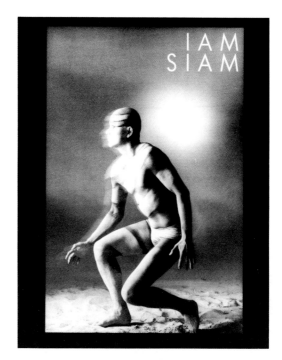

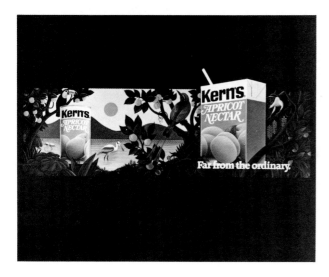

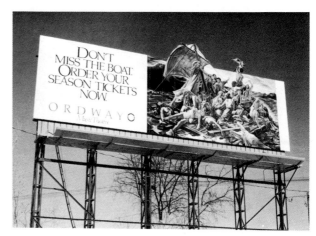

1278

Art Directors Caron Perkal, Diana Daniels
Artist Bob Giusti
Writer Debbie Schwartz
Client Kern Foods
Agency Grey Advertising, Los Angeles, CA
Creative Director Alan Kupchick

1279

Art Director Dick Green
Designer Dick Green
Artist Naegele Outdoor
Writers Dick Green, Maureen Fischer, Glenn
 Karwoski
Client Ordway Music Theatre
Agency Paragon Advertising,
 Minneapolis, MN

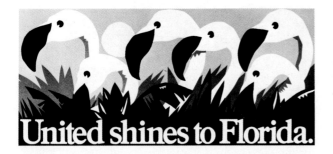

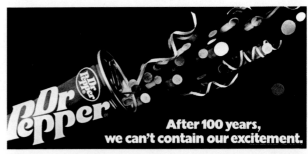

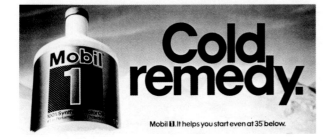

1284

Art Director	Scott DuChene
Writers	Bob Murphy, Vashti Brotherhood, Peter Nichols
Client	The Museum of Fine Arts
Agency	HHCC, Boston, MA

1285

Art Director	Bob Kwait
Designer	Bob Kwait
Artist	Darrel Millsap
Writer	Bob Kwait
Client	The San Diego Zoo
Agency	Phillips-Ramsey, San Diego, CA
Production Artist	Ronnie Van Buskirk

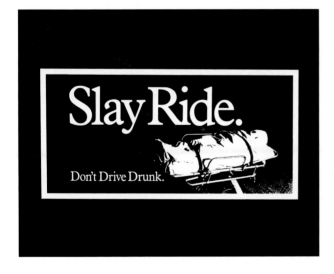

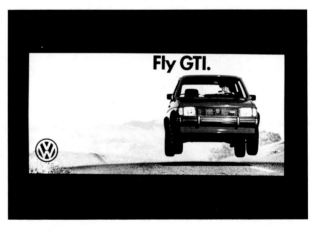

1286

Art Director	William Oakley
Designer	William Oakley
Photographer	David Gold Photography, Inc. St. Louis
Writer	Michael Smith
Client	Victims of Drunk Driving
Agency	William Oakley, St. Louis, MO

1287

Art Director	Stan Jones
Designer	Stan Jones
Photographer	Jeff Nadler
Writer	Brandt Irvine
Client	So. California Volkswagen Dealers Association
Agency	Doyle Dane Bernbach, Los Angeles CA
Production Manager	Paul Newman

1288

Art Director	Phil Milano
Designer	Phil Milano
Photographer	Gill Cope
Writer	Dick Wasserman
Client	Amtrak
Agency	Needham Harper Worldwide, Inc. New York, NY

1289

Art Director	Darryl Shimazu
Writer	Elaine Cossman
Client	Palm Springs Convention & Visitors Bureau
Agency	Gumpertz/Bentley/Fried, Los Angeles, CA

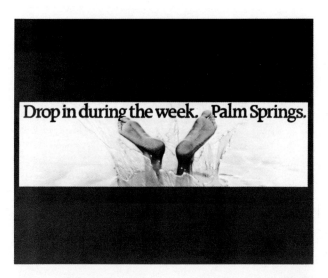

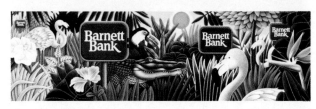

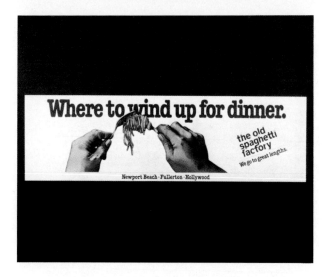

1290

Art Director	Vance Smith
Designer	Vance Smith
Artist	Michael Cacy
Writer	Tom Wiecks
Client	Old Spaghetti Factory
Agency	Wagner, Wiecks, Smith & Lapel, Portland, OR

1291

Art Director	Danny Boone
Designer	Danny Boone
Artist	Jackie Geyer
Writer	Mike Hughes
Client	Barnett Banks of Florida
Agency	The Martin Agency, Richmond, VA
Creative Director	Harry Jacobs

1292

Art Director Jim Hallowes
Designer Jim Hallowes
Photographer Carl Furuta
Writer Peter Brown
Client Tropicana Hotel
Agency Doyle Dane Bernbach/Los Angeles,
Los Angeles, CA
Production Manager Barry Brooks

1293

Art Director Vance Smith
Designer Vance Smith
Artist Michael Cacy
Writer Tom Wiecks
Client Old Spaghetti Factory
Agency Wagner, Wiecks, Smith & Lapel,
Portland, OR

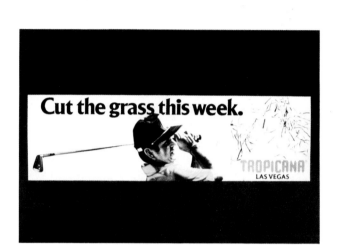

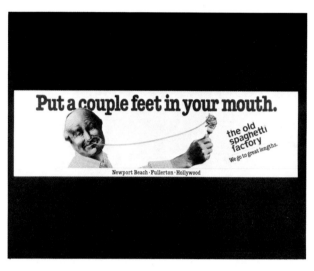

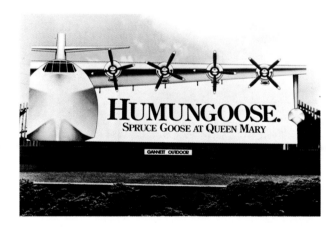

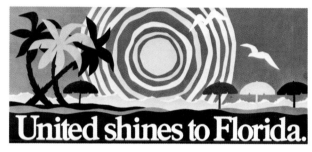

1294

Art Director Darrell Lomas
Artist Dan Long
Writer Harry Woods
Client Wrather Port Properties
Creative Director Chuck Silverman
Agency Cunningham & Walsh,
Fountain Valley, CA
Production Manager Jill Heatherton

1295

Art Director Mary Martin
Writer Jeff Sherman
Client United Airlines
Agency Leo Burnett Co., Inc., Chicago, IL
Creative Director Bud Watts

1296

Art Director Ernie Cox
Writer Allen Cohn
Client Illinois Bell, Bob Campbell
Agency N.W. Ayer, Chicago, IL
Creative Director Allen Cohn

1297

Art Director Dick Loader
Artist McNamara Associates,
Gary Ciccarelli
Client WRBQ
Agency Ensslin & Hall Advertising, Inc.,
Tampa, FL
Creative Director Keith D. Gold

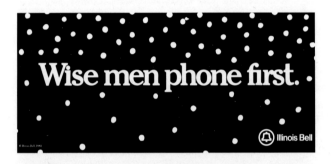

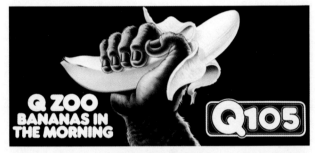

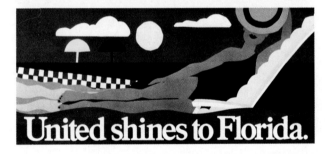

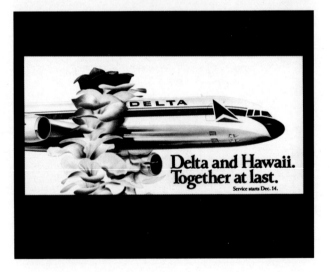

1298

Art Director Mary Martin
Writer Jeff Sherman
Client United Airlines
Agency Leo Burnett Co., Inc., Chicago, IL
Creative Director Bud Watts

1299

Art Director Bill Sowder
Client Delta Air Lines
Agency BDA/BBDO, Inc., Atlanta, GA

We're free Wednesday nights, if you are.

Admission is free at the de Young Museum Wednesday evenings from May 16 through August 29. Join us for famous films, dinner in the Cafe de Young and guest lectures. Call 750-3659 for more information. The de Young Museum. Make a night of it.

Made possible by a grant from Wells Fargo Foundation.

1302

Silver Award

Art Director Tim Hanrahan
Artist Doug Smith
Writer Michael Ward
Client The Boston Museum of Science
Agency HBM/Creamer, Boston, MA

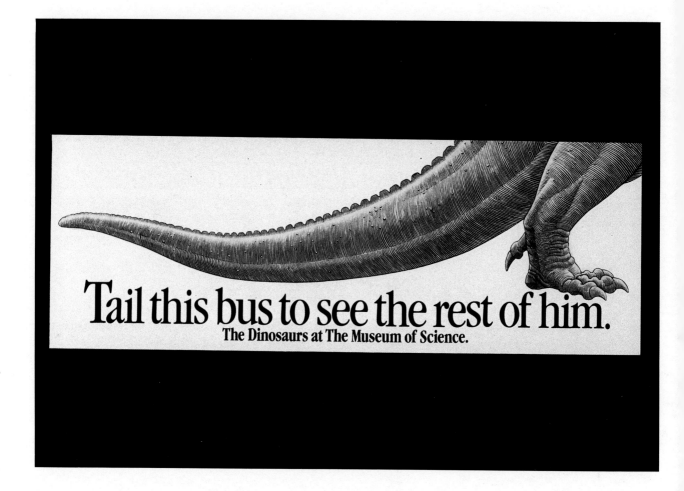

1303
Distinctive Merit

Art Director Bob Appleton
Designer Bob Appleton
Artist Bob Appleton
Writer Susan Grody
Client Hartford Ballet
Publisher Hartford Ballet
Agency Appleton Design, Hartford, CT

1304

Art Director	Tom Kelly
Photographers	Aaron Jones, Lis DeMarco Studios
Client	Tri-Met
Agency	Borders, Perrin & Norrander, Inc., Portland, OR

1305

Art Directors	Nick Nappi, Frank Verlizzo
Designer	Larry Ashton
Artist	Larry Ashton
Writer	Nancy Coyne
Clients	Peek, Herrick, Ezzes and Circle Repertory
Agency	Serino, Coyne and Nappi, New York, NY
Account Executive	Michelle Hale

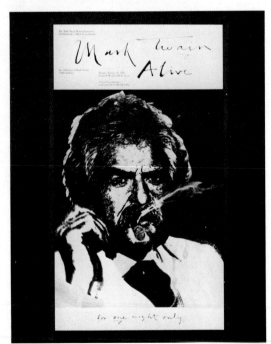

1306

Art Director	Paul Davis
Artist	Paul Davis
Client	New York Shakespeare Festival
Director	Joseph Papp
Agency	Paul Davis Studio, New York, NY

1307

Art Director	Bob Appleton
Designer	Bob Appleton
Artist	Bob Appleton
Writer	Susan Grody
Client	Heublein, Inc.
Publisher	Heublein, Inc.
Director	Erik Pierce, Heublein, Inc.
Agency	Appleton Design, Hartford, CT

1308

Art Director	Milton Glaser
Designer	Milton Glaser
Photographer	Matthew Klein
Writer	Milton Glaser
Clients	Bill Freeland, LaGuardia Communications
Agency	LaGuardia Communications, Long Island City, NY
Printer	K Graphics

1309

Art Director	Frank "Fraver" Verlizzo
Designer	Frank "Fraver" Verlizzo
Artist	Frank "Fraver" Verlizzo
Writer	Nancy Coyne
Client	The Shubert Organization
Agency	Serino, Coyne and Nappi, New York, NY
Account Executives	Matthew Serino, Linda Lehman

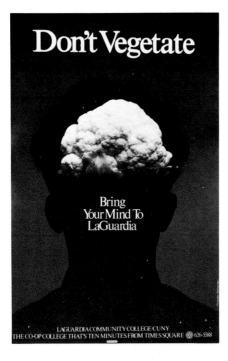

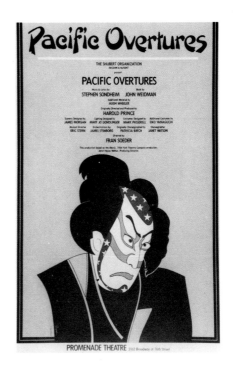

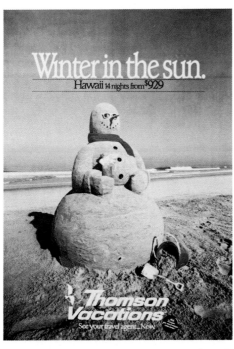

1310

Art Director	Jeff Layton
Designer	Jeff Layton
Photographer	Yuri Dojc
Artist	Jeff Layton
Writer	Mark Levine
Client	Thomson Vacations
Agency	Grey Advertising Ltd., Toronto, Canada
Sand Sculpture	Sand Sculptures International

1311

Art Director	Paul Davis
Designer	Paul Davis
Artist	Paul Davis
Client	Mobil Corporation
Director	Sandra Ruch
Agency	Paul Davis Studio, New York, NY

Gold Award

Art Director	Steff Geissbuhler
Designer	Steff Geissbuhler
Artist	Steff Geissbuhler
Clients	Alvin Ailey American Dance Theater, Alvin Ailey, Artistic Director, Bill Hammond, Executive Director
Agency	Chermayeff & Geismar Associates, New York, NY

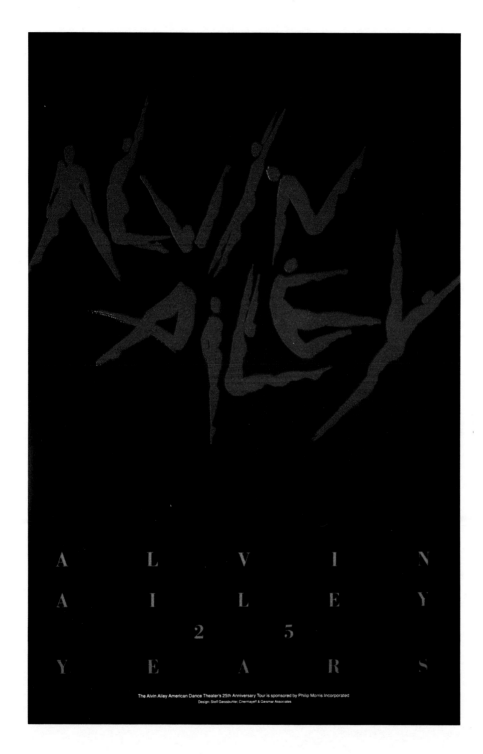

1317
Distinctive Merit

Art Director	Doug Lew
Designer	Doug Lew
Writer	Bob Thacker
Client	Minneapolis Institute of Arts
Agency	Chuck Ruhr Advertising, Minneapolis, MN
Publication	Minnesota Transtop

1318

Distinctive Merit

Art Director Doug Lew
Designer Doug Lew
Writer John Jarvis
Client Minneapolis Institute of Arts
Agency Chuck Ruhr Advertising,
 Minneapolis, MN
Publication Minnesota Transtop

1319

Art Director Bob Barrie
Artist Bob Barrie
Writer Phil Hanft
Client Women Against Military Madness
Agency Fallon McElligott Rice, Minneapolis,
 MN

1320

Art Director Franklin J. Ross
Designer Franklin J. Ross
Artist Ginny G. Ross
Client Younger Womans Club of Louisville
Agency Franklin Ross + Associates,
 Louisville, KY

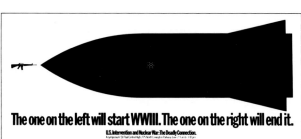

The one on the left will start WWIII. The one on the right will end it.

U.S. Intervention and Nuclear War: The Deadly Connection.

TALLY HO THE FOX

Without a smoke alarm
you may not get a chance
to call for help.

Smoke Alarms
The New York Fire Dept.

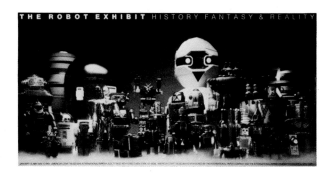

THE ROBOT EXHIBIT HISTORY FANTASY & REALITY

1321

Art Director Marc Surrey
Designer Marc Surrey
Photographer Andy Schweitzer
Writer Marc Surrey
Client New York Fire Department, Jim
 Harding, Commissioner
Publisher Maxwell Graphics
Agency Dancer Fitzgerald Sample, New York,
 NY
Assoc. Creative Director Patti Mullen

1322

Art Director Massimo Vignelli
Designer David Dunkelberger
Photographer Brad Guice
Clients American Craft Museum II,
 International Paper Company
Design Firm Vignelli Associates, New York, NY

1323

Art Director	Mark Steele
Designer	Tom Hough
Writer	Lori Zimring
Client	Dallas Symphony Orchestra
Agency	Dallas Times Herald Promotion Art, Dallas, TX
Calligraphy	Tom Hough

1324

Art Director	Christina Weber
Designer	Gail Slatter
Artist	Denise Moore
Client	Encore! 84 Denver Symphony Orchestra
Agency	Weber Design, Denver, CO

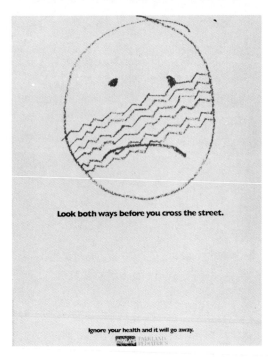

1325

Art Directors	Susan Rogers, Arthur Eisenberg
Designer	Susan Rogers
Artist	Susan Rogers
Writer	Susan Rogers, Phil Waugh
Client	Parkland Pediatrics
Design Studio	Eisenberg Inc., Dallas, TX

1326

Art Director	John Rieben, Chicago, IL
Designer	John Rieben
Photographers	Various
Artist	Carol Townsend
Writer	Jacquelyn Lloyd
Client	AT&T

1327

Art Director	Sheryl Nelson Lauder
Designer	Franklin J. Ross
Artist	Sheryl Nelson Lauder
Client	Association of the Louisville Orchestra
Agency	Franklin Ross + Associates, Louisville, KY

1328

Art Director	Mark Fuller
Photographer	Bob Jones, Jr.
Writer	Mac Calhoun
Client	Richmond Metropolitan Authority
Agency	Finnegan & Agee, Inc., Richmond, VA
Retouching	Charlie Sheffield

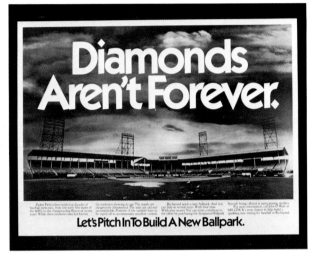

1329

Art Director	Warren Eakins
Writer	Bill Borders
Client	Friends of Pioneer Courthouse Square
Agency	Borders, Perrin & Norrander, Inc., Portland, OR

1330

Art Director	Woody Pirtle
Designer	Woody Pirtle
Artists	Woody Pirtle, Mike Schroeder
Writer	Shakespeare Festival of Dallas
Client	Shakespeare Festival of Dallas
Agency	Pirtle Design, Dallas, TX
Creative Director	Woody Pirtle

1331

Art Directors	Robert Meyer, Julia Wyant
Designer	Julia Wyant
Artist	unknown
Client	International Museum of Photography at George Eastman House
Agency	Robert Meyer Design, Inc., Rochester, NY
Printer	Canfield & Tack, Inc.

1332

Art Directors	Gail Stampar, Michael Aron
Designer	Gail Stampar
Artist	Gail Stampar
Client	Sandy Weitz/City University of New York
Studio	Pushpin Lubalin Peckolick, New York, NY

1333

Art Directors	Paul Black, Jeff Podlesak
Designer	Paul Black
Photographer	Katherine Snedeker
Artist	Barsamian
Creative Director	Bill Hill
Client	Bronx Museum of the Arts
Production	Jacky Travis
Agency	Levenson, Levenson & Hill Adv., Dallas, TX
Printer	Brodnax Printing

1334

Art Director	William Longhauser
Designer	William Longhauser
Client	AIGA/Philadelphia, PA
Agency	William Longhauser Design, Philadelphia, PA

1335

Art Director	Louise Kollenbaum
Designer	Dian-Aziza Ooka
Artist	Matt Mahurin
Publisher	Mother Jones Magazine, San Francisco, CA
Publication	Mother Jones

1336

Art Director	William Longhauser
Designer	William Longhauser
Artist	William Longhauser
Client	Graphic Design Department/ Philadelphia Colege of Art
Agency	William Longhauser Design, Philadelphia, PA

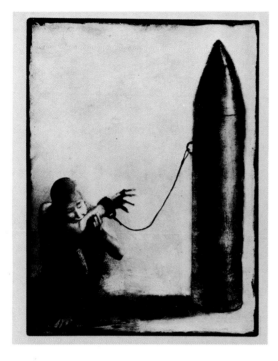

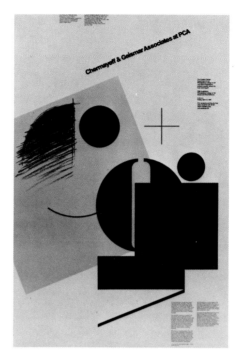

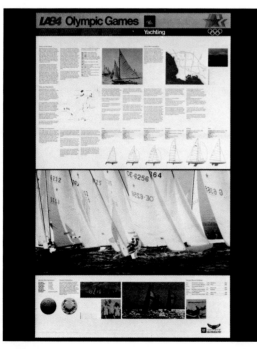

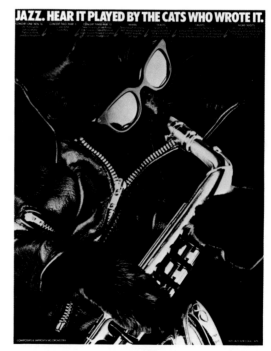

1337

Art Director	John Rieben, Chicago, IL
Designer	John Rieben
Photographer	Karin Olson
Artist	Carol Townsend
Writer	Jacquelyn Lloyd
Client	AT&T

1338

Art Director	Geoffrey B. Roche
Designer	Geoffrey B. Roche
Photographer	Chuck Kuhn
Writer	Kirk Citron
Client	Composers & Improvisors Orchestra
Agency	Citron Roche Assoc., San Francisco, CA

1339

Art Director	Ethel Kessler
Designer	Ethel Kessler
Artist	Patricia Fahie (ceramist)
Client	Smithsonian Institution/Women's Committee
Agency	Ethel Kessler Design, Inc., Washington, DC
Printer	Virginia Lithograph

1340

Art Director	Pat Day Lambert
Artist	Gary Gowans
Client	City of St. Petersburg, FL
City Manager	Alan N. Harvey
Mayor	Corinne Freeman

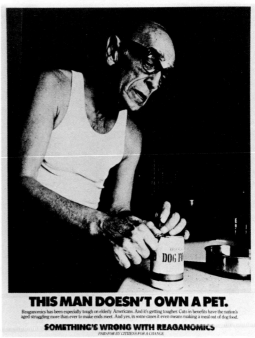

1341

Art Director	Massimo Vignelli
Designer	Michael Bierut
Artist	Michael Bierut, Letterer
Client	The Architectural League and Formica Corporation
Design Firm	Vignelli Associates, New York, NY
Creative Director for Formica	Susan Grant Lewin

1342

Art Director	Bob Marberry
Photographer	Neal Vance
Writer	Jerry Craven
Client	Americans for a Change
Agency	Marberry & Associates Ltd. Inc., Dallas, TX

1343

Art Director Bill Freeland
Designer Bill Freeland
Photographer Anonymous
Writer Bill Freeland
Client Barbara Schwarz
Agency LaGuardia Communications, Long
Island City, NY
Printer Tangent Graphics

1344

Art Director Jerry Berman
Designer Pierre Rademaker
Photographer Nikolay Zurek
Client Sales Corporation of America
Design Firm Sidjakov Berman & Gomez, San
Francisco, CA

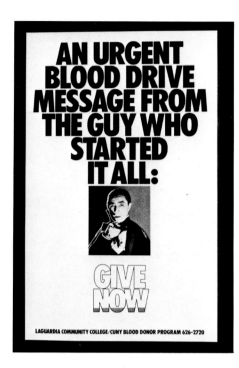

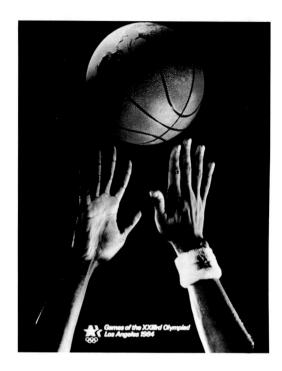

1345

Designer Sara Love
Artist Sara Love
Client Cathedral Arts, Incorporated
Agency Sara Love Graphic Design,
Indianapolis, IN

1346

Art Director Ginny G. Ross
Designer Franklin J. Ross
Artist Ginny G. Ross
Client The Younger Woman's Club of
Louisville
Agency Franklin Ross + Associates,
Louisville, KY

1347

Art Director	Nicolas Sidjakov
Designer	James Nevins
Illustrators	David Stevenson, Nicolas Sidjakov
Clients	California Printing, Bill Shilling
Design Firm	Sidjakov Berman & Gomez, San Francisco, CA

1348

Art Director	Bob Barrie
Writer	Phil Hanft
Client	Minnesota Orchestra
Agency	Fallon McElligott Rice, Minneapolis, MN

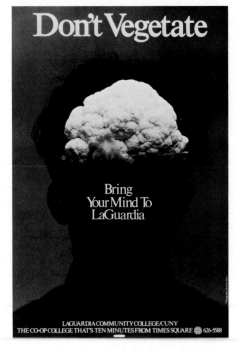

1349

Art Director	Neil Leinwohl
Photographer	Howard Berman
Writer	David Cantor
Client	National Institute on Drug Abuse
Agency	Needham Harper Worldwide, Inc., New York, NY

1350

Art Director	Milton Glaser
Designer	Milton Glaser
Photographer	Matthew Klein
Writer	Milton Glaser
Client	LaGuardia Community College, CUNY
Publisher	LaGuardia Community College
Studio	Milton Glaser Inc., New York, NY

1351

Art Director Kurt Tausche
Writer Jim Newcombe
Client Minnesotans for Reagan
Agency Bozell & Jacobs, Inc., Minneapolis,
MN

1352

Art Directors Terry Lesniewicz, Al Navarre
Designers Terry Lesniewicz, Al Navarre
Artists Lesniewicz/Navarre
Client Ronald McDonald House of
Northwest Ohio
Agency Lesniewicz/Navarre, Toledo, OH

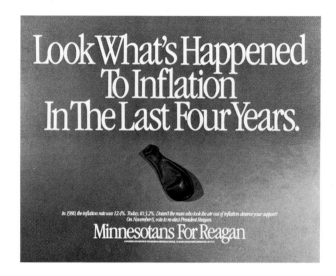

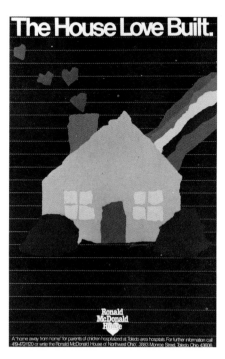

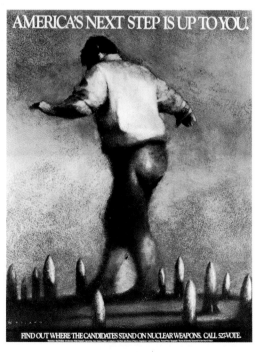

1353

Art Director Keith Campbell
Artist Brad Holland, New York, NY
Writer Steve Sandoz
Client Give Peace a Dance
Director Dick Friel
Agency John Brown & Partners

1354

Art Director James Olsen
Designer James Olsen
Photographer William Wagner
Artists Various
Writer Paul J. Schindel
Client The Newark Museum
Agency Gianettino & Meredith, Inc.,
Mountainside, NJ

1355

Art Director Stephen Miller
Designer Stephen Miller
Artist Robert Forsbach
Writer Stephen Miller
Client Dallas WhiteRock Marathon
Agency Richards Brock Miller Mitchell &
 Associates, Dallas, TX

1356

Art Director David Bartels
Designer David Bartels
Artist Gary Overacre
Writer Donn Carstens
Client Leonard J. Waxdeck/Piedmont HS
Agency Bartels & Carstens, Inc., St. Louis,
 MO
Printing Artcraft Lithographers, Inc.

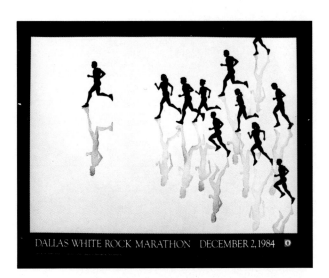

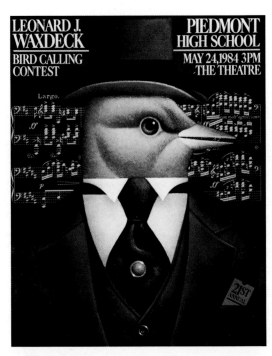

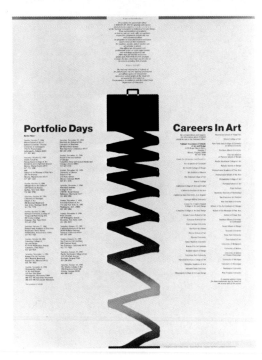

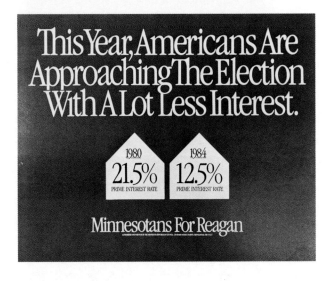

1357

Art Director Vanig Torikian
Designer Vanig Torikian
Artist Vanig Torikian
Writer Steve Weir
Client Art Center College of Design,
 Pasadena, CA

1358

Art Director Kurt Tausche
Writer Jim Newcombe
Client Minnesotans for Reagan
Agency Bozell & Jacobs, Inc., Minneapolis,
 MN

1359

Art Director	Gordon Bowman
Designer	Peter Good
Artist	Peter Good
Writer	Tom Philion
Client	United Technologies/Hartford Ballet
Agency	Peter Good Graphic Design, Chester, CT

1360

Art Director	Neil Raphan
Designer	Neil Raphan
Artist	Lou Myers
Writer	Larry Chase
Client	The Greater N.Y. Blood Bank
Agency	Doyle Dane Bernbach, New York, NY

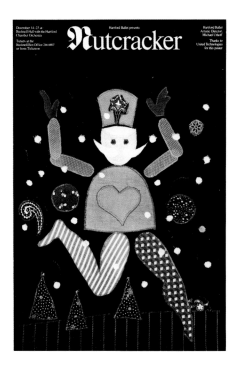

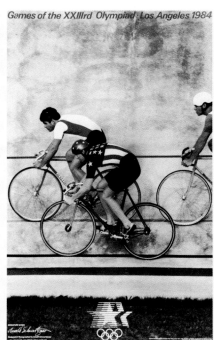

1361

Art Director	Arnold Schwartzman, Santa Monica, CA
Designer	Arnold Schwartzman
Photographer	Arnold Schwartzman
Client	Los Angeles Olympic Organizing Committee

1362

Art Director Eddie Tucker
Designer Eddie Tucker
Photographer Allen Mims
Client Blues Foundation
Agency Ward Archer & Associates, Memphis, TN
Printer Memphis Engraving Company

1363

Art Director Jo Bertone
Designers Jo Bertone, Fred Carr
Photographer Fred Carr
Writer Ginny Cade
Client The Houston Symphony
Publisher San Jacinto Graphic Center
Agency Penny & Pengra, Houston, TX
Retouching Glenn Russen

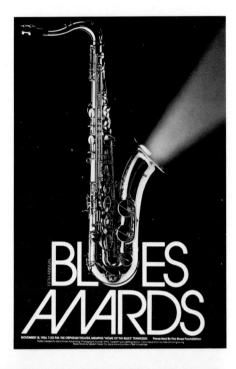

1364

Art Director Harold Burch
Designer Harold Burch
Photographer Harold Burch
Client Junior League of Pasadena
Design Firm Harold Burch Design, Fullerton, CA
Printer Sinclair Printing

1365

Gold Award

Art Director	Milton Glaser
Designer	Milton Glaser
Artist	Milton Glaser
Client	Elaine Benson Gallery
Publisher	Elaine Benson Gallery
Studio	Milton Glaser Inc., New York, NY

1366

Gold Award

Art Director Robert Cipriani
Designer Robert Cipriani
Photographer Clint Clemens
Writer Janet Wright
Client Mead Paper Corporation
Agency Cipriani Advertising, Inc., Boston, MA
Printer Lebanon Valley Offset

1367
Silver Award

Art Directors Bill Kobasz, Richard Wilde
Designers Bill Kobasz, Kathi Rota
Illustrator Kam Mak
Client School of Visual Arts/Master Eagle
Family of Companies
Agency School of Visual Arts Press, Ltd.,
New York, NY
Creative Director Silas Rhodes

1368
Distinctive Merit

Art Director Allen Wong
Designer Allen Wong
Writer Craig Watson
Client Rites & Reason of Brown University
Editors Alice Brown-Collins, George Houston
Bass
Agency Brown Designgroup of Brown
University, Prvidence, RI

1369

<u>**Distinctive Merit**</u>

Art Director Pat Burnham
Artist Don Biehn Advertising Art
Writer Bill Miller
Client WFLD-TV, Metromedia Chicago
Agency Fallon McElligott Rice, Minneapolis,
MN

HITCHCOCK PRESENTS A CAST OF THOUSANDS.

THE BIRDS. ANOTHER FILM CLASSIC FROM WFLD.

32
WFLD TV

1370

Art Director Jack Thorwegen
Designer Jack Thorwegen
Photographer Jon Bruton
Writer James SanFilippo
Client Bob Merz/Anheuser-Busch, Inc.
Agency The Waylon Co., St. Louis, MO

1371

Art Director Mark Drury
Designer Mark Drury
Artist Mark Drury
Writer Linda Eissler
Client Hamman Crume/GiftItalia
Creative Director Arthur Eisenberg
Design Studio Eisenberg Inc., Dallas, TX

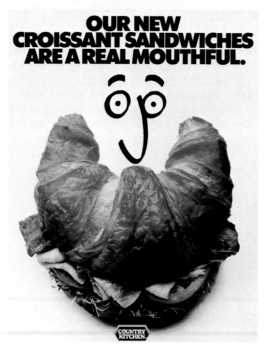

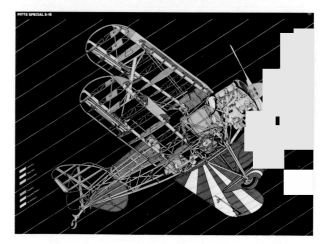

1372

Art Director Bob Barrie
Photographer Frank Miller
Writer Mike Lescarbeau
Client Country Kitchen International
Agency Fallon McElligott Rice, Minneapolis, MN

1373

Art Director Barry Deutsch
Designer Piper Murakami
Artist Ivan Clede
Client Christen Industries
Agency Steinhilber & Deutsch, San Francisco, CA

1374

Art Directors	Scott Eggers, McRay Magleby
Designer	Scott Eggers
Artist	McRay Magleby
Writer	Mark Perkins
Client	White Rock Sailing Club
Agency	Richards Brock Miller Mitchell & Associates, Dallas, TX
Printer	Brodnax Printing

1375

Art Director	Chris Hill
Designers	Chris Hill, Joe Rattan, Regan Dunnick, Jon Flaming
Photographer	Steve Chenn
Artist	Chris Hill
Client	The Art Directors Club of New York
Publisher	Printing Resources
Agency	Hill/A Marketing Division Group, Houston, TX

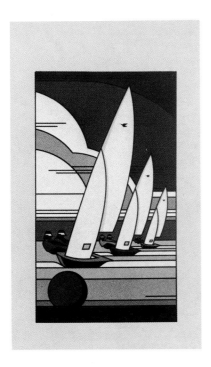

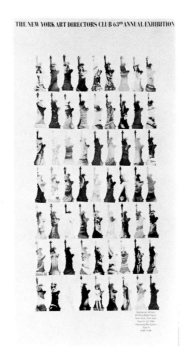

1376

Art Director	Kate Emlen
Designer	Kate Emlen
Artist	Kate Emlen
Client	Billings Farm & Museum
Agency	Kate Emlen/Graphic Design, Hanover, NH
Printer	Sirocco Screenprints

1377

Art Director	Jennifer Morla
Designer	Jennifer Morla
Artist	Andy Warhol
Writer	Jennifer Morla
Client	Levi Strauss & Co.
Agency	Morla Design, San Francisco, CA

1378

Art Directors	Rick Vaughn, Steven Wedeen
Designer	Rick Vaughn
Photographer	Valerie Santagto
Writers	Donna Williams, Steven Wedeen, Rick Vaughn
Client	Academy Printers
Agency	Vaughn/Wedeen Creative, Inc., Albuquerque, NM

1379

Art Director	Milton Glaser
Designer	Milton Glaser
Artist	Milton Glaser
Client	Brooklyn Center for the Performing Arts at Brooklyn College
Publisher	Brooklyn Center for the Performing Arts at Brooklyn Colege
Studio	Milton Glaser, Inc., New York, NY

Brooklyn Center for the Performing Arts at Brooklyn College

BCBC, A Celebration of the 30th Anniversary Season, 1984-85

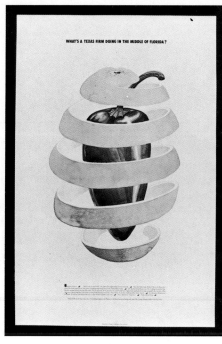

WHAT'S A TEXAS FIRM DOING IN THE MIDDLE OF FLORIDA?

CONNECTIONS

1380

Art Directors	Tom Brightman, Dan Glidden
Designer	Dan Glidden
Artist	Dan Glidden
Writers	JoAnn Stone, Dan Glidden
Client	Walter P. Moore & Associates
Agency	Flat Lizard Graphics, Houston, TX

1381

Art Director	Jim Cross
Designer	Tim Girvin
Artist	Tim Girvin
Client	Simpson Paper
Agency	James Cross, Designers, Seattle, WA

1382

Art Director Don Sibley
Designer Don Sibley
Artist Don Sibley
Client Dallas Designers' Chili Cookoff
Agency Sibley/Peteet Design, Inc., Dallas, TX

1383

Art Director Gary Alfredson
Artist Nicholas Gaetano, New York, NY
Writer Lynn Dangel
Client Creative Access

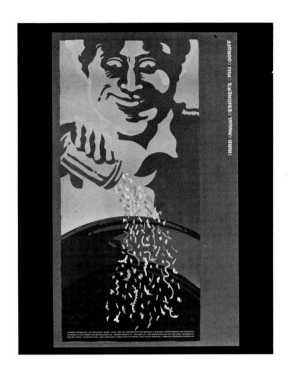

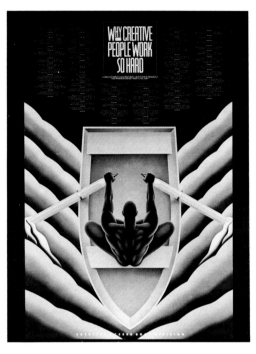

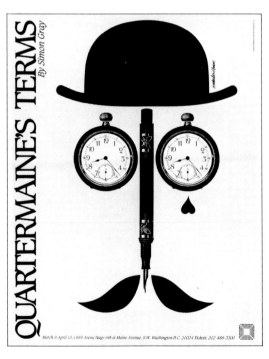

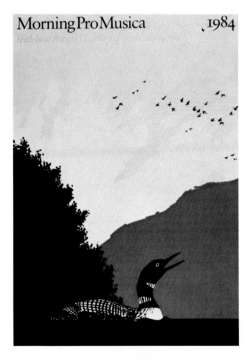

1384

Art Director Michael David Brown
Designers Barbara Raab, Michael David Brown
Artist Michael David Brown
Client Arena Stage
Agency Michael David Brown Inc., Rockville, MD

1385

Art Director Chris Pullman
Artist Chris Pullman
Client WGBH 89.7 FM
Publisher WGBH Educational Foundation, Boston, MA
Silkscreen Orange Line Press

1386

Art Director	Steven Sessions
Designer	Steven Sessions
Artist	Regan Dunnick
Writer	Steven Sessions
Client	University of Texas Alumni Association
Agency	Steven Sessions Inc., Houston, TX

1387

Art Director	Beth Singer
Designer	Beth Singer
Artist	Salvador Bru
Writer	Sarah Valente
Client	National Association of Housing and Redevelopment Officials
Agency	Design Communication, Inc., Washington, DC

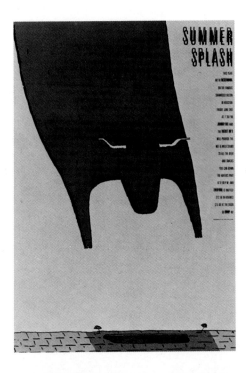

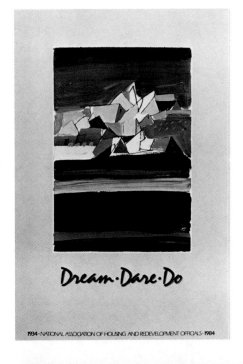

1388

Art Director	Andra Rudolph
Designer	Jim Vandegrift
Artist	Dennis Marks
Client	Luther's Restaurant
Agency	Andra Rudolph Design, Inc., Santa Cruz, CA
Printer	Bayshore Press

1389

Art Director	William Wondriska
Designer	William Wondriska
Artist	William Wondriska
Client	Connecticut Commission on the Arts
Publisher	Connecticut Commission on the Arts
Agency	Wondriska Associates, Farmington, CT
Sponsor	Southern New England Telephone
Printer	Van Dyke Printing

1390

Art Director	Tim Girvin
Designers	Tim Girvin, Chris Spivey, Phil Archibald
Artist	Tim Girvin
Client	Tim Girvin Design, Inc.
Agency	Tim Girvin Design, Inc., Seattle, WA

1391

Art Director	Woody Pirtle
Designer	Kenny Garrison
Artist	Kenny Garrison
Writer	Simpson Paper Company
Client	Simpson Paper Company
Agency	Pirtle Design, Dallas, TX
Creative Director	Woody Pirtle

1392

Art Director	McRay Magleby
Designer	McRay Magleby
Artists	McRay Magleby, Jed W. Porter
Client	Brigham Young University, Humanities Symposium
Agency	BYU Graphics, Provo, UT
Silkscreener	Jed W. Porter

1393

Art Director	Bobbye Cochran
Designers	Bobbye Cochran, Kurt Meinecke
Artist	Bobbye Cochran
Client	Le Bastille Restaurant
Publisher	Proto Grafix
Agency	Bobbye Cochran & Associates, Chicago, IL

1394

Art Director	Milton Glaser
Designer	Milton Glaser
Artist	Milton Glaser
Client	Conrans/Mothercare
Publisher	Conrans
Studio	Milton Glaser Inc., New York, NY

1395

Art Director	Marty Neumeier
Designers	Marty Neumeier, Sandra Higashi
Client	Neumeier Design Team
Publisher	Gazelle Editions
Agency	Neumeier Design Team, Atherton, CA

1396

Art Directors	Harold Matossian, Takaaki Matsumoto
Designer	Takaaki Matsumoto
Artist	Robert Venturi
Client	Knoll International
Agency	Knoll Graphics, New York, NY
Typographer	Susan Schechter

1397

Art Director	Minoru Morita
Designer	Minoru Morita
Photographers	Kyunghun Koh, Dale Whyte
Client	Creative Center Inc.
Agency	Creative Center Inc., New York, NY

1398

Art Director	James Cross
Designer	Ken Parkhurst
Artists	Ken Parkhurst, Denis Parkhurst
Client	Simpson Paper Company
Agency	Ken Parkhurst & Associates, Los Angeles, CA

1399

Art Directors	Rich Doty, Dan Glidden
Designer	Dan Glidden
Artist	Dan Glidden
Writer	Dan Glidden
Client	Aeschbacher Chambers Architects
Agency	Flat Lizard Graphics, Houston, TX

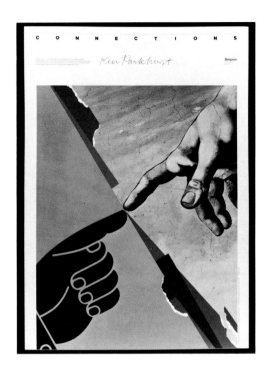

1400

Art Director	Heather Cooper
Artist	Heather Cooper
Client	Ford, Byrne & Associates
Agency	Heather Cooper Illustration & Design Limited, Toronto, Canada

1401

Art Director	Kit Hinrichs
Designers	Kit Hinrichs, D.J. Hyde
Artist	Peter Parnall
Client	The Nature Company
Agency	Jonson Pedersen Hinrichs & Shakery, San Francisco, CA

1402

Art Director	Luis Acevedo
Designer	Luis Acevedo
Artist	Luis Acevedo
Client	Roblee Corporation
Agency	Pirtle Design, Dallas, TX
Creative Director	Woody Pirtle

1403

Art Director	Rick Valicenti
Designers	Rick Valicenti, Ronald Jacomini
Artist	Geoffery Moss
Client	STA, Chicago, IL
Typography	Typographic Resource
Printing	TCR Graphics, Inc.

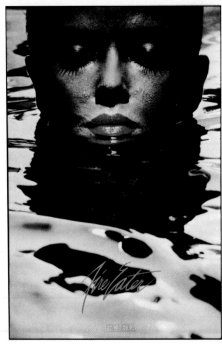

1404

Art Director	Roger Hines
Designer	Jim Heimann
Photographer	Eric Meola
Publisher	Lipman Publishing
Agency	Geer DuBois, New York, NY

1405

Art Director	Mark Oliver
Designer	Mark Oliver
Artist	Mark Oliver
Agency	Mark Oliver, Inc., Santa Barbara, CA

1406

Art Director	Scott A. Mednick
Designers	Scott A. Mednick, Lisa Pogue
Artist	Bryan Honkawa
Client	Gore Graphics
Publisher	Gore Graphics
Agency	Douglas Boyd Design, Los Angeles, CA

1407

Art Director	Gary Kelley
Designer	Gary Kelley
Artist	Gary Kelley
Client	The Dallas Illustrators
Publisher	The Dallas Illustrators
Director	Lyle Miller
Agency	Hellman Associates, Inc., Waterloo, IA

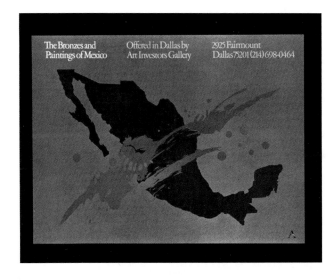

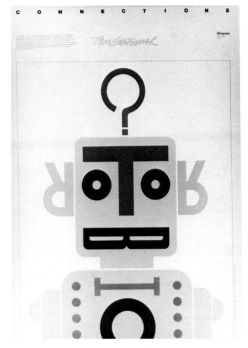

1408

Art Director	Cap Pannell
Designer	Cap Pannell
Artist	Cap Pannell
Writer	Cap Pannell
Client	Sunwest Communications/Art Investors Gallery
Agency	Pannell/St. George, Dallas, TX
Printing	Spruiell Printing

1409

Art Director	James Cross
Designer	Tom Geismar
Artist	Tom Geismar
Client	Simpson Paper Company
Agency	Chermayeff & Geismar Associates, New York, NY

1410

Art Directors	Peter Honsberger, Tom Wright
Designers	Peter Honsberger, Tom Wright
Artists	Peter Honsberger, Tom Wright
Client	Tennessee Dance Theatre, Nashville, TN
Printer	Lithographics, Inc.
Engraver	Graphic Process, Inc.

1411

Art Director	David Jemerson Young
Designer	David Jemerson Young
Artist	David Jemerson Young
Client	Indianapolis Racquet Club
Agency	Young & Laramore, Indianapolis, IN

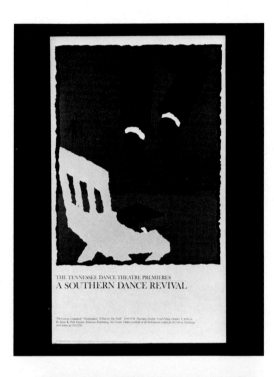

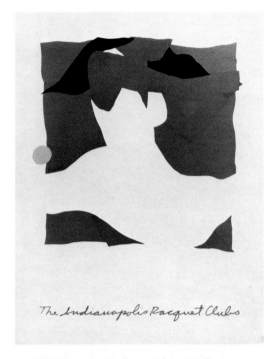

1412

Art Director	Kevin D. Opp
Designer	Kevin D. Opp
Illustrator	Arnie Hall, Graphic Affairs
Client	IBM Design Center at Endicott, NY
Agency	IBM Design Center, Endicott, NY
Printing	Frank J. West

1413

Art Director	Jack Anderson
Designers	Cliff Chung, Jack Anderson
Artist	Nancy Gellos
Client	HealthPlus
Agency	Hornall Anderson Design Works, Seattle, WA

1414

Art Director	Barbara J. Loveland
Designer	Barbara J. Loveland
Artist	Barbara J. Loveland
Client	Tulip Time, Inc., Holland, MI
Printer	Continental Identification Products

1415

Art Director	Rob Dalton
Designer	Rob Dalton
Writer	Jim Newcombe
Client	Vitalis Acupuncture Clinic
Agency	Advertising Au Gratin, Minneapolis, MN

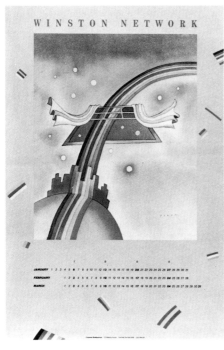

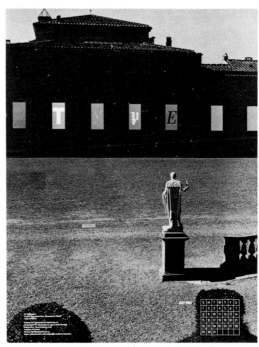

1416

Art Director	Patricia Goff
Designers	Patricia Goff, Neil Keating, Tony Chiumento
Artist	Jean-Michel Folon
Client	Winston Network
Publisher	Marc Winston
Creative Director	Steve Strauss
Design Agency	Goff Design Group, San Francisco, CA
Production	Karen Montgomery

1417

Art Director	Henry Wolf, New York, NY
Client	Ray Morrone, PM Typography

1418

Art Director	David Bukvic
Artist	David Bukvic
Writer	David Bukvic
Client	College of Mount St. Joseph
Publisher	Studio San Giuseppe Art Gallery
Agency	Horwitz, Mann & Bukvic Advertising, Cincinnati, OH

1419

Art Director	Beth Singer
Designers	Beth Singer, Joanne Zamore
Client	American Institute of Architects
Agency	Design Communication, Inc., Washington, DC

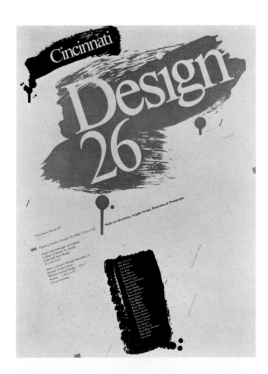

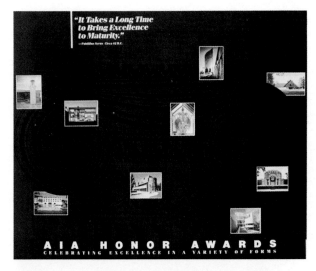

1420

Art Director	Roberta Orshan
Designer	Anek Pooviriyakul
Photographer	Bob Wolfson
Writer	Barbara Worton
Client	AT&T Information Systems
Production Manager	Jane Haber
Agency	Ogilvy & Mather Promotions, New York, NY
Creative Directors	Susan Johnson-Pei, Bill Taylor

1421

Art Director	Michael Mabry
Designer	Michael Mabry
Artist	Michael Mabry
Client	Citizens Utilities Company
Agency	Michael Mabry Design, San Francisco, CA

1422

Art Director	Saul Bass
Designer	Saul Bass
Photographer	George Arakaki
Client	Chicago International Film Festival
Agency	Saul Bass, Herb Yager & Assoc., Los Angeles, CA

1423

Art Directors	Jim Locke, Russell Leong
Designer	Russell K. Leong
Photographer	David Campbell
Artist	Russell K. Leong
Writer	Sue Berman
Client	Apple Computer Inc.
Agency	Russell Leong Design, Palo Alto, CA

1424

Art Director	Alex Granado
Illustrator	Alex Granado
Client	Debbie Granado
Agency	Alex Granado Design, Long Beach, CA
Printer	Rudy & Maria's Inc.

1425

Art Directors	David Shapiro, Rex Peteet
Designer	Rex Peteet
Artists	Rex Peteet, Ken Shafer, Steve Gibbs
Client	Winston-Salem Symphony
Studio	Sibley/Peteet Design, Inc., Dallas, TX
Agency	Long, Haymes & Carr, Inc.

1426

Art Director	Jeff Laramore
Designer	Jeff Laramore
Artist	Jeff Laramore
Client	Pearson, Crahan, Fletcher Group
Agency	Young & Laramore, Indianapolis, IN

1427

Art Director	Ivan Chermayeff
Designer	Ivan Chermayeff
Artist	Ivan Chermayeff
Client	Addison Gallery of American Art
Agency	Chermayeff & Geismar Associates, New York, NY

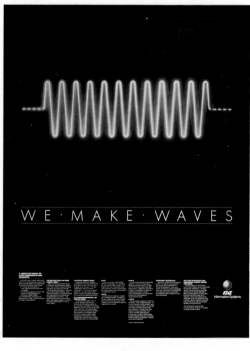

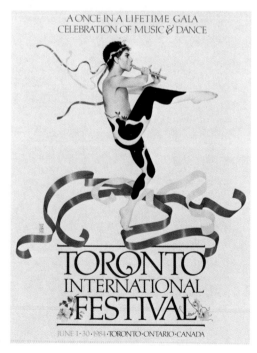

1428

Art Director	Roberta Orshan
Designer	Anek Pooviriyakul
Photographer	Bob Wolfson
Writer	Barbara Worton
Client	AT&T Information Systems
Production Manager	Jane Haber
Agency	Ogilvy & Mather Promotions, New York, NY
Creative Directors	Susan Johnson-Pei, Bill Taylor

1429

Art Director	Heather Cooper
Designer	Heather Cooper
Artist	Heather Cooper
Client	Toronto International Festival
Agency	Heather Cooper Illustration & Design Limited, Toronto, Canada

1430

Art Director	Woody Pirtle
Designer	Alan Colvin
Artist	Alan Colvin
Client	Lakewood Theater
Agency	Pirtle Design, Dallas, TX
Creative Director	Woody Pirtle

1431

Art Director	Larry Klein
Designer	Ken Parkhurst
Artist	Ken Parkhurst
Client	Los Angeles Olympic Organizing Committee
Publisher	Sales Corp. of America Inc.
Agency	Ken Parkhurst & Associates, Los Angeles, CA

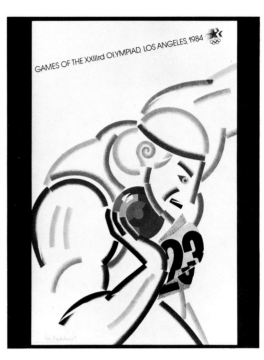

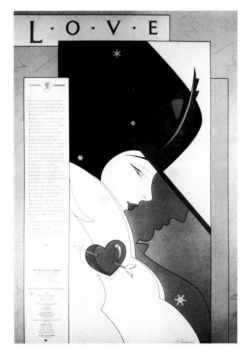

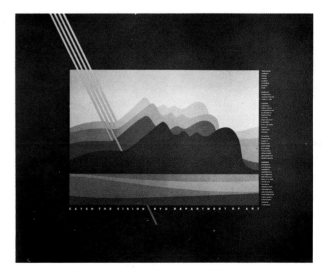

1432

Art Director	The McCarty Company
Artist	Bobbye Cochran
Writer	Barbara J. Terman
Client	The McCarty Company
Agency	Bobbye Cochran & Associates, Chicago, IL

1433

Art Director	McRay Magleby
Designer	McRay Magleby
Artist	McRay Magleby
Writer	Norman A. Darais
Client	Brigham Young University, Art Department
Agency	BYU Graphics, Provo, UT
Silkscreener	Robert G. Carawan

1434

Art Directors Steven Wedeen, Rick Vaughn
Designer Steven Wedeen
Artist Steven Wedeen
Writer Steven Wedeen
Client Academy Printers
Agency Vaughn/Wedeen Creative, Inc.,
Albuquerque, NM

1435

Art Director Rex Peteet
Designer Rex Peteet
Artists Rex Peteet, Ken Shafer
Writers Joan McClendon, Rex Peteet
Client Dallas Museum of Art
Agency Sibley/Peteet Design, Inc., Dallas, TX

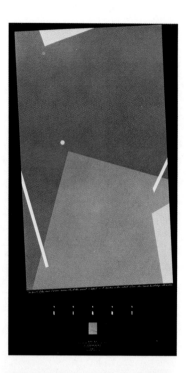

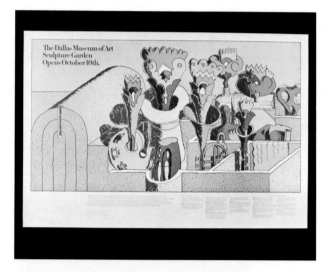

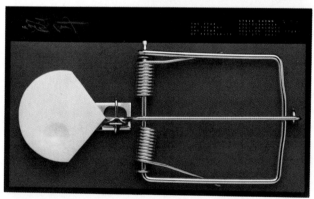

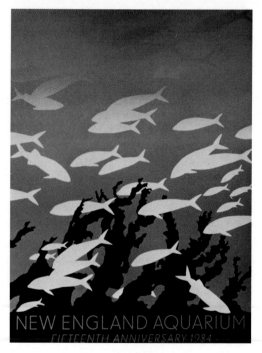

1436

Art Director Chris Hill
Designers Chris Hill, Jeff McKay
Photographer Steve Chenn
Client Steve Chenn
Publisher Printing Resources
Agency Hill/A Marketing Design Group,
Houston, TX

1437

Art Director Steve Snider
Designer Steve Snider
Artist Oren Sherman
Client New England Aquarium
Agency Rossin Greenberg Seronick + Hill,
Boston, MA

1438

Designer	Janet Meagher, Johnston/George Companies
Photographer	Craig Stewart, Craig Stewart Photography
Client	ASAP Printing
Agency	Johnston/George Companies, Houston, TX

1439

Art Director	Alan Colvin
Designer	Alan Colvin
Artist	Alan Colvin
Client	Interaction Associates Inc.
Agency	Pirtle Design, Dallas, TX
Creative Director	Woody Pirtle

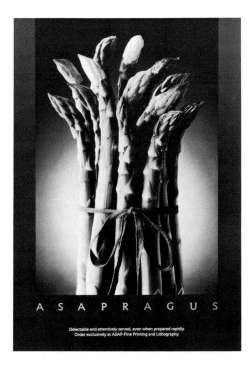

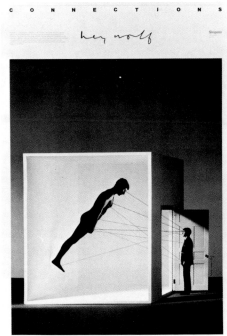

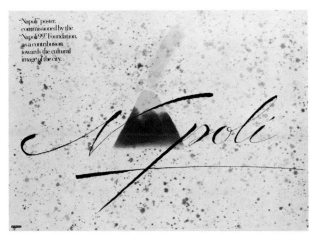

1440

Art Director	Henry Wolf
Client	Simpson Paper Company
Studio	Henry Wolf Productions, New York, NY

1441

Art Director	Milton Glaser
Designer	Milton Glaser
Artist	Milton Glaser
Client	Napoli 99 Foundation
Publisher	Napoli 99 Foundation
Studio	Milton Glaser Inc., New York, NY

1442

Silver Award

Art Director Wes Keebler
Writers Chuck Silverman, Steve Kaplan
Client Tahiti Tourism Promotion Board/UTA
French Airlines
Creative Director Chuck Silverman
Agency Cunningham & Walsh, Fountain
Valley, CA
Production Manager Jill Heatherton

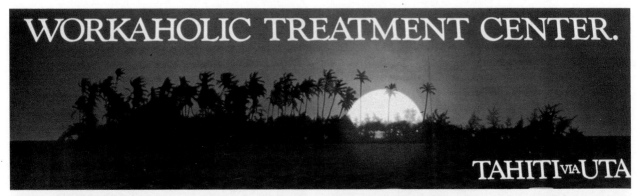

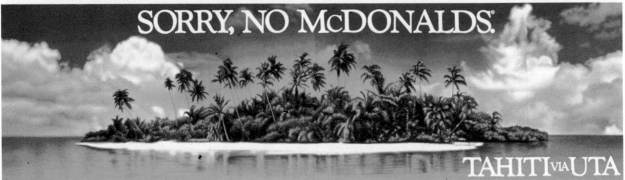

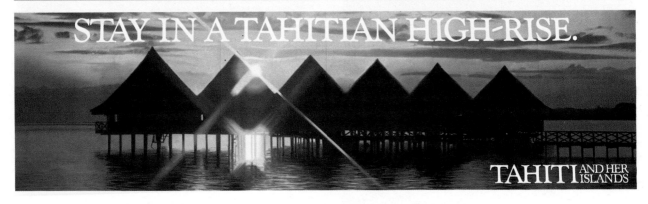

1443

Art Director Darryl Shimazu
Writer Elaine Cossman
Client Palm Springs Convention & Visitors
Bureau
Agency Gumpertz/Bentley/Fried, Los
Angeles, CA

1444

Art Directors Wes Keebler, Darrell Lomas
Artist Fred Nelson
Writers Harry Woods, Chuck Silverman
Client Wrather Port Properties
Production Manager Jill Heatherton
Agency Cunningham & Walsh, Fountain
Valley, CA
Creative Director Chuck Silverman

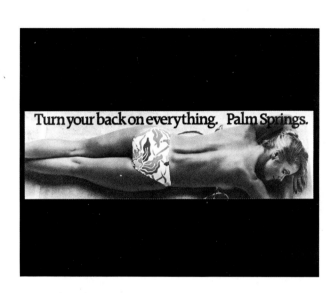

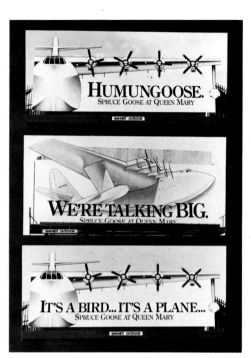

1445

Silver Award

Art Director	André Morkel
Photographer	Bruce Horn
Writer	Gary E. Prouk
Client	Cadbury, Schweppes, Powell Inc.
Agency	Scali, McCabe, Sloves (Canada) Ltd., Toronto

The Chocolate, for the mouth that has everything.

The Chocolate, for the mouth that has everything.

The Chocolate, for the mouth that has everything.

Distinctive Merit

Art Director Dean Hanson
Writer Jarl Olsen
Client 7 South 8th for Hair
Agency Fallon McElligott Rice, Minneapolis, MN

1447

Art Director Marcel Lissek
Designer Marcel Lissek
Writer Greg Carroll
Client WGRZ-TV News Center 2
Agency WGRZ-TV 2 Graphics, Buffalo, NY
Silkscreen Printing Coffas Inc.

1448

Art Directors Stuart Kusher, Don Zubalsky
Photographers Lisa Powers, John Colao
Client Cherokee
Agency Metro Advertising, Studio City, CA

1449

Art Director Marty Neumeier
Designers Sandra Higashi, Marty Neumeier
Artist Sandra Higashi
Writer Marty Neumeier
Client Santa Barbara Metropolitan Transit District
Agency Neumeier Design Team, Atherton, CA

1450

Art Director	Ivan Chermayeff
Designer	Ivan Chermayeff
Artist	Ivan Chermayeff
Client	Jacob's Pillow
Agency	Chermayeff & Geismar Associates, New York, NY

1451

Art Director	Lewis Nightingale
Designer	Lewis Nightingale
Artist	Doug Henry
Writer	Nightingale Gordon
Client	Showtime/The Movie Channel Inc.
Editor	Herb Scannell
Agency	Nightingale Gordon, New York, NY
Printer	Pernicolor

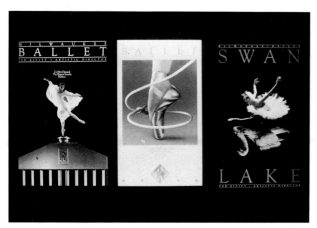

1452

Art Directors	Kathy Sherwood, Kris Jenson
Designers	Kathy Sherwood (Swan Lake & Rolls Royce), Kris Jenson (Rodeo)
Photographer	David Vanderveen
Writer	Steve Laughlin
Client	Milwaukee Ballet
Creative Directors	John Constable (Rolls Royce & Rodeo), Steve Laughlin (Swan Lake)
Agency	Frankenberry, Laughlin & Constable, Inc., Milwaukee, WI
Producer	Paula A. Rothe

1453

Art Director Joseph Michael Essex
Designer Joseph Michael Essex
Writer Tem Horwitz
Client Cloud Hands
Agency Burson•Marsteller/Americas,
 Chicago, IL

1454

Art Director Alan Nurmi
Designer Alan Nurmi
Artists Barbara Sandler, Emanuel Schongut,
 Richard Mantel, David Willardson,
 Charles White III, John Collier, James
 Barkley, Jan Sawka
Client U.S. Information Agency,
 Washington, DC
Project Director Karen Starkey

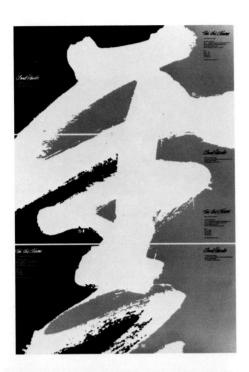

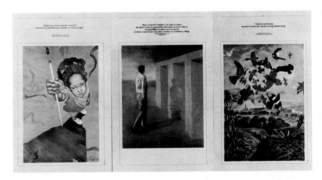

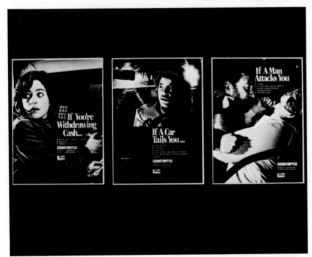

1455

Art Director Stephen F. Smith
Designer Stephen F. Smith
Photographer Carmine Filloramo
Writer Joanne Godfrey
Client Aetna Life & Casualty, Hartford, CT
Editor Joanne Godfrey
Production Lynn Solak

1456
Gold Award

Art Director Don Weller
Designer Don Weller
Artist Don Weller
Writer Dan Gessner
Client Petromalt
Publisher Gralen Gallery
Agency The Weller Institute for the Cure of
Design, Inc., Los Angeles CA

1457
Gold Award

Art Director	Thomas J. Weisz
Designer	Thomas J. Weisz
Photographer	Arthur Beck
Client	IBM Corporation
Agency	Weisz + Yang, Inc., Westport, CT

1458

Distinctive Merit

Art Director Shinichiro Tora, New York, NY
Designer Masakazu Tanabe
Photographer Toshiyuki Ohashi
Artist Masakazu Tanabe
Client Two in One Show

1459

Art Director Reed Agnew
Designer Rob Henning
Photographer John Naso
Client Westinghouse Electric Corporation,
Nuclear Fuel Division
Agency Agnew Moyer Smith Inc., Pittsburgh,
PA

1460

Art Director Heather Cooper
Artist Heather Cooper
Client Toronto International Festival
Agency Heather Cooper Illustration & Design
Limited, Toronto, Canada

1461

Art Director	Pat Burnham
Photographers	Harley Hettick, Jay Dusard, John Running
Writer	Bill Miller
Client	US West
Agency	Fallon McElligott Rice, Minneapolis, MN

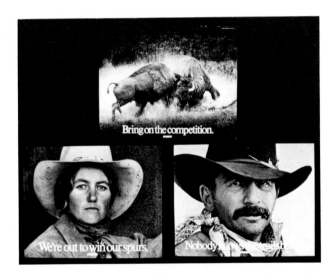

1462

Art Director	Scott Frederick
Designer	Scott Frederick
Photographer	Aron Rezny
Writer	Craig Jackson
Client	Marco Pollo Restaurants International, Inc.
Agency	Northlich, Stolley, Inc., Cincinnati, OH

Illustration (single entries): Advertising, editorial, promotion; b&w
Advertising, editorial, promotion; color
Packaging, P.O.P., display
Book or book jacket
Television news graphics

Campaign entries: Advertising, editorial, promotion campaign; b&w
Advertising, editorial, promotion campaign; color
Packaging, P.O.P., display campaign
Book or book jacket campaign

1463

Gold Award

Art Director	Robert Bailey
Designer	Thomas Kitts
Artist	Thomas Kitts
Client	American Institute of Architects
Agency	Robert Bailey Design Group, Portland, OR

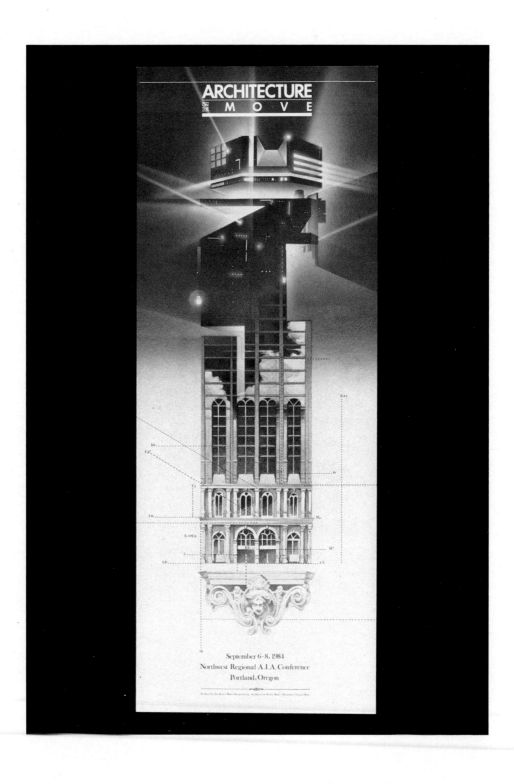

1464

Silver Award

Art Director Nancy Cahners
Designer Kathleen Sayre
Artist Rob Colvin
Client M.I.T. Technology Review
Editor Jonathan Schlefer
Publisher William Hecht
Publication M.I.T. Technology Review,
Cambridge, MA

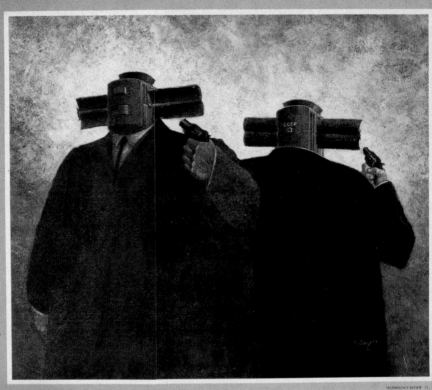

1465
Distinctive Merit

Art Director Barbara Maiolatesi
Designer Barbara Maiolatesi
Artist Kenneth Krafchek, Arlington, VA
Writer Isaac Rehert
Client Baltimore Sun Magazine
Editor Susan Baer
Publisher The Baltimore Sun Newspaper
Publication Baltimore Sun Magazine

By Isaac Rehert

The Second-Time
SINGLE

"I love dating the second time around. The first time I was naive to the point of blindness. When I married, courtship didn't include sexual relations, so we each got a pig in a poke. Now that I'm unattached again, I'm enjoying a sexual freedom and an awareness of what I'm doing that I never knew before."

"I hate dating again. I didn't like it as a kid and was glad when I married and got past it. I don't enjoy the games men and women play during courtship. At my age — I'm 43 now — I feel I ought to be settled down. But I happen to be single again, so I have to date or sit home by myself. But I can't say that I enjoy it."

Contrary to what they once expected, thousands of people over 35 are today engaging in a ritual most of them thought they had left forever behind them: going out on dates.

They are the second-time-singles, one of the largest and fastest-growing groups in contemporary society. In 1980, according to the census, nearly a third of the people over 35 were unmarried. Since then, with a divorce for every two marriages, the numbers have been steadily rising.

This article is the result of an informal, random look at people over 35 in the Baltimore area who are dating for the second time. A few lost their spouses through death; most, by far, were divorced. Because of the sensitive nature of the information given, no names have been used.

Curiously, most of the people asked were willing, almost eager, to be interviewed. Although asked questions about their most intimate affairs, hardly any of them refused to answer. They listened, pondered and peered into their inner selves, and then spoke freely, as if experiencing catharis. Most seemed to welcome an excuse for a review of their lives, for creation of new perspectives.

Discussions inevitably begin with the breakup of a marriage long on the rocks. Naturally, when that breakup occurs, people respond in different, often opposite, ways.

A frequent reaction is an orgy of sexual indulgence. One woman, a 40-year-old federal employee said, "After my divorce I gave a whoop for my new freedom and began enjoying it wherever I could. I had skipped adolescence. I married the boy I went with from the time I was 14, and by the time I was 19, I was having babies. Now that I was free, I decided I was going to have that adolescence I had missed. So I began picking up men wherever I went, and often I took them home with me. It didn't matter who they were, and today I can't remember names or faces or anything. But at the time, I needed that contact with a man. I needed to know that I was still OK.

"I have no regrets. That year and a half of indulgence was good for me. I needed the experience to learn what I had failed to find out about men when I was younger. I did feel some guilt about it and still do. I sometimes got attached to them just because of that guilt. But I've learned to live with that guilt; it's part of being single. Today I'm a lot more discriminating about who I go out with.

On the other side of the fence are those who, still in a state of shock, withdraw completely. A male doctor of 45 said that after moving out of the house, he took an apartment and did not leave it for more than a year except to go to work and buy food. Dating was the furthest thing from his mind.

And still others try to go on with business as usual. A Lutherville woman in her 40s said, "As we approached our divorce, things had gotten so bad I hadn't had relations with my husband in years. After his departure, I hardly missed him. Without him my life went on pretty much as it had before. I had two small children to keep me in the house, so I took up weaving. Between the children and the weaving, I was content for more than a year without any need for close contact with a man."

Counselors look with favor on some kind of "fallow" period af-

ter the breakup of a marriage. Dr. William F. Hug, a Baltimore pastoral counselor and psychologist said, "I advise people to take a year or two as a healing period for processing their grief. In some ways, a failed marriage is even harder to handle than the death of a spouse. With death there is a finality; with breakup, there's a lot of baggage that needs unpacking. There are still positive feelings about the spouse, and there's one's own culpability about the breakup. Dealing with all that takes time. It's a time to learn to live with oneself."

But eventually, loneliness drives most single people into dating. They say dating the second time around is a lot different from the first time. Part of what makes it different is a freer attitude about sex.

"Before I married, in high school and college, I was a tease," a 39-year-old female university employee said. "Nice girls didn't have sex those days, and nice boys didn't try to push it. They knew there was only so far they could go. We understood one another.

"By the time I got my divorce, conditions in the world had changed. Both men and women could now be a lot more open with one another. They could even live together if they wanted to. Shortly after I became free, I fell in love with another man and we moved into an apartment together. We stayed together for nearly a year. But then we broke up, and since then, there have been a number of guys, some of them for just a few months, one of them for nearly a year."

This more relaxed attitude about living together is the result of two recent revolutions: the sexual revolution and the women's movement. The sexual revolution, most middle-aged singles agree, has put sex into perspective, made it less of a goal and a barrier than it used to be. The woman's movement has given women a sense of independence they never had before so that they no longer regard marriage as the only acceptable way for them to live.

In fact, many second-time-single women are deeply distrustful of the married state. As members of the work force, they have become financially self-sufficient achievers, which makes them more independent both financially and emotionally than they have ever been before in their lives.

They admit that, living without men, sometimes they feel lonely. But with the experience behind them of marriage, homemaking, raising children and then divorce, most of them take a little loneliness in stride. As one of them said, "It isn't just when you're single that you feel lonely. The loneliest time of my life was while I was married."

A 38-year-old medical secretary, said, "As I see it now, I was striving for independence all along, and it was that that caused the breakup of my 15-year marriage. My husband never appreciated my need to have a life, an identity, of my own. He insisted that I stay in his shadow. In the early days, when the children were little, I could put up with that. But gradually I couldn't do it

Continued on Next Page

1466

Art Director Bob Eisner
Designer Paula Handler
Artist Bob Newman
Writer Lois Wingerson
Client Newsday Part III Discovery
Editor B.D. Colen
Publisher Newsday, Melville, NY
Publication Newsday

1467

Art Directors Richard L. Buterbaugh, Tony Ross
Artist Richard L. Buterbaugh
Agency Buterbaugh/Prengle, Wilmington, DE
Printer Cedar Tree Press

1468

Art Director Maryanne Fisher
Artist Ronald Searle
Writer Chris Laubach
Client U.S. Postal Service
Agency Young & Rubicam, New York, NY
Publication The Center City Office Weekly
 Welcomate
Associate Creative Director Sy Schreckinger

1469

Art Director Scott A. Mednick
Designers Scott A. Mednick, Lori Precious
Artist Alan Reingold
Client CBS-TV
Agency Douglas Boyd Design, Los Angeles,
 CA
Publication TV Guide

1470

Art Directors	Tom Ruis, Janet Froelich
Artist	Seth Jaben
Writer	Eileen Haas
Publication	Daily News Sunday Magazine, New York, NY

1471

Art Director	Kristin Herzog
Artist	Barbara Roman
Client	Phi Delta KAPPAN
Editor	Robert W. Cole, Jr.
Publisher	Phi Delta Kappa, Bloomington, IN
Publication	Phi Delta KAPPAN

CAN THIS MARRIAGE BE SAVED?

The plight of the computer widow.

BY EILEEN HAAS

AIGA

JOURNAL OF GRAPHIC DESIGN VOLUME 2 NUMBER 1 1984

The Perqs and Pitfalls of Prominence

by Rose DeNeve

FANCY FOOTWORK

Sneaker companies are scrambling to sign top players in a high-stakes game

By Jim Smith

THE CENTERPIECE

1472

Art Director	Elton Robinson
Designer	Margaret Wollenhaupt
Artist	Frank Riccio, Bridgeport, CT
Writer	Rose Deneve
Client	AIGA-The American Institute of Graphic Arts
Editor	Shelley Bance
Publisher	AIGA

1473

Art Director	Warren Weilbacher
Designer	Warren Weilbacher
Artist	Ned Levine
Writer	Jim Smith
Client	Newsday
Editor	Robert Herzog
Publisher	Newsday, Melville, NY
Publication	Newsday

1474

Art Director Gary Rogers
Designer Elsi Meares
Artist Bob Newman
Writer Robert Gillette
Client Newsday Part II
Editor Roy Hanson
Publisher Newsday, Melville, NY
Publication Newsday

1475

Art Director David Bartels
Designer David Bartels
Artist Greg MacNair
Client Ceci Bartels Associates
Agency Bartels & Carstens, Inc., St. Louis, MO

1476

Art Director Joseph A. Anastasi
Designer Joseph A. Anastasi
Artist Robert Ziering
Client Commonwealth Bank
Agency Jones, Anastasi & Mitchell, Erie, PA

1477

Gold Award

Art Directors Bryan Birch, Doug Johnson
Designers Doug Johnson, Anne Leigh
Artist Doug Johnson, New York, NY
Client Armor All Products
Client Dailey & Associates

1478
Gold Award

Art Director Tom Staebler
Designer Kerig Pope
Artist Brad Holland
Writer Laurence Gonzales
Editor Jim Morgan
Publisher Playboy Enterprises, Inc., Chicago, IL
Director Arthur Kretchmer
Publication Playboy Magazine

COCAINE
A SPECIAL REPORT

the world knows that this glamorous drug has turned mean—but only a handful of people know why

article
By LAURENCE GONZALES

IN 1982, a man—call him Tom—was hospitalized for aplastic anemia, a bone-marrow disease. Tom underwent surgery twice. He was 22 years old and psychologically normal, according to his physicians. One effect of his illness was sores in his mouth. As part of his treatment, for pain, he was given the topical anesthetic cocaine—about a third of a gram every four hours for 16 days. It got into his blood stream the same way cocaine gets into the blood stream of people who snort it: through the membranes that line the nose and mouth. A report in the *New England Journal of Medicine* explained what happened as a result:

Day 16 the patient's pulse rose . . . to 140 [beats] per minute, and he had nausea, vomiting, headaches, insomnia, chills and fever, in spite of other normal vital signs. During the next 18 hours, he reported seeing ants on his clothes, in his food, on nursing personnel and throughout his room; his euphoric mood was punctuated by irritability and pressured speech. He saw "shadows" of his mother and related a hallucination in which he witnessed a cardiac arrest in an adjacent room. He became increasingly garrulous and active, pacing his room, cleaning his drawers, upholstering a chair [sic] and re-taping his intravenous needle. During the next six hours, he exhibited jerking muscular movement, twitching of his head and extremities and a fine tremor. A tentative diagnosis of toxic cocaine psychosis was made.

There are a number of important implications of Tom's experience. For one

ILLUSTRATION BY BRAD HOLLAND

1479

Silver Award

Art Director Craig Bernhardt
Designer Ron Shankweiler
Artist Nancy Stahl
Client Maxwell House
Editor Nan Haley Redmond
Agency Bernhardt Fudyma Design Group,
New York, NY

1480
Distinctive Merit

Art Director Michael Pardo
Artist David Kimble
Publisher L. Scott Bailey
Publication Automobile Quarterly Magazine,
Princeton, NJ

THE 427 COBRA S/C

FORD'S ULTIMATE BETTER IDEA

STORY AND CUTAWAY
BY DAVID KIMBLE

The sixties are best remembered by enthusiasts as the muscle car era, a time of freedom, before the federal government stepped in and spoiled the fun. Real performance was then measured in horsepower, not miles per gallon. The ultimate weapon in this unrestrained competition was without question the second generation Ford Cobra, which in showroom form could accelerate from 0 to 60 miles per hour in under four seconds. Automobile Quarterly has previously discussed AC and the Cobra in Volume VI, Number 3, Volume X, Number 1 and Volume XIV, Number 3. Of the 427 and V-8 powered Cobras, the 427 S/C went almost unnoticed as a unique model as less than forty were produced, but they came straight from the Ford dealer with a roll bar, hood scoop and ground-shaking outboard exhaust pipes. They are the Cobras that everyone remembers, and the remaining examples are worth more than an average home today. Their impact is also reflected in the ever-increasing number of fiberglass replicas which duplicate their wonderfully bulbous body contours.

From its inception, the Cobra was the fastest-accelerating production car in the world, a title it acquired when John Christy drove the first unpainted 260 V-8 powered prototype for Sports Car

David Kimble's Cobra illustration depicts CSX 3022, a 1965 427 S/C which was originally owned and raced by Bob Grossman and is thought to be the second S/C produced.

1481

Art Director Heather Cooper
Artist Heather Cooper
Client Controlled Media Communications
Agency Heather Cooper Illustration & Design Limited, Toronto, Canada

1482

Art Director Larry Klein
Designer Ken Parkhurst
Artist Ken Parkhurst
Client Los Angeles Olympic Organizing Committee
Publisher Sales Corp. of America, Inc.
Agency Ken Parkhurst & Associates, Los Angeles, CA

1483

Art Director Michael E. Frakes
Designer Michael E. Frakes
Artist Michael E. Frakes
Client Iowa Public Television
Agency Iowa Public Television, Des Moines, IA

1484

Art Director Bryan Daws
Artist Bryan Daws
Client Le Marche Restaurant
Agency Grafix Studio, Phoenix, AZ

1485

Art Director Heather Cooper
Artist Heather Cooper
Client Ford, Byrne & Associates
Agency Heather Cooper Illustration & Design
Limited, Toronto, Canada

1486

Art Director Bill Jensen
Artist Peter De Séve
Writer Gail E. Pierce
Editor Patrick Kenealy
Publisher Ziff-Davis Publishing, New York, NY
Publication Digital Review

1487

Art Director Michael McLaughlin
Designer Michael McLaughlin
Artist Roger Hill
Writer Stephen Creet
Client Nabisco Brands Ltd.
Agency Carder Gray Advertising Inc.,
Toronto, Canada

1488

Art Director Tina Adamek
Artist John Collier
Publisher McGraw-Hill Publishing
Publication Postgraduate Medicine,
Minneapolis, MN

1489

Art Director	Judy Garlan
Designer	Judy Garlan
Artist	Anita Kunz
Writer	John Keegan
Client	The Atlantic Monthly
Editor	William Whitworth
Publication	The Atlantic Monthly, Boston, MA

1490

Art Director	Broc Sears
Designer	Deborah Withey-Culp
Artist	Deborah Withey-Culp
Editor	Candy Sagon
Publisher	Dallas Times Herald, Dallas, TX
Publication	The Dallas Times Herald Taste Section

1491

Art Directors	Tom Ruis, Janet Froelich
Artist	Jeffrey Smith
Writer	John Lombardi
Publication	Daily News Sunday Magazine, New York, NY

1492

Art Director	Miriam Smith
Designer	Miriam Smith
Artist	Ned Levine
Writer	K.C. Cole
Client	Newsday Magazine
Editor	John Montorio
Publisher	Newsday, Melville, NY
Publication	Newsday Magazine

1493

Art Director	Ken Kendrick
Designer	Ken Kendrick
Artist	Jeff Smith
Client	The New York Times Magazine
Editor	Ed Klein
Publisher	The New York Times, New York, NY
Publication	The New York Times

1494

Art Directors	Jeff Laramore, David Jemerson Young
Designer	Jeff Laramore
Artist	Jeff Laramore
Writer	David Jemerson Young
Client	The Shorewood Corporation
Agency	Young & Laramore, Indianapolis, IN

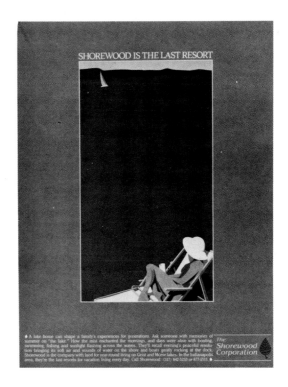

1495

Art Director	Richard Bleiweiss
Designer	Susan Wilder
Artist	Marshal Arisman
Publisher	Bob Guccione
Publication	Penthouse, New York, NY
V.P. Graphics Director	Frank Devino

1496

Art Director	Richard Bleiweiss
Artist	Alan Reingold
Publication	Penthouse, New York, NY

1497

Art Directors Wayne Fitzpatrick, Joyce L. Black
Designer Wayne Fitzpatrick
Artist Matt Mahurin
Writer William F. Allman
Client Science 84 Magazine/American
 Association for the Advancement of
 Science
Editor Allen Hammond
Publisher William Carey
Publication Science 84 Magazine, Washington,
 DC

1498

Art Director Bennett Robinson
Designer Bennett Robinson
Artist Edward Sorel
Client Larry Fox, Janet Wright/Mead Paper
 Company
Agency Corporate Graphics Inc., New York,
 NY
Printer Graphic Arts Center

1499

Art Director Shelley Williams
Designer Sara Christensen
Artist Andrzej Dudzinski
Publisher 13-30 Corporation, Knoxville, TN
Publication Tables Magazine

1500

Art Director Terry Brown
Designer Terry Brown
Artist Mark English
Writer Jeffrey M. Masson
Editor William Whitworth
Publisher The Atlantic Monthly Co., Boston,
 MA
Publication The Atlantic Monthly

1501

Art Director Tom Staebler
Designer Kerig Pope
Artist Bruce Wolfe
Writer John Gardner
Editor Alice K. Turner
Publisher Playboy Enterprises, Inc., Chicago, IL
Director Arthur Kretchmer
Publication Playboy Magazine

1502

Art Director Derek Ungless
Designer Rosemarie Sohmer
Artist Gottfried Helnwein
Publication Rolling Stone Magazine, New York, NY

1503

Art Director Jeff Laramore
Designer Jeff Laramore
Artist Jeff Laramore
Client Ultra Graphics
Agency Young & Laramore, Indianapolis, IN

1504

Art Director Broc Sears
Designer Janis Bryza
Artist Janis Bryza
Editor Kim Marcum
Publisher Dallas Times Herald, Dallas, TX
Publication The Dallas Times Herald Style Section

1505

Art Director	Amy Seissler
Designers	Amy Seissler, Liz Siroka
Artist	Donald Roller Wilson
Publisher	Bob Guccione
Publication	Omni Magazine, New York, NY
V.P. Graphics Director	Frank M. Devino

1506

Art Director	Richard Bleiweiss
Designer	Susan Wilder
Artist	Ori Hofmekeler
Publisher	Bob Guccione
Publication	Penthouse, New York, NY
V.P. Graphics Director	Frank Devino

1507

Art Director	Pamela H. Patrick
Designer	Leslie Kedash
Artist	Pamela H. Patrick
Client	Ad Club of Delaware
Publisher	Innovation Printing
Agency	Pamela Higgins Patrick, Kennett Square, PA

1508

Art Director	Wendy Talve Reingold
Designer	Wendy Talve Reingold
Artist	Peter DeSève
Publication	World Tennis Magazine/CBS Publishing, New York, NY

1509

Art Directors	Tom Ruis, Janet Froelich
Artist	Frances Jetter
Writer	Joanna Torrey
Publication	Daily News Sunday Magazine, New York, NY

1510

Art Directors	Wayne Fitzpatrick, Joyce L. Black
Designer	Wayne Fitzpatrick
Artist	Andrzej Dudzinski
Writer	Sherry Turkle
Client	Science 84 Magazine/American Association for the Advancement of Science
Editor	Allen Hammond
Publisher	William Carey
Publication	Science 84 Magazine, Washington, DC
Story Editor	Barbara Seeber

1511

Art Director	Judy Garlan
Designer	Judy Garlan
Artist	Jean-Michel Folon
Writer	Thomas Powers
Editor	William Whitworth
Publisher	The Atlantic Monthly Co., Boston, MA
Publication	The Atlantic Monthly

1512

Art Director	Tina Adamek
Artist	Matt Mahurin
Publisher	McGraw-Hill Publishing
Publication	Postgraduate Medicine, Minneapolis, MN

1513

Art Director	Derek Ungless
Designer	Elizabeth G. Williams
Artist	Ian Pollack
Publication	Rolling Stone Magazine, New York, NY

1514

Art Director	Scott A. Mednick
Designers	Scott A. Mednick, Lori Precious
Artist	Alan Reingold
Client	Embassy Pictures
Agency	Douglas Boyd Design, Los Angeles, CA

1515

Art Director	Tom Staebler
Designer	Kerig Pope
Artist	Bruce Wolfe
Writer	John Gardner
Editor	Alice K. Turner
Publisher	Playboy Enterprises, Inc., Chicago, IL
Director	Arthur Kretchmer
Publication	Playboy Magazine

1516

Art Director	Robert Boger
Designer	Robert Boger
Artist	Robert Boger
Client	Random House School Division
Agency	Shanner + Pappas, Bridgeport, CT
Typography Design	Susan F. Pappas

1517

Art Director	Barbara Koster
Artist	Robert Risko
Client	Trans World Airlines
Publisher	Paulsen Publishing, Inc.
Publication	TWA Ambassador, St. Paul, MN

1518

Art Director	Marshall Harmon
Designer	Lucille Tenazas
Artist	Joan Hall
Writer	Bruce McKenzie
Client	International Paper Company
Agency	Harmon Kemp Inc., New York, NY
Writer	David Kemp

1519

Art Director Steve Duckett
Designer Mike Bilicki
Artist Mark Braught, Terre Haute, IN
Writer Stuart Mieher
Editor Rick Edmonds
Publisher Florida Trend, Inc.
Publication Florida Trend Magazine

1521

Art Director Jack Koch
Designer Liz Kathman Grubow
Artist Liz Kathman Grubow
Client Downtown Council of Cincinnati
Agency Libby, Perszyk, Kathman, Cincinnati, OH
Printer Hennegan Company

1522

Art Director Karen Kutner Katinas, New York, NY
Designer Karen Kutner Katinas
Artist Charles Katinas
Writer Kimberly Rendleman
Client International Paper Company
Editor Bruce McKenzie

1523

Distinctive Merit

Designer	Keith Sheridan Associates
Artist	Bascove
Client	Aventura
Editor	Erroll McDonald
Publisher	Random House, New York, NY

JULIO CORTÁZAR

WE LOVE GLENDA
SO MUCH AND
A CHANGE OF LIGHT

"Julio Cortázar is an Argentinian who is one of the century's most gifted writers of short stories." —Michael Wood, The New York Review of Books

1524

Art Director	Sara Eisenman
Designer	Wendell Minor
Artist	Wendell Minor
Writer	David Malouf
Publisher	Alfred A. Knopf, New York, NY

1525

Art Director	Meg Crane
Designer	Meg Crane
Artist	Meg Crane
Writers	Meg Crane, Ira Sturtevant
Client	Marty Asher
Editor	Trish Todd
Publisher	Long Shadow/Pocket Books
Agency	Ponzi + Weill Inc., New York, NY

1526

Art Director	Keith Sheridan
Designer	Keith Sheridan
Artist	Anita Kunz
Writer	Michel Tournier
Client	Aventura Books
Publisher	Aventura Books
Agency	Keith Sheridan + Assoc., New York, NY

1527

Art Director	Char Lappan
Designer	Wendell Minor
Artist	Wendell Minor
Writer	Francis King
Publisher	Little, Brown and Co., Boston, MA

1528

Art Directors Beverly Littlewood, Burton Kravitz
Artist Burton Kravitz
Client WNBC-TV News 4, New York, NY

1529

Art Directors Beverly Littlewood, Susan Magnus
Designer Susan Magnus
Artist Susan Magnus
Client WNBC-TV News 4, New York, NY

1530

Art Director Ben Blank
Designer Mark Trudell
Artist Mark Trudell
Client ABC, New York, NY

1531

Art Director Ben Blank
Designer Mark Trudell
Artist Mark Trudell
Client ABC, New York, NY

1532

Art Director Judy Garlan
Designer Judy Garlan
Artist Chris Van Allsburg
Writer William Hauptman
Editor William Whitworth
Publisher The Atlantic Monthly Co., Boston,
 MA
Publication The Atlantic Monthly

1533

Art Director Judy Garlan
Designer Judy Garlan
Artist David Dickinson
Writer Jacques Barzun
Editor William Whitworth
Publisher The Atlantic Monthly Co., Boston,
 MA
Publication The Atlantic Monthly

1534

Gold Award

Art Director	Betsy Halliday
Designers	Betsy Halliday, Ken Kendrick
Artist	Eugene Mihaesco
Client	Equitable Group & Health
Agency	Halliday/Herrmann, Inc., New York, NY

1535

Silver Award

Art Directors Mitch Shostak, Mary Zisk
Designers Louise White, Marjorie Crane
Artist Mark Penberthy
Editor Bill Machrone
Publisher Jeff Weiner
Publication P.C. Magazine, New York, NY
Creative Director Peter J. Blank

1536

Distinctive Merit

Art Director Vásken Kalayjian
Designer Vásken Kalayjian
Artist Guy Billout
Writer Kathy Drew
Client Young Presidents' Organization
Editor Leila Zogby
Publisher Young Presidents' Organization
Director Stephen Gansl
Agency Glazer & Kalayjian, Inc., New York,
Publication New York News

1537

Art Director	Judy Garlan
Designer	Judy Garlan
Artist	Eraldo Carugati
Writer	Gore Vidal
Editor	William Whitworth
Publisher	The Atlantic Monthly Co., Boston, MA
Publication	The Atlantic Monthly

1538

Art Director	Barry Tilson
Designers	Barry Tilson, Radine Bright, Amy Firestone
Artist	Steve Wolf
Writer	Stanley Cohen
Client	Monsanto Company
Editor	Carl Moscowitz
Publisher	Monsanto Company
Agency	Stan Gellman Graphic Design, Inc., St. Louis, MO
Publication	Carpet Retailing Magazine
Production Manager	Rosemary Sturm

1539

Art Director	Shinichiro Tora, New York, NY
Designer	Mitsuo Katsui
Artists	Mark English, Brad Holland, Robert Giusti
Client	Hotel Barmen's Association
Publisher	Dai Nippon Printing Co.
Agency	DNP America, Inc.

1540

Art Director	Mario Jamora
Artists	Daniel Maffia, Brad Holland, John Collier
Writer	Bill Brown
Client	Abbott Laboratories
Agency	Dorritie and Lyons, New York, NY

1541

Art Director	Terry Brown
Designer	Terry Brown
Artist	Mark English
Writer	Jeffrey M. Masson
Editor	William Whitworth
Publisher	The Atlantic Monthly Co., Boston, MA
Publication	The Atlantic Monthly

1542

Art Director	Jerry Pavey
Designer	Jerry Pavey
Photographer	Tom Radcliffe
Artist	Jerry Pavey
Client	Federal Farm Credit Banks Funding Corporation
Publisher	Svec/Conway Printing, Inc.
Director	James Roll
Agency	Jerry Pavey Design, Rockville, MD

1543

Art Director	Amy Seissler
Designers	Amy Seissler, Liz Siroka
Publisher	Bob Guccione
Publication	Omni Magazine, New York, NY
V.P. Graphics Director	Frank M. Devino

1544

Art Director	Fred Woodward
Designer	Fred Woodward
Artist	Jeff Smith
Editor	Gregory Curtis
Publisher	Michael Levy
Agency	Texas Monthly
Publication	Texas Monthly, Austin, TX

1545

Art Director	Judy Garlan
Designer	Judy Garlan
Artist	Edward Sorel
Writer	Nancy Caldwell Sorel
Editor	William Whitworth
Publisher	The Atlantic Monthly Co., Boston, MA
Publication	The Atlantic Monthly

1546

Art Director	Judy Garlan
Designer	Judy Garlan
Artist	Brad Holland
Writer	Walter Reich
Editor	William Whitworth
Publisher	The Atlantic Monthly Co., Boston, MA
Publication	The Atlantic Monthly

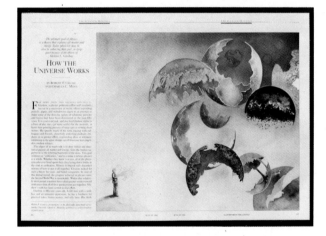

1547

Art Director	Judy Garlan
Designer	Judy Garlan
Artist	Tom Lulevitch
Writers	Robert P. Crease, Charles C. Mann
Editor	William Whitworth
Publisher	The Atlantic Monthly Co., Boston, MA
Publication	The Atlantic Monthly

1548

Art Director	Frank Schulwolf
Artist	Ted Lodigensky, Bill James, Kimberly Smith, Cheryl Nathan, Daniel Schwartz, Robert Altemus, Frank Schulwolf
Writer	Arthur Low
Client	Aviation Sales Company, Inc. A division of Ryder System
Agency	Susan Gilbert & Company, Inc., Coral Gables, FL

1549

Art Director Michael David Brown
Artist Michael David Brown
Client U.S. Postal Service
Agency Michael David Brown, Rockville, MD

1550

Art Director Judy Garlan
Designer Judy Garlan
Artist Jean-Michel Folon
Writer Thomas Powers
Editor William Whitworth
Publisher The Atlantic Monthly Co., Boston, MA
Publication The Atlantic Monthly

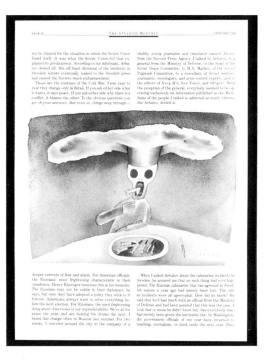

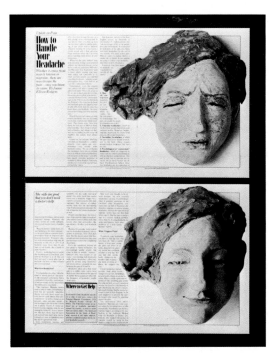

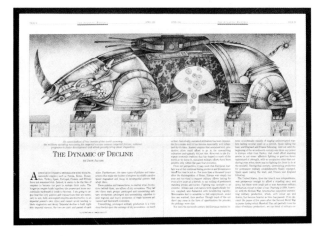

1551

Art Directors Will Hopkins, Ira Friedlander
Designers Will Hopkins, Ira Friedlander
Artist Sculptures by Jane Morse
Editor Owen Lipstein
Publisher T. George Harris
Agency Will Hopkins, New York, NY
Publication American Health Mag.

1552

Art Director Judy Garlan
Designer Judy Garlan
Artist James Endicott
Writer Jane Jacobs
Editor William Whitworth
Publisher The Atlantic Monthly Co., Boston, MA
Publication The Atlantic Monthly

1553

Art Director	Don Smith
Artist	Tom McNeely
Writer	Jean Anderson
Client	McIlhenny Co. (Tabasco)
Director	Joseph L. Killeen Jr.
Agency	Fitzgerald Advertising, New Orleans, LA

1554

Art Director	Bob Ciano
Designer	Bob Ciano
Artist	Paola Piglia
Reporter	June Goldbert
Editors	Richard Stolley, Mary Steinbauer
Publisher	Life Magazine

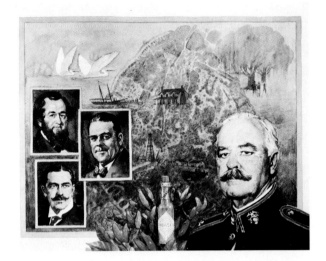

1555

Art Director	Molly Epstein
Designer	Molly Epstein
Artist	Daniel Pelavin
Client	Garan Inc.
Director	Peter Noto
Agency	Shaller Rubin & Winer, New York, NY

1556

Distinctive Merit

Art Director	Dick Sheaff
Designer	Dick Sheaff
Artist	Ray Ameijide
Client	Ginn & Company
Editor	Pat Maka
Agency	Sheaff Design, Inc., Needham Heights, MA
Graphic Arts Director	Constance Tree

Photography (single entries): Advertising, editorial, promotion; b&w
Advertising, editorial, promotion; color
Packaging, P.O.P., display
Book or book jacket

Campaign entries: Advertising, editorial, promotion campaign; b&w
Advertising, editorial, promotion campaign; color
Book or book jacket campaign

1557

Art Directors Bard Martin, Toshi Sakai
Designer Barbara Tanis
Photographer Bard Martin, New York, NY
Client Bard Martin Photography

1558

Art Director Jeff Henson
Photographer Robert Mulligan
Writer Larry DeLamarter
Client Pacific National Bank of Nantucket
Agency DeLamarter & Bennette Advertising,
Inc., Boston, MA

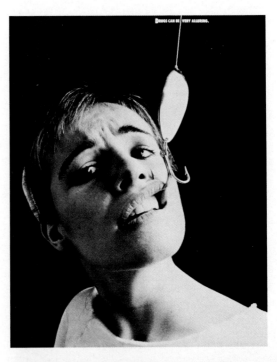

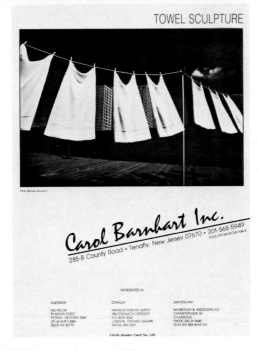

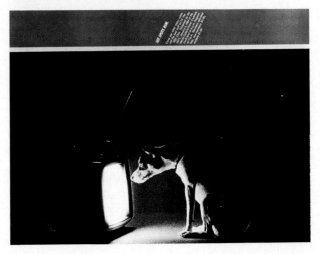

1559

Art Director Michael Baumann
Photographer Michael Baumann
Client Carol Barnhart Inc.
Agency Jäno Group, New York, NY

1560

Art Directors Gae Benson, Andrew Vracin
Designer Gae Benson
Photographer Andrew Vracin
Writers Gae Benson, Mike Malone
Client Dallas Society of Visual
Communications
Agency Andrew Vracin Photography, Dallas,
TX

Art Director John Ciofalo
Designer Ernest Scarfone
Photographer Harold Sund
Writer Julia Scully
Editor Herbert Keppler
Publisher ABC Publishing, New York, NY
Publication Modern Photography

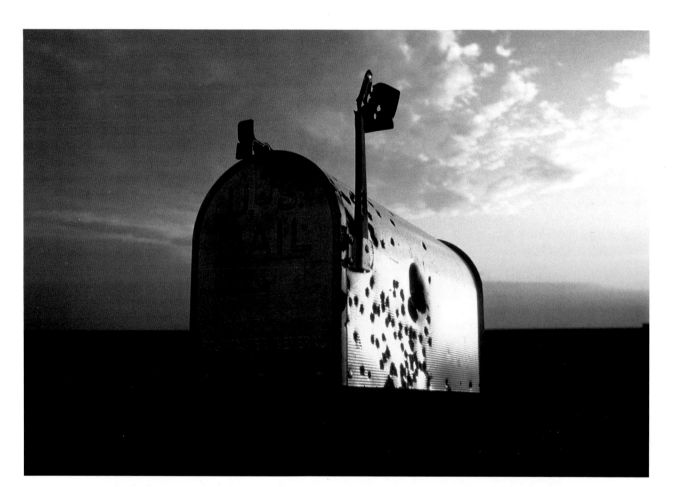

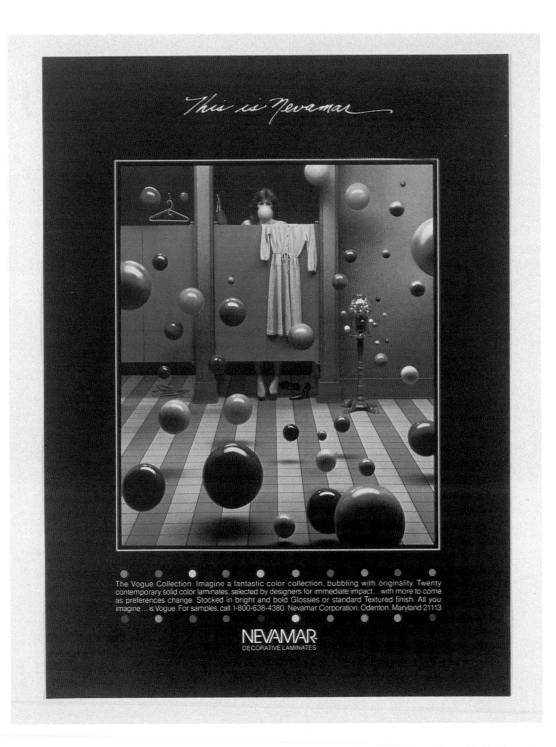

1563
Silver Award

Art Directors	Doug Fisher, Bob Bender
Designers	Doug Fisher, Bob Bender
Photographer	Hickson-Bender
Writer	Ron Etter
Client	Nevamar Corporation
Agency	Lord, Sullivan & Yoder, Marion, OH
Publication	Interior Design

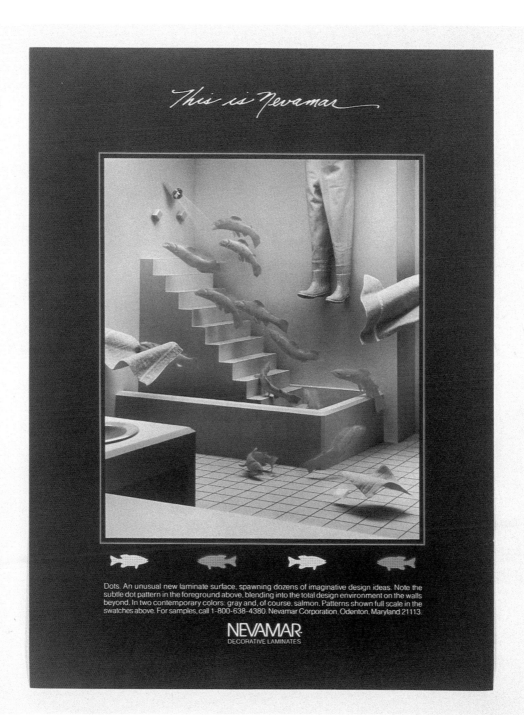

1564

Art Director	Cam Chapman
Designer	Nicholas Sinadinos
Photographer	Cam Chapman
Client	Cam Chapman Photography, Chicago, IL

1565

Art Director	Gene Icardi
Photographer	Jim Sadlon
Client	Bianchi/Vespa of America
Agency	Light Language, San Francisco, CA

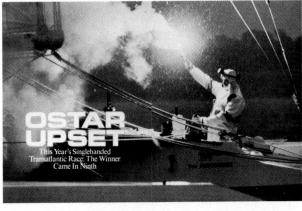

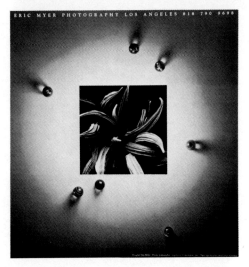

1566

Art Director	Al Braverman
Designer	David Taub
Photographer	J. Guichard/Sygma
Writer	Bill Homewood
Editor	Peter A. Janssen
Publisher	Robert J. O'Conner
Publication	Motor Boating & Sailing, New York, NY

1567

Art Director	Don Weller
Designer	Don Weller
Photographer	Eric Myer
Client	Eric Myer Photography, La Canada, CA
Printer	Lithographix

1568

Art Director Tony Ross
Designer Tony Ross
Photographer Robert D. Prengle
Writer Luann H. Haney
Client Max White/Silverworks
Agency Buterbaugh/Prengle, Wilmington, DE
Printer Veitch Printing Corp.

1569

Art Director Joe Goldberg
Photographer Mark Meyer
Writer Tim McGraw
Client Pratt & Whitney
Agency HCM, New York, NY

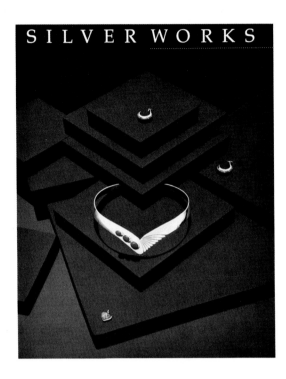

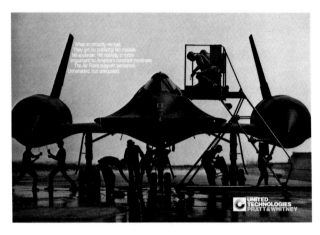

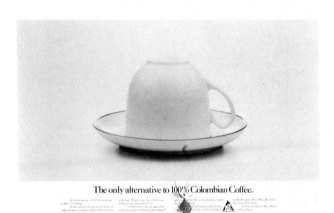

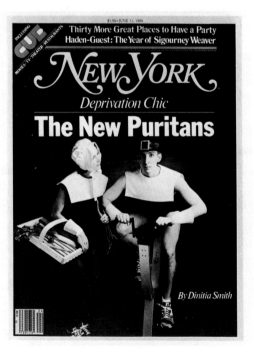

1570

Art Director Ron Louie
Designer Ron Louie
Photographer Harry DeZitter
Writer Chuck Gessner
Client National Federation of Coffee
 Growers of Colombia
Agency Doyle Dane Bernbach, New York, NY
Publication World Coffee & Tea

1571

Art Director Robert Best
Designer Jordan Schaps
Photographer Tohru Nakamura
Writer Dinitia Smith
Editor Edward Kosner
Publication New York Magazine, New York, NY

1572

Art Director Larry Bender, Lawrence Bender &
 Associates
Designer Linda Brandon
Photographer Chuck O'Rear, St. Helena, CA
Client Cetus Corporation

1573

Art Director Al Braverman
Designer Dave Taub
Photographer Charles LeMieux
Writer Charles LeMieux
Editor Peter A. Janssen
Publisher Robert J. O'Conner
Publication Motor Boating & Sailing, New York,
 NY

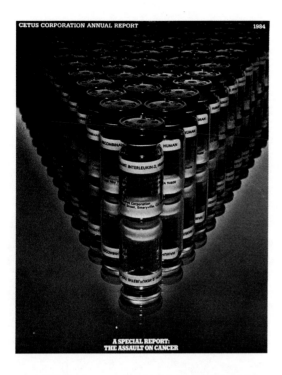

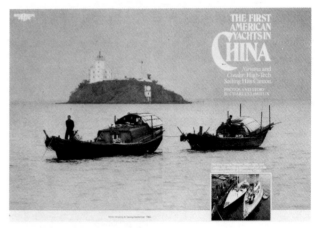

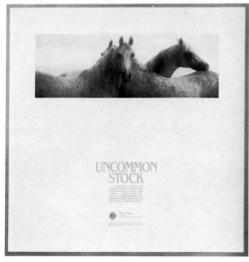

1574

Art Director Ted Nuttall
Designer Mike Dambrowski
Photographer Craig Wells
Writer Sarah Harrell
Client Butler Paper
Agency Dambrowski/Nuttall Design
 Associates, Phoenix, AZ

1575

Art Director Cliff Watts
Designer Cliff Watts
Client Cliff Watts, New York, NY

1576

Art Director Chris Hill
Designer Chris Hill, The Hill Group
Photographer Steve Brady
Client NCAA
Agency Hill Design Group, Houston TX
Retouching Raphaele Inc.

1577

Art Director Wendy Talve Reingold
Designer Wendy Talve Reingold
Photographer Danny Muro, Don Carroll Studio
Writer Reg Lansberry
Publication World Tennis Magazine/CBS
Publishing, New York, NY

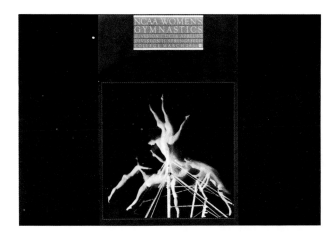

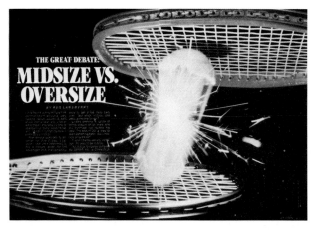

1578

Art Director Greg Nygard
Photographer Neal Vance
Client Neal Vance Photography, Inc.,
Dallas, TX
Publication Advertising Photography In Chicago

1579

Art Director Lloyd Ziff
Designer Karen Lee Grant
Photographer Jacques Dirand
Writer Alice Gordon
Editor Karen Parker Gray
Publisher The Conde Nast Publications, Inc.,
New York, NY
Publication House & Garden

1580

Art Director	Lloyd Ziff
Designer	Lloyd Ziff
Photographer	Tim Street-Porter
Writer	Robert M. Adams
Editor	Elizabeth Sverbeyeff Byron
Publisher	The Conde Nast Publications, Inc., New York, NY
Publication	House & Garden

1581

Art Director	Richard Bleiweiss
Designer	Richard Bleiweiss
Photographer	Pete Turner
Publisher	Bob Guccione
Publication	Penthouse, New York, NY
V.P. Graphics Director	Frank Devino

1582

Designer	Richard W. Smith
Photographer	Richard W. Smith
Client	Smith Photographic, Inc., Greensboro, NC

1583

Art Director	Frank Haggerty
Designer	Frank Haggerty
Photographer	Marvy! Advertising Photography
Writer	Ron Sackett
Client	Normark Corporation
Agency	Carmichael Lynch, Minneapolis, MN

1584

Art Director	John Grant
Designer	Marilyn Appleby
Photographer	Robert Llewellyn, Boston, MA
Client	Spencer Printing, Inc.
Agency	Thomasson, Grant & Howell

1585

Art Director	Amy Schottenfels
Designer	Amy Schottenfels
Photographer	Michael O'Neill
Writer	Helen Klein
Client	Nikon
Agency	Scali McCabe Sloves, New York, NY

1586

Art Director	Christopher Austopchuk
Designer	Christopher Austopchuk
Photographer	Chuck Baker
Writer	Kathleen Jonah
Client	Condé Nast Publications, New York, NY
Editor	Phyllis Starr Wilson
Publisher	Kevin Madden
Publication	Self Magazine

1587

Art Directors	Carl Lehmann-Haupt, Bob Stern
Designer	Ann Kwong
Photographer	Bob Stern
Agency	Bob Stern Studio, New York, NY

1588

Art Director	Wendy Talve Reingold
Designer	Wendy Talve Reingold
Photographer	John Russell
Publication	World Tennis Magazine/CBS Publishing, New York, NY

1589

Art Director	Bernard Rotondo
Photographer	Brian Leatart
Editor	Marilou Vaughan
Publisher	Knapp Communications, Los Angeles, CA
Publication	Bon Appetit Magazine

1590

Art Director	Robert Buchanan
Photographer	Robert Buchanan
Client	Self promo
Photography Studio	Robert Buchanan Photography, Valhalla, NY

1591

Art Director	Sylvia Dahlgren
Photographer	Paul Slaughter, Marina Del Rey, CA
Client	Olson-Travel World, Ltd.
Printer	Colorgraphics

1592

Art Director	Lloyd Ziff
Designer	Karen Lee Grant
Photographer	Balthazar Korab
Editors	Denise Otis, Marie-Paule Pelle, Babs Simpson
Publisher	The Conde Nast Publications, Inc., New York, NY
Publication	House & Garden

1593

Art Director	Lawrence C. Crane
Designer	Lawrence C. Crane
Photographer	Greg Jarem
Writer	Thos L. Bryant
Editor	John Lamm
Publisher	CBS Magazines, Newport Beach, CA
Publication	Road & Track Presents Show Cars

1594

Art Director	Lee Wheat
Photographer	Tomas Pantin, Austin, TX
Client	Topletz Development

1595

Art Director	Derek Ungless
Designer	Elizabeth Williams
Photographer	Richard Avedon
Photo Editor	Laurie Kratochvil
Publication	Rolling Stone Magazine, New York, NY

1596

Art Directors Doug Fisher, Bob Bender
Designers Doug Fisher, Bob Bender
Photographer Hickson-Bender
Writer Ron Etter
Client Nevamar Corporation
Agency Lord, Sullivan & Yoder, Marion, OH
Publication Interior Design

1597

Art Director Lloyd Ziff
Designer Lloyd Ziff
Photographer Karen Radkai
Writer Elaine Greene
Editor Babs Simpson
Publisher The Conde Nast Publications, Inc., New York, NY
Publication House & Garden

1598

Art Director Minoru Morita
Designer Minoru Morita
Photographers Kyunghun Koh, Dale Whyte
Client Creative Center Inc.
Agency Creative Center Inc., New York, NY

1599

Art Director Dominick Algieri
Photographer Eric Meola
Writer Jack Cowell
Client Lehman Bros.
Agency Albert Frank Guenther Law Inc., New York, NY

1600

Art Director Richard M. Baron
Designer Richard M. Baron
Photographer John Lamm
Writer Thos L. Bryant
Editor Thos L. Bryant
Publisher CBS Magazine, Newport Beach, CA
Publication Road & Track Presents Exotic Cars: 2

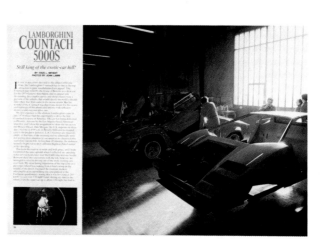

1601

Art Director Tomas Pantin, Austin, TX
Photographer Tomas Pantin
Client Eagle's Nest Gallery
Assistant Ron Sawasky

1602

Art Directors	Doug Fisher, Bob Bender
Designers	Doug Fisher, Bob Bender
Photographer	Hickson-Bender
Writer	Ron Etter
Client	Nevamar Corporation
Agency	Lord, Sullivan & Yoder, Marion, OH
Publication	Interior Design

1603

Art Director	Steve Singer
Designer	Steve Singer
Photographer	James Salzano
Writers	Michael Robertson, Anders Rich
Client	RCA
Agency	Needham Harper Worldwide, Inc., New York, NY
Publication	Business Week North America

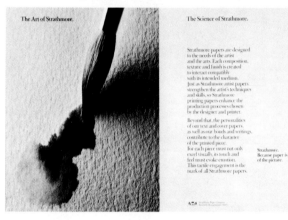

1604

Art Director	Christina Howe
Photographer	Michael Furman Photographer Ltd., Philadelphia, PA
Writer	Jack Soos
Client	Strathmore Paper
Agency	Keiler Advertising

1605
Distinctive Merit

Art Director	Bob Ciano
Designer	Bob Ciano
Photographer	NASA
Reporter	Naomi Cutner
Editors	Richard Stolley, Steve Robinson
Publisher	Life Magazine

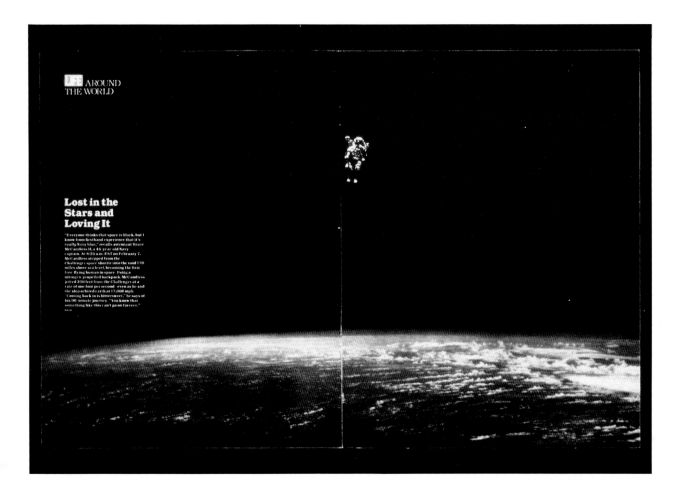

Distinctive Merit

Art Director Bob Ciano
Designer Bob Ciano
Photographer Alan Dorow
Editors Richard Stolley, Steve Robinson
Publisher Life Magazine

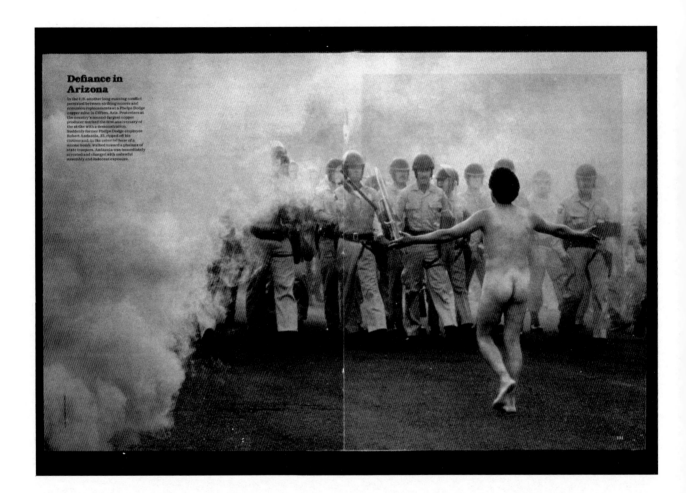

Defiance in Arizona

In the U.S. another long-running conflict persisted between striking miners and nonunion replacements at a Phelps Dodge copper mine in Clifton, Ariz. Protesters at the country's second-largest copper producer marked the first anniversary of the strike with a demonstration. Suddenly former Phelps Dodge employee Robert Andazola, 31, ripped off his clothes and, in the colorful haze of a smoke bomb, walked toward a phalanx of state troopers. Andazola was immediately arrested and charged with unlawful assembly and indecent exposure.

1607

Art Director	Bob Ciano
Designer	Bob Ciano
Photographer	Professor Owen Beattie
Reporters	Donna Haupt, David Craig
Editors	Richard Stolley, Steve Robinson
Publisher	Life Magazine

1608

Art Director	Bob Ciano
Designer	Bob Ciano
Photographer	Heinz Schürch
Editor	Richard Stolley
Publisher	Life Magazine

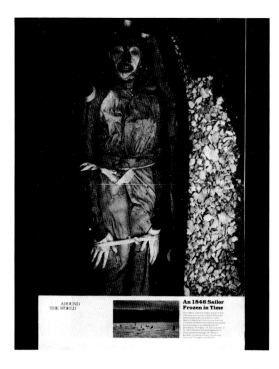

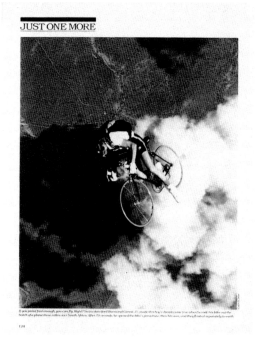

1609

Art Director	Audrey Satterwhite
Designer	Audrey Satterwhite
Photographer	Robert Farber
Client	Atlantic Records, New York, NY
Make-up and Hair	Paddy Crofton

1610

Art Director Bob Defrin
Designer Bob Defrin
Photographer David Michael Kennedy
Client Elektra/Asylum Records
Agency Atlantic Records, New York, NY

1611

Art Director Hal C. Kearney
Designer Robert Amft
Photographer Robert Amft
Client Scott, Foresman and Company, Glenview, IL
Editors Jane Bachman, Andy Adolfson
Publication Landmarks/Gateway

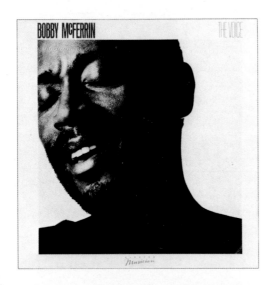

1612

Art Director Anthony Russell
Designer Anthony Russell
Photographer Jay Maisel
Writer John Stefans
Client Manufacturer's Hanover Trust
Agency Anthony Russell Associates, New York, NY

1613

Art Director Hal C. Kearney
Designer Robert Amft
Photographer Robert Amft
Client Scott, Foresman and Company,
Glenview, IL
Editors Jane Bachman, Patty Freeland
Publication Travels/Gateway

1614

Art Directors Julio Blanco, Al Blanco
Designer Michael Fineman
Photographer Michael Fineman
Writer Julio Blanco
Publisher Al Garcia-Serra
Agency Garcia-Serra & Blanco Advertising,
Coral Gables, FL

To describe someone as having "a screw loose" means that the person is "unusual or peculiar." Why might a man be named "Screwloose"? And what if that man also happens to be a robot?

What's Become of Screwloose?

by RON GOULART

1615

Silver Award

Art Director Paul Huber
Designer Paul Huber, Loucks Atelier
Photographer Steve Brady, Houston, TX
Writer Linda Bradford
Client Houston Metropolitan Ministries

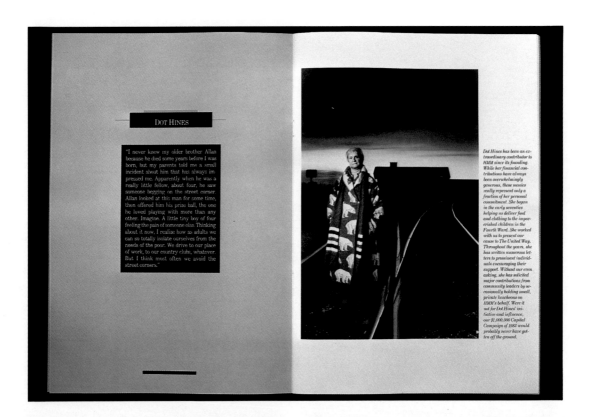

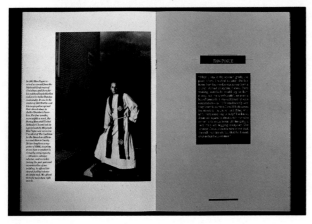

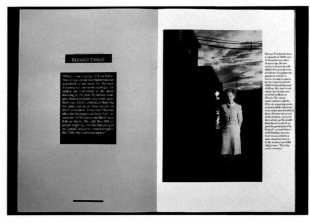

1616

Art Director	Wayne D. Hulse
Designer	Wayne D. Hulse
Photographer	Amy Etra
Client	Lens Magazine
Editor	Barry Tanenbaum
Publisher	Samuel Fisher
Director	Virginia Murphy-Hamill
Publication	Hearst Business Publications, Garden City, NY

1617

Art Director	Amy Seissler
Designers	Amy Seissler, Liz Siroka
Photographer	David Michael Kennedy
Publisher	Bob Guccione
Publication	Omni Magazine, New York, NY
V.P. Graphics Director	Frank M. Devino

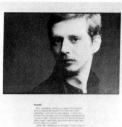

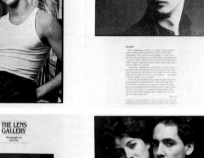

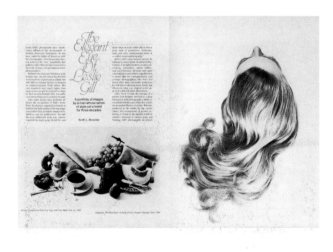

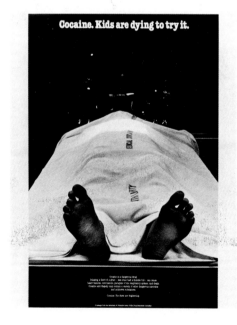

1618

Art Director	Shinichiro Tora
Designer	Shinichiro Tora
Photographer	Leslie Gill
Writer	W.L. Broecker
Client	Popular Photography
Editor	Arthur Goldsmith
Publisher	CBS Magazine, New York, NY
Publication	Popular Photography

1619

Art Director	Keith Owens
Designer	Keith Owens
Photographer	Steve Brady
Writers	Keith Owens, Sherry Healms
Client	Elks Drug Awareness Committee
Agency	Hill & Knowlton, Houston, TX

1620

Gold Award

Art Director Mary K. Baumann
Designer Mary K. Baumann
Photographer Michael O'Neal
Writer Elizabeth Hall
Editor Kevin Buckley
Publisher Knapp Communications, New York, NY
Publication GEO

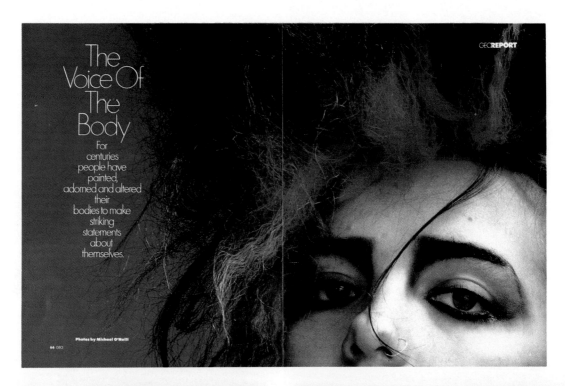

1621
Gold Award

Art Director | Richard Bleiweiss
Photographer | Dennis Manarchy
Photo Editor | Hildegard Kron
Publisher | Bob Guccione
Publication | Penthouse, New York, NY
V.P. Graphics Director | Frank Devino

1622

Silver Award

Art Directors	Wayne Fitzpatrick, Joyce L. Black
Designer	Wayne Fitzpatrick
Photographer	Gordon Gahan/Prism
Writer	Bruce Schechter
Client	Science 84/American Association for the Advancement of Science
Editor	Allen Hammond
Publisher	William Carey
Publication	Science 84 Magazine, Washington, DC
Photo Editor	Margo Crabtree

1623
Silver Award

Art Director Thomas Ridinger
Designer Thomas Ridinger
Photographer Hideki Fujii
Writer Arthur Goldsmith
Client Popular Photography
Editor Arthur Goldsmith
Publisher CBS Magazine
Publication Photography Annual 1985, New York, NY

HIDEKI FUJII The Japanese photographer, Hideki Fujii, is well known to readers of *Popular Photography* and *Photography Annual* for his elegant fashion photographs and nude studies. These graphic abstractions, with their dramatic colors and striking compositions, are a new departure for the versatile and imaginative Fujii. Created by figures in bold, colored leotards and bathing suits, the abstract images are the subject of the 1984 calendar for Trio-Kenwood, a Japanese manufacturer of video equipment. Characteristic of Fujii's style, they achieve their effect with economy and grace, combining an understated traditional Japanese aesthetic with a mastery of contemporary color photography.

1624

Art Director	Joe Rattan
Designer	Chris Hill
Photographer	Gary Braasch
Writer	Robert Frost
Client	Superb Litho, Inc.
Agency	Hill/A Graphic Design Group, Houston, TX

1625

Art Director	Ken Kendrick
Designer	Ken Kendrick
Photographer	Chuck Baker
Client	The New York Times
Editor	Ed Klein
Publisher	The New York Times, New York, NY
Publication	The New York Times Magazine

1626

Art Director	Amy Seissler
Designers	Amy Seissler, Liz Siroka
Photographer	Pete Turner
Publisher	Bob Guccione
Publication	Omni Magazine, New York, NY
V.P. Graphics Director	Frank M. Devino

1627

Art Director	Richard Bleiweiss
Photographer	Eric Meola
Writer	Peter Manso
Client	Penthouse Publications
Publisher	Penthouse Magazine/Bob Guccione, New York, NY
Publication	Penthouse Magazine

1628

Art Director Nancy Hoefig
Designer Nancy Hoefig
Photographer Arthur Meyerson
Writers Mark Perkins, Jess Hay
Client Lomas & Nettleton Housing
Corporation
Agency Richards Brock Miller Mitchell &
Associates, Dallas, TX

1629

Art Director Julia Wyant
Designer Robert Meyer
Photographer Ron Wu
Writer Theodore J. Holmgren
Client Curtice Burns, Inc.
Editor Theodore J. Holmgren
Printer Canfield & Tack, Inc.
Agency Robert Meyer Design, Inc.,
Rochester, NY
Stylist June Foster

CURTICE-BURNS, INC.
Annual Report for the Year Ended June 29, 1984

1630

Art Director Thomas Ridinger
Designer Thomas Ridinger
Photographer Jean Dieuzaide
Writer Jim Hughes
Client Popular Photography
Editor Jim Hughes
Publisher CBS Magazine
Publication Photography Annual 1985, New
York, NY

Art Director Lowell Williams
Designers Lowell Williams, Bill Carson
Photographer Arthur Meyerson
Writer Arthur Meyerson
Client Arthur Meyerson
Agency Lowell Williams Design, Houston, TX

1632

Gold Award

Art Director	Swami Jivan Mahasubh
Designers	Swami Jivan Mahasubh, Paul Mort
Photographer	Christopher Newbert
Writer	Christopher Newbert
Client	Beyond Words
Editor	Paul Berry
Publisher	Beyond Words
Agency	Rickabaugh Design, Portland, OR
Calligraphy	Tim Girvin

1633

Gold Award

Art Director Pete Turner
Photographer Pete Turner, New York, NY
Writer Myrna Massucci
Publisher Prentice Hall

1634

Silver Award

Art Director James B. Patrick
Designer Donald G. Paulhus
Photographer Robert Llewellyn, Boston, MA
Client Foremost Publishers, Inc.
Agency Foremost Publishers, Inc.

Television: Commercial, 10 seconds
Commercial, 30 seconds
Commercial, 60 seconds or over
Commercial campaign, 10 seconds each spot
Commercial campaign, 30 seconds or more each spot
Music video
Public service
Public service campaign
Film titles, logos, signatures, cable breaks, etc.
Film; industrial, educational or promotional
Film promos (10, 30 or 60 seconds)
Animation

1635
Gold Award

Art Director	Bob Kwait
Writer	Rich Badami
Editor	Sonny Klein
Director	Eric Saarinen
Client	The San Diego Zoo
Agency Producer	David Hoogenakker/Phillips-Ramsey Advertising, San Diego, CA
Prod'n Co Producer	Chuck Sloan
Music Production	Ad Music

1636
Silver Award

Art Director	Donna Weinheim
Director of Photography	Peter Wallach
Writer	Doug Fischer
Editor	Jay Gold Films
Director	Peter Wallach
Client	Ron Corin/R.C. Cola
Agency Producer	Susan Scherl/Dancer-Fitzgerald-Sample, Inc., New York, NY
Production Company	Mike Ferman/Peter Wallach Productions

TIGER
10-second
WOMAN: Here kitty, kitty, kitty
ANNCR: The world's greatest zoo, the San Diego Zoo is right in your own backyard.
SINGER: You belong in the zoo.

LITER OF THE PACK
10-second
ANNCR: Introducing RC Cola in a giant 3 Liter bottle. The big bottle in town. 3 Liter RC.
SINGERS: The Liter of the Pack.

1637

Silver Award

Art Director	Annette Osterlund
Writer	Frank Fleizach
Director	Murray Bruce
Client	Hertz
Agency Producer	Richard Berke/Scali, McCabe, Sloves, New York, NY

1638

Art Director	Rich Silverstein
Director of Photography	Keith Mason
Writers	Andy Berlin, Jeff Goodby
Editor	Tom Bullock
Director	Jon Francis
Client	Oakland Invaders
Agency Producer	Debbie King/Goodby, Berlin & Silverstein, San Francisco, CA
Production Company	Sandra Marshall, Bass/Francis

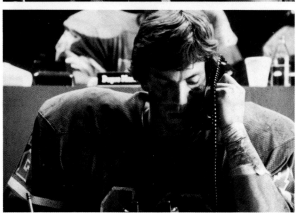

HERTZ FINGERS
10-second
ANNCR (VO): The next time you rent a car, consider your choices.
Hertz.
Or.

OPERATOR
10-second
ANNCR VO: If you've had trouble reaching the Invaders ticket line, . . .
PLAYER: Hello? . . .
ANNCR (VO): . . . please be patient.
PLAYER: Hello? . . .
ANNCR (VO): Our operators are standing by to take your call.
PLAYER: Hello? Hello?

1639

Art Director	Robert Reitzfeld
Designer	Robert Reitzfeld
Writer	David Altschiller
Editor	Randy Illowite
Director	Michael Schrom
Client	Boar's Head
Agency Producer	Jinny Kim/Altschiller Reitzfeld Solin Advertising, New York, NY
Prod'n Co Producer	Roberta Groubman

1640

Art Director	Bob Kwait
Writer	Rich Badami
Editor	Sonny Klein
Director	Eric Saarinen
Client	The San Diego Zoo
Agency Producer	David Hoogenakker/Phillips-Ramsey Advertising, San Diego, CA
Prod'n Co Producer	Chuck Sloan
Music Production	Ad Music

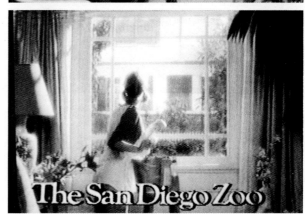

BRANDING
10-second
ANNCR (VO): Next time you look for ham, look for the Boar's Head brand.
SFX: SSSSSSSS.
It's your assurance that the ham you buy isn't a turkey.

ORANGUTAN
10-second
ANNCR: The world's greatest zoo, the San Diego Zoo is right in your own backyard.
SINGER: You belong in the zoo.

1641

Art Director	Andrew Hirsch
Artist	J.C. Suarés
Writer	Fred Walker
Client	MONY
Agency Producer	Andrew Weber/Marschalk Company, New York, NY
Production Company	Buzzco Productions, Inc.

1642

Art Director	Mike Murray
Writer	Bob Thacker
Editor	Tony Fischer
Director	Jim Lund
Client	Rogers Cablesystems
Agency	Chuck Ruhr Advertising, Minneapolis, MN
Prod'n Co Producer	Mary Schultz

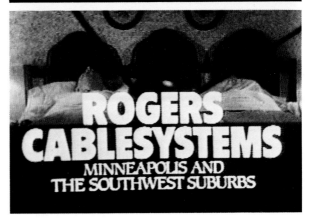

UNCLE SAM
10-second
Ever notice . . . every time you get a raise . . . the I.R.S. . . . gets one, too?
Call MONY Financial Service. We help people . . . manage their money.

MAGNUM P.I.
10-second
VO: If you think Magnum P.I. is P.U. you're ready for Rogers.

1643

Art Director	Roy Grace
Director of Photography	Fred Moore
Writer	Neal Gomberg
Editor	Pierre Kahn
Director	Michael Ulick
Client	Volkswagen of America
Agency Producer	Jim deBarros/Doyle Dane Bernbach, New York, NY
Production Company	Liz Kramer/Michael Ulick Productions

1644

Art Director	Steven Feldman
Writer	Frank Anton, Jr.
Editor	Jerry Bender
Director	Steve Steigman
Client	Granada TV Rental
Agency Producers	Michael Pollock/Dottie Wilson/TBWA Advertising, Inc., New York, NY
Prod'n Co Producer	Pat Dorfman
Advertiser Supervisor	Pierre Delerive

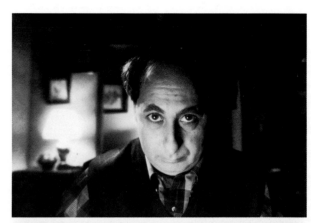

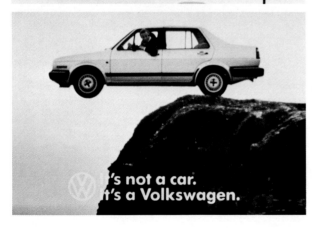

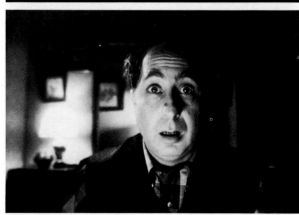

CLIFF
10-second
MUSIC THROUGHOUT
VO: The stories about the volkswagen
Jetta's remarkable performance are slightly exaggerated.
Jetta.
It's not a car,
It's a Volkswagen.

BOBBING HEAD
10-second
ANNCR (VO): Some people will put up with anything . . .
ANNCR: . . . when they have to pay for TV repairs . . .
ANNCR (VO): . . . rent from Granada and all repairs are free.

1645

Art Directors	Ken Amaral, Richard Kimmel
Writer	Allen Cohn
Editor	Jack Tohtz
Director	Bert Steinhauser
Client	Bob Campbell - Illinois Bell
Agency Producer	Sue Thompson/N.W. Ayer, Chicago, IL
Prod'n Co Producer	Donna Imbarato
Creative Directors	Allen Cohn, Ken Amaral

1646

Art Director	Alan Chalfin
Writer	Larry Vine
Editor	The Tape House
Director	Jim Connolly
Client	Lea & Perrins
Agency Producer	Sarah Fader/Geers Gross Advertising, New York, NY
Production Company	Close Up

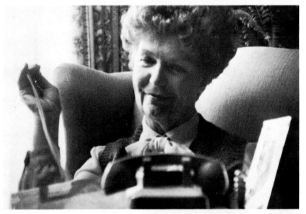

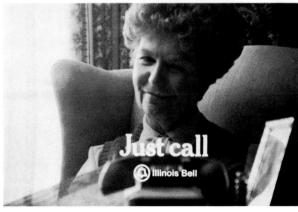

MOTHER
10-seconds
ANNCR (VO): It's Sunday, have you called your mother yet?

WINE
10-second
ANNCR (VO): If you want superior body . . . rich bouquet . . .
Fine aging and vintage taste
Lea & Perrins Worcestershire Sauce has it all wrapped up.

1647
Gold Award

Art Director	Rick Elkins
Writer	Rhonda Peck
Editor	Larry Plastrik
Director	Richard Greenberg
Client	IBM
Agency Producer	Susan Calhoun/Doyle Dane Bernbach, New York, NY
Production Company	R. Greenberg Assoc.

1648
Gold Award

Art Directors	Michael Hart, Bob Donnellan, Frank Nicolo
Artist	Mike Beck (Edstan Studio)
Writers	Laurie Birnbaum, Jim Patterson
Editor	Bob Derise (A Cut Above)
Director	Gerard Hameline
Client	Showtime/The Movie Channel
Agency Producers	Paul Frahm, Ben Fernandez/J. Walter Thompson, New York, NY
Production Company	Michael Daniels Productions
Music	HEA Productions

INVISIBLE COPIER
30-second
ANNCR (VO): A copier is one of those things people notice when it's not working. Which is why an IBM Model 60 tends to become invisible. It's so reliable, people take it for granted.
WOMAN: Just one quick copy?
MAN: Oh, sure.
ANNCR (VO): It's easy to use and has all the features you'd expect in a much more expensive copier, which makes it the kind of value you don't see every day. The invisible copier from IBM.

WE MAKE EXCITEMENT
30-second
ANNCR (VO): Presenting Showtime Cable TV!
SINGERS: We make excitement!
Showtime excitement!
You're gonna see TV
With some real excitement!
We make excitement!
Showtime excitement!
Applause, applause
Get Showtime because
We make excitement!

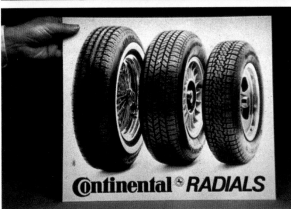

DUMMY
30-second
DUMMY: This micro has macro modelling and comes with multiple mini modems.
DUMMY: It'll format, forecast, ferret, figure, file, and form formulations.
ANNCR (VO): Some computer salespeople seem to know more about buzzwords than computers.
DUMMY: It's compatable and expandable. It's. . . .
ANNCR (VO): But at Businessland, our people have an average of 4 years experience in the computer industry and years of business experience, which is why our sales people . . .
DUMMY: . . . able and infallible.
ANNCR (VO): Businessland. Where business people are going to buy computers.

NO FRILLS
30-second
At continental we spare no expense designing great tires for Germany. But we won't spend one extra cent on commercials.
Our tire in action.
Designed for 170 days of rain a year in Northern Germany.
Limitless speeds on the autobahn.
And tons of snow in the Alps.
So, imagine what they can do on American roads.
At Continental, we don't make great tire commercials, we make great tires.

1651
Distinctive Merit

Art Director	Tony LaMonte
Writer	Michael Shevack
Editor	Dennis Hayes
Director	Patrick Morgan
Client	Black & Decker
Agency Producer	Nancy Perez/BBDO, New York, NY
Production Company	Fairbanks Films

1652

Art Directors	Martha Holmes, Don Schneider
Writer	Martha Holmes
Editor	Howie Weisbrot
Director	Howard Guard
Client	Pepsi-Cola/Diet Pepsi
Agency Producer	Jeff Fischgrund/BBDO, New York, NY
Production Company	Iris Films

GREAT PICK UP
30-second
This is Car Vac . . .
from Black & Decker's Car Care series.
Plug it in,
rev it up,
feel its power.
Black & Decker's Car Vac starts fast,
It's great on the curves,
great on the straightaways.
Its 16 foot cord really goes the distance.
Watch it corner,
maneuver through tight spots.
Car Vac handles like a dream and even stops on a dime.
Car Vac. It's got great pick-up
because it's the only car vacuum that's
built like a Black & Decker.

ROOMATES
30-second
WOMAN I: So I finally get to meet him.
WOMAN II: He'll be here any minute.
WOMAN I: You've been keeping him a secret.
WOMAN II: Oh, come on . . . here, hold this.
WOMAN I: Diet Pepsi does taste better than it used to. Hard to believe that's one calorie.
WOMAN II: They improved it.
WOMAN I: With NutraSweet.
WOMAN II: Don't drink it all!
WOMAN I: Are those my shoes?
WOMAN II: No!
WOMAN II: (DING DONG) Here he is!
WOMAN I: I'm ready.
WOMAN I: I'll probably steal him from you during dinner.

1653

Art Director	Ed Maslow
Writer	Eliot Riskin
Editor	Bob DeRise
Director	Henry Sandbank
Client	Black & Decker Corp.
Agency Producer	Russel Hudson/BBDO, New York, NY
Prod'n Co Producer	Henry Sandbank

1654

Art Director	Dave Martin
Designer	Dave Martin
Writer	Mike Rogers
Editor	Ciro
Director	Pat Kelly
Client	Hershey
Agency Producer	Liza Leeds/Doyle Dane Bernbach, New York, NY

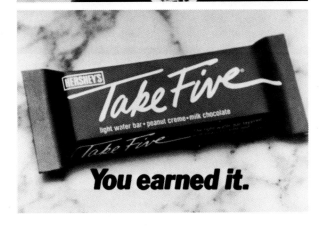

QUALITY TESTING
30-second
VO: There's a special group of men at Black & Decker who do terrible things to tools.
They torture our drills . . .
they smash our grinders . . .
they pummel our saws.
They're much harder on our tools here at the factory than you'd ever be on the job.
But it's the only way
we can be sure
that every tool we make
is truly built . . .
like a Black & Decker

YOU EARNED IT
30-second
ANNCR (VO): When you earn a break, there's a great new way to enjoy it. Take five. Light wafers, silky peanut creme, in Hershey's milk chocolate. The richness of a candy bar without the heaviness. So it makes your break fulfilling, without filling you full.
WIFE: Hi! How'd everything go?
HUSBAND: A little slow.
ANNCR (VO): Take Five. You earned it.

1655

Art Directors	Martha Holmes, Don Schneider
Writer	Martha Holmes
Editor	Howie Weisbrot
Director	Howard Guard
Client	Pepsi-Cola/Diet Pepsi
Agency Producer	Jeff Fischgrund/BBDO, New York, NY
Production Company	Iris Films

1656

Art Director	Bill Puckett
Designer	Bill Puckett
Writer	John Schmidt
Editor	Morty Ashkinos
Director	Geoffrey Mayo
Client	Thermos
Agency Producer	Frank DiSalvo/Calet, Hirsch & Spector, Inc., New York, NY
Production Company	Geoffrey Mayo Films

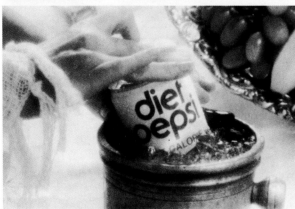

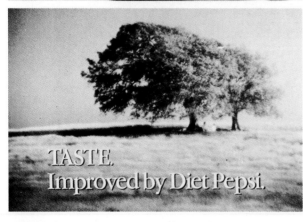

PICNIC
30-second
HIM: When you invite a man out to a nice place for lunch, you really mean it.
HER: May I show you to your seat, sir?
HER: This is our most popular
HER: patch of sunshine
HIM: Start with a drink?
HER: Diet Pepsi?
HIM: Diet Pepsi . . .
HIM: great taste with NutraSweet.
HER: I'm sure it'll be to your liking.
HER: Yes?
HIM: Yes, to everything, with no reservations.
HER: You don't need reservations.
HER: sir.

HOTFOOT
30-second
WIFE: Honey, you forgot the cooler.
ANNCR (VO): Thermos would like to remind you:
when it's 95 on the beach, it's 107 on the sand.
. 114 on the pavement
. . . . and over 125 degrees in the car.
But inside a Thermos cooler
. . . it's always ice cold.
Thermos. The hottest name in coolers.
For a limited time, save up to $5 on selected Thermos coolers.

1657

Art Director	Roy Grace
Director of Photography	Jack Churchill
Writer	Diane Rothschild
Editor	Dick Stone
Director	Tibor Hirsch
Client	Miles Laboratories Inc.
Agency Producer	Cheryl Nelson/Doyle, Dane, Bernbach, New York, NY
Production Company	THT Productions/Marty Gillen

1658

Art Director	Peter Hirsch
Writer	Ken Majka
Editor	Morty Ashkinos
Director	Mark Story
Client	Corning Optical
Agency Producer	Frank DiSalvo/Calet, Hirsch & Spector, Inc., New York, NY
Production Company	Pfeifer, Story, Piccolo

NEW YORK LADIES IV
30-second
GRACE: Sit, Aunt Rose. I'll do that.
UNCLE: She'll do that.
ROSE: You're not using Brillo?
GRACE: I switched to S.O.S.
ROSE: Our family uses Brillo.
GRACE: I know. But S.O.S. has special soap that cuts grease better.
UNCLE: We have grease.
GRACE: S.O.S. even works better on burnt-on grease.
UNCLE: We have that too!
GRACE: And S.O.S. makes everything feel so clean.
ROSE: You're done already?!
GRACE: Just because you're used to something, doesn't mean you shouldn't try something better.
UNCLE: She's got a point.

HILL
30-second
ANNCR (VO): Switching from eyeglasses to sunglasses can be very inconvenient.
Unless you have Corning Lenses That Change. Indoors they're light. Outdoors they change to sunglasses in less than sixty seconds. Ask your eyecare professional about Corning Lenses That Change in brown or gray.

1659

Art Director	Roy Grace
Director of Photography	Michael Ulick, Fred Moore
Writer	John Noble
Editor	Dick Stone
Director	Michael Ulick
Client	Mobil Oil Corporation
Agency Producer	Susan Calhoun/Doyle Dane Bernbach, New York, NY
Production Company	Liz Kramer/Michael Ulick Productions

1660

Art Director	Andy DeSantis
Writer	Nicole Cranberg Crosby
Editor	The Editors
Director	Lee Smith
Client	GTE
Agency Producer	Jill Gordon/Doyle Dane Bernbach, New York, NY
Production Company	Michael Daniels Productions

PARKING LOT
30 second
#1: You know, we haven't messed up an engine all day.
#2: It was your idea to come here.
#3: Yeah! Big parking lot. Lots of cars.
#4: Has the whole world switched to Mobil Super Unleaded Gasoline.
#3: It's so powerful
#2: And it's got high octane!
#4: What do they have against knocking and pinging?
#1: Fellas, fellas, lets forget about Mobil Super Unleaded.
#3: Why?
#1: It's beneath us.

CALL FORWARDING
30-second
ANNCR: What's it like to have call forwarding?
It's like having your office phone with you when you leave your office. Because your calls are automatically forwarded to where you're going. So when you get there, you'll receive every call that would have gone to your office. And you can use call forwarding whether you go a short distance from your office . . . or a long distance. For more information, visit your GTE Phone Mart.
MUSIC: Come to the GTE Phone Mart.

1661

Art Director	Katherine Stern
Writer	Heni Abrams
Editor	Frankie Cioffredi
Director	Mike Karbelnikoff
Client	Pierre Cardin Licencees
Agency Producer	Gene Lofaro/BBDO, New York, NY
Production Company	HKM Productions

1662

Art Directors	John Greenberger, Charlie Miesmer, Ed Maslow
Writers	John Greenberger, Charlie Miesmer
Editor	Jeff LeShaw
Directors	Ken Madsen, Dennis Gelbaum
Client	Black & Decker Corp.
Agency Producer	Dennis Gelbaum/BBDO, New York, NY
Production Company	Bean/Kahn

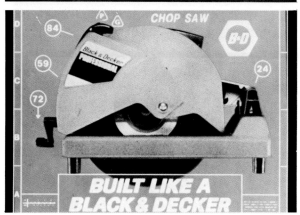

FRENCH LESSON WOMAN
30-second
MALE VO: Bonjour. The lesson begins . . . S'il vous plait.
Le peignoir.
La Chemisier.
Les bas.
Les bijoux.
Le sac.
La jupe.
Les baggages.
Le tailleur.
FEMALE VO: For style this international, you need but one foreign phrase: Pierre Cardin.
SUPER: Pierre Cardin Men Women Children.
TAG

LIGHTHOUSE
30-second
AVO: Most people who use Black & Decker power tools on weekends probably don't know why they keep on going strong year in year out. But the pro who's got to cut through two inch angle iron with a Black & Decker Chop Saw he knows why. He knows that like everything Black & Decker makes his Chop Saw is built tough and reliable and strong.
In other words it's built like a Black & Decker.

1663

Art Director	Neil Leinwohl
Director of Photography	Glenn Kirkpatrick
Writer	Kevin McKeon
Editor	John Carey
Director	Ken Matson
Client	Eagle Telephonics
Agency Producer	Milda Misevicius/Korey, Kay & Partners, New York, NY
Production Company	Bud Kahn, Bean Kahn Films International

1664

Art Director	Olavi Hakkinen
Writer	Rick Meyers
Editor	Dennis Hayes
Director	Barry Meyers
Client	Pepsi-Cola Company
Agency Producer	Phyllis Landi/BBDO, New York, NY
Production Company	Sunlight Productions

UNUSUAL
30 second
GUY: Notice anything unusual about my office? Sure you do! There's no phone on my desk! It's being replaced by a much better phone system. An Eagle. It does things like hold on to my messages if I'm out. Then display them when I return. With this new system, not even an executive can mess up a call. Soon, Eagles will be landing in everyone's office. Hopefully, on their desks.
ANNCR (VO): The Eagle One.
Now all other phone systems are endangered species.

SHARK
30-second
SFX: SEA GULLS, OCEAN, WIND
SFX: OMINOUS MUSIC
VO: When a killer thirst is in pursuit of great refreshment,
VO: the choice is inescapable.
SFX: OMINOUS MUSIC GETS FASTER, MORE ANXIOUS.
SFX: OMINOUS MUSIC CONTINUES
MUSIC STOPS
BOY: Pepsi please.
VO: Pepsi. The choice of a new generation

1665

Art Director	George Tweddle
Writer	David Johnson
Editor	Dennis Hayes
Director	Tony Scott
Client	Pepsi-Cola Company
Agency Producer	Nancy Perez/BBDO, New York, NY
Production Company	Fairbanks Films

1666

Art Director	Tony LaMonte
Writer	Michael Shevack
Editor	Jay Gold
Director	Bruce Nadel
Client	Black & Decker
Agency	David Frankel/BBDO, New York, NY
Production	Nadel Productions

REFLECTIONS
30-second
SFX: Motorcycle going full throttle. Upbeat music in background.
SFX: Motorcycle slows down a bit.
SFX: Gears shift down one gear.
SFX: Motorcycle pauses, then accelerates.
SFX: Engine echoes off passing building.
SFX: Rock beat and surrealistic sounds.
SFX: Rock beat continues.
SFX: Bike slows, gears shift, gravel hits metal.
VO: In this whole wide world, there's one
VO: spectacular taste,
VO: you just can't
VO: pass up.
VO: Pepsi.
VO: The choice of a new generation.

MANTLE
30-second
AVO: Somewhere in this room is a beautiful antique, hidden under layer upon layer of paint. Now Black & Decker will find it with Heat'n Strip the remarkable paint stripper that works with hot air, not caustic chemicals.
Heat'n Strip bubbles away years of paint with less work and a lot less mess.
It makes all other ways of stripping paint antique.
Heat'n Strip . . . It's built like a Black & Decker.

1667

Art Director	Bill Arzonetti
Director of Photography	Ray Parslow
Writer	Jim Walsh
Editor	Joe Laliker
Director	Lee Lacy
Client	Seagram Wine Co.
Agency Producer	Regina Ebel/Doyle Dane Bernbach, New York, NY
Prod'n Co Producer	Barry Munchick

1668

Art Director	Elmer E. Yochum
Designer	Elmer E. Yochum
Director of Photography	Joe Rivers
Writer	John F. Waldron
Editor	Peter Stassi, Startmark
Director	George M. Cochran
Client	Stouffer Foods Corporation
Agency Producer	Elmer Yochum, John Waldron, HBM/Creamer, Inc., Pittsburgh, PA
Production Company	Sharon DeSouza, George M. Cochran, Inc.

RHINO

30-second
FADE UP MUSIC (THROUGHOUT)
WOMAN: The Farnsworths are coming to dinner. What do you suggest?
GIELGUD: Hide and pretend you're not at home.
WOMAN: (Laughs)
GIELGUD: If that fails, serve Paul Masson Wine in these handsome carafes. Carafes add a touch of elegance and Paul Masson Wine is delicious because it's made with so much time and care.
WOMAN: Well, I'll just go and make myself beautiful.
GIELGUD: Hope springs eternal.
GIELGUD/VO: Paul Masson will sell no wine before its time.

LOBSTER

30-second
In the icy-cold waters of the Atlantic,
between New Brunswick and Prince Edward Island,
fishermen trap the famous Northern Lobsters . . .
called Homarus americanus.
Stouffer's uses the meat from the claws
and the tails of these glorious crustaceans.
Each morsel is firm and pink
with a taste and character
that is rich beyond measure.
Now you know one of the reasons
why Stouffer's Lobster Newburg is
as good as can be.

1669

Art Director Tom Peck
Writer Stefanie Samek
Editor Nitza From
Director Rick Levine
Client Richardson-Vicks-Oil of Olay
Agency Producer Helen Nelson/Y&R, New York, NY
Production Company Rick Levine Productions
Y&R Music Producer Hunter Murtaugh
Casting Sherry Sabin, Cindy Bielak

1670

Art Director Eileen Kirz
Writer Harold Kaplan
Editor Bill Bruder
Director Jonathan Maller
Client American Home Products/Whitehall Labs
Agency Producer Ted Storb/Y&R, New York, NY
Production Company Ed Silverstein, Burton Communications
Casting Anne Batchelder

STOPS PAIN WITH JUST ONE TOUCH

FLYING
30-second
MUSIC INTRO.
LYRIC: The first time ever I saw your face . . .
ANNCR (VO): You still remind him of the first time.
MUSIC
ANNCR (VO): Because Oil of Olay helps replenish fluids your skin once knew. Each greaseless drop eases dryness to revive the radiant look he loves.
LYRIC: Your face . . . your face . . .
ANNCR (VO): Oil of Olay. It can help you look younger too.

CRYING BABIES
30-second
ANNCR (VO): When babies teethe, their little mouths go through big pains. How can you stop it?
With new Baby Anbesol.
Because it works . . .
on contact.
With just one touch of new Baby Anbesol . . .
teething pain is all gone.
For temporary relief of teething pain, new Alcohol Free Baby Anbesol . . .
Stops pain with just one touch.

1671

Art Director	Michael Hampton
Writer	Nina DiSesa
Editor	Nitza From
Director	Stu Hagmann
Client	General Foods Corp.-Jell-O Gelatin Pops
Agency Producer	Sarah Peckham/Y&R, New York, NY
Production Company	Hagmann, Impastato, Stephens & Kerns
Y&R Music Producer	Craig Hazen
Casting	Sybil Trent

1672

Art Director	Tom Burden
Director of Photography	Allan Charles
Writers	Ken Fitzgerald, Allan Charles
Editor	Michael Swerdloff/First Edition Editorial
Director	Allan Charles
Client	Schmidt's Baking Company
Agency Producer	Georgia Sullivan/Trahan, Burden & Charles, Inc., Baltimore, MD
Production Company	Charles Street Films

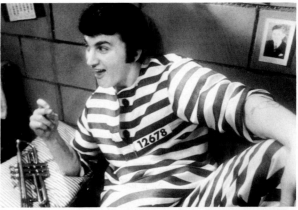

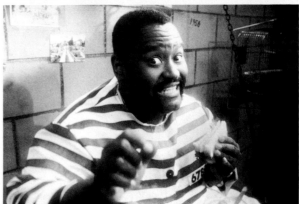

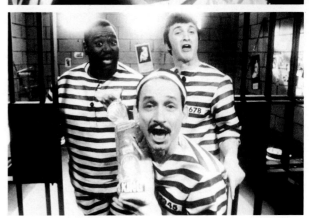

POP STAND
30-second
ANNCR (VO): Jell-O Brand Gelatin Pops presents the Little Rascals.
SPANKY: Stop eatin' those pops! We gotta sell em!
ALFALFA: I can't help it.
SCOTTY: Tastes fruity.
DARLA: Soft!
SPANKY: Well, force yourselves.
SCOTTY: A customer!
WOMAN: Hmm. What's this?
ALFALFA: New Jell-O Gelatin Pops.
WOMAN: Delicious! I'll take two more.
RASCALS: Great!!
SPANKY: Where are all the pops?
ALFALFA: Look!
RASCALS: Buckwheat!!

JAILHOUSE ROCK
30-second
I like bread and water
They serve it all the time.
I like Schmidt's Blue Ribbon Bread.
I'm glad that's not a crime.
You can taste the freshness.
It's so good to squeeze.
We just tell the warden,
Schmidt's Blue Ribbon please.
Yeah, Yeah, Yeah,
I like Schmidt's Blue Ribbon.
Yeah, Yeah, Yeah,
Schmidt's Blue Ribbon Bread.
Yeah, Yeah, Yeah,
I like Schmidt's Blue Ribbon.

1673

Art Director	Grant Richards
Designer	Robert Forsbach
Artist	Ed Brock
Writer	David Fowler
Client	The Southland Corporation/Citgo
Production Company	Brock Films
Agency	The Richards Group, Dallas, TX

1674

Art Director	Scott Shelstrom
Writer	Bob Graham
Director	Norman Griner
Client	Ramada
Agency Producer	Bill Artope
Production Company	Chris Stefani, Griner/Cuesta & Associates, New York, NY

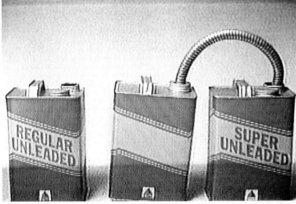

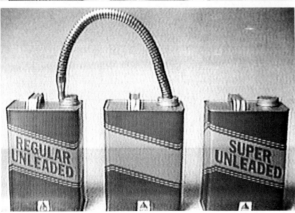

SPOUT
30-second
ANNCR: Citgo introduces a surprising new gasoline.
It combines the high octane of super unleaded,
with the low price of regular unleaded.
(SFX: SIGH)
Introducing Unleaded Plus 2, The Performer. Higher octane, at a lower price.

LOST IN SPACE
30-second
MAN: Try to remember. When you checked in, the guy said it's simple. Nothing to it. Room 343 is up two flights, down one. I did that.
MAN: Turn right by the ice machine, through the swinging doors, did that.
MAN: By the Jefferson room. Did that. This must be it. Great!
DOOR SLAMS SHUT.
ANNCR (VO): Next time, Ramada. Where they know how to take care of business.

1675

Art Director Michael Cheney
Writer George Kase
Client Turtle Wax, Inc.
Agency Producer Marea Tesseris/Lou Beres &
Associates, Inc., Chicago, IL

1676

Art Director John Constable
Writer Karen Ninnemann
Director Allen Gray
Client Abigail Nash (Newspapers, Inc.)
Agency Producers Karen Ninnemann, John Constable
Frankenberry, Laughlin & Constable
Inc., Milwaukee, WI

DUEL/PROTECTANT
30-second
ANNCR (VO): New Turtle Wax Clear Guard vinyl protectant . . . clearly
outshines them all!

MILTON
30-second
SFX: MUSIC UNDER.
WIFE: Milton, those curtains have got to go.
VO: When you have something to sell, it'll go fast in The Milwaukee
Journal and Sentinel classified sections.
WIFE: Milton, your moose doesn't go with the curtains. It'll have to go.
VO: Classified reaches a million readers a day, so even a little ad goes
a long way.
WIFE: Milton, your chair doesn't go with the candelabra. It'll
have to go.
WIFE: Milton . . . you don't go with the chair . . .
VO: Call classified at 224-2121.
Our going rates are very reasonable.

1677

Art Director Stuart Baker
Writers James Lowther, Derrick Miller
Editor Ian Weil, Rush Cutters
Director John Marles, Midnight Movies
Client Allied National Brand
Agency Producer Louise Kidman
Production Company Tony Sherwood/Saatchi + Saatchi
Compton, New York, NY
Cameraman Mike Malloy

1678

Art Director Tom Shortlidge
Writer Mike Faems
Client Pabst Brewing Company
Agency Producer Patricia McNaney/Young & Rubicam,
Chicago, IL
Prod'n Co Producer Don Guy/Dennis, Guy & Hirsch

FLYING DOCTOR
45-second
BRUCE: G'day. G'day. Is that the flying doctor, over?
DOCTOR: Copy you, Bruce.
BRUCE: Billy has real croup, doc. He's sweatin' like crazy, temperature of a 104 . . .
Well, he looks terrible.
What'll we do, over?
DOCTOR: Give him a cold drink. The coolest thing in the house until I get to you, otherwise . . .
Well, it could be real bad.
BILLY: What'd the doc say, Bruce?
BRUCE: He said it's gonna be real bad, Billy.
(VO): Castlemaine XXXX is Australia's best selling lager.
In fact, Australians wouldn't give a Castlemaine XXXX for any other lager.

T-SHIRT GIRL
30-second
ANNCR: And now, some of the best beer bellies in America . . .
These beer bellies are brought to you by new Pabst Light beer . . . just 96 great-tasting calories that won't fill you up. Or out.

1679

Art Director	Lila Sternglass
Writer	Bill Hamilton
Client	Morty Schwartz
Editor	Morty Schwartz
Director	Stew Birbrower
Client	New York State Lottery
Agency Producer	Lois Goldberg/Rumrill Hoyt, New York, NY
Prod'n Co Producer	Chris Stefani

1680

Art Director	Mike Fazende
Writer	Richard M. Coad
Client	Cole National
Agency Producer	Lee Lunardi/Young & Rubicam, Chicago, IL
Prod'n Co Producer	Dick Loew/Gomes-Loew

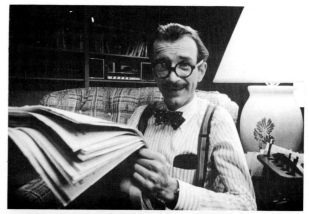

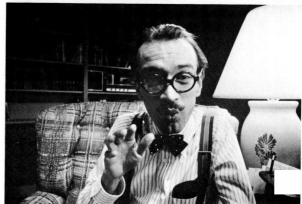

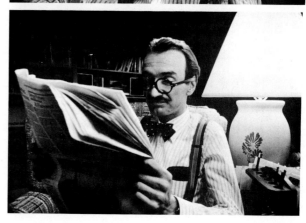

LOU EISENBERG/JOIN THE FAMILY
30-second
LOU: Hi, I'm Lou Eisenberg, one of New York Lottery's first multi-million-dollar Lotto winners. But, I'm not the last.
ANN: I'm Ann Watkins.
I won 3 million dollars.
ANDY: I'm Andy Tegerides.
I won 5 million dollars.
CARLOS: I won a million and a half.
LISA: 2 and a half.
MIKE: 3.
CURTIS: 5 million bucks!
LOU: Every week, twice a week, you've got a chance to hit the jackpot and join our growing family of Lotto millionaires.
GWEN: Lou, you look like a million.
CURTIS: Right on!

I DON'T GET IT
30-second
MAN: You know this kills me . . . this new Eyeworks place says that you can get a complete eye exam and new glasses in only a few hours . . .
. . . what's the big hurry? They say they have over 4,000 different frames . . .
. . . how many does a person need? And this really kills me . . .
. . . they say they got a computer that figures out which frames look best on your face . . .
. . . what's so hard about that . . .
I picked these . . .
VO: Come to The Eyeworks . . . Now there's a better way to take care of your eyes.

1681

Client Paul Maurer
Director of Photography Michael Werk
Writer Patty Volk Blitzer
Editor Pelco
Director Michael Werk
Client Audi
Agency Producer Jim deBarros/Doyle Dane Bernbach, New York, NY
Production Company Petersen Communications

1682

Art Director Tom Burden
Director of Photography Allan Charles
Writers Ken Fitzgerald, Allan Charles
Editor Michael Swerdloff/First Edition Editorial
Director Allan Charles
Client Maryland State Lottery
Agency Producer Georgia Sullivan/Trahan, Burden & Charles, Inc., Baltimore, MD
Production Company Charles Street Films

CLASSICAL GT
30-second
MUSIC: Beethoven's Ninth Symphony
VO: The Audi Coupe GT.
It speaks for itself.

ZERO IN LOVE
30-second
COACH: Come on Zero, move-it, move-it! Get rollin'!
ZERO: Yes, sir!
ZERO: Wow!
COACH: Zero, snap out of it. Stop looking at that Lotto ball.
ZERO: She's gorgeous!
COACH: You should be worried about tonight's Number's Games, or else it's a ticket back to Bingoville.
ZERO: I'm in love sir.
COACH: Come on Zero, move-it! You could be a winner tonight!
ZERO: Ms, 10, we could have a ball together.
ANNCR: The Number's Games, you're going to love them.

SURF GIRL
30-second
ANNCR: And now, some of the best beer bellies in America . . .
These beer bellies are brought to you by new Pabst Light beer . . . just 96 great-tasting calories that won't fill you up. Or out.

SINGING TERMITES
30-second
MUSIC UP: INTRO.
SINGING TERMITES: We are the baddest bugs in town . . .
WOMAN: Oh no!
SINGING TERMITES: We love to sneak around . . .
MAN: Call Terminix.
SINGING TERMITES: We love to come into your house and drive you crazy . . . we are the baddest bugs in town.
ANNCR: No matter how bad the termites, we'll make your problems go away. Because nobody's better at stopping termites scientifically than Terminix.
And we guarantee it.
Terminix. No more bugs. No more worries.

1685

Art Director Craig Barnard
Writer Rob Donnell
Editor Mark Polyocan/Tape House
Director Gary Perweiler
Client New England Telephone
Agency Cabot Advertising/Lou Stemoulous
Prod'n Co Producer Gena Soja/Perweiler Studio, Inc.,
New York, NY

1686

Art Director Faye Kleros
Writer Diane Hughes
Editor Janet Patterson
Director Greg Hoey
Client Bob Campbell—Illinois Bell
Agency Producer Sue Thompson/N.W. Ayer, Chicago, IL
Creative Director Allen Cohn

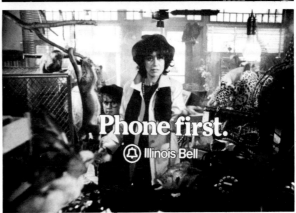

MAJOR FAILURE
30-second
No one in this house will ever know
that something terrible
is about
to happen to their phone.
Because . . .
by the time anyone
can dial a number . . .
New England Telephone will have switched
all the calls that would have normally gone over
the downed lines to alternte routes . . .
and this call will go through as if nothing ever happened.
FILTERED VOICE: Hello . . .
A phone isn't a phone . . .
without New England Telephone.

PARROT
30-second
SFX: APPROPRIATE PET STORE SOUNDS THROUGHOUT.
SFX: DOOR OPENING, BELL.
WOMAN: Good morning, my son here has his heart set on a green,
red, yellow and blue parrot. Do you have one?
CLERK: No.
WOMAN: Hello, do you have a green, red and yellow parrot?
CLERK: Sorry.
WOMAN: Do you have a green and red parrot?
CLERK: How 'bout a blue and red fish?
WOMAN: Have you got <u>anything</u> with a beak?
SINGERS: Phone First.

1687

Art Director Sam Scali
Writer Ed McCabe
Director Henry Holtzman
Client Perdue Farms
Agency Producer Carol Singer/Scali, McCabe, Sloves, New York, N.Y.
Prod'n Co Producer N. Lee Lacy

1688

Art Director Joe Toto
Writer Chet Lane
Editor Barry Walter/Startmark
Director Steve Horn
Client The Equitable
Agency Producers Joe Davidoff, Leslie J. Stark/DMM, New York, NY
Production Company Joan Chaber/Steve Horn Inc.
Concept Al Hampel

WAITING FOR A RING
30-second
MAN: Mr. Perdue, I have a complaint.
I prepared four of your cornish hens just as you did on TV . . .
I showered and I shaved just as you did on TV . . .
I dressed just as you did on TV . .
I chilled the champagne
and I laid the birds on a bed of wild rice just as you did on TV . . .
Your advertising is misleading.
No pretty girls have knocked on my door.

BASEBALL
30-second
SONG: The good life in America means reachin' for your dream . . .
GEORGE C. SCOTT: (MUSIC UNDER) In the land where baseball was born, every kid dreams of someday being a professional ball player. Along the way The Equitable helps millions of them. We protect the futures of one out of every three beginners, little leaguers, one third of the players in almost every game played in the country. And every single professional player who does make the major leagues will have The Equitable to protect his health and family and provide for his retirement.
SONG: We are the Equitable
And we'll help you live the good life.
We are the Equitable
We can help your dreams come true.
Count on the Equitable

1689

Art Director	Sam Scali
Writer	Ed McCabe
Director	Henry Holtzman
Client	Perdue Farms
Agency Producer	Carol Singer/Scali, McCabe, Sloves, New York, NY
Prod'n Co Producer	N. Lee Lacy

1690

Art Director	Donna Weinheim
Writer	Arthur Bijur
Client	Bill Welter/Wendy's International, Inc.
Agency Producer	David Dyke, DFS, New York, NY
Prod'n Co Producer	Dick Lowe

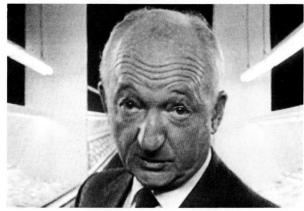

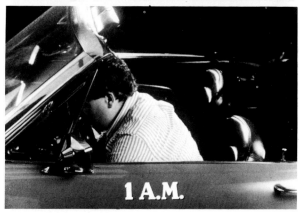

PERDUE DON'T MAKE ME DO IT
30-second
FRANK PERDUE: Have you noticed how many chicken companies have packages that look like Perdue's?
Do you suppose they could be? . . .
Nooo. They wouldn't.
But I'd suggest you be careful not to pick up the wrong yellow and red package.
Otherwise I'll have to take drastic measures to keep you from becoming confused.
(SILENT)
Don't make me do it!
(SILENT)

LATE NIGHT PICK-UP
30-second
WAITRESS: Welcome to Wendy's. Your order please.
GUY: I'd like a Chicken Sandwich and Louise here wants fries.
A single for me and a salad for lovely Linda. Hold the onions.
Give me a frosty with two spoons.
ANNCR: For those evenings that don't end at midnight Wendy's Pick-Up Window is now open late.
WAITRESS: Your order please.
GUY: Coffee black. Say, uh, what's your name.
ANNCR: Wendy's Pick-Up Window. Something later for Wendy's kind of people.

1691

Art Director	Tony Anthony
Designer	Carolyn Hall
Director of Photography	Al Leavitt
Writer	Mack Kirkpatrick
Editor	Av Fine/Editor's Center
Director	Bill Linsman/Linsman Films
Client	Napa Brakes
Agency Producer	Earl McNulty/Tucker Wayne & Company, Atlanta, GA
Prod'n Co Producer	Marilyn Field
Make-up	Charles Schram

1692

Art Director	Steven Feldman
Writer	Frank Anton, Jr.
Editor	Jerry Bender
Director	Steve Steigman
Client	Granada TV Rental
Agency Producers	Michael Pollock, Dottie Wilson/TBWA Advertising, Inc., New York, NY
Prod'n Co Producer	Pat Dorfman
Advertiser Supervisor	Pierre Delerive

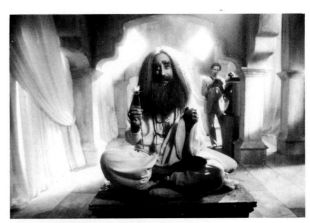

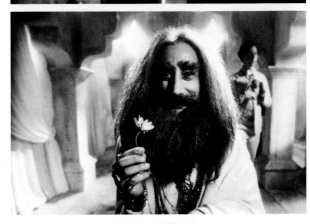

JAKE
30-second

JAKE: I just bought my last set of disc pads and brake shoes for this car. Right, Fred?
FRED: You bet!
JAKE: NAPA Lifetime Warranty Brakes.
JAKE: Not 12 months. Not 12 thousand miles. LIFETIME!
JAKE: NAPA backs up their premium disc pads and brake shoes with a LIFETIME warranty for as long as you own your car.
JAKE: A car's lifetime can be a *long, long* time. Right, Fred?
FRED: Aw, gimme a break.
JAKE: No—you give me a brake! Ha! Ha!
ANNCR (VO): Tell your serviceman you want—
—NAPA Lifetime Warranty Brakes!

MAHARISHI
30-second

PILGRIM: Master, what is the secret of happiness?
MASTER: True happiness is to own nothing. Have no possessions. Be free of material belongings.
PILGRIM: But great one, the TV, VCR and video camera, you do not own them?
MASTER: No, I rent them from Granada TV Rental. One low monthly payment covers everything. Even free repairs.
PILGRIM: And your tape, "Inner Bliss - My Way", that too can be rented?
MASTER: No, that you must buy.

1693

Art Directors	Earl Cavanah, Larry Cadman
Writer	Larry Cadman
Director	Tim Newman
Client	Playboy
Agency Producer	Dane Johnson/Scali, McCabe, Sloves, New York, NY
Production Company	Jenkins, Covington, Newman

1694

Art Director	Tony De Gregorio
Writer	Lee Garfinkel
Director	Rick Levine
Client	Subaru
Agency Producer	Bob Nelson/Levine, Huntley, Schmidt & Beaver, New York, NY

PLAYBOY SOME GUYS HAVE ALL THE LUCK
30-second
Some guys have all the luck
Some guys get all the fun
Some guys have all the luck, all the luck
Take me in your arms & let your luck begin to run.

WEDDING
30-second
MUSIC: TARANTELLA
SFX: HORRIBLE THUNDER CLAP
OLD WOMAN: (RISING WITH HER POCKET BOOK) Let's go home.
SFX: THUNDER CONTINUES.
DAUGHTER: (Crying to father) Daddy!
FATHER: (IN DESPERATE HOPE TAKES MiCROPHONE FROM BAND LEADER) Please, stop! Nothing is going to ruin this wedding. So if it takes all night—I'll personally drive each of you home in my car . . . my Subaru.
MUSIC: TARANTELLA STARTS UP UPROARIOUSLY.
ANNCR: Drive a Subaru with on demand four wheel drive. And don't let the weather spoil a good time.
SUPER: Subaru. Inexpensive. And Built To Stay That Way.

1695

Art Director Dean Hanson
Writer Tom McElligott
Editor Tony Fischer
Director Jim Lund
Client Minnesota Federal
Agency Producer Judy Carter/Fallon McElligott Rice,
Minneapolis, MN
Production Company James Productions

1696

Art Director Corinne Hilcoff
Writer Maryann Barone
Editor David Dee
Director Steve Horn
Client Jordan Marsh
Agency Producer Ann Finucane/HHCC, Boston, MA

CHECKING—BAD NEWS
30-second
(MUSIC)
VO: All across Minnesota, banks are quietly notifying their customers
that they're raising the price of checking . . .
. . . while their customers are not so quietly reacting.
VO: MUSIC CONTINUES
VO: If your bank is charging you more for checking,
there is one place where the cost of checking is not going up . . .
Minnesota Federal.

GET READY
30-second
SFX: ALARM BUZZER/RADIO COMES ON
DJ: (OVER RADIO) Fall. . . .
MUSIC: "GET READY" BY THE TEMPTATIONS—OPENING
INSTRUMENTAL
DJ: At Jordan Marsh
(SWITCH TO HEAVY SOUND SYSTEM)
DJ: This is the place . . . to Get Ready . . .
MUSIC: LYRICS UP
SFX: ALL MOVEMENT, AMBIENT SOUND
MUSIC: FADE OUT
ANNCR: This is the place. Jordan Marsh.

1697

Art Directors	Larry Yearsley, Keith Chow
Writer	Foster Hurley
Editor	Lisa DeMoraes, FilmCore
Director	Patrick Pittelli
Client	Chrysler Corporation, Import Division
Agency Producer	Joe Rein/Kenyon & Eckhardt, Inc., New York, NY
Production Company	Pittelli Production Ltd.
Sr. V.P. Creative Director	Hy Yablonka

1698

Art Director	Ken Sausville
Writer	Maryanne Renz
Editor	Gary Wachter
Client	Walter Layton/Kitchen Aid
Agency Producer	Gaston Braun/Patti McGuire, N.W. Ayer, Inc., New York, N.Y.
Production Company	Bill Hudson/Bill Hudson Films Inc.

GARAGE
30-second
ANNCR (VO): For 1985, Colt, the Japanese car famous for quality . . . economy . . . and performance . . .
now comes with a great new addition . . .
ANNCR (VO): four doors.
COLT SFX: (JAPANESE VOICE)
COMMUTER: Six o'clock.
ALL COMMUTERS: Six o'clock.
ANNCR (VO): The Colt is imported for Dodge and Plymouth . . .
COLT SFX: (JAPANESE VOICE)
ANNCR (VO): . . . and built by Mitsubishi in Japan.
COLT SFX: (JAPANESE VOICE)
ANNCR (VO): Colt. It's all the Japanese you need to know.

FATHER AND SON
30-second
DAD: Ever notice how some people wash their dishes before they put them in the dishwasher? They don't wash their clothes before they put them in the washing machine. Maybe they just don't have this new KitchenAid dishwasher.
SON: You didn't eat all your peas.
DAD: Even this much food left on a plate isn't a problem . . .
. . . because KitchenAid's unique new triple filtration system with a hard food disposer . . .
. . . gets your dishes cleaner than any other leading brand.
So you can either get a KitchenAid.
SON: Or you can eat all your peas.
SINGER/MUSIC: KitchenAid. For the way it's made.

1699

Art Director	Kathy McMahon
Writer	Bonnie Berkowitz/Linda Kaplan
Editor	Tony Siggia (First Edition)
Director	Ron Dexter (The Dexters)
Client	Eastman Kodak
Agency Producer	Pamela Maythenyi/J. Walter Thompson, New York, NY
Prod'n Co Producer	Sharon Starr (The Dexters)
Music	Fred Thaler (Lucas McFaul)

1700

Art Director	Bob Cox
Writer	Bob Cox
Editor	Morty Ashkinos
Director	Dick James
Client	Tri-Honda Auto Dealers Association
Agency Producer	Carolyn Roughsedge/Needham Harper Worldwide, Inc., New York, N.Y.
Production Company	Gregg Stern/Big Sky Photo Ranch

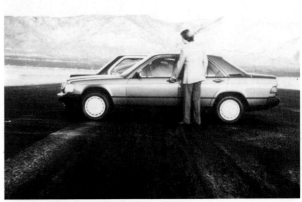

BABIES
30-second
VO: Hey there baby, listen to this, there's a new film for the Kodak disc!
SONG: The new disc film makes you look so fine, makes you look so sharp, really lets you shine.
You oughtta be in pictures, that's why I'm gonna get you with the Kodak Disc.
VO: Hey baby, now Kodak's got a new baby, too! New Kodacolor VR Disc Film for better, clearer color pictures. Oh yeah!
SONG: You got so much style with that silly ol' smile, I'm gonna get you with the Kodak Disc!

CAR OF THE YEAR
30-second
FADE UP: MUSIC THROUGHOUT.
ANNCR: The winner of the coveted 1984 Import Car of the Year Award from Motor Trend Magazine was not the Mercedes 190.
Nor was it the BMW 318i.
Not even the Audi 5000S.
It was this car: The Honda Civic CRX.
To win, it had to beat out some tough competition like this second place Honda Prelude. And third place, Honda Civic Hatchback.
MUSICAL SIGNATURE

1701

Art Director	Bob Cox
Writer	Bob Cox
Editor	Morty Ashkinos
Director	Neil Tardio
Client	Xerox Corporation
Agency Producer	Carolyn Roughsedge/Needham Harper Worldwide, Inc., New York, N.Y.
Production Company	Nan Simons/Neil Tardio Productions

1702

Art Director	Bob Cox
Writer	Bob Cox
Editor	Morty Ashkinos
Director	Dick James
Client	Tri-Honda Auto Dealers Association
Agency Producer	Carolyn Roughsedge/Needham Harper Worldwide, Inc., New York, NY
Production Company	Gregg Stern/Big Sky Photo Ranch

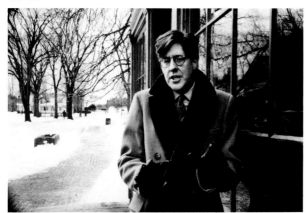

GREENFIELD VILLAGE
30-second
MAN: Greenfield Village. Looks like a typical small town wouldn't you say? With its small hardware store, small clothing store, small post office. And small people with small ideas.
Oh, you don't think so?
Well, Xerox doesn't think so either. They've never liked the word small. They much prefer . . . growing.
And Xerox thinks that a growing business should be treated just as well as a more established business. They've even formed a team of machines and people to help businesses of all sizes. It's called Team Xerox.
Yes, I know. You think Xerox is just doing it for themselves. Well, they probably wouldn't disagree.
You see, they feel that somewhere in a little shop like this, they might find the same kind of growing businessman that started right here.

FERRARI
30-second
FADE UP: MUSIC THROUGHOUT
ANNCR: Recently, the editors of Road and Track Magazine performed a slalom test on the Ferrari 308GTBi. Then they tested four other cars they found to be faster.
The Honda Civic CRX.
The Honda Civic Hatchback.
The Honda Civic Four Door.
And the Honda Civic Wagon.
And just think, for the price of the Ferrari, you could own all these Hondas, and then some.
MUSICAL SIGNATURE.

1703

Art Director	Ed Kennard
Designer	Ed Kennard
Director of Photography	Quentin Masters
Writer	Ed Kennard
Editor	Andy Walter/Rushes LTD., London
Director	Quentin Masters
Client	British Caledonian Airways
Agency Producer	Ed Kennard/Winius-Brandon Advertising, Bellaire, TX
Production Company	SW 1 One

1704

Art Director	Bob Tucker
Director of Photography	Werner Hlinka
Writers	Bonnie Folster/John Noble
Editor	Pelco
Director	Werner Hlinka
Client	Audi Corp.
Agency Producer	Bill Perna/Doyle Dane Bernbach, New York, NY

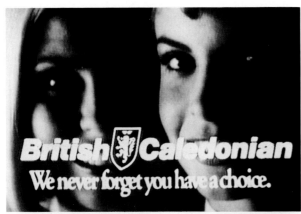

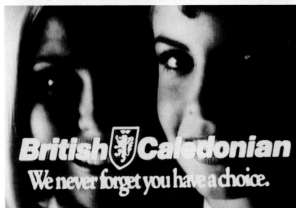

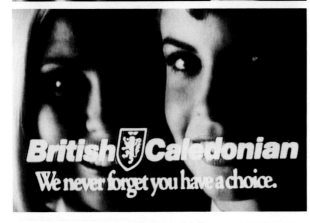

GREAT BRITAIN AERIALS
30-second
I am the rolling hills of Dorset.
I am the white cliffs of Dover.
I am a bridge over the River Thames.
I am a stately home in the English countryside.
I am a castle in the sea.
I am the best of Great Britain.
I am British Caledonian Airways.

RIGHTNESS OF DESIGN
30-second
MUSIC THROUGHOUT
ANNCR V/O: There is much to be said about "the rightness of design."
Few things in life attain it. And those that do,
in the beginning, may go unrecognized . . .
. . . by many. But,
they are heralded . . .
by experts because they are that . . .
unique and exquisite blend of form and function.
The Audi 5000S Wagon has that . . .
"rightness of design."
While others may leave their best ideas on the drawing board,
we put ours on the road.

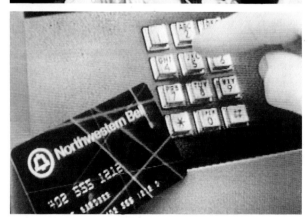

RIDE ONE
30-second
VOCAL MONTAGE: "In Milwaukee, a new era has begun . . .
. . . "Evolution in Action" . . .
. . . "The new Harley-Davidson Company is living up to its name . . ."
. . . "These bikes . . . have given Harley a new image and made their motorcycles more interesting to those who now ride the machines of other countries . . ."
. . . "Harley achieved this modernization sacrificing none of the unique character of its machines . . ."
. . . "As an emotional device, the Harley stands as much-copied but as yet unequalled."
. . . "More power at every engine speed . . . as oil tight as a thermos . . ."
"A Harley does something that no other motorcycle does. And I can't tell you what it is. If you want to find out for yourself, go ride one . . ."

STRIKE OUT/REVISED CARD
30-second
MUSIC UNDER THROUGHOUT.
STUDENT: Sally? Bert. You busy tonight? Your loss!
Debbie. Bert.
Lori. Bert.
Judy.
Cindy.
Kathy.
Buffy.
ANNCR (VO): When you have a lot of local calls to make, it's nice to have a Northwestern Bell Card.
STUDENT: Hi, mom. Bert Bert.
VO ANNCR (VO): Your Northwestern Bell Card. Use it for local calls too.

1707

Art Director	Howard Cohen
Writers	Brian Sitts, Hal Friedman
Editor	Steve Schreiber
Director	David Ashwell
Client	Burger King Corp.
Agency Producer	Gary Bass/J. Walter Thompson, New York, NY
Production Company	Fairbanks Films

1708

Art Directors	Peter Burkhard, Darry Gayle
Writer	Peter Burkhard
Editor	Carl Kesser
Director	Don Guy
Client	National Education Association
Agency Producer	Darry Gayle/Beber Silverstein & Partners, Miami, FL

DAWN OF BURGERS
30-second
ANNCR: Burger King presents the Dawn of Burgers.
In the beginning it was hard to get a hamburger at all. So when you got one you made the most of it . . .
by cooking over fire.
Today some have forsaken flame and turned to the practice of frying . . .
forgetting the sizzling taste that only comes from flame broiling.
But at Burger King we say, when you have something as delicious as flame broiling . . .
you stay with it for a long, long time.

HOMEROOM
30-second
They want fearless leadership. Clear communication. And the truth. They want the truth. You give it to them, and you still have to earn their respect. But if you do, you may be one of the only people in the world they do respect. Can you imagine how good that makes you feel!
CLASS: (SCATTERED)
MAN: Good morning, class. Are we motivated today?????
VO: John Engle. Isn't he the kind of teacher you want teaching your kids? So does the NEA.

1709

Art Director	Ron Anderson
Writer	Bert Gardner
Client	Northwestern Bell
Agency Producer	Jackie Hirsch/Bozell & Jacobs, Inc., Minneapolis, MN
Production Company	Sandbank Films Co.

1710

Art Director	Herb Briggs
Writer	Michael Litchfield
Director	Tom Barron
Client	Memorex Media Products Group
Agency Producer	Jan Herdlick
Production Company	Robert Abel & Associates
Creative Director	John Mercer

WHAT IF
30-second
JAMES WHITMORE: There's been a lot of talk about local telephone rates. But what if everything had gone up the way phone rates have the last 25 years. Today's ten thousand dollar car would cost only five thousand. Today's seventy-eight thousand dollar house would cost only twenty-eight thousand. And you could get a college education for just four thousand dollars instead of sixteen thousand.
So when they talk about high phone rates, tell 'em talk is cheap . . .
. . . especially on the telephone.

A SLIGHT EXAGGERATION
30-second
Memorex brings you a slight exaggeration.
Most floppy disk edges are sealed just here . . . and there. But not Memorex.
We seal every inch of every edge with Solid . . . Seam . . . Bonding.
So a Memorex edge fights bulges, puckers, wraps. Because if all that jams your disk drive, you can lose all your data. And that's no exaggeration.
Memorex . . . has the edge.

1711

Art Director	Diane Cook Tench
Writer	Andy Ellis
Editor	Lenny Mandlebaum
Directors	Diane Cook Tench, Andy Ellis, Frank Soukup
Client	FMC
Producer	Frank Soukup
Agency	The Martin Agency, Richmond, VA
Creative Director	Mike Hughes

1712

Art Director	Alan Chalfin
Writer	Larry Vine
Editor	The Tape House
Director	Jim Connolly
Client	Lea & Perrins
Agency	Sarah Fader/Geers Gross Advertising, New York, NY
Production Company	Close Up

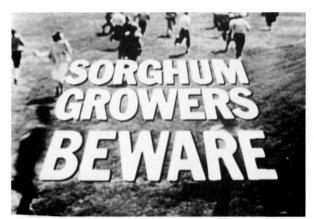

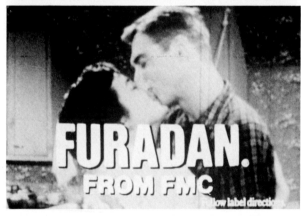

FURADAN SORGHUM
30-second
(MUSIC IN: TYPICAL SCIENCE FICTION DRAMATIC ORCHESTRATION)
ANNCR (VO): Insects. Every year they threaten to wipe out sorghum growers. Destroying yields. Up to 1,000 pounds an acre.
To fight back, use Furadan at planting. Nothing controls more sorghum pests. To assure you a better stand and greater yields.
Use Furadan from FMC.
And kiss most of your insect problems goodbye.
(MUSIC SWELLS AND ENDS)

WE GOT IT COVERED
30-second
ANNCR (VO): If you want a Worcestershire sauce that goes to great lengths to gather fine ingredients instead of the most available . . .
Lea & Perrins has it wrapped up.
If you want one made the old world way, rather than the most expedient . . .
Lea & Perrins has it wrapped up.
And if you want a Worcestershire aged in wooden casks rather than poured into a bottle . . .
Lea & Perrins has it all wrapped up. The original, genuine Worcestershire sauce.

1713

Art Director	Mary Means Morant
Director of Photography	Ed Martin
Writers	Tom Mabley, Bob Sarlin
Editor	Allen Rozek
Director	Stu Hagman
Client	IBM Corp.
Agency Producer	Robert L. Dein/Lord, Geller, Federico, Einstein, Inc., New York, NY
Production Company	Dick Kerns/H.I.S.K.

1714

Art Director	Cabell Harris
Writer	Mike Hughes
Editor	Lenny Mandlebaum
Director	Bill Randall
Client	FMC
Producer	Frank Soukup
Production Company	AFI Productions
Creative Director	Mike Hughes
Agency	The Martin Agency, Richmond, VA

SKATES
30-second
ANNCR (VO): In these modern times, even the best manager needs help to succeed.
For, when pressure builds, it becomes harder to keep things rolling without losing control and falling behind.
A manager could use the IBM Personal Computer . . . for smoother scheduling and greater productivity.
It can help a manager excel and become a big wheel in the company.
The IBM Personal Computer.
Call, for a store near you.

SPOKESMAN
30-second
Let's say I'm a sunflower and I was treated at planting with Furadan insecticide.
Now here's a sunflower who wasn't treated with Furadan. Just look what sunflower beetles and grasshoppers did to him.
And once those stem weevils got to him . . . why if you were harvesting, you'd run right over a little guy like that. So take some advice from a sunflower who knows. Use Furadan at planting. It's the best way I know to keep your heads up. Furadan from FMC.

1715

Art Director	Bill Hogan
Director of Photography	Tim Francisco
Writer	Rik Meyers
Editor	Dale Cooper
Director	Tim Francisco
Client	WCCO Radio
Agency Producer	Cathy Grayson/Carmichael-Lynch, Minneapolis, MN
Production Company	Molly Shaw/James Productions

1716

Art Director	Sam Woods
Writer	Len Alaria
Editor	Tim McGuire
Client	American Dairy Association
Agency Producer	William Valtos/D'Arcy MacManus Masius, Chicago, IL
Creative Director	William Valtos
Associate Producer	Lisa Muzik
Associate C.D.	Greg Bashaw

**Real Radio.
WCCO 8·3·0**

EVOLUTION
30-second
(UNDER EACH SCENE, VERY BAD MUSIC FROM EACH ERA)
ANNCR (VO): Once there was rock and roll radio. But times changed.
New radio stations came and went. And man evolved. Now, modern
man and woman are ready for the one radio station that informs,
entertains, and treats them like adults.
SINGERS: Real radio.
ANNCR: Welcome to the real world.
SINGERS: WCCO.

CHEESE GLORIOUS CHEESE
30-second
(MUSIC—BASED ON THE SONG "FOOD GLORIOUS FOOD" FROM
OLIVER)
SINGERS: (SLOW, SENSUAL)
Cheese, glorious cheese!
So sumptuous and luscious . . .
(PACE QUICKENS)
Cheese
Marvelous cheese . . .
Makes everything
Scrumptious . . .
What else is
So versatile . . .
Real cheese is
Always a hit!

1717
Art Director	Hector Robledo
Writer	Susie Townsend
Director	John St. Clair
Client	Corning Glassworks
Agency Producer	Lewis Kuperman, Foote Cone Belding, New York, NY
Production Company	Petersen Communications

1718
Art Director	Garrett Brown & Lila Sternglass
Director of Photography	Kelvin Pike
Writers	Garrett Brown, Anne Winn, Bill Hamilton
Editor	Burke Moody
Director	Garrett Brown
Client	Martlet Importing Company
Agency Producer	Matthew Borzi/Rumrill Hoyt, New York, NY
Prod'n Co Producer	Ellen Shire

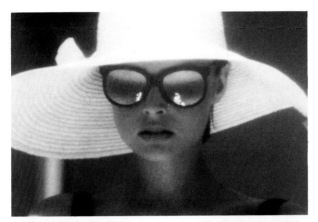

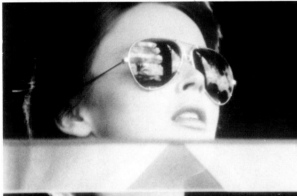

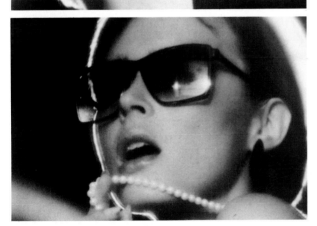

CHAMELEON FEMALE 1984

30-second
SINGER: You're just an old Chameleon
You're changing all the time.
In the sun you're sex-appealeon
In the shade you're so sublime.
You're drivin' me up the ceileon
With them changin' rangin' eyes.
You're a bad ole mean Chameleon
Got your daddy hypnotized.
ANNCR: Chameleon Sunglasses from Corning.
CHAMELEON: They can change your whole outlook.

WHEN YOU'VE GOT IT RIGHT/LOCATION

30-second
WALKIE TALKIE SFX: "That's a wrap, thank you. 6 AM . . ."
MAN: Okay . . . 8,000 crowd extras, by the river, 6 AM . . .
WOMAN: This is wrong?
MAN: Yeah, this should be scene 20.
WOMAN: So . . . tell Akhmet, hold the elephants, right?
MAN: Don't tell him that! (LAUGHS) Watch the dust!!. . .Thirsty?
WOMAN: Sure! . . . Look, we need . . . Where did you get that? . . .
MAN: I flew them in . . .
WOMAN: Cold?
MAN: That's a special effect, isn't it?
ANNCR: Molson Golden. From North America's oldest brewery, Molson of Canada . . . Since 1786. Molson makes it Golden.

1719

Art Director	Hal Tench
Writer	Ed Jones
Editor	First Edition
Director	Sid Myers
Client	Bank of Virginia
Producer	Craig Bowlus
Production Company	Myers Films
Creative Director	Mike Hughes
Agency	The Martin Agency, Richmond, VA

1720

Art Director	Dave Pernell
Writer	Dave Pernell
Editor	Leon Seith
Director	Richard Kooris
Client	First City National Bank of Austin
Agency Producer	Cindy Weddle/Rives Smith Baldwin Carlberg + Y&R, Houston, TX
Production Company	Laura Kooris/Texas Pacific Film Video
Creative Director	Chuck Carlberg

ASTRONAUT TV

30-second
(SFX: RADIO TRANSMISSION HISSES, POPS, CRACKLES, ETC.)
GROUND CONTROL: Commander, you've got an important call.
ASTRONAUT: Er, Roger, go ahead.
BANK: Hello, Commander, this is Bank of Virginia. Uh, sir, you've
slightly overdrawn your checking account.
ASTRONAUT: I did?
ANNCR: (CONVERSATION BETWEEN ASTRONAUT AND BANK
CONTINUES UNDER) There are many good reasons you should
change to Bank of Virginia. Like getting a phone call instead of a
bounced check.
ASTRONAUT: I'm sorry. I've been out of town and I couldn't deposit
my check. But I'll be right down. I fully understand the gravity of this
situation. (A CHUCKLE)

SPECIAL OLYMPICS

30-second
MUSIC: UNDER
ANNCR (VO): In Austin, a special Olympics is held. No famous
names are there. No world records are set. What makes these games
special is that all the participants are handicapped. We at First City
are proud to be sponsors of these Olympics and wish to congratulate
all the athletes.
Because they've won more than a few races. They've won our hearts.
MUSIC: UP AND OUT

1721

Art Director David Jenkins
Writer Jon Jackson
Client Hershey Foods Corp.
Agency Producer Susan Birbeck/Ogilvy & Mather
Advertising, New York, N.Y.
Creative Director Jay Jasper

1722

Art Director Bill Halliday
Director of Photography Ed Martin
Writer Bill Kurth
Editor Allen Rozek
Director Stu Hagmann
Client IBM Corp.
Agency Producer Jack Harrower/Lord, Geller, Federico,
Einstein Inc., New York, N.Y.
Production Company Dick Kerns/H.I.S.K.

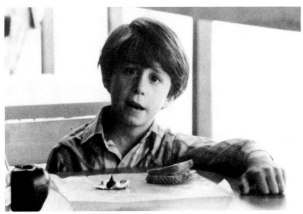

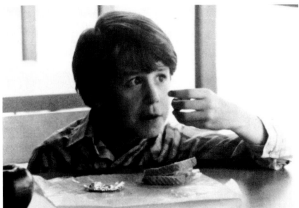

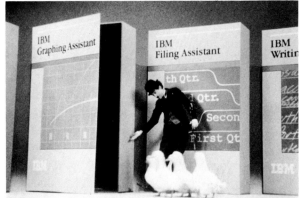

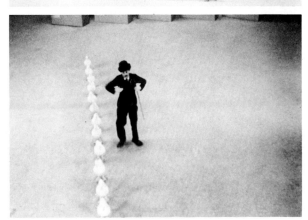

LUNCH BOX
30-second
BOY: My sister is the pretty one—
my brother is the smart one—
and me, I'm the klutz.
When my mother says, "Nobody's perfect,"
I know just who she means.
After yesterday I expected bread and
water for lunch—
But look:
Today Mom gave me a Kiss—
a little Hershey's Kiss.
When my mother says "Nobody's perfect"—
she could mean my sister.
ANNCR: Hershey's Kisses.
They're only little 'til you taste them.

DUCKS
30-second
ANNCR (VO): When things are out of control . . . a person could use
the personal computer software programs in IBM's Assistant Series.
Start by entering facts and figures into Filing Assistant. Then move
the facts around
to work up a plan . . .
or draw up a graph.
There's Writing Assistant to help you handle words . . . and Reporting
Assistant to pull everything together. The Assistant Series from IBM.
Getting all your ducks in a row has never been easier.

1723

Art Directors	Garrett Brown, Lila Sternglass
Director of Photography	Haskell Wexler
Writers	Garrett Brown, Anne Winn, Bill Hamilton
Editor	Burke Moody
Director	Garrett Brown
Client	Martlet Importing Co.
Agency Producer	Matthew Borzi/Rumrill Hoyt, New York, N.Y.
Prod'n Co Producer	Ellen Shire

1724

Art Director	Mac Talmadge
Director of Photography	Larry Boelens
Writer	Robin Goodfellow
Editor	Tom Schachte
Director	Bob Eggers/Eggers Films
Client	Conwood Corporation/Hot Shot Household Insecticide
Agency Producer	Earl McNulty/Tucker Wayne & Company, Atlanta, GA
Prod'n Co Producer	Bobby Weinstein
Props (Bugs)	Joanne McPherson

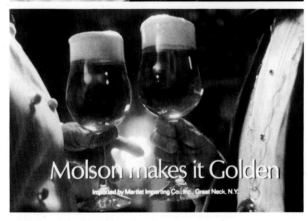

WHEN YOU'VE GOT IT RIGHT/SOMMELIERE

30-second

WOMAN: Aahhh, forty-seven apricot souffles in one evening. I think that's a world's record . . .
MAN: It was all for one gentlemen too, did you know that?
WOMAN. (LAUGHING) No..!!
MAN: Courage, my dear, you were terrific . . .
. . . Care for a souffle?
WOMAN: I don't think so.
MAN: How about a magnum of Chateau Canadienne?
WOMAN: Ahh, always Jacques . . .
. . . a perfect choice.
MAN: Call me Jack.
WOMAN: Sure . . .
ANNCR: Molson Golden. From North America's oldest brewery. Molson of Canada . . . since 1786. Molson makes it Golden.

HOWARD

30-second

WOMAN: Oh, oh, Howard. Here they come again. Do you hear them? I can't stand that sound. Don't they bother you? They bother me. We really need something that'll get 'em fast.
They really bother me. Don't they bother you?
WOMAN: Hot Shot?
HOWARD: Hot Shot.
VO: Hot Shot knocks down flying bugs fast.
HOWARD: Fast.
WOMAN: I'm so happy, Howard. Aren't you happy?
We finally got some peace and quiet.
I've always found that peace and quiet is very peaceful, very quiet.
VO: For a big bug problem, give it your best shot. Hot Shot.

1725

Art Director	Mark Yustein
Writer	Richie Russo
Editor	Bob Lefkowitz
Director	Dick Stone
Client	WCBS-TV
Agency Producer	Peter Yahr/Della Femina, Travisano & Partners, New York, N.Y.
Production Company	Peter Mansfield/Stone Clark Productions

1726

Art Director	Michael Vitiello
Writer	Bob Lapides
Director	Henry Sandbank
Client	Subaru
Agency Producer	Bob Nelson/Levine, Huntley, Schmidt & Beaver, New York, NY

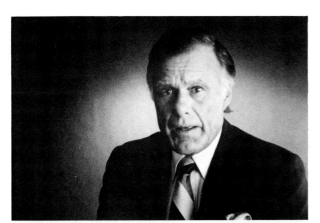

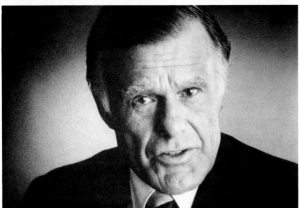

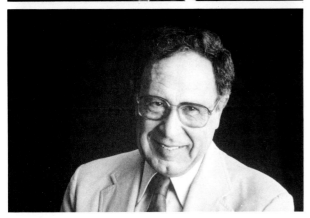

JIM/NOW
30-second
JIM: Here at Channel 2 we've been trying to put together the best news team in town. That's never, ever, easy, the requirements are pretty tough, it's quite difficult.
Then someone comes along having 25 years of experience. Someone who is already well established, having a closet full of awards. Someone already loved, respected by millions.
The consummate professional, someone whom I guess you could call a legend in his field.
FRANK: Did someone say field?
VO: Channel 2 News. The new home of Dr. Frank Field.

SKI TEAM
30-second
ANNCR: Each member of the U.S. Ski Team has their own individual way of going down the mountain. And while they may not agree on what equipment should get them to the bottom, they do agree on what equipment should get them to the top.
Sabaru. Official car of the U.S. Ski Team since 1976.
SUPER: Subaru. Official Car of the U.S. Ski Team.
"We've earned it."

1727

Art Director	Ervin Jue
Writer	Dean Hacohen
Editor	Pelco
Director	Terry Bedford
Client	Volkswagen
Agency Producer	Lee Weiss/Doyle, Dane, Bernbach, New York, NY
Production Company	Mindy Goldberg/Jennie & Co.

1728

Art Director	Aaron Bell
Writer	Judith Burnett
Editor	Michael Schenkeim, MS Editorials
Director	Lee Smith
Client	Burger King Corporation
Agency Producer	Bill Allen, UniWorld Group, Inc., New York, NY

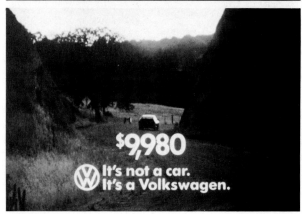

WIND
30-second
(SFX: WIND STARTS TO BUILD) WIND BLOWS THROUGH TREE. BIRDS FLY OUT. DEER POPS HEAD UP. (SFX: ENGINE ZOOM. WIND GUST.) WEATHER VANE SPINS. (SFX: ENGINE ROOM. WIND GUST.) PICKET FENCE COLLAPSES. (SFX: ENGINE ZOOM. WIND GUST.) BARN DOORS FLY OFF. SCIROCCO APPEARS.
VO: The 1985 Volkswagen Scirocco.
German engineering. Precision handling.
Outstanding performance. And you're about to see the most exciting thing of all.
(SFX: WIND GUST)
PRICE APPEARS.
VO: Scirocco. It's not a car. It's a Volkswagen.

GREAT BALLS O' FIRE
30-second
ANNCR: A red hot message from Burger King.
SING: Burger King cooks their burgers over a flame.
Flame broiling's great
There's nothing quite the same.
It taste so good it leaves you satisfied.
Goodness gracious—great balls o' fire.
Flame broiling flavor's really dynamite.
You get that beefy, juicy taste in every bite.
It taste so good it leaves you satisfied.
Goodness gracious—great balls o' fire.
Aren't you hungry for Burger King now?

1729

Art Director	Mark Shap
Writer	Veronica Nash
Editor	Frank Cioffredi/Dennis Hayes Editorial
Director	Gerard Hameline
Client	Avon Products, Inc.
Agency Producer	Susan Chiafullo/Ogilvy & Mather Advertising, New York, NY
Production Company	Annie Friedman/Michael-Daniel Productions
Music Director	Faith Norwick

1730

Art Director	Bud Watts
Writer	Cheryl Berman
Editor	Bruce Frankel
Client	United Airlines
Agency Producer	Michael Rafayko/Leo Burnett Company, Chicago, IL
Production Company	Levine Pytka Production Company
Executive Producer	Al Lira

LOCKER ROOM
30-second
ANNCR (VO): These women have a dream . . . to be the first . . . in the first Olympic Women's Marathon.
This event has been Avon's dream.
The Avon International Marathons . . . gave women the opportunity they needed to prove themselves to the world and to the Olympic Committee.
SFX: BUZZER
ANNCR (VO): For them . . . the dream is about to become a reality.
For Avon . . . it already has.

OLYMPIC FEVER REV
60-second
DUVALL: Once every four years fever sweeps the land; a fever that burns within us all to be champions.
Olympic fever.
VO: The bar is at twenty-one feet.
He's going
for a new world record—Can he make it.
SING: On your way you're climbin' high
Like the mornin' sun
In a golden sky
VO: She'll be attempting a triple somersault with a one-and-half twist.
She approaches the platform.
SING: So many new horizons waitin' for you
SING: Reach out for the brightest star

1731

Art Director	Marguerita Breen
Writer	Morleen Novitt
Editor	H. Lazarus
Client	Kim Armstrong/ATT Communications
Agency Producer	Elizabeth Krauss, N.W. Ayer, Inc., New York, NY
Production Company	Ron Lieberman/Harmony Pictures

1732

Art Director	Mike Gilliland
Artists	Paul Chilton, Mike Eckhard
Writer	Mike Gilliland
Editor	Mike Gilliland
Client	St. Louis Football Cardinals
Agency Producers	Mike Gilliland, Mindy Keyser/ Gardner 2, St. Louis, MO

ANGELS
30 second
MUSIC UP AND UNDER
JULIA VO: Growing up in Canada . . . my sister Louise and I
thought that winter was a present
just for us. I'm about as far
from that now as I can be.
JULIA OC: But I still keep close to Louise. By telephone. And now we
can enjoy a nice long chat on Saturdays when you can call Canada all
day and save 35% with AT&T's new low rates.
Now matter how far you are from Canada, you can stay close with
a call.
JULIA OC: Louise, guess what, I'm making angels.
VO: AT&T. We bring the world closer.

TEN GREAT AMERICAN CITIES
30-second
Now, see ten great American cities for only $155.
See the Nation's Capital . . .
The Big Apple . . .
The Big 'D' . . .
For the low price of a Big Red Season
Ticket, you can see ten great American cities, including . . .
The City of Brotherly Love . . .
Call now for information on Big Red Season Tickets. 421-1600.

1733

Art Director	Donna Weinheim
Writer	Cliff Freeman
Director	Joe Sedelmaier
Client	Bill Welter/Wendy's International, Inc.
Agency Producer	Susan Scherl, Rich Durkin/Dancer-Fitzgerald-Sample, Inc., New York, NY
Production Company	Marsie Wallach/Joe Sedelmaier Productions

1734

Art Director	Simon Bowden
Writer	Frank Fleizach
Director	Henry Sandbank
Client	Volvo
Agency Producer	Jean Muchmore/Scali, McCabe, Sloves, New York, NY
Production Company	Sandbank Films

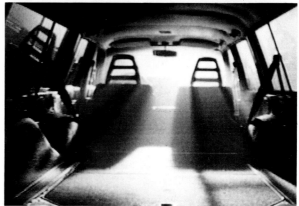

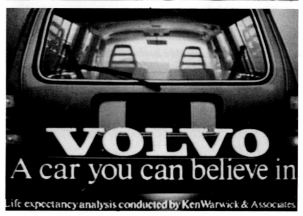

FLUFFY BUN IV
30-second
CLARA: Where's The Beef?
ANNCR: When you drive to Wendy's and you order a single you get more beef than the Whopper or the Big Mac.
CLARA: Where's The Beef?
ANNCR: At Wendy's you never have to ask "Where's The Beef?"

SPACE VEHICLE
30-second
MUSIC: SYNTHESIZER; SPIRAL TO SUSTAINED CODA.
ANNCR (VO): With a life expectancy of 16.5 years . . . this is the space vehicle that could transport you . . . into the 21st century.

1735

Art Director	Dick Lopez
Writer	Mike Drazen
Director	Mark Story
Client	Sharp
Agency Producer	Richard Berke/Scali, McCabe, Sloves, New York, NY
Production Company	Pfeifer Story Piccolo

1736

Art Director	Sam Scali
Writer	Ed McCabe
Director	Henry Holtzman
Client	Perdue Farms
Agency Producer	Carol Singer/Scali, McCabe, Sloves, New York, NY
Prod'n Co Producer	N. Lee Lacy

GARDEN PARTY
30-second
MUSIC: THROUGHOUT.
ANNCR: With all their space-age technology most microwave ovens still cook too many things unevenly. Undercooked here. Overcooked there. A problem you won't have with the Sharp Carousel II/Convection Microwave. Thanks to Sharp's turntable design . . . that cooks food evenly at every turn. After all, what's the point of owning a microwave if it can't even do the little things right?
Sharp Carousel II Microwave ovens. From Sharp minds come Sharp products.

PERDUE APPEARANCE
30-second
FRANK PERDUE: Some people criticize me
for being overly concerned about the appearance of my chickens.
I just don't find a pale white chicken . . .
or a chicken with hairs on its wings,
or a chicken with scrapes and bruises very appetizing.
I suppose it would taste alright.
As long as you
didn't have to look at it.
(SILENT)

1737

Art Director	Erica Fross
Writer	David Cohen
Editor	Steven Fineman
Director	Howard Guard
Client	Hanes Hosiery
Agency Producer	Sandy Semel/DFS, New York, NY
Prod'n Co Producer	Maxine Tabak
Creative Director	William M. Warner
Executive Creative Director	Eric Weber

1738

Art Director	Mark Shap
Writer	Veronica Nash
Editor	Barry Stillwell/Dennis Hayes Editorial
Director	John St. Claire
Client	Avon Products, Inc.
Agency Producer	Elaine Keeve/Ogilvy & Mather Advertising, New York, NY
Production Company	Madelaine Delves/Petersen Communications
Music Director	Gena Greher

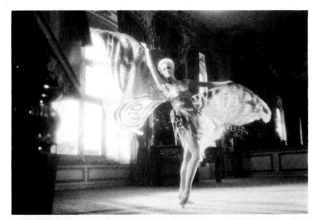

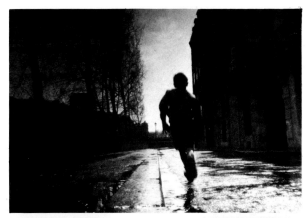

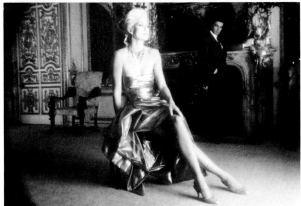

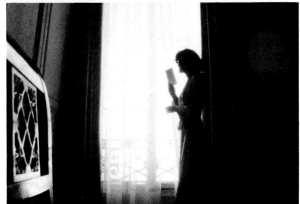

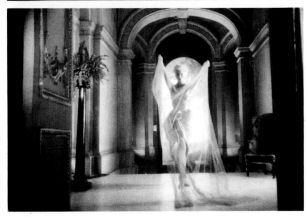

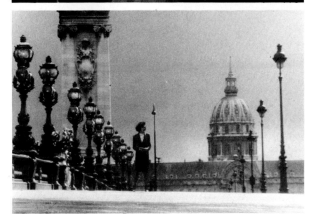

PAPILLON
30-second
(MUSIC UNDER)
ANNCR (VO): Borne of whispers and breezes.
A whole new creation in pantyhose.
Papillon.
Luxurious
beyond belief.
Elegant beyond dreams.
Papillon.
(MUSIC)
A whisper of softness.
A flutter of sheerness.
Papillon pantyhose.
Capture the feeling and fly.
Papillon. Newly created by Hanes.

AVON/VIVAGE
30-second
ANNCR (VO): Some things . . . can make your heart beat a little faster
. . . Vivage . . . is one of them.
ANNCR (VO): Some things . . .
can make your heart beat a little faster . . .
Vivage . . . is one of them.
Louis Feraud's Vivage.
Designed in France . . .
exclusively for Avon.

1739

Art Director	Bob Tucker
Designer	Bob Tucker
Directors of Photography	Manfred Rieker, Werner Hlinka
Writer	John Noble
Editor	Even Time
Directors	Manfred Rieker, Werner Hlinka
Client	Audi Corp
Agency Producer	Ellyn Epstein/Doyle Dane Bernbach, New York, NY
Prod'n Co Producer	Ellen Rieker

1740

Art Director	Joseph Genova
Writer	Jim Parry
Director	Steve Steigman
Client	Crowley Foods, Inc.
Agency Producer	Bertelle Selig
Production Company	Steigman Productions
Agency	Posey & Quest, Inc., Greenwich, CT

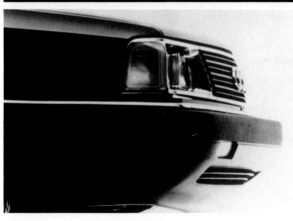

THE SHAPE OF THINGS TO COME
30-second
ANNCR (VO): Aerodynamic design. Form that follows function. Optimal thrust. Intelligence. Elegance. Every inch . . . every edge, engineered to perfection. The shape of things to come, has come. Audi 5000S. Sedan . . . wagon . . . turbo. Audi. The art of engineering.

YOGURT HATERS REVISED
30-second
ANNCR: Crowley Creme Yogurt made with real cream is so good that yogurt haters can't believe it's yogurt.
MAN: I really love it. What is it?
ANNCR: Crowley Creme Yogurt
MAN: This isn't yogurt.
WOMAN: Mmmmm. What is it?
ANNCR: Crowley Creme Yogurt.
WOMAN: No, it isn't.
KID: Great. What is it?
ANNCR: Crowley Creme Yogurt.
KID: (LAUGHS) I wasn't born yesterday.
ANNCR: Crowley Creme Yogurt—made with real cream.

1741

Art Director Jon Parkinson
Writer Carole Anne Fine
Director Nick Lewin
Client Revlon
Agency Producer Jean Muchmore/Scali, McCabe,
Sloves, New York, NY
Production Company Lewin, Matthews, Springhall, Watson

1742

Art Director Bob Curry
Writer Tony Winch
Editor David Dobb
Director Dan Driscoll
Client Spalding
Agency Producer Maggie Hines/HHCC, Boston, MA
Prod'n Co Producer Jane Barden

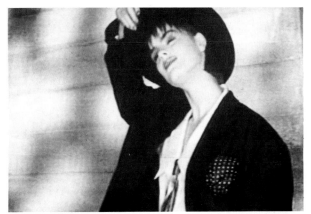

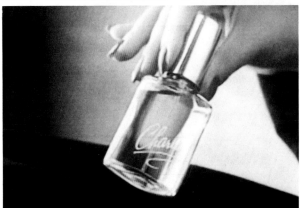

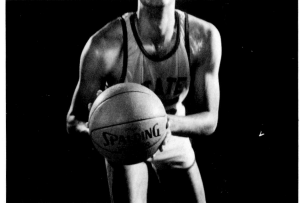

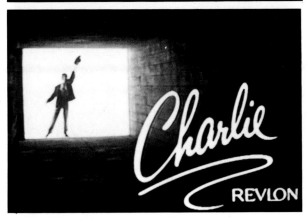

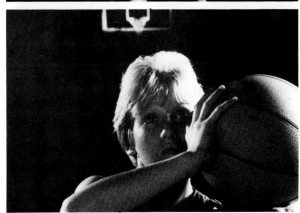

CHARLIE HAT TRICK
30-second
MUSIC: A *NOW* VERSION OF THE CLASSIC CHARLIE MUSIC.
VO: When you wear Charlie . . .
. . . you wear one of . . .
. . . the world's great originals.
VO: Charlie.
The Original Original.

BASKET BALL (BIRD TOO)
30-second
VO: The only ball to win every NBA game played in 1984.
Including the NBA championship. The only ball to win every NCAA
play-off game as well as the NCAA championship. The only ball that
will win every WABA game not to mention the 1984 WABA champion-
ship. Spalding. We *are* basketball.

1743

Art Director	Pat Burnham
Director of Photography	Eric Young
Writer	Jarl Olsen
Editor	Steve Shepherd
Director	Eric Young
Client	Knox Lumber
Agency Producer	Judy Carter/Fallon McElligot Rice, Minneapolis, MN
Production Company	Wilson-Griak
Music, EFX	John Penney

1744

Art Director	Mark Yustein
Director of Photography	Michael Butler
Writer	Jim Weller
Editor	Bobby Smalheiser
Directors	Jim Weller, Mark Yustein
Client	WCAU-TV
Agency Producer	Michael Eha/Della Femina, Travisano & Partners, New York, NY
Production Company	Jenkins Shulman Berry/Charles Brown
Music	Shelton Leigh Palmer

RIGHT STUFF
30-second
SFX; SNAPS SOUND LIKE SMALL EXPLOSIONS.
SFX: ELECTRONIC HUM.
VO: You have a mission to accomplish.
CONTINUE SFX.
VO: You need the right attitude.
SFX: CHAINS.
VO: The right tools.
SFX: TORCH BEING LIT.
VO: The right materials.
CONTINUE SFX.
SFX: SKILL SAW.
VO: You need the right stuff.
SFX: METAL AGAINST METAL.

IF
30-second
ANNCR (VO): If there were no arms race.
If there were no crime.
If your job didn't depend on economic
factors outside Philadelphia.
If you didn't have to be concerned
About your children's school.
If you didn't have to worry about
Accidents or disease . . .
. . . You wouldn't have to watch
Channel 10 News.
Channel 10 News.
More complete.
More experienced.
More meaningful.

1745

Art Director Julie Markell
Designer Julie Markell
Artist Chris Jelley
Director of Photography Roger Flint
Writer Linda Hays
Editor Terence Thier
Director Roger Flint
Client J. Walter Thompson, L.A., CA
Agency Producer Marc Malvin
Prod'n Co Producer Susan Turk

1746

Art Director Gary Goldsmith
Designers Gary Goldsmith, Tom Yobbagy
Director of Photography Paul Beeson
Writer Tom Yobbagy
Editor Pierre Kahn
Director John St. Clair
Client Volkswagen
Agency Producer Jim deBarros/Doyle Dane Bernbach, New York, NY
Production Company Chris Petersen, Petersen Communications
Voice Over Roy Scheider

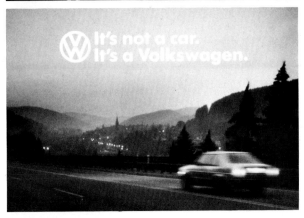

HOT
30-second
CHER: So there we were. Three grown women <u>dancing</u> in the streets, in shorts and high heels.
Nobody could believe their eyes.
We knew we looked hot. That's the whole idea, isn't it?
Hey, I don't bust my buns working out every day for nothing!

GERMAN ROAD CAR
30-second
(MUSIC THROUGHOUT)
MAN: Guten Morgen.
WOMAN: Morgen.
MAN: Wir nehmen den neuen Jetta?
WOMAN: Aaahh . . . Paris.
ANNCR (VO): Introducing the new Volkswagen Jetta. The first affordable German road car.
GUARD: Allex-ci.
ANNCR (VO): Exhilarating performance.
(MUSIC)
ANNCR (VO): Precise, responsive handling.
(MUSIC)
ANNCR (VO): With the new Jetta, half the fun is getting there.

1747

Art Director Gary Ciccati
Writer Eileen Sandler
Editor The Editors/Ciro DeNettis
Director Sid Myers
Client People Bank
Agency Producer Paula Santa-Donato/Doyle Dane
Bernbach, New York, NY
Prod'n Co Producer Jill Friedman

1748

Art Director Ira Madris
Writer Bruce Nelson
Editor Take 5 Editorial, Howard Lazarus
Client Miles Laboratories, Alka-Seltzer
Agency Producer Linda Kramer/McCann-Erickson,
New York, NY

LITTLE COAT
30-second
GAIL: Arthur, does your middle name end in an "i" or a "y"?
ARTHUR: (SLEEPILY) Why?
GAIL: (WRITING BUSILY) Thanks.
ARTHUR: Why?
GAIL: I'm filling out a People's loan application.
ARTHUR: (CONCERNED) Why?
GAIL: The car's making that woo woo noise again. And People's has
terrific car loans.
You know, People's makes loans for just about anything we could
think of—we could add a nice little den . . .
Or get you a nice little sailboat—Get me, a nice little mink coat!
ARTHUR: What?
GAIL: Or a nice little mink jacket.

APRIL 16TH
30-second
VO: The more *you* make, the more *they* take. That's the price of
success. So for April 16th, and the accompanying anxious upset
stomach that comes with the thumping head, and the thumping head
that comes with the anxious upset stomach, there are the medicines
of Alka-Seltzer. Alka-Seltzer. For these symptoms of stress that can
come from last year's success.

1749

Art Director — Ron Louie
Designer — Ron Louie
Director of Photography — Henry Sandbank
Writer — Cynthia Beck
Editor — David Dee
Director — Henry Sandbank
Client — Citicorp
Agency Producer — Liza Leeds/Doyle Dane Bernbach, New York, NY

1750

Art Director — John Eding
Writer — Ute Brantsch
Editor — Simon Laurie
Client — Schenley/Dubonnet
Prod'n Co Producer — Michael Birch/Leo Burnett Company, Chicago, IL
Production Company — R.S.A. Limited
Executive Producer — Al Lira

LUGGAGE IN THE SEA
30-second
VO: Ah, the islands. Too bad your luggage won't be going there with you. But now, Citicorp Travelers Checks announces the Citicorp Travelers Advantage—a great new insurance package for flight delays . . . trip interruptions . . . and luggage going adrift. You can only get it when you buy Citicorp Travelers Checks. Here's one place to get more details.
(Call for more details.)
The Citicorp Travelers Advantage.
For things that can't possibly happen. And do.

DO WHAT YOU DO/TOMBOY
30-second
SING: How do you do
Dubonnet
What you do
Dubonnet . . .
How do you do what you do, Dubonnet
How do you mix
How do you mingle
Make it magic
Make it new. Dubonnet
ANNCR: Dubonnet and collins mix. Together, the taste is magic. Taste a Dubonnet Tomboy.
SING: How do you do
GIRL: How do you do?
SING: How do you do what you do Dubonnet.

1751

Art Director	Tom McCarthy
Writer	John Welsh
Director	Peter Corbett
Client	Star Market
Agency Producer	Amy Mizner, HBM/Creamer, Boston, MA
Production Company	Phil Marco Productions

1752

Art Director	G. Oliver White
Writer	Charles Ashby
Editor	Larry Krantz, Jayan Films
Director	Chuck Clemons, Jayan Films
Client	South Carolina National Bank
Agency Producers	G. Oliver White, Charles Ashby/ McKinney Silver & Rockett, Raleigh, NC
Production Company	Sharon Haislip, Jayan Films

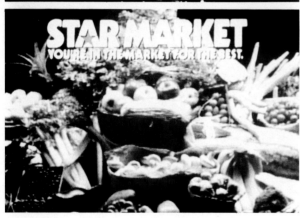

PRODUCE
30-second
MUSIC UNDER.
ANNCR: Asparagus. Artichokes. Apples, Granny Smith
Apples, Rome Apples, Golden Delicious Apples.
Alfalfa Sprouts. Arrugula. Anise. Apricots.
And that was only the A's.
At the best produce markets, you get the best of every season. Like
the produce market at Star Market.
Where it's all *gloriously* fresh, and all at supermarket prices.
At Star, you're in the market for the best.

AUTO OPTION TELEVISION
30-second
MUSIC UNDER THROUGHOUT.
The car of your dreams. Now. Trouble is, an option here. An option
there. This year's great new thing. Suddenly, it's loaded—and your
dream car loads you down with nightmare payments. But now there's
the SCN Auto Option. A new way to borrow that lets you buy more car,
make lower monthly payments. Ask us about it. All things considered,
it may be this year's most exciting new option.

1753

Art Director Jim Spencer
Writer Michael Patti
Editor Rye Dahlman
Director Dennis Gelbaum
Client Chrysler/Dodge Division
Agency Producer Arnie Blum/BBDO, New York, NY
Production Company Navarac Films, Ltd.

1754

Art Directors Nick Vitale, Beth Petrie
Writer Phil Slott
Editor Steve Schreiber
Director Bill Hudson (Hudson)
Client Gillette Company
Agency Producer Arnie Blum/BBDO, New York, NY
Production Company Bill Hudson Films

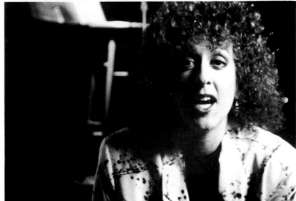

BEAUTY
30-second
MUSIC
It starts with a subtle glance and suddenly you remember what it was like to discover something wonderously new.
Today you can recapture that same kind of feeling for Dodge Aries K.
Sleek, new styling that will captivate you, performance that will infatuate you.
You always knew Aries for economy,
now you'll love it for its beauty.
And now you'll know how it feels to be seduced by Dodge Aries.
MUSIC

COMEDIENNE
30-second
Well there were 3 nevers in comedy.
Never follow a better comedienne.
Never give a heckler the last word.
And no matter how bad a joke bombs, although it's never happened to me personally,
never let them see you sweat.
That's what Dry Idea is all about
less water, more wetness protection. It keeps you drier than the leading roll-on.
In comedy, being nervous is natural
looking nervous is deadly.
Dry Idea. Never let them see you sweat.

1755

Art Director	Wally Littman
Writer	Bill White
Director	Joe Sedelmaier
Agency Producer	Alan Clark/Benton & Bowles, Inc., New York, NY
Group Head	Art Tuohy

1756

Art Director	Tom McCarthy
Writer	John Welsh
Director	Peter Corbett
Client	Stanley Works
Agency Producer	Jerry Kreeger, HBM/Creamer, Boston MA

UPHILL/FP
30-second
SFX: MUSIC THROUGHOUT
AVO: When your car knocks driving uphill does everybody pass you?
WOMAN: Everybody's passing you.
MAN: I'm well aware of that fact Eunice.
WOMAN: It was only a comment Walter
MAN: And I took note of the comment Eunice.
AVO: Try Texaco's higher octane that gave powerful turbos even more power. Against regular unleaded Texaco's super unleaded boosted acceleration almost twelve percent.
WOMAN: Isn't that Werner Lutz? We went to high school together.
MAN: By golly, you're right. I thought Werner was dead.
AVO: Texaco super unleaded.
Super starpower for more carpower.

TOUGH HAMMER
30-second
MUSIC UNDER
ANNCR: At Stanley we make our products tougher than they have to be.
We do this test 300 times.
Government buying standards only require 20 times.
The government says do this one twice.
Stanley does it 25 times.
We even do tests the government doesn't require. Our quality testing never stops. So you can count on Stanley for quality that won't quit.
SINGERS: Stanley. We want to help you do things right.

1757

Art Director	Sal Vergara
Creative Director	Dan Mountain
Executive Creative Director	Kenneth Dudwick
Director of Photography	Joe Sedelmaier
Writer	John Seroogy
Editor	Peggy DeLay
Director	Joe Sedelmaier
Client	Lyon's Restaurants
Agency Producer	Debora January/Ketchum Advertising, San Francisco, CA
Prod'n Co Producer	Ann Ryan
Prod'n Co. Executive Producer	Herb Hall

1758

Art Director	Dean Hanson
Director of Photography	Lee Lacy
Writer	Tom McElligott
Editor	Steve Shepherd
Director	Lee Lacy
Client	Minnesota Federal
Agency Producer	Judy Carter/Fallon McElligott Rice, Minneapolis, MN
Production Company	Kay Millet/N. Lee Lacy & Associates
Music	Ray Charles

DON'T ASK REVISED
30-second
MUSIC: UNDER THROUGHOUT
AVO: At family restaurants, most people ask . . .
MAN: Is the fish fresh?
WIFE: Is the fish fresh?
Is the fish fresh?
WAITRESS: Is the fish fresh?
Is the fish fresh?
BUSBOY: Don't ask.
WAITRESS: Don't ask.
WIFE: Don't ask.
MAN & WIFE: Don't ask.
AVO: At Lyon's, you don't have to ask. Because Lyon's features ocean-fresh fish . . . every day! Not fresh frozen. Not frozen fresh. But *fresh* fresh. At Lyon's low prices.

HIT THE ROAD JACK
30-second
AUDIO: Does it seem like the only time your bank isn't happy to see you . . .
. . . is when you want to borrow money?
MUSIC BEGINS: Hit the road, Jack
MUSIC COMES UP, CONTINUES.
MUSIC.
MUSIC BUILDS.
MUSIC, SINGING.
AUDIO: Next time, come to Minnesota Federal . . .
With millions of dollars to lend . . .
. . . we're not about to tell you to take a walk. Minnesota Federal.
. . . we're not about to tell you to hit the road jack.

1759

Art Director	Beth Pritchett
Writers	Kathy McMahon, Linda Kaplan
Editor	Tony Siggia, First Edition
Director	Ian Leech, Ian Leech & Assoc.
Client	Eastman Kodak
Agency Producer	Sid Horn/J. Walter Thompson, New York, NY
Production Company	Michael Jones/Ian Leech & Associates
Music	Larry Hochman, Newfound Sound

1760

Art Director	Rich Silverstein
Director of Photography	Keith Mason
Writers	Andy Berlin, Jeff Goodby
Editor	Tom Bullock
Director	Jon Francis
Client	Oakland Invaders
Agency Producer	Debbie King/Goodby, Berlin & Silverstein, San Francisco, CA
Production Company	Sandra Marshall/Bass/Francis

GETTING IN SHAPE
30-second
SINGERS: If you're getting in shape
And you're looking like this.
Then I'm gonna get you
with the Kodak Disc!
I'm gonna get you with the Kodak Disc
And sure as shootin' I'm not gonna miss.
Not when it's easy, as easy as this.
I'm gonna get you with the Kodak Disc.
ANNCR (VO): The Kodak disc camera is easy to load, advances
automatically and has a built-in flash. Think you're gonna find a
camera that's easier than that? Fat chance!

POEM/OAKLAND INVADERS
30-second
PLAYER 1: We're Oakland Invaders . . .
PLAYER 2: Not the kind from outer space . . .
PLAYER 3: We play professional football . . .
PLAYER 4: All over the place . . .
PLAYER 5: We run the ball . . .
PLAYER 6: We pass the ball . . .
PLAYER 7: We're gone without a trace . . .
PLAYER 8: We want you to see us . . .
PLAYER 9: We'll save you a place . . .
PLAYER 10: So call us up for tickets . . .
PLAYER 11: Or I'll break your face.
ANNCR (VO): The second season opens at home, March 4th. For
season tickets, call 638-7800 now. Operators are standing by.

1761

Art Director	Jim Scalfone
Designer	Jim Scalfone
Writer	Marvin Honig
Editor	Pierre Kahn
Director	Michael Ulick
Client	American Greetings
Agency Producer	Lora Nelson/Doyle Dane Bernbach, New York, NY

1762

Art Director	Woddy Litwhiler
Writer	Ted Charron
Director	Just Jacken
Client	Eastern Airlines
Agency Producer	Bob Schenkel
Prod'n Co Producer	Lee Lacy

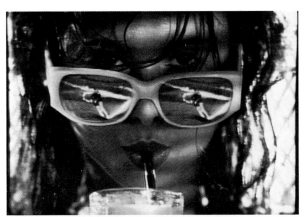

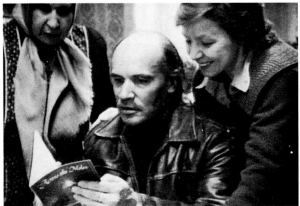

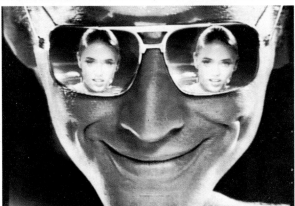

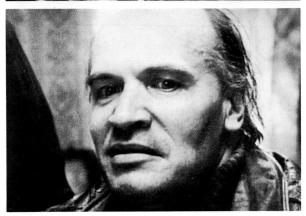

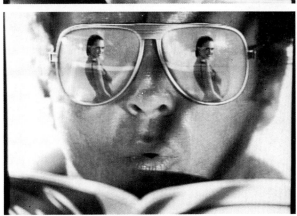

PEACE
30-second
ENGLISH TRANSLATION FROM RUSSIAN
DAD: Good evening my dearests.
DAUGHTER: How are you, Papa?
DAD: Hello daughter, how are you doing today?
DAUGHTER: Good, and you?
WIFE: At long last!!
GRANDMA: Is everything all right?
How are you doing?
DAD: I'm okay, as always. I hope you're all doing fine. But look what we got—from far away as America!!
ALL: We don't believe it!! From America!!
VO: If people everywhere exchanged greetings of peace, hope and love the world . . .

SEE YOUR WAY CLEAR
30-second
MUSIC (REGGAE STYLE):
JAMAICAN ACCENT VO: Now you can see your way clear to the Caribbean. Eastern Airlines has lowered their prices . . . for only $449 including coach airfare and hotel you can spend eight days and seven nights in Nassau, in the Bahamas, for only $499 you can spend the same amount of time in Aruba, Barbados, or San Juan. See Eastern or your Travel Agent . . . the Caribbean's beautiful this time of year and at prices like these, its worth reflecting on.

1763

Art Director	Jack Gorton
Director of Photography	Paul Lohmann
Writers	Jack Gorton, Garth DeCew
Editor	J. Scott Ogden
Director	Jack Gorton
Client	Marcy Fitness Products
Agency	Gorton Advertising
Production Company	Brad White/Melrose Film, Los Angeles, CA
Addl. Sound	Frank Serifini

1764

Art Director	Roger Everhart
Director of Photography	Eric Saarinen
Writer	Dan Drackett
Editor	Sonny Klein/The Film Place
Director	Eric Saarinen/Plum Productions
Client	The Phoenix Gazette
Agency	WFC Advertising, Phoenix, AZ
Production Company	Plum Productions, L.A.

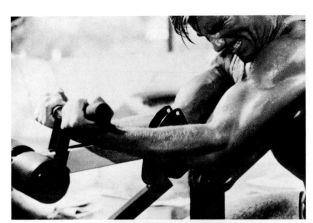

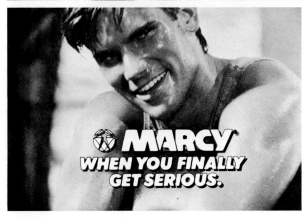

EVERY MORNING?
30-second
WOMAN: Do you do this every morning?
ANNCR (VO):
Marcy. When you finally get serious.

NOSE FOR NEWS
30-second
SFX: Door closes.
ANNCR: No matter how The Phoenix Gazette gets to you, it's gonna
get to you, with page after page of hometown news.
World news and features.
DOG: Whimpers
SFX: Door closes
DOG: Oh Oh
DOG: Whimpers.
OFF CAMERA VOICE: Thanks, Chauncy!
You got a nose for news?
DOG: Whimpers
Get the Phoenix Gazette *and* The Sunday paper for just 85¢ a week.

1765

Art Director	F. Paul Pracilio
Writer	Jeffrey Atlas
Editor	Phil Messina
Director	Steve Horn
Client	American Express
Agency Producer	Ann Marcato/Ogilvy & Mather Advertising, New York, NY
Creative Director	Tom Rost

1766

Art Directors	Jim Hallowes, Peter Brown
Writers	Peter Brown, Jim Hallowes
Editor	Charlie Chubak/FilmCore
Director	Phil Marco
Client	Comprehensive Care Corporation
Agency Producer	Randy Zook/Doyle Dane Bernbach, Los Angeles, CA
Production Company	Phil Marco Productions
Music	H/K Sound

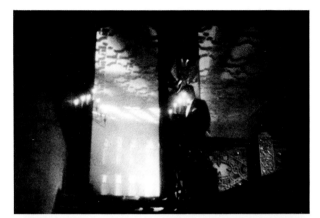

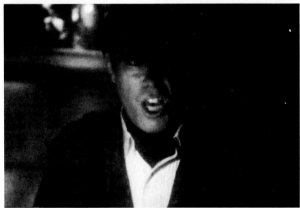

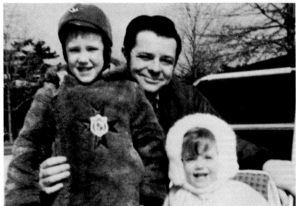

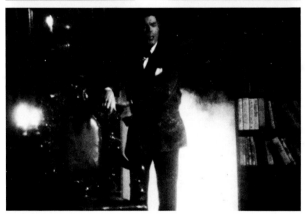

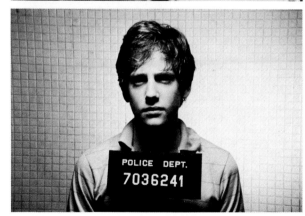

STEPHEN KING
30-second
STEPHEN KING: Do you know me?
It's frightening how many novels of suspense I've written.
But still, when I'm not recognized, it just kills me.
So instead of saying I wrote *Carrie,* I carry the American Express Card.
Without it, isn't life a little scary?
ANNCR: To apply for the card, look for this display. And take one.
STEPHEN KING: The American Express Card.
Don't leave home without it.

FAMILY ALBUM
30-second
MUSIC BEGINS HERE.
VO: There's nothing in the world that holds . . .
. . . greater promise than a young life.
And nothing quite as sad as seeing . . .
. . . that life somehow go terribly wrong.
MUSIC ENDS.
SFX: BANG (TA DUM) ACCOMPANIES FLASH OF LIGHT.
DRONE REPLACES MUSIC.
VO: If your child has a problem with alcohol or drugs . . .
SFX: BANG (TA DUM) ACCOMPANIES LIGHT FLASH.
VO: . . . call the . . .
. . . Adolescent CareUnit.
When you've done everything you can.
DRONE FADES OUT.

1767

Art Director	Don Zimmerman
Writer	Elin Jacobson
Editor	H. Lazarus
Client	Jeremy Pudney/DeBeers
Agency Producer	Gaston Braun, N.W. Ayer, Inc., New York, NY
Production Company	Sarah Moon/Film Consortium

1768

Art Director	Bob Kwait
Writer	Rich Badami
Editor	Sonny Klein
Director	Eric Saarinen
Client	The San Diego Zoo
Agency Producer	David Hoogenakker/Phillips-Ramsey Advertising, San Diego, CA
Prod'n Co Producer	Chuck Sloan
Music Production	Ad Music

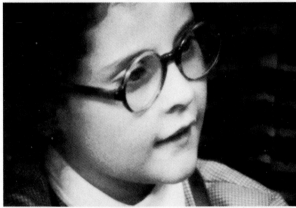

OUR ANNIVERSARY
30-second
MUSIC UNDER THROUGHOUT
GIRL: Mommy will you read me a story?
MOTHER: Which one, that one?
GIRL: (GASP) What's that?
MOTHER: Your daddy gave it to me.
GIRL: What for?
MOTHER: Our anniversary.
GIRL: Do you like it?
MOTHER: Oh, I love it.
It felt as if . . . it was the most wonderful feeling, like when I was 20 and your daddy asked me to marry him.
GIRL: Did you say yes?
MOTHER: Of course, you've got the greatest daddy in the world.

BACKYARD
30-second
WOMAN: Here kitty, kitty, kitty. You might be so close to it, you just might be missing it. The world famous San Diego Zoo. It's right in your own backyard. So there's really no excuse to miss it, because the world's greatest zoo, the San Diego Zoo, is right in your own backyard.
SINGER: You belong in the zoo.

1769

Art Director	Marcia Christ
Writer	Jimmy Cohen
Creative Director	Jay Schulberg
Client	American Express Travelers Cheques
Agency Producer	Nancy Perez/Ogilvy & Mather
	Advertising, New York, NY
Prod'n Co Director	Production Partners/Steve Tobin

1770

Art Director	Bill Yamada
Writer	Perri Feuer
Editor	Joe Laliker/Pelco
Director	Jean Marie Perier
Client	Murjani/Gloria Vanderbilt
Agency Producer	Lorraine Schaffer/Doyle Dane
	Bernbach, New York, NY
Prod'n Co Producer	Heidi Nolting

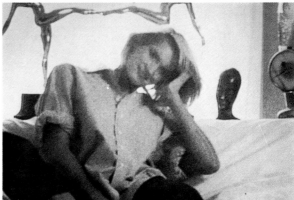

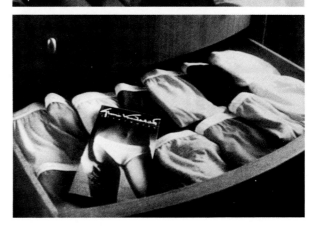

UNDERCOVER COP
30-second
SFX: PEOPLE RUNNING, CAR SCREECHING.
MAN: Stop!!
WOMAN: I can't believe it!!
MAN: It'll be all right.
UNDERCOVER COP: What happened?
MAN: Just leave us alone!
UNDERCOVER COP: Police.
WOMAN: Oh, officer, these kids stole my purse. I mean, they got our cash . . .
MAN: . . . and our travelers cheques . . .
WOMAN: Yeh.
UNDERCOVER COP: You better go down and fill out a report. You said you had travelers cheques?
WOMAN: Yeh, yeh.

FIT FOR A WOMAN
30-second
ANNCR: Gloria Vanderbilt man-tailored all cotton underwear
Designed by a woman to fit a woman.
Possibly the most comfortable underwear around.
After all, look what she did for jeans.
Gloria Vanderbilt underwear.
Designed by a woman to fit a woman.

1771

Art Director	Roy Grace
Director of Photography	Henry Sandbank
Writer	Tom Yobbagy
Editor	Pierre Kahn
Director	Henry Sandbank
Client	Volkswagen of America
Agency Producer	Jim deBarros/Doyle Dane Bernbach, New York, NY
Production Company	Jon Kamen/Sandbank Films

1772

Director	Michael Grasso
Client	Kimball Howell
Agency	WABC-TV, New York, NY
Prod'n Co Producer	Angie Gordon
Executive Producer	Kimball Howell
Account Supervisor	Kathy Soifer

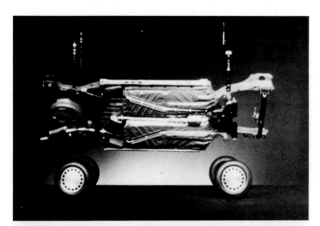

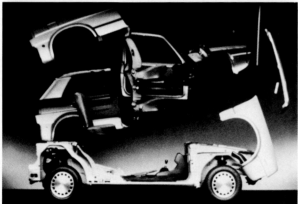

FALLING PARTS

30-second
(MUSIC THROUGHOUT)
ANNCR (VO):
Introducing the new Volkswagen Golf.
When you work on the new Golf
as hard as we have,
for as long as we have, everything just falls into place.
Golf.
It's not a car.
It's a Volkswagen.

INSIDER REPORT—MICHAEL STEWART

30-second
Transit police claim he was injured resisting arrest but to his family it looked like murder.
Michael Stewart arrested for drawing graffiti in the subway. Thirteen days later he was dead.
This is the kind of story that demands persistence. Whatever it takes to uncover the facts.
Louis Young has done over sixty insider reports on the Michael Stewart case and he may do sixty more.
Channel 7 brings you an insider report every weeknight at 6 o'clock.
Watch for it.

1773

Art Director Jerry Whitley
Writer Elizabeth Cutler
Director Henry Sandbank
Client Club Med Inc.
Agency Producer Lorange Spenningsby, Ammirati & Puris Inc., New York, NY
Production Company Sandbank Films

1774

Art Director Steve Kambanis
Writer Steve Fechtor
Client Coca-Cola USA—Diet Sprite
Agency Producer Martha Pfeffer/Marschalk Company, New York, NY

WHAT TO DO FIRST/ANTIDOTE
30-second
(MUSIC UNDER)
SFX: BREATHING
ANNCR (VO): In a Club Med Village there are so many different things to do there's only one difficult decision you'll ever have to make . . . which thing to do first.

HERE COMES TROUBLE
30-second
VOICEOVER THROUGHOUT.
GIRL I: Uh-oh. Here comes trouble.
GIRL II: I hate her.
GIRL I: Yeah. But do you think she's happy?
GIRL II: With those looks? Nah . . . probably not.
GIRL I: (SIGH) It's worse than I thought.
GIRL II: Hey, what's that she's drinking?
GIRL I: Looks like Diet Sprite.
GIRL II: Do you think she *knows* it's the only lemon-lime soft drink that's sugar-free, *and* has the great taste of Lymon?
GIRL I: That would mean she has brains, too.
GIRL II: Oh, I don't want to think about it.
MUSIC: IT'S ONLY DIET SPRITE FOR YOU.

1775

Art Director	Martin Stevens
Writer	Rita Grisman
Editor	Morty Schwartz
Director	Sarah Moon
Client	Revlon, New York, NY
Producer	Kate Sinclair-Perry
Production Company	Bill Hoare, The Film Consortium

1776

Art Director	Steve Ohman
Writer	Harold Karp
Client	March of Dimes
Agency Producer	Mindy Gerber/Marschalk Company, New York, NY

WE'VE GOT YOUR COLOR NO. III
30-second
For dancing or training or staying at home.
We've Got Your Color
For shopping or christening or skiing downhill
We've Got Your Color
For sinning or hunting or tying the knot
We've Got Your Color
269 creamy shiny shades for your lips
143 long, long wearing shades for your fingertips
We've Got the Revlon Color for You!
BABY: Waaaaah!

EMBRYO
30-second
ANNCR (VO): This is where it all begins:
Water on the brain,
open spine,
sickle cell anemia,
Tay-Sachs Disease,
deformed extremities,
mental retardation,
Downs Syndrome.
There are over 3000 different birth defects.
And one thing that can stop them.
The March of Dimes.
We have more than 3000 enemies.
We need all the friends we can get.

1777

Art Director	Nick Vitale
Writer	Elliot Firestone
Editor	Steve Bodner
Director	Patrick Russell
Client	Contac/Menley & James Company
Agency Producer	Phyllis Landi/BBDO, New York, NY
Production Company	Film Consortium

1778

Art Director	Robert Reitzfeld
Designer	Robert Reitzfeld
Writer	David Altschiller
Editor	Randy Illowite
Director	Henry Sandbank
Client	Pioneer
Agency Producers	Jinny Kim, Ann Faxon/Altschiller
	Reitzfeld Solin Adv., New York, NY
Prod'n Co Producer	John Kamen

FEET

30-second

ANNCR (VO): Come on, America! On your feet!
SONG: We keep you out there working.
We keep you out there playing.
Contac keeps you going 'till the day is complete.
Contac.
We keep America on its feet.
ANNCR (VO): When you have a cold, nothing opens you up and lets you breathe better than Contac.
To keep you on your feet.
SONG: Contac. We keep America on its feet.

RAY CHARLES/MTV/DURAN DURAN

30-second

RAY CHARLES: Music Video? I can't see it. If the music don't sound good, who cares what the picture looks like? Then Pioneer gives me LaserDisc. It's a video turntable that works by laser beam. And I'm amazed.
The stereo's as good as anything I ever heard on my stereo. And according to the experts, the picture blows videotape away.
ANNCR (VO): The Pioneer LaserDiscs brand videodisc player. Video for those who really care about audio.
RAY: I like it so much, I got one for George Shearing.

1779

Art Director	Theodore Duquette
Writers	Margaret Wilcox, Gail Schoenbrunn
Editor	Duck Productions
Director	Bruce Van Dusen
Client	Boston Phoenix Radio WFNX
Agency Producer	Steve Cavanaugh, Ingalls, Boston, MA
Production Company	Duck Productions

1780

Art Director	Gary Goldsmith
Designer	Gary Goldsmith
Director of Photography	John Taylor
Writer	Steve Landsberg
Editor	Pierre Kahn
Director	Willi Patterson
Client	Volkswagen
Agency Producer	Regina Ebel/Doyle Dane Bernbach, New York, NY
Production Company	Jim Maniolas/Fairbanks Films
Voice Over	Roy Scheider
Singer	Chuck Berry

BRACES
30-second
SUSAN: Hey, why so glum?
CAROL: His new braces.
SUSAN: So?
CAROL: So, listen.
RADIO: Music (CULTURE CLUB: "Miss You Blind" . . .)
CAROL: He's picking up Boston Phoenix Radio.
RADIO: Boston Phoenix Radio. The best in music, arts and entertainment, news and lifestyle.
CAROL: It's like having the Boston Phoenix Newspaper on the air.
OPENS MOUTH, AGAIN MUSIC:
SUSAN: Aww, at least now people will listen to you.
RADIO: WFNX 101.7 FM. The radio station of the Boston Phoenix.

NO PARTICULAR PLACE
30-second
(MUSIC AND LYRICS AS FOLLOWS)
BERRY: Riding along in my GTI. My baby sitting by my side. I stole a kiss at the turn of a mile. My curiosity runnin' wild. Cruisin' and playin' the radio with no particular place to go.
ANNCR (VO): The New Volkswagen GTI is fun, even with no particular place to go. GTI. Motor trend's car of the year.

1787
Gold Award

Art Director	Harvey Hoffenberg
Writers	Phil Dusenberry, Ted Sann
Editors	Bobby Smalheiser, Pam Power
Director	Ridley Scott
Client	Pepsi-Cola Company
Agency Producer	Phyllis Landi/BBDO, New York, NY
Production Company	Fairbanks Films

1788
Gold Award

Art Directors	Tim Mellors, Steve Grounds
Designer	Peter Hampton
Writers	Tim Mellors, Steve Grounds
Editor	Simon Laurie
Director	Tony Scott
Client	Derek Dear
Agency Producer	Maureen Rickerd
Prod'n Co Producer	Jo Godman
Creative Director	Jeremy Sinclair

SPACESHIP
60-second
OMINOUS MUSIC
SOUNDS OF BOY AND DOG PLAYING.
BOY: Fetch boy
OMINOUS MUSIC
DOG BARKS.
OMINOUS MUSIC GETS INCREASINGLY LOUDER.
SFX: WIND
SFX: LIGHT, COMPUTER-LIKE SOUNDS.
SOOTHING MUSIC
VO: Pepsi. The Choice of a New Generation.

WIDER SEATS
60-second
MUSIC
VO: This is British Airways' Super Club Class seat.
The widest seat in the air.
But being the widest seat in the air, it isn't the easiest to fit through the door.
Now on all our long-haul flights.
The world's widest airline seat.
From the airline that cares about everyone that flies.
Super Club. From the World's Favourite Airline.

Art Directors	Steve Goldsworthy, Dennis Gelbaum
Writer	Craig MacIntosh
Editor	Rye Dahlman
Director	Bill Butler
Client	Chrysler/Dodge Division
Agency Producer	Dennis Gelbaum/BBDO, New York, NY
Production Company	Bean/Kahn

Art Director	Howard Benson
Writer	Barry Biederman
Editor	Tony Siggia
Director	Owen Roizman
Client	ITT Corporation
Agency Producers	Howard Benson, Jean Galton/ Biederman & Co., New York, NY
Production Company	Skip Short/Roizman Short Visual Productions

CITY STREETS
60-second
DRAMATIC MUSIC AND SFX THROUGHOUT
ANNCR (VO): Dodge Daytona Turbo Z.
It is an American Revolution.

BRAKE CONTROL
60-second
ANNCR (VO): When a road is slippery, braking your car can cause skidding . . . or worse.
(SFX)
ANNCR (VO): You can see why on this test track. The surface is wet and slippery. When wheels lock here, your car can go out of control.
(SFX)
ANNCR (VO): Now Teves, an ITT company, has developed an anti-lock brake system that keeps wheels from locking when they shouldn't. The ITT Teves braking system has a built-in computer. It senses what's happening to your wheels. It automatically pumps the brakes faster than any driver could.
(SFX)
ANNCR (VO): This ITT brake system is beginning to reach cars this year. Not a winter too soon.

1791

Art Director	Dan Soldann
Writer	Bob Smith
Editor	Bob DeRise
Director	Joe Hanwright
Client	Pepsi-Cola/Mt. Dew
Agency Producer	Tony Frere/BBDO, New York, NY
Production Company	Kira Productions

1792

Art Director	Harvey Hoffenberg
Writer	Phil Dusenberry, Ted Sann
Editor	Dennis O'Connor
Director	Bob Giraldi
Client	Pepsi-Cola Company
Agency Producer	David Frankel/BBDO, New York, NY
Production Company	Bob Giraldi Productions/Bob Giraldi

 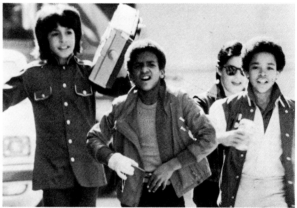

BREAK DANCE

60-second
SINGERS: Give me some fun in the blazin' sun
Give me a friend or two
And when my thirst is at its worst
Give me a Mountain Dew
Dew it to it
Mountain Dew
Dew it to it
To see me through
When I got a thirst
Quench it, drench it, smooth it, cool it
Dew it to it
Mountain Dew!

JACKSONS/STREET

60-second
(JACKSONS MUSIC)
JACKSONS: You're a whole new generation
Dancing through the day
Grabbin' for the magic on the run
A whole new generation
You're loving what you do. Put a Pepsi . . .
into motion
The choice is up to you
Hey-Hey-Hey, You're the Pepsi generation
Guzzle down and taste the thrill of today, and feel the Pepsi way.
Taste the thrill of today, and feel the Pepsi way.
You're a whole new generation, You're a whole new generation, You're
a whole new generation.

1793

Art Director	Harvey Hoffenberg
Writer	Ted Sann
Editor	Bobby Smalheiser
Director	Barry Meyers
Client	Pepsi-Cola Company
Agency Producer	Phyllis Landi/BBDO, New York, NY
Production Company	Sunlight Productions

1794

Art Directors	David McMath, John Triolo
Writer	Bob Clancy
Editor	Lenny Friedman
Director	Dick Sorensen
Client	AT&T Communications
Agency Producer	Paul Gold, Young & Rubicam, New York, NY
Production Company	Lofaro & Associates
Y&R Music Producer	Craig Hazen
Casting	Barbara Badyna

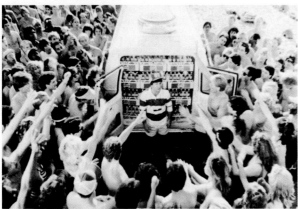

SOUNDTRUCK
60-second
SFX: BEACH SOUNDS, I.F., WIND, WATER.
BACKGROUND
AVO: D.J. from radio.
Sounds of speakers being raised atop truck.
Sounds of ice cubes being dropped into glass.
Sound is heard across beach.
Sound of popping top.
Sound of popping top echoes over beach.
Sound of popping continues.
Sound of fizzing soda.
Sounds of fizzing soda are heard across beach.
Sounds of fizzing soda continue.
BOY: . . . Aah . . .

CONNECTION
60-second
MUSIC
SFX: BREATHING, FOOTSTEPS
ANNCR (VO): For over 100 years AT&T has been making long distance connections.
MUSIC
ANNCR (VO): This year, AT&T is proud to sponsor the running of the Olympic Torch . . . throughout America to Los Angeles. Making possible another special . . . long distance connection.
SFX: SWOOSH OF FLAME
ANNCR (VO): AT&T. We're what you call long distance.

1795

Art Director	Robert Reitzfeld
Designer	Robert Reitzfeld
Writer	David Altschiller
Editor	Randy Illowite
Director	Henry Sandbank
Client	Pioneer
Agency Producers	Jinny Kim, Ann Faxon/Altschiller Reitzfeld Solin Adv., New York, NY
Prod'n Co Producer	John Kamen

1796

Art Director	Hal Nankin
Writer	Richard Bianchi
Director of Photography	Lee Lacy
Writer	Alan Barcus
Editor	Milt Loonan
Director	Lee Lacy
Agency Producer	Christine Jones/Benton & Bowles, Inc., New York, NY
Production Company	Barry Munchik/N. Lee Lacy Assoc.

RAY CHARLES/MTV DURAN DURAN
55-second
RAY CHARLES: Music Video? I can't see it. If the music don't sound good, who cares what the picture looks like? Then Pioneer gives me their LaserDisc player. It's a video turntable that works with a laser beam. And that laser beam makes all the difference, they tell me. I'm a little skeptical, but I listen.
I listen to *Flashdance.* I listen to *Duran Duran.* I listen to *Raiders Of The Lost Ark,* and I even listen to me. And I sound good. I sound better than good. Fact is, the stereo on the Pioneer LaserDisc is as good as anything I ever heard on my stereo. And according to the experts, the picture blows videotape away. Now, who am I to argue?
ANNCR (VO): The Pioneer LaserDisc brand videodisc player. Video for those who really care about audio.
RAY: I like it so much, I got one for my friend, George Shearing.

IN-LAW C-ID/FP
60-second
SON: Okay. Nothing to worry about. Food is coming down the home stretch.
GRANDMOTHER: Oh, that's wonderful, darling, we can't wait. Ha ha ha ha.
GRANDFATHER: What I'd tell ya? Come over here on a weeknight and we'll starve.
GRANDMOTHER: Yes, darling.
GRANDFATHER: She's got a full time job. What's she gonna cook?
AVO: Blue Flower Corningware cookware.
GRANDFATHER: Hi, sheriff. Ah, got a key? Can Grandpop get out of jail now? Ha ha.
GRANDSON: No.
AVO: See-through Visions Top-of-Range cookware by Corning.

1797

Art Director	Arnold Wicht
Director of Photography	Peter James
Writer	Tim Heintzman
Editor	Richard Unruh
Director	Jeremiah Chechik
Client	Ontario Ministry of Tourism and Recreation
Agency	Camp Associates Advertising Limited, Toronto, Canada
Prod'n Co Producer	Charlene Kidder
Creative Director	John McIntyre

1798

Art Directors	Greg Weinschenker, Tony Viola
Writers	Bonnie Berkowitz, Linda Kaplan, Gerry Killeen
Editor	Tony Siggia (First Edition)
Director	Joe Pytka
Client	Eastman Kodak Company
Agency Producer	Meredith Wright, J. Walter Thompson, New York, NY
Production Company	Meg Mathews (Pytka Productions)

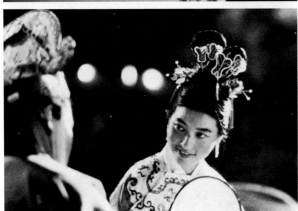

DIVERS
60-second
(MUSIC THROUGHOUT)
Start at the dawn
of a new day
exploring the wide open road.
Follow the trail where
it's leading you and
Discover Ontario.
You'll see the mist
on the water and feel
the sun shining strong;
You'll find the smile
of a friendly face
that says this is where
you belong.

REUNION
60-second
SINGER: HERE WE ALL ARE AGAIN
NOW I CAN SAY I KNEW YOU WHEN
THOUGH THE YEARS HAVE COME BETWEEN US
WE STILL SEE EYE TO EYE
WITH LOVE THAT SHINES
AS TIME GOES BY.
AVO: Remember it just the way it was on Kodacolor VR films. The
sharpest, brightest, most dazzling line of color print films Kodak has
ever made. There's no better, more beautiful way to color your
memories.
SINGER: OH, WE REALLY WERE A HIT
YOU KNOW, YOU HAVEN'T CHANGED A BIT
LOOKIN' FINE
AS TIME GOES BY.

1799

Art Directors	Dick Pantano, Corinne Hilcoff
Writer	Maryann Barone
Editor	David Doob
Director	Dan Driscoll
Client	Jordan Marsh
Agency Producer	Maggie Hines/HHCC, Boston, MA

1800

Art Directors	Michael Hart, Bob Donnellan, Frank Nicolo
Artist	Mike Beck (Edstan Studio)
Writers	Laurie Birnbaum, Jim Patterson
Editor	Bob Derise (A Cut Above)
Director	Gerard Hameline
Client	Showtime/The Movie Channel
Agency Producers	Paul Frahm, Ben Fernandez, J. Walter Thompson, New York, NY
Production Company	Michael Daniels Productions
Music	HEA Productions

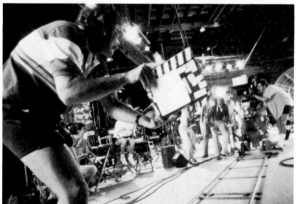

PASSPORT SPRING
60-second
(SFX: TRAIN STATION, STEAM ENGINE, WHISTLE ECHO, FOOT-STEPS RUNNING, MOS)
MUSIC: POST-SCORED IN THE FEELING OF "AS TIME GOES BY"
DIRECTOR: And action . . .
(VOICES OVER ACTION)
AGENT: Is your passport in order?
When this is over, you'll be a star . . .
(SFX: CHURNING OF TRAIN WHEELS, CHUGGING OF ENGINE)
LADY: Is it the place . . .?
AGENT: The same, but different . . .
LEADING LADY: How does Jordan Marsh fit in?
AGENT: Wardrobe, everything you need . . .

WE MAKE EXCITEMENT
60-second
ANNCR (VO): Presenting Showtime Cable TV!
SINGERS: Today's the day we're gonna make it happen.
Today's the day we'll make it come alive.
Today's the day we're gonna make you happy.
Showtime's gonna make you realize.
We make excitement
Showtime excitement
You're gonna see TV
With some real excitement
Showtime has thrillers and chillers
We've got the best for you
Showtime has songs and laughter
There's nothing we won't do
To make excitement

1801

Art Director	Arthur W. Taylor
Writers	David Lyday, Delores Stark
Director	Melvin Sokolsky
Client	Al Swinney, Republic Health, Dallas, TX
Agency Producer	Leigh Mergehenn
Production Company	Sunlight Pictures

1802

Art Director	Dean Hanson
Artist	Lamb & Co.
Director of Photography	Jim Hinton
Writer	Tom McElligott
Editor	Jeff Stickles
Director	Jim Hinton
Client	First Tennessee
Agency Producer	Judy Carter/Fallon McElligott Rice, Minneapolis, MN
Production Company	Wilson-Griak
Music	Judy Collins

CALL ME
60-second
WOMAN: Hello, my name is Sarah Williams.
I'd like to talk to you about something that's a problem for many women: alcohol. I understand . . . you drink because you're lonely. Because it numbs the pain and the guilt.
Sometimes being sober is almost unbearable. There are women here who've been where you are. . . . They can help you to learn to live without alcohol. I'd call you if I could. But I can't. So please call me. When you leave here you'll look better. You'll like yourself better. And you'll be ready to love and be loved by the people you care about most. All you have to do is call me.
Raleigh Hills
1-800-4-Call Me
Call Raleigh Hills for answers.

DAUGHTERS
60-second
HAL RINEY VO: For generations, the sons and daughters of Tennessee have served the world with uncommon vision and dedication. And for generations, one bank has served Tennessee with uncommon vision and dedication . . . First Tennessee.
First Tennessee . . . an uncommon bank for uncommon people.

1803

Art Director	Mary Means Morant
Director of Photography	Ed Martin
Writers	Tom Mabley, Bob Sarlin
Editor	Allen Rozek
Director	Stu Hagmann
Client	IBM Corp.
Agency Producer	Robert L. Dein/Lord, Geller, Federico, Einstein Inc., New York, NY
Production Company	Dick Kerns/H.I.S.K.

1804

Art Directors	Tim Mellors, Steve Grounds
Designer	Morris Spencer
Writers	Tim Mellors, Steve Grounds
Editor	Simon Laurie
Director	Tony Scott
Client	Derek Dear
Agency Director	Maureen Rickerd/Saatchi + Saatchi Compton, New York, NY
Prod'n Co Producer	Jo Godman
Creative Director	Jeremy Sinclair

SKATES
60-second
In this rapidly changing world, even the brightest and best
manager in the company may need more than a loyal staff to run
a smooth operation.
For, when headquarters calls and pressure builds,
it becomes harder to keep things rolling without running into mixups,
losing control of the operation, and falling behind.
For rapid improvement, a manager could use a tool for modern times,
the IBM Personal Computer . . .
for smoother scheduling,
better planning,
and greater productivity.
It can help a manager excel and . . . become a big wheel in
the company.
The IBM Personal Computer.

LUNAR COUNTDOWN
60-second
ASTRONAUT: Go, go, go!!!
ASTRONAUT: Where is he going now?
ASTRONAUTS: No!!!
All right!!!
VO: When you're next away from home and in need of a little help,
it's worth remembering British Airways has people in more places
than any other airline.
TICKET AGENT: Smoking or non-smoking?
ASTRONAUTS: Non-smoking!
VO: British Airways. The World's Favourite Airline.

1805

Art Director	Jean Goldsmith
Client	Jane Gallagher
Editor	Matt Cope
Director	Roger Flint
Client	Kayser-Roth/Leg Looks
Agency Producer	Catherine Land, Grey Advertising, New York, NY
Prod'n Co Producer	Roger Flint
Associate Creative Directors	Kurt Haiman, Judy Frisch

1806

Art Directors	Greg Weinschenker, Rob Snyder
Writers	Marty Friedman, Linda Kaplan, Gerry Killeen
Editor	Tony Siggia (First Edition)
Director	Joe Pytka
Client	Eastman Kodak Company
Agency Producer	Meredith Wright, J. Walter Thompson, New York, NY
Production Company	Meg Mathews, Pytka Productions

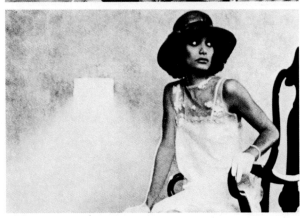

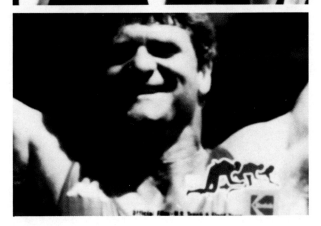

POSTER
60-second
Leg Looks—It isn't a look without Leg Looks

THE MOMENT
60-second
SINGER: Well, here you are at last
How high can you go,
How far, how fast?
Will you go the distance?
Well, first you have to try
And you'll do fine
As time goes by.
AVO: Capture the moment in all its glory on Kodacolor VR films. The sharpest, brightest, most dazzling line of color print films Kodak has ever made. For all your golden moments.
SFX: STARTER'S GUN
SINGER: Like a brilliant shooting star
Reaching for the sky
How you'll shine

1807

Art Director	George Radwan
Director of Photography	Danny Quinn
Writer	Steve Fenton
Editor	Arthur Williams
Director	Bob Giraldi
Clients	Judith Ranzer, Ann Weeks
Agency Producer	Charlotte Rosenblatt/Benton & Bowles, Inc., New York, NY
Production Company	Ralph Cohen/Bob Giraldi Productions

1808

Art Directors	Earl Cavanah, Larry Cadman
Writer	Larry Cadman
Director	Tim Newman
Client	Playboy
Agency Producer	Dane Johnson/Scali, McCabe, Sloves, New York, NY
Production Company	Jenkins, Covington, Newman

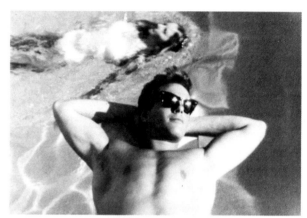

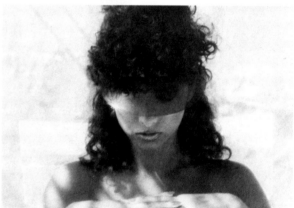

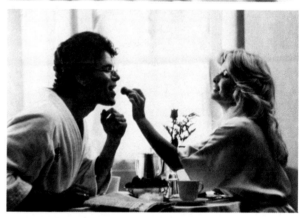

WALL/WICH/FP
60-second
1ST MAN: George, you've got MCI long distance.
Think it's right for my business?
2ND MAN: MCI. State of the art. Top banks and brokers use it to save on long distance calls.
1ST MAN: Gee.
2ND MAN: Yes. GE. GAF. RCA. AMF.
(SFX): MUSIC BEGINS.
2ND MAN: Three fifty of the Fortune five hundred use MCI anytime.
2ND MAN (OC): To anywhere.
Coast to coast.
1ST MAN: Well.
(SFX): HORN HONKING
2ND MAN: Did you say wells?

SOME GUYS HAVE ALL THE LUCK
120-second
Some guys have all the luck, some guys get all the fun,
Some guys have all the luck, all the luck.
Ooh, What're you gonna do when your luck begins to run?
(OOH'S)
Uh—Such a lucky dog; it's good luck—push it.
I get turned on by everything you do to me.
Don't say you shouldn't do that; push your hard luck hard, push it.
Ow! To take a kiss from lady luck tonight,
Oh yeah, I want to (so much).
Ooh the way it feels when you find out there's a pearl in it,
Ooh the way it feels when you get it.
Some guys have all the luck, some guys get all the fun.
I get to hear you talk, see you walk.
Take me in your arms & let your luck begin to run.

1809

Art Director	Eli Rosenthal
Director of Photography	Allan Charles
Editor	Michael Swerdloff/First Edition Editorial
Director	Allan Charles
Client	Campbells Soup
Agency Producer	Tony Frere/BBDO
Prod'n Co Producer	Georgia Sullivan/Charles Street Films, Baltimore, MD

1810

Art Director	Tony De Gregorio
Director of Photography	Steve Horn
Writer	Lee Garfinkel
Editor	David Dee
Director	Steve Horn
Client	Subaru
Agency Producer	Rachel Novak/Levine, Huntley, Schmidt & Beaver, New York, NY

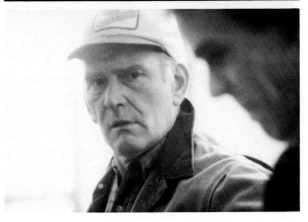

ROCK PANTOMIME
60-second
Coming to ya, on a dusty road,
good lovin', I gotta truck load.
And when you get it, you got something.
I'm a soul man. I'm a soul man. I'm a soul man. I'm a soul man.
And that ain't all.
I was brought up, on a side street,
I learned how to love, before I could eat.
I'm a soul man.
I'm a soul man.
ANNCR: Hey Ziggy, Chunky's the soup that eats like a meal and it's a lot easier to make. Go ask your momma!

FARMBOY
60-second
SON: Remember when you were my age Dad? C'mon, you under-stand what I mean, it's my first car.
DAD: It's your money son, but if you want my advice, buy another Subaru. It's been good to us.
SON: (ASSURINGLY) Sure, Dad.
SFX: (MUSIC SHIFTS FROM SOFT HOMESPUN MUSIC TO HARD ROCK N' ROLL)
DAD: I thought we agreed . . . you'd buy a Subaru.
SON: But Dad . . . I did.
ANNCR: The new Subaru XT Coupe. Inexpensive. And built to stay that way.
SUPER: Subaru. Inexpensive. And Built To Stay That Way.

1811

Art Director	Donna Weinheim
Writer	Clifford Freeman
Editor	Peggy DeLay
Director	Joe Sedelmaier
Client	Bil Welter/Wendy's International, Inc.
Agency Producer	Susan Scherl/Dancer-Fitzgerald-Sample, Inc., New York, NY
Production Company	Marsie Wallach/Joe Sedelmaier Productions

1812

Art Director	Arthur W. Taylor
Writers	David Lyday, John Sealander
Director	Melvin Sokolsky
Client	Al Swinney, Republic Health
Agency Producer	Leigh Mergehenn/Tracy-Locke/ BBDO, Dallas, TX
Production Company	Sunlight Pictures

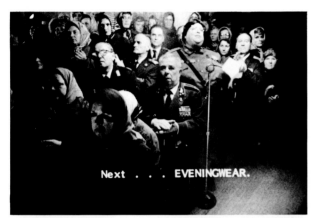

FASHION SHOW
60-second
WOMAN: Pay attention please. Thank you.
Is next . . . Daywear. Very nice.
Is next . . . Eveningwear. Very nice.
ANNCR: Having no choice is no fun. So everyone who wants choice is at Wendy's. Wendy's has a new light menu featuring low calorie salads, hot stuffed baked potatoes with many delicious toppings. 6 kinds of sandwiches with regular or multi-grain buns, hot chili and more. Having a choice is better than not.
WOMAN: Is next . . . Swimwear.
ANNCR: Wendy's. There's no better choice.

CALL ME
60-second
WOMAN: Hello, my name is Elizabeth Harmon.
If your husband's drinking is causing problems in your family, I'm the person that can help. Call me. I can tell you about a program we offer called "intervention." It's a plan that you and I work out, together, to help encourage your husband to accept treatment, where he can have help to stop drinking. Call me. I know you have questions . . . What really happens in treatment? What will people think? Who pays the bills? How do I get him to go? Will he still love me? Call. Intervention does work. You can have the man you married back . . . without the alcohol. And believe me . . . you don't have to do it alone.
Raleigh Hills
1-800-4-CALL ME
Call Raleigh Hills for answers.

1813

Art Director	Hector Robledo
Writer	Ted Littleford
Editor	Howie Lazarus (Take Five Editorial)
Director	Barry Myers
Client	Data General
Agency Producer	Sherri Fritzson/Foote, Cone & Belding, New York, NY
Production Company	Carrie Hart/Spots Films, Timothy Hayes/Sunlight Pictures
Music	Elias Associates

1814

Art Director	Frank Lopez
Designer	Frank Lopez
Writer	Craig Cassidy
Client	Cinemax, New York, NY
Producer	Craig Cassidy
Director of On-Air Promotion	HBO, Tim Miller

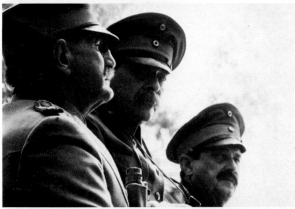

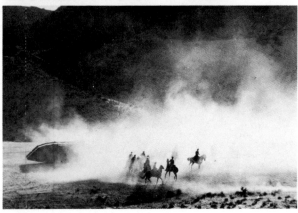

TANK
60-second
MUSIC UP, SFX.
ANNCR (VO): Data General asks . . . in tomorrow's business battle, will you be buying yesterday's technology?
At Data General, our computer systems are so advanced, we win more major contracts than any other company.
Talk to Data General.
A generation ahead.

RICHARD BELZER: THE CONTRACT
85-second
VO: Just behind this door lurks the unpredictable, the uncontrollable comic mind of Richard Belzer—hard at work—busy as a beaver on his new show. But what's he up to? What's the Belz got planned? Well, we don't know . . . but what if we dropped in on the Belz and payed him a surprise visit! What if we—
Oh, Belz I'm sorry. Uh, look, we'll pay . . . I mean we tried to call but the line was busy—
BELZER: Whoa! Slow down, babe. Here's my wallet—take it, it's yours. No questions. I don't have any plastic—hey, you're the guy from Cinemax. Hey, babe, cut me a personal break here. What's going on?
VO: Uh, we just wanted to sneak a peek at your—
BELZER: Sneak a peek? You mean like cop a feel? Well, I don't have it.

1815

Art Directors	Dick Pantano, Bob Curry
Writers	Tony Winch, Doug Houston
Editor	Dennis Hayes
Director	Joe Pytka
Client	Wang Laboratories, Inc.
Agency Producer	Ann Finucane/HHCC, Boston, MA
Prod'n Co Producer	Meg Matthews

1816

Art Director	Hector Robledo
Writer	Ted Littleford
Editor	Howie Lazarus (Take Five Editorial)
Director	Barry Myers
Client	Data General
Agency Producer	Sherri Fritzson/Foote, Cone & Belding, New York, NY
Prod'n Co Producers	Carrie Hart/Spots Films, Timothy Hayes/Sunlight Pictures
Music	Elias Associates

PIANO TUNER
60-second
(SFX: SOUNDS OF TUNING PIANO PLUS TENSION MUSIC, UNDER)
VO: No company can simply deliver a computer and feel it has delivered on the promise of office automation. At Wang, we provide service and support along with our computers so that the people who use them will always be able to perform to their fullest potential. Wang. We put people in front of computers.

CATAPULT
60-second
MUSIC UP, SFX.
ANNCR(VO): Data General asks . . . in tomorrow's business battle, will you be buying yesterday's technology?
At Data General, our computer systems are so advanced, we win more major contracts than any other company.
Talk to Data General.
A generation ahead.

1817

Art Director	Danny Boone
Writer	Mike Hughes
Editor	First Edition
Director	Sid Myers
Client	Barnett Banks of Florida
Producer	Craig Bowlus
Agency	The Martin Agency, Richmond, VA
Production Company	Myers Films
Creative Director	Harry Jacobs

1818

Art Director	Steve Ohman
Writer	Harold Karp
Editor	Vito DeSario
Director	Steve Horn
Client	W.R. Grace & Co.
Agency Producer	Mindy Gerber/Marschalk Company, New York, NY
Production Company	Steve Horn, Inc.

LOCAL AUTONOMY
60-second
(MUSIC UNDER)
ANNCR: At most banks in Florida, the bankers have to go to great lengths to get an answer for you.
BANKER: I'm from a branch in the west, and I need a decision on a matter of great importance to one of our customers.
GURU 1: You'll have to go higher than me, my son.
ANNCR: In fact, major decisions usually have to go all the way to the top.
GURU 2: You've only just begun, Blue Suit.
ANNCR: At Barnett we don't work that way.
BANKER: Our customer's waiting for a decision
GURU 3: Higher, my son.
ANNCR: Barnett's structured so that local decisions are made locally. That means that the decisions that affect you . . .

BABY
60-second
SFX: FOOTSTEPS.
MAN: Morning.
Shall we get down to business?
Now that you've joined us, you'll enjoy numerous rights and privileges. But you will share certain problems, as well.
Specifically, you owe the United States government, in round numbers, $50,000.
BABY: Waaaaahhhhh.
ANNCR (VO): If federal deficits continue at their current rate, it's as if every baby born in 1985 will have a $50,000 debt strapped to its back.
MAN: Let us review these figures for you.
ANNCR (VO): At W.R. Grace & Co., we're not looking for someone to blame. We're too busy crying out for help.
Write to Congress. If you don't think that'll do it, run for Congress.

1819

Art Directors	Roger Mosconi, Susan Barron
Writer	Paul Cappelli
Editor	Dennis Hayes
Director	Howard Guard
Client	General Electric
Agency	Jeff Fischgrund/BBDO, New York, NY
Production Company	Howard Guard Productions

1820

Art Director	Mike Fazende
Writer	Bert Gardner
Client	Control Data Institute
Agency Producer	Lisa Jarrard/Bozell & Jacobs, Inc., Minneapolis, MN
Production Company	Greg Hoey/Film Fair

THE POWER OF MUSIC
60-second
SFX: METEOR SHOWERS.
MUSIC THROUGHOUT
AVO: In the third millennium, four adventurers came upon a city imprisoned in silence.
SFX: MUSIC UP
EXPLODING CRYSTALS
AVO: The Power of Music. No one lets you experience it like General Electric.

MORNING
60-second
WIFE: Honey, you've got to go to work!
HUSBAND: No!
WIFE: Yes!
HUSBAND: No!
WIFE: Yes!
HUSBAND: No!
WIFE: Yes!
HUSBAND: No!
WIFE: Please?!
HUSBAND: No!!
ANNCR (VO): A lot of people don't look forward to going to work in the morning.
Maybe they don't have a job they can look forward to.

1821

Art Director	Robert Joiner
Writer	Rob Schapiro
Editor	Dick Spraggins
Director	John Francis
Client	Sports Illustrated
Agency Producer	Harvey Greenberg/Richards Group, Dallas, TX
Production Company	Bass/Francis Films
Music	Tom Faulkner

1822

Art Director	Cynthia Wojdyla
Designer	Alan Rodrick-Jones
Director of Photography	Stephen Goldblatt
Writer	Wendy Cassell
Editor	Jim Edwards
Director	Brian Gibson
Client	Blue Bell, Inc.—Wrangler
Agency Producer	Jack Smart
Production Company	Olivier Katz/Lofaro & Associates, New York, NY
Executive Producer	Houston Winn

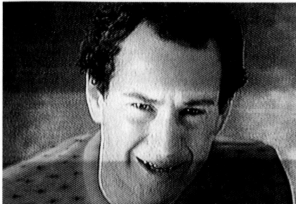

McENROE
120-second
ANNCR (VO): Tennis star John McEnroe on the joy of Christmas shopping.
McENROE: How'd you like to have to pick out a Christmas present for me? You probably think I'm tough to please, right?
Gimme a break. I'm just like any other guy. I'd be thrilled to get this. A subscription to Sports Illustrated.
What guy wouldn't? The writing's great. The photography's great. It's the number one sports machine in America, isn't it? And I'll tell you something else about this gift. It keeps coming. Every week. All year long.
Look. for starters I get this special double issue, the Sportsman of the Year. Then I get a good look at the best part of football season.

GEM
60-second
SUSPENSEFUL MUSIC
SUNG: Live it
to the limit.
Live it to the limit in Wrangler.
ANNCR: Out here, people need
Wrangler styles and great fit.
'Cause no matter what they're doin'
Wrangler pants and jackets look good anytime, anywhere.
SUNG: So live it to the limit in Wrangler.

1823

Art Directors	Lou DiJoseph, Don Easdon
Writer	Lee Kovel
Editor	Jerry Bender
Director	Bob Brooks
Client	Dr Pepper—Sugar Free
Agency Producer	Laurie Kahn/Y&R, New York, NY
Production Company	Brooks, Fulford, Cramer, Seresin
Y&R Music Producer	Hunter Murtaugh

1824

Art Directors	Lou DiJoseph, Don Easdon
Writer	Lee Kovel
Editor	Jerry Bender
Director	Bob Brooks
Client	Dr Pepper—Regular
Agency Producer	Laurie Kahn/Y&R, New York, NY
Production Company	Brooks, Fulford, Cramer, Seresin
Y&R Music Producer	Hunter Murtaugh

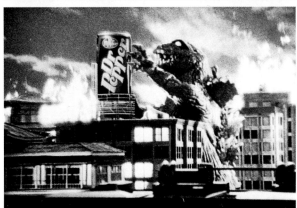

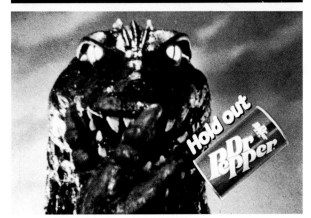

LITTLE RED
60-second
MUSIC
(VO) HUMMING.
SFX: ROAR.
WOLF: ROARS.
GIRL: SCREAMS.
GIRL: Please, I'm on my way to grandma's.
WOLF: WHINES.
GIRL: Well, how about some cottage cheese, maybe, a diet soda.
WOLF: ROARS.
GIRL: Well, I was saving this for myself, but . . .
CHORUS SINGING THROUGHOUT: Hold out, hold out for the out of
the ordinary, hold out for Dr Pepper. Don't be sold out, hold out, it's a
taste that's extraordinary, no doubt it's Dr Pepper, Dr Pepper.
GIRL: Awesome, mama warned me about wolves.

GODZILLA
60-second
JAPANESE MAN: The monster! Godzilla! The monster.
AMERICAN REPORTER: We must stop Godzilla before he destroys
the city. I'm saying a prayer . . . a prayer for the whole world. What
could he want? Unless we find something to appease him . . . we're
doomed.
CHORUS: Hold out, hold out for the out of the ordinary, hold out for Dr
Pepper. Don't be sold out, hold out, it's a taste that's extraordinary, no
doubt it's Dr Pepper, Dr Pepper.
GODZILLA: (SFX) Burp!

1825

Art Director	Bob Cox
Writer	Bob Cox
Editor	Morty Ashkinos
Director	Neil Tardio
Client	Xerox Corporation
Agency Producer	Carolyn Roughsedge/Needham Harper Worldwide, Inc., New York, NY
Production Company	Nan Simons/Neil Tardio Productions

1826

Art Director	Tana Klugherz
Writer	Stephanie Arnold
Director	Bert Steinhauser
Client	McCall's Magazine
Agency Producer	Rachel Novak/Levine Huntley Schmidt & Beaver, New York, NY
Production Company	Bert Steinhauser Productions

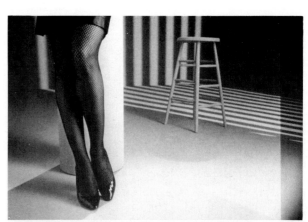

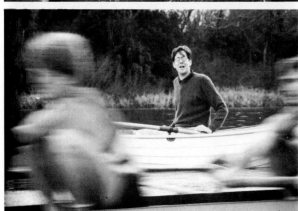

ROWING
60-second
MAN IN BOAT: You know, the ancient Egyptians found these to be invaluable objects for propelling a boat through water. Course, if you only have one, you just go around in circles.
(SFX: TWO CREWS OF EIGHT PASS ED HERRMANN IN ROWBOAT.)
In a modern racing shell, each crew member is trained to work perfectly with his teammates. Imagine how much more productive you could be if all your office machines could pull together like that. Well, Xerox has found a way to make that happen. It's called Team Xerox. They've got work stations working with computers or laser printers.
It boggles the mind. Of course it helps to have people with the knowledge and experience to keep it all going.
Xerox has that too.

TINA TURNER/CARLY SIMON
10-second
SFX: (TINA TURNER MUSIC)
SFX: (MUSIC FADES)
VO: One of the drab homebodies who reads McCall's.
McCalls. More than the expected.

1827

Art Director	Phil Silvestri
Writer	Rita Senders
Editor	Jeff Dell
Director	Bert Steinhauser
Client	Beck's Beer
Agency Producer	Linda Tesa/Della Femina, Travisano & Partners, Inc., New York, NY
Prod'n Co Producer	Cindy Alkens

1828

Art Directors	Earl Cavanah, Simon Bowden, Mark Erwin
Writers	Larry Cadman, Frank Fleizach
Client	Volvo
Agency Producers	Mike Moskowitz, Jean Muchmore, Richard Berke/Scali, McCabe, Sloves, New York, NY

NEW YORK/WASHINGTON/LOS ANGELES
10-second
ANNCR (VO): In New York, the nation's big apple, the word around town is German.
PERSON: Becks.
ANNCR (VO): The number one imported German beer in New York.

0-55/SAFETY/SPACE VEHICLE
10-second
ANNCR (VO): If you owned the intercooled Turbo from Volvo . . . this is all the time it would take you . . . to go from 0 to 55 miles per hour. The 740 Turbo by Volvo.

1829

Art Directors	Roy Grace, Jill Shuken
Directors of Photography	Henry Sandbank, Frank Tidy, Fred Moore
Writers	Tom Yobbagy, Steve Landsberg, Neal Gomberg
Editor	Pierre Kahn
Directors	Henry Sandbank, Ross Cramer, Michael Ulick
Client	Volkswagen of America
Agency Producers	Jim deBarros, Regina Ebel/Doyle, Dane, Bernbach, New York, NY
Production Companies	Jon Kamen, Sandbank Films/Susan Kirsen, Power & Light/Liz Kramer, Michael Ulick Prodns.

1830
Gold Award

Art Director	Peter Coutroulis
Designer	Peter Coutroulis
Director of Photography	Fred Petermann
Writer	Howard Krakow
Director	Fred Petermann
Client	U.S. Borax
Agency Producer	Davis, Johnson, Mogul & Colombatto, Los Angeles, CA
Production Company	Petermann/Dektor

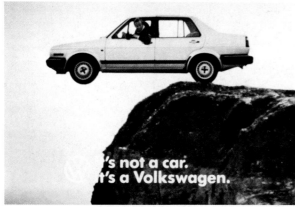

FALLING PARTS/PIGGY BANK/CLIFF
10-second
MUSIC THROUGHOUT
VO: The new 1985 Volkswagen Golf has arrived.
Drop in for a test drive.
Golf. It's not a car,
it's a Volkswagen.

COLORED CLOTHES/WHITE CLOTHES
30-second
ANNCR (VO): Danger is unleashed when chlorine bleach enters the water. And then, the price you pay for clean clothes can be the price of the clothes themselves.
Make it safe to put all your clothes back in the water again . . .
Bleach with Borateem Bleach . . .
The Safe, Great White.
SUPERS: Borateem Bleach
The Safe Great White
© U.S. Borax Chemical Corporation 1984

Art Director Jim Burt
Designer Jim Burt
Director of Photography Ivor Sharp
Writer Graham Watt
Directors Graham Watt, Jim Burt, Ivor Sharp
Client The Ontario Milk Marketing Board
Agency Producer Garry Warwick/Mckim Advertising
Production Company Watt Burt Advertising, Inc., Montreal,
Canada and Roger Main/Cineservice

Art Director Ira Madris
Writer Bruce Nelson
Editors Howie Lazarus, Jeff Halpern
Director Henry Sandbank, George Gomes
Client Miles Laboratories
Agency Producer Bailey Weiss, McCann-Erickson,
New York, NY

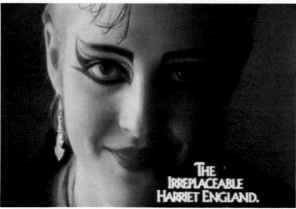

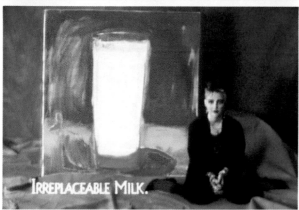

THE IRREPLACEABLE HARRIET ENGLAND/REBECCA RANKIN/LILI HOCKMANOVICH
30-second
I've got you
under my skin.
I've got you
deep in the heart of me.
So deep in my heart,
you're really a part of me.
I've got you
under my skin.

WAITING ROOM/BOARDROOM/9TH INNING
30-second
ANNCR (VO): Giving birth to the anxious upset stomach that comes with the thumping head?
Luckily, there are the medicines of Alka-Seltzer.
NURSE: Girl. Girl. Boy. Girl. Boy. Boy. Boy. Boy.
MAN: Oh, boy.
ANNCR (VO): Alka-Seltzer. For those symptoms of stress that can come from newly-born success.

1833

Art Director Elmer E. Yochum
Designer Elmer E. Yochum
Director of Photography Joe Rivers
Writer John F. Waldron
Editor Peter Stassi, Startmark
Director George M. Cochran
Client Stouffer Foods Corporation
Agency Producers Elmer Yochum, John Waldron, HBM/
Creamer, Inc., Pittsburgh, PA
Production Company Sharon DeSouza, George M.
Cochran, Inc.

1834

Art Director Roy Grace
Directors of Photography Fred Moore, Bob Bailin
Writer John Noble
Editor Dick Stone
Director Michael Ulick
Client Mobil Oil Corporation
Agency Producers Susan Calhoun, Lora Nelson/Doyle
Dane Bernbach, New York, NY
Production Company Liz Kramer/Michael Ulick
Productions

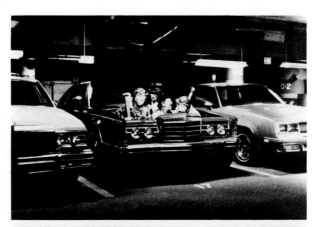

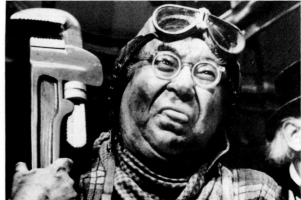

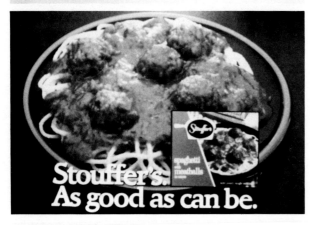

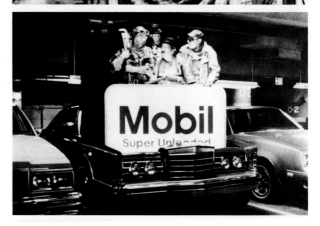

TOMATO/GREEN PEPPER/LOBSTER
30-second
In Santa Clara County, California,
a few miles north of the Monterey Peninsula,
they grow a remarkably firm, bright-red tomato.
Stouffer's calls it The Perfect Murrieta.
Not quite as large as a tennis ball,
it's juicy and meaty . . .
and filled with the hearty,
rich taste of a great sauce tomato.
Now you know *one* of the reasons
Why Stouffer's Spaghetti with meatballs is
as good as can be.

PUSH UP/PARKING LOT/SNACK SHOP MODULE
30-second
#1: What a bummer, another engine we can't mess up.
#2: How could Mobil do this to me?
#3: Yeah, make their Super Unleaded
Gasoline that good.
#4: It's really powerful.
#3: High octane is so disgusting.
#2: Knocking and pinging is becoming a lost art.
#1: Yeah!
#3: I just hope nobody else finds out how good their gasoline is.
#4: How could they find out?
#1: Mobil could make a television commercial.
ALL: Naw.

1835

Art Director	Robert Jones
Designer	Robert Jones
Writer	Robert Jones
Editor	VTA–Video Tape Associates
Director	Bob Hulme
Client	Bojangles' of America
Agency	McDonald & Little, Atlanta, GA
Production Company	Paisley Productions
Consultant	Greg Guirard

1836

Art Directors	Lee Stewart, Vicki Smith
Writer	Bill Teitelbaum
Director	Bill Teitelbaum
Client	Southern National Bank
Agency Producer	Bill Teitelbaum/Howard, Merrell & Partners, Raleigh, NC
Production Company	Audiofonics

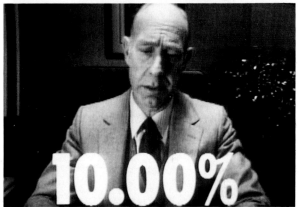

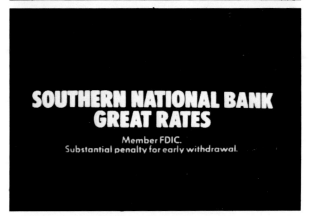

BOAT/PORCH/LANE
30-second
MAN #1: Mmmm!
BOY: What you said, eh?
MAN #1: I was just thinkin' 'bout Bo's fried chicken.
BOY: Bo?
MAN #1: You know, that man would sit up all night soakin' that chicken in what he call his secret Cajun recipe.
That's what makes it taste so good.
BOY: Bo? Mais, who that is, eh?
MAN #2: Bo, that's just his front name.
MAN #1: His behind name, that's Jangles.
(LAUGHTER)
SING: Now his name is up in lights.
Biscuits, chicken and dirty rice.

ALKA-SELTZER/FREE LUNCH/PREMIUMS
30-second
BANK MANAGER (OCV): Unlike most banks, that try to pay as little as possible for your money . . . Southern National Bank tries to pay as much as possible.
Right now for example, this is the interest we're paying on 6-month CDs.
(Isn't that . . . generous.)
And here comes the annual yield.
How can we offer rates like this?
SFX: PLOP, PLOP, FIZZ.
It's not easy.
ANNCR (VO): Great Rates, only from Southern National Bank.

1837

Art Director	Mac Talmadge
Director of Photography	Larry Boelens
Writer	Robin Goodfellow
Editor	Tom Schachte
Director	Bob Eggers/Eggers Films
Client	Conwood Corporation/Hot Shot Household Insecticide
Agency Producer	Earl McNulty/Tucker Wayne & Company, Atlanta, GA
Prod'n Co Producer	Bobby Weinstein
Props (Bugs)	Joanne McPherson

1838

Art Director	Gary Gibson
Director of Photography	Leslie Smith
Writer	Rich Flora
Directors	Rich Flora, Gary Gibson
Client	Dallas Times Herald
Agency Producer	Greg Gibson/Richards Group, Dallas, TX
Production Company	Group Seven

HOWARD/FLOYD/RANDALL
30-second

WOMAN: Oh, oh, Howard. Here they come again. Do you hear them? I can't stand that sound. Don't they bother you? They bother me. We really need something that'll get 'em fast.
They really bother me. Don't they bother you?
WOMAN: Hot Shot?
HOWARD: Hot Shot.
VO: Hot Shot knocks down flying bugs fast.
HOWARD: Fast.
WOMAN: I'm so happy, Howard.
Aren't you happy?
We finally got some peace and quiet. I've always found that peace and quiet is very peaceful, very quiet.
VO: For a big bug problem, give it your best shot. Hot Shot.

DABNEY/RUSSELL/MANLEY
30-second

COLEMAN: What does Steven Reddicliffe say about yours truly? "Dabney Coleman is the best heel player we have right now. He plays a great jerk. He is wonderfully disagreeable—a one-man Dyspepsia Challenge. Coleman is first-rate and in excellent form.
There you have it, folks. The kind of honesty in journalism that makes us all, well makes us all proud we can read.
ANNCR (VO): Steven Reddicliffe takes an honest look at TV. To read his column, just ask, "What does the Herald say?"

Art Director	Martin Shewchuk
Director of Photography	Stephen Amini
Writer	David Himelfarb
Editor	Norm O'Dell
Director	Stephen Amini
Client	Procter & Gamble Inc.
Agency Producer	Frances Russo/Leo Burnett Company, Ltd., Toronto, Canada
Production Company	Shooters
Creative Director	Ed Nanni
Executive Producer	Judy Ankerman

Art Directors	Gary Yoshida, Pam Cunningham
Writers	Bob Coburn, Carol Ogden
Editor	The Reel Thing
Directors	Henry Sandbank, Don Guy, Michael Werk
Client	American Honda Motor Company, Inc.
Agency Producers	Helmut Dorger, Joel Ziskin/Needham Harper Worldwide, Los Angeles, CA
Production Companies	Sandbank Films, Dennis Guy & Hirsh, Petersen Communications

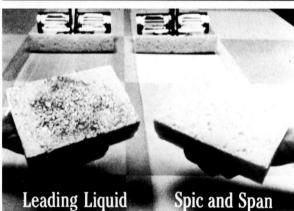

POWERFUL DEMONSTRATION/DEMONSTRATION OF POWER
30-second
MUSIC: (ALL THE ACTION IN THIS SPOT TAKES PLACE TO THE ACCOMPANIMENT OF BEETHOVEN'S FIFTH SYMPHONY)
VO: Spic and Span power.
Spic and Span clean.

RHONDA/RIGHT GAS/CAR OF THE YEAR
30-second
VO: This is Rhonda, the happy owner of a Honda Civic CRX.
Rhonda loves her Honda.
It's fun to drive.
But the people who love Rhonda's Honda most,
are her mom and dad,
who live 120 miles away
in Fonda.
And now see a lot more of Rhonda.
SINGERS: Honda.

1841

Art Director	Earl Cavanah
Writer	Larry Cadman
Editor	Jay Gold
Director	Dick Loew
Client	Volvo
Agency Producer	Richard Berke/Scali, McCabe, Sloves, New York, NY
Prod'n Co Producer	Gomes Loew

1842

Art Directors	Lila Sternglass, Gail Nakasone
Writers	Bill Hamilton, Douglas Parker
Editor	Morty Schwartz
Director	Stew Birbrower
Client	New York State Lottery
Agency Producers	Lois Goldberg, Marilyn Cook/Rumrill Hoyt, New York, NY
Prod'n Co Producer	Chris Stefani

VOLTMAN/QUALITY/SPACE VEHICLE
30-second
ANNCR: At Volvo, we have a lot of dummies. Most of them spend their days crashing into walls. But one of these guys is too good for that. A thermal mannequin named Voltman. He's wired with sensors and he can sit in a Volvo . . . uumph . . . for months, feeding us data on everything from sun ray angles to the efficiency of our heated driver's seat. He's made the Volvo 760 incredibly comfortable. Talented guy. I just wish we could teach him to walk.
ANNCR (TO TECHNICIAN): How about giving me a hand?
TECHNICIAN: APPLAUDS.

ROBERT & PHYLLIS/FAMILY/WEONTA
30-second
ANNCR (VO): This is the story of a detective, a waitress, and how they joined the family of Lotto Millionaires.
ROBERT: I eat here every week.
PHYLLIS: And I wait on him.
ROBERT: When the Lotto jackpot was 6 million, I said, Phyllis, "Forget your tip, I'll split my ticket with you."
PHYLLIS: I picked 3 numbers . . . he picked 3.
ROBERT: And we hit . . .
3 million for her . . . 3 for me.
PHYLLIS: Who says nice guys finish last.
ANNCR (VO): Twice a week, you've got a chance to hit the jackpot and join the family of Lotto millionaires.
ROBERT: The usual.
PHYLLIS: Linguini, white clams sauce . . . ech!

1843

Art Director	Peggy Stinchfield
Director of Photography	Steve Horn
Writer	Claire Hassid
Editor	Frank Ciofreddi
Director	Steve Horn
Client	Denise Johnson
Agency Producer	Jean-Claude Kaufmann, D.F.S., New York, NY
Prod'n Co Producer	Carol Scott
Executive Creative Director	Eric Weber
Associate Creative Director	Ruth Fennessy

1844

Art Director	Tod Seisser
Writer	Jay Taub
Director	Henry Sandbank
Client	Citizen Watch
Agency Producer	Rachel Novak/Levine, Huntley, Schmidt & Beaver, New York, NY

AIRPORT/RETURNING HOME/VACANT LOT
30-second
WOMAN: I hope he's okay.
MAN: The detective says he's fine.
ANNCR (VO): Every year one million children are reported lost or missing. That's why Continental Insurance has a whole new policy against crime:
Victim's Assistance.
One call immediately starts the recovery process, providing the money and resources to help find your child. Only your Continental Agent has Victim's Assistance.
CHILD: Mommy, Mommy.
WOMAN & MAN: Danny, Danny.
ANNCR (VO): Call now or see your newspaper. And get the kind of help people need today.

BIG BEN/ATOMIC CLOCK/GERMANY
30-second
ANNCR: This is Big Ben. And this is the man who sets it. It's his job to keep this clock so accurate, you could set your watch by it. As millions of Londoners do.
The big question is, how does he check the accuracy of Big Ben? With a Citizen. The watch so accurate, you could set a clock by it. Citizen Watches. The smartest engineering ever strapped to a wrist.

Art Director Mark Yustein
Artist M3 Productions, Mark Harden
Writer Jim Weller
Editors Joe Leoni, Jay Gold
Director Steve Gluck
Client Ralston Purina—Meow Mix
Agency Producer Joanne Diglio/Della Femina, Travisano & Partners, Inc., New York, NY
Production Company Diana White/Grand Street Films
Music Shelton Leigh Palmer & Company

Art Director Rick Paynter
Director of Photography Joe Sedelmaier
Writers Lee Rosemond, Rich Middendorf
Editor Peggy DeLay
Director Joe Sedelmaier
Client First National State
Agency Producer Bozell & Jacobs, Inc., Union, NJ

UNIVERSAL FAVORITE/TYPES/TRIO
30-second
BEEP, BEEP, BEEP, BEEP
MEOW, MEOW, MEOW, MEOW
Only Meow Mix brand cat food has the three flavors
Cats love best . . .
And tastes so good, it's become a universal favorite.

MR. LEDTZ/YUNDT/FISH
30-second
SECRETARY (VO): Mr. Ledtz, it's Mr. Not in production.
MR. LEDTZ: Yes, Mr. Not.
MR. NOT (VO): Uh, we have a problem Mr. Ledtz.
MR. LEDTZ: A problem? Ohhhh, I hope it's not a big problem.
WORKER #1: Not a big problem.
WORKER #2: It's not a little problem.
WORKER #1: Not a litle problem. (PAUSE) Problem.
WORKER #2: Problem.
WORKER #1: Problem.
MR. LEDTZ: Uh, what's the problem? (PAUSE)
Uh ha, that is a problem.

1847

Art Directors	John Waldron, Elmer Yochum
Director of Photography	Joe Rivers
Writer	John Waldron
Editor	Peter Stassi
Director	George M. Cochran
Client	Stouffer Foods Corp
Production Company	Sharon DeSouza/George M. Cochran Film Productions Inc., New York, NY

1848

Art Director	Pat Burnham
Director of Photography	Mark Story
Writer	Bill Miller
Editor	Dan Polsfuss
Director	Mark Story
Client	Eric Block, WFLD-TV
Agency Producer	Judy Carter/Fallon McElligott Rice, Minneapolis, MN
Production Company	Nick Wollner/Pfeifer Story Piccolo
Music	John Penney

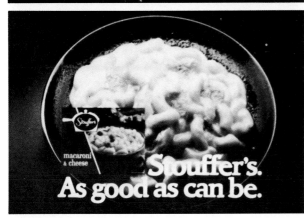

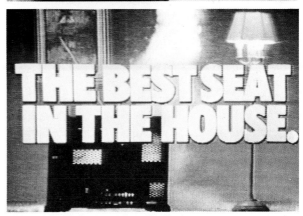

CHEESE/LOBSTER/SPICES
30-second
Along the southern tier of western New York, against the foothills of the Allegheny Mountains, dairymen create a unique, smooth-textured cheese with a brisk sharpness. Stouffer's calls it van Zwanenberg Cheddar. Rich and firm, this natural cheese is aged for almost a year until its cheddary goodness fairly snaps with flavor.

Now you know one of the reasons why Stouffer's Macaroni and Cheese is as good as can be.

ROCKET MAN/COLD BEER/FLUSH
30-second
SFX: National anthem at baseball game, as heard over a television . . . Retro-rockets being fired as chair descends.
DRYSDALE (anncr. at game . . . also over TV) Good afternoon White Sox fans and welcome to another fine day of baseball . . .
ANNCR: When you watch the White Sox on WFLD, you've got the best seat in the house.

1849

Art Director	Gary Gibson
Director of Photography	Leslie Smith
Writer	Rich Flora
Directors	Rich Flora, Gary Gibson
Client	Texas Rangers Baseball Club
Agency Producer	Greg Gibson/Richards Group, Dallas, TX
Production Company	Group Seven

1850

Art Directors	Jack Smart, Ray Krivacsy
Director of Photography	Steve Grass
Writers	Patrick Peduto, Stephen M. Vengrove
Editors	Barry Walter (Startmark), Morty Schwartz (Power Post)
Directors	Fred Petermann, David Farrow
Client	Toyota Motor Sales
Agency Producers	Jack Smart, Ray Krivacsy, DFS, New York, NY
Prod'n Co Producers	Sally Krauss, Chris Kitch
Executive VP/Executive Creative Director	Jack Keil

STEALING/NO HITTER/GREAT CATCHES
30-second
TOLLESON: It all started when I was just a kid. I wondered what stealing was like.
So I tried it. And I got good. But then it got to be a way of life—people expected me to steal.
Oh sure, I've been caught.
But it doesn't matter. I'll steal again.
ANNCR (VO): How 'bout those Rangers. Watch 'em take on the Tigers.

OZ/DRAGSTRIP/SINGING
30-second
LION: Make a right, make a left, make a right.
ANNCR (VO): You don't have to be a wizard (SFX: CRASH) to know that the Toyota Tercel is one of the surest ways . . .
ANNCR (VO): to get from one place to another with more room inside than any other sub-compact.
LION: (UNDER) I'm not afraid.
ANNCR (VO): The 1985 front-wheel drive. Tercel. Toyota's lowest priced car. It's got what it takes—to get you where . . . you want to go . . . even if it's just somewhere . . .
OZ (VO): (SFX: ECHO THUNDER) Over the rainbow!
SONG: Oh Oh Oh Oh What a Feeling . . . Toyota

1851

Art Director	Harvey Baron
Director of Photography	Henry Sandbank
Writer	Diane Rothschild
Editor	Morty Ashkinos
Director	Henry Sandbank
Client	CIGNA
Agency Producer	Cheryl Nelson/Doyle Dane Bernbach, New York, NY
Prod'n Co Producer	John Kamen

1852

Art Director	John Armistead
Directors of Photography	John Alcott, Melvin Sokolsky
Writer	Linda Chandler
Editor	Stuart Waks
Directors	Jim Weller, Melvin Sokolsky
Client	Psychiatric Institutes of America
Agency Producer	Shannon Silverman
Prod'n Co Producers	Carolyn Judd, Cami Taylor
Agency	Della Femina, Travisano, Los Angeles, CA

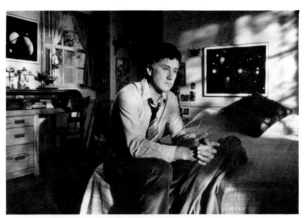

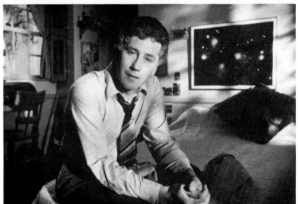

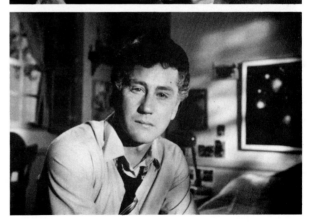

ROWBOAT REV./FREIGHTER/BEDROOM
30-second
SFX: BIRDS CHIRPING.
VO: It might be more interesting to see a polluted lake, angry protesters, and an endless stream of process servers . . .
SFX: SPLASH, SPLASH
VO: . . . but at CIGNA we have a highly sophisticated program to assess a corporation's treatment of toxic and hazardous materials . . . and to help reduce its exposure to environmental liability.
And if that's a concern to your company . . .
what could be more interesting than an exciting afternoon like this?
MUSIC
VO: CIGNA
No one does more to solve problems.

FATHER SON SUICIDE/DRUG ADDICT/WIFE JIM
30-second
FATHER: The second leading cause of death in teenagers is a disease called depression.
I know about it.
My son was hard to handle.
He kept saying he wished he were dead.
I thought he was going through a stage.
Last year, he killed himself.
I guess you could say he died of sadness.
VO: If someone is changing before your eyes, contact your doctor or call Psychiatric Institute.

1853

Art Director — Alan Frank
Designer — Richard Gianchi
Writer — David Hale
Editors — Arthur Williams, Billy Williams
Directors — Bob Regan, Jim Johnston
Agency Producers — Joanne McShane, Carmon Johnston/ Benton & Bowles, New York, NY
Production Companies — Dennis Harrington/Film Tree, Lauren Sann/Johnston Films

1854

Art Directors — David Deutsch, Rocco Campanelli
Writer — Donny Deutsch
Client — Pontiac Dealers Assn. NY/NJ/CT
Agency Producer — Bob Warner/David Deutsch Associates, New York, NY
Production Company — Bill Parrott/Parrott & People

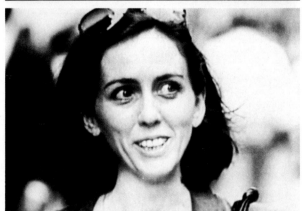

BETTER SCOPE 6 FP/CINDERELLA
30-second
WOMAN: What'll I do if he doesn't call? I could call . . . Maybe he lost my number . . .
We *had* a nice time. *I* had a nice time.
I shouldn't have said he looked like my father.
I'm getting hungry . . . I'm getting fat. Maybe he thought that I was fat. I know, I'll go on a diet. I don't have to go on a diet. He seemed like he was having fun. He liked me. I liked him.
Maybe he thought I had bad breath.
Bad breath? I'm so embarrassed.
I really wish I used my Scope. Why did I forget my Scope?
AVO: It's better to use Scope and be safe, than not use Scope and be sorry.
Cool, tingly Scope works. Better Scope than sorry.

DINNER/TEETH/ENGAGEMENT
30-second
ANNCR (VO): What was the last exciting thing that happened to you? I remember back in 1960, my husband took me out to dinner. I think that was the highlight.
We finally trained the cat how to use the litterbox.
Oh, I just bought a dirty book.
ANNCR (VO): Want real Excitement . . . Team Pontiac's got it. Introducing the all new Grand Am. Front Wheel Drive. Rack and Pinion Steering. A true Performance Coupe. For only $7,995, Team Pontiac's got your excitement.
(ALL DEALERS): We'll excite you.

1855

Art Director	Jim Scalfone
Designer	Jim Scalfone
Writer	Marvin Honig
Editor	Pierre Kahn
Director	Michael Ulick
Client	American Greetings
Agency Producer	Lora Nelson/Doyle Dane Bernbach, New York, NY

1856

Art Director	Terry Iles
Writer	Rick Davis
Editor	Norm Odell, Flashcut
Director	Ray Kelgren, Owl Films Ltd./Stock Footage: Filmsearch, New York
Client	The Ontario Pork Producers' Marketing Board
Agency Producer	Louise Blouin/Doyle Dane Bernbach Advertising, Ltd., Toronto, Canada
Prod'n Co Producer	Marion Bern
Stock Music	Rick Shurman, Air Supply Co.
V.O.	Ray Landry

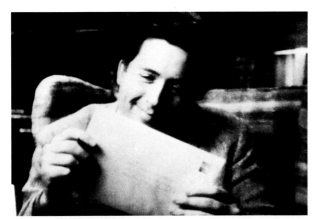

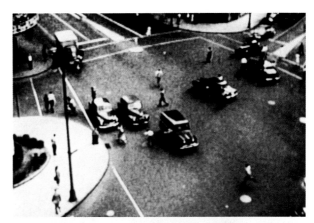

SLIDE/LIZARDS/DADDY
30-second
MUSIC THROUGHOUT
MAN: My Mother it doesn't seem that long ago, Mother was my whole world.
She loved everything I did even when I couldn't do it.
That's why the right card means so much.
Happy Mother's Day Mom.
VO: American Greetings always finds new ways to say love.
American Greetings.
The right card for that special person.

CITY TO CITY/NUTRITION AND FRIENDS/ VARIETY AND RESTAURANT
30-second
ANNCR (VO): It seems people all across the country are concerned with what they eat. From town to town, city to city, the concern spreads.
Don't be concerned.
Because certain cuts of pork are for people who want their meat lean.
Pork is flavourful. There are so many ways to prepare it. And important people know its value.
Excuse me, sir, what do you think of lean pork dishes?
OLDER MAN (O.C.): I love them.
ANNCR: Is that so?
Good for you, Pork.

1857

Art Director	Jim Clarke
Writer	Rich Wagman
Director	Jerry Andreozzi
Client	Airwick Industries/Michael J. Sheets, President
Agency Producer	Barbara Gans Russo/The Bloom Agency, New York, NY
Prop Design	Bob Zaharian, The Prop Shop

1858

Art Directors	Jim Consor, Robert Leung
Directors of Photography	Jack Churchill, Allan Green
Writer	Howard Reed
Editor	Larry Plastrik
Director	Richard Greenberg
Client	AMC Renault
Agency Producer	Nancy Axthelm/Grey Advertising
Production Company	Robert M. Greenberg/R. Greenberg Associates, Inc., New York, NY

STICK IT TO 'EM—GIANT FISH/GIANT SOCK
30-second
VO: Big odors lurk in small places
SONG: Stick it to 'em with stick ups.
VO: Big odors linger in small places.
SONG: Stick it to 'em with stick ups.
VO: Stick ups concentrated air fresheners solve big odor problems in small places
SONG: Stick ups

MAN CHANGES/LAND BRIDGE/CIRCLE
30-second
ANNCR (VO): If you are what you drive, imagine yourself as a Renault Encore.
Expressively sporty in outlook, stylishly European in design.
Renault Encore, from Europe's leading car maker. Built in America.
With independent suspension for amazing handling.
Electronic fuel injection for efficiency.
And true to your ingenuity, you are affordable. 5959.
Are you what you drive?
MAN: I can see myself in a Renault Encore.
SINGERS: The one to watch,
 the one to watch,
 the one to watch,
ANNCR (VO): Renault.

1859

Art Directors	Kathy McMahon, Beth Pritchett
Writers	Bonnie Berkowitz, Kathy McMahon, Linda Kaplan
Editor	Tony Siggia (First Edition)
Director	Ron Dexter (The Dexters)
Client	Eastman Kodak
Agency Producers	Sid Horn, Pamela Maythenyi, J. Walter Thompson, New York, NY
Prod'n Co Producer	Sharon Starr (The Dexters)
Music	Larry Hochman (Newfound Sound)/ Fred Thaler (Lucas McFaul)

1860

Art Directors	Howard Cohen, Frank Perry
Writers	Brian Sitts, Hal Friedman
Editors	Steve Schreiber, Gary Sharfin
Directors	David Ashwell, Geoffrey Mayo
Client	Burger King Corp.
Agency Producers	Gary Bass, Patricia Caruso/J. Walter Thompson, New York, NY
Production Companies	Geoffrey Mayo Films/Fairbanks Films

BABIES/TOYS/SUMMER CHILDREN'S OLYMPICS
30-second
VO: Hey there baby, listen to this, There's a new film for the Kodak disc!
SONG: THE NEW DISC FILM MAKES YOU LOOK SO FINE, MAKES YOU LOOK SO SHARP, REALLY LETS YOU SHINE.
YOU OUGHTTA BE IN PICTURES, THAT'S WHY I'M GONNA GET YOU WITH THE KODAK DISC.
VO: Hey baby, now Kodak's got a new baby, too! New Kodacolor VR Disc Film for better, clearer color pictures. Oh yeah!
SONG: YOU GOT SO MUCH STYLE
WITH THAT SILLY OL' SMILE
I'M GONNA GET YOU WITH THE KODAK DISC!

DAWN OF BURGERS/BABY/McFRYING
30-second
ANNCR: Burger King presents the Dawn of Burgers.
In the beginning it was hard to get a hamburger at all. So when you got one you made the most of it . . . by cooking over fire.
Today some have forsaken flame and turned to the practice of frying . . . forgetting the sizzling taste that only comes from flame broiling.
But at Burger King we say, when you have something as delicious as flame broiling . . . you stay with it for a long, long time.

1861

Art Director	Walt Maes
Writer	Bob Fugate
Editor	Marty Bernstein
Client	Miller Sharp's
Agency Producer	Sam Patrino, Leo Burnett Company, Chicago, IL
Prod'n Co Producer	Richard Shirley
Executive Producer	Sam Patrino

1862

Art Director	Theodore Plair
Director of Photography	Mike Berkofsky
Writer	Robert Phillips
Editor	(First Edition/CF) Howie Weisbrot
Director	Mike Berkofsky
Client	Eastman Kodak Company
Agency Producer	John Scarola, J. Walter Thompson, New York, NY
Production Company	Berkofsky/Barrett
Music	Elias Associates

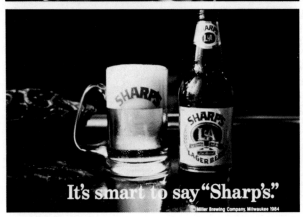

CHILI-REV./FISHIN'/GOLF

30-second
ROY: This Sharp's Beer tastes bold. It's kinda like that boiling bowl of beans I once had that woulda tanned a tough Texan's tonsils.
VO: That's easy for a Sharp's drinker to say.
Because Sharp's has half the alcohol and all the taste of an especially great beer.
MABEL: Enjoy your chili, Boys.
RAY: Ya, Sharp's is bold like the highgrade hardcore jalapenos I had hot enough to heat a whole home.
BOTH: Bold! (THEY TASTE). Hot!
VO: The great tasting beer that just happens to have half the alcohol. It's smart to say "Sharp's".

HELICOPTER/SKYSCRAPER

30-second
MUSIC
The first thing you learn as a professional photographer is, don't take chances.
It's just not worth it. I'm talking about the paper we have our pictures printed on . . . Kodak paper. The overwhelming choice of professional photographers.
We ask for it for our personal pictures too.
So, insist on Kodak paper, wherever you see this sign and don't take chances!

1863

Art Director	Stan Block
Writer	Frank DiGiacomo
Editor	Jay Gold
Director	Michael Ulick
Agency Producer	Peter Yahr/Della Femina, Travisano & Partners, Inc., New York, NY
Prod'n Co Producer	Liz Kramer

1864

Art Director	Steve Kasloff
Writers	Steve Kasloff, Kate Cox, Peter Frankfurt
Editor	Vito De Sario
Client	Ghostbusters
Agency	Coumbia Pictures Industries, Inc., Burbank, CA
Production Company	Randy Wicks, Paula Silver/R. Greenberg & Assoc.
Creative Director	Steve Kasloff

ANTIPASTO/LIGHT LUNCH/CHICKEN-FREEZER
30-second
My cousin, Tessie, makes such a great antipasto she rolls the salami up so tight, you could use it for a toothpick.
Another trick she taught me, use Ziploc storage bags.
You keep your marinated mushrooms in one bag, salami in another . . .
he he . . .
Not only does Ziploc protect the flavor of these little morsels, but your peppers won't smell like your onions.
Ziploc.
We've got the lock on food protection.
Oh gee, I hope it's enough.
Ah.

GHOSTS/RIGHT THERE/STOP THEM
30-second
NARR: Ghosts, they're real . . .
. . . they're real.
. . . and
. . . someone's got . . .
. . . to stop them. It's a job for professionals.
It's a job . . .
. . . for the "Ghostbusters."
DIAL: Hey, anybody see a ghost?"
NARR: They're the best . . .
. . . the brave . . .
. . . the only.
"Ghostbusters"
Coming to save the world this summer.

1865

Art Director	John Sapienza
Writer	Jim Kochevar
Client	Pabst Brewing Company
Agency Producer	Enid Katz/Young & Rubicam Chicago
Production Company	Bob Regan/Harmony Pictures
Agency	Young & Rubicam Chicago, IL

1866

Art Director	Tom Shortlidge
Writer	Mike Faems
Client	Pabst Brewing Company
Agency Producer	Patricia McNaney/Young & Rubicam Chicago
Production Company	Don Guy/Dennis, Guy & Hirsch
Agency	Young & Rubicam Chicago, IL

HELP/BEAR/WATERFALL
30-second
MAN: The great Northwest has some really beautiful canyons.
HIKERS: Help!!!
MAN: We have a great tasting beer too. Olympia. Trouble is a lot of strangers want to come up here and buy Olympia.
HIKERS: Help!!!
MAN: Sometimes, tramping around looking for Oly, they wander in the wrong place.
MAN: Hey, where are you from?
HIKERS: Delaware.
VO: Olympia and Olympia Light.
MAN: Stay where you are. We'll send the beer.

SURF GIRL/T-SHIRT GIRL
30-second
ANNCR: And now, some of the best beer bellies in America . . .
These beer bellies are brought to you by new Pabst Light beer . . . just 96 great-tasting calories that won't fill you up. Or out.

1867

Art Director	Bob Cox
Writer	Bob Cox
Editor	Morty Ashkinos
Director	Neil Tardio
Client	Xerox Corporation
Agency Producer	Carolyn Roughsedge/Needham Harper Worldwide, Inc., New York, NY
Production Company	Nan Simons/Neil Tardio Productions

1868

Art Director	Mike Eakin
Writer	Richard M. Coad
Client	Helme Tobacco Company
Agency Producer	Lee Lunardi/Young & Rubicam Chicago
Production Company	Don Guy/Dennis, Guy & Hirsch
Agency	Young & Rubicam Chicago, IL

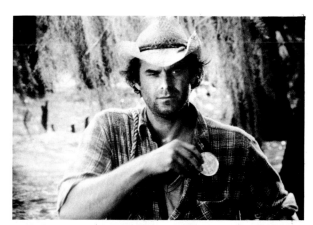

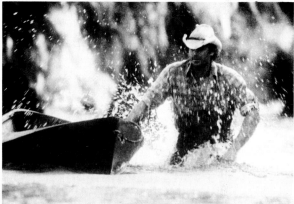

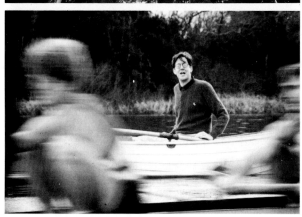

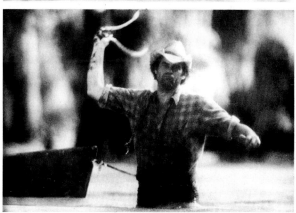

ROWING/GREENFIELD VILLAGE/RACE CAR
60-second
MAN IN BOAT: You know, the ancient Egyptians found these to be invaluable objects for propelling a boat through water. Course, if you only have one, you just go around in circles.
(SFX: TWO CREWS OF EIGHT PASS ED HERRMANN IN ROWBOAT.)
In a modern racing shell, each crew member is trained to work perfectly with his teammates. Imagine how much more productive you could be if all your office machines could pull together like that.
Well, Xerox has found a way to make that happen. It's called Team Xerox. They've got work stations working with computers or laser printers.
It boggles the mind. Of course it helps to have people with the knowledge and experience to keep it all going.
Xerox has that too.

WATER MOCCASIN/QUICKSAND
30-second
SFX: BIRD CRIES AND STRANGE ECHOES.
MUSIC STARTS.
VO: Silver Creek moist wintergreen tobacco.
It's cut a little rougher.

1869

Art Director	Bob Cox
Writer	Bob Cox
Editor	Morty Ashkinos
Director	Dick James
Client	Tri-Honda Auto Dealers Association
Agency Producer	Carolyn Roughsedge/Needham Harper Worldwide, Inc., New York, NY
Production Company	Gregg Stern/Big Sky Photo Ranch

1870

Art Director	Tony De Gregorio
Writer	Lee Garfinkel
Editor	David Dee
Directors	Rick Levine, Joe Sedelmaier
Client	Subaru
Agency Producer	Bob Nelson/Levine, Huntley, Schmidt & Beaver, New York, NY

FERRARI/CAR OF THE YEAR/BREAD BOX
30-second
FADE UP. MUSIC THROUGHOUT
ANNCR: Recently, the editors of Road and Track Magazine performed a slalom test on the Ferrari 308GTBi. Then they tested four other cars they found to be faster.
The Honda Civic CRX.
The Honda Civic Hatchback.
The Honda Civic Four Door.
And the Honda Civic Wagon.
And just think, for the price of the Ferrari, you could own all these Hondas, and then some.
MUSICAL SIGNATURE.

SCHMINSON/WEDDING/FOOTBALL
30-second
CHAIRMAN: Pruit, I want Schminson in that meeting, snow or no snow.
PRUIT: Noonan, I want Schminson in that meeting, snow or no snow.
NOONAN: Boulder, I want Schminson in that meeting, snow or no snow.
BOULDER: Beedlemyer . . .
(BEEDLEMYER PICKS UP SCHMINSON)
ANNCR: You know who to call when you have to get a package there. But what do you do when you have to get a person there, no matter how crazy the weather. You drive a Subaru. Or you may get stuck with something else.
Subaru. Inexpensive. And built to stay that way.
SUPER: SUBARU. INEXPENSIVE. AND BUILT TO STAY THAT WAY.

1871

Art Director	Paul Rubinstein
Writer	Mike Pitts
Editors	Michael Charles, Frank Cioffredi
Directors	Dick Miller, Derek Van Lint
Client	Duracell
Agency Producers	Mootsy Elliot, Sue Birbeck/Ogilvy & Mather Advertising, New York, NY
Creative Director	Jay Schulberg

1872

Art Director	Martin Stevens
Writer	Rita Grisman
Editor	Morty Schwartz
Director	Sarah Moon
Client	Revlon, New York, NY
Agency Producers	Betsy Simson (No.2), Kate Sinclair-Perry (No. 3)
Production Company	Bill Hoare, The Film Consortium

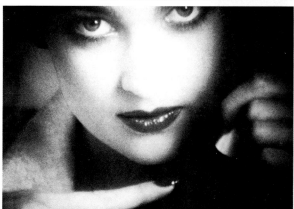

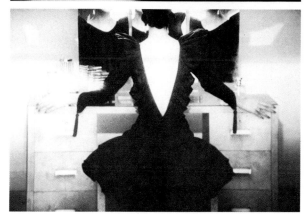

POSTMAN/TRESTLE CAR/DOG
30-second
MECHANICAL SFX
ANNCR (VO): One reason why Duracell batteries deliver such long
lasting power is because we're always improving them.
In fact, today's Duracell batteries will last up to 20% longer than the
ones we made just three years ago.
And we'll keep on improving them. Through rain . . . snow . . . sleet
. . . dead of night . . .
Duracell, the coppertop battery. When it comes to making them last
longer . . .
SFX: TONES, SLAM!
ANNCR (VO): we never stop.

WE'VE GOT YOUR COLOR NO. II/NO. III
30-second
For long skirts
Short skirts
Satin P.J.'s
We've Got Your Color

For Wide cuffs
Straight legs
Grey felt hat
We've Got Your Color

For bare back
Jet jewels
And basic black
We've Got Your Color

1873

Art Director	Tom Gow
Writers	Tom Gow, John Claxton, Bruce Duffey
Client	Anheuser-Busch, Inc., Natural Light
Agency	D'Arcy MacManus Masius/St. Louis, MO
Production Company	Partners Productions

1874

Art Directors	Bob Needleman, Mike Ciranni
Writers	Jim Murphy, Elaine McCormick
Editors	H. Lazarua, Gary Wachter
Client	Dave Shaver, AT&T
Agency Producers	Patti McGuire, Gaston Braun, N.W. Ayer, Inc., New York, NY
Production Companies	Steve Horn/Steve Horn Inc., Steve Steigman/Steve Steigman Productions, Brian Gibson/Lofaro Productions

CHICKEN MONICA/RIBS WITH EMIL'S SAUCE/PIZZA
30-second
CHARACTER: My favorite chicken recipe is the delectable Chicken Monica. This is chicken raised to true art.
And here's how we start.
(TO PHONE): Hello, Monica?
Don't hang up.
I'll never do that again . . . how 'bout dinner? Your place . . . I'll bring the beer . . . Natural Light, the beer with the taste for food.
You know, the blue on the label matches your eyes.
AVO: Yeah, all natural, less filling. It's Natural Light from Anheuser-Busch.
CHARACTER: And the gold on the label matches your hair.

IMPORTANT PEOPLE/BEST VALUE/TAKE FOR GRANTED
30-second
MUSIC UNDER.
AIDE: It's the President.
ANNCR: At AT&T, we never know how important any call will be . . .
INTERCOM: Mr. Brian, It's the chairman.
ANNCR: . . . that's why every product AT&T makes, every business system . . .
MAID: It's MGM.
ANNCR: every inch in the millions of miles of our long distance network . . .
PRIEST: It's Rome.
ANNCR: . . . and every single technical innovation . . .
. . . is made to handle every call . . .
FATHER: It's Bobby.

1875

Art Directors	Roy Grace, Mark Hughes
Designers	Roy Grace, Mark Hughes
Directors of Photography	Henry Sandbank, Fred Moore, Frank Tidy
Writers	Tom Yobbagy, Neal Gomberg
Editor	Pierre Kahn
Directors	Henry Sandbank, Michael Ulick, Ross Cramer
Client	Volkswagen
Agency Producers	Jim de Barros, Lee Weiss/Doyle Dane Bernbach, New York, NY
Production Company	Michael Ulick/Sandbank Films
Voice	Roy Scheider

1876

Art Director	Jack Mariucci
Writers	Barry Greenspon, Jeff Linder
Editors	Ciro, Andy Fields
Directors	Andy Sugden, Andy Fields
Client	Michelin
Agency Producers	Mary Ellen Pirozolli, Jill Gordon/Doyle Dane Bernbach, New York, NY
Production Company	Bob Cardonna/Fields Wall

TWO CAR GARAGE/FALLING PARTS/VACATION
30-second
(MUSIC THROUGHOUT)
ANNCR (VO): Mrs. Smith wanted a small, new car that's built to last.
Mr. Smith wanted a big new car with room for five and lots of suitcases and German engineering.
But the Smiths had less than $7,000.
So, how did they get all they wanted?
They bought a new Volkswagen Golf.
Buying a Volkswagen has always been smart.
But buying a new Golf is simply brilliant.
Golf. It's not a car. It's a Volkswagen.

SNOW MONSTER/20,000 MILES/TAX-FREE
30-second
ANNCR (VO): You never know when the weather's going to turn on you, do you?
That's why Michelin developed the XA4 all-season tire.
The XA4's as good in the snow
as a snow tire,
as good out of the snow
as a great handling highway tire.
And with proper care, its unique all-weather tread lasts up to 60,000 miles.
Michelin. Because so much is riding on your tires.

1877

Art Director	Matthew Gleason
Artist	R&B efx
Director of Photography	Victor Haboush
Writer	John Kutch
Editor	Jerry Weldon/The Reel Thing
Director	Victor Haboush
Client	U.S. Telephone, Inc.
Agency Producer	Cindy Weddle/Rives Smith Baldwin Carlberg + Y&R Houston, TX
Agency Creative Director	Chuck Carlberg

1878

Art Director	Rich Silverstein
Director of Photography	Hiro Narita
Writers	Andy Berlin, Jeff Goodby
Editor	Film Surgeons
Director	Jon Francis
Client	WABC Talk Radio, NY
Production Company	Jocelyn Shorten/Goodby, Berlin & Silverstein, San Francisco, CA

THE TELEFFICIENCY EXPERTS/ANYWHERE/ SAVES BUSINESS 40%

30-second
VO: Excuse me Ma Bell.
MA: Yes?
VO: I'm with U.S. TEL. We're the long distance Teleffisiency Experts.
MA: Aren't you a cutie!
VO: Oh thank you Ma. Uh. . . . Ma. . . . Teleffisiency means saving business up to 40% on long distance. . . .
MA: Huh? I bought it all until you said 40%.
You're history!
You wanna see Teleffisiency? Here we go!
SFX: (SWITCHBOARD ERUPTS, DETONATES)
VO: U.S. Tel. Talk with us.
MA: That means no more milk for the school tomorrow!
HA-HA-HA-HA-HAAAAAAA!

ALLIGATORS/ANTS

30-second
ALAN: This is Alan Colmes WABC Talk Radio, with real sewer foreman, Dan Capola. Dan, once and for all, are there alligators down here?
DAN: No Alan, there are not.
ALAN: You know, maybe it's like the Loch Ness Monster, they're hiding.
DAN: There are no alligators, Alan.
ALAN: Dan, you've never seen a germ, right?
DAN: Yeah . . .
ALAN: But you know they're down there.
ANNCR OVER CARDS: Alan B. Colmes, mornings
It's news, traffic, weather, sports and the real truth about New York.
DAN: Say there's alligators. What do they eat?
ALAN: Have you lost any men, Dan?

1879

Art Director	Jim Scalfone
Designer	Jim Scalfone
Writer	Marvin Honig
Editor	Pierre Kahn
Director	Michael Ulick
Client	American Greetings
Agency Producer	Lora Nelson/Doyle Dane Bernbach, New York, NY

1880

Art Director	Rich Silverstein
Director of Photography	Keith Mason
Writers	Andy Berlin, Jeff Goodby
Editor	Tom Bullock
Director	Jon Francis
Client	Oakland Invaders
Agency Producer	Debbie King/Goodby, Berlin & Silverstein, San Francisco, CA
Production Company	Sandra Marshall/Bass/Francis

EINSTEIN/SLIDE/PEACE
30-second
VO: Albert Einstein,
 Dwight Eisenhower,
 Madam Curie,
 Lou Gehrig,
 Susan B. Anthony,
 Thomas Edison
all started out in life with the love of someone very special.
May 13th is Mothers Day.
American Greetings.

TELEPHONE ROOM/POEM/OPERATOR
30-second
ANNCR: When you call 638-7800 . . .
PLAYER: Oakland Invaders.
ANNCR: You get action.
PLAYER: Yes, sir. We're gonna kick some butt.
ANNCR: You get courtesy.
PLAYER: Would it help if I broke your arm, sir?
ANNCR: And best of all, you get lots of Invaders season tickets.
PLAYER: That check any good?
ANNCR: So call the Nicest Bunch of Guys in the World.
PLAYER: Yeah, we're on KGO Radio Mom. This is big time, you know.
ANNCR: You'll see just how nice we can really be.
PLAYER: You got a real nice voice, lady. You know that?
SFX.

1881

Art Director	Bill Hoo
Writer	Charles McAleer
Director	Lew Gifford
Client	Health Stop
Agency Producer	Debi Peralstein/Clarke GowardFitts, Boston, MA
Production Company	Kim & Gifford

1882

Art Directors	Nick Vitale, Beth Petrie
Writer	Phil Slott
Editor	Steve Schreiber
Director	Bill Hudson
Client	Gillette Company
Agency Producer	Arnie Blum/BBDO, New York, NY
Production Company	Bill Hudson Films

FOOTBALL/DOG BITE/TANGO
30-second
ANNCR: Accidents can happen just like that Now, there's a place that can fix them. Just like that. Health Stop. Your minor disaster area.

ACTOR/COMEDIENNE
30-second
ACTOR: There are three "Nevers" in Hollywood.
Never pick up the phone on the first ring.
Never Say "I'll be right over".
And never, I don't care how much you want the part . . .
Never let 'em see you sweat.
AVO: That's what Dry Idea's all about.
Less water. More wetness protection.
It keeps you drier than the leading Roll-on.
ACTOR: It's ok to be anxious . . .
As long as you don't look anxious.
AVO: Dry Idea
Never let them see you sweat.

1884

Art Director	Audrey Satterwhite
Designer	Audrey Satterwhite
Editor	Audrey Satterwhite
Director	Audrey Satterwhite
Client	David Sonenberg
Agency	White Ink, Inc., New York, NY
Still Photography	Patrice Casanova

1885

Art Directors	Roger Mosconi, Susan Barron
Writer	Paul Cappelli
Editor	Dennis Hayes
Director	Howard Guard
Client	General Electric
Agency Producer	Jeff Fischgrund/BBDO, New York, NY
Production Company	Howard Guard Productions

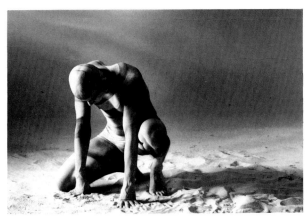

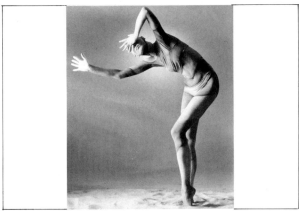

I AM SIAM
30-second
(WHISPERING) I am Siam
 I am Siam
 I am Siam
INSTRUMENTAL
(WHISPERING) I am Siam
 I am Siam
 I am Siam
 I can see you now
 I can hear you now
 I can feel you now
 Come on and talk to me
(WHISPERING) I am Siam
 I am Siam
 I am Siam

THE POWER OF MUSIC
60-second
SFX: METEOR SHOWERS
MUSIC THROUGHOUT
AVO: In the third millennium, four adventurers came upon a city imprisoned in silence.
SFX: MUSIC UP
 EXPLODING CRYSTALS
AVO: The Power of Music. No one lets you experience it like General Electric.

1886

Art Directors	Randy Spear, Joey Wofford
Writers	Lila Alm, Dianna Thorington
Director	George Watkins
Client	Atlanta Advertising Club
Agency Producers	Polly Hathorn, Casey Giarratano/
	Burton-Campbell, Inc., Atlanta, GA
Production Company	Crawford Post Productions

1887

Art Director	Ron Berti
Editor	David Buder
Director	Robert F. Quartly
Client	Corey Hart
Production Company	Champagne Pictures, Toronto,
	Canada

I WANT MY ADDY
5-minute
Nearly 120 Atlanta Copywriters, Art Directors and Producers romped
their way through this MTV look-a-like that became the country's first
video call for entries. An awesome sight.

COREY HART/SUNGLASSES AT NIGHT

Art Director Colin Priestley
Director of Photography Gord Oglan
Writer Steve Ridley
Editor Norm Odell
Director Gord Oglan
Client The Ontario Ministry of the Attorney General
Agency Producer Camp Associates Advertising Limited, Toronto, Canada
Prod'n Co Producer Candace Conacher

Art Director Peter Begley
Director of Photography Carl Norr
Writer Deanna Cohen
Editor Ciro DeNettis Studio
Director Jack Piccolo
Client The Greater New York Blood Program
Agency Producer Lorraine Schaffer/Doyle Dane Bernbach, New York, NY
Production Company Kerri King/Pfeifer, Story, Piccolo, Guliner
Music Fred Weinberger

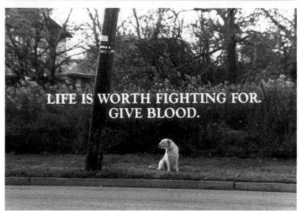

LIFE IS WORTH FIGHTING FOR.
GIVE BLOOD.

FLASHBACK
30-second
SFX: BACKGROUND BAR NOISES—GLASSES CLINKING, PEOPLE LAUGHING
SFX: POST-ACCIDENT SOUNDS. VOICES OF SMALL CROWD GATHERING.
AVO: This man has just created a memory that will last a lifetime.
Not just in his own mind . . .
. . . but in the minds of the family and friends . . .
. . . of the boy he just killed.
SFX: TIRES SQUEALING
AVO: Drinking and driving . . .
SFX: TIRES SQUEALING . . . SOUND OF IMPACT.
AVO: . . . It's a crime.
A message from the Attorney General for Ontario

TOMMY
30-second
(MUSIC THROUGHOUT)
ANNCR (VO): Tommy Garbett could tell you the batting average of any Yankee, for any year.
He was the fastest pizza eater in the whole school.
And when he got on his bike, nobody could catch up with him, except, Rusty his dog
Then, things changed.
Tommy didn't talk much, or eat much, or ride his bike.
Something had caught up with him.
It was Leukemia.
Tommy is fighting for his life.
He needs you to join the fight, by giving blood.
It's true, he won't know who you are, but you will.

1890

Art Director Mike Moser
Writer Brian O'Neill
Director Mike Cuesta
Client California Broadcasters Against Drunk Drivers
Agency Producer Richard O'Neill
Production Company Erwin Kramer/Griner/Cuesta & Associates, New York, NY

1891

Art Director Gary Greenberg
Designer Gary Greenberg
Director of Photography Ed Buffman
Writer Peter Seronick
Editor Century III
Director Ed Buffman
Client National Head Injury Foundation
Agency Producer Peter Seronick/Rossin Greenberg Seronick & Hill, Inc., Boston, MA
Production Company Peg Finucan Century III Boston

THE PARTY'S OVER

60-second
POLICE SIRENS. MAN IS LAUGHING.
OFFICER: Walk. Put you hands on the car.
MAN: (STILL LAUGHING) Is this really necessary? Ouch!
OFFICER: Let's go. Okay, open up.
DESK OFFICER: Empty his pockets. Any jewelry?
OFFICER: He's got his wedding ring.
OFFICER # 2: Look at the camera.
TOUGH PUNK: Hey, don't touch my hat!
ANNCR (VO): Last year, in California, 350 thousand people were thrown in jail for drunk driving. This year the police are cracking down even harder. So, if you're caught driving drunk, rest assured . . .
SFX: CELL DOOR SLAMS
ANNCR (VO): You're going to jail.

NATIONAL HEAD INJURY FOUNDATION

30-second
VO: Suffer a head injury and you might not remember which one of these you put on first . . . or which one of these is for your teeth.
Severe head injury turns everyday objects into everyday problems for thousands of victims every year . . .
It causes long-lasting, mental, physical or emotional handicaps . . .
Victims survive the injury but find it hard surviving day-to-day.
Now . . . there's help and opportunity. The National Head Injury Foundation
. . . Because life after head injury is never the same.

1892

Art Director Dennis Mramor
Writer Tom Amico
Client United Way Services
Agency Producer Linda Polot/Meldrum and Fewsmith,
 Inc., Cleveland, OH
Production Company Jim Riccardi/UAB Productions

1893

Art Director Wally Arevalo, Roger Rowe, Richard
 Croland
Director of Photography Michael Schrom
Writers Ed Smith, Mary Warner
Editor Mel Cohen
Director Michael Schrom
Client American Red Cross
Agency Producers Warren Aldoretta, Marianne
 Cherchevsky/J. Walter Thompson,
 New York, NY
Production Company Erwin Kramer (Griner/Cuesta &
 Associates)

I NEED
30-second
(SFX: MUFFLED CROSS-TALKING, KITCHEN SOUNDS)
MOTHER: Anybody need anything?
BOY: More gravy.
DAD: Lots more.
MOTHER: I need to go out of town next week, so oh (AFTER
THOUGHT) I'll need a new dress . . . (UNDER) remind me . . .
Another drink?
GIRL: I need some more bread.
DAD: Ahh, I needed that.
GIRL: I really need new shoes, Ma.
MOTHER: You need 'em, you get 'em. (HAPPILY) Who needs
dessert? (CHANGE TO STERN) Harold, you don't need . . .
DAD: Just a taste.

PICK UP THE TAB
30-second
VO: For the price of a pizza and a soft drink, you can feed an African
child for one month.
For the price of a family dinner you can feed an African family for
one month.
For the price of a luncheon for business executives, you can feed an
African village for one month.
It's a small price to pay.
So give to the African Famine Relief Campaign.
At your local American Red Cross Chapter.

1894

Art Director Ivan Liberman
Writer Suellen Gelman
Editor Barry Walter/Startmark
Client American Cancer Society
Agency Producer Joe Davidoff/D'Arcy MacManus
Masius, New York, NY

1895

Art Director Jac Coverdale
Writer Jerry Fury
Client Wy Spano
Agency Producer Jac Coverdale/Clarity Coverdale,
Minneapolis, MN
Production Company Gene Borman/Borman & Associates

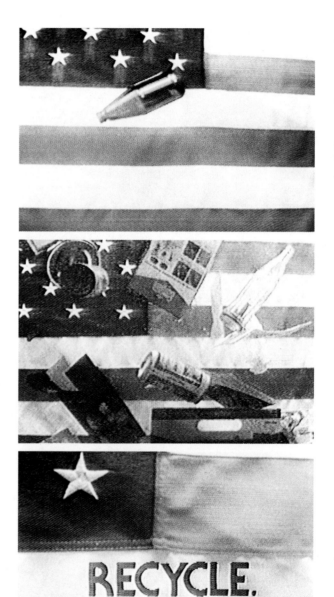

MAMMOGRPAHY
30-second
TAMMY GRIMES (VO): For too long most curable breast cancers could not be found by the only means available, the human hand. Then mammography achieved a great breakthrough by detecting lumps smaller than fingers can feel. Now there's hope this leading cause of cancer deaths will no longer be a threat. If you're over 40 ask your doctor about a mammogram, over 50 have one each year, and send for our free leaflet. Learn the art of self preservation, The American Cancer Society.

GARBAGE
60-second
(PATRIOTIC MUSIC UNDER THROUGHOUT)
ANNCR: This is a message about a favorite American pastime. Creating garbage.
In fact, even though we make up only 5% of the world's population, American's produce 50% of the world's garbage. The effects of this habit are beginning to pile up.
Fact is, we're running out of places to put our garbage. As our present landfill sites fill up, we have to find new ones.
You can help reduce the number of landfill sites needed by composting leaves and grass. Recycling your bottles, cans and newspapers. Start today.
You've got a lot to gain. And only your garbage to lose. Contact your county government for other good ideas on how to beat the garbage problem.

1896

Art Director	Dan Scarlotta
Director of Photography	Rudy Ward
Writer	Ed Korenstein
Director	Rudy Ward
Client	Governor's Safety Council
Agency Producer	Dan Scarlotta/Pringle Dixon Pringle, Atlanta, GA
Production Company	Rudy Ward/Rudy Ward Productions

1897

Art Director	Frank Sobocienski
Writer	Maryann Barone
Editor	Bob Flood
Director	Frank Sobocienski
Client	Citizens Energy
Agency Producer	Gary Streiner, Will McDonald/Hill, Holliday, Connors, Cosmopulos, Inc., Boston, MA
Production Company	Brian Heffron

MIXED DRINKS
30-second
VO: This is what you get when you mix vodka with orange juice.
And this is what you get when you mix gin and tonic.
Scotch and soda.
But this is what you get when you mix drinking and driving.
SFX: BLAST SOUND.
SFX: BLAST SOUND CONT.
VO: Don't jeopardize your life or the lives of others.
Don't drink and drive.
Because drunk driving is just murder on our roads.

WINTER COATS
30-second
(SFX: AMBIENT SOUND OF ACTIONS)
JOE KENNEDY (VO): There's nothing like a winter coat on a cold day.
Sometimes two are even better. Some of us can afford to go to Florida
to get warm.
Others have to go to the kitchen.
If you need help keeping warm this winter—
JOE KENNEDY (ON CAMERA:) Write to me, Joe Kennedy, care of
Citizen's Energy.
JK (VOICE OVER): We'll show you how to get the help you deserve.
No one should be left out in the cold.

1898

Art Director	John Armistead
Director of Photography	John Alcott
Writer	Linda Chandler
Editor	Stuart Waks
Director	Jim Weller
Client	Psychiatric Institutes of America
Agency Producer	Shannon Silverman
Prod'n Co Producer	Carolyn Judd
Agency	Della Femina, Travisano, Los Angeles, CA

1899

Art Director	Wally Arevalo
Director of Photography	Rick Levine
Writers	Ed Smith, Gary Gusick
Editor	Mel Cohen
Director	Rick Levine
Client	American Red Cross
Agency Producer	Warren Aldoretta/J. Walter Thompson, New York, NY
Production Company	Cami Taylor/Rick Levine Productions
Music/Effects	Tabby Andriello

DRUG ADDICT
30-second
VO: He's having problems in school.
He fights with his family.
He hangs out with a different crowd.
He lies.
He's destructive.
He's erratic.
People think he's a problem kid.
Unfortunately he's an addict.
ANNCR: Help him get a clean start.
Call 800-COCAINE.
The hotline that's answered 650,000 calls since 1983.

SWIMMING POOL
30-second
VO: Did you know there's a Red Cross Chapter in your area that offers all kinds of different health and safety classes?
Such as first aid, water safety and life saving CPR.
Last year millions of people took these classes.
Unfortunately, millions of others didn't.

1900

Art Director	Joel Levinson
Writer	Gary Barnum
Editor	Mark Polycon
Client	Major General Jack Bradshaw/US Army
Agency Producer	Jim McMenemy, N.W. Ayer, Inc., New York, NY
Production Company	Lear Levin/Lear Levin Productions

1901

Art Director	Chet Moss
Director of Photography	Dick Miller
Writer	Lew Alpern
Editor	Arthur Williams
Director	Dick Miller
Agency Producer	Charlotte Rosenblatt/Benton & Bowles, Inc., New York, NY
Prod'n Co Producers	Steve Rothfeld, Miller Mason

9 AM REV.
30-second
MUSIC UP
SINGERS: You're reaching deep inside you
For things you've never known
It's been tough, rough going
But you haven't gone alone
ANNCR: We do more before nine a.m. than most people do all day.
SINGERS: Be All That You Can Be.
SOLDIERS: Hey, First Sergeant, good morning.
SINGERS: Find your future in the Army.

STORY/FP
60-second
MAN: The ver ve ver. The very li ta tel little
AVO: This is what it's like to be functionally illiterate.
(SFX): MAN CONTINUES READING IN BACKGROUND
AVO: Unable to read a job application, a street sign or a bedtime story to a child. There are twenty seven million Americans like this. Twenty seven million. We could help that. But we need your help. Call the Coalition for Literacy at this number and volunteer. The only degree you need is a degree of caring.
MAN: I think I ca. I think I can. I think I can.

1902

Art Director	Lou DiJoseph
Writer	Jim Murphy
Editor	Jerry Bender
Client	Major General Jack Bradshaw/US Army
Agency Producer	Jim McMenemy, N.W., Ayer, Inc., New York, NY
Production Company	Neil Tardio/Lovinger, Tardio, Melsky

1904

Art Director	Doug Lew
Writer	Terry Bremer
Editor	Bob Wickland
Director	Steve Griak
Client	Minneapolis Institute of Arts
Agency Producer	Chuck Ruhr Advertising, Minneapolis, MN
Prod'n Co Producer	Mike Monten

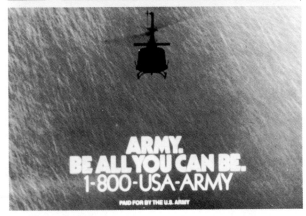

VISIBILITY POOR
30-second
MUSIC UP.
SOLDIER: This is Army 2-1-2 seven miles northwest, low fuel, heavy weather.
CONTROLLER: Army 2-1-2, radar contact turn right heading 1-5-0.
ANNCR: With a fog bound helicopter hanging on your every word it doesn't matter whether you're a man or a woman only that you're good.
CONTROLLER: Over landing threshold.
SINGERS: Be All That You Can Be.
SOLDIER: Thanks for your help.
CONTROLLER: Roger.
SINGERS: You Can Do It in the Army.

TONY BOUZA/LOU HOLTZ/VERNE GAGNE
30-second
TONY BOUZA: I want you to know about a very important bust here in Minneapolis. There have only been two others like it in the world. One back East. And one in Switzerland.
You might say, it began with a French Connection. A real master—Jean-Baptiste Lemoyne. The guy was an artist.
ANNCR: The Bust of Louis XV. Of soft-paste porcelain. Just one of Minnesota's new treasures at the Minneapolis Institute of Arts.
TONY BOUZA: It's a crime if you don't go see it.

1905

Art Directors	Warren Margulies, Pete Sturdy
Director of Photography	Richard Aldridge
Writers	Lisa Duke, Benton Sen, Warren Margulies
Directors	Ed Levien, Warren Margulies
Client	United Way, Forsyth Co., NC
Agency Producer	Long, Haymes & Carr, Inc., Winston-Salem, NC
Production Company	Bridge Productions
Audio Production	Tabby Andriello, Inc.

1906

Art Director	Dennis Mramor
Writer	Tom Amico
Client	United Way Services
Agency Producer	Linda Polot/Meldrum and Fewsmith, Cleveland, OH
Production Company	Jim Riccardi/UAB Productions

ATHLETE/PHONE CALL/STEALING
30-second
VO: (THE ATHLETE IS SPEAKING) Some people think there's no limit to what I can do.
Maybe I *am* one of the lucky ones . . .
So every week, I give a little to the United Way . . . to support groups for the physically and mentally handicapped . . .
Like the Handicapped Childrens Services and the Mental Health Association.
It costs about the same as my morning orange juice . . .
And I know from experience it's money well spent.
ANNCR: The United Way.
Give us a little, we'll give you a lot.

I NEED/RAPE/SHUT-IN
30-second
(SFX: MUFFLED CROSS-TALKING, KITCHEN SOUNDS)
MOTHER: Anybody need anything?
BOY: More gravy.
DAD: Lots more.
MOTHER: I need to go out of town next week, so oh (AFTER THOUGHT) I'll need a new dress . . . (UNDER) remind me . . .
Another drink?
GIRL: I need some more bread.
DAD: Ahh, I needed that.
GIRL: I really need new shoes, Ma.
MOTHER: You need 'em, you get 'em.
(HAPPILY) Who needs dessert?
(CHANGE TO STERN) Harold, *you* don't need . . .
DAD: Just a taste.

1907

Art Director Shelley McCarl
Writers Henry Levkoff, John Emerson
Editor Henry Levkoff
Director Henry Levkoff
Client Charleston Automobile Dealers Association For M.A.D.D.
Agency Cook, Ruef & Associates, Columbia, SC
Production Company Media Associates

1908

Art Directors Tim Boxell, Kirk Henderson, Bill Groshelle
Director Drew Takahashi
Client Warner Amex Satellite Entertainment Company
Agency Producer Marcy Brafman
Production Company Jane Antee, Jana Canellos, Susan Tatsuno/Colossal Pictures, San Francisco, CA
Computer Graphics Pacific Data Images

YOUTH/PARTY
30-second
DRIVING AFTER DRINKING KILLS.
DON'T BE A KILLER.
SUPPORT MOTHERS AGAINST DRUNK DRIVERS.

M-ART HISTORY/L-M-ENTS/M-PATTERNS
10-second
A ten-second tribute to art styles that traces the evolution of creative expression; from the earliest cave paintings through the glory of Michelangelo, the sensitivity of Van Gogh—to what could be defined as art of the present—a winking MTV button!

1909

Art Directors	David Wells, Linda Berger
Designers	David Wells, Linda Berger
Client	KIRO-TV
Producers	Sharon Howard, Regina Brittle
Production Company	KIRO-TV, Seattle, WA
Computer Animation/Art	Atronix, NW

1910

Art Director	Paul Souza
Animator	Paul Souza
Editor	Benjamin Bergery
Client	WGBH Educational Foundation, Boston, MA
Producer	Ledith P. Lugo
Theme Music	Gene Mackles
Animation Camera	Edward T. Joyce/Frame Shop

OLYMPIC GOLD: LOCAL HEROES/TALKING ABOUT TOUCHING
30-second
Good evening and welcome to *Olympic Gold: Local Heroes*.
I'm Steve Raible.
You know, I love watching the Olympic Games. It's a great chance to wave the flag, feel proud, and maybe even shed a tear or two. Corny, you say? Perhaps. But why are 2½ *billion* of us going to be glued to our TV sets in a few weeks, with our hearts racing, goosebumps rising, and smiles on our faces? Perhaps it's because we can live vicariously through our athlete's performances. Maybe we're thinking, 'Hey! They aren't *professionals*. Maybe if I *really* tried, I could win a medal!' It gives us all a chance to dream . . . well, that Olympic dream always begins with work. The work paid off for Washington athletes in the Winter Olympics. We brought four medals home. And it looks just as promising for the Summer games.

HEATWAVE
30-second
THEME MUSIC
ANNCR (VO): Tonight, a special with Paquito D'Rivera.
PERFORMANCE MUSIC

Art Director Neil Sandstad
Writer Neil Sandstad
Animator/Artist Christopher Kogler
Director or Photography John Allison
Original Music Elias Brothers
Editor Bill Stephen
Director Jack Sameth
Client WNET/Thirteen

Art Director/Agency Rob Hugel
Art Directors/Production Company Bruce Dorn, Randy Roberts
Animator/Artists Steve Cooney, Con Pederson
Director of Photography Bruce Dorn
Editors Rick Ross, Phil Gesert, Darr Hawthorne
Director Bruce Dorn
Client Herman Miller, Inc., Zeeland, MI
Agency Producer Pete Hoekstra
Production Company Robert Abel Associates
Music Composers Jerry Kaywell, Dale Herigstad

THE BRAIN TITLE
48-second

EQUA™: A CHAIR FOR PEOPLE WHO CAN'T SIT STILL
4-minute
NO NARRATION OR VOICE-OVER, ONLY MUSIC.

Art Director	Peter Begley
Director of Photography	Carl Norr
Writer	Deanna Cohen
Editor	Ciro DeNettis
Director	Jack Piccolo
Client	The Greater New York Blood Program
Agency Producer	Lorraine Schaffer/Doyle Dane Bernbach, New York, NY
Production Company	Kerri King/Pfeifer, Story, Piccolo, Guliner
Music	Fred Weinberger

Art Director	Fred Charrow
Designer	Fred Charrow
Director of Photography	Pete Turner
Writer	Tracy Simpson
Editor	Sam Ornstein
Directors	Pete Turner, Fred Charrow
Client	Visual Technologies/Bill Parker
Agency Producer	Jay Walker, Executive Producer
Production Company	Pete Turner Inc., New York, NY
Assistant Director	John Harcourt

LIVES
4-minute
ANNCR (VO): Johnathan Price was the baby his parents longed for, prayed for, never gave up the hope of having for 7 long years.
And when he was finally born, was he ever beautiful.
He had his mother's eyes.
His father's mouth.
And something all of his own.
A hole in his heart.
He spent 8 hours in surgery and 16 weeks after that fighting for his life.
10 of you out there joined the fight . . . by giving blood.
Johnathan Price's parents don't know you.
But there's something they want you to know:
Instead of the sadness of an empty crib, they have the joy of a hungry baby.

THE LIGHT SCULPTURE OF BILL PARKER
5-minute
"The progressive painter, who is struggling against his traditional element, the pigment, feels that very soon a transition will come, a transition from pigment to light"
LASZLO MOHOLY-NAGY

1916

Art Director	Bill Yamada
Writer	Perri Feuer
Editor	Joe Laliker/Pelco
Director	Jean Marie Perier
Client	Murjani/Gloria Vanderbilt
Agency Producer	Lorraine Schaffer/Doyle Dane Bernbach, New York, NY
Prod'n Co Producer	Heidi Nolting

1917

Art Directors	Steve Kasloff, Tony Seiniger
Writers	Steve Kasloff, Paul Ross, Steve Perani
Director	Richard Redfield, Steve Kasloff
Client	Micki & Maude
Producer	Columbia Pictures Industries, Inc., Burbank, CA
Production Company	Jon Bloom/Seininger/Bloom Productions
Creative Director	Steve Kasloff

FIT FOR A WOMAN
30-second
ANNCR: Gloria Vanderbilt man-tailored all cotton underwear
Designed by a woman to fit a woman.
Possibly the most comfortable underwear around.
After all, look what she did for jeans.
Gloria Vanderbilt underwear.
Designed by a woman to fit a woman.

SURVIVE
1:08-minute
ANNCR: This is Rob Salinger.
He's happily married to Micki.
Rob desperately wants a child.
ROB: Come on Micki, just one child. A small one.
ANNCR: But Micki doesn't have time to make a dinner date . . .
MICKI: Honey I got to go. Can I see you tomorrow?
ANNCR: . . . Let alone a baby
MICKI: Oh no, no, no, that won't do. I'll have to call you.
ANNCR: Enter Maude
MAUDE: You have wonderful eyes.
ROB: Wonderful eyes?
ANNCR: Who gave him the one thing his wife never did . . .
MAUDE: I'm pregnant.

1918

Art Director	H. Brian O'Neill
Animator/Artist	Larry Chernoff, Filmcore, L.A.
Director of Still Photograpy	Dennis O'Keefe
Writer	H. Brian O'Neill
Editor	Larry Chernoff
Directors (motion stills)	H. Brian O'Neill, Larry Chernoff
Client	KYW-TV Philadelphia, PA
Producer	KYW-TV, H. Brian O'Neill
Production Company	Filmcore, Los Angeles (post-production)
Announcer	Bill O'Connor

1919

Art Director	Paula Silver
Designer	Elizabeth Maihock
Animator/Artist	Kenneth Stytzer
Director of Photography	James Szalapski
Writer	Kate Cox, Marsha Lebby
Editor	Larry Plastrik
Director	Richard Greenberg
Client	Columbia Pictures
Production Company	Robert M. Greenberg/R/Greenberg Associates, Inc., New York, NY
Associate Producer	Peter Frankfurt

WITHOUT A HOME
30-second
SFX: (RAY CHARLES' VERSION OF "AMERICA THE BEAUTIFUL" THROUGHOUT)
VO: If you've ever wondered what life was like without a home, watch Eyewitness News at 5:00 this Thursday and Friday. Then ask yourself. Is this the City of Brotherly Love?
SFX: MUSIC UP

BODY DOUBLE
60-second
(MUSIC UNDER THROUGHOUT)
ANNCR (VO): He thought he was watching her.
But she was watching him.
He thought he was trespassing.
But he was invited.
He knew he'd gone too far.
But he couldn't stop.
He saw exactly what she wanted him to see.
Brian De Palma
the modern master of suspense,
invites you to witness
a seduction,
a mystery,
a murder.

Art Director	Steve Kasloff
Writer	Steve Hull
Editor	Giacomo Vieste
Client	A Soldier's Story
Agency Producer	Columbia Pictures Industries, Inc., Burbank, CA
Production Company	Gary Kanew/Kanew Manger Deutch, Ltd.
Creative Director	Steve Kasloff

Art Director	Tim Boxell
Designer	Tim Boxell
Animator/Artists	Tim Boxell, Regina Herve
Client	CBS Records/Billy Squier
Agency Producer	Stephen Gelbar
Production Company	Jana Canellos/Colossal Pictures, San Francisco, CA

SOLDIER'S STORY—TRUTH

1:23-minute
ANNCR: THE MURDER WAS ONE ALMOST NO ONE WANTED SOLVED.
WILSON: I want whatever you came here to do, completed in three days.
ROLLINS: Sir, I request immediate permission to notify Washington.
WILSON: Permission denied.
ROLLINS: I'm under direct orders.
WILSON: I don't give a damn if Roosevelt himself sent you, Davenport.
ANNCR: The victim was someone, *no one* would mourn for.
WATERS: You're suppose to be an example to your men. I'm going to put you in the stockade for ten days and take away them God damn stripes.

ROCK ME TONIGHT

30-second
VO: Rock and Roll has a name . . .
Billy Squier.
His new album—his Signs of Life.

1922

Art Director	Pat Longan
Animator/Artist	Robert Peluce/Kurtz & Friends
Writer	Al Buono
Director	Bob Kurtz
Client	John Harris
Agency Producer	Al Buono
Production Company	Loraine Roberts/Kurtz & Friends
Creative Director	Bill Drier, McFarland & Drier Advertising, Miami, FL

METAMORPHOSIS
30-second
MUSIC: SCORING TRAC
JOHN BARTHOLOMEW TUCKER (VO): Fifty years ago we opened the
first Dade Savings right in the middle of Miami.
It grew bigger and better.
And before long, we weren't just one Dade Savings, we were ten.
Then twenty. Now thirty-four.
And we're in six counties.
We've grown so much, we've outgrown our name.
We're CenTrust now.
And our future looks even brighter.
CenTrust Savings.
Where your future is our future.

ART DIRECTORS CLUB BOARD OF DIRECTORS
1984—1985

President	Andrew Kner
First Vice President	Ed Brodsky
Second Vice President	Klaus Schmidt
Secretary	Bob Ciano
Treasurer	Jack G. Tauss
Assistant Secretary/Treasurer	Blanche Fiorenza
Chairman Advisory Board	Walter Kaprielian

EXECUTIVE COMMITTEE

Robert Bruce
Richard Wilde
Lee Epstein
Karl Steinbrenner
Jack W. Odette
Laura Duggan

COMMITTEES AND CHAIRPEOPLE

Agency Relations
Kurt Haiman, Chairman

64th Awards Judging
Kurt Haiman, Chairman

64th Awards Presentation
Jack G. Tauss

Gallery Exhibitions
Jean Goldsmith, Chairwoman

Membership
Sal Lazzarotti, Chairman

Newsletter
Ron Couture, Chairman

Portfolio Review
Richard MacFarlane, Jack G. Tauss, Co-Chairmen

Membership & Luncheon Activities
Dick Smith, Dorothy Wachtenheim, Chairpeople

Traveling Show
Shinichiro Tora, Chairman

Visual Communicators Education Fund
Karl Steinbrenner, President

New Breed
Alma Phipps, Bobbi Rosenthal, Chairwomen

ART DIRECTORS CLUB PROGRAMS

Annual Exhibition

64th Annual judging at School of Visual Arts, New York

64th Awards Dinner, Puck Building, New York

Photo: Roberto Sandoval

64th Annual Exhibition, Harkness Plaza, New York

ART DIRECTORS CLUB PROGRAMS

"An Evening with One of the Best" lecture series 1984—1985

George Lois

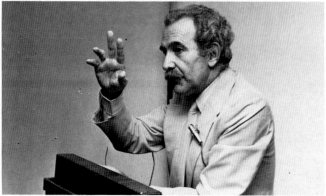
Lee Epstein

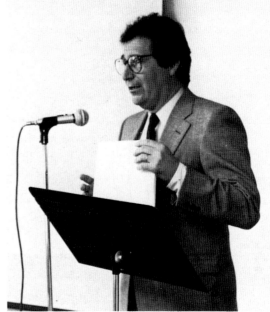
Amil Gargano
and Lou Dorfsman
 Stephen O. Frankfurt
 Harvey Gabor
 Roy Grace
 Len Sirowitz
 Bert Steinhauser
 Henry Wolf

Wednesday Luncheon Speakers

Steve Laughlin, Dennis Frankenberry and John Constable of
Frankenberry, Laughlin, Constable, Inc.

Seth Werner and Gary Ennis, Marschalk Co.

Club photos: Deborah Weathers Thomas

Karen Bernstein, Image Bank

DESIGN CONSULTANT

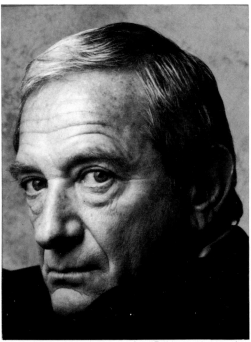

Jerry Freidman, photographer

Gene Federico, designer of the 64th Art Directors Annual, is Vice Chairman of Lord, Geller, Federico, Einstein, Inc. in New York. Prior to co-founding the firm in 1967, he was for seven years, Vice President, Art Group Head at Benton & Bowles. Federico was director of the creative department for D.D. Simon, a small fashion advertising agency and he worked at Doyle Dane Bernbach, Grey Advertising and Abbot Kimball Advertising. For a year he was editorial assistant at Fortune Magazine. While serving for four and a half years in the U.S. Army, he was in charge of graphics for Plans and Operations, 84th Engineers. Federico attended New York City elementary and secondary schools and was a scholarship student at Pratt Institute where he graduated in 1938. He studied with Leon Friend, Tom Benrimo, Howard Trafton and Herbert Bayer.

His freelance clients have included Container Corporation, Harper's Bazaar, Random House, Doubleday, Columbia Records, Decca, Disney, Supima Cotton and Architectural Forum. His advertising and corporate identity work have won awards from the New York Art Directors Club, AIGA and Type Directors Club. He was a prize winner in the Dusseldorf Poster Competition and his work was shown in an international graphic design exhibition in London in 1978. In 1980 he was inducted into the Art Directors Club Hall of Fame.

Articles on his work have been published internationally in Idea (Japan), Graphis (Switzerland), Gebrauchsgraphik (Germany), Modern Publicity (England) and in various U.S. publications including Communication Arts. Federico has served as a judge for numerous design competitions including the American Society of Magazine Photographers, Typography U.S.A. and Art Directors Clubs of New York, Los Angeles and Cleveland. He has been a panelist for international design conferences in Tokyo and Cannes and is a member of the International Executive Committee of Alliance Graphique International. He is a former board member of the AIGA and New York Art Directors Club and is a member of the selection committee for the ADC Hall of Fame.

INDEX

ADC MEMBERSHIP LIST

Joe Hovanec
Elizabeth Howard
Paul Howard
Roy Alan Hughes
Jud Hurd
Morton Hyatt

Ana J. Inoa
Henry Isdith

Joseph Jackson
Robert T. Jackson
Harry Jacobs
Lee Ann Jaffee
Jack Jamison
John C. Jay
Patricia Jerina
Barbara John
D. Craig Johns
Susan Johnston
Bob Jones
Kristina M. Jorgensen
Roger Joslyn
Len Jossel
Christian Julia
Barbara L. Junker

Nita J. Kalish
Kiyoshi Kanai
Walter Kaprielian
Judy Katz
Rachel Katzen
M. Richard Kaufmann
Nancy Kent
Myron W. Kenzer
Michele Kestin
Ellen Sue Kier
Cyd Kilbey-Gorman
Elizabeth Kim
Leslie Kirschenbaum
Judith Klein
Hilda Stanger Klyde
Andrew Kner
Henry Knoepfler
Ray Komai
Robert R. Kopelman
Oscar Krauss
Helmut Krone
Thaddeus B. Kubis
Anna Kurz

James E. Laird
Howard Lamarca
Abril Lamarque
Joseph O. Landi
John Larkin
Pearl Lau
Kenneth H. Lavey
Marie-Christine Lawrence
Sal Lazzarotti
Jeffery Leder
Daniel Lee
John Lenaas
Robert L. Leslie
Robert C. Leung
Robert Leydenfrost
Alexander Liberman
Victor Liebert
Howard Liebman
Beverly Littlewood
Leo Lobell
Henry R. Loomis
Michael Losardo
Rocco Lotito
George Gilbert Lott
Robert Louey
Alfred Lowry
Ruth Lubell

John Lucci
Richard Luden
John H. Luke
Thomas R. Lunde
Lisa Lurie
Larry Lurin
Robert W. Lyon Jr.
Michael J. Lyons

Charles MacDonald
Richard MacFarlane
David H. MacInnes
Frank Macri
Sam Magdoff
Louis Magnani
Nancy Lou Makris
Anthony Mancino
Saul Mandel
Jean Marcellino
John S. Marmaras
Andrea Marquez
Al Marshall
Daniel Marshall
William R. Martin
Caren J. Martineau
Theodore Matyas
Marce Mayhew
William McCaffery
Constance McCaffrey
Robert McCallum
Gerald McConnell
John McCuen
Scott A. Mednick
William Meehan
Mario G. Messina
Lyle Metzdorf
Emil T. Micha
Eugene Milbauer
Jean Miller
Lawrence Miller
John Milligan
Isaac Millman
William Minko
Michael Miranda
Leonard J. Mizerek
Cheryl Mohrmann
Burton A. Morgan
Jeffrey Moriber
Minoru Morita
William R. Morrison
Thomas Morton
Roger Paul Mosconi
Geoffrey Moss
Tobias Moss
Dale Moyer
Marty Muller
Virginia Murphy-Hamill
Ralph J. Mutter

Daniel Nelson
Hilber Nelson
John Newcomb
Stuart Nezin
Deborah Nichols
Raymond Nichols
Marcus Nispel
Joseph Nissen
Ko Noda
Evelyn C. Noether
Cindy Norrick-Sargent
David November
C. Alexander Nuckols

Frank O'Blak
Edward O'Connor
Jack W. Odette
Noriyuki Okazaki
John Okladek

John O'Neil
Susan Alexis Orlie
Garrett P. Orr
Leslie Osher
Larry Ottino
Nina Ovryn
Bernard S. Owett

Onofrio Paccione
Zlata W. Paces
Maxine Paetro
Robert Paganucci
Roxanne Panero
Nicholas Peter Pappas
Jacques Parker
Paul E. Parker Jr.
Grant Parrish
Joanne Pateman
Charles W. Pates
Leonard Pearl
Barbara Pearson
Alan Peckolick
B. Martin Pedersen
Paul Pento
Vincent Pepi
Roberta Perry
Victoria I. Peslak
John Pessalano
John Peter
Christos Peterson
Robert L. Peterson
Ken Petretti
Robert Petrocelli
Theodore D. Pettus
Allan Philiba
Gerald M. Philips
Alma M. Phipps
George Pierson
Michael Pilla
Ernest Pioppo
Peter Pioppo
Robert Pliskin
Raymond Podeszwa
Sherry Pollack
Joseph J. Pompeo Jr.
Robin Poosikian
Louis Portuesi
Anthony Pozsonyi
Brenda M. Preis
Benjamin Pride
Bob Procida
Jay Purvis

Robert Qually
Charles W. Queener
Elissa Querze
Anny Queyroy
Mario Quilles
Kathleen Quinn
Mike Quon

Judith G. Radice
Paul Rand
Richard Randall
Neil Raphan
Robert C. Reed
Samuel Reed
Shelden Reed
Patrick Reeves
Wendy Talve Reingold
Herbert Reinke
Edwin C. Ricotta
Michelle M. Roberge
Ray Robertson
Bennett Robinson
Harry Rocker
Harlow Rockwell
Andy Romano

Louis C. Romita
Barbara Rosenthal
Herbert M. Rosenthal
Charles Rosner
Andrew Ross
James Francis Ross
Richard Ross
Richard Ross
Warren Rossell
Arnold Roston
Leah Roth
Thomas Roth
Wayne Roth
Frank D. Rothmann
Iska Rothovius
Mort Rubenstein
Randee Rubin
Thomas P. Ruis
Robert Miles Runyan
Henry N. Russell
Albert Russo
Don Ruther
Thomas Ruzicka

Stewart Sacklow
Martin Saint-Martin
Robert Saks
Robert Salpeter
Ina Saltz
George Samerjan
Jim Sant' Andrea
John Sargeant
Betty B. Saronson
Audrey Satterwhite
Vincent Sauchelli
Hans Sauer
Sam Scali
Peter Scannell
Ernie Scarfone
Beth Schack
Peter Schaefer
Timothy Schaible
Paula Scher
Klaus F. Schmidt
Joyce Schnaufer
William H. Schneider
Annette Schonhaut
Beverly Faye Schrager
Carol Schulter
Eileen Hedy Schultz
Nancy K. Schulz
Victor Scocozza
Ruth Scott
William C. Seabrook III
David Seager
Debra Seawon
Leslie Segal
Sheldon Seidler
John L. Sellers
Kaede Seville
Antoinette L. Sforza
Ellen Shapiro
Patricia Shea
Alexander Shear
William Sheldon
Mindee H. Shenkman
Jerry Siano
Arthur Silver
Louis Silverstein
Milt Simpson
Leonard Sirowitz
Jack Skolnik
O. Paul Slaughter
Christopher Sloan
Jack Smith
Pamela Smith
Richard Jay Smith
Robert S. Smith

Edward Sobel
Martin Solomon
Harold Sosnow
Nancy E. Spelbrink
Michelle R. Spellman
Victor E. Spindler
Leonard A. St. Louis
David Stahlberg
Mindy Phelps Stanton
Karsten Stapelfeldt
Alexander Stauf
Irena Steckiv
Douglas Steinbauer
Karl Eric Steinbrenner
Karl H. Steinbrenner
Vera Steiner
Charles M. Stern
Daniel E. Stewart
Richard Stewart
Linda Stillman
Ray Stollerman
Bernard Stone
Otto Storch
Celia Frances Stothard
William Strosahl
Ira F. Sturtevant
Len Sugarman
Brenda Suler
Amy Sussman
Ken Sweeny
Robin Sweet

Barbara Taff
Robert Talarczyk
Nina Tallarico
Joseph Tarallo
Melissa K. Tardiff
Melcon Tashian
Bill Taubin
Jack George Tauss
Ciro Tesoro
Giovanna Testani
Richard Thomas
Bradbury Thompson
Marion Thunberg
Robin Ticho
Harold Toledo
Shinichiro Tora
Edward L. Towles
Victor Trasoff
Ronald Travisano
Charles Trovato
Susan B. Trowbridge
Joseph P. Tully
Anne Twomey

Clare Ultimo
Frank Urrutia

Gerard Vaglio
Michael Valli
Elizabeth Thayer Verney
Frank A. Vitale
Richard Voehl

Dorothy Wachtenheim
John Wagman
Charles W. Wagner
Ernest Waivada
Jurek Wajdowicz
Joseph O. Wallace
Mark Walton
Paul Waner
Jill Waserman
Laurence S. Waxberg
Jessica Weber
William Weinberger
Art Weithas

Theo Welti
Ron Wetzel
Ken White
Pamela J. White
Ronald Wickham
Gail Wiggin
Richard Wilde
Rodney Williams
Jack Williamson
David Wiseltier
Rupert Witalis
Cynthia Wojdyla
David Wojdyla
Henry Wolf
Sam Woo
Elizabeth G. Woodson
Orest Woronewych
William K. Wurtzel

Ira Yoffe
Zen Yonkovig

Bruce Zahor
Carmile S. Zaino
Faye Parsons Zasada
Paul H. Zasada
Richard Zoehrer
Alan Zwiebel

ADC INTERNATIONAL MEMBER LIST

ARGENTINA

Daniel Atilio Verdino

AUSTRALIA

Ron Kambourian

AUSTRIA

Mariusz Jan Demner
Franz Merlicek

BERMUDA

Paul Smith

BRAZIL

Leighton David Gage
Oswaldo Miranda

CANADA

John D. Brooke
Israel Fraiman
Brian C. Hannigan
Ran Hee Kim
Fernando Medina

ENGLAND

Jean Govoni
Janice Hildebrand
Roland Schenk

HOLLAND

Pieter Brattinga

INDIA

Brendan C. Pereira

ISRAEL

Asher Kalderon
Dan Reisinger

ITALY

Titti Fabiani

JAPAN

Masuteru Aoba
Yuji Baba
Satoru Fujii
Terunobu Fukushima
Mitsutoshi Hosaka
Michio Iwaki
Toshio Iwata
Yoshikatsu Kosakai
Kazuki Maeda
Seiichi Maeda
Takao Matsumoto
Yasuhara Nakahara
Makoto Nakamura
Toshiyuki Ohashi
Takeshi Ohtaka
Shigeo Okamoto
Motoaki Okuizumi
Tomoyuki Ono
Susumu Sakane
Takayuki Shirasu
Kataoka Shiu
Seija Sugii
Yasuo Suzuki
Teruaki Takao
Masakazu Tanabe
Soji George Tanaka
Yusaku Tomoeda
Norio Uejo
A. Hidehito Yamamoto
Yoji Yamamoto
Takeo Yao

MEXICO

Felix Beltran
Diana Garcia de Tolone
Luis Efren Ramirez Flores

NORWAY

Kjell Wollner

SINGAORE

Chiet-Husen Eng

SPAIN

Norberto Leon

SRI LANKA

Kosala Rohana Wickramanayake

SWITZERLAND

Bilal Dallenbach
Moritz S. Jaggi
Hans Looser

WEST GERMANY

Uwe Horstmann
Olaf Leu
Hans-Georg Pospischil

ADC AFFILIATE MEMBERS LIST

Avon Products, Inc.

Ronald Longsdorf
Timothy Musios
Perry Zompa

Cardinal Type Service, Inc.

Mark Darlow
John Froehlich
Allan R. Wahler

Columbia University Publications Office

Daniel Cacici
Janet Huet

New York City Technical College

Benjamin Einhorn
George Halpern

Parsons School of Design

Al Greenberg
David Levy

Peter Rogers Associates

Leonard Favara
Peter Rogers

Tisdell/Caspescha

Daniel Caspescha
Clifford Tisdell

Toppan Printing Company, Ltd.

Takeo Hayano
Shinichi Soejima
Teruo Tanabe

Union Camp Corporation

Stewart Phelps
Robert Todd

Warner Amex Satellite Entertainment Company

Juli Davidson
Leslie Leventman
Jim Warren

INDEX

ART DIRECTORS

Vaughn, Rick, 12, 791, 1378, 1434
Velardi, Tom, 341
Velmer, Doreen, 749
Vergara, Sal, 1757
Verlizzo, Frank, 1305, 1309
Vidmer, Rene, 265
Vienne, Veronique, 391, 403
Vignelli, Massimo, 1322, 1341
Vinson, Barbara W., 991
Viola, Tony, 1798
Vitale, Nick, 1754, 1777, 1882
Vitiello, Michael, 1726
Vitro, John, 251, 775, 776, 861, 869
Von Kaenel, Axel, 342, 350
Voorhees, Steven, 1093
Vosseler, Ursula P., 1192
Vracin, Andrew, 1560
Vucinich, Andrew, 1301

Wachtenheim, Dorothy, 1225, 1233, 1236
Waddell, Malcolm, 939
Wade, Lee, 1216
Wagman, John, 1034
Wai-Shek, Tom, 346
Waife, Ronald S., 1241
Waldron, John, 1847
Walpin, Estelle, 427
Walsh, Kerry, 865
Walton, Mark, 68, 158
Warkulwiz, Bob, 967
Waters, John, 672
Watts, Bud, 1730
Watts, Cliff, 1575
Waugh, Philip, 1255
Weaver, John, 929
Weber, Christina, 1324
Weber, Jessica, 1243
Wedeen, Steven, 192, 195, 199, 782, 957, 989, 1378, 1434
Weeks, Loren, 712, 716, 758
Weibman, Michelle, 124, 130
Weidert, Joseph, 835
Weilbacher, Warren, 1473
Weinheim, Donna, 1636, 1690, 1733
Weinschenker, Greg, 1798, 1806
Weir, Peter, 1273
Weisz, Thomas J., 1457
Weller, Don, 1165, 1456, 1567
Wells, David, 998, 1909
Wesko, David, 961, 986
Wheat, Lee, 1594
Whelar, Richard J., 1117
Whitcomb, Emilie, 476
White, G. Oliver, 1752
White, Ken, 953
White-Whitley, Kathy, 996
Whitley, Jerry, 56, 170, 222, 246, 1773
Wicht, Arnold, 1797
Wickerden, Dorothy, 603
Wilde, Richard, 1367
Wilkins, Brandt, 56
Willet, Phil, 249, 258
Williams, Lowell, 682, 697, 706, 751, 1631
Williams, Rodney, 493
Williams, Shelley, 1499
Wilson, Dann, 997
Wilson, Fo, 465, 466
Wilson, Jan, 1064
Windett, Peter, 1096, 1097
Windsor, Kenneth, 584, 585, 590, 592, 594, 595, 596, 597
Winner, Harriet, 7

Wiser, Robert L., 1228
Withers, David, 882
Wofford, Joey, 1886
Wojdyla, Cynthia, 1822
Wolf, Henry, 1417, 1440
Wolsey, Tom, 147, 151, 159, 206
Wondriska, William, 1167, 1389
Wong, Allen, 1368
Wood, Mark, 843, 1274
Woods, Alison, 1109
Woods, Sam, 1716
Woodward, Fred, 486, 491, 499, 502, 508, 510, 544, 1544
Wright, Tom, 1410
Wyant, Julia, 624, 633, 637, 1331, 1629
Wyman, Lance, 1046

Yagi, Tamotsu, 923, 1019
Yamada, Bill, 1770, 1916
Yang, Larry, 960
Yeager, Richard, 370
Yearsley, Larry, 1697
Yochum, Elmer E., 1668, 1833, 1847
Yoffe, Ira, 537
Yoshida, Gary, 219, 1840
Young, David J., 217, 367, 786, 1045, 1050, 1411, 1494
Young, Frank, 201, 736
Yustein, Mark, 1725, 1744, 1845

Zamazaki, Kazuhide, 888
Zamore, Joanne, 614
Zdanowicz, Jerry, 1283
Zeek, Paul W., 938
Ziegler, Ellen, 812
Ziff, Lloyd, 439, 470, 485, 494, 509, 535, 1579, 1580, 1592, 1597
Zimmerman, Don, 156, 220, 1767
Zipparo, George, 302, 311, 376
Zisk, Mark, 1535
Zubalsky, Don, 1448

DESIGNERS

Abney, Karen, 738
Acevedo, Luis, 1402
Adam, Robert A., 695, 708
Adamson, Susan, 684, 730
Alexander, Jann, 423, 425, 428
Alexander, Sam, 721
Allen, Nancy Stock, 717
Amft, Robert, 1613
Anastasi, Joseph A., 1476
Anderson, Cal, 893
Anderson, Eric, 213
Anderson, Jack, 741, 902, 942, 1014, 1413
Angeli, Primo, 898
Anthony, Robert, 872, 1141, 1164, 1210, 1211, 1219, 1225, 1232
Antupit, Samuel N., 1142, 1149
Aplin, Jim, 843
Appleby, Marilyn, 1584
Appleton, Bob, 1303, 1307
Aranda, Michelle, 658
Archibald, Phil, 1148, 1390
Arday, Don, 1032, 1035
Arnowitz, Andria, 292
Artinian, Vartus, 661, 1121
Ashcraft, Dan, 951

Ashton, Larry, 1305
Au, David, 895
Austopchuk, Christopher, 449, 537, 1586
Avery, John, 805
Axelrod, Nancy, 1261

Baker, Peter, 971
Barnes, Bill, 813
Baron, Harvey, 40
Baron, Richard M., 484, 1600
Baronet, Willie, 1033, 1051
Barr, Carla, 492, 503, 529, 548
Bartels, David, 1356, 1475
Barton, Ted, 364
Bartz, Lenore, 625, 627, 632, 662, 678
Bass, Saul, 1110, 1422
Bates, David, 991
Baumann, Mary K., 482, 483, 489, 496, 1620
Bechlen, Fred, 619, 1177
Beehler, Carol Hare, 1172
Behm, Dick, 1272
Beidel, Richard, 345, 626, 631, 636
Bellows, Amelia, 1016
Bender, Bob, 273, 278, 334, 1562, 1563, 1596, 1602
Bender, Lawrence, 649
Benedict, Jim, 349
Benes, Michael, 661
Bennett, Keith, 1052
Benson, Gae, 1560
Berger, LInda, 1909
Berish, Bonnie, 602, 803
Berle, Jim, 643, 650
Berman, Jerry, 335
Berndt, Karen, 79, 561, 616
Bertone, Jo, 1363
Besser, Rik, 659
Beirut, Michael, 1341
Bilger, Pat, 164
Billicki, Mike, 1519
Bisher, Nanette, 404
Black, Paul, 1333
Blackwell, Heidi Marie, 696
Blair, Michael, 1072
Bleiweiss, Richard, 1581
Bloom, Karen, 1133
Bodkin, Tom, 421
Bodney, Brenda, 1007
Boelts, Jackson, 723
Boger, Robert, 1516
Bolestridge, Scott, 1112
Bonnell III, Wilburn, 651
Boone, Danny, 305, 852, 1276, 1291
Borowski, Debra, 904
Bowman, Deborah A., 433
Boxell, Tim, 1921
Boyd, Brian, 701, 713
Brandon, Linda, 1572
Brant, Ron, 734
Breslin, Karen, 1188
Brewer, Linda, 405
Brier, David, 578
Bright, Radine, 1538
Brimmer, Henry, 1066, 1127
Brock, Michael, 452, 461, 513, 1067
Brodkin, Tom, 420
Browder, Rodger, 753
Brown, Michael David, 1224, 1384
Brown, Robin, 526
Brown, Terry, 1500, 1541
Bryza, Janie, 1504

Buchanan, Martin, 381
Burch, Harold, 1364
Burlockoff, Sam, 577
Burt, Jim, 1831
Bush-Lobue, Miriam, 978
Byck, Lewis, 1282

Caberga, Leslie, 890
Caldera, Doreen Cheu, 91, 102
Calperin, Peter, 1065
Campisi, Ronn, 432, 460, 475, 549
Capone, Kim, 928
Car, Christine, 722
Carlberg, Chuck, 65
Carlo, Lois, 745, 789, 794, 809
Carr, Fred, 1363
Carson, Bill, 683, 697, 706, 751, 1631
Carson, Steve, 1072
Casado, John, 337
Cassetti, Robert K., 1129
Ceglia, Ann, 1036
Chadwick, George, 956
Challinor, Mary, 493
Chandler, Deborah, 709
Chantry, Art, 792, 1048
Charrow, Fred, 1914
Chencharick, Diane, 338
Chermayeff, Ivan, 322, 1427, 1450
Cheshire, Marc, 1185, 1189, 1193
Chin, Margie, 1073
Chirby, Linda, 999
Chiumento, Tony, 1416
Christensen, Sara, 1499
Christian, Roger, 1115
Christianson, Francene Parco, 755
Chu, Hoi L., 985
Chu, Joy, 1194
Chung, Cliff, 741, 1413
Chung, Il, 951
Church, Jann, 860, 1119
Chwast, Seymour, 1098, 1102
Ciano, Bob, 479, 480, 514, 515, 517, 518, 523, 553, 1180, 1554, 1605, 1606, 1607, 1608
Ciavarra, Paul, 687
Cipriani, Robert, 704, 740, 864, 1366
Clar, Dave, 307
Clark, Casey, 630
Clark, Charlie, 51
Clark, John, 286, 348, 766, 1003
Clarke, Brad, 1227
Closi, Victor J., 471
Closner, Jennifer, 1040
Cochran, Bobbye, 1393
Cohen, Tamar, 1206, 1223
Cohoe, John Tom, 543, 618, 622
Coleman, Joseph, 1128
Colvin, Alan, 1006, 1430, 1439
Conde, Jose, 1011
Condon, John, 1247, 1266
Condon, Mary, 1247, 1266
Cook, Roger, 934, 1084
Cooper, Heather, 1429
Coops, Dinah, 204
Cordella, Andree, 668, 823
Corsillo, George, 1171
Cosmopolos, Stavros, 310, 369, 379, 798, 1069
Coutroulis, Peter, 1830
Cowley, Paul J., 359
Cozens, Bill, 221

WRITERS

Tucker, Eddie, 276
Tuckerman, Alan, 293
Tuerff, Tom, 230
Tully, Barry, 689
Turkle, Sherry, 1510
Turner, Lisa, 858
Tyler, Anne, 428

Valente, Sarah, 1387
Van Meter, Jan, 657
Van Ravenswaay, Charles, 1172
Varisco, Tom, 248,
Vashti Brotherhood, 31, 189, 1284, 1312
Vaughn, Rick, 1378
Vengrove, Stephen M., 1850
Vergati, Ben, 26
Vessels, Jane, 1158
Vidal, Gore, 1269, 1537
Villella, Lynn, 782, 989
Vine, Larry, 346, 1646, 1712
Vogt, Donna, 91, 102
Voornas, Greg, 328
Vucci, Len, 1072
Vuorenmaa, Leila, 876

Waddell, John C., 672
Wagman, Rich, 1857
Wagner, Margaret, 932
Waitzkin, Bonnie, 472
Waldron, John F., 1668, 1833, 1847
Walker, Fred, 1641
Wallace, Margot, 120, 125
Walsh, Jim, 1667
Ward, Michael, 133, 1302
Warner, Mary, 1893
Warren, Irwin, 45, 382
Wasserman, Alvin, 221
Wasserman, Dick, 1288
Watson, Craig, 1368
Watt, Graham, 1831
Watters, James, 1180
Waugh, Phil, 1325
Wecal, Dave, 793
Wedeen, Steven, 1378, 1434
Weidert, Jospeh, 835
Weir, Steve, 1357
Weiss, Jane, 389
Welch, Ray, 911
Weller, Jim, 1744, 1845
Wells, Les, 972
Welsch, Ulrike, 1245
Welsh, John, 1751, 1756
Wesel, Paul, 704
Wesko, David, 961, 986
Westbrook, Bill, 61
White, Ben, 116, 135
White, Bill, 1755
White, Robert, 1143
Whitell, Polly, 462
Whitton, Blair, 1198
Wiecks, Tom, 1061, 1290, 1293
Wierenga, Debra, 1078
Wilcox, Margaret, 1779
Wilk, Pamela, 931
Williams, Donna, 12, 180, 192, 195, 957, 1378
Wilson, Dann, 997
Wimettt, Allen, 313
Winch, Tony, 31, 1742, 1815
Wingerson, Lois, 1466
Winn, Anne, 1718, 1723
Winters, Art, 63
Wood, Dana Lee, 602, 803
Woods, Harry, 36, 1294, 1444
Workman, Lyda, 698
Worton, Barbara, 1420, 1428

Wright, Galen, 356
Wright, Janet, 740, 864, 1366
Wright, Michael, 337, 344

Yanes, Sam, 661
Yobbagy, Tom, 372, 1746, 1771, 1829, 1875
Yoffe, Emily, 423
Young, David Jemerson, 2, 217, 367, 1494
Young, John, 3, 217, 367, 786
Young, Rick, 833
Yourcenar, Marguerite, 1230

Zdanowicz, Jarry, 1283
Zeman, Maryann, 176
Ziefert, Harriet, 1261
Zimring, Lori, 965, 1323
Zumberge, Joellen, 755
Zwicker, Denise, 783

EDITORS

Adolfson, Andy, 1611
Allen, Nina Bell, 469
Anderson, Walter, 537
Ashkinos, Morty, 1656, 1658, 1700, 1702, 1825, 1851, 1867, 1869

Bachman, Jane, 1611, 1613
Baer, Susan, 1465
Baird, Jock, 559, 565, 570
Bance, Shelley, 1472
Bankson, Ross, 1192
Banquer, Lloyd, 635
Barnes, Duncan, 471
Bass, George Houston, 1368
Bassi, Robert A., 772
Bee, Harriet, 1154
Beeson, Nora, 1250
Bell, Harriet, 1171
Bender, Jerry, 1644, 1692, 1823, 1824, 1902
Bergery, Benjamin, 1910
Bernstein, Marty, 1861
Berry, Paul, 1139, 1155, 1632
Bershtel, Sara, 1205, 1234
Blair, Terrie, 392, 400
Bodner, Steve, 1777
Bowen, Diane L., 1197, 1203
Bowles, Jerry G., 630
Briley, Dorothy, 1186
Bristol, Barbara, 1249
Bruder, Bill, 1670
Bryant, Richard V., 619
Bryant, Thos L., 1600
Buckley, Kevin, 440, 496, 543, 618, 1620
Buder, David, 1887
Buettner, Gudrun, 1198
Bullock, Tom, 1638, 1760, 1880
Busch, Richard, 478
Butt, Barbara, 436
Byron, Elizabeth S., 1580

Caldwell, Elaine, 837
Callahan, Sean, 490, 505, 506, 511, 528, 534, 538, 542, 545, 547
Canty, Donald, 564, 573, 610, 621
Capuana, Theresa, 438
Carey, Ayn, 692
Carey, John, 1663

Casey, D. Kay Evans, 1229
Casper, Kathleen, 1221
Century III, 1891
Charles, Michael, 1871
Chavez, Linda, 455
Chernoff, Larry, 1918
Cheshire, Marc, 1185, 1189, 1193
Cheverton, Richard, 404
Chubak, Charlie, 1766
Cioffredi, Frank, 1661, 1729, 1871, 1843
Ciro, 1654
Cohen, Tedd A., 540
Cohen, Mel, 1893, 1899
Cole, Jr., Robert W., 1471
Colen, B. D., 1466
Collins, Alice Brown, 1368
Cook, Judy, 1145
Cooper, Dale, 1715
Cope, Matt, 1805
Cruys, George, 561, 579, 616
Curtis, Gregory, 486, 491, 499, 502, 508, 510

Dahlman, Rye, 1753, 1789
Dakin, Dana, 822
Dauksewicz, Joanne, 1201
De Moraes, Lisa, 1697
De Stein, Susan M., 644
Dee, David, 1696, 1749, 1810, 1870
Delay, Peggy, 1757, 1811, 1846
Dell, Jeff, 1650, 1827
Delton, Hope, 1216
Denettis, Ciro, 1747, 1889, 1913
Derise, Bob, 1648, 1653, 1791, 1800
Desario, Vito, 1818, 1864
Dewey, Donald, 446, 495, 497
Dinkel, John, 484
Doob, David, 1742, 1799
Dougherty, Frank, 737
Duck Productions, 1779
Dunn, Margery G., 1151
Dunne, Tom, 1238

Editor's Center, 1691
The Editors, 1660
Edwards, Jim, 1822
Emmrich, Stuart, 612
English, Margie, 576
Ermoyan, Arpi, 1232
Erskine, Alan, 663
Essex, Joseph Michael, 1176
Ewart, Vian, 417

Fazio, Beverly, 1149
Fields, Andy, 1876
Filler, Martin, 470
Film Surgeons, 1878
Fine, Av, 1691
Fineman, Steve, 1737
First Edition, 1719, 1817
Fischer, Tony, 1642, 1695
Fisher, Joan E., 1142
Flood, Bob, 1897
Ford, Bernette, 1261
Foster, Liz, 1155
Fox, Martin, 598, 606, 1263
Frankel, Bruce, 1730
Frankel, Lory, 1163, 1213
Franklin, Helena, 1265
Freedgood, Anne, 1239, 1244, 1253,
Friedman, Lenny, 1794
From, Nitza, 1669, 1671
Frost, Jim, 1170

Fucito, Frank, 664

Gaffney, Frank, 418
Gallagher, Marsha V., 1157
Geis, Darlene, 1158
Gelb, Arthur, 771
Gelman, Steve, 452, 461, 513
Gesert, Phil, 1912
Giblin, James, 1191
Giddins, Gary, 408
Gilliland, Mike, 1732
Glusman, John, 1269
Godfrey, Joanne, 1455
Goetzmann, William, H., 1157
Gold, Jay, 1666, 1841, 1845, 1863
Jay Gold Films, 1636
Golden, Soma, 409
Goldsmith, Arthur, 500, 1618, 1623
Goldsmith, Caroline, 1178
Gottschall, Edward, 554, 555, 556, 558, 566, 572, 583, 587, 591
Graham, Nan, 1222
Grant, Annette, 414
Gray, Karen Parker, 1579
Green, Ashbel, 1141
Gribbins, Joseph, 617
Gropp, Louis O., 535
Guenther, Wallis, 550

Hale, Judson, 467
Haley, Nan, 613
Halpern, Jeff, 1764, 1776, 1832
Hammond, Allen, 457, 1497, 1510, 1622
Hansen, Larry, 1137
Hanson, Roy, 407, 1474
Harris, Bruce, 1187
Hawthorne, Darr, 1912
Hayes, Dennis, 1651, 1664, 1665, 1729, 1738, 1815, 1819, 1885
Hegstad, Roland R., 571
Helgert, Joe, 779
Herzog, Robert, 1473
Hirasuna, Delphine, 625, 627, 632, 667
Holmgren, Theodore J., 1629
Honeywell, 823
Hoving, Thomas, 492, 503, 529, 548
Hughes, Jim, 1630
Hunt, David C., 1157

Illowite, Randy, 1639, 1778, 1795
Izui, Karen, 608

Janssen, Peter A., 441, 462, 468, 472, 477, 1566, 1573

Kahn, Pierre, 1643, 1746, 1761, 1771, 1780, 1829, 1855, 1875, 1879
Kaplan, Margaret L., 1163, 1213
Karber, Rodger, 723
Kelly, Marguerite, 1140
Kenealy, Patrick, 456, 1486
Keppler, Herbert, 1561
Kesser, Cari, 1708
Klein Ed, 429, 431, 434, 487, 527, 533, 1493, 1625
Klein, Sonny, 1635, 1640, 1764, 1768
Konigsberg, David, 820, 825
Kosner, Edward, 1571

DIRECTORS

Haboush, Victor, 1877
Hagmann, Stu, 1713, 1671, 1722, 1803
Hameline, Gerard, 1648, 1729, 1800
Hamill, Virginia Murphy, 1616
Hanwright, Joe, 1791
Hinton, Jim, 1802
Hirsch, Tibor, 1657
Hlinka, Werner, 1704, 1739
Hoey, Greg, 1686
Holtzman, Henry, 1687, 1689, 1736
Horn, Steve, 1688, 1696, 1765, 1810, 1818, 1843
Hudson, Bill, 1754, 1882
Hudson, Ron, 968
Hulme, Bob, 1835

Jacken, Just, 1762
James, Dick, 1700, 1702, 1869
Jinno, Yoh, 1168
Johnston, Jim, 1650, 1853

Karbelnikoff, Mike, 1661
Kasloff, Steve, 1917
Kelgren, Kay, 1856
Kelly, Pat, 1654
Killeen, Jr., Joseph L., 1553
King, Edward D., 1153
Kobos, William G., 772
Kooris, Richard, 1720
Kretchmer, Arthur, 1501, 1515
Kurtz, Bob, 1922

Lacy, Lee, 1667, 1758, 1796
Lauber, Patricia F., 634
Leech, Ian, 1759
Levien, Ed, 1905
Levine, Rick, 1669, 1694, 1870, 1899
Levkoff, Henry, 1907
Lewin, Nick, 1741
Linsman, Bill, 1691
Lund, Jim, 1642, 1695

Madsen, Ken, 1662
Maller, Jonathan, 1670
Mann, Ken, 903
Marco, Phil, 1766
Margulies, Warren, 1905
Marles, John, 1677
Masters, Quentin, 1703
Matson, Ken, 1663
Mayo, Geoffrey, 1656, 1860
McCann, Walter, 778
Mehl, Ilene, 554, 555, 556, 558, 566, 572, 583, 587, 591
Mesrobian, Arpena, 1134
Meyers, Barry, 1664, 1793, 1813
Michaels, Christiane, 831
Miller, Dick, 1871, 1901
Moon, Sarah, 1775, 1872
Morgan, Patrick, 1651
Morris, John, 635
Myers, Barry, 1816
Myers, Sid, 1719, 1747, 1817

Nadel, Bruce, 1666
Newman, Tim, 1693, 1808
Noto, Peter, 1555
Nugent, Rory, 1170

O'Dea, Patrick, 359
O'Neill, H. Brian, 1918
Oglan, Gord, 1888

Papp, Joseph, 1306
Patterson, Willi, 1780
Perier, Jean Marie, 1770, 1916
Perweiler, Gary, 1685
Petermann, Fred, 1830, 1850
Piccolo, Jack, 1889, 1913
Pierce, Erik, 1307
Pittelli, Patrick, 1697
Pytka, Joe, 1798, 1806, 1815

Quartly, Robert F., 1887

Randall, Bill, 1714
Redfield, Richard, 1917
Regan, Bob, 1853
Rieker, Manfred, 1739
Roizman, Owen, 1790
Roll, James, 1542
Ruch, Sandra, 1311
Russell, Patrick, 1777

Saarinen, Eric, 1640, 1764, 1768
Sandbank, Henry, 1653, 1726, 1734, 1749, 1764, 1771, 1773, 1778, 1795, 1829, 1832, 1840, 1844, 1851, 1875
Satterwhite, Audrey, 1884
Schrom, Michael, 1639, 1893
Schulberg, Jay, 124, 130
Scott, Ridley, 1787
Scott, Tony, 1665, 1788, 1804
Sedelmaier, Joe, 1733, 1755, 1757, 1811, 1846, 1870
Sharp, Ivor, 1831
Silverberg, Gene, 763
Smith, Lee, 1660, 1728
Sobocienski, Frank, 1897
Sokolsky, Melvin, 1801, 1812, 1852
Sorensen, Dick, 1794
Soukup, Frank, 1711
St. Clair, John, 1717, 1738, 1746
Steigman, Steve, 1644, 1692, 1740
Steinhauser, Bert, 1645, 1826, 1827
Stone, Dick, 1725
Story, Mark, 1658, 1735, 1848
Sugden, Andy, 1876

Takahashi, Drew, 1908
Tardio, Neil, 1825, 1867, 1701
Teitelbaum, Bill, 1836
Tench, Diane Cook, 1711
Tompkins, Douglas R., 923
Turner, Peter, 1914

Ulick, Michael, 1643, 1659, 1761, 1829, 1834, 1855, 1863, 1875, 1879

Van Dusen, Bruce, 1779
Van Dyke, John, 652, 660, 733
Van Lint, Derek, 1871
Vogt, Donna, 91, 102

Wallach, Peter, 1636
Ward, Rudy, 1896
Watkins, George, 1886
Watt, Graham, 1831
Weller, Don, 1165
Weller, Jim, 1744, 1852, 1898
Werk, Michael, 1681, 1840
Whalen, Susan, 820, 825, 1027, 1062

Wieder, Laurance, 1161
Wilkerson, Haines, 593

Young, Eric, 1705, 1743
Yustein, Mark, 1744

Zeek, Paul W., 938

PRODUCERS

Aldoretta, Warren, 1893, 1899
Alkens, Cindy, 1827
Allen, Bill, 1728
Artope, Bill, 1674
Ashby, Charles, 1752
Axthelm, Nancy, 1858

Baker, Judy, 1705
Barden, Jane, 1742
Bass, Gary, 1707, 1860
Benson, Howard, 1790
Berke, Richard, 1637, 1735, 1841
Bern, Marion, 1856
Birbeck, Cindy, 1721
Birbeck, Sue, 1871
Birch, Michael, 1750
Blouin, Louise, 1856
Blum, Arnie, 1753, 1754, 1882
Borzi, Matthew, 1718, 1723
Bowlus, Craig, 1719, 1817
Bozell & Jacobs, 1846
Brafman, Marcy, 1908
Braun, Gaston, 1698, 1767, 1874
Brittle, Regina, 1909
Buono, Al, 1922

Calhoun, Susan, 1647, 1659, 1834
Camp Assoc. Adv., 1888
Carter, Judy, 1695, 1743, 1758, 1802, 1848
Caruso, Patricia, 1860
Cassidy, Craig, 1814
Cavanaugh, Steve, 1779
Chanticleer Press, 1196, 1198
Cherchevsky, Marianne, 1893
Chiafullo, Susan, 1729
Clark, Alan, 1755
Collins, Janet, 1684
Columbia Pictures, 1917, 1920
Conacher, Candace, 1888
Constable, John, 1676
Cook, Marilyn, 1842
Coverdale, Jac, 1895

Davidoff, Joe, 1688, 1894
Davis, Johnson, Mogul & Colombatto, 1830
DeBarros, Jim, 1746, 1771, 1829, 1875, 1643, 1681
Dein, Robert L., 1713, 1803
Diglio, Joanne, 1845
Disalvo, Frank, 1656, 1658
Dorfman, Pat, 1644, 1692
Dorger, Helmut, 1840
Durkin, Rich, 1733
Dyke, David, 1690

Ebel, Regina, 1667, 1780
Eggers, Bob, 1684
Eha, Michael, 1744
Elliot, Mootsy, 1871
Epstein, Ellyn, 1739

Faxon, Ann, 1778, 1795

Fernandez, Ben, 1648, 1800
Field, Marilyn, 1691
Finucane, Ann, 1696, 1815
Fischgrund, Jeff, 1652, 1655, 1885
Flint, Roger, 1805
Frahm, Paul, 1648, 1800
Frankel, David, 1792
Frere, Tony, 1791, 1809
Friedman, Jill, 1747
Fritzson, Sherri, 1813, 1816

Galton, Jean, 1790
Gayle, Darry, 1708
Gelbar, Stephen, 1921
Gelbaum, Dennis, 1662, 1789
Gerber, Mindy, 1776, 1818
Giarratano, Casey, 1886
Gibson, Greg, 1838, 1849
Gilliland, Mike, 1732
Godman, Jo, 1788, 1804
Gold, Paul, 1794
Goldberg, Lois, 1679, 1842
Goldberg, Mindy, 1727
Gomes Loew, 1841
Gordon, Jill, 1660, 1876
Gordon, Angie, 1772
Grayson, Cathy, 1715
Greenberg, Harvey, 1821
Groubman, Roberta, 1639
Guy, Don, 1678, 1683

Hall, Herb, 1757
Harrower, Jack, 1722
Hart, Carrie, 1816
Hathorn, Polly, 1886
Hayes, Timothy, 1816
Herdlick, Jan, 1710
Hines, Maggie, 1742, 1799
Hirsch, Jackie, 1706, 1709
Hoekstra, Pete, 1912
Hoogenakker, David, 1635, 1640, 1768
Horn, Sid, 1759, 1859
Howard, Sharon, 1909
Howell, Kimball, 1772
Hudson, Russel, 1653

Imbarato, Donna, 1645

January, Debora, 1757
Jarrard, Lisa, 1820
Johnson, Dane, 1693, 1808
Johnston, Carmon, 1853
Jones, Christine, 1796
Judd, Carolyn, 1852, 1898

Kahn, Laurie, 1823, 1824
Kamen, John, 1778, 1795, 1851
Katz, Enid, 1865
Kaufman, Jean-Claude, 1843
Kaye, Lenny, 891
Keeve, Elaine, 1738
Kennard, Ed, 1703
Keyser, Mindy, 1732
Kidder, Charlene, 1797
Kidman, Louise, 1677
Kim, Jinny, 1639, 1778, 1795
King, Debbie, 1638, 1760, 1880
Kitch, Chris, 1850
Kramer, Linda, 1748
Kramer, Liz, 1863
Krauss, Elizabeth, 1731
Krauss, Sally, 1850
Kreeger, Jerry, 1756
Krivacsy, Ray, 1850
Kuperman, Lewis, 1717
KYW-TV, 1918

PRODUCTION COMPANIES

ARTISTS

AGENCIES

PUBLISHERS

CLIENTS

PUBLICATIONS

When you're asking tough questions, Crafton is the best answer.

Choosing the best printer and getting the best quality and service means putting yourself to the test.

Technology Who has the best trained personnel and state-of-the-art equipment?

Quality Control Who has the best quality assurance program of any printer?

Cost Control Who is best known for delivering jobs within the quoted cost?

Scheduling Who has the best reputation to consistently deliver on time?

Precision Who is best known for printing the really tough jobs?

Back-up Who has the best people to handle your production details?

Location Who has the most convenient location?

Reputation Who turns out the best work and wins the most awards year after year?

CRAFTON
Simply the Best.

Crafton Graphic Co., Inc.
229 West 28th Street
New York, NY 10001
(212) 736-3143